BYZANTIUM

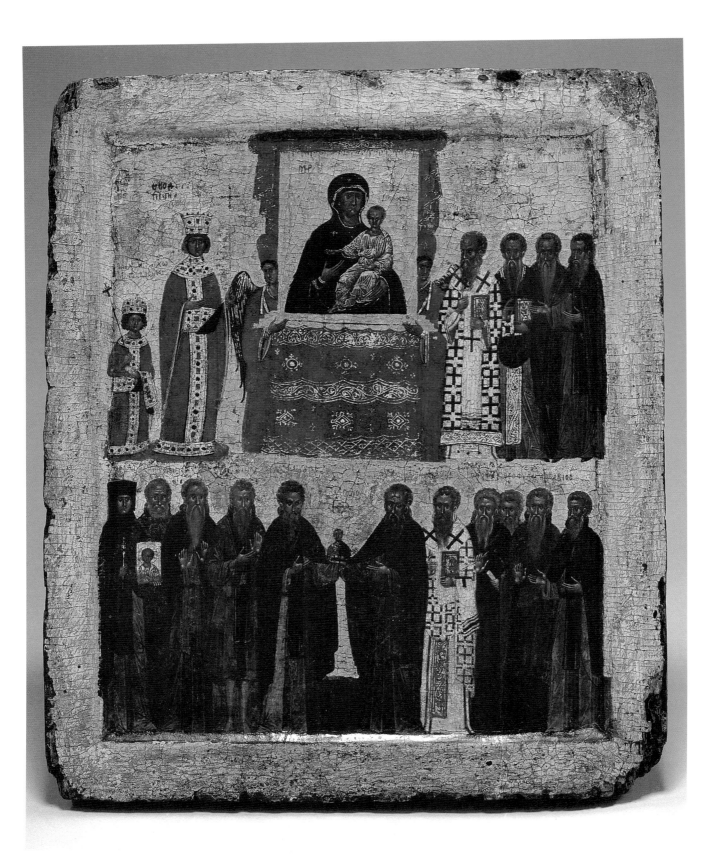

BYZANTIUM

Treasures of Byzantine
Art and Culture
from British Collections

Edited by David Buckton

Published for the Trustees of the British Museum
by British Museum Press

Front cover: Detail of Icon of St John the
Baptist (no. 206)

Back cover: Ivory panel with archangel (no. 64)

Frontispiece: Icon of the Triumph of Orthodoxy
(no. 140)

© 1994 The Trustees of the British Museum
Published by British Museum Press
A division of British Museum Publications Ltd
46 Bloomsbury Street, London WC1B 3QQ

A CIP record for this book is available from the
British Library

ISBN 0–7141–0577–5 (cased)
 0–7141–0566–X (paperback)

Designed by James Shurmer

Phototypeset in Sabon
by Southern Positives and Negatives (SPAN),
Lingfield, Surrey

Printed in Great Britain by Butler & Tanner Ltd,
Frome and London

Contents

Contributors

DMB Donald Bailey, British Museum

DB David Buckton, British Museum

BJC Barrie Cook, British Museum

RC Robin Cormack, Courtauld Institute of Art

KRD Kenneth Rainsbury Dark, Cambridge University

AE Anthony Eastmond, Courtauld Institute of Art

CJSE Christopher Entwistle, British Museum

VF Valika Foundoulaki, Courtauld Institute of Art

ZG Zaga Gavrilović, University of Birmingham

HG-T Hero Granger-Taylor, British Museum

RKL Rowena Loverance, British Museum

JL John Lowden, Courtauld Institute of Art

MMM Marlia Mundell Mango, Ashmolean Museum

SMcK Scot McKendrick, British Library

MAM Michael Michael, Christie's Education

LS Luke Syson, British Museum

MV Maria Vassilaki, University of Crete

JW Jonathan Williams, British Museum

PW Paul Williamson, Victoria and Albert Museum

Foreword

On behalf of the Trustees of the British Museum, I am pleased to introduce this catalogue describing over 250 treasures of Byzantine art and culture from more than thirty collections in the United Kingdom. The carefully chosen objects, brought together for the first time, span the eleven centuries or so between the foundation of the Byzantine capital Constantinople in the fourth century AD and its fall to the Ottoman Turks in the fifteenth. The vast extent of the late Roman Empire and its successor, Byzantium, is represented by finds from as far apart as Britain and Egypt, and Spain and the Crimea.

Previous Byzantine exhibitions in Britain, *Masterpieces of Byzantine Art* at the 1958 Edinburgh Festival and at the Victoria and Albert Museum and *The Byzantine World* at Chichester District Museum in 1978, were both strongly supported by the British Museum, which has one of the finest collections of Early Christian and Byzantine antiquities to be seen anywhere. From the National Icon Collection, housed in the BM, we lent to the Royal Academy of Arts exhibition *From Byzantium to El Greco: Greek Frescoes and Icons* in 1987.

This time we are the hosts, and my thanks and those of the Trustees go to all the institutions and individuals who have supported us by lending their treasures. We thank the scholars who have chosen the exhibits and contributed to this catalogue: their efforts are greatly appreciated. The generosity of the Hellenic Foundation in London and the Foundation for Hellenic Culture in Athens in supporting the educational programme centred on this exhibition is also gratefully acknowledged.

<div align="right">

Dr R. G. W. Anderson
Director, British Museum

</div>

Lenders

Birmingham, Barber Institute of Fine Arts (University of Birmingham): 34 (courtesy of the Barber Institute, the University of Birmingham)

Cambridge, Fitzwilliam Museum: 3, 63, 144, 154, 182 (by permission of the Syndics of the Fitzwilliam Museum)

Cambridge, Gonville and Caius College: 197 (courtesy of the Master and Fellows of Gonville and Caius College, Cambridge)

Cambridge, University Library: 196, 208 (by permission of the Syndics of Cambridge University Library)

Durham Cathedral, The Dean and Chapter: 139 (courtesy of the Dean and Chapter of Durham)

Edinburgh, National Museums of Scotland: 35 (courtesy of the Trustees of the National Museums of Scotland)

Glasgow, University Library: 193 (by permission of the Librarian, Glasgow University Library)

Ham, Keir Collection: 50, 138 (photographs courtesy of the Keir Collection)

Liverpool, National Museums and Galleries on Merseyside, Liverpool Museum: 43, 54, 62, 152, 155 (by permission of the Board of Trustees of the National Museums and Galleries on Merseyside)

London, Bank of England Museum: Coins appendix, section 1: 5 (lent courtesy of the Governor and Company of the Bank of England)

London, British Library: 66, 67, 68, 69, 70, 71, 132, 145, 146, 147, 150, 167, 168, 169, 176, 179, 180, 181, 192, 194, 198, 207, 210, 218, 219, 233, 234 (by permission of the British Library Board)

London, Paul Hetherington: 188b (drawing by James Farrant and Lisa Reardon, British Museum)

London, Michael Peraticos: 228 (photograph by James Rossiter, British Museum)

London, Science Museum: 53 (courtesy of the Board of Trustees of the Science Museum)

London, Society of Antiquaries: 231 (lent by kind permission of the Society of Antiquaries of London; photograph by Saul Peckham, British Museum)

London, University College, Petrie Museum of Egyptian Archaeology: 85 (lent courtesy of the Petrie Museum; drawing by Lisa Reardon, British Museum)

London, Victoria and Albert Museum: 60, 73, 104, 111, 136, 141, 156, 166, 171, 185, 220, 226, 235 (courtesy of the Board of Trustees of the Victoria and Albert Museum)

Lower Kingswood, Church of the Wisdom of God: 42, 92, 93, 211 (lent courtesy of the Parochial Church Council of St Andrew's, Kingswood; photographs reproduced by permission of the Courtauld Institute of Art)

Luton, Wernher Collection, Luton Hoo Foundation: 157 (courtesy of the Wernher Collection, Luton Hoo Foundation)

Manchester, John Rylands University Library: 195 (by permission of John Rylands University Library of Manchester)

Manchester, Whitworth Art Gallery: 137 (by permission of the Whitworth Art Gallery, University of Manchester)

National Trust, Polesden Lacey: 199, 223 (lent courtesy of the National Trust, Polesden Lacey; photograph of no. 199 courtesy of the National Trust, no. 223 courtesy of the National Trust Photographic Library/Derrick E. Witty)

Oxford, Ashmolean Museum: 25, 37, 39, 51, 77, 94, 103, 161, 175, 189, 216, 217 (by permission of the Visitors of the Ashmolean Museum)

Oxford, Bodleian Library: 148, 149, 170, 178 (lent by permission of the Curators of the Bodleian Library, Oxford; photographs reproduced by permission of the Bodleian Library)

Oxford, Christ Church: 177, 209 (courtesy of the Governing Body of Christ Church, Oxford)

Oxford, Pusey House: 9c, 23 (lent courtesy of the Principal and Chapter of Pusey House, Oxford; photographs courtesy of the Ashmolean Museum, where the objects are usually exhibited)

Windsor Castle, The Dean and Canons of Windsor: 236 (lent courtesy of the Dean and Canons of Windsor; photograph by Simon Tutty, British Museum)

Worthing, Museum and Art Gallery: 21 (by permission of the Curator of Worthing Museum)

Private collections: 72, 114, 224, 227, 230 (photographs of nos 72, 224 and 230 courtesy of the lenders; photographs of nos 114 and 227 by Simon Tutty, British Museum)

British Museum items come from the collections of the Department of Medieval and Later Antiquities (BM, M&LA), with the following exceptions: Department of Coins and Medals (BM, CM): 28, 61, 232; Department of Egyptian Antiquities (BM, EA): 38, 112, 121; Department of Greek and Roman Antiquities (BM, GRA): 18, 19, 20, 22, 40, 41; Department of Prehistoric and Romano-British Antiquities (BM, PRB): 4, 15, 16.

Acknowledgements

Committee of Honour

It is a source of pride and satisfaction that a number of distinguished scholars, most of them closely associated with the British Museum, have given encouragement and support to this project: Professor Hugo Buchthal, Professor Ernst Kitzinger, the Viscount Norwich, Professor Sir Dimitri Obolensky and the Hon. Sir Steven Runciman. Tamara Talbot Rice provided a valued link between this Byzantine exhibition and the one organised by her husband in 1958; sadly, she did not live to see the results of her advice and guidance, and this catalogue is dedicated to her memory.

Acknowledgements

The education programme associated with this exhibition has been funded by the Hellenic Foundation, London, and the Foundation for Hellenic Culture, Athens. Their generous backing is gratefully acknowledged.

A year ago the exhibition *Byzantium: Treasures of Byzantine Art and Culture* had not even reached the planning stage, and, for various reasons, work on it and its catalogue could not begin until ten months before the exhibition opened. The compressed timetable imposed enormous demands on everyone involved, and I am immensely grateful for the forbearance and help received from private lenders and from the staff of lending institutions, whether directors, keepers, librarians, curators, registrars, conservators or photographic personnel. The British Library is our principal lender, and I am especially indebted to Janet Backhouse, Scot McKendrick, Shelley Jones and Michael Boggan.

The effort put into this exhibition by colleagues in the British Museum is greatly appreciated. The Department of Coins and Medals, the Department of Conservation, the Design Office and the Photographic Service, as well as British Museum Press, were especially heavily involved. Barrie Cook and Jonathan Williams relieved me of all responsibility for coins, and I am particularly grateful to them and to Allyson Rae (Conservation), Caroline Ingham (Design) and Alan Hills and Peter Stringer (Photographic) for their quite exceptional industry. My greatest debt is to my research assistant, Christopher Entwistle; for a time, also, I was fortunate in having a special assistant, Elena Angelidis, and two voluntary assistants, Marika Leino and Sophie Anagnostopoulos.

The contributors to this catalogue deserve special acknowledgement, often for advising on the choice of exhibits as well as making time in extremely demanding professional lives to write the catalogue entries. I also thank Mr and Mrs Costa Carras, Anthony Cutler, Robert Perrin, Emmanuel Stavrianakis and family, Nicholas Talbot Rice and family, Edmund de Unger and David Whitehouse.

That this catalogue appeared in time for the opening of the exhibition, or indeed at all, is due to Nina Shandloff, of British Museum Press, who shouldered a near-impossible task with unfailing drive and (seldom failing) good humour.

David Buckton

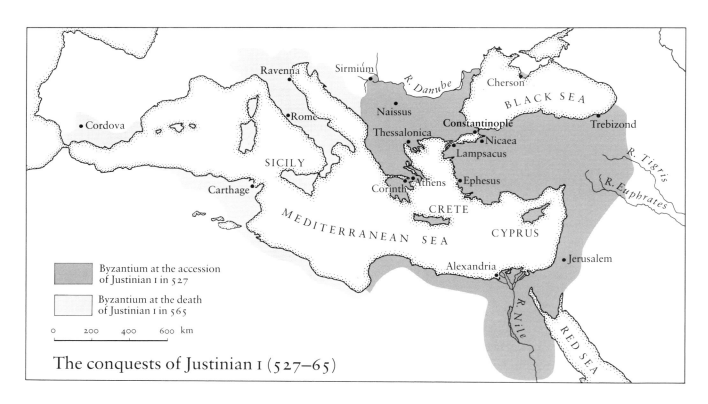

The conquests of Justinian I (527–65)

Byzantium at the accession of Justinian I in 527

Byzantium at the death of Justinian I in 565

0 200 400 600 km

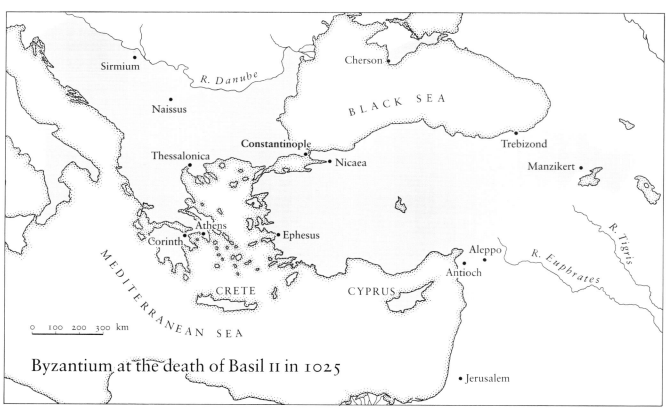

Byzantium at the death of Basil II in 1025

0 100 200 300 km

Introduction

In 1860 the chairman of the Select Committee on the British Museum, questioning Antonio (later Sir Anthony) Panizzi, the museum's Principal Librarian, prompted: 'You have also, I imagine, Byzantine, Oriental, Mexican and Peruvian antiquities stowed away in the basement?' 'Yes', replied Panizzi, 'a few of them; and, I may well add, that I do not think it any great loss that they are not better placed than they are.'

Byzantine antiquities were rescued from the BM basement largely through the scholarship of O. M. Dalton, of the Department of British and Mediaeval Antiquities and Ethnography. Dalton wrote on everything from flint tools and weapons to post-Renaissance *objets d'art*, but he is remembered by Byzantinists for his *Catalogue of Early Christian Antiquities and Objects from the Christian East . . .* (1901), *Byzantine Art and Archaeology* (1911) and *East Christian Art* (1925). These were truly pioneering works and represented immense labour: ploughing the Byzantine furrow, he later remarked, had left him permanently stooped.

It was not until 1958, however, all but a century after Panizzi's dismissive remark (the Principal Librarian was a native of Modena, which is, of course, famous for its vinegar), that Britain had its first Byzantine exhibition, *Masterpieces of Byzantine Art*, at the Edinburgh Festival and subsequently at the Victoria and Albert Museum in London. The exhibition was the creation of David Talbot Rice; John Beckwith, of the V&A, collaborated with him on the catalogue. Since then, *The Byzantine World* at Chichester District Museum in 1978, *The Treasury of San Marco, Venice*, at the British Museum in 1984 and *From Byzantium to El Greco: Greek Frescoes and Icons* at the Royal Academy in 1987 have attracted the interest of the British public and kept Byzantine antiquities out of museum basements.

The present exhibition is intended to show the richness and diversity of the art and culture of Byzantium – the name given to the Byzantine Empire – from the inauguration of its capital Constantinople (present-day Istanbul) on 11 May 330 to the capture of the city by the Ottomans on 29 May 1453. In the course of the fourth century, Constantinople gradually replaced Rome as the administrative centre of the Roman Empire, and in 476 the fall of Rome left the eastern city as the undisputed imperial capital. In the reign of Justinian (527–65) the empire reached its fullest extent since Roman times, and Byzantine art enjoyed its first golden age. It had become very much a religious art, and a theological controversy over the admissibility of religious images eventually resulted in Iconoclasm, which lasted – with one break – from 730 to 843. Once Iconoclasm had been defeated and the ban on religious images lifted, Byzantine art entered another glorious phase: the later ninth, tenth, eleventh and twelfth centuries saw the creation of some of its greatest masterpieces, which were regarded with awe by the rest of Europe. There was envy as well as awe: in 1204 the Fourth Crusade abandoned its objective, to drive the Saracen from the Holy Sepulchre in Jerusalem, and instead attacked and looted the greatest city in Christendom. Constantinople remained under Western control until 1261. Once the Byzantines had re-established their rule, the scene was set for a final magnificent revival of the arts under the Palaeologan dynasty. Political and military endeavours were far less impressive, however, and Constantinople eventually fell to the Ottoman sultan, Mehmet II, in 1453.

The exhibits range in date from a silver dish of 317 (no. 1), commemorating the tenth anniversary of the Emperor Licinius, whom Constantine I (306–37), the founder of Constantinople, was to overthrow seven years later, to a document issued by Mehmet the Conqueror on 1 June 1453, three days after the fall of Constantine's city (no. 234). The objects in the exhibition, all of them chosen from British collections, also reveal links between Byzantium and Britain, which was still a Roman province when Constantine – who had been proclaimed emperor in York – founded the city that was to bear his name. They include silverware (nos 16, 52 and 74) from two sites in Suffolk (one of them the famous ship-burial at Sutton Hoo), a glass flask from an Anglo-Saxon grave in Sussex (no. 21), a bronze cross from a field in Cambridgeshire (no. 144), and silks from the tombs of St Cuthbert in Durham Cathedral and Edward the Confessor in Westminster Abbey (nos 139 and 166). Other exhibits are witness to the fascination which

Byzantium – the name is taken from the ancient town supplanted by Constantinople – has continued to exercise in more modern times: an icon which belonged to John Ruskin (no. 229), for instance, manuscripts collected by Robert Curzon (nos 179, 198 and 210), and architectural sculpture brought to Britain and placed in a Byzantine-plan church in Surrey (nos 42, 92, 93 and 211).

The objects in the exhibition have not been chosen primarily to illustrate over eleven hundred years of Byzantine history, and the complex historical background has been only sketchily indicated (suggestions for further reading are given below). Neither are the exhibits intended to represent the vast extent of Byzantium, at one time reaching from northern Italy to Egypt and from the Strait of Gibraltar to the Caucasus. Each object has been chosen on its own merits, as worthy of being seen and capable of speaking for itself; as part of the material remains of Byzantium, however, each one may contribute to the understanding of a story set in imperial palaces and desert monasteries, in busy trading ports and hermits' caves, and on battlefields and sites of pilgrimage – a story embracing more than a millennium and much of the civilised world.

Suggestions for introductory reading

J. M. Hussey, *The Byzantine World*, London (Hutchinson's University Library), 1957; P. Whitting (ed.), *Byzantium: an introduction*, Oxford (Basil Blackwell), 1971; S. Runciman, *Byzantine Style and Civilization*, Harmondsworth (Pelican Books), 1975; C. Mango, *Byzantium: The Empire of New Rome*, London (Weidenfeld and Nicolson), 1980; P. Hetherington, *Byzantium*, London (Orbis Publishing), 1983; R. Loverance, *Byzantium*, London (British Museum Press), 1988; A. P. Kazhdan, A.-M. Talbot, A. Cutler, T. E. Gregory and N. P. Ševčenko (eds), *The Oxford Dictionary of Byzantium*, 3 vols, New York–Oxford (Oxford University Press), 1991; A[veril] Cameron, *The Later Roman Empire*, London (Fontana), 1993; L. Rodley, *Byzantine Art and Architecture: an introduction*, Cambridge (Cambridge University Press), 1994. All have bibliographies for further reading.

Byzantine coinage

Barrie Cook and Jonathan Williams

The coinage of the Late Roman and Early Byzantine period was firmly based on the empire's gold issues. The solidus (or, in Greek, nomisma) was introduced by Constantine the Great at seventy-two to the Roman pound (thus weighing 24 carats, or 4.55 g). It retained the same general size, weight and fineness well into the tenth century, for most of that period retaining an importance well beyond the bounds of the empire as the predominant trade coin of the Mediterranean region. From the death of Theodosius I (397) gold was normally a monopoly of the Constantinople mint in the east, though gold coin was produced in quantities by the Byzantine mints of Italy, Sicily and North Africa after Justinian's reconquests.

The design of the solidus changed from a profile bust to a three-quarter facing bust in the late fourth century, and to a full facing bust in the sixth century, with occasional full-length or enthroned figures of the emperor. The normal reverse design of the solidus also changed, from a female Victory to a male angel or a cross on steps, indicating the increasing influence of Christian iconography on the coinage.

Emperors increasingly came to include their heirs and co-emperors on the coinage, and also depicted other family members and their own immediate predecessors in order to emphasise dynastic continuity of succession. This sometimes led to several figures being portrayed on both obverse and reverse. Justinian II (685–95, 705–11) introduced the image of Christ to the solidus, displacing the imperial image to the reverse. The practice was renewed under Michael III (842–67), marking the defeat of Iconoclasm and a revival of religious art, and it was thereafter a normal feature of the coinage.

Fractions of the solidus, the half (semissis) and third (tremissis), were struck, though their long unchanging design (retaining a profile portrait up to the late seventh century) would appear to assign them a secondary importance. They ceased to be struck for regular use in the east under Leo III (717–41) but survived in output of the Italian mints until the Lombard conquests of the 740s and 750s. (In Sicily Byzantine power, and the mint at Syracuse, survived until the Arab conquest of 878.)

The sizeable issue of silver coin in the Byzantine empire was relatively infrequent. However, the hexagram was struck in quantity in the first half of the seventh century, and the milaresion, introduced by Leo III (717–41), was produced until the later eleventh century, its principal design being simple: a cross on steps and the imperial names and titles across the field.

The bronze coinage of the later Roman empire dwindled dramatically in size until it was confined to a coin of about 5 mm in diameter. In about 498 Anastasius had introduced a new series of copper denominations to replace these, large multiple pieces representing 5, 10, 20 and 40 nummi, the

last-named being known as the follis. The value in nummi was indicated on the reverse designs by Greek letters: M for 40, K for 20, I for 10 and E for 5. The obverse design changed from a profile bust to a facing bust in the sixth and early seventh centuries.

From the time of the Anastasian reform, copper coin was struck at several mints in the east besides Constantinople, principally Alexandria, Antioch, Cyzicus, Nicomedia and Thessalonica, until they ceased to operate in the early to mid seventh century following the Arab conquests. The copper coinage dwindled both in size of coin and in denominations issued, until by the mid eighth century only the follis was left. From the reign of John I (969–76) to Alexius I's reform of 1092, the follis was anonymous, bearing legends and designs of a purely religious nature.

During the seventh century the inscriptions on coins began a long transition from the use of Latin to Greek, and the titles used for the emperor changed, first from 'Augustus' to 'Basileus', then to 'Basileus Romaion'. In the eighth century 'Despot' began to be used and became general from the eleventh century.

In the reign of Nicephorus II (963–9) the solidus was divided into two distinct forms. One, known as the histamenon nomisma, preserved the ancient standards, although it became broader and thinner in shape and from the 1040s was distinctly concave. The other, the tetarteron nomisma, was lighter in weight but remained smaller and thicker, preserving the appearance of the original coin. From the 1030s both series were subject to debasement, breaking seven centuries of stability. The fineness fell in stages from 24 to 8 carats by the reign of Nicephorus III (1078–81).

A major reform was needed and in 1092 Alexius I Comnenus created a new monetary system based on the gold hyperperon, a coin of the same weight as the old nomisma but $20\frac{1}{2}$ carats fine. The concave form of the eleventh-century gold was retained and also used for the subordinate denominations in electrum ($=\frac{1}{3}$ hyperperon) and billon ($=\frac{1}{48}$ hyperperon initially, though debased to $\frac{1}{184}$ under Manuel I). Under the Comnenans and Angeli, the emperor alone of the imperial family appeared on the coinage, though some variety was provided by the number of saints who joined Christ and the Mother of God in coin designs. Those used were the leading military saints: George, Theodore, Demetrius, Michael and the canonised Constantine the Great.

The hyperperon survived through the Comnenan period and was also struck by the emperors of Nicaea, though it

appears that under the latter its fineness fell to 16–17 carats. This decline continued in the restored empire until the Byzantine gold coinage came to an inglorious end in the third quarter of the fourteenth century. The last gold issues normally carried an obverse design of the Mother of God praying within the walls of Constantinople, with the emperor, often supported by Christ or a saint, on the reverse. The hyperperon survived in name as a unit of account and as silver coinage of poor style, supported by a varied series of copper issues, until the empire's extinction in 1453.

Byzantine silver
Marlia Mundell Mango

Silver plate made in the Empire between 300 and 700 was of high purity (generally between 92 and 98 per cent) and good craftsmanship. Most plate was of hammered body with any attachments possibly cast. Decorative techniques included repoussé, chased and applied relief work, openwork, engraved and niello-inlaid work, gilding, punched beading and other ornament. Written sources refer to imperial objects incorporating gems, other precious stones and pearls. Domestic plate (plates, spoons, ewers, basins, lamps, etc.) continued to be made until at least the mid seventh century. Specific items of church plate (chalice, paten) were introduced by the fourth century at the latest. Traditional mythological subjects continued to decorate silver until the mid seventh century. Contemporary themes (relating, for example, to the hunt) appeared by the fourth century as did, eventually, overtly Christian symbols (e.g. the cross) as ornament on domestic plate. Decoratively inscribed texts were common on state, domestic and church plate. Some types of silver, notably plates and spoons, became increasingly large and heavy after about 300. Between the early fourth century and the mid seventh, some plate was marked with control-stamps, the texts of which are mostly in Greek; by the year 500 they were of some complexity. The precise significance of the stamps is unclear; scientific analysis has demonstrated that stamped and unstamped silver are generally of equal purity. Whatever their intended purpose, the stamps incorporating the names of emperors provide a fairly precise date.

Judging by surviving objects and references in written sources, medieval Byzantine silver plate continued the earlier traditions of craftsmanship, apparently applied to

many of the same types of object. Church plate (often incorporating other materials such as carved precious stones, enamels and gems) accounts for most extant examples (for example those preserved in San Marco, Venice), but texts prove that domestic plate was still produced. Whether it was ornamented with mythological characters similar to those on tenth-century ivory caskets is a matter of speculation.

With two exceptions (nos 35 and 51), the objects in this catalogue belong to the British Museum, which has the world's largest collection of Late Antique silver; unfortunately there is no medieval Byzantine silver in British public collections. Attested find-spots, combined with stamps and inscriptions on the objects themselves, provide valuable information about the origin and destination of silver plate in this period. Only the small plate in the Ashmolean Museum (no. 51) and, possibly, no. 134 are without provenance. Fortunately for scholarship, the find-spots of the other objects are known. The silver found at Traprain Law in Scotland (for example no. 35) lay beyond Roman frontiers. Altogether, the find-spots illustrate both the extent of the empire and the ubiquity of plate. Included here is silver from Rome (the Esquiline Treasure, nos 10–14), northern Africa (the Carthage Treasure, no. 36), Syria (the Kaper Koraon Treasure, no. 95), Cyprus (the 'first' Cyprus Treasure, nos 96 and 135), Asia Minor (the Lampsacus Treasure, nos 76 and 133; the Eros dish, no. 75), Illyricum, now Serbia (the Naissus find, no. 1), and Britain (the Water Newton Treasure, no. 4, the Mildenhall Treasure, no. 16, the Corbridge find, no. 15, and the Sutton Hoo ship-burial, nos 52 and 74).

With regard to their ancient origin, control-stamps on six of the exhibited objects indicate their places of manufacture, extending over four centuries: at Naissus in 317 (no. 1), in an unidentified eastern city in the fifth century (no. 51), in Constantinople between 491 and 518 (no. 52), between 527 and 565 (no. 76) and between 578 and 582 (no. 96), and, possibly, at Tarsus in Cilicia between 641 and 651 (no. 135). A pounced Latin weight-inscription on another object (no. 15) suggests an origin in the Western Empire, while engraved Greek inscriptions (literary and dedicatory) on other silver (nos 95, 133 and 134) point to an eastern source. An owner's Greek name scratched in Greek could mean that other examples (nos 16 a–b) were acquired in the East.

The portability of silver plate is well demonstrated from this information. Although the Naissus dish was found where it was made, objects stamped and made in Constan-

tinople have been discovered in modern times in Britain (no. 52), Asia Minor (no. 76) and Cyprus (no. 96). Other objects probably made in the Mediterranean region have likewise found their way to Britain (nos 15, 16, 35 and 74), much as other objects stamped in Constantinople in the sixth and seventh centuries have been found in northern Russia. Other objects (nos 10–14, 36, 75 and 95), like the Naissus dish, may have been made nearer to where they were eventually found.

Late Antique and Early Byzantine silver can be roughly divided into three main categories according to decoration or function, or both: state, domestic and church plate. The Naissus plate, the Esquiline tyches and, possibly, the Sutton Hoo plate decorated with tyches (nos 1, 13, 14 and 52) were official or state objects. Domestic plate is well represented here by what may have been display objects with either 'pagan' subjects (the plates illustrating the shrine of Apollo on Delos, pairs of Dionysiac figures, Eros and a *ketos*, nos 15, 16 and 75) or Christian ones (the bowl with a military saint, no. 135). The spoons and knife-handle are ornamented with literary texts to amuse (nos 133 and 134). Other utilitarian domestic objects are decorated with neutral subjects (the patera with a frog and the basin with a female bust, nos 36 and 74), with a Christian symbol (the plate with a cross, no. 96), or are undecorated (the small plate and the lamp-stand; nos 51 and 76). The ewer with scriptural subjects in relief (no. 35) may be either domestic or ecclesiastical, but the votive inscription on the chalice clearly identifies it as church plate (no. 95).

Byzantine weights
Christopher Entwistle

The metrological (or measuring) system employed throughout much of the Byzantine period was a duodecimal one. The linchpin of this system was the Byzantine pound or *litra*, derived from the Late Roman pound. The *litra* was in turn divided into twelve ounces or 72 solidi: the solidus, later known as the nomisma, was the standard gold coin introduced by Constantine the Great and current for hundreds of years thereafter. Imperial legislation of the fourth century records that 72 solidi were struck to the pound. The theoretical weight of the solidus is taken by numismatists to be 4.55 g, thus giving a weight for the Late Roman pound of 327.60 g. In reality the weight of both the solidus and the pound fluctuated. The most recent study of Byzantine

metrology suggests a figure for the latter of about 324 g from the fourth to the sixth century, 322 g in the sixth and seventh centuries, 320 g from the seventh to the ninth century, 319 g between the ninth and the beginning of the thirteenth century, and subsequently declining below 319 g. Even these figures should be treated with caution: the British Museum possesses a number of one-pound weights, dating from between the fourth and seventh centuries, which suggest much lower figures.

Although literally thousands of Byzantine weights are preserved in various museum collections, establishing a reliable and precise chronology for them, given the lack of archaeological, epigraphical and textual evidence, has proved elusive. Three materials were employed in the manufacture of Byzantine weights: copper-alloy, glass and, more rarely, lead. Most copper-alloy weights were cast in three shapes: a doubly truncated sphere, a square, and a disk. The limited evidence suggests that the spheroidal type, derived from first-century BC Roman stone weights, was the predominant form from the first century AD until well into the fourth. Gradually it was superseded by the square type, which was in turn replaced by the discoid weight in the latter half of the sixth century. If the stratigraphy at the site of Corinth is to be believed, discoid weights were still being produced as late as the twelfth century.

Typologically, most copper-alloy weights fall into the category of 'miscellaneous'. Although all are inscribed with denominations based on the pound, the ounce or the solidus and their respective multiples and divisions, a great variety of secondary motifs were employed in their decoration. Inlays of silver and pure copper were also used to embellish their appearance. Perhaps the most striking Byzantine weights to have survived are the 'imperial' weights issued in the late fourth and fifth centuries. These are defined by the presence of two or more imperial figures, with attendant regalia, often standing in juxtaposition with tyches or involved in symbolic hunt-scenes (nos 31–3); alternatively, they may be depicted as busts within a victory wreath. Most employ additional symbols or motifs, many derived from Late Roman coinage, to propagandise the legitimacy and stability of the state and to guarantee their validity as 'honest weights'.

Needless to say, fraud was endemic in the Byzantine period, and imperial legislation recommended ferocious punishments for malefactors. The administration of weights and measures devolved to a number of officials. Novel CXXVIII of Justinian, dated to 545, states that commodity weights were the responsibility of the praetorian prefects and coin weights of the *comes sacrarum largitionum*; weights which had previously been kept in post-stations were now 'to be preserved in the most holy church of each city'.

Another official responsible for the issuing of weights was the Prefect of Constantinople. Although by the Middle Byzantine period, according to the Book of the Prefect, his jurisdiction had spread much wider, his responsibility during much of the sixth century appears to have been limited to the control of glass weights. Byzantine glass weights are generally discoid in shape, the majority of them stamped with monograms or inscriptions relating to the prefect of the capital (and probably to provincial eparchs also). Glass had obvious advantages as a material for weights: it was cheap to manufacture, readily detectable if tampered with, and, unlike its metal counterparts, not liable to oxidation or corrosion.

The function of these glass disks has occasionally been disputed on the grounds that they do not correspond exactly with known coin denominations. This argument implies that the weights were intended to be highly accurate and not, as contemporary coin-balances would suggest, rule-of-thumb weights for checking the tolerance above or below which a coin would not be accepted. There seems no reason to doubt that the majority of these glass disks were intended to weigh the solidus/nomisma and its divisions, the semissis and tremissis; a smaller group, as indicated by their denominational marks, weighed not only multiples of the solidus but the ounce and its multiples and divisions.

Over twenty different iconographic types of glass weights are known, but the majority of them fall into seven categories: weights with a box monogram, with a cruciform monogram, with a box or cruciform monogram and an inscription, with imperial figures, with the bust of an eparch and accompanying inscription, with a denominational mark, and with a plain bust. The most common are those stamped with a box or cruciform monogram. On the basis of parallels with coins and other media, the box type appears to have been the dominant type for the first half of the sixth century, and was subsequently gradually replaced by the cruciform type. Most glass weights belong to the sixth century and the first half of the seventh, when the Arab invasions disrupted the administrative system which controlled the manufacture and distribution of these weights.

Byzantine sculpture
Rowena Loverance

The tradition of sculpture in the round was already under strain in the late Roman period, as portraiture gave way to the demand for more symbolic representations, of which the porphyry tetrarchs of San Marco in Venice are perhaps the most famous example. The empire's official adoption of Christianity seems to have exacerbated this trend, with large-scale three-dimensional statues being firmly associated with the pagan past. However, as the group associated with the Victory statuette (no. 25) suggests, mythological subjects rendered on a more domestic scale may have continued to appeal to both pagan and Christian patrons.

Funerary art continued to be a fruitful source of sculptural images in the fourth and fifth centuries. The quantity of surviving sarcophagi, or fragments thereof, from production-centres in Rome, Ravenna and Arles allows a close study of the adaptation of classical and Old Testament themes to Christian use (no. 23) as well as providing some of the best evidence for emerging New Testament iconography (no. 24).

Much of the surviving material from Egypt also comes from funerary contexts, although, as this was frequently not recognised at the time of its original excavation, some confusion of interpretation still exists. Unnecessary distinctions have been sought between pagan and Christian, and between Coptic and Byzantine, though it remains the case that sculpture in marble, which was largely imported, was more likely to reflect trends in Constantinople, while local limestone was subject to local variations (no. 39).

Church building was a great spur to the production of architectural sculpture, though the demand was such that columns and capitals were frequently re-used from earlier buildings, which complicates understanding of the dating sequence. The standard Early Christian church was a rectangular basilica, with a colonnaded nave and aisles and perhaps galleries. Sites of particular appeal to pilgrims, such as those associated with the tombs of saints like that of St John at Ephesus, might have more centralised structures, in this case a cross-shaped church with four radiating arms, built in the fifth century (no. 42). The sixth century saw more ambitious architectural forms, especially in Constantinople; the church at Ephesus was rebuilt, still on its cross-shaped plan but now as a vaulted structure with six domes (no. 92). Churches of the Middle Byzantine period catered for a much smaller population, and are often associated with monasteries (no. 93). The basilica form gave way to a more compact 'cross-in-square' building around a central dome, which, with the gradual evolution of the low chancel screen into the more substantial Middle Byzantine *templon*, gave a wide variety of uses for architectural sculpture. The themes and treatment of sculptured slabs of this period (no. 151) often draw on Near Eastern motifs, perhaps reflecting Byzantine military expansion into Anatolia in the tenth century.

Three-dimensionality made a partial return to Byzantine sculpture in the thirteenth century, with figures in high relief appearing on capitals and on funerary monuments. Much of the evidence for this period, however, comes from the wider Byzantine world, from the Balkans and, especially, from Venice, where the influence of sculptures brought from Byzantium in 1204 inspired local craftsmen to develop a lively Italo-Byzantine range of forms and motifs (no. 199).

Byzantine textiles
Hero Granger-Taylor

Most of the textiles in this catalogue are typically Byzantine in being all-silk and in a complex weave. Silk had been used in the Mediterranean area at least since the fifth century BC but in the early Byzantine period came to be associated in particular with new, more advanced weaves with mechanically repeating patterns. The early general term for such weaves was *polymitos*, '[woven] with multiple shafts'. The variety which came to be dominant and which is represented here by nos 49, 50, 111, and 136–9 is now called 'weft-faced 1:2 compound twill'. This weave was known in late medieval Europe as *samitum*, a term derived from the Greek *hexamitos*, '[woven] with six shafts', a reference to the three or six shafts required for the binding warp of these fabrics.

The textiles in weft-faced compound twill here, starting with the Akhmim silk with its small-scale abstract pattern in two colours only (no. 49) and building up to the Durham silk with its much larger multicoloured roundel design (no. 139), illustrate well the development of this weave. The Durham silk has been known to be certainly Byzantine since the discovery on it of the remains of a Greek inscription. With many other examples, however, the source is less certain. Weft-faced compound twill weave may have originated in Persia rather than the eastern Mediterranean

and was certainly also used there. By 600 or so it had begun to spread eastwards into central Asia and by about 700 had reached China. Inscribed non-Greek examples include one made in Tunis in the eighth century, excavated in Egypt, and one of about the same date labelled as 'Zandaniji', from the neighbourhood of Bukhara, in the treasury of Huy Cathedral in Belgium. Silks of varied origins are often found together, whether in archaeological or church contexts, and Byzantine and Persian products are particularly difficult to tell apart: both were produced in a similarly fine and compact quality and in terms of style and iconography appear to have fed each other constantly.

The most magnificent Byzantine textiles have been preserved in reliquaries and the tombs of saints in western European churches and because of this circumstance are sometimes understood to have been woven specially for church use. In fact this was seldom the case, and even the silks with very large repeating designs were probably made for secular dress (see no. 190). Recent discoveries at Moshchevaya Balka in the northern Caucasus of kaftans and other garments made from central Asian, Byzantine and Persian silks with roundel designs give an idea of what such textiles looked like when made up into clothing. The pagan iconography of certain Byzantine textiles of the eighth and ninth centuries, for example the Maastricht Dioskouroi silk with its depiction of animal sacrifice (no. 137), is less surprising when viewed in the context of fashionable dress.

For large-scale furnishings, the older technique of tapestry weave remained in use. The pair of curtains from Akhmim (no. 112) are typical of Egyptian tapestry in combining wool and linen. Elsewhere tapestries were being woven in all-wool, as in the surviving western European tradition, and also in all-silk. The best surviving example of a Byzantine tapestry is the so-called 'Gunthertuch' at Bamberg Cathedral, a silk wall-hanging found in the tomb of Bishop Gunther which shows a mounted emperor between the tychai of two cities. Gunther was probably bringing the tapestry as a diplomatic gift from the Byzantine to the German emperor when he died on the journey home in 1065.

The elephant silk at Aachen, probably placed in the tomb of Charlemagne by the Emperor Otto III in the year 1000, is perhaps the latest of the extant Byzantine weft-faced compound twill silks with multicoloured designs. From the late ninth century a taste had been growing for silks with monochrome patterning, and by the eleventh century this had brought about the eclipse of compound twill by two new classes of weave using contrasting textures rather than colours. The modern general terms are 'weft-patterned' and 'lampas' but contemporaries used the adjectives *diaspros*, *diarhodinos*, *diacintrinos* (lit. 'two whites', 'two pinks', 'two yellows'), and so on. The white-on-white versions were by far the most common (see nos 166 and 190), and in the long run the Latin word *diasprum* came to refer to these weaves, whatever the colour. The technology perhaps again originated in Persia but the prevalence of the Greek terms indicates that in the early part of the second millennium such textiles were being produced by the Greeks themselves.

Wherever technically complex textiles are produced, a strong workshop tradition is needed to ensure that skills are passed on between generations and that standards are maintained. The disruption at Constantinople brought about by the Fourth Crusade and a general decline in city life no doubt seriously damaged the Byzantine silk-weaving industry. Silks with relatively simple designs continued to be made, and indeed are still made for use in the Orthodox Church. But the court must have become increasingly dependent on imports: a fifteenth-century wall-painting in the Kariye Camii in Istanbul depicts a couple in coats made of textiles with Byzantine monogram designs but worn over undergarments of much more splendid Italian silks.

From weaving, the focus of attention turned to embroidery, and all the great extant Byzantine embroideries date from the period after 1204. Byzantine embroidery developed not as a means of depiction but as a type of enrichment, growing out of the practice of sewing gems, pearls and enamel plaques to textiles. The terms *chrysoklabarika* and *chrysokentita* ('ornamenting with gold', from the Latin *clavus*, or woven band, or 'embroidering with gold') reflect the importance of silver-gilt threads in these embroideries. Later to emerge, Byzantine embroidery was technically quite distinct from that of western Europe, and the effect of its abundant metal thread, sometimes in the form of wire and laid over cotton quilting, was to make it less flexible and more robust. The tradition has been kept alive through the agency of the Orthodox Church, in Russia and the Balkans as well as in Greece, but originally, like the woven silks, gold embroideries had secular as well as religious applications. No. 225 in this exhibition, made for a Serbian patron, is one of the very few secular examples to have survived.

Byzantine lamps

Donald Bailey

The lamps of Byzantium were technically no different from lamps used in earlier periods in the Mediterranean area: a container to hold the fuel and a wick to draw up the fuel so that it would burn in air; all other aspects were refinements: a nozzle to hold the wick so that it could be tamped down to produce a smokeless flame; handles and suspension devices; stands to support the lamp; aesthetic considerations, including decoration to attract the customer and devices of a religious nature. Such a lamp would produce a given amount of light: to improve the lighting more nozzles plus wicks were added when designing a lamp, or several lamps were used: there was no improvement to this situation until the invention in the nineteenth century of the circular wick combined with a glass lamp chimney. Vegetable oils were used as fuel, mainly olive oil and, in Egypt, sesame-seed oil. Wicks were of cloth, often linen, the fibres of which, by capillary action fed the flame with oil.

Most surviving lamps are of fired clay and were made in their thousands in two-part moulds; some of the most decoratively complex examples were of bronze, one-off products of the lost-wax process. It is often possible with the clay lamps, from their style and their fabric, to identify closely where they were made and to suggest their approximate date; the metal lamps are often more difficult to place in these respects, particularly concerning their dating, which sometimes cannot be brought closer than a couple of centuries. Although they were occasionally used earlier, the fifth century saw the introduction in quantity of glass lamps suspended in metal holders (polycandela), and these were used for at least two hundred years. The glass lamps themselves were a regression technically, being a simple container for oil holding a floating wick impossible to keep from smoking. After the seventh century, mould-made clay lamps become uncommon, and coarse wheel-made lamps, often coated with a vitreous glaze, were produced in Byzantine lands for several centuries. Bronze lamps later than the seventh century are largely unidentified.

Byzantine enamel

David Buckton

Enamel is, quite simply, coloured glass. When heated to its melting point, glass bonds to metal with which it is in contact, creating a jewel-like laminate. The best metal for enamelling, gold, was often relatively plentiful in Byzantium, compared with the West, and enamellers had a convenient supply of coloured glasses in the tesserae from which Byzantine mosaics were made.

In the period before the onset of Iconoclasm in the eighth century, Byzantine enamellers worked in a technique derived from the ancient hellenistic tradition of filigree enamel. The enamel was contained in gold strip, soldered edge-on to the surface of the object; other features, including any inscriptions, were rendered in round-section filigree wire and not enamelled. A typical example of Early Byzantine enamelling is the little bird-pendant, no. 98.

The cloisonné enamel for which Byzantine enamellers became famous was introduced from the West at the end of Iconoclasm. At first, from the middle of the ninth to the middle of the tenth century, the subject had a background of translucent enamel, usually green, completely covering the metal of the plaque. Inscriptions were composed of letters of gold strip set on edge in the enamel of the backgrounds. Characteristic is the Beresford Hope cross, no. 141.

From the middle of the tenth century onwards, the cloisonné enamel was let into and silhouetted against the metal of the plaque instead of having an enamelled background. Inscriptions were incised into the metal surround and filled with enamel, a technique which amounted to champlevé. This style of enamel is found on a reliquary-cross in the exhibition, no. 165.

In the twelfth and thirteenth centuries the fashion was again for enamel completely covering the metal of the plaque, but this time the backgrounds were opaque. Inscriptions were fully enamelled, comprising characters fashioned from gold strip bent to conform to the outline of the letter. The letters would then be filled with an opaque enamel contrasting with the enamel of the background: white characters against a dark blue ground were particularly popular. A good illustration is the pendant reliquary, no. 200.

With the use of opaque enamel, especially for backgrounds, gold became something of a luxury, and copper was increasingly used. Examples of this final phase of Byzantine enamelling are the double-sided medallions of saints, no. 201.

Byzantine manuscript illumination

John Lowden

For the purposes of exhibition, study or appreciation, it is a matter of necessity and not merely of convenience that Byzantine manuscript illumination should be selected, organised and considered under a number of headings. Were we not to do this we should be overwhelmed by the thousands of books that have survived, and by the tens of thousands of images that they contain. But there are dangers in such an approach. The Byzantines who made, used and preserved the books that contain the images we admire did not look at them or think about them in the ways we do. If we are to understand their art, then we must understand what they were trying to achieve, and what the limitations and the possibilities were at the time any work was made, which is not easy. Too selective a view can create a highly misleading impression, as will be apparent when it is remembered that even with books on display we are able to look only at a single opening.

From the pre-Iconoclast or Early Byzantine period (sometimes termed Late Antique or Early Christian) the material left to us is sparse. This is unlikely to be entirely the result of accidents of survival, as is sometimes proposed. Most probably there was a relatively limited production of illuminated manuscripts in those centuries. Nonetheless the Cotton Genesis (nos 66–7) and the Canon Table fragments (no. 68) show that Early Byzantine artists were highly inventive and technically skilled (see fig. 1). We can note that the Book of Genesis was never again illustrated in such detail (in any period or place). It is probable that the early books that we still have were preserved not by chance, or even as the result of continued usefulness over many centuries, but because they came to enjoy a relic-like status.

The main bulk of surviving material is post-Iconoclast. It is usually further subdivided into a Middle Byzantine

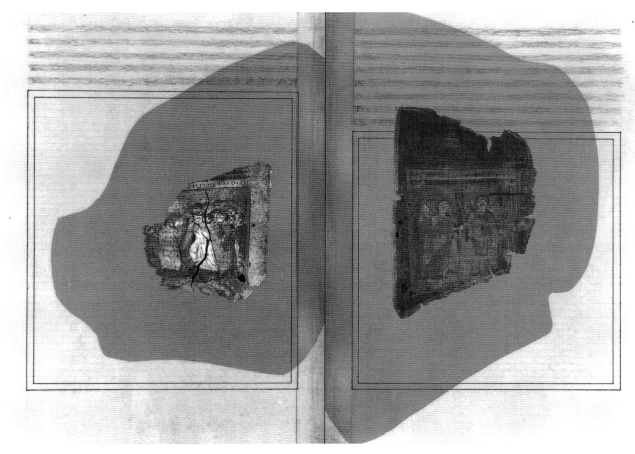

Figure 1 Reconstruction showing the original arrangement of the Cotton Genesis fragments (nos 67 and 66) and their shrinkage as a result of the fire of 1731 (drawing and montage by John Lowden)

period, sometimes termed Macedonian and Comnenan, after the ruling dynasties (see nos 147–50, 167–70, 176–8, 180, 193–7), and a late (or Palaeologan) period (nos 207–10). Between these two periods was the occupation of Constantinople during the Latin Empire (1204–61), although manuscript production was not entirely interrupted at that time, at least in other areas of the Byzantine world. Because so few Byzantine manuscripts contain precise information on when or where they were made, the sub-groupings of the post-Iconoclast books exhibited represent generally accepted views on dating and attribution which are best thought of as open to future research.

The vast majority of all Byzantine illumination is found in texts that can be classified broadly as religious, and more specifically as biblical. Of the exhibited books only two contain non-biblical texts: no. 169 – an illustrated Saints' Lives – and no. 170 – an illustrated collection of Liturgical Homilies. An especially large number of Gospel Books were made (see nos 149, 176–7, 193–7, 207–10), mostly conforming to a standard pattern with decorated Canon Tables, and images and decorative headpieces prefacing the start of each of the four Gospels. Other isolated images might be included (no. 208), but longer cycles of illustrations of the life of Christ were much rarer (no. 196).

Somewhat more ambitious, and definitely more costly in terms of materials and labour, were those books in which the rest of the New Testament was also included (nos 147, 178, 196), while the lack of the four Gospels in no. 148 presupposes that they were available in a companion volume. Some of the Gospel Books were marked for use in the liturgy with the beginnings and endings of the readings indicated, either as an original part of the book (e.g. no. 177) or as a later addition (no. 178). Occasionally, special Gospel lectionaries were made (no. 150). In such cases the texts were arranged around the requirements of the liturgical year, rather than appearing in the usual order. These books might be written in a distinctive script (no. 150) or be given a special cover (no. 147).

After the Gospel Book, the next most popular book to be provided with images was the Psalter, but no standard pattern emerged for its illustration. Most Psalters have prefatory illustrations of some sort, but the marginal Psalter (nos 167–8) was a particularly sophisticated alternative. Companion volumes to the Saints' Lives and Illustrated Homilies (nos 169–70) are also relatively numerous, and many other texts were illustrated in at least one case in a surviving Byzantine book. But the Gospels, which were both the word of God and in book form the very image of God, far outstripped all other texts in popularity.

Few illuminated Byzantine manuscripts reveal explicitly by whom, for whom, when, or where they were made – all issues that we should like to know more about. Dated manuscripts such as nos 207–8 take us only a small way. The Theodore Psalter (no. 168), however, is a remarkably informative exception, and hence a work of fundamental importance. It suggests that one mode of production in Byzantium was that of the monastic craftsman producing work for internal consumption in his monastery. There would also appear to have been lay professional craftsmen, working on commission for wealthy patrons such as members of the imperial family (nos 176–8). The writing and decorating of a book might be divided in a variety of ways between several specialised craftsmen, but on occasions it is clear that a single individual was the principal artist as well as the main scribe (nos 147, 168). Localising the production of a Byzantine manuscript is usually problematic. Constantinople was presumably always a major centre, but monasteries, towns and cities throughout the Byzantine world must also have been centres of production. Between about 1150 and about 1250 we seem to be on firmer ground in identifying books as coming from non-Constantinopolitan regions (nos 193–7). At roughly this time Byzantine art was also being carefully imitated beyond the Byzantine world (no. 180).

The Byzantines liked rich colours, costly materials, superlative craftsmanship and surfaces that gleamed and glittered. The parchment they used in books was polished to a smooth, glossy finish (unlike the nap of the parchment in most Western manuscripts). An unlooked-for result was that the pigments often flaked off, revealing the rudimentary sketching that underlies even the most complex images. On occasions an image was restored or replaced (no. 150), and in some cases new images were added to old books in which the text was still useful (no. 176). Nineteenth-century collectors were not above doing the same, even adding new images in Byzantine style to their precious acquisitions (no. 210).

In Byzantium the illuminated manuscript was never merely functional – there were far less costly and time-consuming ways of producing a copy of a necessary text. Illustration and decoration were intended to impress God and the saints as a form of perpetual prayer. Whether this result was achieved we cannot say, but many such books have survived and they can still impress *us*.

Byzantine icons

Robin Cormack

Despite the many current evocative uses of the word 'icon' to refer to a stereotypical image in any period, Byzantine icons are best treated as panel paintings. These were produced in large numbers throughout the period, and ranged in size from small portable panels appropriate for private prayers in the home or on travels to the largest 'patronal' icons set up in the churches and cathedrals of the Orthodox world. Church settings were gradually developed to allow for the increase in icon display around the altar, and in shrines for personal adoration and prayer elsewhere in the building. Although the low chancel screen of the Early Byzantine church was unsuitable for the display of icons, as it evolved into the Middle Byzantine *templon* and, finally, into the Late Byzantine *iconostasis*, its value for creating a concentrated visual setting for holiness was more and more exploited. By the fourteenth century the sanctuary screen in the Byzantine church had set the basic pattern for Russian and post-Byzantine Orthodox churches of a systematic symbolic cosmos on the screen (ultimately organised upwards into registers: the 'worship' row with 'local' icons and the royal doors, the Deesis row, the row of liturgical feasts of the Church, the Holy Days, the row of Old Testament kings and prophets, and the row of Old Testament patriarchs; the screen was surmounted by a cross). The developed opaque *iconostasis* concealed the holy of holies from the congregation.

Study of the Byzantine icons in the monastery of St Catherine's on Sinai has demonstrated that, from early on, panels were produced in several formats, including hinged diptychs and triptychs. Some icons have integral frames and fixings to allow them to be set up in stands, as well as carried in procession. Certain famous icons in Constantinople (and later elsewhere) were identified as the work of the evangelist St Luke. This idea both legitimated the production of icons (which was officially banned between around 730 and 843, apart from an intermission from 787 to 815) and provided a set of models, particularly of the Mother of God, for reproduction and transmission to other centres. Other early icons, particularly with portraits of Christ, were said to have appeared without human involvement (*acheiropoietos*), and these established a portraiture of Christ. Such icons of the Mother of God and of Christ (and other icons) became connected with the achievement of miraculous cures, and this dimension of

wonder-working enhanced the importance of the medium beyond the purely symbolic. In time, Byzantine theologians, as for example John of Damascus in the eighth century, had to set out a theoretical definition of the relation between the figure portrayed and the actual material portrayal on the icon. In principle the Church maintained a control over the allowable subject matter of icons, and it is the case that the range of subjects found in Byzantium is more limited than in western Europe. The favoured subjects were portraits of Christ, Mary, the saints, the Gospel narratives and saints' lives, especially if these events were celebrated as annual Church festivals.

Byzantine icons are seldom signed or dated, and their art historical study (for attribution and chronology) has therefore often been integrated into the broader study of manuscript painting, wall-painting and mosaic. Since the same artists probably sometimes worked in all these media, this approach has some merits, but it may distort the fact that panel paintings were probably the cheapest to produce and so represent the greatest range of patronage; they probably constituted the most familiar form of art in Byzantine society. The proportion of professional artists to artist-monks remains an issue of debate, but the documentation from the Cretan archives offers a way of quantifying artists in the period from the fourteenth century onwards, and also of understanding workshop practices, including the introduction of 'pricked' cartoon drawings in the 'mass-production' of favoured imagery.

The technical description of icons is currently limited by the lack of databases; however, cleaning and consolidation of icons in recent years has meant that the medium can now be better observed than for several centuries, as layers of dirt and varnish are removed. Restorers have also refined methods of preserving icons with multiple layers of painting, for it was accepted practice that an icon could be over-painted and recycled. Restorers are also rapidly building up a repertory of information about icon techniques. A general picture of workshop methods is emerging, but so far study of pigments and media has not revealed any distinctive chronological developments in technical practices.

The first stage in the production of an icon was the preparation of a wood support, strengthened by cross-grained strips of wood nailed or slotted on to the back to prevent splitting or warping. The woods chosen included lime, elder, birch and cypress, and occasionally cedar and pine. The panel was usually made up from several pieces of wood, and a flat surface was hollowed out at the centre to provide

an integral raised border. The second stage was the preparation of a smooth polished gesso surface, frequently laid over strips of loosely woven linen glued to the panel to inhibit cracks or splits in the wood extending upwards to the paint-surface. The gesso is sometimes more than a millimetre thick, applied in as many as eight separate layers (and consisting of finely ground chalk whiting, sometimes with ground marble or even alabaster, mixed with size). The design of the image was drawn in charcoal, and the outlines sometimes incised with a point. Gold leaf was usually laid not directly on to the gesso but on to bole (a red or yellow clay), after which it was burnished (with a wolf's tooth or agate tool).

In Early Byzantine icons, the medium for binding the pigments was either wax encaustic or egg tempera (the yolk of an egg mixed with a drop of vinegar). After Iconoclasm, tempera was the almost universal medium, but the technique of encaustic is still very occasionally found. The pigments available for icons were a restricted range of earth colours supplemented by azurite, cinnabar, malachite, verdigris, white lead and bone black. The final step was to protect the surface with a glaze, functioning as varnish.

Cretan icons

Maria Vassilaki

There are Cretan icons in museums and galleries throughout the United Kingdom. They are often difficult to find, however, since they are usually kept in storage. On rare occasions they are on show, but even then they are hard for the non-specialist to identify, since they are usually mislabelled. A fifteenth-century Cretan icon of St Jerome (no. 229) was labelled 'Venetian painting, fourteenth century' in an exhibition on St Jerome held at the National Gallery in September 1992. It is, in fact, a late-fifteenth-century Cretan icon.

It is something of an adventure locating Cretan icons in Britain: they are here, there and everywhere. It is exciting to discover a Cretan icon of St George (no. 236) hanging in the Deanery at Windsor Castle and another of the Mother of God as the *Madre della consolazione* in a university Catholic chaplaincy (fig. 2). Some which have found their way into museums have interesting stories to tell about their previous owners. The National Gallery's icon of St Jerome (no. 229), for instance, now part of the National Icon Collection, housed in the British Museum, was once in the possession of John Ruskin. At that time the panel was described as Sienese.

The number of Cretan icons to be found in the museums and galleries of Britain is quite small, although there may well be more, not yet identified. There are a few in private collections, some of them recent acquisitions (e.g. no. 230), reflecting the taste for Cretan icons which dominated the art market between the late 1970s and the early 1990s, as reflected in the sale catalogues of the larger London auction houses.

The Cretan icons in this exhibition belong to the fifteenth and sixteenth centuries. Most of them date from the fifteenth century, the period during which Cretan painting flourished and acquired its own character. Some Cretan icons adopted a purely Late Byzantine style and icono-

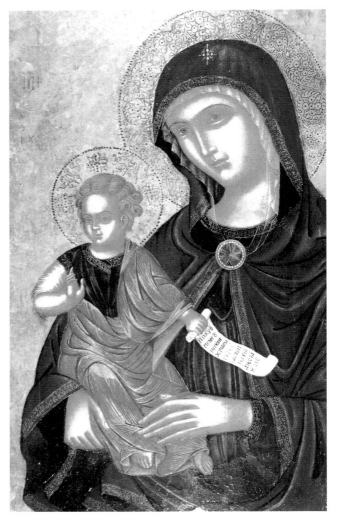

Figure 2

graphy; others mingled western features in compositions otherwise characterised as Byzantine; others are completely westernised, both iconographically and stylistically.

All these icons must be seen as typical products of the circumstances which prevailed on the island of Crete during the time of their execution. From 1210 till 1669 Crete was under Venetian jurisdiction. The Venetian occupation of Crete came as the natural consequence of the Latin conquest of Constantinople in 1204 and the dismembering of the Byzantine Empire: Crete was transformed from a province of the Byzantine Empire into a Venetian colony, the so called Regno di Candia. The first centuries of the occupation were characterised by mutual suspicion and distrust between Venetians and Cretans. However, the fact that the two communities necessarily lived in close proximity, especially in the urban centres of the island, and shared the same environment prepared the ground for their integration. A process of assimilation was even further facilitated from the fifteenth century onwards by two factors: the end of the Byzantine Empire, as a result of the Fall of Constantinople to the Turks in 1453, and a transformation in the character of Cretan society. Urban society had acquired social cohesion. The economic and commercial activity of the urban population increased and resulted in the economic emancipation and social ascent of the islanders. The increasing commercial and maritime activity, beyond the boundaries of Crete, created the conditions for an unprecedented economic expansion and rise in the standard of living.

Under these circumstances Crete became an important artistic centre. In fact it became the most important artistic centre of the post-Byzantine world. Artists' workshops developed in the Cretan cities, and the number of painters increased enormously. There is evidence that in the capital city of Crete, Candia (modern Heraklion), with a population of 15,000, there were a hundred painters at work in the late fifteenth century and a hundred and fifty in the sixteenth. These painters established their own guild, the Scuola or Confraternità di San Luca dei pittori.

Cretan painters mainly followed the iconographic, stylistic and technical principles of the Byzantine tradition, which was always evident in Crete. The presence of Constantinopolitan painters in Candia, already documented by the end of the fourteenth century, was decisive in bringing Cretan painters into a more direct contact with the artistic trends of the capital of Byzantium. The icon of the Nativity (no. 228) can be assigned to a Constantinopolitan painter working on Crete at the beginning of the fifteenth century. But Cretan

Figure 3

painters also became aware of western painting and were influenced by it. Their icons were in great demand not only from Orthodox churches and monasteries on Crete and elsewhere, such as in Sinai and on Mount Athos, but also from Catholic religious foundations. Cretan icons were in great demand, too, with Cretan and Venetian individuals. It follows that Cretan icons were executed either 'alla maniera greca', i.e. in the Byzantine manner, or 'alla maniera italiana', according to the nationality, religion and taste of their clients. The icon of the Deesis (no. 230) is typical 'alla maniera greca' icon, presumably commissioned by someone of the Orthodox faith. The icon of St Jerome (no. 229) and a triptych with the Pietà, St Francis and Mary Magdalen in the Ashmolean Museum, Oxford, is a typical 'alla maniera italiana' or 'latina' work for a Catholic owner. However, it does not necessarily mean that all the 'alla greca' icons were destined for Orthodox clients, individual or not, and all the 'alla latina' for Catholics. For example, an icon with the 'alla latina' iconographic type of the Madre della consolazione has a Greek inscription painted on Christ's scroll (fig. 2). And a completely 'alla latina' composition, the icon with the initials IHS (Jesus Hominum Salvator) painted by Andreas Ritzos (doc. 1451–92), now in the Byzantine Museum in Athens (fig. 3), is characterised in the will and testament of the Veneto-Cretan Andrea Cornaro (1611) as 'cosa pretiosa per pittura greca', 'a precious thing for Greek [Byzantine] painting'.

Cretan icons acquired a characteristic which distinguishes them from the Byzantine ones. Besides fulfilling their strictly religious function and nature as icons, they were also regarded as works of art with their own intrinsic aesthetic value. As such they were used to adorn the walls of

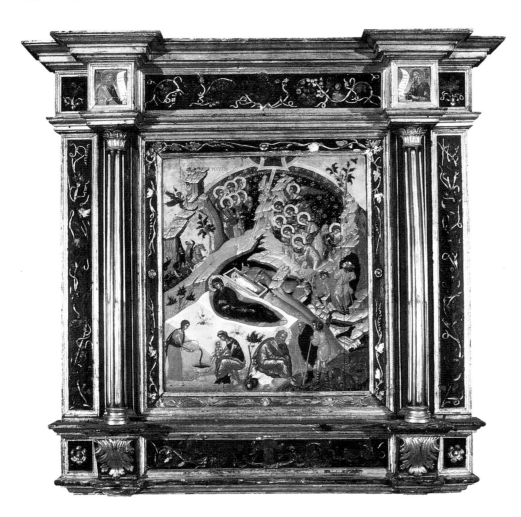

Figure 4

houses and even offices of the Cretan and Venetian nobility and bourgeoisie, as surviving documents indicate. This change in function is clearly illustrated by a Cretan icon of the Nativity, from the second half of the fifteenth century, now in the Greek Institute in Venice (fig. 4), which has its original frame. This frame gives to the strong religious content of the composition a decorative character which can be clearly understood if the icon is seen as being not only for private devotion but also as a work of art for hanging on a wall.

Cretan icons testify to the transformation of the anony-mous Byzantine artist into the named Cretan painter. An impressive number of Cretan icons preserve the name of their painters. Among others, in the fifteenth century we find the names of Angelos, Andreas and Nikolaos Ritzos, Andreas Pavias, Nikolaos Tzafouris, in the sixteenth century Angelos Bitzamanos, Domenikos Theotokopoulos (El Greco), Michael Damaskinos, Georgios Klontzas, and in

the seventeenth century Emmanuel Lambardos, Emmanuel Tzanes, Theodore Poulakis. A question which is hard to answer is when Cretan painters signed their icons and when they did not. The assumption that a painter signed only the high-quality products of his workshop is not tenable, since there are signed icons of poor quality, and excellent pro-ducts patently of the same painter without a signature. Another assumption which may seem reasonable – that an icon destined for a religious foundation, Orthodox or Catholic, did not need a painter's signature in the way an icon for an individual did – is also untenable, since icons still in churches and monasteries sometimes bear signatures, while some icons definitely meant for individuals do not.

Knowledge of Cretan icon-painting has increased enor-mously during the last decades. But the more that is known about Cretan icons, the clearer it becomes that there are many issues still to be resolved.

The Emperor Constantine the Great

Byzantium, the Byzantine Empire, was in existence for well over a millennium, from the inauguration of its capital, Constantinople, in the year 330 to the fall of the city to the Ottoman Turks in 1453. In the course of those eleven centuries – spanning late classical antiquity, the whole of the Middle Ages and much of the early Renaissance – the empire experienced enormous changes in fortune, changes affecting the territories, religions, languages, culture and the political, social and economic structures inherited from the Roman Empire, from which it evolved.

Britain was still a Roman province when Constantine the Great, who had had himself proclaimed emperor at York, took two decisions which completely changed the course of history. The first, in 313, was to allow Christians throughout the empire the freedom to practise their religion. The second, in 324, was to make his capital in the east. Very soon Christianity had become the state religion, and in time Constantinople was the most envied city in Christendom.

It was from the very first a Christian city. In 312, marching on Rome, Constantine had had a vision of a cross, accompanied by the words 'By this sign, conquer'. The following day his soldiers, with the sign painted on their shields, had defeated the army of Maxentius, another usurper, and had taken Rome for Constantine, who was to rule in the western part of the empire, in alliance with the eastern emperor, Licinius, for the next twelve years. The breakdown of this truce was followed by the defeat of Licinius in 324, leaving Constantine as sole emperor.

1 *Largitio* dish of the Emperor Licinius

Made and stamped at Naissus, 317

London, BM, M&LA 1969,9–4,1

Max. diam. 182 mm, H. 50 mm. Weight 304.56 g

Found at Niš, Serbia, in 1901; bought by the British Museum in 1969.

Hammered dish without a foot, the inner concave surface and part of the outer surface (extending 45 mm below the rim) being finished by turning. The narrow rim was formed by rolling the metal forwards. The inner surface is decorated around the sides with a Latin inscription, LICINI AVGVSTE SEMPER VINCAS ('Licinius Augustus, may you always be victorious'), in letters punched between a pair of incised lines. A second punched text, SIC X SIC XX ('As ten, so

twenty'), occupies the centre of the dish, enclosed within a schematic, incised wreath. A small circular stamp containing the letters N[retrograde]AISS ('Naissus') arranged in two lines appears in the top centre of the dish.

This is one of five or six identical dishes found together at Niš (ancient Naissus), the birthplace of Constantine. They were made in the name of Licinius, the eastern emperor (308–24), during a period of truce with Constantine, then the western emperor. The breaking of the truce in 324 and the subsequent victory of Constantine over Licinius effectively marked the start of the Byzantine Empire, with its capital at Constantinople, inaugurated in 330.

The set of dishes was made for distribution as largess (*largitio*) on the occasion of Licinius' tenth anniversary. While similar dishes bearing anniversary inscriptions or imperial images, or both, are known from this and later reigns, relatively few have stamps indicating their origin (Delmaire 1988, pp. 114–15). Very few silver objects are definitely known to have been made in the place in which they were found (Dodd 1961, no. 90; suggested in Shelton 1981, pp. 47–50). Valuable portable objects in silver could travel widely in the Late Roman period. The Naissus stamp is one of the very few control stamps with the text in Latin

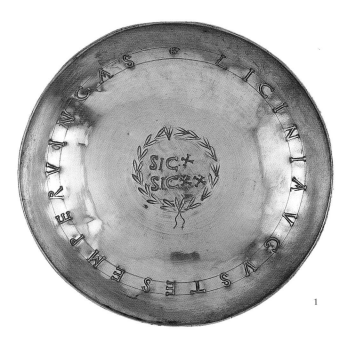

1

rather than Greek (Mango 1992, p. 207). *Largitio* dishes range in size and weight from the Naissus example, which weighs about one Roman pound, to the Theodosian missorium found near Merida in Spain, which is 740 mm in diameter and weighed fifty Roman pounds when made (exh. cat. *Age of Spirituality* (1977–8), no. 64). The weight of one Roman pound corresponds to the amount of silver *donativa* (together with five solidi) designated by law, between the fourth and the sixth centuries, to be given on certain occasions to every soldier (Delmaire 1988, p. 115).

H. Tait, 'Exhibits at Ballots', *Antiquaries Journal* 50 (1970), p. 344; R. Camber, *Burlington Magazine* 114 (1972), pp. 92f; F. Baratte, 'Les ateliers d'argenterie au Bas-Empire', *Journal des savants* (1975), pp. 200–2. Exhibited: *Wealth of the Roman World* (1977), no. 10. MMM

2 Gold coin-set pendant

Probably Constantinople, 4th century

London, BM, M&LA 1984,5–1,1

Max. diam. 92.4 mm

Bought by the British Museum in 1984 with the help of the National Art-Collections Fund.

Gold openwork pendant in the form of an engrailed hexagon with a suspension-loop. In the centre is a broad collet of plain gold sheet enclosing a double solidus of Constantine the Great. The obverse is struck with a profile bust of the emperor to right enclosed by an inscription: D[OMINVS] N[OSTER] CONSTANTINVS MAX[IMVS] AVG[VSTVS]; the reverse is struck with the confronted busts of his two sons Crispus and Constantine II, each wearing consular costume and holding an eagle-headed sceptre; inscribed around them: CRISPVS ET CONSTANTINVS NOB[IS] CAES[ARE]S CO[N]S[VLE]S II (indicating their second consulship, in 321); below the two busts: SIRM[IVM] (the mint, at Sirmium). Between this collar and each of the angles of the hexagon is a miniature bust in high relief, each within a circlet of beaded gold wire and a plain collet. The busts are (from top right clockwise): a female wearing a tiara and veil, a bearded male, a female with crown tress, a male wearing a Phrygian cap, another female with crown tress and, finally, a male wearing a fillet. Between each of the busts is a symmetrical design executed in *opus interrasile*. The design is composed of a heart-shaped motif of reserved gold from which emanate two vegetal scrolls terminating in spirals and turning back on themselves to form a larger openwork heart; in the interstices are running scroll tendrils which are less skilfully repeated on the suspension-loop.

The pendant formed part of a group of jewellery sold at Christie's in 1970. The other pieces were three similar necklace pendants, two of them circular and one hexagonal, a

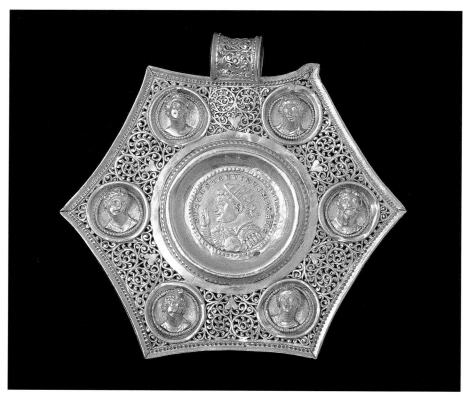

2

gold bracelet, and three dress ornaments: with the exception of one of the circular pendants, now in the Louvre, the other objects are in the Dumbarton Oaks Collection, Washington, D.C. The four pendants all share a central medallic coin of Constantine the Great, six busts in high relief, and a background sheet executed in *opus interrasile*. The identity of the chased and embossed busts remains elusive and contributes little to the dating of the pendants. Although considerable care has been taken in the individualising of each of the busts – physiognomical details, hairstyles and facial expressions vary considerably – only one bust can be identified with any certainty. That is the bust of Attis wearing his characteristic Phrygian cap. The other busts, on this and the other three pendants, seem to be a combination of Greek gods, philosophers, muses, satyrs and contemporary portraits, possibly of Germanic origin. More evidence for the dating of the pendants is possibly provided by gold coins supposedly found with them. These range in date from three of Constans II (353–61) to one of Maximus (d. 388). An earlier terminus post quem is provided by the double solidus in the circular pendant in the Dumbarton Oaks Collection, struck in 324. A date in the middle of the fourth century is suggested by Buckton in his analysis of related material in the British Museum (Buckton 1983–4). The characteristic vegetal scroll can be closely paralleled on a gold mount bequeathed by Sir Augustus Wollaston Franks (1897). The front of the mount is decorated with a lion-hunt reserved against an *opus interrasile* background of identical vegetal ornament; the mount was found in Asia Minor with six gold *aurei* of Constantius II (337–61).

P. Strauss, *Helvetia Archaeologia* 42 (1980), p. 67; N. Dürr and P. Bastien, 'Trésor de solidi (355–388)', *Revue suisse de numismatique* 63 (1984), pp. 205–19; Buckton 1983–4, pp. 15–20; D. Buckton, 'Byzantine coin-set pendant, AD 324–88', *National Art-Collections Fund Review* 1985, pp. 92–3; Tait 1986, p. 99, no. 221; J.-A. Bruhn, *Coins and Costumes in Late Antiquity*, Washington, D.C., 1993, pp. 16–22, fig. 13. Exhibited: *Gesichter: griechische und römische Bildnisse aus Schweizer Besitz*, Bern, 1982, no. 182; *Spätantike* (1983), no. 38. CJSE

3 *Fidem Constantino* ring

Western Empire, early 4th century

Cambridge, Fitzwilliam Museum, Department of Antiquities, GR.1.1975

Max. diam. 27 mm; bezel 16 × 10 mm

From Amiens, France; formerly in the Guilhou Collection, Paris; bought by the Fitzwilliam Museum in 1975.

Gold finger-ring with circular hoop of gold strip to which is soldered a rectangular bezel. The bezel is inscribed FIDEM, the hoop CONSTANTINO.

This ring belongs to a large group found mainly in west-

3

ern Europe: three are known from France, six from Germany, one from Switzerland, one from Hungary and two from former Yugoslavia; two other examples, but with the inscription FIDES CONSTANTI, are known from Norwich and from Birchington, Kent (Noll, pp. 241–3). This distribution pattern has led to the suggestion that these rings were given by Constantine the Great to soldiers to reward or ensure their loyalty (*fidem*) to him (*Constantino*) between his assumption of the title of emperor of the western part of the Roman Empire upon the death of his father Constantius in 306 and his defeat of Maxentius at the Battle of the Milvian Bridge in 312. Ogden's analysis of the Fitzwilliam ring (gold 81.4 per cent, silver 13.1 per cent, copper 5.4 per cent) has led him to reject this argument. Pointing out that the gold purity is much lower than that of contemporary gold coinage or other jewellery, he argues that 'it is thus highly unlikely that these rings could have been supplied on imperial order or, indeed, represent any kind of official insignia' (Ogden, p. 264).

A. Danincourt, 'Étude sur quelques antiquités trouvées en Picardie', *Revue archéologique*, 3rd ser., 7 (1886), p. 88; R. Mowat, 'Notice de quelques bijoux d'or au nom de Constantin', *Mémoires de la Société Nationale des Antiquaires de France* 50 (1889), p. 335; *CIL*, XIII, p. 3, no. 10024.29b; Sotheby & Co., *Catalogue of the superb collection of rings formed by the late Monsieur G. Guilhou of Paris ... 9 November 1937 ... New Bond Street, W.1*, lot 417 or 418; R. Noll, 'Eine goldene "Kaiserfibel" aus Niederemmel vom Jahre 316', *Bonner Jahrbücher* 174 (1974), p. 241, no. 1; J. Ogden, 'Gold in Antiquity', *Interdisciplinary Science Reviews* 17 (1992), p. 264, fig. 3. CJSE

4 Votive plaque with chi-rho

Roman Britain, 4th century

London, BM, PRB P 1975.10–2.18

H. 157 mm, max. W. 113 mm

Part of the Water Newton Hoard, uncovered in February 1975 in a field at Water Newton (ancient Durobrivae), near Peterborough. Declared Treasure Trove and the property of the Crown on 10 September 1975.

Silver, partly gilt, triangle embossed with a herringbone pattern, most of the broadest part taken up by a repoussé medallion containing a chi-rho with alpha and omega, all four of the Greek letters gilded. There are losses above and to the right of the medallion.

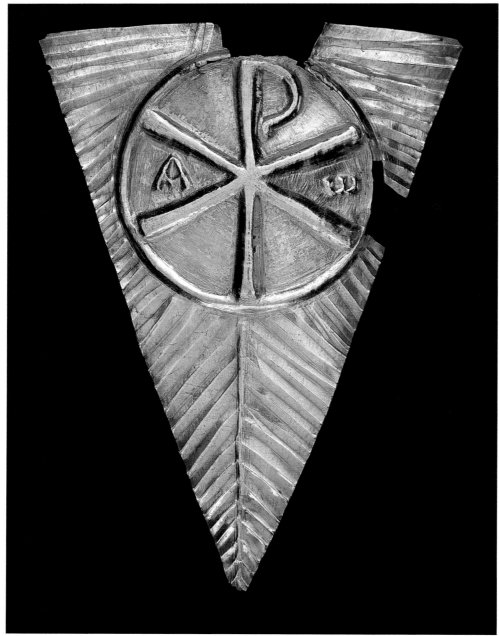

4

From the evidence of a similar plaque with a dedicatory inscription, this object was a votive offering, one of twenty or so in the hoard, at a Christian shrine. It was almost certainly made locally.

In the late Roman and Byzantine periods, silver and copper were often gilded, either all over the metal or, as here, selectively. Gold dissolved in mercury would be applied to the cleaned surface; gentle heat would cause the mercury to evaporate, leaving the gold adhering to the other metal.

Constantine, marching on Rome, had to contend with another usurper, Maxentius, who had seized power there. On the eve of the Battle of the Milvian Bridge, just outside the city, Constantine had a vision: a cross in the sky, accompanied by the words 'By this sign, conquer'. The sign was duly painted on his soldiers' shields, and Constantine defeated Maxentius and entered Rome.

The sign of Constantine's vision is traditionally thought to have been the chi-rho or *labarum*, a combination of the letters chi (X) and rho (P), the first letters of 'Christ' in Greek. For the addition of the first and last letters of the Greek alphabet on the Water Newton plaque, see Revelation 1.8: 'I am Alpha and Omega, the beginning and the end, saith the Lord, which is, and which was, and which is to come, the Almighty.' Constantine's cross in the sky, however, may well have been the *crux monogrammatica*: see no. 5.

K. S. Painter, *The Water Newton Early Christian Silver*, London, 1977. Exhibited: *Wealth of the Roman World* (1977), no. 44. DB

5 Glass disk with *crux monogrammatica*

Probably Alexandria, 4th century

London, BM, M&LA 81,7–19,35

Max. diam. 44 mm

From Alexandria. Bought by the British Museum in 1881.

Moulded disk of greyish green glass with, in relief, a *crux monogrammatica* within an annular border of beading. The disk was probably a seal for a bottle or other stoppered vessel. The *crux monogrammatica*, made up of a 'Latin' cross with the upright in the form of the Greek letter rho (P),

seems to have been the most popular symbol of Christ and Christianity in the fourth century and may well represent Constantine's vision in the sky on the eve of the Battle of the Milvian Bridge (see no. 4). While crucifixion remained an official means of execution of the death penalty in the Roman Empire, a straightforward cross was shunned as a symbol.

Dalton 1901, no. 710. DB

6 Ring with sacred monogram

Rome, 4th century

London, BM, M&LA 1824, ring 5

Ext. H. (bezel to hoop) 31.3 mm, ext. w. of hoop 23.5 mm

Collection of Richard Payne Knight, bequeathed to the British Museum (1824). Payne Knight (1751–1824) was one of the great English collectors, a Regency intellectual and arbiter of taste. His bequest of gems, bronzes and Old Master drawings was one of the most important in the history of the Museum.

Gold ring with outside of hoop ridged longitudinally and with massive oval bezel. The bezel contains a glass imitation nicolo engraved in intaglio with a sacred monogram comprising a chi-rho with an extra horizontal bar.

This particular variant of the sacred monogram, which can be read as a combination of a chi-rho (see no. 4) and a *crux monogrammatica* (see no. 5), is known also from the Roman catacombs (T. Roller, *Les catacombes de Rome: histoire de l'art et des croyances religieuses pendant les premiers siècles du christianisme*, II, Paris, 1881, p. 296).

W. Smith and S. Cheetham, *A Dictionary of Christian Antiquities*, II, London, 1880, p. 1793; Dalton 1901, no. 28; Dalton 1912a, no. 27; Dalton 1915, no. 529. DB

5

6

Late Antiquity and Early Byzantium

Constantine and his son and successor, Constantius II, built churches not only in Rome and Constantinople but also in the Holy Land. The design of most of these was based on Roman public buildings, and in some cases existing structures were pressed into service. Indeed, during the fourth century, against a background of cultural continuity, all types of secular, pagan and Jewish art were being adapted to Christian purposes. In the course of the fifth century a recognisably Christian art became established, although the traditions of classical antiquity remained strong.

At the same time, the focus of the empire was shifting eastwards, away from the seat of those traditions. The New Rome, Constantinople, was establishing itself as the capital and administrative centre of a shrinking empire: Britain was left to its own devices at the beginning of the fifth century, and in 476 Rome itself fell to the first of a succession of Germanic rulers.

In Constantinople, the Emperor Anastasius (491–518) instituted generally popular reforms of taxation and the currency, ensuring that the Byzantine treasury was in a healthy position by the end of his reign. He was succeeded by Justin I, a notable soldier who was content to leave the administration of the empire to an able nephew, Justinian, who himself came to the imperial throne in 527.

7(a–b) Intaglios of the Good Shepherd

Probably Rome, 4th century

London, BM, M&LA

The Good Shepherd is one example of the adaptation of existing motifs to Christian uses. By degrees, the pagan Hermes *Criophorus* ('ram-carrier') had become the secular Good Shepherd, a popular symbol of salvation. It was this comfortable figure (no. 7a) which Christians adopted and identified as Christ (no. 7b). It is against this background that Christ's own claim to be the Good Shepherd (John 10.11 and 14) should be understood.

7(a) Red jasper

M&LA 65,2–24,2

16 × 13.8 mm (mounted)

Bought by the British Museum in 1865.

Octagonal red jasper intaglio of the Good Shepherd. He is dressed in a short tunic and buskins; his left hand grasps the hind and fore feet of a ram slung across his shoulders, while his right holds a *pedum* (crook). The figure partly obscures a dog or, possibly, a sheep, standing behind and slightly to the right. To the right and above is a sapling, which follows the edge of the stone. The ring is modern.

W. Smith and S. Cheetham, *A Dictionary of Christian Antiquities*, I, London, 1893, p. 712; Dalton 1901, no. 18; Dalton 1915, no. 519.

7(b) Burnt plasma

M&LA 56,4–25,22

12.5 × 9.3 mm (mounted)

Collection of the Abbé Hamilton, Rome. Bought by the British Museum in 1856.

Upright oval burnt plasma intaglio of the Good Shepherd. He holds a sheep across his shoulders with both hands. To his left are the letters IH (the first letters of 'Jesus' in Greek) and, to his right, XC (the first and last letters of 'Christ'). The ring is modern.

Dalton 1901, no. 1; Dalton 1915, no. 502. DB

8 Glass beaker from the catacombs

Rome, early 4th century

London, BM, M&LA Sloane 573

Ext. diam. at rim 64.8 mm, depth of vessel 75.5 mm

Said to have been found in the Roman catacombs, this object was among the curiosities collected by the physician Sir Hans Sloane (1660–1753), whose patients included Samuel Pepys and Queen Anne. The somewhat reluctant acceptance by the Nation of the Sloane collections led to the foundation of the British Museum in 1753.

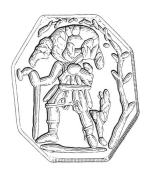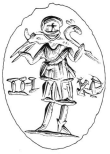

7a, b (enlarged)

8

Colourless blown-glass beaker with slightly everted thickened rim, set in mortar.

From the way the glass is set in the mortar, it could well have been a lamp. It would have been filled with vegetable oil and equipped with a floating wick.

Dalton 1901, no. 656.　　　　　　　　　　　　DB

9(a–c) Three gold-glass medallions

Rome, 4th century

These 'medallions' were originally the bottoms of blown-glass bowls and dishes, apparently made as wedding presents or to commemorate marriages. Gold leaf was applied to a disk of glass, then cut and engraved (and sometimes painted) before the disk was applied to the underside of the vessel, sandwiching and sealing the design. Many of these medallions have been found in the Roman catacombs, more or less carefully cropped and set in mortar. The most likely explanation is that on the death of one of the partners, or after the funerary meal, the vessel would be reduced to its commemorative medallion to mark the burial-place.

9(a) Bridal couple with Christ

London, BM, M&LA 98,7–19,1

Max. diam. 60.4 mm

Probably from the Roman catacombs. Collection of Count Michael Tyszkiewicz, Rome (d. 1897). Bought for the British Museum at the sale of the Tyszkiewicz Collection, in Paris in 1898 (lot 102).

The wall of the vessel, probably a bowl, has been carefully reduced to its rounded foot-ring and grozed. Within a broad annular border are the half-figures of a young couple. The woman (left) is dressed in a tunic with an embroidered scroll-patterned palla; she has an elaborate coiffure and wears earrings and a necklace. The man, beardless and with short curly hair, is depicted in a toga. Above and between their heads is a smaller beardless male figure in tunic and pallium, arms outstretched and with a wreath in either hand. Round the upper half of the medallion, inside the border, runs the inscription DVLCIS ANIMA VIVAS. There are traces of colour on the wreaths, the woman's jewellery, and the *clavi* on the right shoulders of the two male figures. Weathering prevents the medallion being seen from its correct side, through the inside of the bowl, and the colours cannot be identified from the underside, since the gold leaf intervenes.

The figure crowning the bridal couple is readily identifiable from numerous fourth-century representations as Christ. The inscription, 'May you live [long], sweet, soul', suggests that the bowl was a gift from one partner to the other.

W. Froehner, *Collection d'antiquités du comte Michel Tyszkiewicz* (sale cat.), Paris, 1898, p. 35, no. 102, pl. VI; Dalton 1901, p. 121, no. 613, pl. XXVIII; Morey 1959, p. 53, no. 310; Walter 1979, p. 84, fig. 3. Exhibited: *Glass of the Caesars* (1987), no. 157.

9(b) Bridal couple with Hercules

London, BM, M&LA 63,7–27,3

Maximum dimensions of oval fragment: 108.9 × 102.2 mm

Probably from the Roman catacombs. Collection of Count Matarozzi of Urbania. Bought by the British Museum in 1863.

The vessel, probably an oval dish, has been reduced to its shallow oval foot-ring and grozed. Within a double, slightly oval, border are the half-figures of a woman (left) and a man. The woman's face is framed with fronds of her hair; she wears a diadem with ornamented terminals, a complex jewelled collar with *pendilia*, and a toga-like garment. The short-haired and clean-shaven man wears a tunic and a toga. Between the couple, in the upper half of the composition, on a foreshortened disk, stands a smaller figure of Hercules, half-turned to his right. He is bearded, wears a lion-skin and carries a club in his right hand; in his left are represented three apples of the Hesperides. In the double border is the inscription ORFITVS.ET CONSTANTIA.IN NOMINE HERCVLIS and, in the field, ACERENTINO FELICES BIBATIS. Details painted are the apples (green), various elements of the jewelled collar (reddish brown, greenish blue and bluish white), and the *clavus* on the man's right shoulder (reddish brown).

The most convincing reading of the inscription is: *Orfitus et Constantia. In nomine Herculis Acerentini felices vivatis*

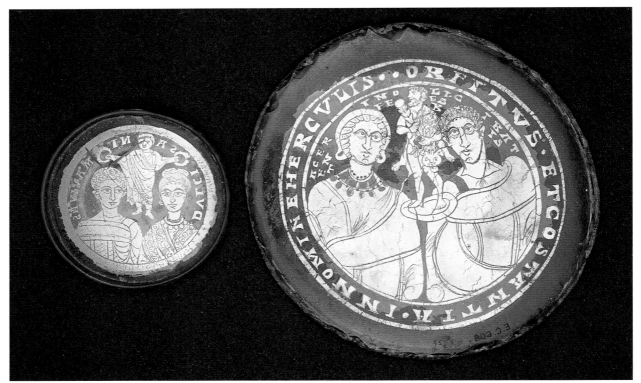

9(a, b)

('Orfitus and Constantia. Live happily in the name of Hercules, Conqueror of the Underworld'). The depiction of apples of the Hesperides, which had been a wedding gift to Hera/Juno, endorses the view that the gold-glass bowl was a present to Orfitus and Constantia on their marriage. A pagan aristocrat by the name of Memmius Vitrasius Orfitus held high office in Rome around the middle of the fourth century (*PLRE* I, pp. 651–3); one of his daughters married Quintus Aurelius Symmachus (see no. 44). The late Professor Morton Smith maintained that the unusual phrase 'in nomine Herculis' had been adapted from an established Christian formula, 'in nomine Jesu' (personal communication). This complements Dr Christopher Walter's view that the iconography of some pagan gold-glass is Christian in origin (Walter 1979, p. 84).

Garrucci 1858, pp. 69–70, pl. XXXV, 1; O. Iozzi, *Vetri cimiteriali con figure in oro conservati nel Museo Britannico*, Rome, 1900, pp. 28–30; Dalton 1901, pp. 119–20, no. 608, pl. XXIX; Morey 1959, p. 54, no. 316. Exhibited: *Masterpieces of Glass* (1968), no. 90; *Glass of the Caesars* (1987), no. 155.

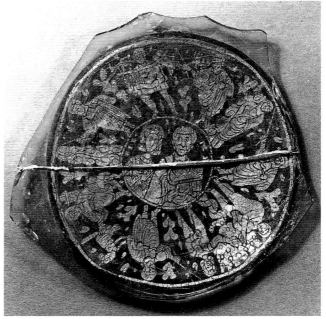

9(c)

9(c) Bridal couple with biblical scenes

Oxford, Pusey House

Diam. 108 mm

Collection of Baron Alessio Recupero. Wilshere Collection, Hertfordshire; bequeathed by C. Wilshere to Pusey House (1926).

The vessel, a plate, has been roughly broken away, leaving a gold-glass disk. The foot-ring is chipped, and there is a crack right across the centre of the fragment. The gold-glass disk has a central medallion in which are the half-figures of a young couple. The woman, who is slightly behind the man, wears a jewelled collar over a tunic and embroidered palla; she has an elaborate coiffure with jewels and holds a scroll in both hands. The beardless man wears a tunic and pallium. An inscription to either side and between their heads reads PIE ZE SES. Radiating from the central medallion are the biblical scenes, clockwise from lower right: (i) *The Fall*. Adam and Eve, naked, flanking the Tree of Knowledge, round the trunk of which is coiled the Serpent. The figures cover their pudenda with their left hands; Eve holds out the apple with her right hand, and Adam reaches for it with his. The Creator, in tunic and pallium grasped with his left hand, holds out a wand in his right. (ii) *The Sacrifice of Abraham*. Abraham, in tunic and pallium, the knife raised in his right hand, holds a naked Isaac by the hair with his left. To the left, the ram; behind Abraham, the altar, a pillar with flames rising from it. (iii) *Moses striking water from the rock*. Moses, identical in appearance and pose to the figure of the Creator in the earlier scene, strikes water from the rock with his wand. (iv) *The Healing of the Paralytic*. To the left, beardless and in a girdled tunic, the healed man carrying his bed; to the right is Christ, a figure identical to

that of the Creator and of Moses in the other scenes, complete with wand. (v) *The Raising of Lazarus*. To the left, Lazarus, in a winding-sheet and with his eyes closed; to the right is Christ, identical to the other representations. In the field are scattered leaf-fronds and dots of various sizes and shapes.

The inscription, PIE ZESES, is a Latin transcription of the Greek for 'Drink, that you may live!'

Garrucci 1881, III, pl. CLXXI,2; Garrucci 1858, pp. 1–3, pl. I,3; Vopel 1899, no. 126; T. B. L. Webster, 'The Wilshere Collection at Pusey House in Oxford', *Journal of Roman Studies* 19 (1929), p. 153, no. 71, pl. v,1; Morey 1959, no. 366. DB

10 The Projecta Casket

Rome, about 380

London, BM, M&LA 66,12–29,1

H. 286 mm, L. 559 mm, W. 432 mm

Part of the Esquiline Treasure, unearthed by workmen in 1793 at the foot of the Esquiline Hill, in Rome. The property of the convent of Minims of San Francesco di Paolo, the silver treasure was sold to Baron von Schellersheim (Florence) between 1795 and 1800 and subsequently, by 1827, to the Duc de Blacas, French ambassador to the Kingdom of the Two Sicilies, who died in 1839. His heir sold the entire Blacas Collection to the British Museum in 1866.

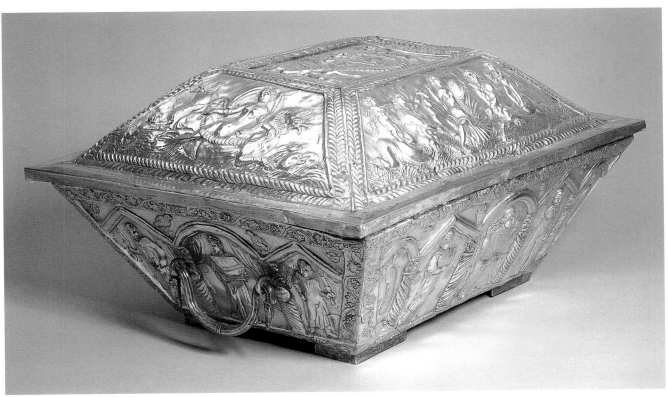

10

Silver casket, the body and hinged lid each a truncated rectangular pyramid with a flat sill; at either end of the body is a hinged handle. The decoration is embossed and partly gilt, that on the lid comprising: in the central rectangular panel, half-figures of a couple, surrounded by a wreath supported by two standing cupids; in the trapezoidal panels, (front) Venus in a shell, dressing her hair, flanked and attended by fantastic sea-creatures and cupids, (either end) a nereid riding a sea-monster, with cupids and dolphins, and (back) two groups of three figures approaching an elaborately domed Roman bath: some are carrying caskets, a ewer and other utensils. On the front, ends and back of the body of the casket, under alternating round and triangular-headed arches, a woman sits dressing her hair, flanked by attendants holding a variety of utensils; a peacock occupies each of the end arched compartments on the long sides. Along the sill at the front of the lid is the engraved inscription SECVNDE ET PROIECTA VIVATIS IN CHRISTO ('Secundus and Projecta, live in Christ'), preceded by a *crux monogrammatica* with alpha and omega. On the edge of the sill, to the left, is the pounced inscription P XXII –III Σ (P[ondo] XXII, [unciae] III, s[emuncia]: '22 pounds, 3½ ounces').

The iconography of the Projecta Casket suggests that it was a toilet casket given as a wedding present. It has long attracted interest because of its combination of mythological and secular scenes and Christian inscription. If the Secundus of the inscription was a member of the pagan Turcius family, as is suggested by the monograms on nos 11 and 12, then it must have been Projecta who was the Christian, charged by the donors of the casket – presumably her parents – with the conversion of her husband to Christianity. The inscription may have been added to a ready-made casket, of course; in any case, Christian scenes may have been considered inappropriate on something as secular as a toilet casket. The death on 30 December 383 of a young married woman by the name of Projecta is commemorated in an epitaph composed by Pope Damasus (366–84); Cameron's analysis of the epitaph supports the view that it was this Projecta who had owned the casket.

Visconti 1793, 3ff, pls I–VI; Dalton 1901, no. 304; Shelton 1981, no. 1, pls 1–11; Cameron 1985; Shelton 1985. Exhibited: *Wealth of the Roman World* (1977), no. 88; *Age of Spirituality* (1977–8), no. 310 (col. pl. IX); *Milano* (1990), no. 1g.1d.1. DB

11 Silver dish with monogram

Rome, 4th century

London, BM, M&LA 66,12–29,12

Diam. 161 mm

Part of the Esquiline Treasure (see no. 10).

Round dish, lathe-turned, with rim grooved and faceted in profile. In the centre is a monogram composed of Roman capital letters, within a wreath of laurel leaves and berries; the monogram and wreath are engraved, nielloed and gilded. On the underside is a foot-ring, a centring-point and two concentric grooves, one within the foot-ring and the other close to the rim. Following the curve of the rim on the underside is the pounced inscription .SCVT.IIII.P V. (*Scut[ellae] IIII. P[ondo] V*: 'four small dishes [weighing] five pounds').

This dish is one of a set of four, as the pounced inscription suggests. The other three are exhibited in the British Museum with the rest of the Esquiline Treasure. The block monogram can be read as *Pelegrinae Turcii* ('[the property] of Pelegrina, of the Turcius family'); a Pelegrina was the owner of a silver ewer in the Esquiline Treasure (Shelton 1981, no. 17), and it has been argued that the Secundus addressed in the inscription on the Projecta Casket (no. 10) was also a Turcius. The Turcii were pagan aristocrats who held high office in fourth-century Rome (see no. 14).

Visconti 1793, 9ff, pl. XIV; Dalton 1901, p. 71, no. 316; Shelton 1981, no. 5, pl. 26; Cameron 1985; Shelton 1985. Exhibited: *Wealth of the Roman World* (1977), no. 92 (66,12–29,11). DB

11

12

12 Silver dish with monogram

Rome, 4th century

London, BM, M&LA 66,12–29,18

202 × 146 mm

Part of the Esquiline Treasure (see no. 10).

Silver rectangular dish with monogram within a laurel wreath, both engraved, nielloed and gilded. The openwork rim is composed of pelta shapes, chased and pierced, with a chased leaf-like projection at each corner. The dish has a rectangular foot-'ring'.

One of a set of four in the Esquiline Treasure, preserved in the British Museum. The monogram is identical with that on the round dish (no. 11).

Visconti 1793, 9ff, pl. XIII; Dalton 1901, p. 71, no. 315; Shelton 1981, no. 9, pl. 27. Exhibited: *Wealth of the Roman World* (1977), no. 91 (66,12–29,15). DB

13 Personification of the city of Rome

Probably Rome, 4th century

London, BM, M&LA 66,12–29,21

H. 187 mm, w. approx. 70 mm, depth 86 mm. Weight 728 g

Part of the Esquiline Treasure (see no. 10).

A hollow cast silver socket has its front formed as a female figure and a large pendent leaf suspended from its lower side. The personification of the tyche or *fortuna* of Rome is seated frontally on the top edge of the oblong socket, her left shoulder raised and her left leg extended forwards. She wears a crested helmet, a sleeveless tunic with high belt, and soft boots; a mantle is draped from her left shoulder, down over her lap. In her right hand she holds an upright spear (now misshapen) and in her (very large) left hand a circular shield (most of the right half is missing). All surfaces but the flesh of the figure and boots are gilded, and many details of punched ornament added: three-dot ornament on the mantle, linear patterns on the tunic, and cusped bands around the edge and boss of the shield.

The hollow socket is square in section (35 × 35 mm) and its opening at the back is framed with a moulding 3 mm thick. Near the opening is a hook with a leaf-shaped soldering plate attached to the right side of the socket. Threaded through the hook is an s-shaped link of a chain (now lost) which once held a pin for insertion in the holes which pierce

the top and bottom sides of the socket. The lugs of the hinged leaf are situated directly behind the tyche's feet. There, a gilt plate (length 45 mm), which terminates in a knob, is cut along the edges and pierced symmetrically in four places to form a palmately lobed leaf. The veins on its front surface are indicated by a series of punched dots and crescents; the reverse side is plain. The figure's nose is rubbed very flat; otherwise, except for missing chain and damaged spear and shield, the socket is in good condition.

For discussion, see no. 14 below.

Dalton 1901, no. 332; Shelton 1981, no. 32; Cameron 1985, 140f; Shelton 1985, 152–5. Exhibited: *Age of Sprituality* (1977–8), no. 155; *Milano* (1990), no. 5b.2e.a. MMM

14 Personification of Constantinople

Probably Rome, 4th century

London, BM, M&LA 66,12–29,23

H. 180 mm, w. approx. 60 mm, depth 84 mm. Weight 706 g

Part of the Esquiline Treasure (see no. 10).

This chair ornament closely resembles that of Roma (no. 13), with which it formed part of a set (see below). Again, the silver socket has its front formed as a female figure and a large pendent leaf suspended from its lower side. The hollow cast figure of the tyche of Constantinople is seated on the top of the oblong socket, with frontal posture very similar to that of Roma. She too wears a crested helmet (here bent down in the front) and the same costume (tunic and mantle) similarly arranged. Her hair, however, is pulled back and she wears two bracelets. The position of her arms also differs: the extended right hand holds a patera and the left arm supports an upright cornucopia. The gilding and punched ornament parallels that of the other figure.

The hollow socket repeats that of Roma, but is slightly smaller (33 × 33 mm in section), and the hook and chain are missing. The position, form, length and decoration of the gilded hinged leaf under Constantinople are the same as on the other socket. The figure's face is less worn than that of Roma, but there is a hole in its side, under the left arm.

With the figure of Roma (no. 13), this socket formed part of a set of four furniture attachments which also included the tyches of Alexandria and Antioch, wearing mural crowns rather than helmets. While three of the figures have very similar poses, Antioch differs, reflecting the Hellenistic original of 296 BC by Eutychides. Like the Naissus dish (no. 1), which was made as an item of *largitio*, these representations of the four main cities of the empire belong to the realm of official art, and may have been insignia of civil or military office. An assembly of tyches was associated with the emperor and Late Antique bureaucracy (K. J. Shelton,

'Imperial Tyches', *Gesta* 18 (1979), pp. 27–38). The figures form pairs, Rome and Constantinople being right- and left-hand images, as are Alexandria and Antioch, respectively, and are thought to have been attached to a *sedes gestatoria*, a sort of sedan chair (Shelton 1981, p. 26; Cameron 1985, p. 141). The question of which office the cities would have been associated with has not been resolved. The Esquiline Treasure includes other silver chair ornaments, in the form of a pair of hands holding mounted spheres (Shelton 1981, nos 34–5); the precise function of these remains even more obscure (*op. cit.*, pp. 25f). Although a theory recently challenged (*op. cit.*, pp. 31–5), it has long been accepted, on the basis of the inscribed objects, that the owners of the Esquiline Treasure were Turcius Secundus and Proiecta Turcii, married from 379 to 383, although another name, Pelegrina, appears on one vessel. Members of the *gens* Turcia of Rome held high office, including that of city prefect (in 339 and from 362 to 364), *quaestor, praetor, comes Augustorum* (337–40), *corrector Piceni et Flaminiae* (339–50), and consul (494). A terminus post quem for the chair ornaments is 324, when Constantinople was founded; a later date (380) has also been suggested for the personification of Constantinople with helmet – copying Roma – and cornucopia (Cameron 1985, p. 141).

Dalton 1901, no. 333; Shelton 1981, no. 30; Cameron 1985, pp. 140f; Shelton 1985, 152–5. Exhibited: *Age of Spirituality* (1977–8), no. 155; *Milano* (1990), no. 5b.2e.b. MMM

15 The Corbridge *Lanx*

Probably Mediterranean, 4th or 5th century

London, BM, PRB P 1993.4–1.1

378 × 506 mm, H. 31 mm. Weight 4632.8 g

Found in 1734, with another silver object (now lost), by the River Tyne near Corbridge; formerly in the collection of the Duke of Northumberland; acquired by the British Museum in 1993.

The oblong dish has a central rectangular concavity, a flat horizontal border and an oblong foot. Mistakenly described in the past as cast, the hammered dish has on its obverse side chased relief decoration embellished with punched and other surface detail. The border has small beading along both edges, with the space in between filled with an undulating vine scroll, sprouting within each curve either a bunch of grapes (on the outer side) or a leaf (on the inner). The central surface of the plate is filled with what has been identified as a representation of the shrine of Apollo on Delos. The scene, set in a landscape, is framed by the key figures of Artemis and Apollo, who both face inwards. Between them are three women, including their mother Leto who is seated spinning on the right, Athena in military dress on the left and Leto's sister Ortygia in the middle. Behind Apollo is a

13

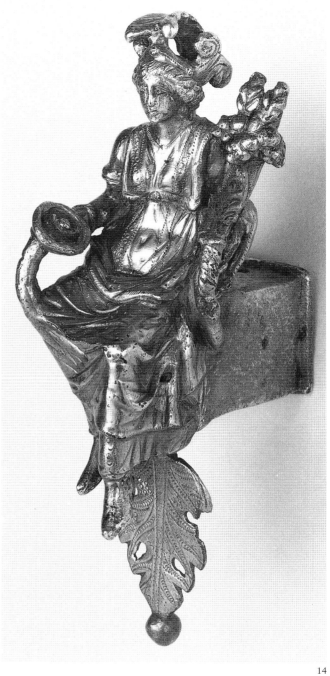

14

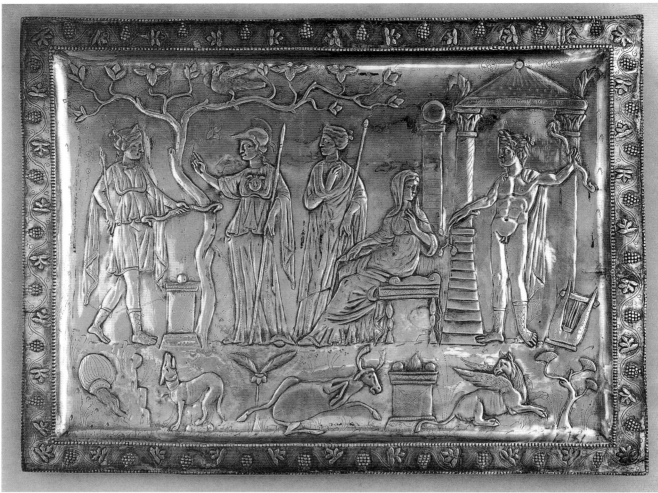

15

small temple with a high staircase and a pillar surmounted by a sphere. In the left background stands a tree filled with birds, and an altar beside it. In the foreground stands a second altar flanked by Artemis' hound and fallen stag, and Apollo's griffin. Ortygia herself was transformed into the island of Delos (birthplace of Artemis and Apollo), further represented by the fallen urn and hill in the lower left corner.

The reverse side of the plate has four flat grooves extending diagonally outwards from the corners of the foot towards the border. Between two of the grooves, and parallel to a short side of the foot, is a dotted weight inscription in Latin (normally given as '14 pounds, three ounces, two scruples'; it should read '19 pounds minus three ounces, two scruples', but its current weight is about fourteen Roman pounds).

An oblong Roman dish is now often called a *lanx*. In Antiquity, its distinguishing feature may have been its shape in section rather than in plan: in Apicius, the *lanx* was a serving dish recessed to contain sauced food (Apicius, ed.

J. André, p. 310), as distinct from the *discus* which was flat and used for unsauced food (*op. cit.*, 309). When oblong, the '*lanx*' is specifically qualified as '*quadrata*' (*Codex Justinianus, Digest,* XXXIV.2.19.4). Other late Roman oblong and square silver plates have been found in Britain (C. Johns and K. Painter, 'The "rediscovery" of the Risley Park Roman lanx', *Minerva*, 2/6 (1991), pp. 6–13; exh. cat. *Wealth of the Roman World* (1977), no. 103), and elsewhere (Cahn and Kaufmann-Heinemann 1984, no. 61; Dodd 1961, no. 11).

Most mythological subjects displayed in Late Antique art appear devoid of a specifically pagan character (see nos 16 and 75). The scene portrayed on the Corbridge *Lanx* is considered cultic and, therefore, not simply mythological but properly pagan, in a religious sense. It is furthermore thought that the scene depicted commemorates a visit by the Emperor Julian the Apostate to the shrine on Delos in 363. This interpretation relies on certain unproven assumptions – that an object as massive as this would have imperial

connections; that only Julian's reign was a time of pagan observance; that the object must portray an important shrine (instead, the specific characters associated with the Delos shrine (Artemis, Leto, etc.) could be conjured up to illustrate any temple of Apollo). This is a matter of pure speculation, and, even if true, the commemoration need not have been contemporary with the event, and the object could be somewhat later.

The figure style of the *Lanx* is notably awkward, particularly in comparison with that of the Mildenhall plates (no. 16) and even the Eros plate (no. 75). For reasons of iconography, it has been suggested that the dish was made in fourth-century Ephesus, given its links with the cults of Artemis, Apollo and Leto. If so, the dish would be, strictly speaking, a product of Byzantine Asia Minor. While the weight inscription on the reverse side is in Latin, and the fact that it was pounced rather than casually scratched may be taken to mean that it was added to the dish at the time and place of manufacture (Strong, 1966, p. 20), Latin was still the official language of the whole empire, particularly in the fourth century. Furthermore, parts of Greece administratively belonged to the Latin West. There is nothing such as stamps, inscriptions or images to suggest, however, that the dish was produced in a state workshop where Latin was in use.

O. Brendel, 'The Corbridge Lanx', *Journal of Roman Studies* 21 (1941), pp. 101–27; T. Dohrn, 'Spätantikes Silber aus Britannien', *Mitteilungen des Deutschen Archäologischen Instituts* 2 (1949), pp. 115–18; S. S. Frere and R. S. O. Tomlin (eds), *The Roman Inscriptions of Britain* II, fasc. 2, Gloucester, 1991, 2414.38. Exhibited: *Age of Spirituality* (1977–8), no. 110. MMM

16(a–b) Plates with Dionysiac figures (Mildenhall Treasure)

Probably Eastern Empire, 4th century

London, BM, PRB, (a) 1946,10–7,2 and (b) 1946,10–7,3

(a) Diam. 186 mm, H. 30 mm. Weight 539 g

(b) Diam. 184 mm, H. 30 mm. Weight 613 g

Found during the 1940s at Mildenhall, Suffolk. Declared Treasure Trove at an inquest on 1 July 1946 and immediately acquired by the British Museum.

A pair of plates, each with a slightly concave inner surface and foot-ring. They have related figural decoration in relief worked from the front, and a series of (a) 65 and (b) 64 large beads around the rim. The plates display pairs of Dionysiac characters (Pan, two Maenads and a satyr), with their cult implements in analogous composition: a pair of standing figures, male on the left, female on the right, face each other, three of them in *contrapposto*. There is studied interplay between straight and curved elements: *pedum*, double-pipes, branch, snake, on one, and *thyrsos*, *pedum*, on the other. Forms at the top and bottom of the plate are repeated: the contours of the nymph and doe on one plate, and those of the dish and fruit-filled skin on the other. The background on both plates is filled with pounced sprigs. The figures on each plate are:

(a) On the left, Pan plays a syrinx; a *nebris* is knotted around his neck and a *pedum* is in one hand. On the right, a Maenad, wearing *peplos* and a billowing mantle, plays double pipes. On the ground between them lies a tambourine; above them a nymph reclines against an urn pouring

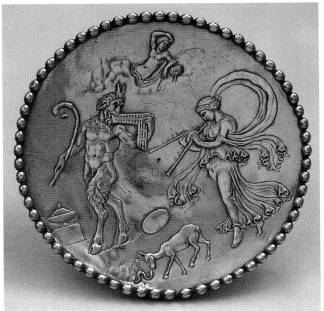

16(a)

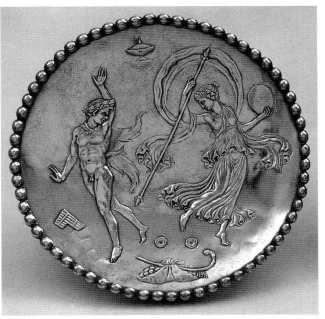

16(b)

water into a pool. In the lower centre of the plate a doe holds a snake in its jaws, and on the far left a covered dish with beaded rims stands on a low plinth.

(b) On the left, a satyr with a *nebris* tied around his neck and a wreath on his head, dances with his arms thrown out; a syrinx lies beside him. On the right, a Maenad, dressed like the one on the other plate, holds a *thyrsos* in one hand and plays a tambourine with the other. Between them lies a pair of castanets and, below those, a fruit-filled skin tied with a *pedum*. Above them stands another covered dish on a plinth.

The reverse side of the plate, outside the foot-ring, has been finished by turning; inside the other foot-ring the metal surface has a horizontal finish. On either plate a Greek inscription, 'of Eutherios', has been scratched into the surface just outside the foot-ring and parallel to it.

The two plates form a set with a much bigger dish (diam. 605 mm) having related subject matter: a Dionysiac marine *thiasos* with a head of Okeanos at the centre. In contrast to the overtly pagan scene on the Corbridge *Lanx* (no. 15), the theme represented on the Mildenhall plates (as well as that on no. 75) belongs to a group of neutralised mythological subjects, common in Late Antiquity up to the mid seventh century and reappearing by the tenth. Such subjects remain an inherent part of the classical heritage of Byzantium, citations from the past which constitute its Greek culture: they are literary rather than religious. These traditional subjects, displayed in both monumental and minor art (see also no. 75), are by Late Antiquity largely devoid of a specifically pagan character. Popular deities have become mere personifications of natural forces or human qualities: Dionysus of earthly fertility, Aphrodite of beauty; so also the wisdom of the pagan sages is invoked (as on the Lampsacus spoons: see no. 133). The large Mildenhall plate is said to represent in its two friezes the gifts of water and the earth (L. Schneider, *Die Dömane als Weltbild: Wirkungsstrukturen der spätantiken Bildersprache* (Wiesbaden, 1983), p. 150). Attributes of the Dionysiac cult (the vine, the *kantharos*) were also taken over into Christian eucharistic symbolism (no. 96). Spoons in the Mildenhall Treasure have the Christian chi-rho prominently incised on their bowls. This mixture of 'pagan' and Christian elements within a single find of Late Antique domestic plate is not uncommon.

The large beads on the plate rims are a characteristic ornament of fourth- and fifth-century silver (see no. 35) and, judging from datable examples, get progressively larger. Given the Greek inscriptions on the plates, their sometime owner, Eutherios, may have acquired them in the eastern empire, where they may also have been made. How and when they reached Britain is a matter of speculation. Attempts to identify the Eutherios named on both plates with an Armenian *cubicularius* serving the Emperor Julian (T. C. Skeat, *Journal of Roman Studies* 38 (1948), p. 102

note 17; Painter, pp. 22f), have not met with widespread acceptance (*RIB*, no. 2424.5; A. Cameron, 'Observations on the distribution and ownership of Late Roman silver plate', *Journal of Roman Archaeology* 5 (1992), p. 182).

J. W. Brailesford, *The Mildenhall Treasure*, London, 1947; T. Dohrn, 'Spätantikes Silber aus Britannien', *Mitteilungen des Deutschen Archäologischen Instituts* 2 (1949), p. 67; K. S. Painter, *The Mildenhall Treasure: Roman Silver from East Anglia*, London, 1977, nos 2–3; *RIB*, nos 2414.5–2414.6.　　　MMM

17 Glass flask with Greek inscription

Asia Minor, early 4th century

London, BM, M&LA 1962,12–2,1

H. 126 mm, diam. 99 mm

Bought for the British Museum at Christie's, 4 December 1962 (lot 17).

Greenish blown-glass vessel with roughly spherical body and a short hemispherical funnel-neck. The upper half of the body is engraved with a band of cross-hatching, the lower part with a palm-frond and the inscription KYPIA in outline characters spaced to occupy the entire circumference; below the inscription is a band of hatching.

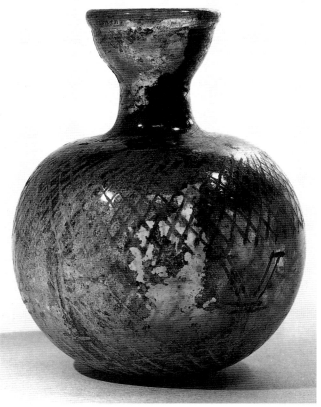

17

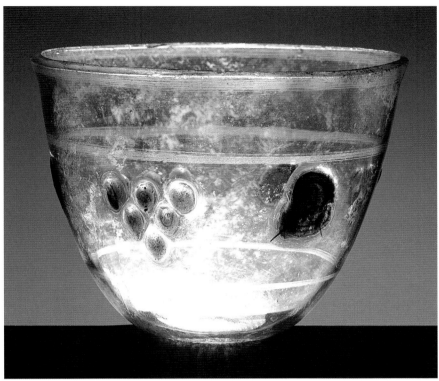

18

The flask belongs to a group of blown-glass vessels characterised by Greek inscriptions in wheel-abraded outline letters and, usually, by wheel-abraded cross-hatching. Dr Harden (most recently in exh. cat. *Glass of the Caesars* (1987), p. 183) has argued for manufacture in Asia Minor in the early fourth century (an earlier, late third-century, group he has assigned to Egypt). The world KYPIA, which Harden took to mean 'for the lady, or mistress', is perhaps better understood as 'power' or 'authority': other vessels of the group are engraved with Greek abstract nouns such as 'joy', 'health' and 'grace'. 'His' and 'her' flasks remain a possibility, however, since one of the group is inscribed 'for the lord, or master'.

D. B. H[arden], 'A Romano-Syrian inscribed glass flask', *British Museum Quarterly* 27 (1963), pp. 27–8, pl. VIII; Harden 1967–8, p. 46, no. 7, fig. 5, pl. 9/3, pp. 52–3. DB

18 Glass bowl

Cyprus, 4th century

London, BM, GRA 1871.10–4.3

H. 95 mm, diam. 123 mm

From Cyprus. L. P. de Cesnola Collection. Given to the British Museum in 1871 by the executors of Felix Slade.

Deep colourless blown-glass bowl decorated with applied blue blobs and wheel-engraved bands.

A shallow bowl with the same decoration (exh. cat. *Masterpieces of Glass* (1968), no. 86) also comes from Cyprus, as does a further example now in Birmingham.

Exhibited: *Glass of the Caesars* (1987), no. 46. DB

19 Glass decanter

Probably Syria, 4th century

London, BM, GRA 1856.10–4.1

H. 270 mm, diam. 121 mm

Found, containing wine, during Duncan MacPherson's excavations at Kerch, at the easternmost end of the Crimean peninsula. Given to the British Museum in 1856 by Dr MacPherson.

Yellow blown-glass jug with applied flat handle and foot, both in green glass. Ovoid body with cylindrical neck and everted rim, coiled yellow trail from rim to shoulder.

The ancient city of Pantikapaion at the extreme eastern tip of the Crimean peninsula was the capital of Cimmerian Bosporos, an ally of Rome. Despite a slow decline in the fourth century, exacerbated around 370 by occupation by the Goths, Bosporos has yielded high-quality fourth- and fifth-century Byzantine silver (exh. cat. *Iskusstvo Vizantii v sobraniyakh SSSR*, I, Moscow, 1977, nos 34–6, 44–50) and

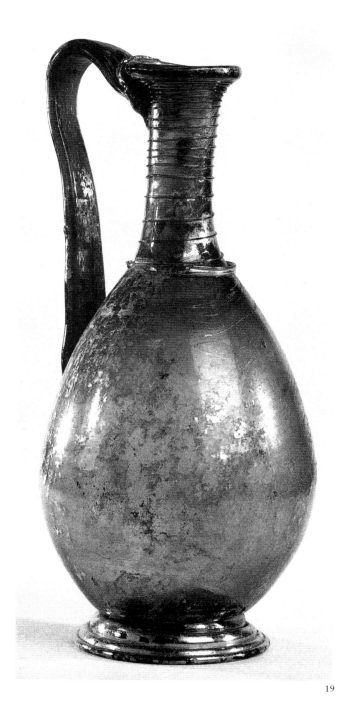

19

at the end of the fourth century remained an important commercial centre with trade links with lands as distant as Syria and even Egypt.

D. MacPherson, *Antiquities of Kertch*, London, 1857, p. 89, pl. VI. Exhibited: *Glass of the Caesars* (1987), no. 74. DB

20 Large glass jug

Syria, 4th century

London, BM, GRA 1900.10–15.1

H. 456 mm, diam. 127 mm

From Syria. Decaristo Collection. Bought by the British Museum in 1900.

Greenish blown-glass jug with applied tooled handle and applied foot with annular trail. The bulbous body tapers into the neck; the rim is splayed and thickened, with a thumb-piece at the top of the handle.

In size and shape this large jug has been compared with silver examples, e.g. the Pelegrina ewer in the Esquiline Treasure (Shelton 1981, no. 17).

Exhibited: *Masterpieces of Glass* (1968), no. 117; *Glass of the Caesars* (1987), no. 75. DB

21 Glass flask from an Anglo-Saxon burial

Egypt, 4th century

Worthing, Worthing Museum and Art Gallery, 3500

H. 203 mm, diam. of rim 60 mm

Found in 1894 in an inhumation grave, grave 49, in the Anglo-Saxon cemetery at High Down, Ferring, near Worthing, Sussex.

Olive blown-glass flask with ovoid body, conical funnel-neck and splayed foot with knop on short stem. The engraved decoration consists of: on the body, a frieze between double-line borders of a hound chasing two hares, the animals separated by clumps of foliage and with blades of grass indicated beneath their bodies; above and below the frieze is a band of s-shapes; the cylinder of the neck is decorated with vertical lines; a double line separates the cylinder from the conical lip, on which is a Greek inscription.

The flask is remarkable for its find-spot, a grave in an Anglo-Saxon cemetery. The inscription is perhaps best read as 'Use me and be of good health' (see Read, pp. 206–7).

C. H. Read, 'Further excavations in a cemetery of South Saxons on High Down, Sussex', *Archaeologia* 55 (1896), pp. 205–8, 212, pl. VIII; *Victoria County History, Sussex*, I, 1905, p. 343, pl. opp. p. 344; A. E. Wilson and E. Gerard, *A Guide to the Anglo-Saxon Collection*, Worthing Museum, 1947, p. 11, frontispiece; D. B. Harden, 'Glass vessels in Anglo-Saxon Britain', *Archaeological News Letter* III/2 (July 1950), p. 26; Harden, 'Saxon glass

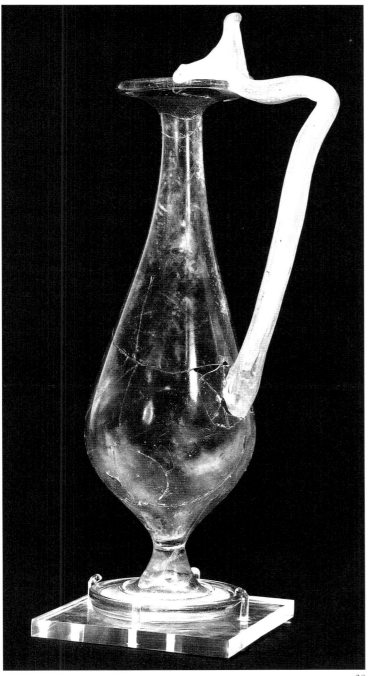

20

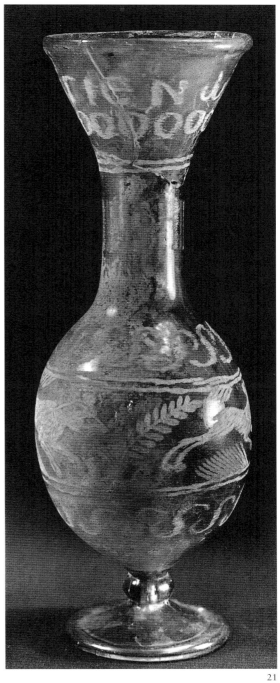

21

from Sussex', *Sussex County Magazine* 25 (1951), pp. 263–4, 266, fig. 10; Harden, 'Glass vessels in Britain and Ireland, AD 400–1000', in: D. B. Harden (ed.), *Dark-Age Britain: Studies presented to E. T. Leeds*, London, 1956, p. 136, pl. xvd; A. E. Wilson, *A Guide to the Anglo-Saxon Collection*, Worthing Museum, 1958, p. 2, pl. i; D. B. Harden, 'The Highdown Hill glass goblet with Greek inscription', *Sussex Archaeological Collections* 97 (1959), pp. 3–20; M. G. Welch, *Early Anglo-Saxon Sussex*, pt ii (British Archaeological Reports, British Series, 112(ii)), Oxford, 1983, p. 472, fig. 103c. DB

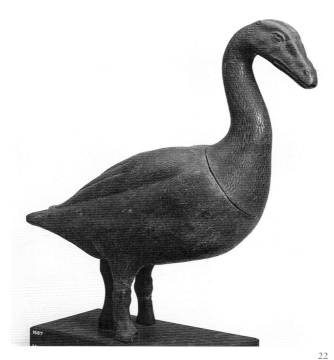

22 Bronze goose

Roman Empire, probably 4th century

London, BM, GRA 1859.6–1.1

H. 415 mm, L. 565 mm

Bought by the British Museum in 1859 from a person in Lord Stratford Canning's service when he was Ambassador to the Porte; said to have been found in the Hippodrome at Constantinople during the construction of a house.

Cast bronze figure of a goose, about life size, made in separate pieces, the body, the neck and head, and the right leg; the neck and head are designed to be removed. A tubular orifice is situated in the beak.

Although possibly part of statuary group of Aphrodite, the goose was meant to serve a purpose. A fountain has been suggested, but the method of introducing the water is not apparent, and would require the neck to be sealed to the body. Perhaps a combustible substance was introduced and smoke was intended to emerge from the beak. Possibly it was a representation of a Capitoline goose.

Walters 1899, no. 1887; O. Keller, *Die antike Tierwelt*, II, Leipzig, 1913, p. 223, fig. 84. DMB

23 Alfresco banquet, from a sarcophagus

Probably Rome, 4th century

Oxford, Pusey House, 65.4

H. 300 mm, W. 700 mm, thickness 80 mm

Wilshere Collection, Hertfordshire (probably bought in Rome). Bequeathed to Pusey House by C. Wilshere (1926).

22

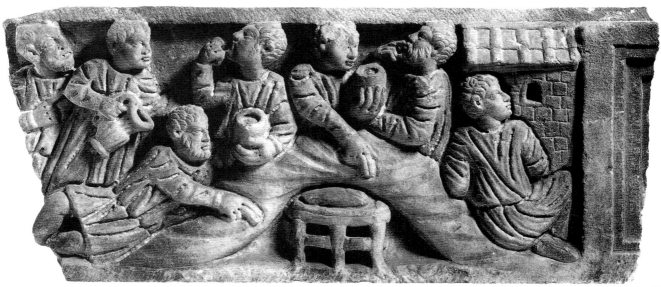

23

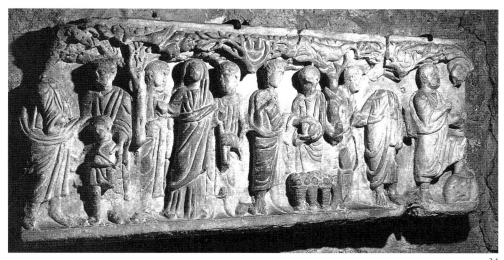

24

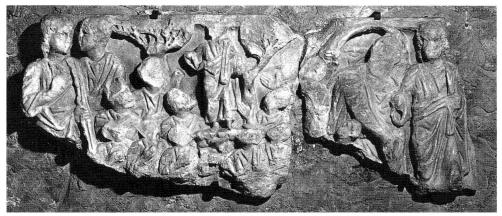

24

Part of a marble sarcophagus lid, carved in relief with an outdoor banqueting scene. Seven figures are standing or lying around a sigma-shaped table; there is a small table in the foreground and a two-storey house in the background.

The banquet is the characteristic culmination of hunts carved on sarcophagi (e.g. Andreae 1980, no. 27, from Déols, where the banquet is also taking place in the open air). The scene on the Pusey House fragment is a striking example of the transference of iconographic motifs to Christian use, replacing the customary boar's head of the hunting scenes with loaves or fishes. However, it is often hard to distinguish which eucharistic meal is being referred to: the multiplication of the loaves, the Last Supper, or the sacrament of the Eucharist (Gerke 1940, pp. 110–51, pls 25 and 26,1).

Webster 1929, pp. 150–4. RKL

24 Sarcophagus fragments with biblical scenes

Probably Arles, end of 4th century

London, BM, M&LA 1993,4–6,1

H. 600 mm, W. 1450 mm; thickness 100 mm and H. 400 mm, W. 1120 mm; thickness 80 mm

Recorded in 1808 in a country house in the environs of Carpentras (Vaucluse). It belonged to Hyacinthe Olivier, better known as Olivier-Vitalis (1764–1842), canon of Beauclaire. It was probably removed on Vitalis's death, as it could not be found for inclusion in an 1886 publication. It was rediscovered in the chapel of La Madeleine, outside Bédoin (Vaucluse), by Fernand Benoît and published by Wilpert in 1936. It was bought by the British Museum in 1993.

Two marble panels carved in relief with scenes from the Bible; the larger panel represents two-thirds of a side of a sarcophagus. The scenes, framed in an arcade of trees inhabited by nesting birds, are probably to be identified as (left to right): Christ raising the widow's son, a female orant

between two saints, the multiplication of the loaves, Moses with the altar he built to the Lord, and Moses receiving the tablets of the Law. The orant presumably represents the deceased. The smaller panel probably depicts the Sermon on the Mount, flanked by two further scenes: (left) Christ with a disciple, and (right) the healing of the centurion's servant; the lower third of these three scenes is missing.

Twenty-seven examples are known of this type of sarcophagus, where abbreviated biblical scenes are punctuated by the trunks of trees, the foliage of which forms a series of arches. They are found both at Rome and in Provence, notably at Arles. Stable isotype analysis of samples from the two panels suggests that the marble was quarried at Carrara or, possibly, in the Pyrenees.

Lavagne suggests alternative identifications of the two scenes flanking the central orant: the healing of the blind man, and Daniel poisoning the dragon, which Lavagne claims to see wrapped round the tree-trunk. Two scenes are missing from the left end of the sarcophagus: Wilpert reconstructs these as the marriage at Cana and the raising of the widow's son (the healing of the blind man, presumably, if one of the surviving scenes is correctly identified as the raising of the widow's son).

O. Millin, *Voyage dans les départements du Midi de la France*, IV, Paris, 1808, p. 136; G. Wilpert, *I sarcofagi cristiani antichi*, III, Vatican City, 1936, pp. 33, 35, pl. CCLXXXXII; F. Benoît, *Sarcophages paléochrétiens d'Arles et de Marseille*, Paris, 1954, pp. 16–17, 31, 45, 48, 52; H. Lavagne, 'Les deux sarcophages paléochrétiens de la chapelle de la Madeleine à Bédoin (Vaucluse)', *Cahiers archéologiques* 41 (1993), pp. 15–30. RKL

25 Small statue of Victory

Probably Rome, about 400

Oxford, Ashmolean Museum, Department of Antiquities, M. 156

H. 620 mm, W. 340 mm; thickness 160 mm

In the Ashmolean by 1882.

Small marble group of three standing figures: a large female figure with draped lower torso, the head and neck, left arm and most of the right arm missing; a smaller male figure, naked, the head missing; and a male figure with draped lower torso, the head and upper part of the body missing. The female figure rests her left foot on a stump; behind the group is a tree. The marble is white and well polished; at the back, the female figure is only roughly finished and the smaller figures not modelled at all. The base has a concave moulding and is approximately oval across the top.

The figure of Victory belongs to a well-known Roman type. The smaller male figures appear to be a prisoner and possibly a personification of the Genius Populi Romani. The statuette is a late example of three-dimensional sculpture. Similarities in size, style, workmanship and the type of

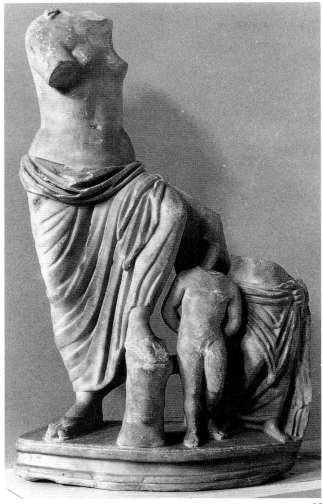

25

moulded base to a group of Late Antique sculptures, a newly identified Hercules in the Garden of the Hesperides in New York (Lehmann 1945) and a Ganymede recently excavated at Carthage (Gazda 1981), place it in the context of a revival of interest in mythology and classical philosophy in the later fourth century.

A. Michaelis, *Ancient Marbles in Great Britain*, transl. C. A. M. Fennell, Cambridge, 1882, p. 156; L. Bonfante and C. Carter, 'An absent Herakles and a Hesperid: a Late Antique marble group in New York', *American Journal of Archaeology* 91 (1987) pp. 247–57, fig. 11. RKL

26 Gold marriage-ring

Western Roman Empire, 3rd or 4th century

London, BM, M&LA 1971,8–2,4

L. 21 mm; L. of bezel 15 mm

From Cairo. Bequeathed to the British Museum by Sir Augustus Wollaston Franks (1897). Franks joined the British Museum in 1851 and became Keeper of British and Mediaeval Antiquities and Ethnography in 1866. His bequest of 3330 items to the Museum crowned decades of generosity towards the institution he had served.

Gold finger-ring with a hoop of plain gold strip edged with twisted wire, the joins between the hoop and bezel masked by three gold granules. The bezel is an oval box-setting containing a discrete gold sheet embossed with two clasped hands within a pearled border. The edge of the bezel is embellished with twisted wire.

The clasped hands refer to the gesture of *dextrarum iunctio* (the joining of the right hands), a common rite in the Roman marriage ceremony. Marriage-rings were worn on the *anularius*, the third finger of the left hand, since it was believed that this contained a sinew which connected directly to the heart. Rings of this type were produced in gold, silver and bronze. Their find-spot distribution suggests that they were manufactured mainly in the western part of the empire. An example found at Grovely Wood, Wiltshire, together with gold coins, indicates that this type was still in vogue in the late fourth century (exh. cat. *Wealth of the Roman World* (1977), no. 140).

F. H. Marshall, *Catalogue of the Finger Rings, Greek, Etruscan, and Roman, in the Departments of Antiquities, British Museum*, London, 1907, pp. 48–9, no. 275. CJSE

27 Gold marriage-ring

Eastern Mediterranean, 4th or 5th century

London, BM, M&LA AF 304

Max. diam. 26 mm; L. of bezel 12 mm

Bequeathed to the British Museum by Sir Augustus Wollaston Franks (1897).

Gold finger-ring with an inverted square bezel and a hoop composed of seven medallions inlaid with niello. The bezel is deeply engraved with a confronted male and female bust, with a small cross above the heads. The woman, at left, wears a mantle, earrings and necklace; the man, who is bearded, wears a chlamys fastened by a fibula. The hoop of the ring is decorated with alternating male and female busts, the males each wearing a chlamys fastened by a fibula on the right shoulder and the long-haired women wearing necklaces and earrings. The joins between the medallions are masked at top and bottom by a gold granule.

The best parallels for the exquisitely engraved busts on the bezel are found on another marriage-ring in the Dumbarton Oaks Collection, Washington, D.C., which is also engraved with the names of the couple, Aristophanes and Vigilantia (Ross 1965, pp. 48–50, no. 50, pl. 39). The busts are so close in style as to suggest that both rings were made in the same workshop. Numerous examples of marriage-rings with confronted male and female busts have survived, in silver and bronze as well as gold (Ross 1965, pp. 48–50, for bibliography). The fibulae which adorn the male busts are of a type generally associated with high imperial officials and suggest that this ring was made for one.

C. E. Fortnum, 'On a Roman key-like finger-ring of gold, and a Byzantine bicephalic signet of the same metal', *Archaeological Journal* 29 (1872), pp. 304–13, fig. 2; Dalton 1901, pp. 32–3, no. 207; Dalton 1912a, p. 21, no. 127; Ward *et al.* 1981, p. 47, no. 100. Exhibited: *Jewellery* (1976), no. 436; *Spätantike* (1983–4), no. 257. CJSE

28 Official coin-weight

Western Roman Empire, late 4th century

London, BM, CM 48,8–19,157

16.6 × 20.8 mm. Weight 3.73 g

Pembroke Collection; bought by the British Museum in 1848.

Sub-rectangular copper-alloy *exagium solidi* (official standard weight for the solidus) struck on the obverse with three imperial busts, diademed and wearing paludamenta, with

26 (enlarged)

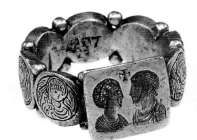

27 (enlarged)

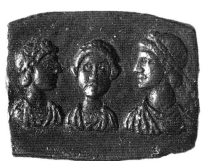

28 (enlarged)

the bust on the right being larger. On the reverse is a wreath enclosing an inscription in two lines: AV CC (*Augusti*).

An identical example is in the Kunsthistorisches Museum, Vienna (Pink 1938, col. 100, no. 950). Pembroke proposed that the busts represented Constantine, Fausta and Crispus. This interpretation is untenable: not only are all the busts clearly male, but *exagia solidi* do not appear to have been introduced until the reign of Julian. Sabatier identified the busts as those of Arcadius, Honorius and Theodosius II, whereas Pink preferred Gratian, Valentinian II, and Valens. This latter suggestion is the more compelling: much the best parallels for the busts are to be found on gold ingots issued by these emperors in the 370s (see coins appendix, section I).

T. Pembroke, *Numismatica Antiqua*, London, 1746, P.3.T.31; Sabatier 1862, p. 96, no. 4, pl. 3; Pink 1938, col. 77, no. 4.　CJSE

29　Silver-inlaid weight

Probably Constantinople, late 4th or early 5th century

London, BM, M&LA 1980,6–1,35

37.4 × 40.1 mm. Weight 79.86 g

Roper Collection. Bought by the British Museum in 1980.

Square copper-alloy weight pounced and engraved with three seated imperial figures. Each emperor is diademed and nimbate, wears a cuirass and paludamentum and holds a sceptre and an orb. Beneath the feet of the central figure is the denominational mark for three ounces, and below the feet of the flanking figures an elaborately decorated footstool. The emperors' faces, hands, legs, feet and the denominational mark are inlaid with silver.

The design on this weight is reproduced in a larger format on a two-pound example in the Vatican (C. Cechelli, 'Exagia inediti con figure di tre imperatori', *Scritti in onore di B. Nogara*, Vatican City, 1937, pp. 69–88). Like so many

of the symbols found on weights of this period, the design of one or more seated emperors is derived from Late Roman coinage. The three emperors may possibly represent Honorius, Arcadius and Theodosius II.

Unpublished.　CJSE

30　Silver-inlaid weight

Western Roman Empire, 4th or 5th century

London, BM, M&LA 50,1–17,69

29.4 × 29.6 mm. Weight 52.03 g

Bought by the British Museum in 1850.

Square copper-alloy weight engraved on the face with the denominational mark SOL/XII (12 solidi) with, above the mark, an abbreviated inscription VSLDN, all inlaid with silver.

Babelon, comparing the weight with an example in the Musée Lavigerie, Carthage, inscribed VSVALE INTEGR SOLIDI, and another in the Cabinet des Médailles, Paris, inscribed VSVSOL, proposed a reading for the above inscription of *Usuales Domini Nostri*. Pink, pointing out that the letters DN could equally stand for *denarius*, a term employed in the Late Roman period to signify 'coin' or 'money', translated it as *Usuales denarius*. Weights of this type often have their denominations expressed both in ounces and in solidi (cf. Dalton 1901, p. 95, no. 469; they have been found predominantly in North Africa (especially at Carthage) and Sicily, suggesting an entirely western origin for their manufacture.

Dalton 1901, p. 95, no. 470; E. Babelon, 'Notes sur quelques exagia solidi de l'époque constantinienne', *Bulletin archéologique du Comité des Travaux Historiques et Scientifiques* 8 (1918), pp. 240–2; Pink 1938, cols 41–2.　CJSE

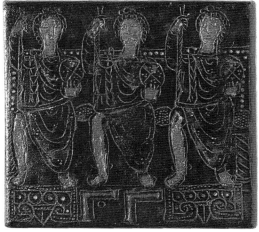

29 (enlarged)

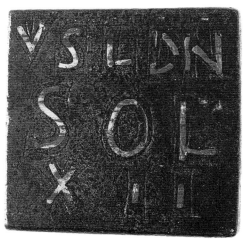

30 (enlarged)

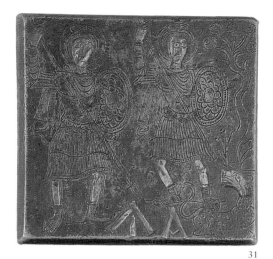

31

32

31 Silver-inlaid weight

Probably Constantinople, late 4th to late 5th century

London, BM, M&LA 63,12–28,1

60.9 × 62.8 mm. Weight 323.76 g

Given to the British Museum by F. W. de Salis in 1863.

Square copper-alloy weight pounced and engraved with two imperial figures. Each emperor is diademed and nimbate, wears a cuirass, paludamentum, pteruges and opened-toed boots, and holds a spear in his left hand and an imbricated shield in his right. In the bottom right corner is the figure of a leopard with, above it, a tree the lower branches of which terminate in berries, the upper in round fruit. At centre bottom is the denominational mark for one pound. Parts of the shields, cuirasses, paludamenta, sleeves and boots are inlaid with copper, the emperors' faces, hands, legs, denominational mark and leopard's head with silver.

The composition of two standing emperors attacking an animal or animals can be paralleled on a number of weights. Another one-pound weight in the British Museum follows a similar design but substitutes a lion for a leopard (see no. 32). Two two-ounce examples, auctioned in 1988 and 1989, again replicate the design, although on one weight the emperors hold compound bows and there is a snake entwined around the tree (sale cat. H.-W. Müller, Solingen, 23–4 September 1988 (auction 59), lot 787; sale cat. Kunst und Münzen AG, Lugano, 18–21 April 1989 (auction 27), lot 1647). A one-pound weight in the De Menil Collection, Houston, depicts two similarly attired emperors holding spears above the figures of two running leopards. These figures, however, hold orbs instead of shields and are depicted within an architectural framework (Weitzmann 1979, p. 343, no. 324). The figures on the British Museum weight have often been erroneously described as military

saints: Dalton suggests they may represent 'either St Demetrius and St George, or St Theodore Stratelates and St Theodore Tyron'. But the cuirass, paludamentum fastened by a fibula and the type of diadem are all imperial attributes. As well as giving legitimacy to the weight, the two emperors symbolise the political unity of the empire at a time when for administrative purposes it was divided in two.

J. Sabatier, 'Poids byzantins en cuivre', *Revue numismatique* 18 (1863), p. 17, no. 4, pl. 2; Dalton 1901, no. 483. CJSE

32 Inlaid metal weight

Probably Constantinople, late 4th to late 5th century

London, BM, M&LA 1980,6–1,2

60.7 × 61.2 mm. Weight 323.71 g

Roper Collection. Bought by the British Museum in 1980.

Square copper-alloy weight engraved with two imperial figures. Each emperor is diademed and nimbate, wears a cuirass, paludamentum, pteruges and calf-length boots, and holds a spear in his left and a shield in his right hand. In the bottom right corner is the figure of a rearing lion with, above it, a tree with branches terminating in five-petalled blossoms. In the bottom left corner, within a square frame, is the denominational mark for one pound; above the head of the left-hand emperor is a cross. The cross, emperors' faces, hands and legs, shield bosses, denominational mark and the face of the lion are inlaid with silver, parts of the sleeves, paludamenta and boots with copper.

See no. 31.

Unpublished. CJSE

33 Inlaid metal weight

Probably Constantinople, late 4th to late 5th century

London, BM, M&LA 1980,6–1,3

56.9 × 58.3 mm. Weight 318.11 g

Roper Collection. Bought by the British Museum in 1980.

Square copper-alloy weight engraved with a frame enclosing two imperial busts, both diademed and wearing paludamenta. On either side of the frame is the draped figure of a tyche, appearing to support the frame with an outstretched arm; above each tyche is a cross. The tyche on the right has a mural crown and holds a torch in her right hand. Between the tyches is a kneeling, half-nude, female figure with arms akimbo; beneath her left arm is a shield and, flanking her head, the denominational mark for one pound. The cross, tyches' faces, arms and parts of their drapery, the kneeling figure's face and arms, the denominational mark and emperors' faces are inlaid with silver (four of the faces modern restorations); the emperors' diadems and paludamenta, the frame, torch, crown of the left-hand tyche, and parts of the tyches' and woman's drapery are inlaid with copper.

Representations of tyches (personifications of particular cities) are not uncommon on fourth- and fifth-century weights. They are generally found in conjunction with one or more imperial figures as, for instance, on a one-pound weight in the De Menil Collection, Houston, which depicts a tyche flanked by two standing emperors (Weitzmann 1979, no. 325). The arrangement of two imperial busts within an icon-like frame can be paralleled on another weight from the De Menil Collection, where two figures, perhaps personifications of the abundance of the earth and the sea, recline beneath the frame. There are no known parallels for the kneeling female figure on the British Museum weight. Her semi-nakedness and submissive pose suggest that she might be a iconographic variant of the vanquished barbarian so often found on Late Roman coins. The two tyches presumably represent Rome and Constantinople.

Unpublished. CJSE

34 Inlaid-metal weight

Probably Constantinople, late 4th to 6th century

Birmingham, the Barber Institute of Fine Arts, Whitting no. 5317

54 × 57.8 mm. Weight 321.77 g

From Istanbul; given to the Barber Institute by P. D. Whitting in 1970.

Square copper-alloy weight pounced and engraved with an arch in the form of a double half-wreath resting on two spiral columns, enclosing a cross above the denominational

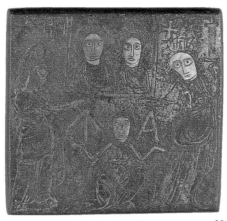

33

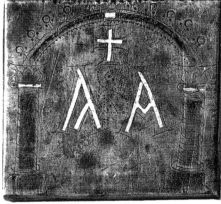

34

mark for one pound, both inlaid with silver; between the two elements of the mark is a pounced imperial bust, diademed and wearing a paludamentum. The arch, columns and socles are inlaid with copper, the centre of the arch and the bases of the capitals with silver.

Weights with architectural decoration fall into two categories: they are decorated either with a simple arch, often in the form of a wreath, resting on two columns, or with a more elaborate façade composed of a central rounded arch flanked by two triangular pediments and resting on four columns. One example of the former type in the British Museum is engraved with the older omicron-upsilon abbreviation for the ounce, suggesting that this type originated in the fourth century. Another weight in the British Museum, a 24-nomisma example, is engraved with a simple rounded arch enclosing a box monogram, which implies that this type was still being produced in the sixth century. The imperial bust on the Barber Institute weight is a later addition.

P. D. Whitting, *Byzantine Coins*, London, 1973, p. 62, no. 85.

CJSE

35 Silver-gilt ewer from Traprain Law

Mediterranean, probably late 4th century

Edinburgh, National Museums of Scotland, GVA 1

H. 210 mm

Excavated in 1919 at Traprain Law, east of Edinburgh, together with nearly 150 items or fragments of silver plate. Given to the National Museum of Antiquities by the Earl of Balfour in 1920.

The hammered ewer has an ovoid body on a broad base and a convex moulding on the neck, which flares upward to a

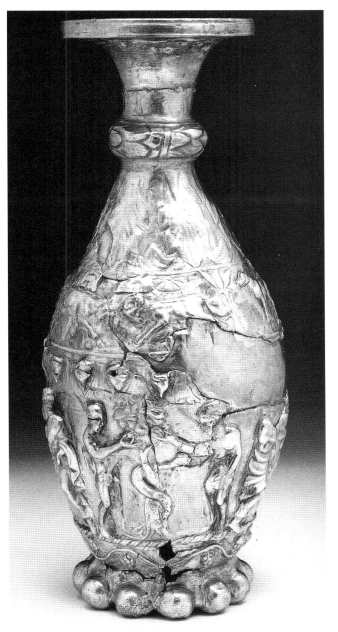

35

round mouth encircled by a straight pendent rim. The base is surrounded by very large beads, while the neck moulding is covered with a laurel wreath. The body is decorated with five zones of repoussé relief. Under the neck moulding a band of vertically pendent acanthus leaves surrounds the upper body. Below this is a pastoral frieze interspersed with shrubs: two sheep (possibly with a fragmentary shepherd) flanking a hut, and a pair of butting rams. The lower half of the body is occupied by another figural frieze, banded above by leaf and egg ornament and below by an undulating vine enclosing bunches of grapes. The frieze itself consists of four scriptural scenes – Adam and Eve, a scene tentatively identified as the Betrayal, the Adoration of the Magi, and Moses striking water from the rock. Raised areas, except for the flesh of the figures, are gilded. The bottom of the ewer is decorated with three raised concentric rings with a cruciform rosette in the middle. The ewer may have had a handle. When found, the vessel had been cut into three pieces, which were folded or crushed. The ewer has been restored to its original shape, and the gilding has been reapplied.

The shape of the ewer has many contemporary parallels (M. Mundell Mango, *The Sevso Treasure*, II, forthcoming); well-known elements include the neck moulding covered with a wreath, the pendent leaves below it, the beads around the base, and, in particular, the rich relief decoration arranged in registers. The Traprain hoard contained many pieces of cut, folded and crushed plate (*Hacksilber*), reduced to bullion, suggesting the booty of brigands. The find-spot is only two miles from the sea, and it is thought that the silver could have been seized from anywhere in the empire, not necessarily from Britain to the south. The silver itself is remarkably homogeneous in type, possibly suggesting a single looted source. Whatever the proximate source, the objects themselves, including the ewer, were probably manufactured in the Mediterranean region of the empire. Silver coins found with the plate provide a terminus post quem of 395 for the deposit.

Despite its scriptural decoration, the ewer lacks a dedicatory inscription which would identify it as ecclesiastical. It is known from church inventories and inscribed surviving objects (e.g. Mango 1986, nos 14, 37 and 38) that ewers formed part of liturgical equipment. But this and other similarly decorated objects may be Christianised domestic silver (Strong 1966, p. 185), like the plate with a cross (no. 96) and the bowl with a saint (no. 135). The choice of scriptural decoration reflects an early (third- to fifth-century) canon, evident also in catacomb and gold-glass decoration, where Old Testament subjects were freely mixed with New Testament scenes (see no. 9c). The pastoral frieze may have had paradisiacal associations.

Curle 1923, no. 1; Strong 1966, p. 185. Exhibited: *Wealth of the Roman World* (1977), no. 193. MMM

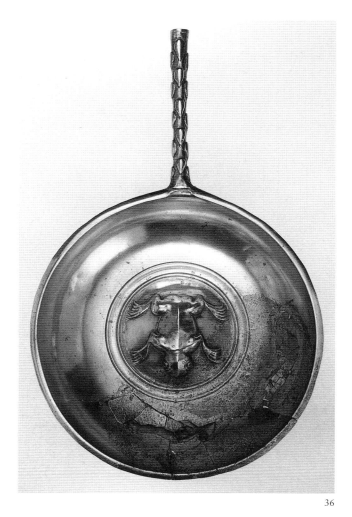

36

patera with a horizontal handle, is one of three types of silver basins known from Late Antiquity. The second type, also with a single horizontal handle, is the *trulla*, of saucepan shape, with a deeper and narrower bowl (e.g. Dodd 1961, nos 14 and 77); the third is the larger, often fluted, basin which sometimes has a pair of drop handles (see no. 74). While the larger basins (*pelves*) may have formed part of general household silver (e.g. as in *Codex Justinianus, Digest*, XXXIII.10.3), several contemporary illustrations of meals suggest that the patera type was used for hand-washing at table, together with a ewer; the *trulla* may have been used in the bath. All three types often have aquatic decoration, comprising fish, shellfish, water birds, fishermen and Nilotic imagery, as well as mythological marine characters such as nereids, tritons and Aphrodite (Shelton 1981, p. 68 n. 15; for other patera-type silver basins see *op. cit.*, no. 3, and Dodd 1961, nos 1 and 30). In the case of the Carthage basin, the decoration of a large frog recalls the frog-shaped clay lamps popular in Egypt, whence the attribution of manufacture to northern Africa. The significance of the Hercules' club handle is uncertain, but its tubular shape is more traditional than the flat profile of the Esquiline and other Late Antique patera handles.

Dalton 1901, no. 360, pl. XXI.　　　　　　　　　　MMM

36　Silver patera decorated with frog

Possibly Carthage or Alexandria, about 400

London, BM, M&LA AF 3279

Max. diam. 157 mm, L. of handle 87 mm, H. 50 mm.
Weight 311.3 g

Part of the Carthage Treasure, found at Carthage on the Hill of St Louis. Bequeathed to the British Museum by Sir Augustus Wollaston Franks (1897).

Low bowl on raised, flaring foot-ring, with straight handle attached to one side. The bowl and foot rims were hammered inwards to thicken them. A set of concentric grooves surrounds the raised centre of the bowl, which is ornamented with a large frog in repoussé relief, with circular eyes and its skin covered with circles formed by dot punches. The solid handle, round in section, imitates the form of Hercules' club, being decorated with series of teardrop bosses systematically positioned five each on its top, bottom and two sides.

This vessel, which takes the shape of a flat and broad

37　Gold *opus interrasile* bracelet

Eastern Mediterranean, 5th century

Oxford, Ashmolean Museum, Department of Antiquities, 1977.272

Ext. diam. 79 mm, int. diam. 53 mm. Weight 40.04 g

Found in Syria. De Clercq and Bomford collections. Bought from the Ashmolean Bomford Bequest Trust in 1977.

The bracelet, a continuous hoop D-shaped in section, is decorated in *opus interrasile*, except for a solid L-shaped band of metal at the two inner edges which forms an inner support. Four vertical strips of metal are placed at intervals along the inner surface of the bracelet. Let into the open-work of the bracelet are eight collet settings for alternating

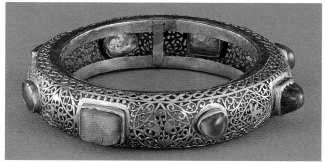

37

oblong emeralds and oval sapphires. The innermost bands of *opus interrasile* are a chain-pattern. The eight spaces between these two bands and between the stone settings form two types of panels which alternate in pairs: (i) a roundel enclosing a lozenge containing four peltas, and (ii) a lozenge enclosing a second lozenge or a roundel containing a leaf. The interstices of the panels and around the mounts are mostly filled with scrolls.

The openwork decoration of the bracelet, *opus interrasile*, was used in Late Antiquity on a variety of gold jewellery – pendants, necklaces, fibulae and rings. Two of these groups provide evidence for dating: four pendants which incorporate imperial medallions of 321 and 324 (e.g. no. 2; Buckton 1983–4) and cross-bow fibulae with an archaeological context of the second half of the fifth century (J. Heurgon, *Le trésor de Ténès*, Paris, 1958, pp. 29–30); being insignia of office, the fibulae were probably contemporary with the burials in which they were found (e.g. that of Childeric, d. 482). A third datable group consists of pieces found in Egypt with other jewellery containing coins or medallions of the sixth and seventh centuries. Attempts to establish a chronology of the technique on typological grounds alone (Lepage, pp. 1–23) have not proved successful: the Ashmolean bracelet is less likely to have been made in the late third century (Lepage, p. 9, Type IV) than in the fifth, because of resemblances to the fibulae.

Like the fibulae, this and some other bracelets differ from the fourth-century group of *opus interrasile* in the variety of leaves (e.g. trefoils) making up the scrollwork, and in the single motifs seen in it (peltas, birds, crosses, openwork leaves). Notably close to the Oxford bracelet is the fibula found in an Italian tomb together with fifty-five coins dated between 450 and 477 (M. Degani, *Il tesoro barbarico di Reggio Emilia*, Florence, 1959, p. 56). The vine leaf, worked in relief on the pendants and related pieces, is rendered flat on the fibulae and Ashmolean bracelet. On the latter, the pierced area around the reserved metal has been entirely cut away, in constrast to the preliminary circular or other perforations still detectable on certain pieces (Buckton 1983–4, p. 17; also *op. cit.*, fig. 6, and Heurgon, pl. XXV, 3).

Legislation of the fifth and sixth centuries restricted the use of gold set with pearls, emeralds and 'hyacinths' to imperial belts and bridles; exceptions were granted for finger-rings and for women's jewellery, such as this bracelet (*Codex Justinianus*, XI.xi.1). It has been suggested that the four pendants (of unknown provenance) were, like their medallions, made in the imperial mint at Sirmium, or in a mint elsewhere. The fibulae, unearthed in Italy, Romania and France, were probably also made in a state workshop. Openwork bracelets have been found in Syria, Egypt, Algeria, and in western Europe. Other pieces are said to come from Asia Minor and Thrace. The Ashmolean bracelet came from the same Syrian find as four or five nearly identical bracelets

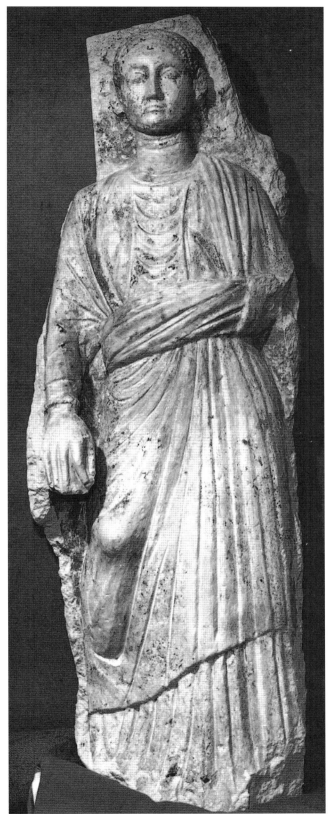

38

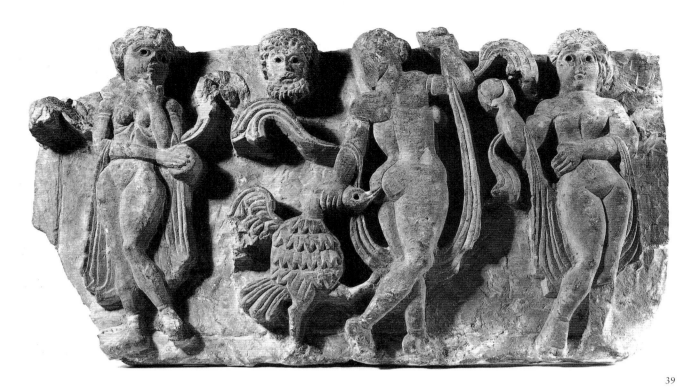

39

of graduated sizes in the de Clercq Collection, all or some of which originated in the same workshop; one pair from the group is now in Richmond, Virginia (M. C. Ross, 'Jewels of Byzantium', *Arts in Virginia* 9 (1968), no. 16).

A. de Ridder, *Collection de Clercq*, VII, pt I, Paris, 1911, no. 1313(?); C. Lepage, 'Les bracelets de luxe romains et byzantins du IIe au VIe siècle: étude de la forme et de la structure', *Cahiers archéologiques* 21 (1974), pp. 8–9; Mango, forthcoming. MMM

38 Limestone statue of a woman

Egypt, 4th or 5th century

London, BM, EA 1847

H. 1380 mm, W. 440 mm; thickness 180 mm

Said to come from Oxyrhynchus (Behnasa), Egypt. Bought by the British Museum in 1971.

Limestone statue of a woman, originally standing in a niche. The woman is wearing a long flowing robe through which her right knee is clearly visible. Traces of the original red, yellow and black paint can still be seen.

Flinders Petrie's excavations at Oxyrhynchus in 1921 produced some figural sculpture from archaeological contexts (Petrie 1925, pp. 12f, pl. xxxix), but many more examples, which largely lack precise find-spots, were unearthed by Brecchia between 1927 and 1932 (E. Brecchia, *Le Musée Gréco-Romain 1925–31*, Bergamo, 1932, pp. 60–3, pls xxxix–li). It seems that both were excavating

in a necropolis which may have remained in use from the pagan into the Christian period. Grave stelae for men, women and children have been found, many including pagan iconographic details. The niche, which appears in both pagan and Christian examples, may be a way of representing the afterlife. This sculpture, which is practically free-standing, probably comes from a tomb-chapel; it is a rare example of sculpture in the round from this period.

K. Parlasca, 'Der Übergang von der spätrömischen zur frühkoptischen Kunst im Lichte der Grabreliefs von Oxyrhynchos', *Enchoria* 8 (1978), pp. 115–20, n. 30. RKL

39 Relief panel of Leda and the Swan

Egypt, 4th or 5th century

Oxford, Ashmolean Museum, Department of Antiquities, 1970.403

H. 330 mm, W. 565; thickness 90 mm

Bought by the Ashmolean in 1970.

Limestone panel in high relief, perhaps from the side of a sarcophagus. Leda, flanked by two nymphs, is approached from behind by the swan. A bearded face, presumably that of the river god Eurotas, on whose river-bank the seduction took place, looks on. Leda's head and the scarf of one of her attendants are badly damaged, otherwise the surface is well preserved, although no trace of paint survives.

The theme of Leda and the Swan has been used as a case-

study in the argument over the transition from pagan to Christian Coptic art, and far-fetched Christian interpretations of the scene have been put forward, such as that it represents St Anne's conception of the Virgin Mary by means of the Holy Spirit in the form of a dove (Torp 1969). There seems, however, no reason to relate sculptures with mythological themes to Christianity. The lively style of this piece is typical of sculptures from Ahnas (Heracleopolis Magna), where Naville found many pieces of mythological sculpture in a building which he identified as a church but which could well have overlain a pagan funerary chapel (Naville and Lewis 1894, p. 32).

Most Coptic representations of Leda and the Swan focus on a later stage of their encounter (Kitzinger 1937, p. 193, pl. LXXIII, 4 and 5; Torp 1969, p.108, pl. VIb). The initial approach, featuring Leda's rear view, is found on a third-century mosaic from Palaepaphos, Cyprus, and also on a

pilaster capital in the British Museum (GRA 1907.1–18.2) which, like this panel, has Leda raising her right arm, perhaps to repel the swan. However, the humorous detail of the swan biting Leda's bottom seems to be an invention of the artist, and is in accord with other amusing touches on Coptic sculpture (Torp 1969, p. 109, pl. VIIa).

P.R.S. Moorey, 'Recent museum acquisitions: two fragments of early Coptic sculpture', *Burlington Magazine* 113 (1971), p. 214, fig. 59; C. Saliou, 'Leda Callipyge au pays d'Aphrodite: remarques sur l'organisation, la fonction et l'iconographie d'une mosaïque de Palaepaphos (Chypre)', *Syria* 72/2 (1990), pp.369–75, fig.3; J. Boardman (ed.), *Oxford History of Classical Art*, Oxford, 1993, no. 377. RKL

40 Marble head

Probably from Athens, 4th or 5th century

London, BM, GRA 1816.6–10.247

H. 340mm, W. 210mm

Bought for the Nation from the 7th Earl of Elgin in 1816.

Marble head, over life size, the nose and left eye missing and the right side of the head shorn off. The hair and beard are deeply cut and the eyebrows and beard strongly marked; wrinkles are roughly engraved on the forehead. The figure wears a rounded diadem.

This head in archaising style, Smith suggests, may be a portrait of a poet, perhaps Sophocles. The surface treatment of the forehead wrinkles and the contrast between the carefully treated bushy beard and the sketchy hair above the diadem suggest parallels with a fifth-century head from Aphrodisias, now in the Musées Royaux d'Art et d'Histoire, Brussels (Inan and Alföldi-Rosenbaum 1979, no. 204).

Smith 1904, no. 1956. RKL

41 Marble head

Probably Asia Minor, 5th century

London, BM, GRA 1889.4–15.1

H. 430mm, W. 190mm; thickness 230mm

Bought by the British Museum in 1889.

Portrait head sculpted from white marble with fine-grain crystals, possibly Proconnesian. The nose, eyes and the hair above the forehead are damaged.

The staring oval eyes of this head date it conclusively to the fifth century. In profile, the cap-like treatment of the hair and the decorative arrangement of the ear and beard make it strikingly similar to a head from Istanbul, dated to the third quarter of the fifth century (Inan and Alföldi-Rosenbaum 1979, no. 275).

Smith 1904, no. 1959; L'Orange 1933, no. 120, pl. 225. RKL

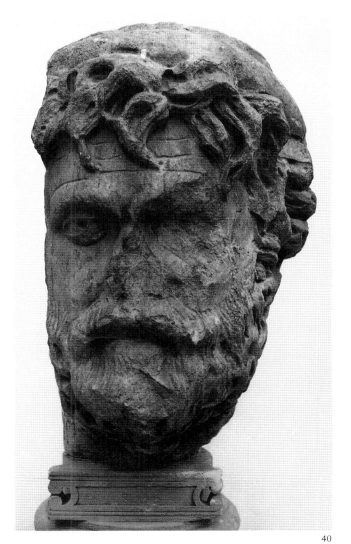

40

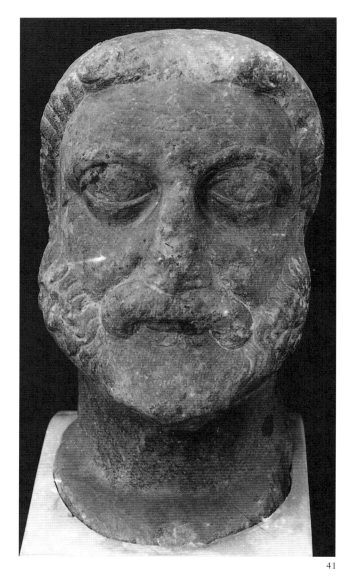

41

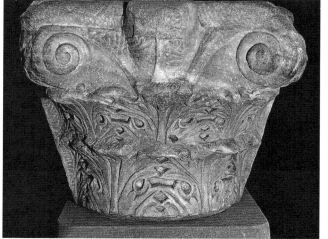

42

42 Marble capital

Ephesus, 5th century

Lower Kingswood, Surrey, Church of the Wisdom of God

H. 670 mm, L. 880 mm, W. 860 mm

Brought from Ephesus, after 1861, by Dr Edwin Hanson Fresh-field. Placed in the newly built church at Lower Kingswood in 1902. Dr Freshfield was an archaeologist and traveller; his wife was brought up in Smyrna, and he made frequent visits to the Near East. He provided a permanent home for many of the items which he and his wife had collected in a church which he commissioned in his own parish of Lower Kingswood, Surrey. Designed by Sidney Barnsley in the Byzantine style, it was consecrated in 1892, three years before Westminster Cathedral, and played an important part in the rediscovery in Britain of the heritage of Byzantium.

Large marble Corinthian capital, with two tiers of flatly carved but deeply cut acanthus leaves. There is a roughly cut cross on each boss.

This capital and a second of similar proportions, which Dr Freshfield also brought from Ephesus, fit very well with the known capitals from the original fifth-century church of St John there, particularly one from the narthex (Kautzsch 1936, no. 266, pl. 18). Freshfield suggested that the crosses were added later, but there seems no evidence for this, in view of the (admittedly better carved) cross which appears on the boss of another capital from the church (Kautzsch 1936, no. 267, pl. 18).

Unpublished. RKL

43 Ivory diptych-leaf: dignitaries presiding over a stag-hunt

Northern Italy, early 5th century

Liverpool, National Museums and Galleries on Merseyside, Liverpool Museum, M.10042

291 × 117 mm, depth 8 mm

First known in the collection of P. G. de Roujoux at Macon in 1804. Thereafter in the collections of Vivant Denon (Paris), Gabor Fejérváry and Joseph Mayer, who gave it to the town of Liverpool in 1867. Mayer (1803–86) was a Liverpool goldsmith and jeweller who formed an outstanding collection of antiquities, all of which he gave to the town.

The left leaf of a diptych the other half of which is lost. The panel is good condition, with only a small repair in the top right corner of the acanthus-leaf border. Three officials, dressed in senatorial togas, sit in a box behind an elaborate parapet, carved with herm-posts and dolphins. The central man pours a libation from a patera; the older balding man to his right gestures towards him, and the younger beardless man to his left holds a mappa to his breast. They preside over a *venatio* (stag-hunt), which takes place in an arena. In the centre of the arena a *venator* (huntsman) impales a

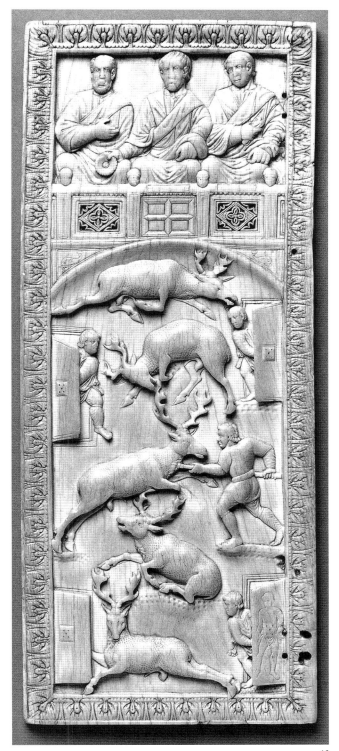

43

Mesopotamian deer with his spear. Three other men watch from doors into the arena, one of which is carved with the image of a victorious *venator*. Four other deer, two of which have already been fatally wounded, are scattered around the arena; they are carved with remarkable precision and detail. The depth of the carving of this panel is very pronounced, and the illusion of depth is further accentuated by reverse perspective applied to the open doors.

The identity of the three men is unknown, as is their official status, since none wears the triumphal toga of a consul (see no. 62). Stylistic comparisons with the apotheosis ivory (no. 44), and the Lampadii leaf in Brescia (Volbach 1976, no. 54) suggest a date in the early fifth century. The issue of ivory diptychs by officials beneath the rank of consul ordinary was banned in the eastern part of the empire by Theodosius in 384 (Cameron, pp. 126–7), which suggests that this ivory was carved in the West, probably in north Italy. The composition, with its emphasis on the spectacle rather than the donors, is also comparable with the Lampadii leaf, which shows a chariot race. This demonstrates the ritual and political importance of the games as the main symbolic display of the officials' status, wealth and generosity.

Pulszky 1856, no. 16; Delbrueck 1929, no. 58; Volbach 1976, no. 59; Kitzinger 1977, pl. 69, pp. 37–8; A. Cameron, 'A note on ivory carving in fourth century Constantinople', *American Journal of Archaeology* 86 (1982), pp. 126–9; Gibson 1994, no. 7. Exhibited: *Carvings in Ivory* (1923), no. 25; *Liverpool Ivories* (1954–5), no. 12; *Age of Spirituality* (1977–8), no. 84; *Spätantike* (1983–4), no. 222. AE

44 Leaf of an ivory diptych: an apotheosis

Rome, 402

London, BM, M&LA 57,10–13,1

301 × 113 mm, depth 8 mm

Formerly in the Gherardesca Collection. Bought by the British Museum in 1857.

The right-hand leaf of a diptych, the other leaf of which is lost. In good condition, except along the left edge, where the hinges have broken off elements of the design. The scroll on the top contains a monogram, deciphered to read SYMMA-CHORUM (Weigand 1937). The panel shows the apotheosis (deification) of a pagan figure in three overlapping stages. At the bottom, four elephants draw a carriage carrying a dignitary, who sits beneath an aedicula with a gabled roof. He wears a senatorial toga, and carries a staff and laurel branch. Beyond the carriage is a draped funeral pyre surmounted by a quadriga bearing a youthful god. From this pyre fly two eagles: one represents the soul of the dignitary, the other probably that of the figure on the other lost leaf. The third element shows the man borne by personifications of two winds (with wings on their backs and on their

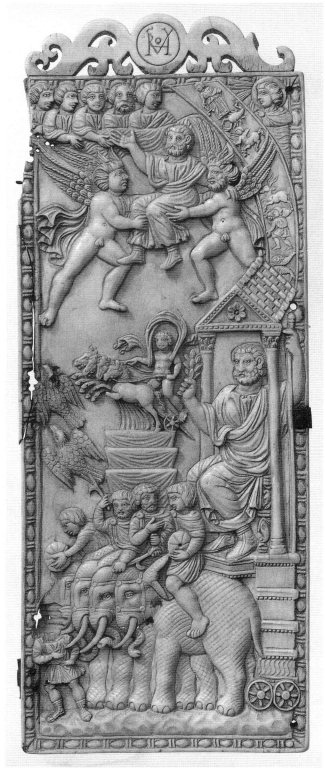

44

heads) into heaven, where he is welcomed by five figures, probably ancestors. He passes an arc with six zodiacal signs, and is watched by the sun god Helios. There is a striking contrast between the solemnity of the commemoration and the informality of its depiction, notably the distracted elephant drivers, two of whom hold elephant-rattles. The illusion of depth and solidity in the panel is given by the heavily incised outlines around the figures which can be paralleled on another diptych in St Petersburg (Volbach 1976, no. 60).

The identity of the man and the date of the panel are controversial. It has often been assumed to commemorate the anniversary of the birth or death of a pagan emperor, usually Julian the Apostate (St Clair 1964). However, the most recent and convincing interpretation (Cameron 1986) is that it commemorates the apotheosis of Q. Aurelius Symmachus after his death in 402. It is further argued that the Symmachi panel in the Victoria and Albert Museum (Volbach 1976, no. 55) was commissioned for the same purpose, and so, like it, the other leaf of this diptych related to the Nicomachus family. The Symmachus family was one of the leading pagan families in Rome at the end of the fourth century, and this piece represents one of the final commissions of pagan art in Rome before the triumph of Christianity. The stylistic contrast between the classicising panel at the V&A and the apotheosis leaf, with its complex spatial arrangement, suggests that the same family could commission works of art in a variety of co-existent styles to suit their needs.

Pulszky 1856, no. 18; Dalton 1909, no. 1; Delbrueck 1929, no. 59; E. Weigand, 'Ein bisher verkanntes Diptychon Symmachorum', *Jahrbuch des Deutschen Archäologischen Instituts* 52 (1937), 121–38; A. St Clair, 'The Apotheosis Diptych', *Art Bulletin* 64 (1964), 205–11; Volbach 1976, no. 56; A. Cameron, 'Pagan ivories', in: F. Paschond (ed.), *Colloque Genèvois sur Symmaque*, Paris, 1986, pp. 41–72. Exhibited: *Age of Spirituality* (1977–8), no. 60; *Spätantike* (1983–4), no. 248. AE

45 Ivory of the empty Sepulchre

Probably Rome, between about 420 and 430

London, BM, M&LA 56,6–23,6

75 × 99 mm

From the Maskell Collection. Bought by the British Museum in 1856.

Ivory plaque carved in high relief with two women seated one on either side of a sepulchre, and two sleeping soldiers seated in the foreground. The women are wrapped in enveloping *maphoria*; each has a hand raised to chin or cheek; one props herself up with her free arm, while the other rests her forearm on her lap. The soldiers, whose figures overlap those of the women, are conventionally dressed; each has a

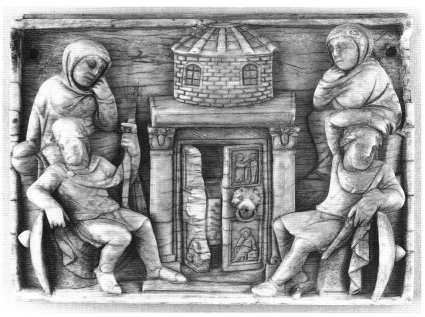

45

round shield (foreshortened in the composition) and, originally, a spear. The sepulchre, a rectangular building with columns and a drum supporting a conical roof, occupies the centre third of the composition. One of its double doors is ajar; the other, wider open, reveals an empty sarcophagus. Each door is decorated in relief; in the middle is a massive lion-head door-handle. One relief shows the raising of Lazarus; the two lower panels display transposed mirror-images of the sorrowing women. Much of the left-hand door is missing; the colour of the ivory at the break suggests that the damage is relatively recent.

The plaque is one of four carved with scenes from the Passion of Christ; they are among the best-known ivories of the Early Christian period. Probably made in Rome between about 420 and 430, they were originally the sides of a square box; the plaques are rebated at the top for a lid and have a groove along their lower edge for the base. The scenes are: Pilate washing his hands, Christ carrying the Cross, and Peter's denial; Judas hanging himself, and the Crucifixion; the women at the Sepulchre; and the incredulity of Thomas.

Professor Lieselotte Kötzsche has pointed out that, as a representation of the women at the Sepulchre, the scene is highly unusual. In Christian art from the third to the sixth century, in accordance with the Gospel narrative, the women are generally shown approaching the tomb; while the doors of the sepulchre may be open or closed and the soldiers present or absent, the Angel of the Lord is invariably included in the scene.

On the British Museum ivory the women are shown not approaching the tomb but sitting by it, sorrowful, hunched and withdrawn. It is possible that a different episode in the Gospels is intended, e.g. Matthew 27.61: 'And Mary Magdalene was there, and the other Mary, sitting over against the sepulchre', where Christ's body lay. Militating against this, however, are the patently empty tomb, the open doors and the sleeping guards, who were posted only after and rendered 'as dead' later still.

The withdrawn, grief-stricken female figure seated beside a tomb was, however, an established convention in the art of classical antiquity. Numerous examples occur as terracotta statuettes, in vase-painting and on sepulchral reliefs and sarcophagi. Kötzsche suggests that the carver of the ivory, who would have been familiar with such pictorial conventions (including the open door of a tomb as a symbol of the passing of the soul into the next world), added the seated female mourners to the sepulchre in conformity with this tradition.

Westwood 1876, p. 44; Dalton 1901, no. 291; A. Maskell, *Ivories*, London, 1905, pp. 89–93; Dalton 1909, no. 7; R. Delbrueck, *Probleme der Lipsanothek in Brescia*, Bonn, 1952, pp. 95–8; L. B. Ottolenghi, 'Stile e derivazione iconografiche nei riquadri cristologici di Sant'Apollinare Nuovo a Ravenna', *Felix Ravenna* 47 (1955), p. 19, fig. 23; J. Beckwith, *The Andrews Diptych*, London, 1958, pp. 31–4, fig. 41; J. Kollwitz, *Reallexikon für Antike und Christentum*, IV, Stuttgart, 1959, s.v. 'Elfenbein' (1119–21); Volbach 1976, no. 116; L. Kötzsche, 'Die trauernden Frauen. Zum Londoner Passionskästchen', in: D. Buckton and T. A. Heslop (eds), *Studies in Medieval Art and Architecture presented to Peter Lasko*, Stroud–London–Dover (New Hampshire), 1994, pp. 80–90. Exhibited: *Age of Spirituality* (1977–8), no. 452; *Gallien in der Spätantike* (1980–1), no. 31; *A l'aube de la France* (1981), no. 35.
DB

46

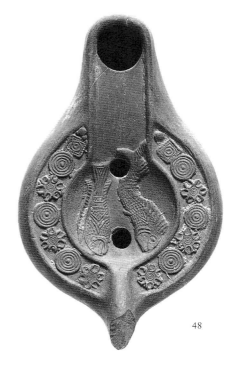

48

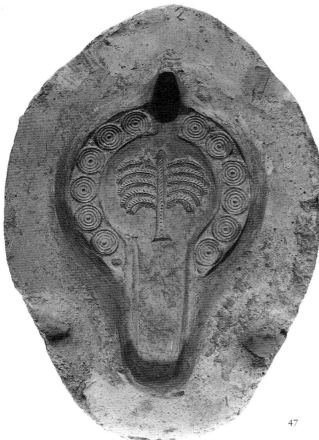

47

46 Pottery bowl with stamped decoration

Made in northern Tunisia (Byzacena), between about 400 and 450

London, BM, M&LA 1928,4–13,8

Diam. 414 mm

Said to be from Egypt. Bought by the British Museum in 1928, from a Cairo dealer.

Bowl of African red slip ware (Hayes form 67), the floor decorated with alternating impressed grilles and cloverleaf patterns within cabled circles.

J. W. Hayes, *Late Roman Pottery*, London, 1972, p. 113 no. 9, pl. XIIIb; A. Carandini *et al.*, *Enciclopedia dell'arte antica classica e orientale, atlante delle forme ceramiche*, I; *Ceramica fine romana nel Bacino Mediterraneo*, Rome, 1981, pp. 80–1. DMB

47 Mould for pottery lamps

Made in central Tunisia (Byzacena), about 5th century

London, BM, M&LA 1983,10–1,4

L. 229 mm, W. 157 mm

Acquired at el-Djem. Bought by the British Museum in 1983.

Upper element of a two-piece mould for the production of African red slip ware lamps, made of plaster. The resultant lamp was decorated by a palm-tree, its shoulders adorned with targets.

Bailey 1988, Q 1834. DMB

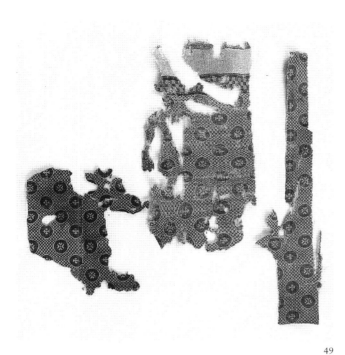

49

49 (drawing)

48 Pottery lamp

Made in central Tunisia (Byzacena), about 5th century

London, BM, M&LA 1984,10–3,3

L. 142 mm, w. 86 mm

Acquired at el-Djem. Bought by the British Museum in 1984.

African red slip ware lamp decorated with two fishes, the shoulders patterned with sixfoils, targets and squares.

Bailey 1988, Q 1829. DMB

49 Silk with trefoils and rosettes

Eastern Mediterranean, about 5th century

London, BM, M&LA OA 10722

Approx. 150 × 80, 95 × 90, and 200 × 50 mm

Details of acquisition by British Museum unknown, but fragments of the same cloth in other collections are recorded as coming from Akhmim in Egypt (R. Förrer, *Römische und byzantinische Seiden-Textilien aus der Gräberfeld von Achmim-Panapolis*, Strasbourg, 1891, pl. IX.4); other fragments are in Budapest, Düsseldorf, Lyons, Zurich, the Victoria and Albert Museum (Martiniani-Reber 1986, no. 34, with refs), and in the Musées Royaux d'Art et d'Histoire, Brussels (Errera 1916, no. 368).

Three irregular fragments of compound twill in white and brick-red silk. The repeating design has alternate rows of four-petalled rosettes and trefoils in circles on a background of tiny chequers (the vertical axis of the design is in the direction of the weft). At the right side of the smallest fragment, a short warp fringe marking the edge of the cloth is preceded by a plain cream band and a band of larger chequers.

Weft-faced compound 1\2 twill, two lats, very fine texture. Warp yarn z-twist cream silk; approx. 30 single threads of each warp per cm. Weft yarn without twist, brick red, white and cream; approx. 72 passes per cm. Lengthways (reverse) repeat approx. 1.1 cm, widthways repeat approx. 2.1 cm.

The fragments are almost certainly from a piece of clothing, probably a tunic. Tiny semi-abstract designs such as this and the naturalistic figurative designs illustrated by no. 50 are equally typical of extant Late Antique and Early Byzantine silks. There is no exact match for this design among the textiles which have survived in western Europe, but parallels exist in wool and silk compound twill as well as in silk twill damask (B. Schmedding, *Mittelalterliche Textilien in Kirchen und Klöstern der Schweiz*, Bern, 1978, nos 49, 126 and 186; exh. cat. *Tissu et vêtement* (1986), p. 156, no. B.5).

Unpublished. HG-T

50 Silk and wool textile with hunters and animals

Eastern Mediterranean, 5th or 6th century

London, Keir Collection

Four fragments, the largest approx. 310 × 700 mm

Acquired in Greece; almost certainly found in Egypt. Another fragment is in the Abegg-Stiftung, Bern, donated by Edmund de Unger.

Four large fragments of compound twill weave in wool and silk. The design, in light brown wool against undyed cream silk, consists of roundels containing the following motifs: (i) a panther or lioness couchant, (ii) a nude hunter with spear and flying cloak, running towards (iii) a charging lion, and (iv) a running ibex or wild goat. The borders of the roundels are formed by interlacing ribbons. Within the borders and the small compartments between them are vine stems with leaves and bunches of grapes, peacocks, snakes and other birds and animals. The design reverses regularly down the length of the cloth and once across the width. The vertical axis of the design is in the direction of the weft.

Weft-faced compound 1\2 twill, two lats, fine texture. Warp yarn z-twisted cream silk; approx. 18 single threads of each warp per cm. Weft yarns, z-spun light brown wool and undyed cream silk without twist; approx. 40 passes per cm. Lengthways (reverse) repeat approx. 22 cm, widthways repeat approx. 5.4 cm.

Designs with small roundels containing a huntsman and a line of hunted animals are widespread among Late Antique and Early Byzantine textiles. Another occurs, for example, on a fragment of a mattress-cover of wool and

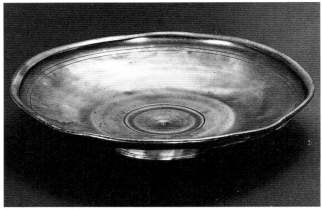

51

linen in compound tabby weave (BM, EA 1888,5–12,120 (21703), exhibited in room 41 of the British Museum, case 19). These silk and wool fragments almost certainly derive from a piece of clothing. Fragments of a green and yellow compound twill silk recently acquired by the Abegg-Stiftung, with a design also based on interlacing ribbons but containing erotes rather than huntsmen and animals, can be reconstructed as a woven-to-shape tunic (inv. no. 3945).

King 1981, pp. 100–1; King and King 1990, no. 7. HG-T

51 Small silver plate

Eastern Mediterranean, 5th century

Oxford, Ashmolean Museum, Department of Antiquities, 1980.72

Diam. 115 mm, H. 24 mm. Weight 103.9 g

Roper Collection. Bought by the Ashmolean in 1980.

Small hammered plate with a low foot-ring and shallow concave inner surface. The rounded outer rim was formed by rolling the metal inwards; the reverse, outside the foot-ring, is finished. The only decoration on the plate consists of incised lines: on the obverse, a concentric groove at the centre of the plate creates a small medallion, and a pair of lines runs just inside the rim; in a corresponding position a single line encircles the reverse. A pair of lines ornaments the outer surface of the foot-ring. Symmetrically positioned inside the foot-ring are two rectangular control stamps, both containing the Greek letters spelling 'of Elias', arranged around a cross. A hole in the side of the plate has been repaired with resin.

This is one of the smallest plates produced in the period. A few examples slightly wider may be cited: the Eros plate (no. 75) is 120 mm in diameter, while two plates, decorated with a monogram and found in Cyprus, and others from Izmir measure approx. 130 mm (Dodd

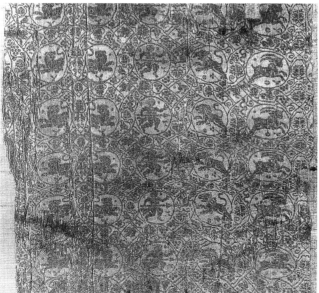

50

1961, nos 37, 39, 44–6). One of the latter group, stamped between 613 and 629/30 (*op. cit.*, no. 44) is, like the Ashmolean example, undecorated. Another small plain plate stamped slightly later was found near Alkino (*op. cit.*, no. 74). At least some of these small plates probably formed part of a dinner-service and are later, reduced, versions of the set of four plates (diam. 161 mm) in the Esquiline Treasure, which have a central monogram (no. 11); see also no. 96.

The stamps on the plate belong to a group of about fifteen published examples which seem to date to the late fourth and the fifth centuries (Mango 1992, p. 206), that is to the period between the early stamps of the type which appears on the Naissus dish (no. 1) and the series of five-stamp control marks introduced by Anastasius (see nos 52 (only four stamps), 76, 96 and 135). None of the fifteen objects with this middle group of stamps has imperial decoration. Five have stamps with figures of tyches; the other ten are circular or, like the present examples, rectangular, and contain Greek names in the

genitive. With the exception of one tyche stamp which appears to name Constantinople ('CONS': Dodd 1961, no. 83), none of the stamps is associated with a particular city.

Mango 1992, p. 206 and n. 24; Mango, forthcoming.　　MMM

52 Large silver plate from the Sutton Hoo ship burial

Made and stamped at Constantinople, between 491 and 518

London, BM, M&LA 1939,10–10,76

Diam. 720 mm, H. 98 mm. Weight 5640 g

Found, together with no. 74, in 1939, at Sutton Hoo, Suffolk, in the famous seventh-century ship burial. Given to the Nation by Mrs Edith May Pretty, JP, in August 1939.

Large plate with slightly concave surface, standing on a very high and somewhat flaring foot-ring. The horizontal outer border of the plate has a vertically pendent rim and is orna-

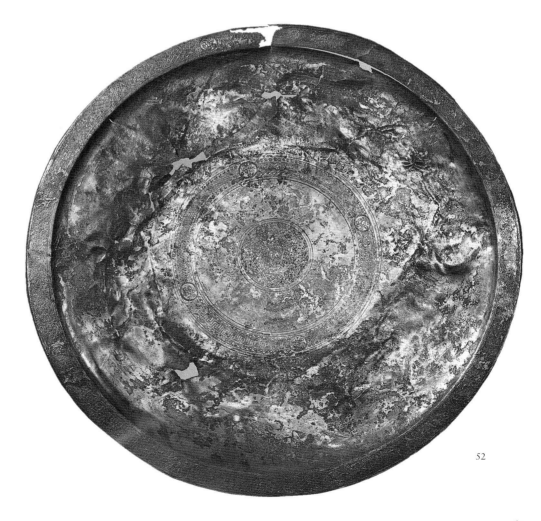

52

mented on its upper surface with a nielloed frieze. A similar frieze surrounds the plate's central medallion, which contains two concentric octagons composed of interlocking squares; the interstices are filled with stylised foliage and the edges of the larger octagon are covered in a wave pattern. An eagle stands at the centre of the octagons. The inner and outer friezes, composed of bands of ovals, circles, hearts, swastikas and hatching, are each interrupted by four roundels containing running putti (in two confronted pairs on the outer frieze) and tyches (two seated, two running on the inner frieze). The upper surface of the plate is badly corroded and metal is missing in several areas, but the foot-ring and much of the reverse side are in good condition. There are four control stamps dating from the reign of the Emperor Anastasius inside the foot-ring.

With its relatively plain surface and large size, the Sutton Hoo plate was probably intended as a serving-dish (see also no. 96). In scale, layout, ornament and decorative technique, it resembles another large plate (diam. 553 mm) likewise found outside the empire in a barbarian burial, at Conçesti, Moldavia. While bands of ornament along the rims of that and other plates are similarly interrupted by medallions with incised figures (a convention derived from earlier Roman vessels with theatre-masks recurring in relief in figural borders), the Sutton Hoo plate is probably unique in having a frieze repeated near its centre.

This and other silver found at Sutton Hoo circulated from Byzantium to the barbarian West, reaching the same destination as had the Corbridge *Lanx* and the Mildenhall and Traprain Law plate (nos 15, 16, 35) at least a century earlier. (The Water Newton silver may have been made in Britain itself; see no. 4.) Thanks to its control stamps, applied between 491 and 518, we know that the Sutton Hoo plate was in use for at least a hundred years before being buried in Anglo-Saxon England. While the Corbridge and Mildenhall silver had travelled within the empire to Roman Britain, the Sutton Hoo silver (see also no. 74), left the confines of a smaller state, by then centred on Constantinople, perhaps as a diplomatic gift or by trade.

Kitzinger 1940, pp. 40–50; Dodd 1961, no. 4; Bruce-Mitford 1983, pp. 4–45, 166–78. MMM

53 Portable sundial and calendar

Probably Constantinople, about 500

London, Science Museum, 1983–1393

Diam. 135 mm

Bought by the Science Museum in 1983.

Brass portable sundial with calendrical gearing, comprising front plate, suspension-arm, arbor with ratchet and two gear-wheels, and arbor with moon-disk, with traces of tin-

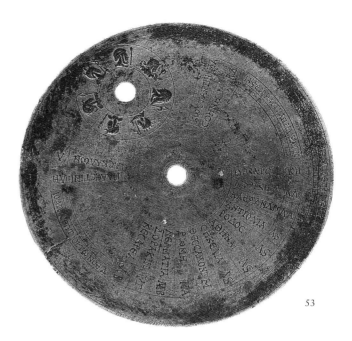

53

plating, and gear-wheel. The front plate, with a central hole, is engraved with the Greek names of sixteen towns and provinces, together with their geographical latitudes, a quadrant scale from nought to ninety degrees, and a declination scale marked in months, some divided into three periods. Round an off-centre hole are heads of seven personifications of the days of the week. The moon-disk is engraved with Greek letters indicating scales from one to twenty-nine and from one to thirty.

For use as a sundial, the suspension-arm would be set to the correct latitude and the gnomon (vane, now missing) to the month or part of the month. The instrument would then be suspended by the ring at the end of the suspension-arm and rotated until the gnomon cast its shadow.

For use as a calendar, a pointer indicating the day of the week would be advanced daily by hand. This was linked by a gearing mechanism to the moon-disk, turning it once every fifty-nine days and indicating, on its consecutive scales of one to twenty-nine and one to thirty, how many days had elapsed since the previous new moon. Two dark disks set opposite one another on the tinned surface of the moon-disk would have shown the current phase of the moon through a circular aperture, a useful aid to the planning of any night activity. As reconstructed (exh. cat. *Early Gearing*, no. 4), the instrument would also have shown the positions of the sun and the moon in the Zodiac.

J. V. Field and M. T. Wright, 'Gears from the Byzantines: a portable sundial with calendrical gearing', *Annals of Science* 42/2 (February 1985), pp. 87–138. Exhibited: *Early Gearing: Geared Mechanisms in the Ancient and Mediaeval World*, London (Science Museum), 1985, no. 3. DB

54 Limestone frieze with inhabited vine-scroll

Egypt, 5th or 6th century

Liverpool, National Museums and Galleries on Merseyside, Liverpool Museum, 1966.155.1/2

H. 400 mm, W. 1000 mm; thickness 60 mm and H. 400 mm, W. 1300 mm; thickness 60 mm

Bought by the Liverpool Museum in 1966.

Two limestone fragments of the same frieze, carved in shallow relief with a plain border at top and bottom and two interlocking vines, enclosing a lion and a hare, alternating with bunches of grapes. The lion fragment forms the right end of the frieze. There is no trace of paint.

The fragments are said to come from Ashmunein (Hermopolis Magna) in Egypt, but this seems unlikely in view of the lack of figural sculpture known from the site (A. Wace, A. H. S. Megaw, T. C. Skeat and S. Shenouda, *Hermopolis Magna, Ashmunein*, Alexandria, 1959). Inhabited acanthus-scroll friezes are common on late Roman sites in Egypt, particularly Ahnas and Oxyrhynchus, while vine-scroll friezes are especially characteristic of the architectural orna-

ment at Bawît (E. Chassinat, *Fouilles à Baouît* (Mémoires de l'Institut Français de l'Archéologie Orientale, 13), Cairo, 1911, pl. 85; Kitzinger 1937, p. 198, pl. LXXII, 5). However, the flat carving of the vine-scroll on the Liverpool frieze might suggest that it comes rather late in the development of this type of ornament.

Unpublished. RKL

55(a–b) Fragments of a large mosaic pavement

Carthage, late 5th or early 6th century

London, BM, M&LA

Excavated by the Revd Nathan Davis at Bordj-Djedid, 1857; acquired by the British Museum in 1860. The Revd Davis excavated at Carthage on behalf of the British government between 1856 and 1858, the British Museum benefiting greatly from his finds.

Hunting scenes formed the principal motifs of a large decorative mosaic some nine metres long. The tesserae are of

54(a)

54(b)

65

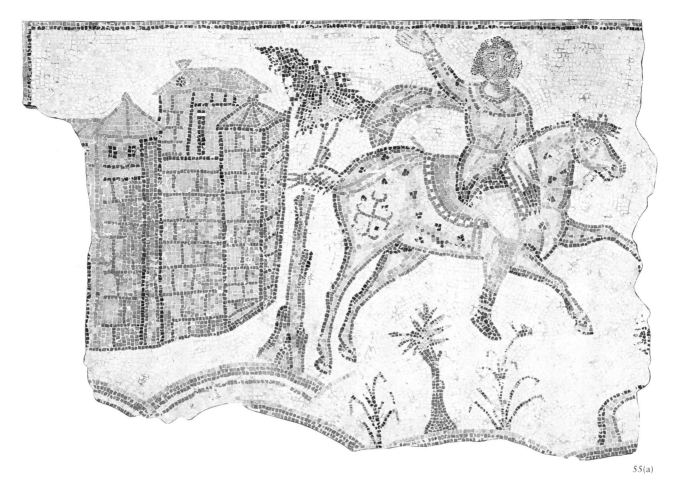

55(a)

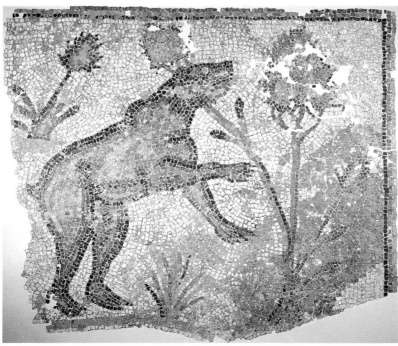

55(b)

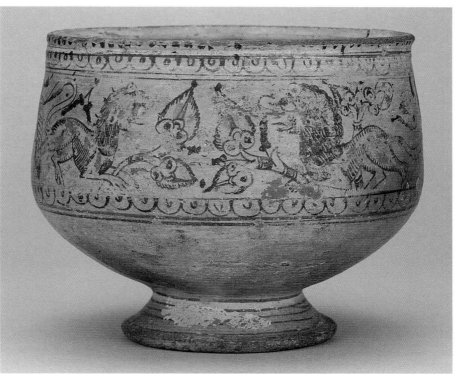

56

natural stone, ceramic and, occasionally, glass, in black, white, five shades of grey, seven browns, yellow, orange, two reds, pink, and three blues and three greens.

Other fragments of this mosaic are on exhibition at the top of the stairs in the north-western corner of the British Museum. The 'germanic' dress and facial hair of the horsemen depicted on the pavement suggest that it may have been commissioned by a wealthy Vandal landowner.

Franks 1860, 225–6 (no. 5); Davis 1861, pp. 539ff; Morgan 1886, pp. 272–3; Hinks 1933, pp. 144–8.

55(a) Horseman in front of a building

M&LA 1967,4–15,18

1755 × 2435 mm (mounted)

The horseman wears a tunic, red and white dotted cuffs, a cloak, breeches, leggings, and boots. He has a moustache. The horse has a cross branded on its hindquarter, a bridle and crupper, and a saddle. Between the imposing building and the horseman is a tree. In the field are plants with flowers. The tesserae employed for the face and hands of the horseman are smaller than those used generally. Glass tesserae were used only in the bridle of the horse.

M. I. Rostovtsev, *Social and Economic History of the Roman Empire*, Oxford, 1926, pl. lx.2, opp. p. 476; Hinks 1933, p. 145, no. 57d, pl. XXXII.

55(b) Bear

M&LA 1967,4–5,21

1340 × 1525 mm (mounted)

Bear scratching the side of its head and neck on the branch of a bush; below, another bush or shrub. A buff, red and black border runs along the right edge, a black and grey border along the top. In this expressive fragment, glass tesserae have been used only in the foliage.

Hinks 1933, pp. 145, 147, no. 57g, fig. 165. DB

56 Pottery bowl with painted animals

Made in Egypt, 5th or 6th century

London, BM, M&LA 1927,2–17,3

H. 178 mm, diam. 198 mm

Bought by the British Museum in 1927, from a Cairo dealer.

Deep footed bowl of Nile silt ware, covered with an orange to cream-coloured slip. There is a frieze of animals and plants between bands and ovolos: a female and a male lion confronted, an oryx and a hare, and two oryx confronted, all interspersed with stylised trees and plants, most of which are probably vines, painted in black, with red details.

Unpublished. DMB

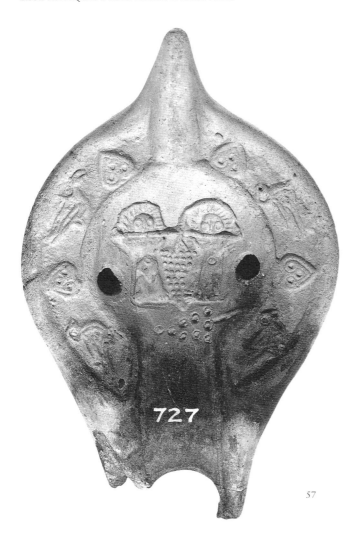

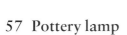

57

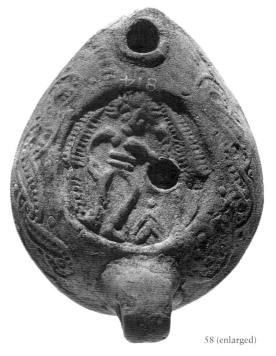

58 (enlarged)

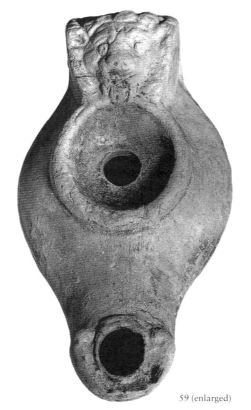

59 (enlarged)

57 Pottery lamp

Made in the Carthage area, between about 440 and 550

London, BM, M&LA 60,10–2,46

L. 131 mm, W. 84 mm

Excavated for the British Museum in 1860 by the Revd Nathan Davis at Carthage (see no. 55).

Decorated with a representation of the spies sent by Moses into the land of Eshcol, returning bearing a huge bunch of grapes (Numbers 13.23); on the shoulder, doves and hearts.

Dalton 1901, no. 727; Bailey 1988, Q 1841. DMB

58 Pottery lamp

Made at the shrine of Abu Mena, west of Alexandria, 5th or 6th century

London, BM, M&LA 82,5–10,45

L. 83 mm, W. 63 mm

Acquired by the Revd Greville J. Chester in Alexandria. Bought by the British Museum in 1882.

Decorated with a victorious charioteer crowning himself, flanked by palm-branches.

Bailey 1988, Q2199. DMB

59 Pottery lamp

Made in Anatolia, between about 500 and 600

London, BM, M&LA 1981,3–5,5

L. 97 mm, W. 56 mm

Ohrtmann Collection. Bought by the British Museum in 1981.

Lamp with its handle formed as a lion's head.

Bailey 1988, Q3167. DMB

60 Gold belt-tab

Eastern Mediterranean, 5th or 6th century

London, Victoria and Albert Museum, Metalwork and Jewellery Collection M. 12–1970

L. 55 mm, W. 27 mm

Said to have been found near Malaga, Spain. Bought by the V&A in 1970.

Gold belt-tab comprising a square panel hinged to an oval pendent unit by five attachment-loops. The panel, which is

of thin gold sheet, is embossed and chased on one side with a vase flanked by two rampant lions, each with a paw on the top of the vase; in the field, foliate ornament and stippling. The reverse is decorated with acanthus foliage. One end of the square panel is open and threaded with three attachment-pins. The oval unit, which is edged with coarse beading, is decorated on both sides with a raised border of gold sheet terminating in two internal volutes embellished with a gold bead. This border encloses further acanthus foliage on one side, and a running scroll of rosettes and whorls enclosing the diminutive figure of a bird on the other; near the base of the oval unit, on both sides, is a row of beaded wire.

Although the form of the belt-tab appears to be unique, a number of its decorative elements can be broadly paralleled in other media. Animals such as peacocks, deer and gazelles flanking a central vase or *kantharos* can be observed on numerous fifth- and sixth-century mosaic pavements (B. Brenk, *Spätantike und frühes Christentum* (*Propyläen Kunstgeschichte. Supplementband* 1), Frankfurt am Main–Berlin–Vienna, 1977, pls 136b, 137, 180 and 383). The heavy beading which edges the oval unit can be compared with that on a variety of gold belt-plaques ranging in date from the mid fourth to the early fifth century (Dalton 1901, nos 252 and 261). Lions serving as handles on bronze vessels or as the feet of lamp-stands are also ubiquitous in the fifth and sixth centuries (Dalton 1901, no. 496; Ross 1965, no. 40). The stippled background most closely resembles that on an early fifth-century bracelet decorated with a bust of Athena, in the Metropolitan Museum of Art, New York (exh. cat. *Age of Spirituality* (1977–8), no. 282). The almost classical execution of the acanthus foliage perhaps argues for a fifth rather than a sixth century date. The tab would have been attached to the end of one of a number of decorative straps hanging from a belt.

Unpublished. CJSE

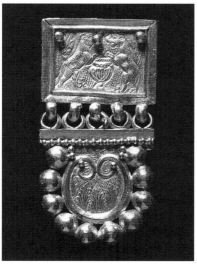

60 (enlarged)

The Emperor Justinian

In the course of the fifth century most of the western part of the empire had been lost: Ostrogoths ruled in Italy, Visigoths in Spain, and Vandals in northern Africa. Justinian I (527–65) devoted most of his resources to the recovery of the western provinces and, through the brilliance, bravery and ruthlessness of his generals Belisarius and Narses, turned the Mediterranean back into what it had once been, 'the Roman lake'.

For Justinian, Latin-speaking and westward-looking, the continuity of the Roman Empire was of prime importance. His lawyers drew up the *Codex Justinianus*, a compilation of the valid edicts of all the emperors since Hadrian, and the *Digest*, comprising rulings and precedents of the classical Roman lawyers. The *Codex* was to remain the basis of law and order in Byzantium until the fall of Constantinople in 1453, and its influence has long been felt outside the frontiers of the empire.

Justinian's other lasting achievement is Hagia Sophia, the Church of Holy Wisdom in Constantinople, which has had such a strong effect on both Islamic and western architecture. Churches as well as fortresses were built all over the enlarged empire, and the greatness of the age is still evident in their furnishings: mosaics, paintings, woven silks, carved ivories, illuminated manuscripts, gold ornaments, silver plate and cast bronze. Pilgrimage to holy sites, many of them graced with splendid new churches, developed its own popular art.

61 Gold medallion of Justinian (electrotype)

Mint of Constantinople, probably between 527 and 538

London, BM, CM *BMC*, p. 25

Diam. 82 mm. Weight (of original): 164.05 g

Original found near Caesarea in Cappadocia in 1751 and acquired for the Cabinet du Roi, Paris (now the Cabinet des Médailles, Bibliothèque Nationale); stolen in 1831 and presumably melted down. In 1898 the presence was discovered in the British Museum's Department of Coins and Medals of sulphur casts made before the theft, which were then used to make two electrotype copies now in the British Museum and Bibliothèque Nationale.

Electrotype copy of gold medallion of Justinian I (527–65), equivalent to thirty-six solidi. Obverse: three-quarter facing bust of Justinian, nimbate, wearing ornamented helmet with plume, diadem, cuirass and military cloak, holding a spear in his right hand and with a shield behind his left

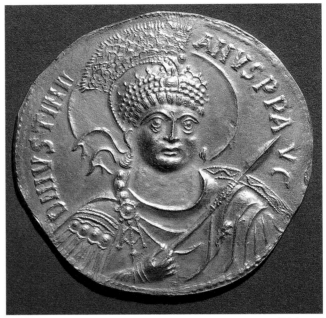

61 (obverse)

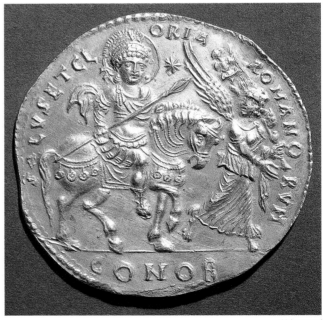

61 (reverse)

shoulder; the legend reads DN IVSTINIANVS PP AVG ('Our Lord Justinian Perpetual Emperor'). Reverse: Justinian, holding a spear, on a horse moving right; he is nimbate and wearing plumed helmet, diadem, cuirass, military cloak and boots. The horse wears a decorated saddle-cloth and jewelled trappings and is preceded by winged Victory holding a palm and trophy. In the field is a star, in the exergue CONOB; the legend reads SALVS ET GLORIA ROMANORVM ('The salvation and glory of the Romans').

Large gold medallions, multiples of the gold solidus coins and based on their design, were produced during the late Roman and early Byzantine empires. They were presumably for ceremonial or presentation purposes, though the specific circumstances behind their striking is not usually known.

The largest surviving example is a six-solidus piece of Maurice, which is also the latest such medallion known. Other medallions now known are of $4\frac{1}{2}$, 3 and $1\frac{1}{2}$ solidi. All of these are unique types. However, the largest specimen to survive into modern times was the 36-solidi (half a Roman pound) so-called 'Victory medallion' of Justinian, lost in 1831. Even larger pieces are recorded: the historian Gregory of Tours describes several one-pound medallions he was shown in 581, which had been sent as gifts by Tiberius II to the Frankish king Chilperic I (*Historia Francorum*, Book VI, 2).

This medallion has been identified with a coin mentioned by the historian Cedrenus which, he reported, had Justinian on one side and his general Belisarius on the other, and was thus assigned to around 534, when Belisarius celebrated his triumph for the conquest of Africa (Babelon III, p. 331). This identification has since been generally accepted but may be doubtful, as Cedrenus's description does not fully accord with the surviving piece: for instance, he describes a reverse legend in Greek which names Belisarius. In *BMC* Wroth accepted the link as likely but dated the medallion more generally to before 538/9, as the bust design on it matches that in use on the solidus coinage up to that year (*BMC*, p. 25).

W. Wroth, *Catalogue of the Imperial Byzantine Coins in the British Museum*, London , 1908, p. 25. On the modern history of the medallion, see E. Babelon, 'Histoire d'un médaillon perdu: Justinien et Bélisaire', in: *Mélanges numismatique*, 4 vols, Paris, 1892–1912, III, pp. 305–26, and 'Deux médaillons disparus de Dormitien et de Justinien, note additionelle', *Revue numismatique* (1899), pp. 1–8. For a brief general discussion of medallions, see P. Grierson, *Byzantine Coins*, London–Berkeley, 1982, pp. 51–2.

BJC

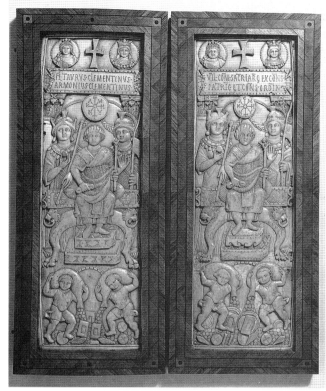

62

62 The Clementinus Diptych

Constantinople, 513

Liverpool, National Museums and Galleries on Merseyside, Liverpool Museum, M.10036

384 × 123 mm (excluding frame)

In use in the eighth century in southern Italy. Purchased in Nuremberg by Joachim, the father of G. P. Negelein, before 1742; in the collection of Count Wiczay in Hédervár by 1798; in the collection of Gabor Féjerváry in 1834; in the Mayer Collection in 1855. Given to the town of Liverpool by Joseph Mayer in 1867.

The two leaves are mounted in reverse in a marquetry frame, probably of the eighteenth century. Both leaves are in good condition, although heavily worn.

The left (front) leaf names the consul as FL[AVIVS] TAVRVS CLEMENTINVS ARMONIVS CLEMENTINVS, and the right (rear) leaf gives his present and previous titles V[IR] IL[LVSTRIS] COM[ES] SACR[ARVM] LARG[ITIONVM] EX CONS[VLE] PATRIC[IVS] ET CONS[VL] ORDIN[ARIVS]. His name is repeated in Greek in the star monogram above his head.

The two leaves show the same scene, with only minor changes in costume and decoration: the consul sits on a lion-headed throne, wearing the triumphal toga, his feet raised on a two-step dais. In his left hand he holds a mappa, and in

his right a sceptre surmounted by a bust of the Emperor Anastasius. Clementinus is supported by the personifications of Constantinople (left) and Rome (right) (Cameron, p. 41). Above the inscriptions, held up by columns, are roundels containing portraits of the Emperor Anastasius, and the Empress Ariadne, with a cross between them. Clementinus supervises a *sparsio* (distribution of largess, lit. 'sprinkling'), with two youths in short tunics pouring out bags of coins on to the floor of the arena, already littered with money, bullion and palm leaves. The reverse contains an inscribed prayer, dated to 771/2, the first year of the pontificate of Hadrian I (Sansterre, pp. 641–7).

Consular diptychs were handed out to officials and friends by consuls on their appointment to this annual office, usually with messages written in wax in the sunken area on the reverse. Flavius Taurus Clementinus became Consul Ordinary of the East in 513. Clementinus, a monophysite sympathiser, was imperial finance minister under the Emperor Anastasius, but little else is known about him.

A second Clementinus leaf can be seen in the Victoria and Albert Museum, but its inscriptions and faces have been re-cut to commemorate Orestes, the western consul of 530 (Netzer, pp. 265–71).

Pulszky 1856, nos 29–30; Delbrueck 1929, no. 16; Volbach 1976, no. 15; A. Cameron, 'Notes on the iconography of Constantinople', *8th Annual Byzantine Studies Conference: Abstracts of Papers*, Chicago, 1982, p. 41; N. Netzer, 'Redating the consular ivory of Orestes', *Burlington Magazine* 125 (1983), pp. 265–71; J.-M. Sansterre, 'Où le diptyche consulaire de Clementinus fut-il remployé à une fin liturgique?', *Byzantion* 54 (1984), pp. 641–7; Gibson 1994, no. 8. Exhibited: *Carvings in Ivory* (1923), no. 26; *Liverpool Ivories* (1954), no. 13; *Masterpieces* (1958), no. 26; *Age of Spirituality* (1977–8), no. 48. AE

63(a–b) Ivory panels with evangelists

Probably Egypt, 6th century

Cambridge, Fitzwilliam Museum, Department of Applied Arts, (a) M.10 and (b) M.11–1904

(a) 334 × 135 mm and (b) 335 × 135 mm

In the seventeenth century the panels were in the monastery of St Maximin, Trier, or in a monastery dedicated to the same saint in nearby Luxemburg. Bateman Collection, Derbyshire, no later than 1857, sold by Sotheby's in 1893 (lot 29, £182). McClean Collection. Bequeathed to the Fitzwilliam Museum by Frank McClean (1904).

Two panels of ivory, each carved in low relief with two full-length bearded figures in front of three columns with Corinthian capitals. Each of the figures, wearing tunic, pallium and slippers with socks, holds a book with a composite cross on the cover; two of them have draped left hands, while the other two raise their right in blessing. On each panel the columns support a transom, above which is a scene from the

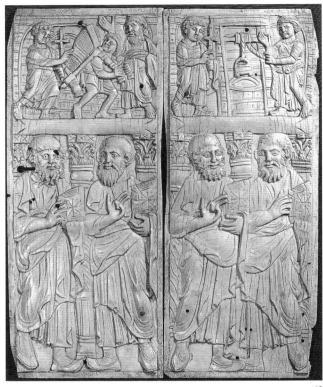

63

life of Christ, set against the background of a masonry wall with arches.

(a) *Christ and the woman of Samaria at Jacob's well* (John 4.6–26). From the left approaches a clean-shaven Christ, in tunic, pallium and sandals. He carries a jewelled or studded cross in his left hand and makes a gesture of benediction with his right. He has no halo. To the right stands a woman, drawing water from the well in the centre of the composition

(b) *Christ healing the Paralytic* (Matthew 9.1–7). Christ, virtually identical to the representation on the other panel, approaches from the left. In the centre, a beardless male, barefoot and in a short tunic, carries a bed and bedding away from Christ. At the right is a bearded figure in tunic and pallium, right hand raised.

The panels have rebates cut all round on both faces, brass rivets and small holes. (b) has a keyhole off-centre near its left edge, as well as straight and compass-drawn grooves on the reverse.

The figures with books presumably represent the four evangelists, each holding his own Gospel; the ivories could therefore have been made for a Gospel-cover. At some time they were evidently reused as parts of a casket. They are generally believed to have decorated an episcopal throne in St Maximin's, Trier, together with ivories now in Brussels, Tongeren and New York (Volbach 1976, nos 153–5). How-

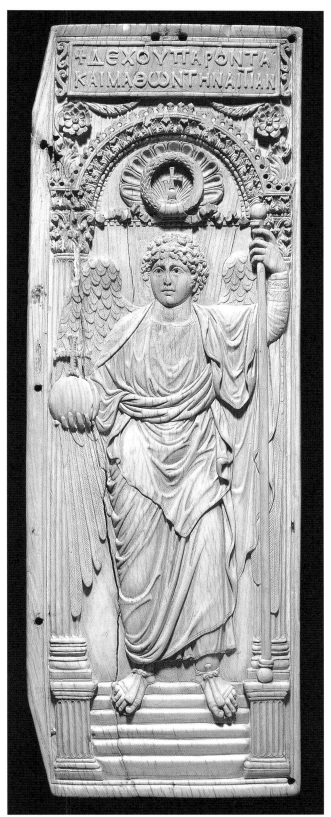

64

ever, while the curious footwear of the evangelists on the Fitzwilliam panels is similar to that on both the Brussels and Tongeren ivories, the drapery is far more fluent, betraying the hand of a different artist. The drapery style of the Fitzwilliam evangelists is, in fact, reminiscent of that of the Constantinopolitan archangel ivory (no. 64), although less accomplished. Nancy Ševčenko (exh. cat. *Age of Spirituality*) relates the style of the Christological scenes to that of pyxides thought have been carved in Egypt; Capps draws parallels between the footwear of the evangelists and footwear represented in wall-paintings from Bawît, Egypt.

A. Wiltheim, SJ (d. 1694), *Luciliburgensia sive Luxemburgum Romanum* (ed. and publ. A. Neijen, Luxemburg, 1842), nos 188–9, pl. I, p. 197; Westwood 1876, pp. 49–50 (nos 114–15); H. Graeven, 'Fragment eines frühchristlichen Bischofsstuhls im Provinzial-Museum zu Trier', *Bonner Jahrbücher* 105 (1900), pp. 153–4; Dalton 1912b, pp. 84–7, nos 32–3, pl. IV; E. Capps, Jr, 'An ivory pyxis in the Museo Cristiano and a plaque from the Sancta Sanctorum', *Art Bulletin* 9 (1926–7), p. 337, fig. 9; J. Baum, 'Frühchristlicher Bischofsstuhl in Trier', *Pantheon* 4 (1929), pp. 374–8 (illustration on p. 375); W. F. Volbach, 'Frühmittelalterliche Elfenbeinarbeiten aus Gallien', *Festschrift des Römisch-Germanischen Zentralmuseums in Mainz*, Mainz, 1952, p. 52, pl. 7,3; H. Schlunk, 'Beiträge zur kunstgeschichtlichen Stellung Toledos im 7. Jahrhundert', *Madrider Mitteilungen* 11 (1970), p. 172, pl. 53; Volbach 1976, p. 100, no. 152, pl. 79. Exhibited: *Age of Spirituality* (1977–8), no. 486. DB

64 Ivory panel with archangel

Constantinople, second quarter of 6th century

London, BM, M&LA OA 9999

428 × 143 mm, depth 9 mm

The acquisition details of this ivory are unknown, but Francis Pulszky refers to it in 1856 in a manner implying that it had been in the British Museum for some time (Pulszky 1856).

This is the largest surviving Byzantine ivory panel and is of exceptionally high quality, combining delicacy and detail in a clear but striking composition. It once formed the right panel of a diptych the other half of which is now lost. Apart from the long crack running down the left-hand side of the panel, and a few areas of loss, it is in good condition. The size of the panel is such that it exceeded the width of the curved tusk from which it was carved, resulting in the angled corners on the left-hand side.

An archangel, holding a sceptre and orb surmounted by a jewelled cross, stands under an arch at the top of a flight of steps. The arch is decorated with acanthus leaves, and contains a cross in a laurel wreath in a scallop shell niche. There is a certain spatial ambiguity between the angel and his surroundings, since the angel appears in front of the two columns, yet the steps on which he stands recede behind

them. The angel thus appears to loom fowards from the panel. The inscription in iambic trimeters at the top reads: +ΔΕΧΟΥ ΠΑΡΟΝΤΑ / ΚΑΙ ΜΑΘϢΝ ΤΗΝ ΑΙΤΙΑΝ, which may be translated: 'Receive the suppliant before you, despite his sinfulness', although other translations have been proposed (Wright 1977). On the reverse is a barely legible ink inscription in a seventh-century hand, which may have recorded a prayer or other liturgical text.

The style of the carving, particularly of the volutes around the tabula, is closely associated with other ivory diptychs from the 520s (Cutler 1984). The size and magnificence of the carving have led scholars to assume an imperial, Constantinopolitan, origin for the panel. The ivory has been directly associated with the accession of Justinian in 527, and it has also been argued that the angel was presenting the orb to the emperor, who was depicted on the other lost leaf, although these assertions cannot be proved.

Dalton 1909, no. 11; Volbach 1976, no. 109; A. A. Vasiliev, *Justin the First*, Cambridge, Mass., 1950, pp. 418–26; D. H. Wright, 'Ivories for the emperor', *3rd Annual Byzantine Studies Conference: Abstracts of Papers*, New York, 1977, pp. 6–9; A. Cutler, 'The making of the Justinian diptychs', *Byzantion* 54 (1984), pp. 75–115; Cutler 1994, p. 244. Exhibited: *Age of Spirituality* (1977–8), no. 481. AE

65 Ivory pyx with the martyrdom of St Menas

Probably Alexandria, 6th century

London, BM, M&LA 79,12–20,1

H. 78 mm, diam. 122 mm

From the church of San Paolo fuori le mura, Rome, where it was bought by Alexander Nesbitt, FSA (the cataloguer of the Slade Collection of glass), sometime before 1879, when it was purchased by the British Museum.

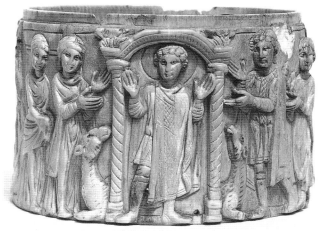

65

Two scenes are represented on the round box, one either side of the hinge and lock of the lid. The lid, its fittings, and the base are now lost. The rim is chipped, and areas of high relief have been worn smooth.

The first scene conflates the trial and execution of St Menas, an Egyptian soldier martyred under Diocletian. On the left a prefect, holding his sceptre of office, raises his hand to order the execution of the saint. He is accompanied by a soldier and an official in a chlamys, who holds a diptych. On the right, a second soldier raises his sword to kill Menas, whose hair he grasps. Menas wears only a loin-cloth; his arms are bound behind his back. An angel flies in with veiled hands to receive the saint's soul. In the second scene, St Menas, now nimbed and wearing a chlamys with *tablion*, stands in his sanctuary in orant pose. He is approached by four figures, two women on the left, two men on the right. On either side of the sanctuary are camels, the attributes which identify the saint.

The arrangement of figures and the schematic representation of the shrine match the mosaic image of votive donors at the shrine of St Demetrius (about 600, now lost) in his church in Thessaloniki (Cormack 1985, fig. 29). This suggests that the pyxis was a votive offering by the four figures around the sanctuary, who probably represent a married couple and their children. It is possible that the man originally wore a metal diadem, and that the daughter held something in her veiled hands. Both her hands and those of the angel are veiled to signify their proximity to the sacred. The chlamys and *tablion* worn by St Menas in this scene is the same as that worn by the official in the execution scene, indicating the elevated social position accredited to the saint after his martyrdom. The origin and date of this piece are controversial, but stylistic links and the strong centre of the cult of St Menas near Alexandria suggest a sixth-century origin in that city.

Dalton 1909, no. 12; Volbach 1976, no. 181; J. Kollwitz, 'Alexandrische Elfenbeine', in: *Christentum am Nil. Internationale Arbeitstagung zur Ausstellung 'Koptische Kunst'*, Recklinghausen, 1964, pp. 207–20. Exhibited: *Age of Spirituality* (1977–8) no. 514; *Spätantike* (1983–4), no. 176. AE

66 The Cotton Genesis

Eastern Mediterranean, perhaps Egypt (Alexandria), late 5th or 6th century

London, British Library, Cotton MS Otho B.VI, folios 27v and 28r

Folio 270 × 220 mm; fragments 144 × 87 mm (left), 160 × 105 mm (right)

In Venice in the first half of the thirteenth century. In England before 1575. Said to have belonged to Henry VIII, Elizabeth I and Sir John Fortescue (d. 1607). In the collection of Sir Robert Cotton by 1611, when lent to Sir Henry Savile. Lent to Thomas Howard, 14th Earl of Arundel (d. 1646) and bought back from his heirs by

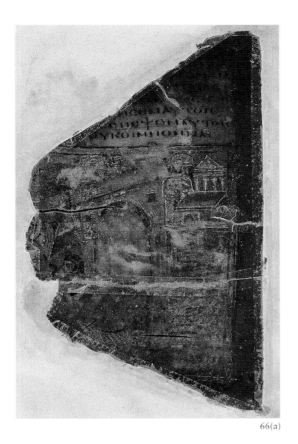

66(a)

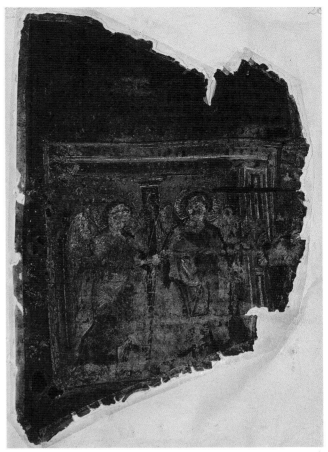

66(b)

Sir John Cotton before 1691. At the death of Sir John in 1702 became, by gift, national property. Incorporated into the British Museum on its foundation in 1753.

These charred and shrunken fragments were conserved and mounted under Sir Frederic Madden's direction between 1842 and 1856. On the left can be seen the closing words of Genesis 19.1–2 (Lot meets two angels by the gate of Sodom and bids them stay the night in his house). In the accompanying image the city of Sodom is represented, its buildings embellished with strips of gold leaf. Lot can be made out, kneeling at the left, and part of an angel. Originally another page intervened at this point (see no. 67, and fig. 1, p. 19), before the page we now see at the right. In this we can read part of Genesis 19.12–13 (the angels warn Lot to leave the city with his family, for God will destroy it). The two angels are seen within Lot's house; he is just visible at the right. Even in its terribly damaged state, enough can be made out to confirm the highly accomplished technique of this painting.

Despite its woeful condition – the result of a disastrous fire in 1731 at Ashburnham House, where the Cotton Library was then kept – the Cotton Genesis, as it is known, retains much of the status it enjoyed in the seventeenth and eighteenth centuries as one of the most important biblical manuscripts. In particular, the book is remarkable because it seems originally to have contained some 339 miniatures, illustrating the text of Genesis in a uniquely full fashion. In this way Genesis was made to fill an entire volume of some 440 pages, originally measuring roughly 330×250 mm (much larger, therefore, even than the volume in which they are now mounted). In the fierce heat of the fire, the parchment leaves shrank rapidly to about half their original size before melting or charring. Whether other books of the Bible were also illustrated so extensively in the fifth and sixth centuries remains an intriguing controversy.

K. Weitzmann and H. L. Kessler, *The Cotton Genesis*, Illustrations in the Manuscripts of the Septuagint, 1, Princeton, 1986; J. Lowden, 'Concerning the Cotton Genesis and other illustrated manuscripts of Genesis', *Gesta* 31 (1992), pp. 40–53. Exhibited: *Christian Orient* (1978), no. 1. J L

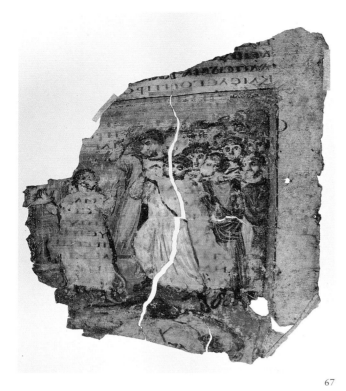

67

leaves for more than a century. (In 1796 only eighteen fragments could be found.) Gifford's reprehensible removal of this and the three other fragments he left to Bristol thus went unnoticed. The fact that less of this leaf survives than of the leaves that flanked it on either side (displayed as no. 66) suggests that Gifford's action itself led to further damage (and compare the watercolour of this page made in 1743: Weitzmann and Kessler 1986, col. pl. 3.IV).

Bibliography: see no. 66. JL

68 Canon Tables from a Gospel Book

Eastern Mediterranean, 6th or 7th century

London, British Library, Additional MS 5111, folios 10 and 11

Folios now approx. 210 × 175 mm; originally at least 260 mm wide and probably more than 300 mm high

Preserved when bound into Additional MS 5111 (see no. 69).

These pages were covered with gold leaf and then decorated to form part of a set of Canon Tables. On the left page is the end of the letter of Bishop Eusebius (d. 339/40) to Carpianus, explaining the use of the tables (on the recto), with part of the first table with cross-references to biblical passages that occur in all four Gospels, numbered with Greek letters (on the verso). The right page has parts of the ninth and tenth tables (the last) on the recto and verso, ending with the passages occurring in only one of the Gospels. The tables are set within a sumptuous architectural frame, decorated with medallion busts of unidentified saints, probably the apostles.

The complete integration of text and illustration on these superb pages and the use of the same ink for the writing and for complex details of the design, such as the capitals, indicate that a single craftsman was both artist and scribe. The fragments are a unique survival and imply that entire Gospel Books may have been written on pages of gilded parchment (or perhaps only the prefatory material was treated in this way). The painting is executed with thickly applied pigment in a technique reminiscent of encaustic. In the decoration the artist preferred bold effects rather than naturalism, but the treatment of the birds and fish show that he was capable of a more naturalistic style as well. The strong modelling of the saints' heads, with their far from idealised physiognomies, is characteristic of sixth- and seventh-century work in a variety of media.

C. Nordenfalk, *Die spätantiken Kanontafeln*, Gothenburg, 1938, pp. 127ff; K. Weitzmann, *Late Antique and Early Christian Book Illumination*, London, 1977, p. 116. Exhibited: *Christian Orient* (1978), no. 2; *Splendeur de Byzance* (1982), no. M3. JL

67 The Cotton Genesis: Bristol fragment

Eastern Mediterranean, perhaps Egypt (Alexandria), late 5th or 6th century

London, British Library, Cotton MS Otho B.VI, fragment 4

Fragment 110 × 94 mm

Removed from the fragments of the Cotton Genesis (no. 66) by Andrew Gifford, assistant librarian in the Department of Manuscripts of the British Museum from 1756, and bequeathed by him in 1784 to Bristol Baptist College. Returned to the British Museum on loan in 1928, and purchased in 1962.

The story of Lot, the angels, and the people of Sodom in no. 66 is continued here. Originally the image on this fragment was on a left page, facing the right page of no. 66 (see fig. 1, p. 19). Part of Genesis 19.11 can be seen above (the angels smite the Sodomites with blindness). Lot, the small figure at the left, is standing outside his house being harangued by a large crowd of Sodomites who demand that he should bring out the angels to them (Genesis 19.7–9). The hand of one of the angels, grasping Lot by the waist to pull him back into the house, can just be made out at the far left (cf. Genesis 19.10). The irregular shapes in the foreground might be the bodies of the men who have been blinded and have wearied of finding the door.

Until Sir Frederic Madden organised the conservation of the Cotton Genesis in the mid nineteenth century (see no. 66), it seems to have been left as a pile of crumpled

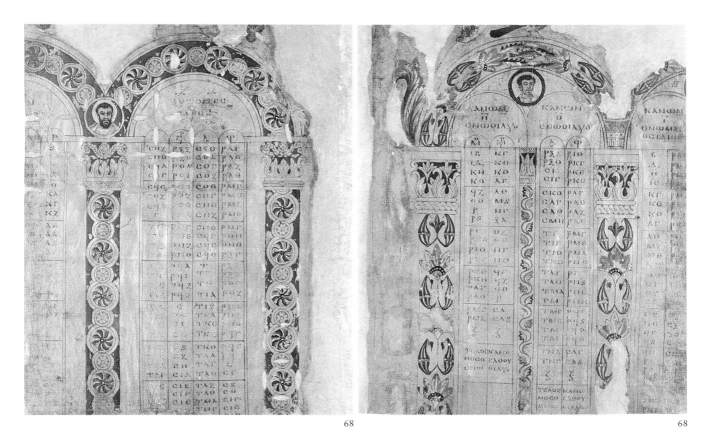

68

68

69 Gospel Book with sixth-century Canon Tables

Byzantium, shortly before 1189

London, British Library, Additional MS 5112, folios 2v and 4r

Folio 255 × 175 mm

The death of the book's writer, Gregorios the monk, on 4 January 1189 is recorded on folios 235v and 241r. Purchased by the British Museum at the sale of Dr Anthony Askew's manuscripts, 15 March 1785 (lot 622). Possibly passed to Askew from Richard Mead, MD (1673–1754).

At the left is the end of the list of titles of chapters in St Luke's Gospel. At the right, the Gospel text begins with a decorated initial E beneath a headpiece. The manuscript is carefully written but not of the highest quality; the headpiece could be the scribe's own work. The image of St Luke (no. 70) was inserted in this opening so as to face the start of his Gospel.

This book containing the Gospels of St Luke and St John is the second volume of a Gospel Book (Additional MS 5111, with Matthew and Mark, forms volume one). Into the two volumes were bound at some date, perhaps even when the book was made, the two fragments of sixth-century Canon Tables (no. 68; the manuscript also has its own complete set of such tables) and three evangelist images on single leaves

(no. 70; the Mark is lost). The images were much too large and had to be cut and folded for insertion. The same seems to have been true for the Canon Table pages, unless they had already been cut down in some earlier reuse. There is no way of knowing whether the monk Gregorios was responsible for these insertions, but this is a possibility.

Spatharakis 1981, no. 168. JL

70 Image of St Luke added to the preceding Gospel Book

Byzantium, second half of 12th century

London, British Library, Additional MS 5112, folio 3

Image 252 × 189 mm

History: see no. 69.

St Luke bends forward in the act of writing his Gospel. The purple pigment used extensively appears thin and rather muddy, implying some lack of care (or perhaps of expense, or even of skill) in the execution of the image. The illustration has been cut down. A vertical fold at the right shows where it was folded to be stitched into Additional MS 5112 (no. 69), while the left margin was also folded so as not to project.

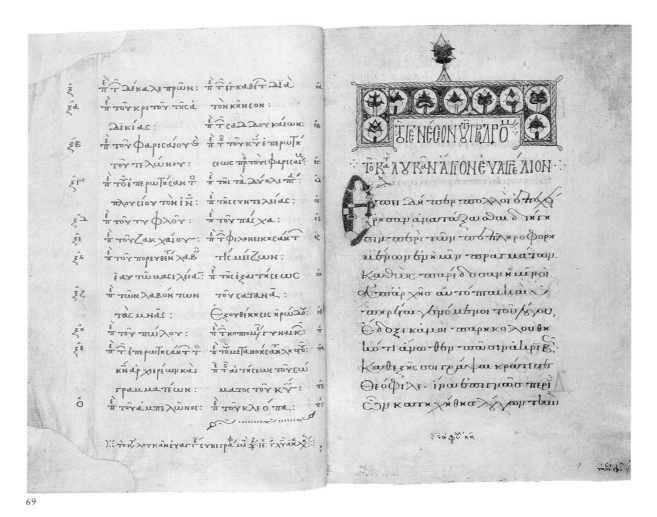

69

On stylistic grounds the image appears to be a work of the second half of the twelfth century, perhaps the third quarter. It must have been made originally as part of a set for a Gospel Book (or perhaps a Gospel Lectionary) of exceptionally large size, some 350×270 mm or larger. Since these images were on single leaves of parchment, it is conceivable that they were never inserted into the book for which they were intended and somehow survived to find their way into Additional MSS 5111–5112. The Canon Tables (no. 68) must also originally have been in a book of comparably large dimensions. Perhaps the evangelist images were specifically made for a volume planned to include the Canon Table fragments. This volume would have been left unwritten and in due course the leaves bound into Add. MSS 5111–5112. Alternatively we must imagine that the images were removed from a parent book in order to be reused, and this appears an unattractive hypothesis.

Bibliography: see no. 69. Exhibited: *Christian Orient* (1978) no. 8.

JL

71 The Codex Purpureus Petropolitanus

Eastern Mediterranean, probably Asia Minor or Syria, 6th century

London, British Library, Cotton MS Titus C.xv, folios 2v–3r

Folio 320 × 265 mm

Owned by Sir Robert Cotton (d. 1631) by about 1600. At the death of his grandson, Sir John Cotton, in 1702 the manuscript became by gift national property. Incorporated into the British Museum on its foundation in 1753.

Two luxurious leaves preserve part of St Matthew's Gospel (26.61–5; 27.26–30) written on very thin, purple vellum in monumental uncial letters penned entirely in silver (now black through oxidation) except for the *nomina sacra* in gold. Ammonian section and Eusebian canon numbers are added in the margins in a smaller script.

Together with two further leaves (fols 4 and 5) preserving part of St John's Gospel, these leaves once formed part of gatherings 13 and 46 of an important early manuscript of the four Gospels. Known as the Codex Purpureus Petro-

70

politanus after the largest surviving portion (182 leaves) which was discovered at Sarmiisaklii in Cappadocia in the middle of the nineteenth century and moved to St Petersburg in 1896, this Gospel Book was probably broken up as early as the twelfth century. Two further leaves reached the Vatican Library by 1600 and another two the Imperial Library in Vienna by 1670. Thirty-six leaves are dispersed between Patmos, Athens, New York and Lerma.

Only three other purple Greek Gospel Books survive, namely the Beratinus, Rossanensis and Sinopensis. All are thought to be of similar origin and date to the Petropolitanus. All four volumes are certainly luxury objects which show clear signs of having been produced for persons more concerned with appearance than content and were probably intended primarily as objects for admiration in religious ceremonies. Apart from the Beratinus all contain very similar, incorrect versions of the so-called Byzantine text. The Rossanensis may indeed derive from a common exemplar with the Petropolitanus. All except the Petropolitanus are further embellished with fine illustrations.

H.S. Cronin, *Codex Purpureus Petropolitanus*, Cambridge, 1899; F.G. Kenyon, *Facsimiles of Biblical Manuscripts in the British Museum*, London, 1900, IV; G. Cavallo, *Ricerche sulla maiuscola biblica*, Florence, 1967, pp. 98–104. SMcK

71

72

72 Painted image of St Kollouthos

Egypt, 6th century

Private collection

575 × 1230 mm

Acquired in the 1970s.

Egg tempera on thick canvas. The saint is shown frontally, bust-length, perhaps originally full-length. He is depicted as an aged man with a short white beard and short white hair. He extends both his arms outwards, with the palms of his hands forward, perhaps in a gesture of prayer. He is dressed in a plain white *chiton* and mantle, which has two black stripes around the cuffs. The saint has an ochre halo. The figure is set against a dark background, apparently against a festooned curtain. The name of the saint, ΑΠΑΚΩΛΛΟΥΘΟC, is written on either side of his halo.

St Kollouthos was a martyr of Egyptian origin especially venerated in Egypt (Crum 1929–30, pp. 323–7). Representations of him are rare, but there is one in the burial chapel of Theodosia in Antinoë (Antinoopolis), Egypt, for which a date between the late fourth (Breccia 1938, p. 293) and the sixth centuries (Salmi 1945, pp. 161–9) has been suggested (Grabar has also accepted a date later than the fourth century: Grabar 1946, p. 34, fig. 136). An unidentified saint on an encaustic icon (J 68825) in the Egyptian Museum, Cairo, dating from the late fifth or early sixth century (exh. cat. *Age of Spirituality* (1977–8), no. 496), might also represent St Kollouthos.

The Egyptian origin of this representation is supported not only by the fact that it shows a saint exclusively vener-
ated in Egypt but also by the prefix ΑΠΑ, signifying 'our father' (Cabrol 1907, cols 2494–500), which forms an integral part of his name (also found in the representation of the saint in Antinoë) and was exclusively used in Egypt (see also the sixth-century encaustic icons from Egypt in the Louvre with ΑΠΑ Menas and Christ and in Berlin with ΑΠΑ Abraham: *Age of Spirituality* (1977–8), no. 497; Effenberger-Severin 1992, no. 84).

Because of its monumental size, it is difficult to describe this piece simply as an icon. Since it may originally have been an almost life-size depiction of the saint, it may have been intended as a hanging in a church dedicated to St Kollouthos.

Unpublished. MV

73 Mosaic head of Christ

From the apse of San Michele in Africisco, Ravenna, dedicated on 7 May 545

London, Victoria and Albert Museum, Sculpture Collection, 4312–1856

535 × 380 mm

Purchased in Italy in 1856 by John Charles Robinson as a 'fragment of an ancient wall mosaic. Roman work'.

Mosaic head set in a wooden frame and in nineteenth-century lime plaster. The gold-glass ground is modern, replacing the cross nimbus of the original mosaic. The blue tunic and red mantle are restorations. Most of the hair in glass tesserae is original with a few modern tesserae mixed

in. The flesh parts are in a mixture of stone and glass tesserae which are mostly original. The eyes and nose are reworked and the mouth partly remade. In all about half the tesserae are original, and their corrosion indicates that the mosaic was in a very poor state by the nineteenth century.

Until recently the mosaic was thought to be the head of a saint and said to have come from the church of Sant'Ambrogio in Milan. It was supposed that parts of the face might be original but the remainder heavily restored. A reappraisal of the mosaic was made in 1988 by Irena Andreescu-Treadgold, with the convincing argument that the mosaic, although wrecked by restorations both when it was on the wall and after its removal, nevertheless represents one of the few surviving fragments of the apse decoration of San Michele in Africisco at Ravenna which was taken down in 1884.

The mosaics of the apse and triumphal arch of this church were purchased by the Prussian King Friedrich Wilhelm IV and supposedly transported to Berlin for the display in the Staatliche Museen. But the mosaics in Berlin have always aroused scepticism about their authenticity: Ricci in 1905 wrote: 'If Ravenna has one fewer Byzantine mosaic, Berlin certainly does not have an additional one'.

Andreescu-Treadgold has finally resolved the debate about the extent of restoration in the Berlin mosaics by declaring the ensemble a 'complete fake' and offering an alternative history of the fate of the mosaics of the church in the nineteenth century. In 1805 the church was closed and sold, and the left nave used as a fish-market. The next owner of the church sold the mosaics in 1842 to an agent of the Prussian king. The detachment of the mosaics was organised by a dealer from Venice in 1843 – as the local population was united in the protest about the despoliation of the monument. In 1844 the mosaics were first recorded *in situ* and then removed to Venice for repair and dispatch to Germany. But the mosaics were still in Venice in 1848–9, when they were damaged by a bomb blast. In 1850–1 the mosaics were packed and sent to Berlin by the (infamous) restorer Giovanni Moro. These crates remained unopened in Berlin until 1875 and, when finally the contents were examined, they were found to have deteriorated in storage. The mosaics which Moro had sent were cleaned and reassembled, but returned to storage in 1878. In 1900 the mosaics from Moro were restored again, and finally set up on display in 1904. In the Second World War they were damaged during bombing and were restored in 1951–2.

Once the set of mosaics sent by Moro to Berlin are recognised to be fakes in new materials which he substituted for the originals, this sorry story of museology becomes irrelevant to the fate of the pieces salvaged from San Michele. But it seems that the Ravennate pieces were in any case already considerably damaged by the time of their removal and had

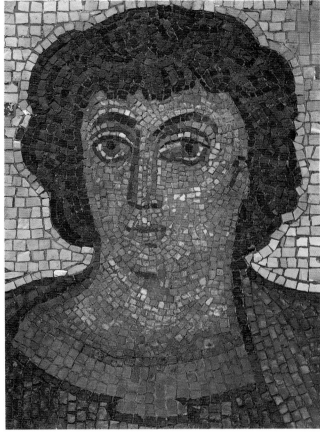

73

probably already been subject to restoration. It may be that Moro was only able to salvage and dispose of a few pieces of the original mosaics. Andreescu-Treadgold reckons that the only candidates for the original pieces are the V&A head (Christ), two heads of the archangels Michael and Gabriel in the Museo Provinciale at Torcello and, possibly, an angel in the Hermitage at St Petersburg (purchased for the Basilewsky Collection in Paris in 1884).

Although the V&A piece is grossly restored (the halo of Christ has gone, the right eye has gone, and the whole surface is distorted), it is clear that the image of a young Christ in this apse, as in the apse of San Vitale a few years later, is of interest for the Orthodox portrayal of Christ. We know from a drawing of the church before the mosaics were removed that the original ensemble consisted of a standing figure of Christ between archangels in the conch; on the triumphal arch surrounding the apse were Sts Cosmas and Damian; and above the conch was an enthroned (bearded) Christ flanked by two archangels holding instruments of the Passion and seven angels of the Apocalypse blowing their trumpets. Now that the mosaics in Berlin and their relation to the original have been clarified, this fragment in the V&A can be studied in a new light.

A. Effenberger, *Das Mosaik aus der Kirche San Michele in Africisco zu Ravenna*, 2nd ed., Berlin, 1989; I. Andreescu-Treadgold, 'The wall mosaics of San Michele in Africisco, Ravenna, rediscovered', *Corso di Cultura sull'Arte Ravennate e Bizantina* 37 (1990), pp. 13–57. RC

74 Silver basin from Sutton Hoo

Eastern Mediterranean, 6th century

London, BM, M&LA 1939,10–10,77

Max. diam. 407 mm, restored height 150 mm. Total weight 2246 g

Found, together with no. 52, in 1939, at Sutton Hoo, Suffolk, in the seventh-century ship-burial. Given to the Nation by Mrs Edith May Pretty, JP, in August 1939.

Large basin with two drop handles, a fluted body, horizontal rim, and a low foot-ring. The body, now crushed, bent and torn, was concave, having sides decorated inside and out with fifty-three broad, straight flutes. The flutes originate at the central medallion and terminate in semicircles at the upper rim, which has a rounded edge and a pair of decorative grooves on what was originally a horizontal surface. The central medallion is composed of three concentric grooved bands, an incised ornamental band between the outer two grooved bands, and a profile female head in repoussé relief in the centre. The ornamental band comprises a series of thirty-two vertical leaves with small florets between them, on a stippled ground. Positioned somewhat off-centre on the right of the medallion, the female head faces left; although the head is in profile, the eye is seen frontally. The woman wears a small diadem around which the front of her hair is pulled back over her ears and drawn up in a loose knot at the back of her head. (Tool marks are visible around the head from work giving emphasis to the relief probably executed from behind; the turning point of the basin is on the jaw-line.) A pair of drop handles was originally attached to the outer surface of the body, on horizontal axis with the profile head. The handles are each composed of a thick wire, octagonal in section, which is straight in the centre and bent vertically at right angles at the ends. Its tapering ends were threaded through soldering plates and bent upwards. In plan, the plates are round and straight along one edge where a projecting thick wire is bent back into a loop; the convex reverse sides of the plates were filled with solder. In addition to the damage done to the body of the basin, one handle plate is broken along one side.

Like the Sutton Hoo plate (no. 52), the basin was a utilitarian domestic item. Most silver basins of this type have been dated between the third and fifth centuries (e.g. Shelton 1981, no. 4; Cahn and Kaufmann-Heinemann 1984, no. 41). The flutes on the bodies take three forms: straight flutes deriving from earlier shell-shaped vessels, alternating

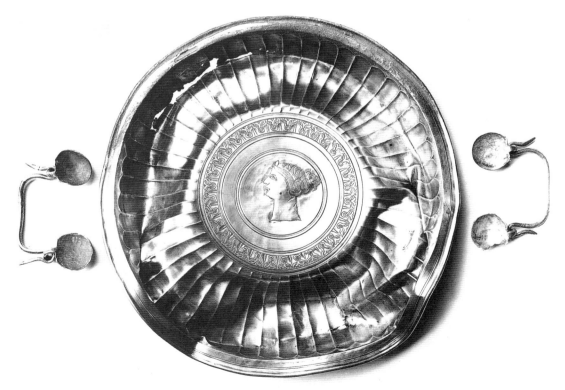

74

fluted and flat segments, and spiral flutes (Mango and Bennett 1994, no. 13). None of these silver basins has the same combination of features as the Sutton Hoo vessel (straight flutes, rim, foot and handles), the closest parallel to which may be a copper-alloy basin excavated at Antioch, which has a broadly fluted body, horizontal rim, foot-ring and very similar drop handles (G. W. Elderkin (ed.), *Antioch-on-the-Orontes*, I: *The Excavations 1932*, Princeton–London–The Hague, 1934, p. 74). Other more narrowly fluted versions in copper-alloy have been found in Egypt (Strzygowski 1904, nos 9040–2). Drop-handle basins with smooth sides, also cast in copper-alloy and dating from the sixth and seventh centuries, have been found as Byzantine exports at numerous sites in barbarian Europe, including the Sutton Hoo burial itself (Bruce-Mitford 1983, pp. 732–52). Stylistic analysis of the Sutton Hoo silver basin justifies its attribution to the sixth century (*op. cit.*, p. 63).

Kitzinger 1940, pp. 40–50; Bruce-Mitford 1983, pp. 45–69, 178–84. MMM

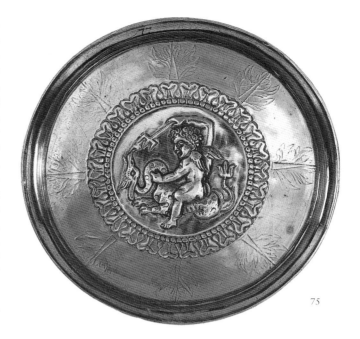

75

75 Small decorated silver plate

Alexandria or Asia Minor, late 6th century

London, BM, M&LA 1969,12–3,1

Diam. 120 mm, H. approx. 23 mm. Weight 163.58 g

Found in Asia Minor. Acquired by the British Museum in 1894.

Small plate with concave inner surface and slightly flaring foot-ring. The upper rim has a *cyma* moulding. A central medallion has a surrounding band of twenty-six plain leaves combined with a band of small beads. The medallion itself is decorated in repoussé relief with the image of Eros facing in profile to the left, seated on the back of a *ketos*, also facing left, with its snout and tail turned upwards. With his left hand Eros grasps the neck of the beast; his right hand is raised over his head, holding a trident. Eros has mature facial features, short curly hair, and wings. The hide of the *ketos* is covered with large punched rings. In the area between the medallion and the rim of the plate are incised eight large upright acanthus leaves, pointing outwards. The reverse of the plate is covered outside the foot-ring with four sets of incised Nilotic motifs (a crocodile, an ibis, a dog and serpent and a fisherman), each separated by large water-plants. There are no obvious traces of gilding.

The plate illustrates the persistence of classical subjects well into the Byzantine period; vessels with mythological subjects bear control stamps as late as the mid seventh century (Dodd 1961, nos 56, 57, 70 and 75). The London plate closely resembles in size, layout and iconography one of a set of six plates found at Bubastis in Egypt (Volbach,

'Silber- und Elfenbeinarbeiten . . .', *Akten zum VII. Internationalen Kongress für Frühmittelalterforschung*, Graz–Cologne, 1958, p. 31) and now in the Benaki Museum, Athens (S. Pelekanides, 'Argyra Pinakia tou Mouseiou Benaki', *Archaiologike Ephemeris 1942–1944* (1948), p. 59). The styles of the medallions differ, however, with the figures in Athens being in lower relief and of finer detail; the bead and leaf border is absent from this other plate, and the eight single leaves in London are replaced by a frieze of nine linked acanthus leaves. A set of eight dishes (attributed to the first century BC) with similar marine and other images in medallions and their inner sides covered by imbrications was excavated in a Sarmatian burial near Kaposhina (V. V. Kropotkin, *Rimskie importnye izdeliya v vostochnoy Evrope 2v. do n.e.–5v. n.e.*, Arkheologiya SSSR, svod arkheol. istochnikov, D1–27, Moscow, 1970, no. 432). Byzantine objects with related decoration, featuring a figural medallion surrounded by prominent radiating leaves, Nilotic motifs or ornament on the inner and outer surface, have been found elsewhere in Egypt, in Russia and, possibly, at Ravenna. Neither the London nor the Athens plate has control stamps (ascertained by personal examination; see Boyd, p. 68 n. 6), but some of the other objects were stamped in the sixth century (Boyd, pp. 68–71). The general assumption that five-stamp control marks ('Imperial stamps') were applied only in Constantinople (Dodd 1961, pp. 34f) has recently been challenged (see no. 135 below), and it is possible to suggest, on the same basis, that at least one of these related objects, a handled basin with erotes and Nilotic decoration (Dodd 1961, no. 1) was made and

stamped at Alexandria and that sets of Eros plates likewise originated there.

Walters 1921, no. 77; Curle 1923, p. 47; Matzulewitsch 1929, pp. 79–80; S. Boyd and G. Vikan, *Questions of Authenticity among the Arts of Byzantium*, Washington, D.C., 1981, p. 13, no. 4; S. Boyd, 'A sixth-century silver plate in the British Museum', in *Okeanos: Essays presented to Ihor Ševčenko on his Sixtieth Birthday by his Colleagues and Students*. Harvard Ukrainian Studies 7 (1983), pp. 66–79. MMM

76 Silver lamp-stand

Made and stamped in Constantinople, between 527 and 565

London, BM, M&LA 48,6–1,1

H. 210 mm, w. at base 110 mm. Weight 333 g

Found at Lapseki (ancient Lampsacus), Turkey, together with no. 133, as part of the Lampsacus Treasure. Given to the British Museum by Earl Cowley in 1848.

Tripod lamp-stand with a broad apron-base and a baluster staff supporting a flat disk with convex bottom, from the top of which projects a tapering pricket, square in section. The apron-base and feet are hollow; the other parts of the lamp-stand are solid. The staff is composed of one central baluster and tapering concave sections with flanges, above and below. The upper disk has concentric grooves on its upper and lower surfaces, around the pricket and along the edge. The surfaces of the apron-base are subdivided vertically by six convex seams. One foot and part of the apron above it have been re-attached to the object, and a small piece of metal is missing from above another foot. Inside the base are five imperial control stamps dating from the reign of Justinian I (527–65).

This lamp-stand belongs to a small but significant group of three silver examples stamped between 527 and 630 in two different cities. The Lampsacus stand was stamped at Constantinople between 527 and 565; another, excavated at Antioch, had been stamped in that city between 602 and 610; the third, found at Mytilene, had been stamped at Constantinople between 610 and 630. The close correspondence of shape, size and weight at workshops operating at some remove of time and space from each other indicates a level of standardisation and supports the theory that the state manufactured stamped silver, rather than stamped privately manufactured silver plate (Mango, 1992, p. 212). Other silver lamp-stands, which differ in form from these three, are earlier (Kaiseraugst, Cleveland, Beaurains) or unstamped (the Kaper Koraon or Hama Treasure; see no. 95); however, a set of sixth-century stamped lamp-stands found in Bulgaria is of different design (S. Boyd, 'A bishop's gift: openwork lamps from the Sion Treasure', in: F. Baratte (ed.), *Argenterie romaine et byzantine*, Paris, 1988, p. 202 n. 65). The silver baluster lamp-stand was

76

often copied in cast copper-alloy metal (e.g. exh. cat. *Byzantine and Post-Byzantine Art* (1986), no. 186), sometimes with imitation stamps provided inside the foot (personal examination of a lamp-stand in the Historical Museum, Heraklion; also sale cat. Sotheby's, London, 27 November 1986, lot 86).

Dalton 1901, no. 376; Rosenberg 1928, pp. 712–13; Dodd 1961, no. 19; Mango 1992, pp. 212–13. MMM

77 Brass bucket with hunting scenes

Eastern Mediterranean, possibly Antioch, 6th century

Oxford, Ashmolean Museum, Department of Antiquities, 1975.308

H. of body (excluding lugs) 135 mm, max. diam. 235 mm

Bought by the Ashmolean in 1975.

Hammered brass situla with a flat bottom, straight sides and an arched handle. Two integral lugs project upwards from opposite sides of the rim; one has broken off and been loosely riveted back in place. The handle, octagonal in section, is threaded through the lugs and its tapering ends bent upwards. The outer surface of the situla has a pounced hunting frieze framed by two rows of punched circles. The hunt is composed of two scenes each involving a pair of hunters: one pair attacks a griffin, the other a lion. The hunters wear only mantles, wrapped round their necks, and boots; their arms include shields, stones, a sword and a bow. On one side of the situla, a tree separates the two groups. Three copper coins of Anastasius (491–518) were soldered at equidistant points near the outer edge of the base of the situla, to act as feet. The base was repaired in antiquity.

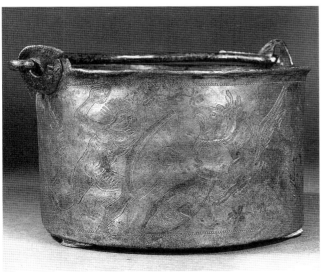

77

The object belongs to a group of copper-alloy situlae of which eight were known in 1989 (Mango *et al.*, p. 298). Since then, two more have come to light (sale cats *Objects with Semitic Inscriptions 1100 B.C. – A.D. 700: Jewish, Early Christian and Byzantine Antiquities*, L. Alexander Wolfe, Jerusalem, and Frank Sternberg, Zurich, auction no. 23, 20 November 1898, lot 416, and *Hesperia Arts Auction*, 27 November 1990, lot 25, now at Amherst College, Massachusetts). These situlae can be compared in shape and decoration to other Late Antique versions in silver and carved glass.

All of the ten copper-alloy situlae have flat bases; three have upwardly flaring sides, while the others, like the Ashmolean situla, have straight sides. Like the latter, several have cracked near the base and two other situlae have also had three feet added to the base. Two of the situlae have silver- or tin-plating in their decoration, and eight are decorated with hunting-related scenes; one features Achilles, and another, dedicated to a church, has a series of crosses; ornamental bands are repeated among the group. Seven situlae have Greek inscriptions of which four refer to health, and their owners – a *comes*, two other men, and a woman (Mango *et al.*, p. 298, nos 1, 3, 5, 7 and 8; Wolfe/Sternberg; *Hesperia*). The friezes and inscriptions were nearly all executed with the same or similar chisels and dot, ring and matt punches. The Homeric figures on the Achilles situla and the hunters all have wig-like hair composed of bushy ringlets. The animals in the hunt scenes are mostly feline; other animals (hares, stag, gazelle) shown without hunters appear on the smallest buckets. The Ashmolean and Amherst College hunts include a griffin. The nudity of the hunters places the friezes within the realm of mythology (cf. the Achilles situla). The four hunters on the Amherst College situla have inscribed names, three of which are mythological and repeat those on a hunting mosaic pavement outside Antioch (Mango *et al.*, p. 299).

The close similarity in shape, size, decorating tools, and subject matter suggest a common place of manufacture, and the Greek inscriptions place this in the East. The situlae subsequently travelled widely: two were found in Britain (Bromeswell, Chessell Down), one in Spain (Bueña), one in Turkish Mesopotamia (Kale e-Zerzevan) and one (the Achilles example) apparently in Palestine. It has been suggested on various grounds that the situlae may have formed part of military kit (at least for officers), which could explain a wide distribution pattern caused in part by the return home of European mercenaries. Analysis of several situlae has established their chemical composition as brass, in contrast to the more numerous cast bronze vessels (misleadingly termed 'Coptic') which have been found largely in European burial contexts of the late sixth and seventh centuries. Some of these bronze objects bear Greek

phrases about health and washing, relating to those on the situlae and suggesting a water-linked function for the situlae as well. While bronze vessels have been dated to around 600 on the basis of archaeological contexts, the situlae have been dated fifty years earlier on palaeographic grounds (e.g. the inclined chi and the split omega).

J. Arce, *La situla tardorromana de Bueña (Teruel)*, Madrid, 1982; Bruce-Mitford 1983, pp. 749–50, 756; M. M. Mango, C. Mango, A. Care Evans, M. Hughes, 'A 6th-century Mediterranean bucket from Bromeswell Parish, Suffolk', *Antiquity* 63 (1989), pp. 295–311; Mango, forthcoming. MMM

78 Weight from Theodoric's Italy

Probably Rome, between 493 and 526

London, BM, M&LA 1982,1–5,1

25.7 × 25.4 mm. Weight 22.44 g

Formerly in the collection of Apostolo Zeno, and subsequently in the collection of the Stift St Florian, Austria, until auctioned in 1957; bought by the British Museum in 1982.

Square copper-alloy weight engraved on the face with a silver-inlaid inscription in three lines: DN THEOD/ERICI (*Domini Nostri Theoderici*). On the base is a wreath enclosing the silver-inlaid denominational mark for one ounce with, in each corner, a four-lobed motif. Around the edge of the weight is a further inscription: CATV/LINVS / VC.ET / INL.PFV (*Catulinus vir clarissimus et inlustris praefectus urbi*); most of the silver inlay from this inscription is missing.

Two similar examples of three ounces are in the Louvre and the Cabinet des Médailles, Paris (Babelon and Blanchet 1895, pp. 696–7, no. 2285; de Ridder 1915, p. 171, no. 3400). The British Museum also possesses a three-solidus weight with an identical inscription (Dalton 1901, p. 93, no. 444). The Catulinus named on these weights has generally been identified with an individual of that name mentioned by Sidonius Apollinaris and known to have been *vir clarissimus* in 461 and subsequently *vir inlustris* (*PLRE*, II, pp. 272–3). There is no evidence, however, that this Catulinus ever held the office of *praefectus urbi* (the City Prefect), and the Catulinus named on the weights may have been a different person. The Theoderic of the inscription, King of the Ostrogoths, ruled much of Italy from 493 to 526.

L. A. Muratori, *Antiquates Italicae mediiaevi sive dissertationes*, Milan, 1739, pp. 577 and 581; G. R. Carli, *Dell'origine e del commercio della Moneta e dell'instituzione delle zeche d'Italia dalla decadenza dell'Impero sino al secolo decimosettimo*, Venice, 1751, p. 95; L. A. Muratori, *Dissertazioni sopra le Antichità Italiane*, I, Milan, 1751, p. 485; Pink 1938, cols 58 and 92. CJSE

78 (enlarged) 79 (enlarged)

79 Coin-weight from Somerset

Possibly Constantinople, 6th century

London, BM, M&LA 66,12–11,3

23.7 × 23.8 mm. Weight 23.22 g

Found near Taunton, Somerset. Given to the British Museum by Augustus Wollaston Franks in 1866.

Square copper-alloy weight with a double-grooved profile and the face in the form of a raised medallion set in from the edge. The face is engraved with a wreath enclosing a box-monogram above the denominational mark for six nomismata, all inlaid with silver, some of which is missing. Above and flanking the monogram are three silver-inlaid trefoils; in the three extant corners of the face is an L-shaped motif. The top left-hand corner of the weight is missing.

Only three other Byzantine weights have been discovered in English contexts: an eight-siliqua example found in a sixth-century grave at Watchfield, Oxfordshire (C. Scull, 'A sixth-century grave containing a balance and weights from Watchfield, Oxfordshire, England', *Germania* 64 (1986), p. 115, no. 21, fig. 18) and a two-nomisma and another eight-siliqua weight, both from Gilton, Kent (B. Faussett, *Inventorium sepulchrae* (ed. C. Roach Smith), London, 1856, pl. 17). The monogram resolves as 'of Eudaimonos'. A Eudaemon was Prefect of Constantinople in 532 (*PLRE*, III, p. 455).

Dalton 1901, p. 94, no. 453. CJSE

80 Spheroidal weight

Probably Constantinople, 6th century

London, BM, M&LA 1988,3–1,2

Max. diam. 36.5 mm, H. 22.4 mm. Weight 158.25 g

Bought by the British Museum in 1988.

Lathe-turned copper-alloy weight in the form of a flattened sphere, doubly truncated, with deep centring points on the face and base. The face is engraved with the denominational mark for six ounces, above which is a box-monogram; both the mark and the monogram are inlaid with silver.

Weights of spheroidal form were the predominant type throughout the Roman Empire from the first to the fourth century. During the course of the fourth century they were gradually superseded by the square type. The above example can be attributed to the sixth century on the grounds that it combines the older type of monogram with the later gamma-omicron abbreviation for 'ounce'. The only other spheroidal weight which can be assigned to the sixth century is a one-pound example in the Cabinet des Médailles, Paris, which is engraved with a monogram of the Emperor Justinian and an inscription stating that it was issued by Phocas, ex-consul and praetorian prefect of the East (A. de Ridder, *Les bronzes antiques du Louvre*, II: *Les instruments*, Paris, 1915, p. 172, no. 3411; *PLRE*, III, p. 1029). The monogram on the British Museum weight, which resolves as 'of Iustinos', probably refers to the issuing official rather than either of the two sixth-century emperors named Justin.

Unpublished. CJSE

81 Weight from the reign of Maurice Tiberius

Constantinople, 592

London, BM, M&LA 1980,6–1,118

Max. diam. 28.7 mm. Weight 25.73 g

Roper Collection. Bought by the British Museum in 1980.

Discoid copper-alloy weight engraved on both sides with the denominational mark for one ounce, inscribed on the face ✝ ᴆN MAURICIUS and on the base ✲ PERPETAUS ᴣNNO x̄ (*Dominus noster Mauricius perpetuus augustus anno X*). Both the denominational marks and the inscriptions are inlaid with silver.

The inscription dates the weight to the tenth year of the reign of the Emperor Maurice (582–602) and places it in a very rare category: weights with indictional inscriptions. The British Museum has another example, a three-nomisma

weight dated to the tenth year of the reign of Justin II (575). Two other unpublished examples, one in the Archaeological Museum, Istanbul, and the other in a private collection in Switzerland, replicate the inscription above. The forms of the letters in the inscription – in particular the D, M, R and U – closely mirror those found on the coins of Maurice Tiberius, suggesting that the weight was made in an imperial mint, probably that of Constantinople (Bellinger 1966, pp. 295–315).

Unpublished. CJSE

82 Glass weight from the reign of Justinian I

Probably Constantinople, between 527 and 565

London, BM, M&LA 1986,4–6,18

Max. diam. 24.7 mm, max. diam. of incuse 17.5 mm. Weight 4.24 g

Bought by the British Museum in 1874.

Olive-green glass weight stamped with a bust of the Emperor Justinian wearing a diadem with a trefoil ornament; below the bust is a retrograde cruciform monogram resolving as CEPΓIOY ('of Sergios') and, around, the inscription DNIVSTINIANVSPPAVC (*Dominus noster Iustinianus perpetuus augustus*).

An identical example was once in the Fouquet Collection in Cairo (Schlumberger 1895, p. 75, no. 39). A weight with a not dissimilar monogram, also resolving as 'of Sergios', has, instead of the imperial bust, an abbreviated inscription describing Sergius as 'the most glorious prefect of [New] Rome', i.e. Constantinople (Grégoire 1907, pp. 322–7).

Unpublished. CJSE

80 (enlarged)

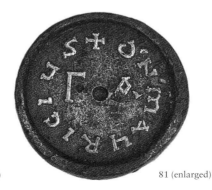

81 (enlarged)

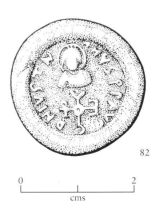

82

0 2
cms

83 Pound weight in glass

Eastern Mediterranean, 6th century

London, BM, M&LA 1986,6–2,1

Max. diam. 103.7 mm, max. diam. of incuses approx. 15 mm.
Weight 314 g (one pound, or 72 nomismata)

Bought by the British Museum in 1986.

Green glass weight stamped with five box-monograms, the upper now completely erased. The weight is weathered, with heavy iridescence and extensive surface exfoliation.

Surface exfoliation has made the monograms on this weight hard to decipher. Enough remains of them, however, to suggest that the same single die was employed to make all five impressions. Only two letters, an alpha and a rho, are clearly discernible on all four surviving monograms; an omicron and an upsilon, which appear only on the left-hand monogram, can reasonably be inferred for the others. Although a mu and a nu are also clearly visible only on the left-hand monogram, enough survives of their diagonals on the right-hand and bottom monograms to suggest that they were also integral to each. The complete monogram would probably have resolved as MAPINOY ('of Marinos'). A Marinus was chief financial adviser to Anastasius I (*PLRE*, II, pp. 727–8).

Sale cat. *Ancient and Islamic Coins*, Sotheby's, New Bond Street, London, 20–1 May 1986, lot 264. CJSE

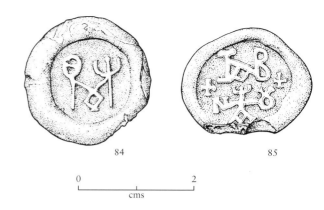

84 85

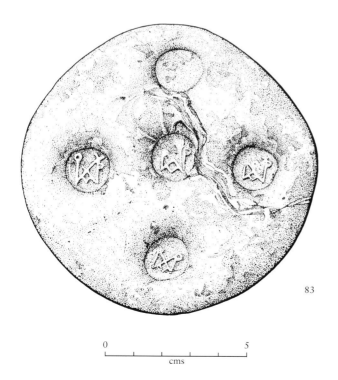

83

84 Glass weight with box-monogram

Eastern Mediterranean, 6th century

London, BM, M&LA 1987,7–3,4

Max. diam. 22.9 mm, max. diam. of incuse 14.7 mm. Weight 3.78 g

Bought by the British Museum in 1987.

Mauve glass weight stamped on its face with a box-monogram resolving as 'of Thomas'. The weight is weathered, scoured and chipped, and has a layer of earth adhering to its base.

Although unparalleled on glass weights, the monogram is replicated on an 18-nomisma copper-alloy weight excavated at Feniki, Albania, during the 1930s (L. M. Ugolini, *Albania Antiqua*, II: *L'Acropoli de Fenice*, Milan–Rome, 1937, p. 179, fig. 113). A Thomas was Eparch of Constantinople in 547 (*PLRE*, III, p. 1317).

Unpublished. CJSE

85 Glass weight with box and cruciform monograms

Eastern Mediterranean, 6th century

London, University College, The Petrie Museum of Egyptian Archaeology, UC.36359

Max. diam. 20 mm, max. diam. of incuse 15 mm. Weight 4.16 g

Colourless glass weight stamped with a box-monogram above a cruciform monogram; in the field, to left and right, a cross.

This is the only known example of a glass weight stamped with both a box and a cruciform monogram. It may have been specifically issued to introduce and validate the change from one type to the other. The top monogram probably resolves as 'of Bassianos' and the lower as 'of Ioannes'.

Petrie 1926a, p. 14, no. 79, pls 1 and 14. CJSE

86 Glass weight issued by Flavius Gerontius

Probably Constantinople, 6th century

London, BM, M&LA 92,6–13,59

Max. diam. 25 mm, max. diam. of incuse 16 mm. Weight 4.27 g

Given to the British Museum by Sir Augustus Wollaston Franks in 1892.

Green glass weight stamped with the bust of an eparch holding a mappa and inscribed in Greek: '+ In the time of [the eparch] Flavius Gerontius'.

Numerous examples of weights issued by this eparch have been preserved in European and American collections (Forien de Rochesuard, nos E8b–e). Recently excavated examples are known from Sucidava in Romania (Popescu 1976, p. 310, no. 302) and Tel Shiqmona in Israel (unpublished). A Flavius Gerontius was Prefect of Constantinople in about 561 (*PLRE*, III, p. 534).

Schlumberger 1895, p. 67, no. 11; Dalton 1901, p. 133, no. 665; Forien de Rochesuard 1987, p. 78, no. E8a; *PLRE*, III, p. 534.

CJSE

87 Glass weight issued by Flavius Zemarchus

Constantinople, 6th century

London, BM, M&LA 1987,7–3,18

Max. diam. 18.9 mm, max. diam. of incuse 14.4 mm. Weight 1.64 g

Bought by the British Museum in 1987.

Green glass weight stamped with the bust of an eparch holding a mappa and inscribed in Greek: '+ In the time of [the eparch] Flavius Zimarchos'.

A Flavius Zemarchus was Eparch of Constantinople on two occasions, the second being in 565 (*PLRE*, III, p. 1416). A similar weight in the De Menil Collection, Houston, has a letter beta in the field, and Vikan has suggested that this is an indication that it was issued in Zemarchus' second term of office (Vikan, forthcoming, no. B50). If this interpretation is correct, then the British Museum example was presumably issued during his first tenure of the office of eparch. Four copper-alloy weights inscribed with this official's name

have also survived: a 72-nomisma weight once in the Kircheriano Museum, Rome (Garrucci 1846, pp. 207–8, no. 63), a 36-nomisma example in a British private collection, an 18-nomisma weight in the Cabinet des Médailles, Paris (Dieudonné 1931, p. 14, no. 22, pl. 2), and an unpublished three-nomisma weight in the Benaki Museum, Athens. All four are inscribed with his title 'the most blessed Eparch of Rome', 'Rome' in this instance meaning 'New Rome', i.e. Constantinople.

Unpublished.

CJSE

88 Glass weight issued by the eparch John

Probably Constantinople, 6th century

London, BM, M&LA 93,2–5,75

Max. diam. 25.1 mm, max. diam. of incuse 16 mm. Weight 4.31 g

From Egypt. Given to the British Museum by Augustus Wollaston Franks in 1893.

Blue-green glass weight stamped with a box-monogram and the Greek inscription: '+ In the time of the eparch John'.

Similar examples are in the De Menil Collection, Houston (Vikan, forthcoming, no. B89), the American Numismatic Society Museum, New York (unpublished), and the Cabinet des Médailles, Paris (Jungfleisch 1932, p. 251, no. 5417 bis). Excavated examples are known from Pergamum (Regling 1913, p. 333, no. 6) and Anemurium in Turkey (unpublished). Grégoire translated the central monogram as 'eparch of Rome', but there is no chi or omega among its constituent letters. Petrie offered the plausible suggestion 'of Maurice Tiberius' but slightly misread the monogram, conflating the kappa and sigma on the right vertical into a beta (nor is the letter tau part of the monogram). The most likely solution is that recently proposed by Vikan, ΕΠΙ ΜΑΥΡΙΚΙΟΥ ('In the time of [the emperor] Maurice'). If correct, this would date the weight to between 582 and 602.

Schlumberger 1895, pp. 67–8, no. 13; Dalton 1901, p. 133, no. 664; Grégoire 1907, pp. 322–7; Petrie 1926a, pl. 24; Forien de Rochesuard 1987, p. 85, no. F18a.

CJSE

86

87

0 ⸻ 2

cms

88

89 Glass weight with cruciform monogram

Probably Constantinople, between about 550 and 650

London, BM, M&LA 1981,6–1,5

Max. diam. 61.1 mm, max. diam. of incuse 11.2 mm. Weight 1.15 g

Bought by the British Museum in 1981.

Discoloured brown-green weight stamped with a cruciform monogram resolving as 'of Addaeos', slightly weathered, with surface pitting.

Two identical weights are in the De Menil Collection, Houston (Vikan, forthcoming, nos B144 and B145). An Addaeus was Eparch of Constantinople in 565 (*PLRE*, III, pp. 14–15).

Unpublished. CJSE

90 Glass weight with busts of Christ and an emperor

Probably Constantinople, between about 550 and 650

London, BM, M&LA 1984,1–8,2

Max. diam. 29.8 mm, max. diam. of incuse 19 mm. Weight 6.66 g

Bought by the British Museum in 1984.

Blue-green glass weight stamped with a bust of Christ, with cruciform nimbus, and the nimbed bust of an emperor; below them, a cruciform monogram resolving as 'of Genethlios'.

Similar examples are in the Cabinet des Médailles, Paris (Jungfleisch 1932, p. 242, no. 25), and the American Numismatic Society Museum, New York (unpublished). This weight could correspond either to $1\frac{1}{2}$ solidi (theoretical weight 6.77 g) or to a hexagram (theoretical weight 6.82 g), a silver coin first introduced by the Emperor Heraclius in 615 (Grierson 1982, p. 103). The appearance of a bust of Christ on a small number of glass weights would appear to predate its use on coins by nearly a hundred years: such busts were first introduced on the coins of Justinian II.

Sale cat. *Antike Münzen. Griechen-Römer-Byzantiner . . .*, Frank Sternberg, Zurich, Auction no. 13, 17–18 November 1983, lot 1179, pl. 59. CJSE

91 Glass commodity weight

Eastern Mediterranean, possibly 7th century

London, BM, M&LA 1990,6–1,10

Max. diam. 79.5 mm, max. diam. of incuse 34 mm. Weight 97.27 g

Reputedly from Krak des Chevaliers, Syria; bought by the British Museum in 1990.

Mottled grey glass weight stamped with a box-monogram; in the field to the left, the uncial omicron-gamma sign and,

89

0 _____ 2
cms

90

to right, two indeterminate motifs; weathered, with exfoliating surfaces.

One of the motifs to the right of the monogram may represent a delta. This weight would appear to belong to a class of weights with 'debased' box-monograms considered by Balog to have be privately issued by Coptic merchants after the fall of Egypt to the Arabs in the 640s and before the introduction of purely Arabic glass weights by Abd ʿAl Malik in the early 690s (Balog 1958, pp. 127–37). The problem with this interpretation lies in the form of monogram supposedly being copied by these merchants. According to the generally accepted chronology of monograms, the box type had passed out of regular use at least fifty years earlier. If the monograms being copied and 'debased' were of the cruciform type, then Balog's thesis would carry more conviction. Perhaps, instead, monograms of this simple form should be regarded as the precursors of the standard box type and thus dated to the fifth century. This weight is one of only two known examples stamped with the uncial sign, proof that glass was also employed for commodity as well as coin-weights.

Unpublished. CJSE

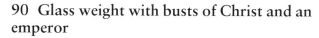

91

0 _____ 5
cms

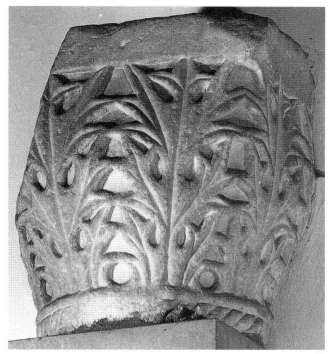

92

92 Marble capital

Ephesus, 6th century

Lower Kingswood, Surrey, Church of the Wisdom of God

H. 430 mm, W. 320 mm; thickness 270 mm

Said to have come from the Church of St John at Ephesus. Brought to Britain, after 1861, by Dr E. H. Freshfield and placed in the church at Lower Kingswood in 1902 (see no. 42).

Small marble capital, with tall, narrow, profile, a wide band at the top and a narrow ribbed band at the bottom. The face is covered with an all-over pattern of flat acanthus leaves. The top left corner is missing.

The architectural sculpture of the Justinianic church of St John at Ephesus, which was begun before 548 and completed by 565, is better known for its Ionic impost capitals, some of which have carved monograms of the emperor and empress, Justinian and Theodora. Smaller column-shafts and capitals were found in the excavation, but the best parallel to this Lower Kingswood capital comes from a cistern in Constantinople (Kautzsch 1936, no. 669, pl. 40, where it is also given a sixth century date).

Unpublished. RKL

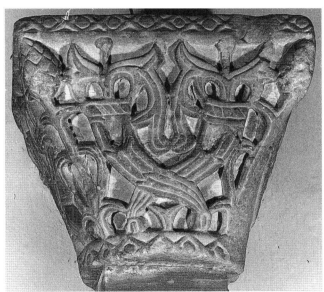

93

93 Marble capital

Constantinople, 6th or 7th century

Lower Kingswood, Surrey, Church of the Wisdom of God

H. 580 mm, W. 520 mm; thickness 350 mm

Said to have come from the monastery of St John Stoudios. Brought to Britain after 1861, by Dr E. H. Freshfield. Placed in the church at Lower Kingswood in 1902 (see no. 42).

Marble capital, carved on two sides with crossed cornucopiae, with a flowering pine-cone at the corners of the capital. A narrow band at top and bottom has a criss-cross pattern filled with circles. The right-hand side is plain except for a circular band, the contents of which have been deliberately defaced.

The church of St John Stoudios dates from the mid fifth century (453–63), and there is no record of rebuilding until the renewal of the monastery between 798 and 826 by the monastic reformer Theodore of Stoudios. The relationship to the monastery of this capital, and a second of similar design and the same provenance, is therefore not altogether clear. The double-cornucopia design is known from early seventh-century capitals in Constantinople (Kautzsch 1936, no. 688, pl. 41), while the medallion on the side-face also appears on a similarly shaped capital from Jerusalem (*op. cit.*, no. 720, pl. 43).

Unpublished. RKL

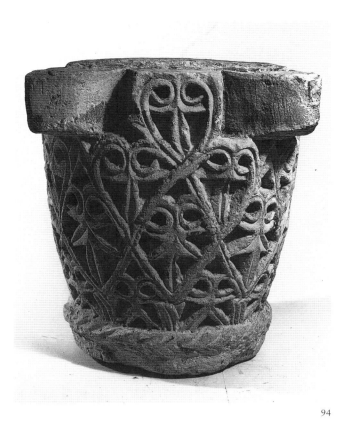

94

94 Limestone capital

Egypt, 6th century

Oxford, Ashmolean Museum, Department of Antiquities,
1956.1086

H. 370 mm, w. 310 mm; thickness 320 mm

From Fustat. Given to the Ashmolean by D. Wood.

Limestone impost capital, covered on both sides by a deep
but roughly cut pattern of highly stylised leaves.

Coptic capitals of the sixth century retain only the faint
echo of acanthus decoration in their all-over lattice patterns:
the decoration on this one is almost purely geometric. There
are similar, if better cut, examples in the Cairo Museum
(Kautzsch 1936, no. 839, pl. 48).

Unpublished. RKL

95 Silver chalice with dedicatory inscription

Probably Antioch, first half of 7th century

London, BM, M&LA 1914,4–15,1

H. 189 mm, diam. 186 mm. Weight 642.8 g

Found in northern Syria, apparently at Stuma as part of the Kaper
Koraon Treasure. Seen in Aleppo or Beirut in 1910. Offered for
sale to T. E. Lawrence in the Baron Hotel, Aleppo, in 1913. Bought
by the British Museum in Jerusalem in 1914.

Hammered chalice with a broad cup supported on a flaring
foot with knop. The foot was apparently attached to the cup
by means of a collar, into which it was soldered. The outer
surface of the vessel was finished by turning, and its decora-
tion is limited to engraved lines around the upper rim and
on the foot. Between two of the upper set of lines runs an
incised inscription in large Greek letters: '+ In fulfilment of a
vow of Sergius and John'.

In shape, the chalice conforms to a type which is normally
stamped and more elaborately decorated in having niello
inlaid in the inscription (see Mango 1986, no. 1). The chal-
ice is identified as church plate by its dedicatory inscription
(L. Jalabert, R. Mouterde *et al.*, *Inscriptions grecques et
latines de la Syrie*, Paris, 1929–82, nos 210 and 2046). The
lettering on this vessel is so close to that on a paten in the
Kaper Koraon Treasure that the two objects may have
formed a joint offering. Together, they were called a
diskopoterion. The dedications on some objects in this trea-
sure specifically mention their donation to the church of
St Sergius in the village (*kome*) of Kaper Koraon, probably

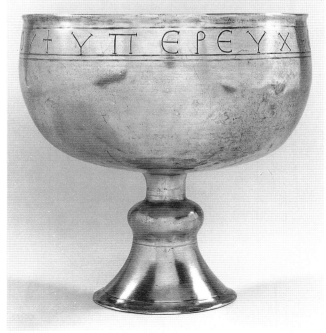

95

modern Kurin, near Stuma, where the objects may have been found. The treasure has recently been reconstructed as containing up to the fifty-five objects later divided into what have become known as the Hama, Riha, Stuma and Antioch treasures. All four groups, as well as a few single objects such as this chalice, are attested as having been found in the area of Aleppo in about 1910 (Mango 1986, pp. 3–34). All of the objects but one (*op. cit.*, no. 17) are contemporary, dating from between about 540 and 640; several are stamped. In its simple design and relatively light weight (just under two Roman pounds), the chalice is typical of silver given to the Kaper Koraon and other village churches during the sixth and seventh centuries and provides an interesting contrast to the contemporary but more pretentious Sion church silver treasure from Asia Minor (M. M. Mango, 'The monetary value of silver revetments and objects belonging to churches, AD 300–700', and S. A. Boyd, 'A "metropolitan" treasure from a church in the provinces: an introduction to the study of the Sion Treasure', in Boyd and Mango (eds), *Ecclesiastical Silver Plate in Sixth-Century Byzantium*, Washington, D.C., 1992, pp. 123–36 and pp. 5–37 respectively).

Dalton 1921, p. 108; G. Downey, 'The inscription of the silver chalice from Syria in the Metropolitan Museum of Art', *American Journal of Archaeology* 55 (1951), p. 353 n. 11; M. R. Lawrence (ed.), *The Home Letters of T. E. Lawrence and his Brothers*, Oxford, 1954, p. 246; Ross 1962, p. 11; D. Buckton, 'Material and method of manufacture of the Early Byzantine chalice', *Abstracts of the 17th International Byzantine Congress*, Washington, D.C., 1986, p. 51. Exhibited: *Wealth of the Roman World* (1977), no. 155; *Silver* (1986), no. 29. MMM

96 Silver serving-plate from Cyprus

Made and stamped in Constantinople, between 578 and 582

London, BM, M&LA 99,4–25,1

Diam. 268 mm, H. 35 mm. Weight 2160 g

Found six miles west of Kyrenia, Cyprus, at the end of the nineteenth century, together with no. 135, as part of the (first) Cyprus Treasure. Bought by the British Museum in 1899.

The plate has a shallow concave surface, a rounded outer rim and a low integral foot-ring. The restrained decoration consists of a central medallion formed of two concentric grooved and gilded bands framing a niello-inlaid Latin cross; the cross has flaring arms with pairs of tear-drop terminals at their corners. The area between the gilded bands is filled with a niello-inlaid undulating vine scroll from which fourteen ivy-leaves point alternately inwards and outwards; the leaves are each framed by two pairs of tendrils. A concentric groove encircles the plate just inside its rim. Hammer marks are clearly visible all over the reverse side of the plate. The rim of the plate was corroded

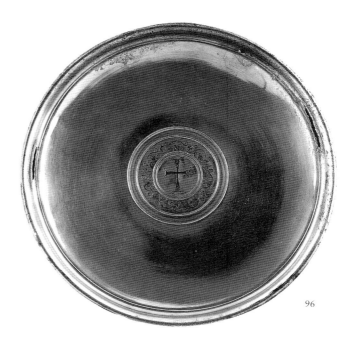

96

when found; some metal is missing near the rim as is some inlay from the central medallion, where most of the gilding has also worn away. Inside the foot-ring are five imperial control stamps (one double-struck) dated to the reign of Tiberius II.

Among the most common types of stamped silver, plates with small crosses at the centre have often been referred to as church patens. They are, instead, domestic plates forming part of a dinner-service and have been found both singly and as sets in graduated sizes within treasures. The plates with a small cross are shallow and concave, while church patens have a flat inner surface often ornamented with a large cross, high raised sides and, usually, a dedicatory inscription. The plates are very close in shape and in the motifs accompanying the cross (e.g. wreaths, scrolls) to plates with a central monogram of the owner. Such monograms adorn sets of round and oblong plates in the Esquiline Treasure (nos 11 and 12) as well as other plates said to belong to the Cyprus Treasure itself (Mango 1986, nos 103–5); bowls in the Lampsacus Treasure have a central monogram set inside a large cross-pattern (Dalton 1901, nos 378–9). On such dishes, the small cross occasionally (perhaps when bought ready-made) replaced the monogram which, in Greek at least, had itself become cruciform by the reign of Justinian.

Dalton 1901, no. 397; Dodd 1961, no. 28. MMM

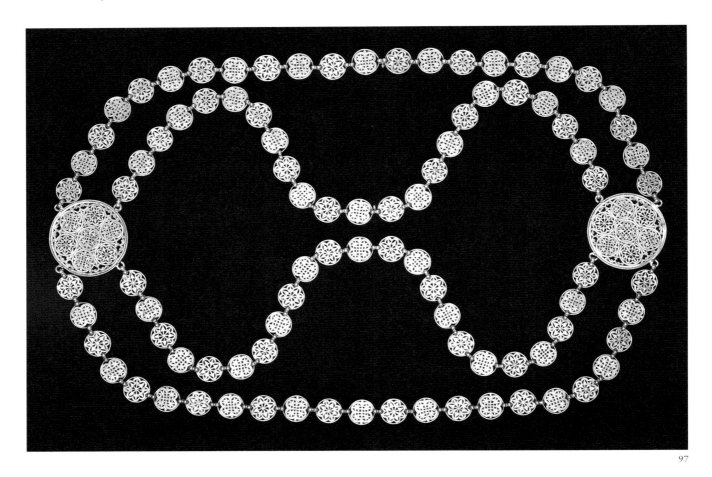

97

97 Gold body-chain

Eastern Mediterranean, about 600

London, BM, M&LA 1916,7–4,1

Diam. of large medallions 77.8 mm, diam. of small medallions 26 mm, L. of chain 720 mm

From Egypt. The body-chain, together with a necklace, two earrings and two bracelets, was given to the British Museum in 1916 by Mrs Walter Burns, the sister of J. Pierpont Morgan, the American millionaire and philanthropist, who had himself acquired ten objects from the treasure in 1912.

Gold openwork body-chain composed of two large central medallions connected to each other by four chains. Each large medallion is composed of seven smaller openwork medallions, the central one in the form of a quatrefoil enclosing four cinquefoils in a symmetrical arrangement; this design is repeated three times in the surrounding medallions alternating with a design composed of an octofoil containing a symmetrical design of alternating trefoils and spear-head motifs; in the interstices between each medallion is a trefoil emerging from a double running-scroll. To the outer edge of each large medallion are soldered four equidistant loops – each embellished with a granule at the junc-

tion of loop and edge – to which are attached the four openwork chains. Each chain is constructed of twenty-three small medallions alternately repeating the designs of which the central medallions are composed; the medallions are connected to each other by a double biconical loop of plain gold strip.

This body-chain, the largest piece of jewellery to have survived from the Early Byzantine period, was part of a treasure of thirty-six objects said to have been found either at Tomet, near Assiut, or at Shêkh Abâda (ancient Antinoë), on the east bank of the Nile. The treasure is now divided between the British Museum, the Metropolitan Museum of Art, New York, and the Staatliche Museen Preussischer Kulturbesitz (Antikenabteilung), Berlin. The objects in the treasure range in date from the third to the sixth century. One of the gold pectorals from the treasure (Dennison 1918, no. 3) is set with a semissis and a tremissis of the Emperor Maurice Tiberius (582–602), giving a terminus post quem for some of the objects. The body-chain almost certainly belongs to this later group. The style of openwork, which is much less tightly organised than on earlier *opus interrasile*, is typical of jewellery of this period. In addition, the best comparisons for the decorative motifs employed on

the body-chain are to be found on early seventh-century objects. A late sixth- or early-seventh-century necklace from Kyrenia, Cyprus, is constructed of nineteen small openwork medallions (A. Pierides, *Jewellery in the Cyprus Museum*, Nicosia, 1971, p. 52, pl. 35); one of the designs employed on these medallions consists of four trefoils arranged within a lozenge, the trefoils being not dissimilar to those which alternate with the spear-head motifs on the body-chain. Further comparisons for the trefoils and the spear-head motifs can be found on an elegant pendent medallion dating from around 600 now in the Virginia Museum of Fine Arts, Richmond, Virginia (exh. cat. *Age of Spirituality* (1977–8), no. 291).

A number of Roman terracotta figures from Egypt illustrate how the body-chain would have been worn (e.g. Dennison 1918, p. 150, fig. 43). The two large medallions were worn on the breast and the back, with two of the chains over the shoulders and two under the arms.

W. Dennison, *A Gold Treasure of the Late Roman Period*, London, 1918, pp. 149–50, no. 15, pls 39 and 40; Dalton 1925, p. 324; Brown 1984, pp. 17–20, figs 12 and 13; Tait 1986, p. 100, no. 323. Exhibited: *Jewellery* (1976), no. 190; *Wealth of the Roman World* (1977), no. 163. CJSE

98 Gold and enamel pendant

Probably Constantinople, about 600

London, BM, M&LA 1989,11–1,1

27.3 × 18.6 mm; thickness (excluding suspension-loop) 6.25 mm

From a United States collection. Bought by the British Museum in 1989.

Engrailed octagonal gold and enamel pendant with suspension-loop, both fashioned from gold sheet over a core of sulphur. One side of the pendant is decorated with enamel depicting a long-legged bird and leaves on a stalk; the enamel is largely missing, and what remains is heavily weathered. The glass in the leaves has a convex surface,

protruding beyond the strip which contains it. The leaves and the enamel in the border are translucent green, the bird was probably originally blue. The other side of the pendant is embossed with the bust of an imperial figure wearing a diademed helmet with *pendilia*.

The pendant is a rare example of Early Byzantine enamelling, one of some half-dozen items of jewellery characterised by isolated motifs, mostly birds, standing proud of the surface of the object. In every case the enamel is contained within gold strip soldered edge-on to the surface; other features are executed in round-section wire. One item from the group, a pendent cross in Washington, comes from a late sixth-century hoard said to have been found in Syria (Ross 1965, pp. 135–9, no. 179H, col. pl. D); another example, a medallion in Mainz, is part of a Byzantine necklace stylistically datable to around 600 (Brown 1984).

Unpublished. DB

99 Bracelet with bust of the Mother of God

Eastern Mediterranean, about 600

London, BM, M&LA AF 351

Max. diam. of hoop 62 mm, max. diam. of medallion 44 mm

Said to come from Syria. Bequeathed to the British Museum by Sir Augustus Wollaston Franks (1897).

Gold bracelet composed of a central medallion and an openwork hoop. The medallion is embossed and chased in very high relief with an orant bust of the Mother of God, nimbed and wearing a *himation* and enclosed by a border of openwork lozenges; contiguous to this border is a scalloped rim. Flanking the medallion are two oblong settings for gems, now empty, the joins between the medallion and settings partly masked by applied gold disks. On the reverse of each

98 (enlarged)

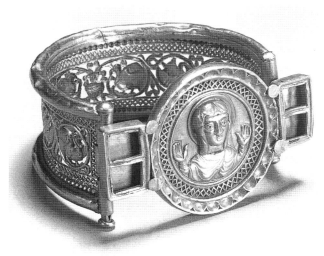

99

setting is a tube of gold sheet which marries with corresponding tubes on the hoop and was fastened by two split pins, one of which survives. The hoop is constructed of two tubes of gold sheet enclosing an openwork panel decorated with a central vase from which emanate two running-scrolls, each inhabited by two peacocks (or guinea-fowl) flanking a pair of confronted swans. Above and below the panel is a band of openwork lozenges within a pseudo-beaded border.

This bracelet was one of a pair sold in Cairo, the companion piece being formerly in the collections of Count Michael Tyszkiewicz and Alessandro Castellani (W. Froehner, *Collections du Château de Goluchów: l'orfèverie*, Paris, 1897, pp. 74–5, no. 198, pl. 17); its present whereabouts is unknown. This portrayal of the Mother of God is otherwise unparalleled on Early Byzantine jewellery. The British Museum possesses a pendant decorated with a figure of the Mother of God, but this is of the standing orant type and of considerably inferior craftsmanship (Dalton 1901, no. 283, pl. 5). The hoop can be loosely compared with that on a bracelet in the Dumbarton Oaks Collection, Washington, D.C., although that is embossed rather than in openwork (Ross 1965, no. 2, pls 6 and 7). The three-dimensional quality of the hoop is due to the gold sheet being first hammered into a matrix into which the design had been cut in negative. The piece was then turned over and embedded in mastic or a similar medium for support, while details were chased and punched from the front, and the piercing was done, probably with chisels.

Dalton 1901, no. 279; Tait 1986, p. 206, no. 499. Exhibited: *Jewellery* (1976), no. 355; *Wealth of the Roman World* (1977), no. 170. CJSE

decorated with a palmette. On the reverse, in the centre, is a cruciform monogram reading ΦΩС / ΖΩΗ ('light/life'); at the end of each arm is a pear-shaped depression containing four double crescents and a triangle.

This cross may be compared with one from the Mersin hoard, Cilicia, now in the Hermitage Museum, St Petersburg (A. Bank, *Byzantine Art in the Collections of Soviet Museums*, Leningrad, 1977, p. 288, no. 99, pl. 99), and with another found in the district of Agios Vasileios, Rethymnon, Crete (exh. cat. *Byzantine Art a European Art* (1964), no. 412, fig. 412). Both these examples, however, have less elaborate palmettes and empty central settings. The inscription on the reverse is replicated, although in acrostic rather than monogrammatic form, on other crosses: a gold and enamel example in the Dumbarton Oaks Collection, Washington, D.C., dating from around 600 (Ross 1965, no. 179H, pl. 97), on a pendent cross attached to a gold and enamel necklace of about 600, now in the Römisch-Germanisches Zentralmuseum, Mainz (Brown 1984, p. 2), and on a further gold example excavated in Caesarea Maritima (A. Frova (ed.), *Scavi di Caesarea Maritima*, Rome, 1966, p. 237, fig. 294). For copper-alloy buckles, dating from the seventh century, decorated with similar monograms, see: J. Werner, 'Byzantinische Gürtelschnallen des 6. und 7. Jahrhunderts aus der Sammlung Diergardt', *Kölner Jahrbuch für Vor- und Frühgeschichte* 1 (1955), p. 47, pl. 8, fig. 113.

O. M. Dalton, 'A gold pectoral cross and an amuletic bracelet of the sixth century', *Mélanges offerts à M. Gustave Schlumberger*, Paris, 1924, pp. 386–9, pl. 17. CJSE

100 Gold and garnet pectoral cross

Eastern Mediterranean, 6th or 7th century

London, BM, M&LA 1923,7–16,66

H. (incl. suspension-loop) 67 mm, W. 46 mm

From the Krym area of the Ukraine. This cross, and the earrings nos 101 and 102, came from the collection of General A. L. Berthier-Delagarde (1842–1920), a prominent military engineer and archaeologist. The objects in his collection, which ranged in date from the second to the thirteenth century, covered disparate cultures and were principally assembled from sites in the Crimea and the southern part of what was until recently the USSR. Part of his collection was purchased by the British Museum from his sister, Madame Beliavsky, in 1923.

Gold pectoral cross with flaring arms, composed of two embossed, chased and punched gold sheets with traces of a supporting fill; at the top, a separately applied suspension-loop. In the centre of the obverse is a cruciform setting inlaid with four square-cut garnets. Each of the arms of the cross is

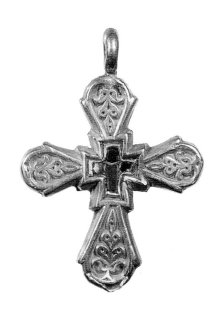

100

101 (enlarged) 102 (enlarged)

101 Gold openwork earring

Provincial Byzantium, 6th or 7th century

London, BM, M&LA 1923,7–16,67

H. 32 mm, W. 27.5 mm

From the Krym area of the Ukraine. See no. 100.

Gold openwork earring with lunate body and separately applied suspension-loop. The body, which is edged with a strip of plain gold sheet contiguous to a border of beaded wire, is chased and punched with the design of a bird with spread wings.

Similar examples are in Bloomington, Indiana, and the Benaki Museum, Athens (W. and E. Rudolph, *Ancient Jewelry from the Collection of Burton Y. Berry*, Bloomington, 1973, p. 242, no. 196; B. Segall, *Katalog der Goldschmiedearbeiten, Museum Benaki, Athen*, Athens, 1938, p. 155, no. 242, pl. 48). Both the find-spot and the poor technical quality of this and the earring no. 102 suggest that they either represent the work of a provincial Byzantine workshop or are 'barbarian' copies.

Unpublished. CJSE

102 Gold openwork earring

Provincial Byzantium, 6th or 7th century

London, BM, M&LA 1923,7–16,68

H. 27 mm, W. 20.5 mm

From the Krym area of the Ukraine. See no. 100.

Gold openwork earring with lunate body edged with beaded wire, and separately applied suspension-loop. The body is chased and punched with the highly stylised figures of two addorsed birds.

See no. 101.

Unpublished. CJSE

103 Gold openwork earring

Eastern Mediterranean, 6th or 7th century

Oxford, Ashmolean Museum, Department of Antiquities, 1980.56

H. 71 mm, W. 60 mm

Bought in 1980.

Gold openwork earring with lunate body and separately applied suspension-loop. The body is embossed and chased with a cross (part of which is missing) flanked by two peacocks, and is enclosed by a raised border of beaded wire. Contiguous to this are two borders composed of a running scroll, the upper less elegantly articulated. Applied to the edge of the body is a raised rim to which are soldered triangular arrangements of three granules alternating with gold spheres, mostly now incomplete.

This is one of the standard types of earring produced in the Early Byzantine period; they have been found as far apart as southern Germany and the Crimea. Variant types substitute for the cross a number of motifs: a vase, a monogram, an inscription or two nesting birds. The peacock was a ubiquitous motif in art of this period and had various connotations; in general it was regarded as a symbol of immortality. For a selection of the numerous examples which have survived, see Dalton 1901, nos 276–7, P. Orsi, *Sicilia bizantia*, I, Rome, 1942, pl. 11, fig. 4, Ross 1965, nos 87 and 90, and E. Riemer, 'Byzantinische Körbchen- und Halbmondohrringe im Römisch-Germanischen Museum Köln (Sammlung Diergardt)', *Kölner Jahrbuch für Vor- und Frühgeschichte* 29 (1992), pp. 121–36.

Unpublished. Mango, forthcoming. CJSE

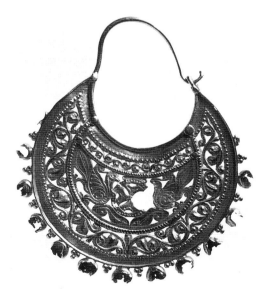

103

104 Embossed gold earring

Eastern Mediterranean, 6th or 7th century (or perhaps Middle Byzantine)

London, Victoria and Albert Museum, Metalwork and Jewellery Collection, M. 42–1963

H. (incl. loop) 77 mm, W. 45.5 mm

Bequeathed to the V&A by E. H. Wallis (1963).

Gold sheet earring with a lunate body and separately applied suspension-loop; one end of the loop has a scrolled terminal through which the other end is threaded. The body is embossed and chased with a central vase from which emanate two large tendrils with trefoil terminals, in the interstices of which are two peacocks with backward-turned heads, all enclosed within a border imitating beaded wire. The edge of the gold sheet is decorated with a border of fine twisted wire. The join between the loop and body is masked in three places by an applied gold disk.

Earrings with this iconography are generally executed in openwork and dated to the Early Byzantine period. An unpublished gold earring from the Burges Bequest in the British Museum (M&LA 81,8–2,2) does, however, raise the possibility that the V&A earring might be later in date. The British Museum earring is also embossed with two peacocks with backward-turned heads separated by a not dissimilar tendril motif, but in shape it recalls the gold and enamel head-dress pendants (*kolty*) produced in Kiev in the eleventh and twelfth centuries. These are thought to have derived in shape and ornament from contemporary Byzantine jewellery, and so a Middle Byzantine date for the embossed earrings cannot be entirely ruled out.

Unpublished. CJSE

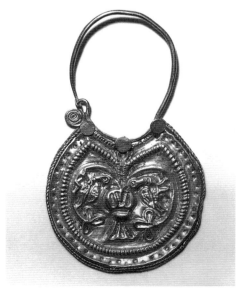

104

105 (enlarged)

105 Gold ring with tyche figure

Probably Constantinople, 6th century

London, BM, M&LA 1964,12–4,1

Diam. of hoop 29 mm, W. of bezel 19 mm

Formerly in the Guilhou Collection, Paris. Bequeathed to the British Museum by Sir Allen George Clark (1964).

Gold finger-ring with slightly bevelled hoop and shoulders and an oval bezel. The latter is engraved with a seated figure holding a staff in its left and an indeterminate object in its right hand; by its feet is a shield. In the field, to left and right, are box-monograms.

The indeterminate object held by the figure represents either an orb or a cornucopia. The figure is presumably a tyche, the personification of a particular city, probably Constantinople in this instance. While tyches are commonly depicted on coins and weights, the appearance of one on a ring would appear to be unparalleled. For a gold roundel decorated with the bust of a tyche wearing a mural crown and holding a spear and cornucopia, see Ross 1965, no. 32, pl. 26. The left-hand monogram resolves as 'of Paulos', the right-hand one possibly as 'of Euthemia'.

Sale cat. Guilhou collection of rings, Sotheby's, New Bond Street, London, 9 November 1937, lot 459. Exhibited: *Jewellery* (1976), no. 416. CJSE

106 Gold marriage-ring

Eastern Mediterranean, 6th or 7th century

London, BM, M&LA AF 231

Diam. of hoop 23 mm, max. diam. of bezel 18 mm

Bequeathed to the British Museum by Sir Augustus Wollaston Franks (1897).

Gold and niello finger-ring with an octagonal hoop and an applied bezel in the shape of an octofoil. The bezel is engraved in the centre with the standing figure of Christ and the Mother of God placing wedding crowns on the heads of a bridegroom and bride respectively; above their heads is a star and, beneath an exergual line, the inscription 'Harmony' in Greek. Both the figures and the inscription are

inlaid with niello, some of which is missing. The hoop is decorated with seven nielloed scenes from the life of Christ, beginning from the right-hand side of the bezel: the Annunciation, the Visitation, the Nativity, the Baptism, the Adoration of the Magi, the Crucifixion and, finally, the Angel at the Tomb.

The basic design of this ring can be paralleled on two others, one in the Dumbarton Oaks Collection, Washington, D.C. (Ross 1965, no. 69), and the other in the Museo di Palermo, Sicily (C. Cecchelli, 'L'annello bizantino del Museo di Palermo', *Miscellanea Guillaume de Jerphanion, Orientalia Christian Periodica* 13 (1947), pp. 54–6). The Dumbarton Oaks ring differs in a number of aspects. In place of the Adoration of the Magi and the Angel at the Tomb are depicted the Presentation in the Temple and Christ appearing to the Holy Women (unlike the British Museum example, the Christological scenes are shown in the correct order). In addition, the names of the bride and groom, Theodote and Peter, are mentioned in invocative inscriptions around the edge of the bezel, and there is a quotation from John 14.27 on the two edges of the shank. The Palermo ring was found near the arsenal in Syracuse and has often been associated (with little reason) with the death of Constans II, who was murdered in Sicily in 668. Rings with octagonal bezels and hoops apparently had an amuletic function. The sixth-century physician Alexander of Tralles recommended rings of this shape as a cure for colic.

Dalton 1901, p. 21, no. 129, pl. 4; Dalton 1912a, pp. 8–9, no. 46; Ward *et al.* 1981, p. 49, no. 107; Tait 1986, p. 236, no. 606. Exhibited: *Jewellery* (1976), no. 437; *Wealth of the Roman World* (1977), no. 165. CJSE

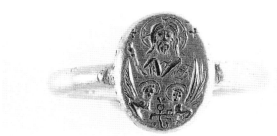
106 (enlarged)

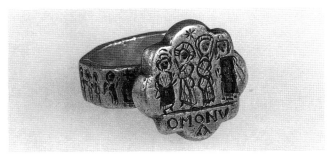
107 (enlarged)

107 Gold ring with bust of Christ

Eastern Mediterranean, 7th century

London, BM, M&LA AF 223

Max. diam. 29 mm, L. (of bezel) 15.7 mm

Bequeathed to the British Museum by Sir Augustus Wollaston Franks (1897).

Gold finger-ring with plain hoop and applied oval bezel. The latter is decorated with a bust of Christ, bearded and with a cross-nimbus, flanked by two crosses. Below him are two adoring angels separated by a cruciform monogram. Around the edge of the bezel is inscribed in Greek 'Holy, Holy, Holy, Lord Sabaoth'.

An almost identical ring, but with an additional cross instead of a monogram is in the British Museum collection (Dalton 1901, no. 189); it was found in the eastern Mediterranean region with coins of Heraclius (610–41). The inscription on the bezel refers to the Trisagion, the 'thrice-holy [hymn]', a chant which accompanied the procession into church at the beginning of the Eucharist. The monogram, which is retrograde, resolves as 'of Georgios'.

Dalton 1901, no. 120; Dalton 1912a, no. 38. CJSE

108 Lathe-turned weight

Eastern Mediterranean, 7th to 9th century

London, BM, M&LA 1982,5–6,20

Max. diam. 38.9 mm. Weight 80.48 g

Kapamadji Collection. Bought by the British Museum in 1982.

Discoid copper-alloy weight with double-grooved profile, lathe-turned, with rims and centring points on the face and base. The face is engraved with a herring-bone wreath enclosing a cross above the denominational mark for three ounces, both inlaid with silver.

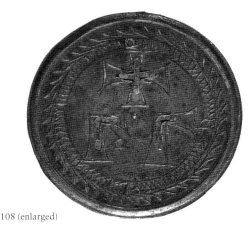
108 (enlarged)

109

Similar weights are in the Coptic Museum, Cairo (Strzygowski 1904, no. 7148, the Petrie Museum of Egyptian Archaeology, London (Petrie 1926b, nos 5310 and 5376), the Cabinet des Médailles, Paris (Dieudonné 1931, no. 19), and the Musée d'Art et d'Histoire, Geneva (Dürr 1964, nos 14, 16 and 262). The British Museum has a further seven examples. Excavated weights of this typology are known from Anemurium (Russell 1982, p. 155) and Yassi Ada (Sams 1982, p. 203, no. W3) in Turkey, Beth Shean in Israel, Mafraq in Jordan and San Vincenzo al Volturno in Italy, the last three as yet unpublished. The contexts for Yassi Ada and Beth Shean suggest an early to mid seventh century date for this type, those of Mafraq and San Vincenzo a mid eighth and early ninth century date respectively.

Unpublished. CJSE

109 'Steelyard' balance

Asia Minor, 7th century

London, BM, M&LA 1988,11–2,1

L. 1055 mm

From near Milas, Turkey. Bought by the British Museum in 1870 and transferred from the Department of Greek and Roman Antiquities in 1988.

Copper-alloy 'steelyard' balance in the form of a beam of rectangular cross-section with two suspension-hooks acting as fulcra; the terminals of the beam are in the form of animal-heads, one of them a boar's. Corresponding to the fulcra, two of the faces of the beam are pounced with Greek numerals: E ([8]5) ..Π (80) ..E ([7]5) ..O (70) ..E ([6]5) ..Ξ (60) ..E ([5]5) ..N (50) ..E ([4]5) ..M (40) ..E ([3]5) ..Λ (30) ..E ([2]5) ..K (20) ..E ([1]5) .. IB (12), with single units marked with an engraved vertical line and each unit divided into two by a notch and a dot; and M ([2]40) ..E ([23]5) ..Λ ([2]30) ..E ([22]5) ..K ([2]20) ..E ([21]5) ..I ([2]10) ..E ([20]5) ..C (200) ..E ([19]5) .. Ϥ ([1]90) ..E ([18]5) ..Π ([1]80) ..E ([17]5) ..O ([1]70) ..E ([16]5) ..Ξ ([1]60) ..E

([15]5) ..N ([1]50) ..E ([14]5) ..M ([1]40) ..E ([13]5) ..Λ ([1]30) ..E ([12]5) ..K ([1]20) ..E ([11]5) ..I ([1]10) ..E ([10]5) ..P (100) ..E ([9]5) .. Ϥ (90) ..E ([8]5) ..Π (80), with intermediate units marked as above. Between the two fulcra is a pounced inscription in Greek: '[the property] of Kyriakos'.

The Byzantine *kampanos* (Lat. *statera*, anachronistically 'steelyard') generally consists of a lever of two unequal arms and two or three fulcra. From the shorter arms hangs a suspension unit to support the goods to be weighed, while the longer arm is graduated on two or three faces, depending on the number of fulcra. Along this arm, the counterpoise weight would be moved until the steelyard was in a state of equilibrium and the weight of the goods indicated by its position on the relevant scale. The outermost fulcrum was used for the heaviest, the innermost for the lightest amounts. Only one counterpoise weight was calibrated for use in all positions. On the British Museum balance, one scale reads from twelve to eighty-five pounds, the other from eighty to two hundred and forty.

The boar's head terminal may be compared with those on two other steelyards: on an example found off the island of Donousa in the Aegean (Delivorrias 1987, pp. 251–2, no. 159), and on another from an early seventh-century shipwreck at Yassi Ada, off the coast of Turkey (Sams 1982, p. 214, no. B1).

Walters 1899, no. 2986; J. Garbsch, 'Wagen oder Waagen', *Bayerische Vorgeschichtsblätter* 53 (1988), pp. 218–19, no. 3. CJSE

110 Counterpoise weight for 'steelyard'

Constantinople, between 602 and 610

London, BM, M&LA 67,10–5,1

H. 191 mm, max. w. 144.5 mm. Weight 5.4 kg

From Haifa. Bought by the British Museum in 1867.

Copper-alloy weight, with lead core, in the form of an imperial bust. The bearded face is long and angular, with

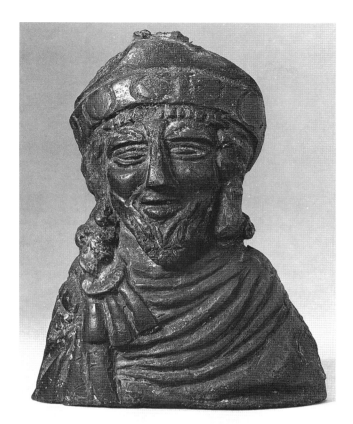

110

Viola, Cairo. Bought by the v&a from L. Kreizman in 1949. Another fragment of the same silk, measuring approx. 130×165 mm, is in the Cleveland Museum of Art, Cleveland, Ohio (no. 50.520).

Four irregular fragments of compound twill silk with a design of small parrots in grass-green with white heads and claws on a dull pink ground. The parrots occur in three different postures, accompanied by two plant sprigs. The vertical axis of the design is parallel to the weft, and in this direction the same motif repeats without a break. In the direction of the warp the three different images succeed each other and on the third-largest fragment appear reversed.

Weft-faced compound 1\2 twill, three lats, very fine texture. Warp yarn of dull pink silk, z-twisted, 31–5 single threads of each warp per cm. Weft yarns of white (poorly

almond-shaped eyes, high cheek-bones and a prominent nose, all framed by long hair. The figure wears a diadem and a paludamentum fastened on his left shoulder by a circular fibula with three *pendilia*. On his upper left arm is a round ornament engraved with a cross; on the crown of his head, the remains of the base of a suspension-loop. Part of the undecorated back is damaged and exposes the lead core, some of which is missing.

Dalton suggested that the bust represents the Emperor Phocas. The identification is probably correct: the best parallels for the style of the beard and the circular type of fibula with three *pendilia* are found on this emperor's coins (Grierson 1982, pp. 47–8, pl. 2).

Dalton 1901, no. 485; F. O. Waagé, 'Bronze objects from Old Corinth, Greece. 1: an Early Christian steelyard weight', *American Journal of Archaeology* 39 (1935), pp. 77–86. CJSE

111 Silk with a design of parrots

Eastern Mediterranean, about 6th century

London, Victoria and Albert Museum, Textiles and Dress Collection, T.104–1949

Approx. 150×290, 160×170, 100×120 and 45×100 mm

Undoubtedly found in Egypt. Originally purchased from Robert

111

preserved), grass-green and dull pink silk without twist, 55–60 passes per cm. Some weaving faults. Lengthways repeat 9.2–9.6 cm, widthways repeat 2.8–2.9 cm.

Fold lines and traces of sewing on these fragments and on the piece in Cleveland indicate that they come from a tunic, from the tuck that habitually was sewn across the garment at waist-level.

Birds of all kinds were very popular as a decorative theme at this period: see, for instance, a silk now in the Cooper-Hewitt Museum (A. C. Weibel (ed.), *Two Thousand Years of Textiles*, New York, 1952, fig. 48). Tunics with designs of repeating birds, probably in reality made of silks very like these, are to be seen in the mosaic panel with the Empress Theodora at San Vitale, Ravenna, worn by two ladies on the empress's left. Birds identifiable as parrots are present in many works of art: for example, in the mosaic of the be-ribboned parrots from Antioch (D. Levi, *Antioch Mosaic Pavements*, I, Princeton, 1947, p. 358, pls lxxxv,c and cxxxvii,d). In the Antioch mosaic, the ribbon around the necks of the parrots and their formal strutting posture makes clear their Persian origin. On this silk, while the

drawing of the birds is much more naturalistic, the bright green plumage can be seen as part of a change in taste to simple primary colours that was also oriental in inspiration.

Unpublished. HG-T

112 Pair of curtains

Egypt, about 600

London, BM, EA 1897,1–12,1352 (EA 29771)

Excluding fringes, approx. 2670 × 1450 and 2480 × 1510 mm

Said to come from Akhmim. Bought in Egypt in 1897 by E. A. W. Budge for the British Museum.

Large pair of curtains, an undyed linen ground with tapestry-weave decoration in coloured wool. The curtains are generally well preserved, but stained and decayed in certain areas. Across the top is a band containing, on a red ground, an undulating green vine-stem, in the curves of which are bowls of flowers and fruit, bunches of grapes, nereids, standing birds and running, nimbed, leopards. Below this is

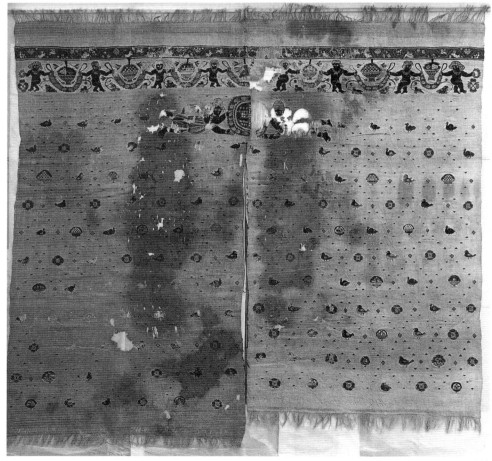

112

a frieze made up of eight erotes holding between them garlands of leaves and flowers; the erotes have purple skin, orange hair and green eyes; above the garlands there are baskets of fruit and flowers and a parrot (at the join), and other spaces are filled with vine-stems, leaves and bunches of grapes. Below the frieze are two large flying Nike figures, coloured as the erotes but wearing blue and red *peploi*. The Nikai hold up between them a wreath containing a jewelled Greek cross and the remains of a four-line Greek inscription, the top line reading from left to right, the other three from right to left: ΡΟϹ…/…ΘΕωΤω/…ΟΥΘΗϹ/…ϹΕΝ. Below and to the side of the Nikai and reaching to the bottom of the curtains is an open network of lozenges built up from red petals. Each lozenge encloses a single motif: a bird (at least seven types are shown), a four-petalled rosette, or a bowl of fruit or flowers; superimposed on some of the bowls is a human head, a pair of doves, or a pair of leopards or dogs to either side of a stylised tree.

The two curtains were originally sewn together at the top to just below the wreath. From this point down the inner edges have an applied red wool plait. Preserved on the right-hand curtain are four short lines of red wool tacking. At the horizontal edges of each curtain are warp fringes preceded by self-stripes and, at the bottom, a band of bare warp threads. A fold and an absence of fading at the top of the curtains indicates that they were used with the first 100 mm or so of cloth turned back. Bands of similarly unfaded linen in the lower half of both curtains (on the right side, approx. 180 mm deep) may indicate shortening tucks (as woven, the curtain on the left is longer than that on the right).

Warp-faced simple tabby with areas of decoration in tapestry weave on grouped warp threads. Warp yarn s-spun undyed linen, 18–19 ends per cm. Weft yarns undyed linen and dyed wool in at least sixteen different colours, all s-spin, approx. 11 picks per cm in the ground and 30–45 per cm in tapestry areas. Samples of twelve wool yarns have been analysed for dyestuff (BM Conservation Research Report 1990/22), and three dyes identified: madder for reds, weld for yellows and indigotin from woad or indigo for blues; the greens, oranges and purples were made by combining two of these three dyes.

Curtains and other textile furnishings have been preserved in Egypt through their use as burial wrappings. This pair would originally have been used as door-curtains or room dividers rather than as window-curtains. The fact that they were joined together at the top and have most of their decoration concentrated at this upper level indicates that they were hung with this upper area stretched out and that only the areas with the lozenges were pulled back. The method of suspension is not certain. It is possible that a rod was threaded under the 100 mm of cloth turned back at the top. But other curtains from Egypt have loops sewn to them, and contemporary depictions of curtains certainly show

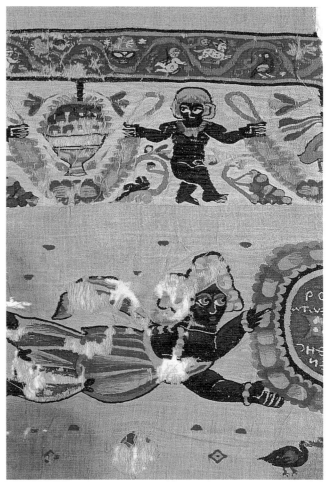

112(detail)

them hanging as if provided with loops or rings (see especially Errera 1916, no. 302, and Pierre du Bourguet, *Musée National du Louvre, Catalogue des étoffes coptes*, I, Paris, 1964, no. E.119; for an early Byzantine depiction of curtains see, for example, the post-Arian infilling of the niches on the façade of Theodoric's palace in the mosaics of Sant'Apollinare Nuovo, Ravenna, reproduced in Ernst Kitzinger, *Byzantine Art in the Making*, London, 1977, fig. 107).

Although the ornament is classical in composition, the comparatively late date of these curtains is indicated by the abstract use of colour, the simplification of the forms and the presence of a number of Persian motifs – the nimbed leopards, the disembodied heads and the paired animals flanking a Tree of Life.

A fragment with a Nike and wreath, probably also from curtains and again from Akhmim, is in the Victoria and Albert Museum (Kendrick 1920–1, no. 317).

Unpublished. HG-T

113(a–b) Two Byzantine censers, one from Glastonbury

Eastern Mediterranean, between about 550 and 650

London, BM, M&LA

113(a) Copper-alloy censer

M&LA 1994,6–10,13

H. 79 mm, max. diam. 94 mm, L. of suspension-unit 427 mm

From Syria. Marcopoli Collection. Bought by the British Museum in 1994. The Marcopoli family settled as traders in Aleppo, Syria, in the sixteenth century, and for many generations thereafter members of the family were the hereditary consuls of Venice in Aleppo. Well known as collectors of antiquities, they included T. E. Lawrence among their acquaintances. The family was expelled from Syria in 1912, at the outbreak of hostilities between Italy and the Ottoman Empire.

Copper-alloy censer with a carinated rim and hemispherical body resting on three claw-feet. The interior of the bowl and the exterior and base of the body are decorated with lathe-turned concentric circles. Attached to three suspension-lugs is an elaborate suspension-unit constructed of three chains of twisted s-shaped links, each chain interrupted by a cross and openwork cross in a circle, all attached to a central distributor, and a further cross and a hook.

Three main body-types for non-figural censers predominate in the Early Byzantine period: cylindrical, hexagonal and, as here and in no. 113b, hemispherical. The censer most closely resembles examples from Sardis in Turkey, from Catania in Sicily, from an unspecified find-spot in Egypt, from Glastonbury in England (no. 113b), and in the Stathatos Collection, Athens (J. C. Waldbaum, *Metalwork from Sardis: the Finds through 1974*, Cambridge (Mass.)–London, 1983, no. 585; P. Orsi, *Sicilia Byzantina*, Rome, 1942, pp. 193–5; Strzygowski 1904, pl. 32; *Collection Hélène Stathatos*, III: *Objets antiques et byzantins*, Strasbourg, 1963, no. 240, p. 290, pl. 45); an unpublished example in the Joslyn Art Museum, Omaha, Nebraska, reputedly came from Galilee, near Tiberias. This widespread distribution pattern argues for more than one centre of manufacture. The limited archaeological evidence suggests a rough terminus ante quem of the early to mid seventh century for this form, as both Syria and Egypt had fallen to the Arabs by the 630s and 640s respectively. In addition to their ecclesiastical functions and their obvious domestic uses, it has been suggested that censers were employed to mask the noxious fumes caused by dye-shops (J. S. Crawford, *The Byzantine Shops at Sardis*, Cambridge (Mass.), 1990, p. 15).

Unpublished.

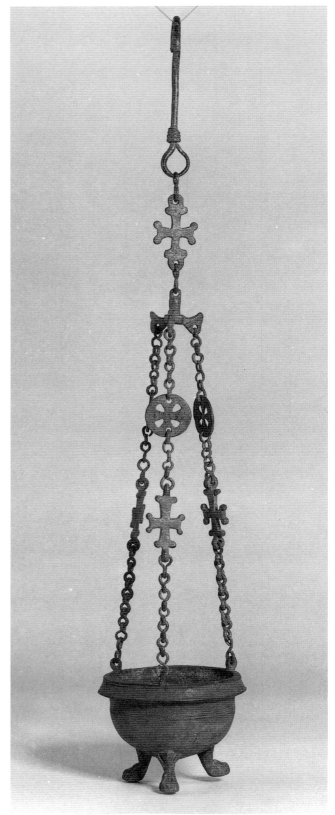

113(a)

113(b) Leaded brass censer

M&LA 1986,7–5,1

H. 73 mm (including suspension-lugs), max. diam. 87.5 mm

Said to have been found in the early 1980s somewhere outside Glastonbury Abbey, Somerset, perhaps in the Silver Street area. Bought by the British Museum in 1986.

Leaded brass censer with a carinated rim and hemispherical body resting on three quadrangular-sectioned, slightly splayed feet. The rim and the body are decorated with sets of lathe-turned concentric circles. Soldered to the rim are three suspension-lugs, two with the remains of a chain constructed of twisted s-shaped links. Part of the rim and body is cracked. Within the bowl is a dark burnt deposit.

Analysis of the deposit within the bowl shows it to consist of ash, metal corrosion products and traces of gum resin. The resin may be derived from a typical incense material such as myrrh or olibanum. Although Early Byzantine copper-alloy utensils such as bowls and buckets are not infrequently found in England in sixth- and seventh-century burials, this censer appears to be a unique import. For comparable examples, see no. 113a.

Exhibited: *Anglo-Saxon Connections* (1989), no. 49; *The Making of England: Anglo-Saxon Art and Culture* AD 600–900, London (British Museum), 1991, no. 68.　　　　　　　　　CJSE

114 Cross protected by a curse

Eastern Mediterranean, 6th or 7th century

Private collection

392 × 223 mm; thickness between 5 and 6 mm

Cross pattée moline of solid copper-alloy, with tang also moline (terminating in a fishtail). The cross is punched or engraved with two Greek inscriptions: (on the upper stem) '+ Holy Mary, Mother of God, be mindful of your servant Konon +', and (on the transverse arms and the lower stem) '+ If anyone dare steal this cross, may the lot of Judas be his', the latter inscription ending with a *crux monogrammatica*. Some letters contain traces of inlay, probably niello. At the intersection of the arms and stem is a pounced medallion containing a crude representation of the Mother of God on a straight-backed throne, holding the infant Christ; there is an eight-pointed star above Christ's head and other, indeterminate motifs in the field. Below the medallion is an orant figure, presumably representing the suppliant, Konon. The back is plain, with traces of gilding.

Although dated to the twelfth century in the catalogue of the exhibition *Masterpieces of Byzantine Art*, this cross was there compared with a seventh-century example in the de Grüneisen Collection (de Grüneisen 1930, p. 47, no. 167, pl. 12), and an Early Byzantine date for both crosses is likelier on grounds of palaeography and epigraphy.

Cursing was regularly used in the Byzantine world to protect documents and other manuscripts, and property generally.

Exhibited: *Masterpieces* (1958), no. 169.　　　　　DB

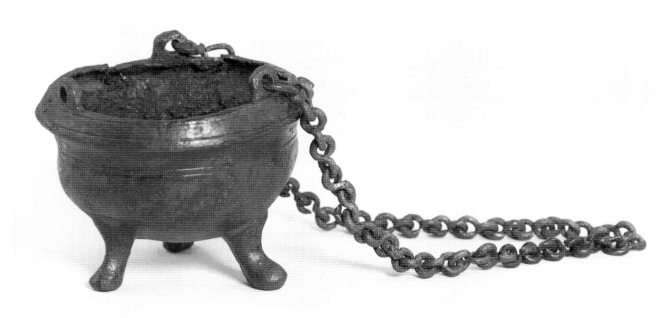

113(b)

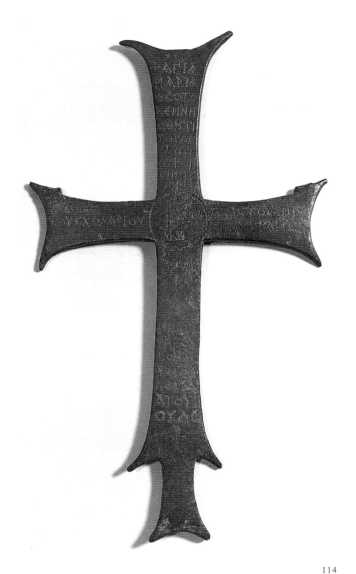

115

115 Glass hanging-lamp

Syria, 6th century

London, BM, M&LA 1900,4–12,1

H. 130mm, diam. 158mm

From Tyre. Bought by the British Museum at Tyre in 1900.

Green blown-glass bowl, in shape about three-quarters of a sphere, with a rim turned out and bowed inwards. Three suspension-loops applied as trails are spaced around the circumference of the body.

 The lamp would have been partially filled with oil and furnished with a wick-float, the light shining through the glass.

Exhibited: *Anglo-Saxon Connections* (1989), no. 27. DB

114

116 Monogrammed polycandelon

Eastern Mediterranean, between about 550 and 650

London, BM, M&LA 1994,6–10,11

Max. diam. 280mm, L. of suspension unit 870mm

From Syria. Marcopoli Collection. Bought by the British Museum in 1994. The polycandelon and nos 113a, 117 and 118 form part of a group of twenty-one copper-alloy objects (including eleven other polycandela, four censers and two lamp-fixtures) recently acquired by the British Museum from the Marcopoli Collection (see no. 113a).

Copper-alloy polycandelon in the form of a pierced disk with a central openwork cross enclosed by nine circular perforations. Three chains composed of double biconical links alternating with closed s-shaped chains attach the disk

to a smaller openwork one with trefoil finials and a central cruciform monogram. This disk is in turn fixed to a large hook by a chain of twisted s-shaped links.

Polycandela were multiple holders for glass oil-lamps. They embraced designs ranging from the architectural, as exemplified by a polycandelon in the form of a church in the Hermitage Museum, St Petersburg (Weitzmann 1979, no. 559), to the geometric, such as the perforated silver disks mentioned by Paul Silentarius in his description of the polycandela of St Sophia, Constantinople. The *Liber Pontificalis* mentions polycandela of gold and silver, as well as of bronze; examples in silver from the Lampsacus and Sion treasures are in the British Museum and the Dumbarton Oaks Collection, Washington, D.C., respectively (Dalton 1901, no. 393; Boyd 1992, pp. 24–7, pls S25.1–S35.1). The best parallels for the British Museum polycandelon are to be found in the Staatliche Museen, Berlin (O. Wulff, *Altchristliche und mittelalterliche Bildwerke*, Berlin, 1909, no. 1006), the Dumbarton Oaks Collection, Washington, D.C. (Ross 1962, no. 43) and the Corinth Museum (Davidson 1952, no. 859). None of these examples, however, has the additional smaller disk with a cruciform monogram. The only other polycandela which have monograms as an integral part of their design are twelve silver ones from the Sion Treasure with the monograms incorporated in the main unit (Boyd 1992). The monogram on the British Museum example, which resolves as either 'of Anastasios' or 'of Iustinianos', is an important diagnostic feature for the dating of copper-alloy polycandela as it is of a type which was current during the second half of the sixth and the first half of the seventh century. Most polycandela held between three and nine lamps, but a particularly elaborate version in the British Museum was designed to hold sixteen (Dalton 1901, no. 529). Polycandela were employed in both religious and secular contexts; in churches they were suspended between columns, or above altars and tombs. Some idea of the glittering effects created by these multiple lamp-holders can be gleaned from contemporary sources. Arculf, a bishop of Gaul, on a visit to Jerusalem in 670, described the Church of the Ascension on the Mount of Olives as follows '. . . to the customary light of the eight lamps . . . on the night of the feast of the Lord's Ascension it is usual to add innumerable other lamps; and under the terrible and wondrous gleaming of these, pouring out copiously through the glass shutters of the windows, all Mount Olivet seems not alone to be illuminated, but even to be on fire, and the whole city, situated on the lower ground nearby, seems to be lit up' (D. Meehan (ed.), *Adamnan's De Locis Sanctis*, 2nd ed., Dublin, 1983, p. 69).

Unpublished. CJSE

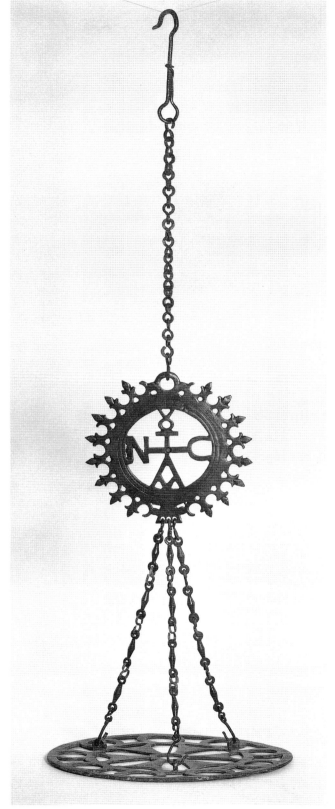

116

117 Light-fitting

Eastern Mediterranean, between about 550 and 650

London, BM, M&LA 1994,10–6,19

H. 390 mm, W. 230 mm

From Syria. Marcopoli Collection (see no. 113a). Bought by the British Museum in 1994.

Copper-alloy light fitting in the form of a cross with central roundel and slightly flaring arms. At the top of the vertical arm is a hinged suspension-ring; at the bottom of the vertical arm and at either end of the horizontal arm is a hinged hook in the form of a stylised finger.

 The precise function of this object is uncertain, but it seems likely that it was a multiple lamp-holder. Alternatively, censers or some other type of liturgical equipment could have been suspended from the three hooks. For a less massive example found in Hungary, see E. Tóth, 'Frühbyzantinisches Lampenhangeglied aus Brigetio', *Folia Archaeologica* 28 (1977), pp. 143–54, pls 1–2.

Unpublished. CJSE

118 Candelabrum

Eastern Mediterranean, between about 550 and 650

London, BM, M&LA 1994,6–10,18

H. 450 mm, W. 195 mm

From Syria. Marcopoli Collection (see no. 113a). Bought by the British Museum in 1994.

Copper-alloy candelabrum in the form of a cross with central roundel and slightly flaring arms. At the top and bottom of the vertical arm and beneath each end of the horizontal arm is a suspension-loop through which is threaded a link of chain and a hook. Soldered to each end of the horizontal arm are a drip-pan and pricket, on which the candle would have been fixed. The upper surface of each pan is decorated with two pairs of concentric circles.

 Although this object could also have served as a double lamp-holder, the length and cross-section of the prickets and the relatively small diameter of the pans suggest candles as the more likely light-source. Middle Byzantine monastic inventories suggest that most Byzantine candelabra were made of bronze, although examples of jasper and rock-crystal are described in an inventory of 1386 of Hagia Sophia, Constantinople. The form of the pan and pricket can be loosely compared with one of the 'Amalfitans' candelabra in the Grand Lavra on Mount Athos (L. Bouras, 'Three Byzantine bronze candelabra from the Grand Lavra monastery and Saint Catherine's monastery in Sinai', Δελτίον τῆς Χριστιανικῆς Ἀρχαιολογικῆς Ἑταιρείας, 1989–90, p. 19, fig. 1).

Unpublished. CJSE

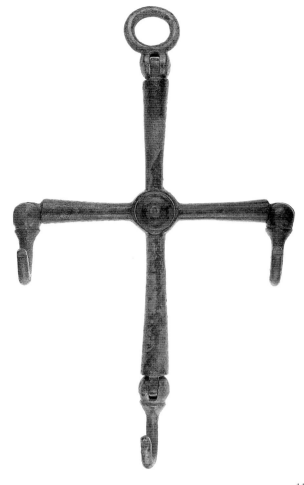

117

119 Bronze lamp and stand

Probably Egypt, 6th or 7th century

London, BM, M&LA 50,7–19,1

L. of lamp 179 mm, H. 196 mm, H. of stand 305 mm

Bought by the British Museum in 1850.

Copper-alloy lamp with a deep rounded body and long nozzle, flaring to a rounded tip. The handle is of double-rod form, curving up from substantial leaf springs on each side of the body; it is very elaborate, with leaves, roundels, volutes and a knob at its apex: a cross rises from a central roundel which is riveted on to the handle. The lid has a complex double hinge. The lamp stands on a high, flaring base, within which is a square hole for the pricket of the stand. The stand itself has a tripod foot of stylised lions' legs, a 'draped' lower element and a baluster shaft. At the top is a reel-shaped drip-tray, from the centre of which rises the pricket for the lamp.

Dalton 1901, no. 495. DMB

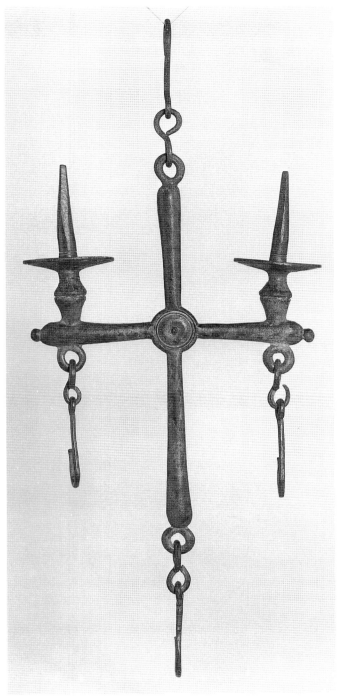

118

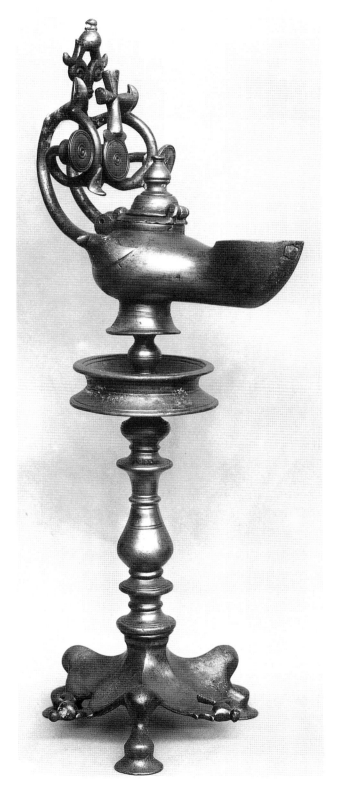

119

120 Bronze lamp in the form of a peacock

Probably Egypt, 6th or 7th century

London, BM, M&LA 65,4–14,1

L. 146 mm, H. 140 mm

Collection of the Earl of Cadogan. Bought by the British Museum in 1865.

Copper-alloy lamp cast in the shape of a peacock. The tail, the spine of which curves up to a knob, has a flaring tip forming the nozzle. There is a tuft of three feathers on the bird's head. The peacock's wings and legs are indicated in relief on each side of the lamp. The filling-hole, through the bird's back, is of pointed oval shape and has a lid, hinged just behind the neck. The lamp stands on an oval base, with three heavy mouldings; at its centre underneath is a square socket for a lampstand pricket, with a short rounded sleeve inside the lamp.

Dalton 1901, no. 509; M.C. Ross, in *Archaeology* 13 (1960), p. 134; Ross 1962, p. 39. DMB

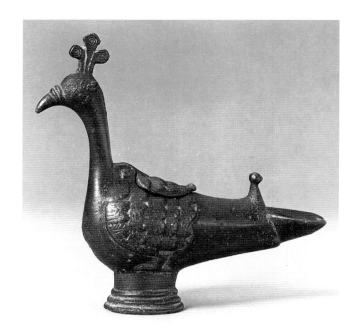

120

121 Pottery lamp with Greek inscription

Made at Aswan, Egypt, between about 500 and 650

London, BM, EA 1912.11–9.656

L. 92 mm, W. 67 mm

Excavated at Faras, Nubia, Western Cemetery 4, grave 39. Bought by the British Museum in 1912.

Pottery lamp, bearing the Greek inscription: 'Great is the name of God'.

Liverpool Annals of Archaeology and Anthropology 14 (1927), p. 73; Bailey 1988, Q 2224. DMB

122 Pottery lamp

Made in eastern Thrace (Bulgaria), between about 550 and 650

London, BM, M&LA 81,7–19,58

L. 69 mm, W. 46 mm

Bought by the British Museum from the Revd Greville J. Chester in 1881.

Pottery lamp with cruciform handle.

Dalton 1901, no. 829; Bailey 1988, Q 3225. DMB

123 St Menas pilgrim-flask

Abu Mena, near Alexandria, between about 450 and 550

London, BM, M&LA 75,10–12,16

H. 151 mm, W. 109 mm

Bought by the British Museum in 1875.

Earthenware ampulla of coarse orange fabric with oval body, two handles and short cylindrical neck, one of the handles and most of the neck being a modern repair. The body is decorated on one side with the nimbed orant figure of St Menas, wearing a tunic and chlamys and flanked by two camels; on either side of his head, a Greek inscription: 'St Menas'. All this is enclosed by a retrograde inscription: 'We receive the blessing of St Menas'. The design is repeated on the reverse, where the retrograde inscription is replaced by a wreath and the inscription on either side of the saint's head is illegible.

Earthenware ampullae, filled with earth, water or oil from holy sites, were mass-produced in the Early Byzantine period and are found throughout the Mediterranean region. Not only did they serve as pilgrims' mementoes but they also fulfilled important amuletic and medicinal functions. This and no. 124 are both associated with the cult of St Menas, an Egyptian soldier in the Roman army martyred for his refusal to recant his Christian faith. According to his *Vita*, after his death his body was transported by two camels until they reached the place of his eventual shrine at Abu Mena, south-west of Alexandria, where they stopped and refused to move. At this site was a spring which was subsequently endowed with miraculous properties through prox-

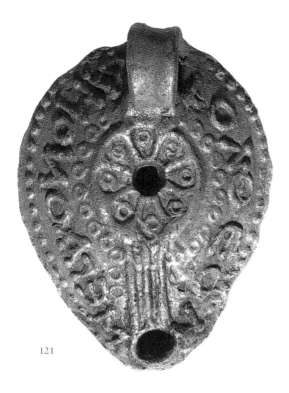

121

122

imity to the saint's relics. Ampullae were filled either with this sanctified water or, as described in a Coptic text, with oil from a lamp suspended before the tomb of St Menas (Kötting 1950, p. 198). The particular representation of St Menas flanked by two camels may derive from an image of the saint, now lost, which decorated his shrine.

Excavations in the 1960s at Kom el-Dikka, Alexandria, succeeded in establishing a rough chronology for the various types of ampullae which were produced at Abu Mena from the late fourth to the mid seventh century. This example, where the image is repeated on both sides and is accompanied by an inscription, is thought to date from the middle of the fifth to the middle of the sixth century (Kiss 1969, p. 152). For a selection of the numerous examples of this type, see Wulff 1909, pp. 268–9, nos 1378–82, pl. 68; Kaufmann 1910, p. 107, fig. 42; Metzger 1981, p. 25, nos 1–2, figs 10–11.

Dalton 1901, no. 860, pl. 32; C. M. Kaufmann, *Handbuch der christlichen Archäologie*, Paderborn, 1913, p. 616, fig. 249. CJSE

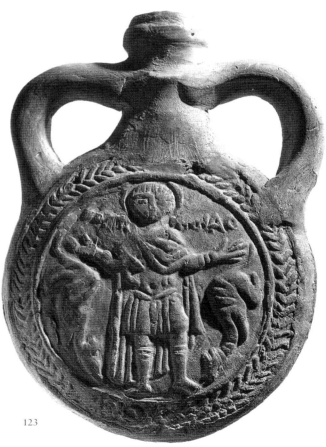

123

124 Pilgrim-flask with St Menas and ship

Abu Mena, near Alexandria, first half of 7th century

London, BM, M&LA 82,5–10,51

H. 91 mm, W. 61 mm

Bought by the British Museum in 1882.

Earthenware ampulla of light orange-brown fabric with round body, two handles and inverted neck. The front is decorated with a border of raised dots enclosing the orant figure of St Menas wearing a tunic and chlamys and flanked by two camels; on either side of his head is a cross. On the reverse is a ship.

It has been suggested that ampullae with this more schematic and perfunctory representation of St Menas and the camels, all within a border of raised dots, belong to the final phase of production of Menas ampullae, probably during the reign of Heraclius (Kiss 1973, pp. 138–44). Although St Menas, unlike, e.g., St Phocas, had no specific connection with seafarers, the proximity of the great port of Alexandria to Abu Mena meant that many pilgrims must have arrived and departed from there. Given the hazardous nature of travel by sea in antiquity, the image of the ship was probably intended, in conjunction with the saint's image, as amuletic. For similar ampullae, see Wulff 1909, p. 270, no. 1387, pl. 69; Kaufmann 1910, p. 168, fig. 104.

Dalton 1901, no. 883, pl. 32. CJSE

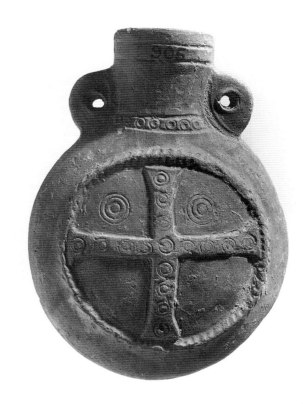

125

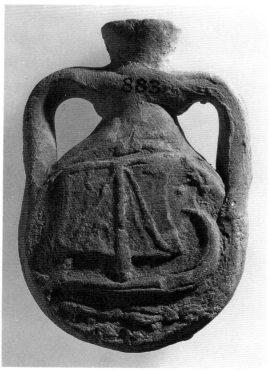

124

125 Pilgrim-flask with crosses

Eastern Mediterranean, 6th or 7th century

London, BM, M&LA 56,8–26,370

H. 96 mm, W. 70 mm

From Kalymnos. Given to the British Museum by Lord Stratford de Redcliffe in 1856.

Earthenware ampulla of red fabric with oval body and two small pierced handles attached to the neck. Both sides are decorated with a wreath enclosing an equal-armed cross decorated with ring-and-dot motifs.

This ampulla is said to have come from the foundations of a Byzantine monastery on the island of Kalymnos, excavated by Charles Newton, HM Vice-Consul at Mytilene.

Dalton 1901, no. 905. CJSE

126 Pilgrim-flask with evangelist

Asia Minor, between about 550 and 650

London, BM, M&LA 83,8–8,1

H. 69 mm, W. 48 mm

From Ephesus. Bought by the British Museum in 1883.

Earthenware ampulla of orange fabric with oval body, cylindrical neck with bevelled rim, and pierced shoulders. The body is decorated on one side with the seated figure of a bearded evangelist holding a stylus and a book. In front of him is a column-shaped object, perhaps intended to represent a table. On the reverse is a long-haired bearded figure, perhaps another representation of the evangelist, holding a book and flanked by two palm-branches.

Ampullae of this type have predominantly been found in Ephesus and its environs, and are probably to be associated with the great cult centre of St John the Evangelist, constructed at Ephesus between 548 and 565. They may have contained the healing dust said to have been blown by the saint up to the surface of his tomb, a once-yearly event which took place on his feast-day; this dust was credited with formidable healing powers. The seated figure, which can be paralleled in the contemporary Rabbula Gospels, may represent St Prochorus, St John's scribe. There are a number of similar examples in the Louvre (Metzger 1981, pp. 45–6, nos 113–15, figs 95–7).

Dalton 1901, no. 912. CJSE

127 Pilgrim-flask with figure of St Andrew

Eastern Mediterranean, 6th or 7th century

London, BM, M&LA 92,6–13,49

H. 68 mm, W. 47 mm

Given to the British Museum by Augustus Wollaston Franks in 1892.

Earthenware ampulla of reddish-brown fabric with oval body, cylindrical neck with slightly bevelled rim, and pierced shoulders. The body is decorated on both sides with the half-length figure of a bearded saint holding a book adorned with a cross. On either side of the saint's head are traces of an inscription.

Three identical examples in the Louvre have much clearer inscriptions and allow the saint to be identified as St Andrew (Metzger 1981, pp. 49–50, nos 123–5, figs 104–6). As with no. 126, this form of ampulla, with its narrow pierced shoulders, may have been suspended on a cord around the neck or from the waist.

Dalton 1901, no. 913. CJSE

128 Pilgrim-token with Entry into Jerusalem

Holy Land, 6th or 7th century

London, BM, M&LA OA 9312

Max. diam. 48 mm

Blacas Collection. Bought by the British Museum in 1867.

Round earthenware pilgrim-token of brown fabric, decorated in relief with the Entry into Jerusalem. Within a circular border, the nimbed figure of Christ, holding a cross,

126

127

rides to left on a donkey. In front of him are two standing figures holding palm-branches; in front of Christ's head is a star.

Of unusually large size for a pilgrim-token, this may be compared with two others in the British Museum: one from Smyrna, which depicts the same scene (Dalton 1901, no. 967), and another from Edfu, Egypt, decorated with the Annunciation (Dalton 1901, no. 968). The iconography of the Entry into Jerusalem may have had amuletic connotations.

Dalton 1901, no. 966 CJSE

129 Pilgrim-token with a stylite

Syria, 6th or 7th century

London, BM, M&LA 1991,6–1,1

Max. diam. 34 mm

Bought by the British Museum in 1991.

Round earthenware pilgrim-token of dark brown fabric, depicting in relief, in the centre, a hooded and cloaked bust perched on a column and flanked by two angels, possibly holding crowns. In the lower right field is a ladder and a cock, and in the lower left field a kneeling monk holding a censer with, behind him, a palm-branch.

The cowled bust is a representation of St Symeon Stylites the Younger (d. 592) who, in imitation of an earlier St Symeon, spent many years atop a column (*stylos*) on a hill to the south-west of Antioch. This token belongs to a discrete group thought to have been made from the earth which surrounded the base of the column on the 'Miraculous Mountain', as the hill was known. The saint's *Vita* reveals that one of the purposes of these tokens was medicinal: the dust from which they were made, when mixed with water to form a paste, could cure a wide range of diseases. When a token made of this dust was dissolved and sprinkled on a stormy sea, it calmed it, subsequently saving the life of a monk named Dorotheos (van den Ven 1962, p. 325).

Iconographic variants on this token include angels with palm-branches, the substitution of supplicants or the Baptism of Christ for the venerating monk, an additional monk climbing the ladder, and a variety of Greek and Syriac inscriptions (G. Vikan, *Byzantine Pilgrimage Art*, Washington, D.C., 1982, figs 22, 24, 25 and 29a; for a detailed discussion of their significance as medical panacea see: Vikan 1984, pp. 65–86).

Unpublished. CJSE

130 Six earthenware pilgrim-tokens

Holy Land, 6th or 7th century

London, BM, M&LA 1973,5–1,1/4/19/30/47 and 78

Max. diams 17.5 mm, 17.4 mm, 16.8 mm, 16.2 mm, 16.9 mm and 15.8 mm

From Syria. Bought by the British Museum in 1973.

Six earthenware pilgrim-tokens of dark brown fabric depicting the Annunciation, the Nativity, the Baptism of Christ, the Entry into Jerusalem, the Angel at the Sepulchre and a bust of Christ.

These six tokens form part of a group of eighty reputedly found in a glass bowl (no. 131a) at Qal'at Se'mān in Syria. Other scenes depicted on the remaining tokens include the Adoration of the Magi, the Mother of God with the infant Christ, flanked by two angels, the miraculous draught of fishes and the Adoration of the Cross; a further group appears to depict a coiled snake, around which is inscribed 'Solomon' in Greek. Rahmani (pp. 114–15) has argued that a number of these tokens should be attributed to specific

128 (enlarged)

129 (enlarged)

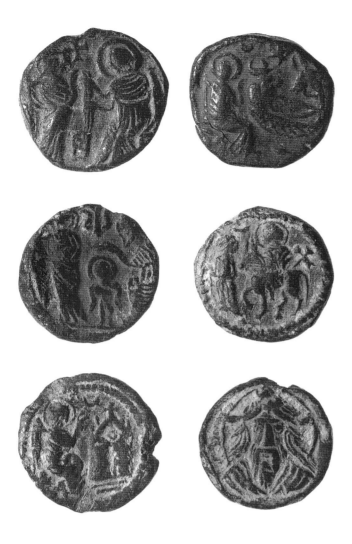

130 (enlarged)

sites in the Holy Land. Thus those with representations of the Angel at the Tomb relate to the Church of the Holy Sepulchre in Jerusalem, those with the Adoration of the Magi to the Church of the Nativity in Bethlehem, and those with the miraculous draught of fishes to a number of possible sites on the shores of the Sea of Galilee, such as the basilica at Capernaum. Alternatively, it has been suggested that the homogeneity of this group argues for a single source, perhaps from the storeroom or workshop of a major cult-centre (Vikan 1984, p. 82). If this is the case, the provenance of the British Museum tokens, provided it is genuine, is intriguing: a large pilgrimage complex dedicated to St Symeon Stylites the Elder existed at Qal'at Sem'ān.

Camber 1981, pp. 99–106; Vikan 1984, pp. 81–2; L. Y. Rahmani, 'Eulogia tokens from Byzantine Bet She'an', 'Atiqot 22 (1993), pp. 109–19. CJSE

131(a–c) Mould-blown glass vessels

The technique of blowing glass into a mould, which could give it both shape and relief decoration, had been known since early in the Roman period. In Byzantium, however, it is particularly associated with pilgrim-vessels, in which sanctified oil from a shrine or earth from a holy site could be taken away by pilgrims.

131(a) Glass bowl

Syria, 6th century

London, BM, M&LA 1973,5–1,81

H. 46 mm, diam. 170 mm

Said to have been found at Qal'at Sem'ān, near Antioch, Syria, containing eighty pilgrim-tokens, including no. 130.

Heavily weathered shallow glass bowl with mould-blown decoration in relief: a Maltese cross with at its centre a twelve-petalled rosette, surrounded by a wreath of chevrons, from which project the four flaring arms of the cross, each decorated with a chevron-pattern. In the interstices is a honeycomb pattern, and the whole design is marked off from the rim of the bowl by concentric rings.

Camber 1981, p. 99, fig. 1; Rahmani (see no. 130), p. 109.

131(a)

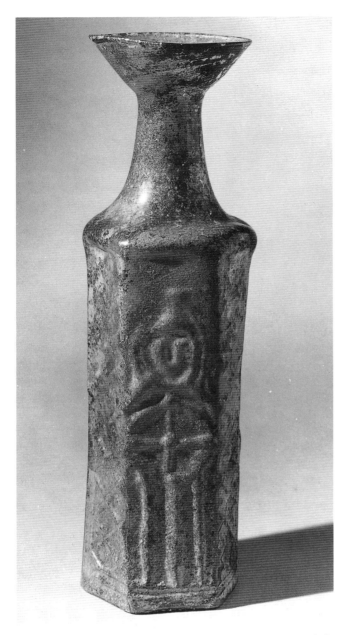

131(b)

bust above a cross in a circle on a pillar, and another trellis.

The cowled bust represents a stylite, a monk who spent his life on a pillar (*stylos*). These ascetics were particularly associated with Syria, where the first stylite, Symeon the Elder, died in 459. Production of these pilgrim-flasks may well have continued until the Islamic conquest of Syria in about 640.

Exhibited: *Masterpieces of Glass* (1968), no. 80.

131(c) Glass jar

Holy Land, last quarter of 6th or first half of 7th century

London, BM, M&LA 1971,10–2,2

H. 79.5 mm, max. w. 67.5 mm

Bought by the British Museum in 1971.

Hexagonal bottle of brown glass, with round splayed neck folded inwards. The decoration of the six rectangular sides comprises different motifs, all in intaglio (sunk relief), all symmetrical, all surrounded by dotted borders, and all but one difficult to make out. The only clear motif consists of two concentric lozenges, with rounded depressions at each corner of the rectangular field; this design has been tentatively identified as representing a book-cover. The other five motifs are triangular-footed; two are surmounted by trefoils, two, apparently, by heart-shapes, and one by an inverted heart or an arrowhead. Three of the motifs bulge in the

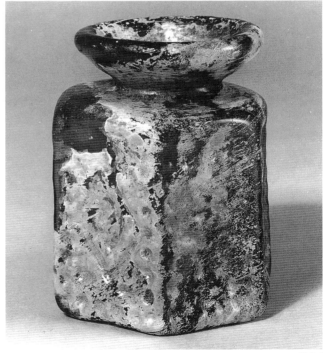

131(c)

131(b) Glass bottle

Syria, mid 5th to early 7th century

London, BM, M&LA 1911,5–13,1

H. 225 mm, w. 65 mm

From Aleppo, Syria. Bought by the British Museum in 1911.

Hexagonal bottle of dull green glass, with cylindrical neck and splayed rim. The sides are decorated in relief with, respectively, a palm-frond, a cross above a column, another palm-frond, a trellis-pattern of lozenges, a cowled human

middle, while two are waisted. The glass is weathered, with some purple iridescence.

The jar belongs to Professor Barag's 'unassigned' group, i.e. vessels bearing no demonstrably Christian or Jewish symbol (*Journal of Glass Studies* 13–14 (1971–2), pp. 45–51). For the Christian vessels from the Holy Land he argues a date between 578 and 636 (*Journal of Glass Studies* 12 (1970), p. 45); the very similar examples with Jewish motifs and the 'unassigned' vessels must be contemporary.

Unpublished. DB

132 Paschal Letter

Patriarchal Chancery, Alexandria, 577 or 672

London, British Library, Papyrus 729

215 × 335 mm

Excavated in the Fayyûm, Egypt, by B. P. Grenfell and A. S. Hunt, in 1895/6. Presented by Grenfell to the British Museum in 1896.

Large fragment of papyrus roll preserving part of a Festal Letter sent by the Patriarch of Alexandria to his Egyptian clergy. It begins towards the end of the preface with a quotation from the Commentary on St John's Gospel by St Cyril

of Alexandria (d. 444), and then moves on to the regulations concerning Easter. The Lenten feast is to start on Phamenoth 19 (15 March), and Holy Week on Pharmouthi 24 (19 April). Easter Day is to be Pharmouthi 30 (25 April). The letter concludes with prayers for victory to the emperors over their enemies and peace and unity in the Church, and with a doxology. All the text is formally written in fine Alexandrian uncials.

At the First Council of Nicaea, in 325, the Alexandrian method of calculating the date of Easter prevailed over other methods, and the privilege of appointing the date for the most important day in the Church calendar was conceded to the Bishop of Alexandria. The date set, the Sunday after the first full moon after the spring equinox, needed to be independently calculated with the aid of astronomical tables, a skill that was well established at Alexandria.

B. P. Grenfell and A. S. Hunt (eds), *New Classical Fragments and Other Greek and Latin Papyri*, Oxford, 1897, no. 112; *New Palaeographical Society*, Series 1, pls 48, 203; G. Cavallo and H. Maehler, *Greek Bookhands of the Early Byzantine Period, A.D. 300–800*, London, 1987, no. 37. SMcK

133(a–f) Silver spoons with inscriptions

Eastern Mediterranean, 6th century

London, BM, M&LA

Found at Lapseki (ancient Lampsacus), Turkey, before 1848 as part of the Lampsacus Treasure. The spoons reached the British Museum in four instalments: as the gift of Earl Cowley in 1848, by two purchases, in March and July 1886, and as part of the Franks Bequest (1897).

Each spoon is composed of a pear-shaped bowl attached at its narrow end, by means of a vertical disk, to a straight tapering handle with a baluster finial. The handle is square in section for the first 45 mm from the bowl, becoming round thereafter. The bowl has a narrow horizontal rim inlaid in niello with a wave pattern pointing on both sides towards the tip of the spoon, where the waves meet in a peak. The spoon is inscribed with two texts, a verse in hexameter followed by a short, sometimes jocular, addition; both texts are to be read while holding the spoon in the right hand. The first text starts on the inner surface of the bowl and continues on the upper surface of the square section of the handle. The second text is inscribed on the outer surface of the same square section. Under this latter inscription, on the vertical disk, is a Greek monogram enclosed in a wreath; on the other side of the disk is a foliate motif composed of three pendent pointed leaves below two upright volute-shaped tendrils with a circle between them. This motif, the inscriptions and monogram are all engraved and inlaid with niello. The back of the bowl, covered with a gouged foliate pattern, is very worn from the middle to the outer end. On three spoons (b, d and f) the right side of the tip of the bowl is also very worn.

(a) Both texts in Greek: 'Chilon, in hollow Lacedaemon, said "Know yourself"'; 'And urge yourself ceaselessly'.

M&LA 86,3–18,4

L. 265 mm. Weight 75.25 g

Bought by the British Museum in March 1886.

Dalton, no. 388; Hauser, no. 103.

(b) Both texts in Greek: 'Pittacus, who was from Mytilene, said "Nothing in excess"'; 'Love those who mock you'.

M&LA AF 379

L. 265 mm. Weight 75.28 g

Bequeathed to the British Museum by Sir Augustus Wollaston Franks (1897).

Dalton, no. 390; Hauser, no. 106.

(c) Both texts in Greek: '"Imagine the end of life", said Solon, in sacred Athens'; 'How one should live life'.

M&LA 48,6–1,10

L. 265 mm. Weight 74.74 g

Given to the British Museum by Earl Cowley in 1848.

Dalton, no. 387; Hauser, no. 104.

(d) Both texts in Greek: '"Most men are evil", declared Bias of Priene'; 'Those who detest pleasure'.

M&LA 48,6–1,12

L. 265 mm. Weight 76.55 g

Given to the British Museum by Earl Cowley in 1848.

Dalton, no. 389; Hauser, no. 105.

(e) First text in Latin, second in Greek: 'O handsome youth, do not believe too much in beauty'; 'You cannot be beautiful without money'.

M&LA 48,6–1,11

L. 134 mm (part of handle missing)

Given to the British Museum by Earl Cowley in 1848.

Dalton, no. 392; Hauser, no. 108.

(f) First text in Latin, second in Greek: 'Love conquers all, and we yield to love'; 'Eat, you who are lovesick'.

M&LA 86,7–9,1

L. 265 mm. Weight 73.40 g

Bought by the British Museum in July 1886.

Dalton, no. 391; Hauser, no. 107.

The six spoons formed part of a set with two others, one in Paris and the other now lost (Hauser, nos 103–10); originally the set would have comprised twelve (Martin, p. 83). In his analysis of eleven types of fifth- to seventh-century silver spoons, Hauser groups the eight Lampsacus spoons with others of similar shape which have been found in Lebanon, Bulgaria, England, Egypt and, perhaps, Syria (Hauser, nos 102–20). The Lampsacus Treasure contains another set of spoons inscribed with a different monogram and names of the apostles (*op. cit.*, nos 160–1, 196–201). The monogram on the disk of the spoons under discussion, which would give the owner's name, has been read as 'of Andreas Episkopos' (*op. cit.*, p. 65), but this reading is difficult to derive from the Greek letters represented.

The texts of the main Greek inscriptions on nos a–d – those quoting Chilon, Pittacus, Solon and Bias – are four epigrams which form part of the Sayings of the Seven Sages (Palatine Anthology, IX.366); a fifth Sage, Periander, appears on another spoon from the same treasure, now in the Louvre. Citations from the other two Sages, Cleobulus and

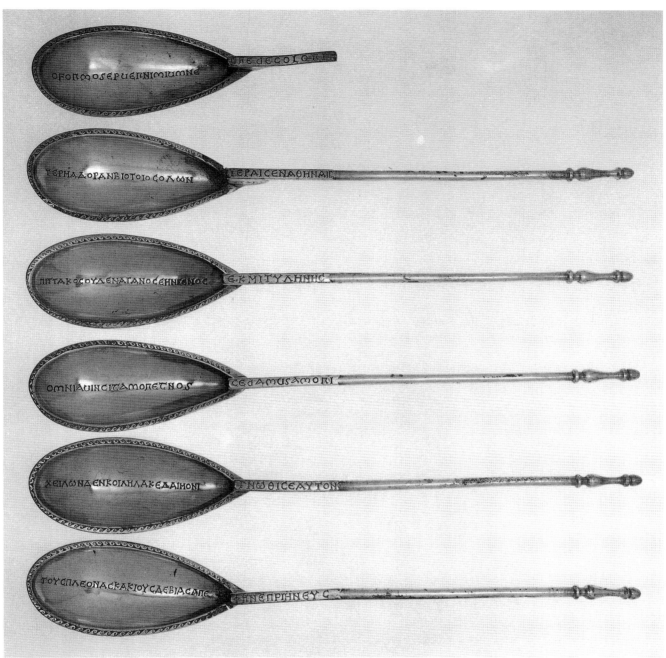

133 (e, c, b, f, a, d)

Thales, probably adorned spoons now missing. As the original set would have numbered twelve, the quotations of the Seven Sages had to be supplemented: on three of the surviving spoons there are Latin verses, from Virgil on nos e and f (*Eclogues*, II, 17 and X, 69; on the third text, see F. Baratte, 'Vaisselle d'argent, souvenirs littéraires et manières de table: l'exemple des cuillers de Lampsaque', *Cahiers archéologiques* 40 (1992), pp. 10–11).

Whereas the verses are correctly copied and spelt, the shorter texts contain some misspellings, which may suggest that they were specially composed for the spoons. The shorter texts on the two Lampsacus spoons not in London (Hauser, 69 C 7, 73 C 8) read 'When your mistress hates you' and 'In sacrificing, watch your hernia'. Witticisms in Greek, similar to the shorter Lampsacus texts, appear on a knife (no. 134) and on other sixth- and seventh-century spoons.

The Lampsacus spoons exemplify both the elegant tableware and cultural pretensions of Late Antiquity. The Sayings of the Seven Sages have been found inscribed on walls and on floors of rooms used for convivial gatherings (exh. cat. *Silver* (1986), pp. 186f, 218; Baratte, *op. cit.*). Inscriptions and images on spoons date back to the second century, and the Lampsacus set has been described as the culmination of this tradition (*op. cit.*, p. 12).

Dalton 1901, nos 387–92; V. Milojcic, 'Zu den spätkaiserzeit-lichen und merowingischen Silberlöffeln', *Bericht der Römisch-Germanischen Kommission* 49 (1968), pp. 140–1; M. Martin, in: Cahn and Kaufmann-Heinemann 1984, fig. 48, no. 78; S. R. Hauser, *Spätantike und frühbyzantinische Silberlöffel*, Münster, 1992, nos 103–8. MMM

134 Silver knife-handle with Greek inscription

Eastern Mediterranean, probably 6th century

London, BM, M&LA 66,12–29,50

L. 67 mm. Weight 24.33 g

Said to have been found in 1793 in Rome as part of the Esquiline Treasure (see no. 10), but possibly a subsequent addition to the treasure when it was sold to the Duc de Blacas.

Described as a knife-handle by both Dalton and Shelton, the object is of solid silver and octagonal in section, flaring to a flat termination at one end; the blade is missing from the other. The elaborately decorated surface is complete except for some inlay. Two of the four narrow facets of the handle are incised with a single-stroke Greek inscription, divided into two parts: MH ΛΥΠΙ and CEAYTON ('Do not be despon-

dent'). Both parts of the inscription are flanked by undulating vines, each with five leaves inlaid with gold. The other two narrow facets of the handle are undecorated. The four broader facets are each ornamented with bands of incised and nielloed guilloche interrupted by a central band of fretwork, each incorporating three crosses inlaid with gold. The flat end of the handle is incised with a zigzag border enclosing three palmette motifs, each with central elements inlaid with gold.

Spoons were the only type of eating implement regularly in use at the Roman table: table knives were unnecessary, as the food was cut up in the kitchen, and forks were relatively unknown (Strong 1966, p. 129), although a 'fuscina' is included in the Auxerre inventory of Late Antique domestic silver plate (Adhémar 1934). Known silver forks have handles similar to those of spoons or are part of a joined and folding set of utensils (see F. Baratte *et al.*, *Le trésor de la place Camille-Jouffray à Vienne (Isère)*, Paris, 1990, pp. 80–1). Known table knives (as distinct from knives used as weapons or tools) generally have bone handles; those excavated at Corinth and attributed to the Byzantine period include one that is somewhat like this one in shape and has similar overall geometric ornament (Davidson 1952, no. 4144); two Roman knives with bronze handles have gilding, silver and other inlay (Walters 1899, nos 2973–4).

The knife-handle belongs to a group of Greek-inscribed flatware of which the most elaborate texts adorn the Lampsacus spoons (no. 133). Compared with these, the wording and letter-forms on the knife-handle are simple but its decoration is extremely rich, with minutely formed gold inlay. On the text of the inscription, see no. 133.

Dalton 1901, no. 331; Shelton 1981, pp. 19–21, 94, no. 59, fig. 28, pl. 48. MMM

135 Silver bowl with bust of a military saint

Made and stamped at either Constantinople or Tarsus, between 641 and 651

London, BM, M&LA 99,4–25,2

Diam. 243 mm, preserved height 78 mm. Weight 922 g

Found six miles west of Kyrenia, Cyprus, at the end of the nineteenth century, together with no. 96 as part of the (first) Cyprus Treasure. Bought by the British Museum in 1899.

Large bowl with a horizontal rim, which curves downward, and a flaring foot. The vertical sides of the bowl are plain, in contrast to the large central medallion which fills the lower inner surface. A wide niello-inlaid band frames a half-length relief portrait of a nimbed saint. Beardless and with short curly hair, he wears dress military costume consisting of a long-sleeved tunic with *segmentum* at the shoulder, a chlamys with *tablion* held at the shoulder by a crossbow-fibula, and

134

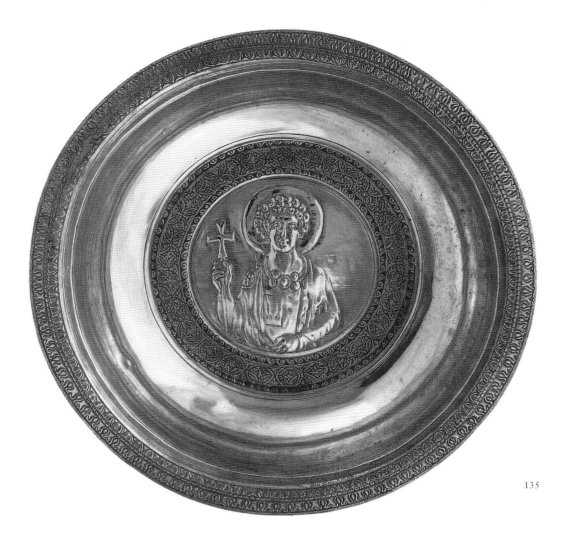

135

a torque (*maniakion*), apparently inlaid with five stones. In his right hand he holds a Latin cross on a staff. The band framing the saint, composed of three sets of overlapping circles and semicircles, with the interstices filled with intersecting strokes, is edged by two wave-patterns pointing to the right and both facing out. The upper rim of the bowl is decorated in relief with bands of flat leaves, beads, and simplified acanthus-leaves. Some metal is missing from the rim, and the broken lower edge of the foot-ring forms a jagged line. Inside the foot-ring, arranged around the central turning-point, are five imperial control-stamps dated to the reign of Constans II (641–51).

Although not identified by inscription, the saint on the bowl may be Sergius, as he is portrayed in monumental and minor art (e.g. exh. cat. *Age of Spirituality* (1977–8), no. 493). The vessel also lacks an inscription dedicating it to a church (see no. 95) for a liturgical or other sacred purpose. It may instead be another example of Christianised domestic plate (see no. 96), one type of which is illustrated by a story set in Alexandria. There, a man named Eutropius ordered two silver plates to be made. One, engraved with his name, was to be offered to the church of St Menas; the other, with the name of the saint, the man would use for meals at home until his death, when it would pass to the church (H. Delehaye (ed.), 'Menas, Inventio et miracula', *Analecta Bollandiana* 29 (1910), pp. 146–50, mir. 2). The British Museum vessel has the portrait rather than the name of a saint; it would have been a suitable object for a military man devoted to a military saint. The second Cyprus Treasure contains consular and other medallions of the Emperor Maurice which would have been appropriate imperial largess to a person of high military rank. The Cyprus bowl is one of the last silver objects to be stamped, perhaps at Tarsus, which is named twice within one stamp (Mango 1992, p. 207 and n. 38).

Dalton 1901, no. 398. Exhibited: *The Anatolian Civilizations* (II: *Greek, Roman and Byzantine*), Istanbul (Hagia Eirene), 1983.

MMM

Iconoclasm

The achievements of Justinian I, particularly the reconquest of the western Mediterranean, had exhausted Byzantine resources, and his successors had little money and few soldiers. The Avars and the Slavs occupied the Balkan peninsula, cutting off the western part of the empire, where the Lombards were conquering Italy and the Visigoths reconquering Spain. The Persians, who had seldom troubled Justinian, now overran Syria, Palestine, Egypt and Asia Minor, making off with the holiest of all relics, the True Cross, from Jerusalem.

In 622 the Emperor Heraclius embarked on a six-year campaign culminating in the collapse of the Persian Empire and the recovery of the True Cross. However, 622 had been the year of the Hijra, the flight of Muhammad from Mecca to Medina, and Byzantium was soon facing a totally unexpected enemy. Palestine and Syria were abandoned to the Arabs, who quickly took over the defeated Persian Empire, at the same time invading Egypt and heading along the northern coast of Africa.

The Byzantines were now engaged in almost constant warfare. The threat was not only from the Arabs, who twice besieged Constantinople, but also from the Bulgars, who had arrived in the territory that now bears their name. These and other disasters, particularly when contrasted with Arab successes, led the Emperor Leo III to blame Byzantine misfortune on idolatry. Accordingly he banned the veneration of religious images, a prohibition which lasted – with one interruption – from 730 to 843, the period known as Iconoclasm. Leo was a Syrian, advised by eastern bishops, and his action must be seen in the context of a puritanism which affected all religions in the Near East. There had long been differences of opinion about the use of images in worship, but now the theological controversy was intense and bitter, and the effect on Byzantine art catastrophic.

136 Silk panel from a tunic

Eastern Mediterranean, around 700

London, Victoria and Albert Museum, Textiles and Dress Collection, 2128–1900

Approx. 250 × 260 mm

From Egypt, probably from Akhmim. Given to the V&A by Robert Taylor in 1900. (Not exhibited: part of a similar panel and large fragments of the bright yellow silk from which the tunic was principally made, V&A, T.2158–1900.)

Fragmentary square panel of compound twill silk from the knee area of a tunic. The incomplete repeating design, in black against purple, is a lattice built up of quatrefoil frames. Within the quatrefoils, in alternate rows, are two differently elaborated palmette motifs. Above and below each quatrefoil is a simplified and symmetrical cruciform monogram, apparently built up from the Greek letters Y, K and A.

Weft-faced compound 1/2 twill, two lats. Warp yarn, z-twist brown silk; approx. 22 single threads of each warp per cm. Weft yarns, purple and black silk without twist; approx. 35 passes per cm. Lengthways repeat approx. 19 cm, widthways (reverse) repeat approx. 9.7 cm.

The design of this silk can be seen as a development on the design of a fragmentary red and yellow silk from the shrine of St Mandelbertha in Liège Cathedral, which includes the monogram of the Emperor Heraclius (610–41; Volbach 1969, figs 53–4; exh. cat. *Splendeur de Byzance* (1982), no. TX.1). In the case of the V&A example, the monogram is symmetrical, following the reversing pattern repeat, and it is not clear whether it was ever intended to be read or was simply copied from a more carefully-woven textile of the period.

The dark purple and black colouring of the figured silk panels looks back to classical antiquity, when purple was the dominant colour for areas of contrasting decoration on clothing. However, the dye is unlikely to be real purple, derived from sea-snails, since this had gone out of common use by the seventh century. The bright yellow ground of the original tunic represents a real departure from classical colour schemes: at earlier periods, purple had usually been combined with plain white or with toning colours such as pink, dark red and violet.

Kendrick 1920–1, no. 856. HG-T

136 (design)

137 Silk from the tomb of St Servatius

Byzantium, about 8th century

Manchester, City Council, on long-term loan to the Whitworth Art Gallery (University of Manchester), T.13756

Approx. 175 × 200 mm

Bought by the Manchester City Corporation from Canon Franz Bock of Aachen in 1883. The fragment is part of a larger textile discovered in 1863 in the twelfth-century shrine of St Servatius of Tongeren (d. 384) in the church of Sint Servaas, Maastricht. Further fragments are in the Kunstgewerbemuseum, Berlin, the Musée Historique des Tissus, Lyons, the Metropolitan Museum of Art, New York, and the Musée des Arts Décoratifs, Paris. Like this fragment, the piece in Lyons was bought from Franz Bock, and it is probable that all of the fragments to have left Maastricht were removed and sold by him.

Fragment of compound twill silk with a design of repeating roundels in white, green, red and dark blue on a red background. Represented on this fragment are the following: a flying *genius* pouring something from a small container; to the right, a standing man holding a staff and a shield and wearing a cuirass, a long tunic and, probably, a helmet; to the right again, part of an identical but reversed man; below the *genius*, the head of a man and the hindquarters of an ox; on the left, part of the roundel frame containing stylised rosebuds set either side of a curving stem; outside the frame, a ground-line with the trunk of a tree.

Like the standing man, the other figures and motifs visible here would have reappeared reversed in the other half of the roundel. Absent altogether, but known from larger pieces of the same cloth, are: an altar-like column with a bull's mask tied to it, on which the central pair stand; the front part of the oxen and the lower part of the men who, crouched on one knee, hold the oxen down; small roundels, also with rosebuds, that cover the borders at the four points that the main roundels touch; three leaf-like branches of the tree between the roundels.

Weft-faced compound 1\2 twill, four lats. Warp yarn, z-twist pink silk; 17–21 single threads of each warp per cm. Weft yarn, white, red, green and blue silk without twist; 28–30 passes per cm. Lengthways repeat approx. 27.5 cm, widthways (reverse) repeat approx. 13.5 cm.

Since the time of Bock, the paired standing figures have been identified as the Dioskouroi, the twins Castor and Pollux, who, as divine horsemen, were patrons of the Hippodrome at Constantinople. It is also possible that they represent another pair of twins. Romulus and Remus, the founders of Rome and, according to the sixth-century writer Malalas, the originators of the circus factions which had become so prominent a part of Byzantine life. The two identifications need not be regarded as contradictory, since the two sets of twins were not clearly distinguished by contemporaries (G. Dagron, *Naissance d'une capitale:*

Constantinople et ses institutions de 330 à 341, Paris, 1974, pp. 338–44). Although it is unrecorded, there may have been at Constantinople, perhaps in the Hippodrome, a column surmounted by a double statue which served as a direct source for the central motif of the silk. Whether or not this was the case, the central figures can be traced back to the image of a standing emperor, a long sceptre in one hand and a shield in the other, which commonly occurs on the reverse of Late Roman coins and medallions (e.g. F. Gnecchi, *I medaglioni Romani*, I–III, Milan, 1912, pls 29/4, 36/3, 36/8, 43/6 and 75/6). On the silk, the duplication of the single figure by means of the patterning mechanism of the loom may have been perceived by contemporaries as a visual pun.

A connection with the circus or hippodrome appears to be confirmed by the presence of two flying *genii*, who seem to be pouring from purses a stream of coins, a symbolic representation of a *sparsio* (lit. 'sprinkling'), the practice of distributing gifts of money to the circus audience. A similar stream of coins can be seen on a roughly contemporary textile, the Quadriga silk at Aachen, where, below the main motif of the chariot and its driver, two men or boys pour money from a sack into a vessel (von Falke 1913, fig. 56, Volbach 1969, fig. 56). For an earlier representation of the *sparsio*, see no. 62.

The extent to which the subject matter of the Maastricht silk is not merely secular but actually pagan can be understood by an examination of the complete design for the lower half of the roundel. The special dress of the men with the oxen identifies them as being among those whose job it had been to kill the larger animals at sacrifices in Rome. With one hand on the oxen's necks, they are in the act of pushing the animals on to their knees in preparation for slaughter. Christian piety may have caused the omission of the sacrificial weapon, but that a sacrifice is about to take place is confirmed by a comparison with earlier versions of the same scene where one man similarly dressed has an axe in his extended right hand. Such scenes again appear on Roman coins and medallions (Gnecchi, *op. cit.*, pls 50/2–3, 63/2 and 9, and 89/2–5), and a particularly clear version, showing the sacrifice in front of the Temple of Jupiter at the end of an emperor's triumph, occurs on a silver cup from Boscoreale (F. Baratte, *Le trésor d'orfèvrerie romaine de Boscoreale*, Paris, 1986, pp. 73–5).

The Maastricht silk relates to a number of others of the same period; the Charioteer silk from Munsterbilsen, now in Brussels, is perhaps the closest Byzantine silk in style and scale and likewise exhibits a complex iconographic scheme (von Falke 1913, fig. 74, Volbach 1969, fig. 49); a group of bi-coloured silks found in Akhmim and thought to have been woven in Egypt have a variation on the same roundel border (von Falke 1913, figs 59–63; Volbach 1969, fig. 45; Martiniani-Reber 1986, nos 61, 68, 72, 74, 76, 77, 79 and

137

137 (design)

80); a Sogdian silk found in Egypt and now in Berlin takes the sacrifice scene from the lower half of the Maastricht roundels and uses it as its main design (von Falke 1913, fig. 81; L. von Wilckens, *Mittelalterliche Seidenstoffe*, Berlin, 1992, no. 25).

The churches and abbeys of the Rhine-Maas area are exceptionally rich in silks of the later part of the first millennium, a circumstance due in particular to the patronage of Charlemagne and his family. It is possible that both Charles Martel and his grandson Charlemagne had the shrine of St Servatius at Maastricht opened for them, and either could have given this silk. A recorded donor is Bishop Bernharius of Worms, who is known to have given a *pallium*, or length of cloth, in 826.

This fragment unpublished, but see F. Bock and M. Willemsen, *Die mittelalterlichen Kunst- und Reliquienschätze zu Maastricht*, Cologne, 1872, pp. 29ff; A. Stauffer, *Die mittelalterlichen Textilien von St. Servatius in Maastricht*, Riggisberg, 1991, no. 1; Martiniani-Reber 1986, no. 84. HG-T

138 Silk with archers and tigers

Eastern Mediterranean, perhaps Egypt, 8th or 9th century

London, Keir Collection

Approx. 280 × 65, 170 × 65, and 60 × 60 mm

Probably found in Egypt. Acquired in Lucerne, from the E. Kofler-Truniger Collections.

Three fragments of compound twill silk, parts of a repeating roundel design in green, dark blue, yellow and cream on a red background. The two larger fragments have the main motifs reversed: a standing archer who prepares to shoot at a rampant tiger below him (the archer has long hair and wears a tunic with bands of decoration, a cloak, breeches and lacing boots). The extant sections of the roundel border show it to have been circular on the inside but with lobes, probably six, around the outside; the main design within the border is of stylised rosebuds seen from the side, with leaves and smaller buds between. The third fragment has the upper part of a peacock and stylised vegetable elements, part of the decoration between the roundels. The peacock holds in its beak a leaf which is divided into bars of colour and curved at the point. Similar leaves on a larger scale recur at other places in the design.

Weft-faced compound 1\2 twill weave, five lats. Warp yarn z-twisted red silk; approx. 18 single threads of each warp per cm. Weft yarns, silk without twist, five colours as above; approx. 30 passes per cm. Lengthways repeat approx. 25.5 cm; widthways (reverse) repeat approx. 13 cm. The three fragments have cut vertical edges with parallel traces of folds and sewing. The two larger fragments have part of one of the widthways edges of the cloth,

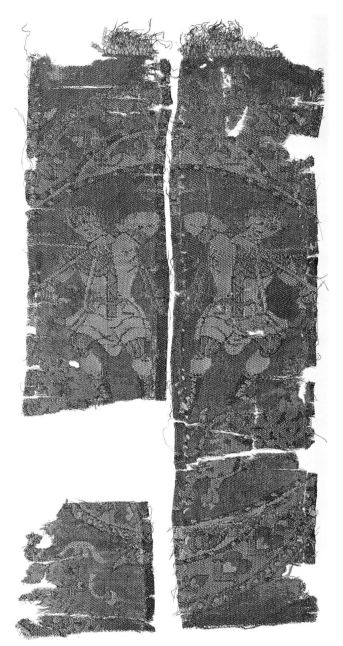

138

a fringe of warp threads preceded by several thick picks of yellow silk.

The folds and lines of stitching along the sides of these fragments indicate that they had been used as ornamental panels on another textile, probably a piece of clothing. Analogous panels of decoration are indicated on the tunic of the archer on the silk itself; the arrangement shown worn by the archer, with a central band rather than two shoulder stripes or *clavi*, was specifically oriental in its connotations.

Though the iconography is here much simpler, as with the silks nos 137 and 139, the main motifs of this design can be traced back to Roman and Late Antique art: good precedents for both the archer and the hunted animal occur, for instance, on a fifth-century silver plate now at Dumbarton Oaks (Ross 1962, no. 4). A commoner variation on the design, showing the archer mounted, is represented by silks from both Egypt and western Europe (Stauffer 1991, no. 35; exh. cat. *Tissu et vêtement* (1986), pl. XIV; Kendrick 1921–2, no. 810). Some of these silks may have been produced in provincial centres, and those found in Egypt were perhaps woven there.

Volbach 1969, fig. 50; King 1981, pp. 102–4; King and King 1990, no. 10. HG-T

139 Silk from the tomb of St Cuthbert

Probably Constantinople, around first half of 9th century

Durham, Cathedral, Dean and Chapter

Approx. 450 × 515, 565 × 385, 330 × 615, 415 × 300, 300 × 340, 270 × 250 mm, and many smaller fragments

Discovered in 1827 in the tomb of St Cuthbert (d. 687) in Durham Cathedral.

Fragments of compound twill silk with a design of very large repeating roundels in yellow, dark blue, green, white and purple on a dark pink background (colours faded). The main motif is the upper half of a long-haired female figure holding two short sceptres and a scarf filled with branches bearing fruit; she wears a tunic patterned with lozenges enclosing leaf motifs, a jewelled collar and a jewelled belt; the ends of her hair and of her scarf are also embellished with jewels; her head is missing altogether but traces of leaves and stalks in the area around it indicate that it would have been surmounted by further branches of fruit. The half-figure is shown rising out of water, and a representation of water fills the lower third of the roundel; two pairs of duck swim on the surface, while below there are six fish.

The design of the roundel border consists principally of pairs of different sorts of fruit alternating with bunches of grapes; a narrow outer border imitates a twisted cord. Between the roundels are large urns filled with bunches of grapes, flanked by pairs of large ducks wearing jewelled collars.

Three fragments carry the remains of the lower border of the silk, a warp fringe preceded by a double row of white disks or 'pearls' on a background of purple (the purple faded and the white weft decayed); just discernible within some of the disks are the remains of a woven inscription including a cross marking its beginning or end, an eta, a theta and the upper part of an upsilon or chi.

Weft-faced compound 1\2 twill, four lats with additional colours introduced as 'pseudo-brocading'; very compact

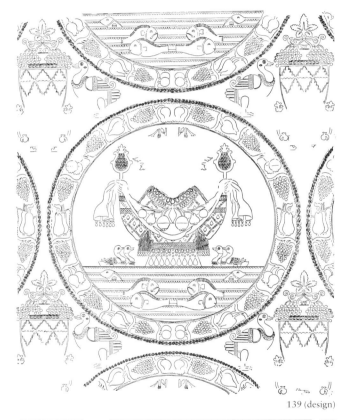

139 (design)

139 (inscription)

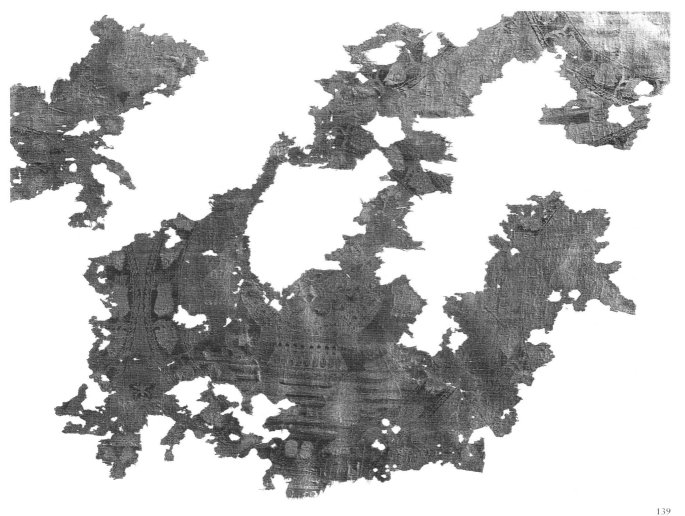

139

139 (inscription)

weave. Warp yarn, z-twisted brownish silk, 16–18 paired thread of the main warp per cm and 16–18 single threads of the binding warp. Weft yarns, silk without twist, six colours as above, 55–65 passes per cm. Lengthways repeat approx. 60 cm, widthways (reverse) repeat approx. 30.5 cm.

In this silk, the widthways reverse repeat, instead of producing paired images as in nos 137, 138, 166 and 190, has been employed to create a single central figure. The figure is Autumn or, more precisely, since she is shown in opposition to water, Earth, Ge or Gaia; her son, Okeanos, is not present as a personification but is shown literally as the waves of the sea, the swimming ducks and fish illustrating his richness in the same way as the fruit illustrates hers. We know that the theme of Earth and Ocean was an old one in textile decoration. The first-century writer Philip of Thessaloniki, in one of the epigrams in his *Garland*, describes a cloth sent as a gift to the Emperor Gaius from Queen Kypros, wife of Herod Agrippa: on this cloth was 'a perfect copy of the harvest-bearing earth, all that the land-encircling ocean girdles . . . and the grey sea too' (*Palatine Archaeology*, IX, p. 778). As with nos 137 and 138, there are also earlier visual sources for the Durham silk: the main figure can be compared, for example, to a Roman bronze figure of Autumn in the British Museum (Walters 1915, pl. 58). But a more modern, oriental, influence can be seen in the formality of the overall style, and individual elements of the design can be traced to Persia, in particular the goddess's jewelled belt and the pearled collar of the larger ducks.

In that they both have overtly pagan subjects, this Durham silk is similar to the silk from Maastricht, no. 137, and both were probably woven in the capital. But the differences between the two silks are illuminating. The larger scale and greater number of colours in the Durham silk are partly due to its somewhat later date, but a detail that proves without doubt its higher quality is the number of threads per cm in the weft. Both silks have roughly the same number of warp elements per cm, around 17–21 single main warp threads in the Maastricht silk and around 16–18 paired main warp threads in the Durham silk; in the weft however, the Maastricht silk has 28–30 passes per cm while the Durham silk has 55–65 passes, a number that is similar to that of the very fine early silks nos 49 and 111, but with at least twice the number of threads in each pass. The exceptional quality of the Durham silk is further confirmed by the remnants of a woven inscription: the only comparable inscriptions are those on a small group of lion silks of around the tenth century, where the names of Byzantine emperors are given in the genitive after *epi* ('in the time of . . .'), and the Elephant silk at Aachen of around the year 1000, where the inscription refers to two functionaries at Constantinople, Michael, *primikerios* and *eidikos*, and Peter, *archon* (A. Muthesius, 'A practical approach to the history of Byzantine silk weaving', *Jahrbuch der Österre-*

ichischen Byzantinistik 34 (1984), pp. 235–54). The probability is that the Durham textile, along with these other inscribed silks, belonged to the category of forbidden cloths made for the emperor's own use or for distribution by him (R. S. Lopez, 'Silk industry in the Byzantine Empire', *Speculum* 20 (1945), pp. 20–2).

The extant textile closest in style and quality to the Durham silk is the so-called shroud of St Victor, or Lion-Strangler silk, at Sens Cathedral (von Falke 1913, fig. 129). It is possible that both textiles travelled to western Europe under the favourable treaty with Byzantium negotiated by Charlemagne in 812. It has been suggested (F. W. Buckler, *Harunu'il Rashid and Charles the Great*, 1931, appendix) that the Durham silk passed to England as one of the gifts sent in 926 to Æthelstan of Wessex by Duke Hugh of France when Hugh became betrothed to Æthelda, sister of Æthelstan. In William of Malmesbury's list of these gifts there is no mention of textiles, but a number of objects associated with Charlemagne are recorded, including the lance which Charlemagne had won from the Saracens and which since then had been in the treasury at Sens.

St Cuthbert, Abbot and later Bishop of Lindisfarne in Northumbria from 664 to 687, was, until the martyrdom of Thomas à Becket in 1170, England's most revered saint. The silks found in his tomb are the only collection of early medieval textiles to have survived in Britain. The embroidered stole believed to be that donated to his shrine by King Æthelstan in 934 is a masterpiece of early Opus Anglicanum which, in its style, demonstrates a strong Byzantine influence (C. F. Battiscombe (ed.), *The Relics of St Cuthbert*, Durham, 1956, pls XXIV and XXXIII). The Earth and Ocean silk may have been among Æthelstan's gifts, but it is more likely to date from a visit to the shrine in 945 by Æthelstan's brother, King Edmund of Wessex, who, that year or shortly after, was recorded in the *Historia de Sancto Cuthberto* as having, with his own hand, wrapped the body of the saint with two *pallia graeca* – lengths of Greek cloth.

Flanagan 1956, pp. 505–13; C. Higgins, 'Some new thoughts on the Nature Goddess silk', in: G. Bonner, D. Rollason and C. Stancliffe (eds), *St Cuthbert, his Cult and his Community to AD 1200*, Woodbridge, 1989, pp. 329–37; H. Granger-Taylor, 'The Earth and Ocean silk from the tomb of St Cuthbert at Durham: further details', *Textile History* 20 (1989), pp. 151–66. HG-T

The Middle Byzantine period

The defeat of Iconoclasm in 843 was hailed as a return to Christian orthodoxy and, it was confidently expected, imperial greatness. A gradual recovery of the eastern territories from the Arabs was boosted from 867 by the Macedonian dynasty, whose military commanders – two of whom usurped the imperial throne from 963 to 976 – continued the advance eastward, consolidated Byzantine power in southern Italy, recovered Palestine, Cyprus and Crete from the Arabs, and defeated the Bulgars. At the death of Basil II in 1025, Byzantium was at its most extensive since Justinian I. This time, however, the reconquests had not put undue strain on Byzantine resources.

The wealth of the empire was reflected in church-building and in an artistic revival – the 'Macedonian Renaissance'. Many of the new churches had the ground-plan of an equal-armed cross within a square building, with a central dome and smaller domes at the corners; this became the standard Byzantine church and is still copied today. New churches demanded new religious art: artists who, because of Iconoclasm, had no live tradition of their own and artists who had escaped the effects of the ban on images by working beyond imperial jurisdiction introduced new iconography, styles and techniques, particularly from the Latin West.

Under the Comnenan dynasty, in the late eleventh century and most of the twelfth, there was a thriving intellectual life in the capital. Turkic tribes threatened from the north, however, and the Seljuq Turks were advancing across Anatolia. In 1071 the Byzantine army was almost wiped out at Manzikert (between Erzurum and Lake Van) and the Emperor, Romanos IV, captured. To the west, the Normans were moving into the Balkans, and, although some of these setbacks were reversed by the Comnenes, Byzantium was about to encounter the Crusades.

140 Icon of the Triumph of Orthodoxy

Constantinople, around 1400

London, BM, M&LA 1988,4–11,1 (National Icon Collection, no. 18)

390 × 310 mm

Formerly in a private collection in Sweden, the icon was privately purchased at Sotheby's on 15 February 1984. It was exhibited at Bernheimer Fine Art in 1987, and bought by the British Museum in 1988 with the help of the National Art-Collections Fund (Eugene Cremetti Fund).

Painted in egg tempera on gold leaf on a wood panel surfaced with gesso and linen. The Greek lettering is in red on gold. There are traces of a title on the icon to the right of the representation of the Mother of God Hodegetria; the letters which can be made out, . . . IA . . . , most likely represent ORTHODOXIA. The subject is the Triumph of Orthodoxy; this refers to the Restoration of the Holy Images in 843, at the end of Iconoclasm. This icon is the feast icon for the Sunday of Orthodoxy, the first Sunday in Lent. It represents famous icons and iconophiles.

The panel is divided horizontally into two registers. The central representation at the top is one of the most renowned icons of Constantinople, the icon of the Mother of God Hodegetria, claimed to have been painted by the Evangelist St Luke from life and so to represent her authentic appearance. The prominent figures on the left in the upper register are the rulers at the time of the official ending of Iconoclasm in 843: the regent Empress Theodora together with her young son, the Emperor Michael III. They wear the dress and insignia of their power and are labelled with their titles. All the inscriptions on the icon are considerably rubbed, and some are more certain than others. The name and title of Emperor Michael III is easily legible; beside the Empress Theodora we can read THEODO[RA] and PISTE ('faithful in Christ'). On the right is the Patriarch Methodios (in office 843–7) with three monks; beside the figure of the patriarch, wearing a *sakkos*, ME[THODIOS] is readable.

In the lower register of eleven figures, the saint on the extreme left is clearly inscribed THEODOSIA. The next three inscriptions cannot be read. Above the fifth figure from the left are the letters [THEO]PHAN[ES], and above his companion TH[EODOROS]. The next few inscriptions are very rubbed, and it is not entirely clear to which figures they apply. The seventh figure, the bishop, may have the letters [TH]EO[DOROS], and the eighth may have been THEOPH[ANES]; the tenth and eleventh figures have THEOPHILAK[TOS] and ARSAKIOS. (The identifications of the figures given here differ in some cases from the original Sotheby's catalogue entry of 1984 and the entry by Petsopoulos of 1987. Petsopoulos read the last three figures as Theodore, Theophilos and Thessakios.)

In the lower register certain of the figures are highlighted by their position and by their triumphant act of displaynig icons. In the centre the figures holding between them an (oval?) icon of Christ are probably St Theophanes the

Confessor and St Theodore the Studite. To their right is a bishop and four further figures, of which we can most confidently make out the names of the two on the extreme right: St Theophilaktos the Confessor and, finally, St Arsakios. Other fragmentary letters point to the inclusion between Theodore the Studite and St Theophilaktos of the two monastic brothers who fought on behalf of the iconophile cause during Iconoclasm, St Theodore and St Theophanes, the Graptoi. On the extreme left is a martyr saint, portrayed as a nun. She too holds an icon of Christ (this icon has the detail of a ring at the top). The nun is identified by her inscription as St Theodosia, and she must be St Theodosia of Constantinople, who reputedly tried to save the Chalke icon of Christ from destruction at the outbreak of Iconoclasm.

The icon features the restoration of icons after Iconoclasm, commemorated each year in the Orthodox Church as the Festival of Orthodoxy on the first Sunday in Lent (probably instituted by Patriarch Methodios in 843).

This seems to be earliest known example of the iconography. The composition reflects the schemes used for council representations and in cycles of the Akathistos hymn. On grounds of style, it can be attributed to Constantinople around 1400. Two other later icons of this subject are published. One panel is in the collection of the Church of St George of the Greeks in Venice (M. Chatzidakis, *Icônes de Saint-Georges des Grecs*, Venice, 1962, no. 63, p. 96). It is signed by the Corfiote painter Emmanuel Tzanfournaris (about 1570–5; d. after 1631) and is entitled 'Orthodoxy' (*Orthodoxia*). Chatzidakis recorded the various inscriptions which allow identification of most of the participants: Theodora and Michael III, Methodios, Theophylaktos of Nicomedia, Michael of Synnada, Euthymios of Sardis, and Emilianos of Cyrica. In the register below, Chatzidakis identifies the figures as the 'confessors': Theophanes and Theodore the Studite in the centre with an icon; on the left Theodosia (with an icon), Ioannikios, Stephanos the Higoumenos, Thomas, and Peter; on the right Makarios of Pelekete, Stephen the Younger (with an icon of the Mother of God), Joseph, John Katharon, Arsenios, and Andrew.

The other icon, in the Benaki Museum, Athens, is entitled 'The Restoration [*Anastelosis*] of the Icons' (A. Xyngopoulos, *The Collection of Helen A. Stathatos* (in Greek), Athens, 1951, no. 6, pp. 8–10). This has the signature of the same artist as the icon in Venice. This is the largest of the three icons, and the most complex: there are more figures, including several women and singers (with 'authentic' coloured costumes – see N. K. Moran, *Singers in Late Byzantine and Slavonic Painting*, Leiden, 1986, fig. 87 and pp. 136, 149), and some hold candles or inscriptions which anathematise iconoclasts. Xyngopoulos assumes that the figure of the nun with the icon of Christ Emmanuel on the left side of the lower register is St Cassia. The suggestion is no doubt based on the notice by Dionysius of Fourna, who

mentions this saint and not Theodosia (P. Hetherington, *The Painter's Manual of Dionysius of Fourna*, London, 1974, p. 65). According to Dionysius of Fourna, the components of the 'Restoration of the Holy Images' are: Methodios, deacons holding the Hodegetria icon, Theodora and Michael, and other figures including John, Arsakios, Isaiah and Cassia. St Cassia would have been an appropriate choice: she was a hymnographer in the first half of the ninth century who supposedly competed in a bride show for Theophilos with Theodora, and who was assumed to be on the iconophile side.

This subject also appears in the wall-paintings of 1525 by Theophanes the Cretan in the catholikon of the Laura monastery on Athos and at Stavroniketa on Athos. In the Athonite examples (for the Laura, see G. Millet, *Monuments de l'Athos*, Paris, 1927, pl. 131, 2; also M. Chatzidakis, *The Cretan Painter Theophanes*, Athos, 1986, pls 122–3) the scene is altered by the placing of the Hodegetria icon, the imperial figures and Methodios below and the other figures in the register above. The Triumph of Orthodoxy likewise appears in the sixteenth century in Cyprus, in wall-paintings in the catholikon of the monastery of St Neophytos, near Paphos, around 1500 (the cycle includes church councils) and at St Sozomenos at Galata in 1513 (both studied in a London MA (1993) by Tassos Papacostas). The list can be increased further.

The miraculous icon of the Hodegetria is represented here on a red draped stand, with red curtains drawn back to reveal it. The large panel is held up by two winged figures with red hats, not apparently angels. N. P. Ševčenko saw these as members of the brotherhood who maintained the cult, suggesting that their wings were a device to elevate both them and the festival to a 'heavenly' or 'liturgical' level so that 'the image celebrates simultaneously the historical event, its inner meaning, and its eternal re-enactment'. Dionysius of Fourna speaks of two 'deacons' with 'shoes woven of gold' holding the Hodegetria (Hetherington, *op. cit.*, p. 64).

Sale cat. *Russian Pictures, Icons*, Sotheby's, London, 15 February 1984, lot 156; Y. Petsopoulos, *East Christian Art*, London, 1987, pp. 49–50; U. Abel, *Ikonen – bilden av det heliga*, Hedemora, 1988, pp. 32–3; R. Cormack, 'The Triumph of Orthodoxy', *National Art-Collections Fund Review* 1989, London, 1989, pp. 93–4; N. P. Ševčenko, 'Icons in the liturgy', *Dumbarton Oaks Papers* 45 (1991), pp. 45–57, esp. p. 48; R. Cormack, 'Women and icons', in: L. James and R. Webb (eds), forthcoming. Exhibited: *East Christian Art*, London (Bernheimer Fine Art), 1987, no. 43.

RC

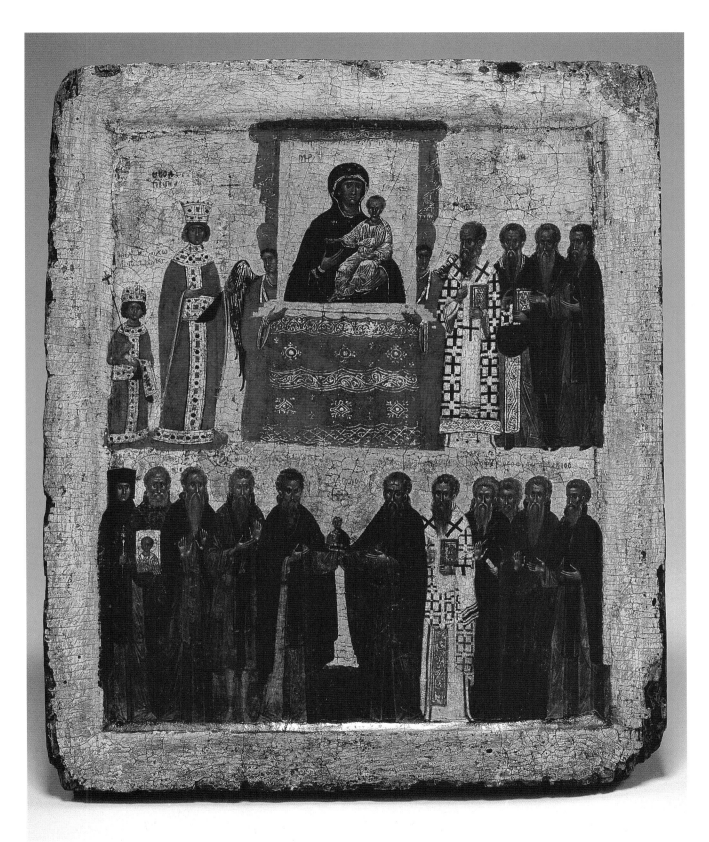

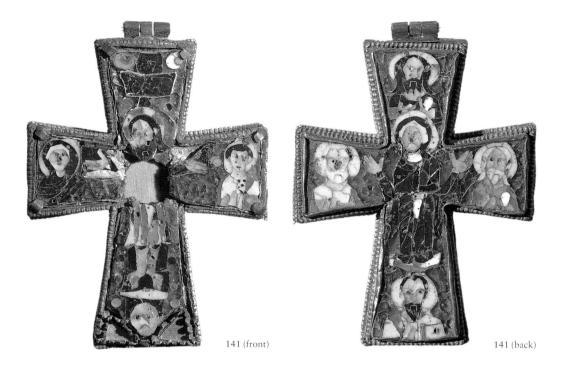

141 (front) 141 (back)

141 The Beresford Hope Cross

Eastern Mediterranean, second half of 9th century

London, Victoria and Albert Museum, Metalwork and Jewellery
Collection, 265/265A–1886

H. overall 91.3 mm, W. 57 mm, thickness 17 mm

Debruge Duménil Collection; Beresford Hope Collection. Bought
by the V&A in 1886.

Silver-gilt reliquary-cross, hinged to open, either side covered
with a cruciform gold cloisonné enamel plaque. On the
front is a depiction of Christ crucified between half-figures
of the Mother of God and St John the Evangelist; above are
the sun and a crescent moon, and below is Adam's skull.
Somewhat bungled Greek inscriptions in thin gold strip set
on edge in the enamel approximate to the conventional
abbreviation for 'Jesus Christ' and Christ's words from the
cross: '. . . behold thy son! . . . Behold thy mother! (John
19.26–7). On either side of Adam's skull is an empty trian-
gular setting; there is a large hole through the centre of this
half of the reliquary. On the back is the Mother of God in
orant pose, standing on a *suppedaneum*. At each end of the
cruciform enamel is the bust of a saint: John the Baptist
above, Peter to the left, Andrew to the right, and Paul below.
Identifying inscriptions share the technique of those on the
front and are scarcely more competent.

The figure-drawing is crude and the enamelling inexpert.
Three translucent colours are used on the cross, green, dark
blue and reddish brown, as well as a semi-translucent
brown; at least eleven opaque colours were employed.

The Beresford Hope Cross was made to contain a relic,
probably a fragment of the True Cross; it would have been
worn on a chain around the neck. The cloisonné enamel is
Vollschmelz, 'full enamel', where the figures have fully
enamelled backgrounds. These backgrounds, as on the cross,
are typically translucent green in the first phase of Byzantine
cloisonné enamelling, from the end of Iconoclasm in 843 to
around the middle of the tenth century. The cross has often
been attributed to Rome but fits perfectly into the first half-
century or so of Byzantine cloisonné enamelling: it is less
'primitive' than the Fieschi–Morgan reliquary in New York
(D. Buckton, 'The Oppenheim or Fieschi–Morgan reliquary
in New York, and the antecedents of Middle Byzantine
enamel', *Abstracts of the Eighth Annual Byzantine Studies
Conference*, Chicago, 1982, pp. 35–6; A. D. Kartsonis,
Anastasis: the Making of an Image, Princeton, 1986,
pp. 94–125) and less accomplished than the votive crown
of Leo VI (886–912) in Venice (exh. cat. *Treasury of San
Marco* (1984), no. 8).

J. Labarte, *Description des objets d'art qui composent la collec-
tion Debruge Duménil*, Paris, 1847, pp. 569–71; N. Kondakow
(N. P. Kondakov), *Geschichte und Denkmäler des byzantinischen
Emails . . .* , Frankfurt am Main, 1892, pp. 176–7, figs 49–50;
Rosenberg 1922, pp. 52–6; J. Reil, *Christus am Kreuz in der
Bilderkunst der Karolingerzeit*, Leipzig, 1930, pp. 74, 103–4;
Y. Hackenbroch, *Italienisches Email des frühen Mittelalters*, Basle,
1938, pp. 16–18; exh. cat. *Byzantine Art a European Art* (1964),
pp. 392–3; Wessel 1967, no. 8; M. Campbell, *An Introduction to
Medieval Enamels*, London, 1983, p. 15, pl. 5; exh. cat. *Treasury
of San Marco* (1984), pp. 124, 139, fig. 9A. DB

142 Gold and enamel earrings

Byzantium, first half of 10th century

London, BM, M&LA AF 338

47.0 × 38.8 and 44.6 × 36.1 mm

Burges Collection; Franks Collection. Bequeathed to the British Museum by Sir Augustus Wollaston Franks (1897).

Each earring of hollow construction, the front and back consisting of arcs of cloisonné enamel with, below, triangles of granules alternating with paired pearls threaded on projecting wires. Many of the pearls are missing. At the centre of the concave top is a gold bead surmounted by a hollow disk, the faces of which are cloisonné enamel medallions (one missing). Round the edge of each disk are wire loops for a string of seed-pearls, which would have run through a hole in the bead. Similar loops are soldered on either side of a flange on the top and the underside of the body; no strung pearls survive. On either of the rectangular ends of the earring is a gold sphere; the hoop of the earring is of tapering wire, the thicker end soldered into a hole in one of the spheres and the thinner end fitting into a hole in the other.

The enamel designs of the medallions consist of: obverse, a bird with a small almond-shaped wing, looking backwards, with a twig in its beak; at the other end of the twig is a leaf, and there is an isolated leaf-shape in the field. Reverse, a double quatrefoil rosette (missing from one of the earrings). The designs on the curved enamels are: obverse, at each end, a bird with a small almond-shaped wing, facing outwards, with a single-leaved twig in its beak; in the centre is a similar bird, looking upwards, also with a single-leaved twig in its beak and, in the field, between each pair of birds, is a round cell. Reverse, in the centre, a bird identical to the bird in the centre of the obverse with, to either side, a running vegetal scroll. The enamel on both earrings is iridescent and has lost almost all of its original colour. There are, however, indications that the backgrounds were once translucent green, and that the birds on the curved enamels had opaque white heads and necks, translucent blue bodies

and opaque blue wings. The heads and necks of the birds on the medallions were probably always the same colour as the bodies; the wings appear to have originally been opaque white.

The closest parallel with regard to size and shape is provided by a pair of earrings in the Kanellopoulos Museum, Athens (Brouskari 1985, p. 144), which measure 54.25 × 40 mm. Along the convex underside of each, triangles of granulation alternate with wire stalks; on each of the extant stalks is threaded an amber bead, almost certainly a modern replacement. Instead of the discoid elements of the British Museum earrings, the equivalent component above the arc on each of the Kanellopoulos Museum examples is almond-shaped. However, fragments of a similar earring in the same museum include a disk with cloisonné enamel rosettes on either side, still partly surrounded by strung pearls, and earrings forming part of the Preslav Treasure also have disks surmounting the arcs (exh. cat. *La Bulgarie médiévale, art et civilisation*, Paris (Grand Palais), 1980, nos 163 and 165; Totev 1983, figs 15, 18–19). A striking parallel to some of the birds on the British Museum earring can be found on a necklace in the Preslav Treasure, particularly on the terminals (Totev 1983, fig. 9), where, against a translucent green background, gold cloisonné enamel birds with white heads and necks, translucent blue bodies and small opaque blue almond-shaped wings hold single-leaved twigs in their beaks.

The consensus of opinion, from Sir Arthur Evans in 1884 to Professor Haseloff as recently as 1990, has been that the British Museum earrings date from the sixth or seventh century. However, examples of the type form part of the Preslav Treasure, discovered on the site of Great Preslav, Bulgaria, which was founded at the end of the ninth century; included in the treasure are fifteen silver coins from the reign of Constantine VII Porphyrogennetos and Romanos II (945–59). Other earrings of the type, from Crete, are said to have been unearthed together with Byzantine coins, the latest being a gold nomisma of Constantine Porphyrogennetos and Romanos II (*Collection Stathatos*, nos 4A–B, 5A–B, 12, pls II–II *bis*). Technically, the enamel of the earrings fits comfortably into the late ninth and the first half of the tenth century, when cloisonné enamel with translucent green backgrounds was the norm.

A. J. Evans, 'Antiquarian researches in Illyricum', *Archaeologia* 48 (1884), p. 51; Dalton 1901, no. 267, pl. IV; Rosenberg 1922, pp. 8–9, figs 16, 21; Dalton 1925, p. 338; *Collection Hélène Stathatos, objets byzantins et post-byzantins*, Limoges(?), 1957, p. 20 (a), pp. 22–3, fig. 5; Haseloff 1990, pp. 21–2, 24, 47 fig. 22a–d. Exhibited: *Das Reich der Salier, 1024–1125*, Speyer (Historisches Museum der Pfalz), 1992, no. 3. DB

 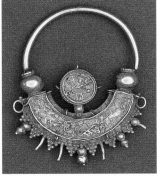

142

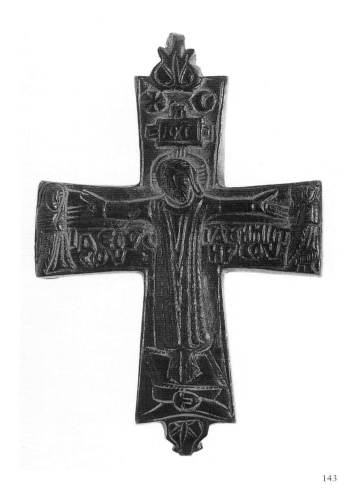

143

143 Reliquary cross

Eastern Mediterranean, 9th or 10th century

London, BM, M&LA 1985,3–5,1

H. 122 mm, W. 79 mm

Bought by the British Museum in 1985, with the help of Neil Phillips, QC.

Copper-alloy reliquary cross cast in two separate pieces and hinged at top and bottom (one of the upper loops missing). On the front, in relief, is a figure of the crucified Christ, flanked by the diminutive figures of the Mother of God (left) and St John the Evangelist (right). Christ has a cross-nimbus, wears a *colobium*, and rests his feet on a *suppedaneum*, beneath which is a crude representation of Adam's skull; above Christ's head is a *tabula ansata* inscribed ĪC XC̄, and representations of the sun and moon. Beneath each of his arms is the Greek inscription, in two lines: 'Behold thy son; behold thy mother' (John 19.26–7). On the reverse is the draped figure of the Mother of God Nikopoios and, in roundels at the extremities of the cross, busts of the four evangelists, three of whom are bearded. In the field to the left and right of the Mother of God is a vertical inscription: НАГІА / ѲЕОТОНΙ.

Although reliquary crosses with similar iconography have been found in sixth- and seventh-century contexts (M. von Bárány-Oberschall, 'Byzantinische Pektoralkreuze aus ungarischen Funden', *Forschungen zur Kunstgeschichte und christlichen Archäologie* 2 (1953), pp. 207–51), a number of factors suggest a post-Iconoclastic date for this example. The juxtaposition of the Crucifixion on one side with the Mother of God Nikopoios on the other can be observed on several other reliquary crosses: on a gold example excavated at Pliska, Bulgaria, which has four Church Fathers in place of the evangelists (L. Dontcheva, 'Une croix pectorale-reliquaire en or récemment trouvée à Pliska', *Cahiers archéologiques* 25 (1976), pp. 59–66), on two silver and niello crosses, one in a private collection in London (A. D. Kartsonis, *Anastasis: the Making of an Image*, Princeton, 1986, figs 27a–b) and the other in the church of San Nicolò di Mendicoli, Venice (I. Kalavrezou, 'Images of the Mother: when the Virgin Mary became Meter Theou', *Dumbarton Oaks Papers* 44 (1990), fig. 6), both with busts of the four evangelists, identified by inscriptions, and, finally, an identical copper-alloy example in the Kanellopoulos Museum, Athens (exh. cat. *Splendeur de Byzance* (1982), no. Br.13). As on the British Museum example, all these crosses give the image of the Mother of God the title 'Theotokos', which, together with the representations of the Church Fathers on the Pliska cross, argues for – at the earliest – a late eighth or ninth century date (on the dating of 'Theotokos' in this context, see Kartsonis, *op. cit.*, pp. 105–9, and Kalavrezou, *op. cit.*, pp. 165–72).

Sale cat. *Icons, Russian Pictures, Works of Art and Fabergé*, Sotheby's, London, 20 February 1985, lot 21. CJSE

144 Crucifix from Cambridgeshire

Eastern Mediterranean, 9th or 10th century

Cambridge, Fitzwilliam Museum, Department of Applied Arts, M.11–1978

88.5 × 59 mm

Found at Haddenham, Cambridgeshire, in 1977. Bought by the Fitzwilliam Museum in 1978.

Copper-alloy cross with slightly flaring arms, cast in one piece with a simple suspension-loop. On the face, in relief, is a representation of Christ crucified, below a *tabula ansata* bearing the superscription IC XC ('Jesus Christ'); he wears a *colobium*. At either end of the horizontal beam of the cross is a bust in relief; at either end of the vertical beam are twinned busts. The relief is ill-defined, either through wear or, more probably, through faulty casting. On the reverse there is a cruciform depression at the intersection of the

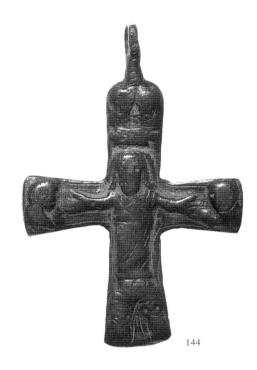

144

completes a list of patriarchs of Constantinople with the patriarchate of the iconoclast Theodotos (815–21), giving its duration as five years and nine months. Immediately after this entry a later hand, using a darker ink, continues the list to the patriarch Polyeuktos (956–70).

Only two manuscripts preserve the *Breviarium* of Nikephoros, both dating from the tenth century. The text they contain, however, is not the same. The most obvious difference is that the present text concludes with the overthrow of Philippikos Bardanes in 713, whereas that of the other manuscript (Vatican gr. 977) ends fifty-six years later, with the marriage of Leo IV to Eirene in 769. The London manuscript also presents many differences of wording, particularly in the early part of the text.

One good explanation is that the London manuscript contains a copy of an early version of Nikephoros's work, made by a scribe who was unaware that Nikephoros's text had been partly revised by the author as it now appears in the Vatican manuscript. These two volumes therefore preserve something very rare, namely two attempts by a Byzantine writer at writing what would be accepted as proper history.

arms of the cross, and deliberate scratches, some of which can be read as Greek letters.

The busts to either side of Christ almost certainly represent the Mother of God and St John the Evangelist (cf. no. 143). Those at the top and bottom of the cross may represent the four evangelists. The cruciform depression on the back may have been intended to hold a relic; the metal-casting, however, was inexpert, and the cavity is too shallow for that purpose. Byzantine representations of the Crucifixion in which Christ is wearing a *colobium* are generally earlier than those in which he wears a loincloth.

Unpublished. D B

145 The *Historia Syntomos* (*Breviarium*) of Nikephoros

Eastern Mediterranean, first half of 10th century

London, British Library, Additional MS 19390, folios 23v–24

Page 205 × 145 mm

From a monastic library, possibly on Mount Athos. Bought by the British Museum from the forger Constantine Simonides in 1853.

On the right the *Breviarium* of Nikephoros, Patriarch of Constantinople from 806 to 815 (d. 828), begins its account of the fortunes of the Byzantine Empire in 602, at the death of the Emperor Maurice and accession of Phokas. Red capitals highlight the title, and a decorated initial M set in the margin marks the beginning of Nikephoros's text, which continues in minuscule. On the left the same hand

145

The original list of patriarchs forms part of the *Chronographikon syntomon*, a short set of chronological tables attributed elsewhere to Nikephoros. Together with the preceding copy of the *De dormientibus in fide*, purportedly by John of Damascus, it and the *Breviarium* form the last fifth of an originally much larger codex.

L. Orosz, *The London Manuscript of Nikephoros 'Breviarium'*, Budapest, 1948; Nikephoros, Patriarch of Constantinople, *Short History*, ed. C. Mango, Washington, D.C., 1990, pp. 23–5. SMcK

146 Works of Lucian with additions by Arethas of Patrae

Constantinople, between about 912 and 914

London, British Library, Harley MS 5694, folios 72v–73r

Folio 305 × 215 mm

In southern Italy by the second half of the fifteenth century, when it was owned by Ioannes Chalkeopylos, of Constantinople. Given by Henricus Casolla, of Naples, to Antonio Seripandi (d. 1539). Bequeathed by Cardinal Girolamo Seripandi (d. 1563) to the Augustinian Canons of San Giovanni di Carbonara, Naples, from whom it passed to Jan de Witt (d. 1701) and thence to Jan van der

146

Marck. Purchased for Edward Harley, 2nd Earl of Oxford, in 1726 at the sale of the library of John Bridges (d. 1724). Bought for the British Museum from Margaret, Duchess of Portland, in 1753.

On the right page is the beginning of the Lexiphanes by the second-century Atticist author Lucian: a dialogue between Lycinus and Lexiphanes, a linguistic pendant, on the use and misuse of language. On the left is the conclusion of Lucian's dialogue between the Cynic Crato and Lycinus on the subject of dance. Numerous scholia written in very small uncials and formed into attractive shapes in the right margin comment on the minuscule text of the Lexiphanes.

This is the oldest manuscript of the works of Lucian. It was probably transcribed by the notary Baanes. The scholia, which are particularly profuse in the Lexiphanes, are in the hand of the first owner of the manuscript, the scholar Arethas of Patrae, Archbishop of Caesarea from 902. They illustrate the deep interest of a prominent Byzantine churchman in classical antiquity, its pagan literature and Attic prose. Sadly, only a quarter of the original manuscript survives.

E. Maunde Thompson, *Catalogue of Ancient Manuscripts in the British Museum*, pt 1: *Greek*, London, 1881, pp. 15–16, pl. 18; C. E. Wright, *Fontes Harleiani*, London, 1972, pp. 82, 97, 100, 233–4, 249, 302 and 357; N. G. Wilson, *Scholars of Byzantium*, London, 1983, p. 124. SMcK

147 St Luke and the beginning of the Acts of the Apostles

Constantinople, mid 10th century

London, British Library, Additional MS 28815 (New Testament), folios 162v–163r

Folio about 290 × 210 mm; image 170 × 130 mm

Bought by the British Museum from Sir Ivor Bertie Guest, 2nd Bart (1835–1914), in 1871. The last gatherings of the book (see below) were purchased separately in Ioannina in 1864 for Angela Burdett-Coutts. It is not clear how, where, or when before 1864 they were separated.

St Luke stands writing on a long scroll unrolling across his desk. Further scrolls, two of them tied with lengths of ribbon, are seen below. The hand of God appears from a segment of heaven to instruct the evangelist in what he is to write. Luke holds a tubular pen-case with spare reed pens and, perhaps, weighted cords. The artist used thick layers of opaque pigment, superimposed boldly to suggest shadows and highlights. On the facing page is the opening of Acts – believed to have been written by Luke – with a headpiece above the title, 'Acts of the Holy Apostles', written in an ornate gold display-script, and a large but plain gold T. The headpiece, in 'fretsaw' (*Laubsäge*) style (Weitzmann), is simply coloured with gold, blue and green, within bounding lines drawn in a red lake ink. The same red lake was used to

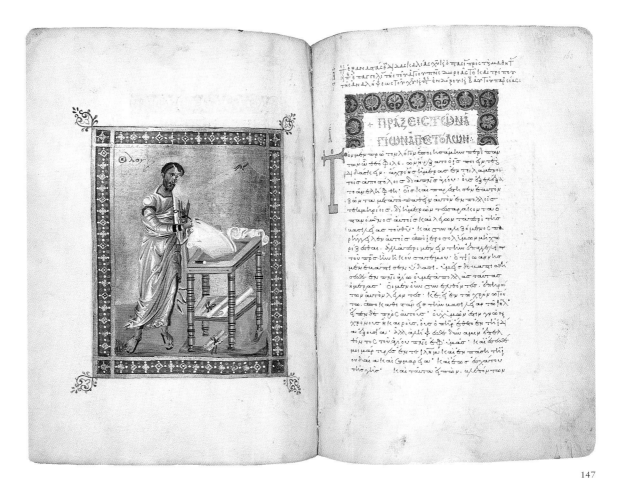

147

write the text above, the title of the first chapter in Acts. The image on the facing page also uses the same pigments, and the evangelist's name is written in the brown ink of the main body of the text. It seems likely, therefore, that a single craftsman was responsible for all the writing and painting seen in this opening – he was both artist and scribe.

This manuscript together with BL Egerton 3145 once formed a complete New Testament in more than 370 folios. Images of Matthew and Mark have been removed from the Gospels (Luke and John survive on folios 76v and 126v), and lists of the chapters have also been cut out before each Gospel. Between folios 75 and 76 (before Luke) are the stubs of a double leaf of purple-dyed parchment, on which the chapter titles were written in gold, and there are offsets of gold from similar lists before Mark and John. These testify to an effort to make the book particularly magnificent. Although not prepared or adapted at a later date for liturgical use, the decoration of the front cover of the book implies that it was used processionally and symbolically in the liturgy, at least from about the sixteenth century. The cover is repoussé work on gilded base metal. In the centre is a Deesis, the three figures with translucent enamel haloes.

This is framed by four panels, the same two patterns repeated twice, testifying to the reuse of a mould. One pattern contains the four evangelists with Peter and Paul. The other is most unusual: it shows the overthrow of the heretics Nestorius and Noetus, with accompanying inscriptions.

Weitzmann 1935, p. 20, figs 136–9; *Catalogue of Additions to the Manuscripts 1936–45*, 1, London, 1970, pp. 337–8 (on Egerton 3145); J. Walter, 'Heretics in Byzantine art,' *Eastern Churches Review* 3 (1970), pp. 47–8, fig. 5 (the cover). Exhibited: *Byzantine Art* (1964), no. 293; *Splendeur de Byzance* (1982), no. M6.
JL

148 St James and the beginning of his Epistle

Constantinople, mid 10th century

Oxford, Bodleian Library, MS Canon. Gr. 110 (Acts and Epistles), folios 106v–107r

Folio 190 × 130 mm; image 135 × 112 mm

Bought by the Bodleian at the sale of the Canonici Collection, Venice, in 1817.

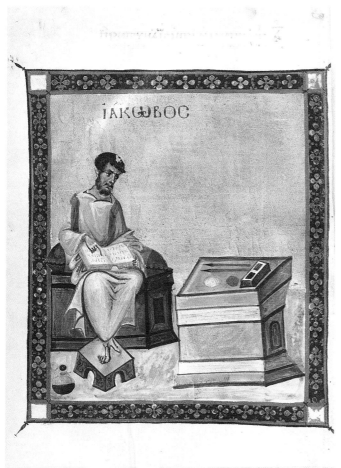

148

148

The image on the left page is visually divided into two halves. The apostle James, beneath the conspicuous carmine title ʼΙΑΚΩΒΟϹ ('James'), is seated at the far left, his cushion extending over the frame. He points with his right index finger to the illegible text of the book on his lap, emphasising his role as author. His desk is the main element in the right half of the miniature, and displays carmine and black ink, two reed pens, a sponge and what may be pumice; a large bottle of ink is placed in the foreground. The gilded background has been incised with buildings to left and right. On the facing page the title of the epistle is displayed in a gilded headpiece. There is a gold initial I below, and the *kephalaion* title, written entirely in gold, is conspicuous above. The opening is in excellent condition, with the exception of the square blue panels at the corners of the frame of the image, which have flaked off.

The image is one of a set with those of the other authors of Acts (Luke) and the Epistles (Peter, John, Jude and Paul). All are on single leaves and appear to have been an original part of the plan for this very carefully and expensively produced book. The artist seems to have sought variety in the five author images: Luke, James and Paul were set awkwardly far to the left, Peter and Jude to the left of centre, and John centrally. All five look to the right, emphasising their link to the text on the facing pages, but each holds his book, roll or pen in a different way. The contrast between the range and handling of the pigments in the images, as distinct from the headpieces, is striking, but this is a difference of stylistic convention and not necessarily an indication of different craftsmen at work.

Hutter 1977, no. 3, col. pl. II, figs 11–26; Hutter 1982, p. 316; M. L. Agati, *La minuscola 'bouletée'*, Littera Antiqua, IX, 1–2, Vatican City, 1992, pp. 117–18. Exhibited: *Byzantine Art a European Art* (1964), no. 302.

JL

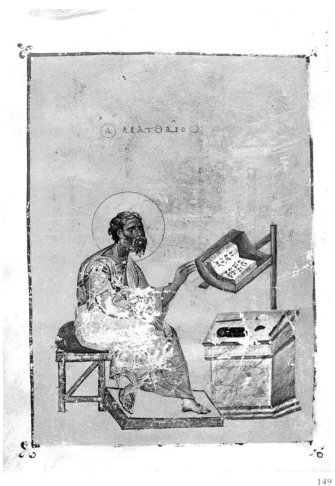

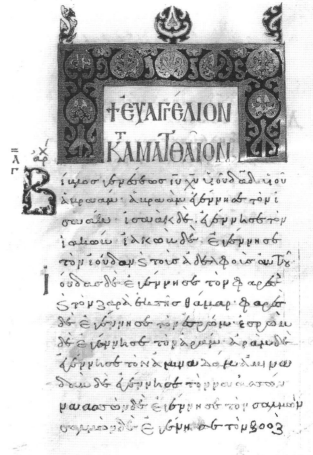

149

149

149 St Matthew and the beginning of his Gospel

Constantinople, mid 10th century

Oxford, Bodleian Library, MS Cromwell 16 (Gospel Book), folios 30v–31r.

Folio 205 × 145 mm; image 135 × 97 mm

In the possession of the father of a certain Ioannes Doukas, whose birth in 1276 is recorded on folio 1 verso. The manuscript, with five others, came to the Bodleian from the Pantocrator Monastery, Mount Athos, in 1727. (Despite the shelf-mark, there is no connection with Cromwell.)

On the left page Matthew pauses from writing his Gospel. He is seated on a cushion on a simple bench. His left hand is stretched out to the lectern on which he has written the opening words of his Gospel in a book. His right hand, holding a reed pen, rests on his right leg. Below the lectern is a blue marble desk. The overall gold setting has been incised with a building to either side, linked by a wall with apertures, above which feathery trees can be made out. On the facing page is the title in gold and carmine letters with a Π-shaped headpiece of 'fretsaw' style executed in blue, green and gold. Below, the text begins with a gold and blue B. The margins of both pages have been darkened by dirty fingers, and the text has been re-inked in places for legibility. The pigments of the evangelist's drapery and arm have flaked extensively, but fortunately the head is well preserved. It was painted with a very fine brush, and shows minute attention to detail. The artist paid special attention to Matthew's waving hair and curling beard. A silk curtain which protects the miniature when the book is closed may date, like part of the binding, from the fourteenth century.

Although only one evangelist survives, together with decorated Canon Tables, we can assume that a set of four was made and included. It has been suggested (Hutter 1977, p. 10) that the Matthew image, which is on a single leaf, was added a few decades after the book had been written, but the gold and colour of the Matthew headpiece on folio 31r have left no trace on folio 29v, which would have happened if folio 30 (with the Matthew image) had not been present

(see also Hutter 1982). Although different in style and technique from its headpiece, the Matthew image must therefore be original. The book was adapted for liturgical use, by marginal annotations and additions at the beginning, by the father of a Ioannes Doukas, around 1276.

Hutter 1977, no. 5, figs 34–43; Hutter 1982, pp. 317–8. J L

150 St Luke with the opening of the lections from his Gospel

Byzantium, possibly Italy, or Cappadocia, second half of 10th century

London, British Library, Arundel MS 547 (Gospel Lectionary), folios 94v–95r

Folio about 290 × 220 mm (heavily trimmed); image 185 × 155 mm

Acquired by Thomas Howard, 14th Earl of Arundel (d. 1646); presented to the Royal Society in 1667 by his grandson, Henry Howard, 6th Duke of Norfolk. Transferred to the British Museum in 1831.

St Luke writes the Gospel in the book he holds. Black and red ink and various scribal tools can be seen on his desk. Where the pigment has flaked, underdrawing in a pale brown ink can occasionally be seen. The overlapping rectangles of gold leaf in the background are also visible. On the facing page is the title ('First Saturday [of readings from St Luke]. The Beginning of the Indiction of the New Year [1 September]') set within an ornate headpiece of ornate stylised flowers, resembling cloisonné enamelwork. Below, an ornate T, some 100 mm tall, introduces the Gospel reading (Luke 4.31ff), with this page written entirely in gold. The unusual initial is formed of an arm, brandishing the cross-bar of the T, supported on a pair of legs. The similar palette used on these two pages suggests that the same artist could (but need not) have painted both.

This large book shows many signs of wear and tear and is incomplete at the end (folio 329). In addition to the Luke, it contains original images of Matthew (folio 63v) and Mark (folio 131v). The John on folio 1 verso, however, now very damaged by flaking of the pigment, is a replacement leaf painted around the middle of the fourteenth century, indicating that the book continued in use at that time. Its bold and stylised majuscule script is characteristic of lectionaries and doubtless was intended to make a visual link with a tradition seen as dating back to earliest Christian times. There is an ekphonetic notation throughout, and many decorative initials and smaller headpieces.

Summary Catalogue, pp. 48–9; Weitzmann 1935, pp. 70–1, figs 473–7; A. Grabar, *Les manuscrits grecs enluminés de provenance italienne (IXe–XIe siècles)*, Paris, 1972, no. 32, figs 214–19.
 J L

151 Marble panel with eagles and hares

Probably Constantinople, 10th century

London, BM, M&LA 1924,10–17,1

L. 2450 mm, H. 920 mm; thickness 80 mm

From Constantinople. Bought by the British Museum in 1924.

Panel of grey marble, carved in deep but flat relief with, in the centre, an eagle grasping a snake and, on either side, an eagle standing on a hare. The background is filled in by three leafy branches. The group on the right differs from the other two in the treatment of the eyes, feathers and leaves. The panel is broken into ten pieces, the top right corner missing. The edges are roughly finished; the left side is cut away to 40 mm. There are three dowel holes on the base.

The length of this transenna, or closure slab, suggests that it may come from the gallery of a church: a similar outsize example measuring 2610 mm in length is known from the Yenikapi area of Constantinople (Firatli 1990, p. 362, pl. 100). The motifs of eagle and snake and eagle and hare are frequently found in Middle Byzantine sculpture (e.g. on the Little Metropolis in Athens: Grabar 1963, p. 124, pl. LXIV, and II, no. 81b, pl. LXVIII), and are presumably symbolic. The sculptures of the tenth-century north church of Constantine Lips in Constantinople perhaps provide the nearest iconographic parallel to this piece, though there the eagle and hare theme is treated with rather more vigour (C. Mango (ed.), 'The monastery of Lips (Fenari Isa Camii) at Istanbul', *Dumbarton Oaks Papers* 18 (1964), pp. 249–315).

E. Kitzinger, *Early Medieval Art in the British Museum*, London 1940 (3rd ed. 1983), p. 58, pl. 34; R. Wittkower, *Allegory and the Migration of Symbols*, London, 1977, p. 35, fig. 44; V. M. Strocka, 'Byzantinisch oder ptolemäisch?', *Festschrift Gosebruch*, 1984, pp. 29–36, fig. 10.
 RKL

152 Ivory panel with St John the Baptist

Constantinople, 10th century

Liverpool, National Museums and Galleries on Merseyside, Liverpool Museum, M.8014

241 × 103 mm

Bought by Fejérváry from Böhm in Vienna in 1844. Subsequently acquired by Joseph Mayer, who donated it to Liverpool in 1867.

The tall, elegant figure of St John the Baptist, standing on a footstool and holding an unfurled scroll, has been removed from a larger ivory, and is now displayed against a modern ivory background. The face and left foot of the saint are damaged, but otherwise the figure is in excellent condition.

The Baptist is shown in a long belted tunic, and a cloak whose rough edges recall the coat of skins traditionally associated with him. The broken stump of a staff or cross

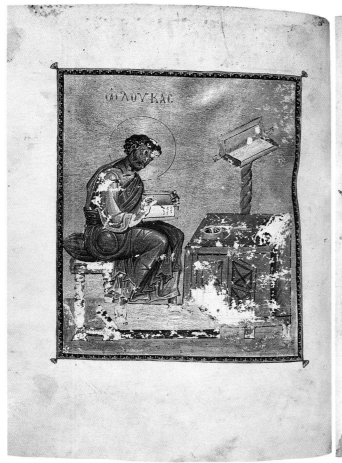

150

150

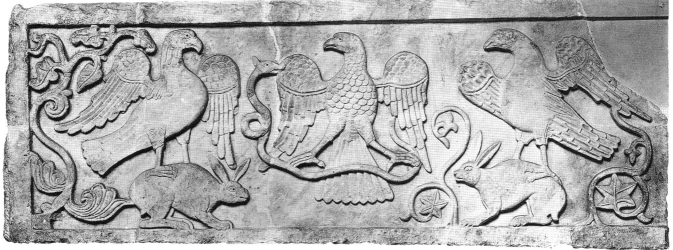

151

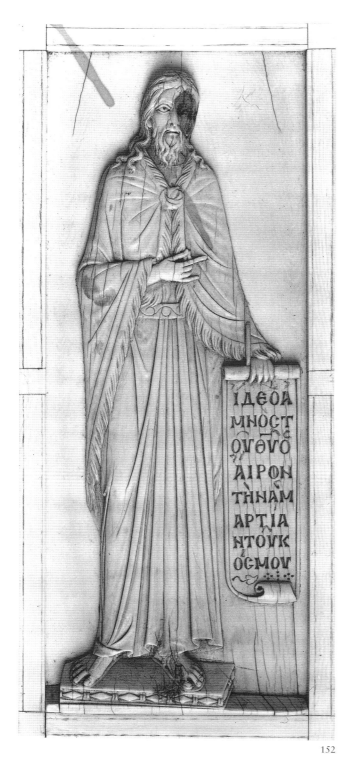

152

can be seen in his left hand. The Greek inscription on the scroll reads: 'Behold the Lamb of God, which taketh away the sins of the world' (John 2.29).

The tall slim proportions of the Baptist are very characteristic of ivories of the so-called Romanos group, associated with the ivory of the Emperor Romanos in Paris (Goldschmidt and Weitzmann 1934, no. 34), which is now generally thought to represent Romanos II. In the original ivory, the Baptist was probably gesturing towards either Christ (as part of an unusual Deesis with the Theotokos (Mother of God) on the left of Christ; cf. no. 155), or to the Theotokos holding the infant Christ (cf. no. 156). The long inscription on the scroll is unique in Byzantine ivories; the accents over the Greek letters are very lightly carved and look to be a later addition.

Pulszky 1856, no. 44; Westwood 1876, p. 175; Gatty 1883, no. 28; Goldschmidt and Weitzmann 1934, II, p. 52; Gibson 1994, no. 20; Cutler 1994, pp. 17, 208, 210, 221, 278 n. 73, fig. 13f. Exhibited: *Carvings in Ivory* (1923), no. 57; *Art byzantin* (1931), no. 77; *Liverpool Ivories* (1954–5), no. 21; *Masterpieces* (1958), no. 76; *Byzantine Art a European Art* (1964), no. 68. AE

153 The Borradaile Triptych

Constantinople, 10th century

London, BM, M&LA 1923,12–5,1

272 × 157 mm (centrepiece), 78 × 85 mm (leaves), depth 10 mm

Said to be from a convent in Rheims. Bought in 1905/6 by Charles Borradaile, who bequeathed it to the British Museum (1923).

The central panel shows Christ crucified, watched by the Mother of God and St John the Evangelist. Above their heads is a Greek inscription, which reads: 'Behold thy Son; Behold thy Mother' (John 19.26–7). The archangels Michael and Gabriel witness the event from above. The leaves show saints in pairs, all identified by Greek inscriptions. Left leaf: Sts Kyros; George and Theodore Stratilates; Menas and Procopius; right leaf: Sts John (paired with Kyros on the other leaf); Eustathius and Clement of Ankyra; Stephen and Kyrion. When closed the two leaves display crosses, each inscribed 'Jesus Christ *nika*' ('is victorious'), with roundels containing busts of Sts Joachim and Anna in the centres, with Sts Basil and Barbara, and John the Persian and Thekla at the terminals. Traces of a painted lozenge border can be seen on the right-hand leaf.

The elongated figures are characteristic of tenth-century style (cf. the St John the Baptist panel, no. 152), but the angularity most noticeable in the carving of Christ's arms and legs is less common; in some areas, such as the chins of the Mother of God and St John and the tops of the archangels' wings, the carving is cruder. It can be closely compared with the Crucifixion triptych in Paris (Goldschmidt and Weitzmann 1934, no. 39). There are some

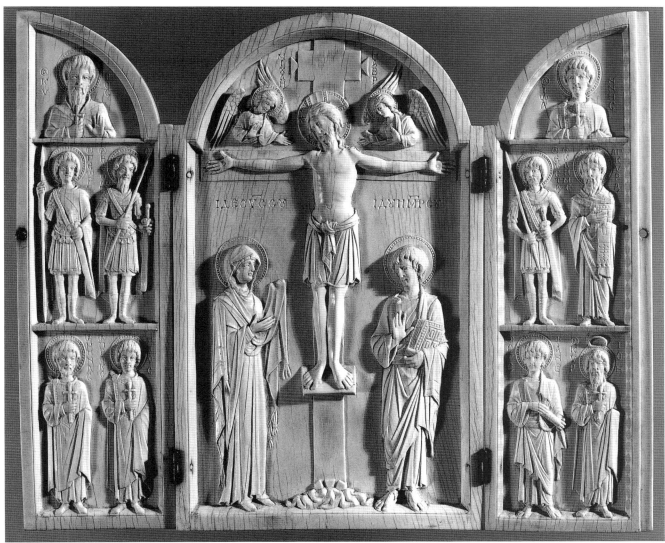

153

peculiarities, notably the absence of any inscription ident-
ifying Christ, especially given the presence of the *tabula*
above Christ's head. The pairing of saints is also unusual,
such as St Eustathius (a warrior martyr) with Clement of
Ankyra (a Church Father). St Kyrion, one of the Forty
Martyrs of Sebaste, is not normally seen on his own, and the
disk above his head is unexplained, except, perhaps, as a
martyr's crown. The choice of saints must reflect the par-
ticular interests of the patron, who remains unidentified
(Goldschmidt and Weitzmann's proposal of Anna, daughter
of the Emperor Romanos II, cannot be supported).

O. M. Dalton, in *Proceedings of the Royal Society of Antiquaries*
26 (1913–14); Goldschmidt and Weitzmann 1934, no. 38;
Kitzinger 1955, pp. 57, 108, pl. 32; D. Talbot Rice, *Art byzantin*,
Paris–Brussels, 1959, pp. 104–5; I. Kalavrezou-Maxeiner, 'Eudokia
Makrembolitissa and the Romanos Ivory', *Dumbarton Oaks*

Papers 31 (1977), p. 324, fig. 23; Cutler 1994, p. 235, fig. 242.
Exhibited: *Carvings in Ivory* (1923), no. 55; *Masterpieces* (1958),
no. 124; *Byzantine Art a European Art* (1964), no. 79; *Sint Michiel*
(1979), no. 51; *Splendeur de Byzance* (1982), iv.9. AE

154 Ivory panel with Christ Pantocrator

Constantinople, end of 10th century

Cambridge, Fitzwilliam Museum, Department of Applied Arts,
M.13–1904

138 × 97 mm

From the (relatively modern) cover of McClean MS no. 30, a Gospel
Lectionary produced in Ottonian Germany. Formerly in the
Barrois Collection, Ashburnham (sold June 1901, lot 189).
McClean Collection. Bequeathed to the Fitzwilliam Museum by
Frank McClean (1904).

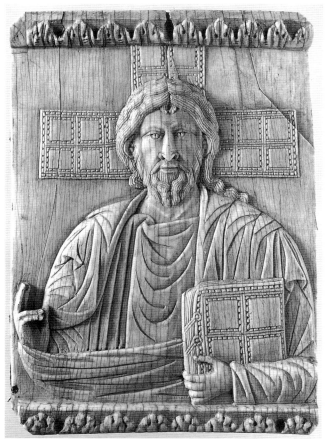

154

Ivory panel carved with a half-figure of Christ Pantocrator (all-powerful, Almighty), in tunic and pallium, a book with a jewelled cover in his left hand, his right raised in benediction. There is no halo, but behind Christ's head is carved the upper part of a *crux gemmata*. There is a raised acanthus border at the top and bottom of the ivory, pierced and plugged in places; the panel has been cut down at the sides. While the carving is generally in low relief, the foremost fingers of the right hand are sculpted in the round, with the palm hollowed out behind.

Almost identical representations of Christ Pantocrator are to be found in the Louvre in Paris and in the Hermitage in St Petersburg (Goldschmidt and Weitzmann, II, nos 146–7). Holes in the borders of all these ivories suggest that they were once the centrepieces of triptychs, presumably representing the Deesis, with the Mother of God and St John the Baptist carved on the wings.

Dalton 1912b, p. 36, no. 37, pl. VIII; M. H. Longhurst, 'Two Byzantine ivory reliefs at South Kensington', *Burlington Magazine* 44 (1924), p. 252, and *Catalogue of Carvings in Ivory* (Victoria & Albert Museum), I, London, 1927, p. 40; Goldschmidt and Weitzmann 1934, p. 65, no. 148, pl. LII. Exhibited: *Carvings in Ivory* (1923), no. 61; *Masterpieces* (1958), no. 65. DB

155 Ivory panel with the Deesis

Eastern Mediterranean, 10th or 11th century

Liverpool, National Museums and Galleries on Merseyside, Liverpool Museum, M.8020

146 × 108 mm, depth 7 mm

Bought by Fejérváry from Böhm in Vienna in 1844. Subsequently acquired by Joseph Mayer, who donated it to Liverpool in 1867.

The panel has a long crack running down its right side, but is otherwise well preserved. It shows the 'Deesis': the intercession of the Mother of God and St John the Baptist with Christ, who stands in the centre, holding the Gospels and raising his right hand in a gesture of blessing. Above these three figures are busts of two angels and of Sts Peter and Paul. The carving is very shallow, and drapery and expressions are shown with a maximum of economy.

This panel was probably the centre of a triptych, the four original holes in the upper and lower borders acting to secure it to a larger frame. It is associated with a number of other panels, similar in scale and iconography, whose dating is imprecise. In comparison with the other ivories in the exhibition, the execution of this piece is relatively crude:

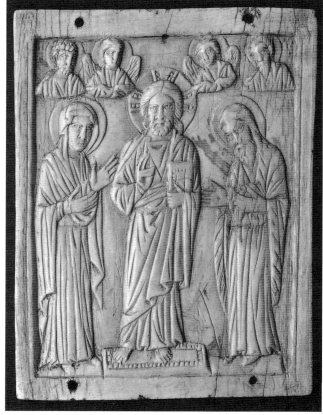

155

drapery is shown sketchily, and the busts in the upper row are very cursorily depicted.

Pulszky 1856, no. 38; Gatty 1883, no. 33; Goldschmidt and Weitzmann 1934, no. 173; Gibson 1994, no. 19. Exhibited: *Carvings in Ivory* (1923), no. 62; *Liverpool Ivories* (1954), no. 25; *Masterpieces* (1958), no. 92. AE

156 Ivory statue of the Mother of God

Probably Constantinople, probably late 10th or 11th century

London, Victoria and Albert Museum, Sculpture Collection, 702–1884

H. 325 mm

Castellani Collection. Bought by the V&A in 1884.

Ivory figure of the Mother of God Hodegetria ('showing the way', i.e. through the infant Christ), carved in the round. Part of the base has been lost, and in many areas the details of the statue have been lost through polishing. The head of Christ is a later restoration. The proportions of both figures are elongated: on the Mother of God this is most pronounced below the waist, whereas on Christ it is the torso which is extended. The thinness and elegance of the Mother of God, so apparent from the front, is not so pronounced when viewed from the rear. Both are identified by small inscriptions on their robes. A lozenge-pattern of dots is visible on the Mother of God's cloak (most noticeable on her left arm, and across her shoulders), suggesting that the statue was originally painted and gilded. The narrow slot running down her right arm seems to have been carved deliberately, but its purpose is unclear.

This is the only surviving free-standing Byzantine sculpture in the round. Because of its uniqueness, its dating is problematic. However, the proportions and style of drapery are similar to a number of ivory reliefs of the same subject which are normally dated to the end of the tenth or to the eleventh century.

Longhurst 1927, no. 41; Goldschmidt and Weitzmann 1934, no. 51; J. Beckwith, ' "Mother of God showing the Way": a Byzantine ivory of the Theotokos Hodegetria', *Connoisseur* 150 (1962), pp. 2ff; *The Medieval Treasury Catalogue* (Victoria & Albert Museum), London, 1986, pp. 166–7; Cutler 1994, pp. 18, 54, 262 n. 94, fig. 60. Exhibited: *Art byzantin* (1931), no. 132; *Masterpieces* (1958), no. 156; *Splendeur de Byzance* (1982), Iv. 27. AE

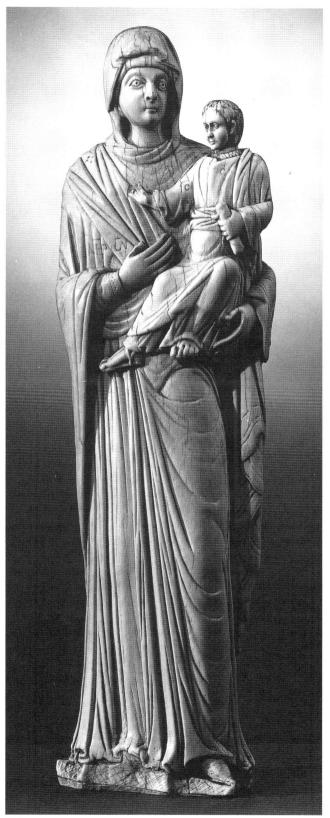

156

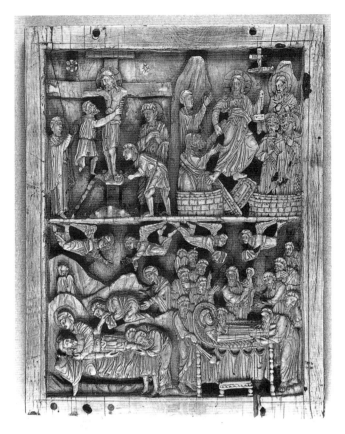

157

157 Ivory panel with Passion scenes

Byzantium, or Venice, 11th century

Luton, Wernher Collection, Luton Hoo Foundation, EE. 89

185 × 135 mm, depth 9 mm

Bought by Sir Julius Wernher in about 1900.

The panel contains four scenes, in two registers. On top are the Deposition and Anastasis (Harrowing of Hell) and, below, the Lamentation and Koimesis (Dormition of the Virgin). There is no vertical division between scenes. There is extensive undercutting of the ivory, which has been done with great expertise but has resulted in many breakages where the surface has been weakened. There are also two cracks running down the sides of the panel. The carving of the haloes caused some compositional problems, most noticeably in the Lamentation, where the Mother of God is shown supporting Christ's halo, rather than his head.

The carving is unusual in that the figures are carved in a flat style in the front plane of the ivory but are then very heavily undercut to give a sense of depth and volume. The dense style of the ivory, in terms both of crowded composition and of intricately depicted drapery, is similar to a group of ivories generally dated to the eleventh century. It has been argued that the ivory was made in Venice (Keck), but it could equally have been carved within the empire.

A. S. Keck, 'A group of Italo-Byzantine ivories', *Art Bulletin* 12 (1930), pp. 147–62; Goldschmidt and Weitzmann 1934, no. 209. Exhibited: *Carvings in Ivory* (1923), no. 65; *Byzantine Art a European Art* (1964), no. 85. AE

158 The Clephane Horn

Southern Italy, 11th century

London, BM, M&LA 1979,7–1,1

L. 575 mm, max. w. 115 mm

Sir Walter Scott implied that the Clephane Horn had been used for sounding the alarm from the battlements of Carslogie Castle, a seat of the Clephane family near Cupar, in Fife; according to tradition it had been in the castle since the Middle Ages. Since 1914 it has been in the British Museum, on loan from the Marquess of Northampton until 1979, when it was purchased for the Museum from the estate of the Sixth Marquess.

Oliphant, an ivory horn fashioned from a whole elephant-tusk, carved in relief with bands of ornament, comprising a frieze of stiff-leaved acanthus, contiguous roundels, animals and fantastic creatures, and running vegetal scrolls, as well as figural decoration identified by Dalton as scenes from the Hippodrome at Constantinople.

More recent scholarship has suggested that all oliphants were made in southern Italy, where Byzantine and Islamic influences were strong and where, incidentally, hippodrome scenes are found in pavement mosaics (E. Kühnel in *Jahrbuch der Berliner Museen* 1 (1959) and in *Die islamischen Elfenbeinskulpturen*, Berlin, 1971, H. Swarzenski in *Bulletin of the Boston Museum of Fine Arts* 60 (1962), and H. Fillitz in *Monographien der Abegg-Stiftung Bern* 2 (1967)). The Clephane Horn is in poor condition, with numerous cracks and losses; it was once encircled by silver bands, to which a shoulder-strap or cord would have been attached.

Sir Walter Scott, *Border Antiquities of England and Scotland*, 1814; O. M. Dalton, 'The Clephane Horn', *Archaeologica* 65 (1913–14), pp. 213–22; Cutler 1994, p. 78. DB

159 Plaque with Hodegetria and saints

Constantinople, 10th century

London, BM, M&LA 1981,1–3,1

H. 95.5 mm, w. 108.3 mm

Bought by the British Museum in 1981.

Rectangular copper-alloy plaque cast in low relief with the Mother of God Hodegetria flanked by the archangel Michael and St Theodore. In the centre is the full-length figure of the Mother of God, nimbed and draped, standing slightly to left and supporting the infant Christ on her left arm; Christ,

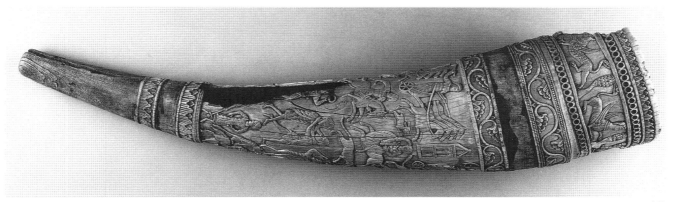

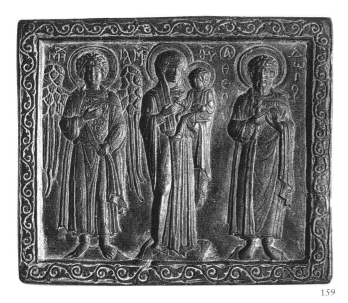

159

beeswax, using much the same skills and sorts of tool employed by ivory-carvers. When the wax model was finished, it would have been encased in clay, which was then baked to form a mould, the wax melting and escaping through holes left for that purpose. Molten casting-metal, bronze in this instance, would then have been poured in and allowed to cool before the mould was broken open to release the metal plaque for cleaning and finishing. Moulds used in this method of casting were, of course, not reusable.

Sale cat. *Medieval, Renaissance and Baroque Works of Art*, Sotheby's, London, 11 December 1980, lot 35. Exhibited: *Splendeur de Byzance* (1982), no. Br.24. CJSE

160 Gilded plaque with St Theodore

Constantinople, mid 11th century

London, BM, M&LA 90,7–1,3

H. 125 mm, W. 67 mm

Bought by the British Museum in Smyrna in 1890.

Oblong gilded copper-alloy plaque pierced at the top and with a broken projection at the bottom. The front is cast in low relief with the standing figure of St Theodore, nimbed, bearded and in military costume. The saint, who wears a sword, holds a spear in his right hand and an imbricated shield in his left. There is an identifying inscription in the upper field.

The composition of a standing military saint holding a spear and shield can be broadly compared with those on three other copper-alloy plaques ranging in date from the eleventh to the thirteenth century. Two are in the Museum Mayer van der Bergh, Antwerp, and the Kanellopoulos Museum, Athens (exh. cat. *Splendeur de Byzance* (1982), nos Br.23 and 28), while the third was once in the Königliche Museen, Berlin (G. Schlumberger, *L'épopée byzantine à la fin du dixième siècle*, pt II, Paris, 1900, p. 493). The elegant figural style of the saint's head, with its tightly arranged curls, long drooping moustache and

who is nimbed, holds a scroll in his left hand and extends his right towards his mother; to either side of her head is the abbreviated Greek inscription in intaglio 'Mother of God'. To the left is the winged and nimbed figure of the Archangel Michael, standing frontally, wearing a girdled tunic beneath a chlamys with *tablion*; to either side of his head is an abbreviated identifying inscription. To the right is the bearded figure of St Theodore, standing frontally, holding a cross in his right hand and raising his left in a gesture of benediction; he is nimbed and similarly attired to the archangel. On either side of his head is the intaglio inscription in Greek 'St Theodore'. The figures are enclosed by a raised border decorated with a running leaf-scroll. The plaque is slightly bowed and has traces of solder on the reverse.

The relief can be dated to the tenth century by stylistic comparison with ivories. Such a method is particularly apt in that the metal plaque was cast using the 'lost wax' process, entailing the creation of an original out of hard

pointed beard, finds even closer stylistic parallels in eleventh-century steatite plaques depicting St Theodore as, for instance, on three fragmentary plaques in the Dumbarton Oaks Collection, Washington, D.C., the Cherson Museum, and the Museo Sacro, in the Vatican (Kalavrezou-Maxeiner 1985, nos 5–7, pls 6–7). The military costume, which consists of a cuirass, military skirt, officer's sash and a knee-length mantle fastened on the right shoulder, is also consistent with apparel on eleventh-century ivories, steatites and seals.

The exact function of the plaque is unclear. The broken projection at the bottom of the plaque must originally have been a tang; this would suggest that the plaque was inserted into some sort of frame or stand, where it may have served as an ex-voto. Much of the gilding on the upper surfaces of the plaque has been lost, possibly through the continual contact of suppliants. The reverse of the plaque has multiple vertical striations of particular regularity. This suggests that the wax model from which the cast was constructed

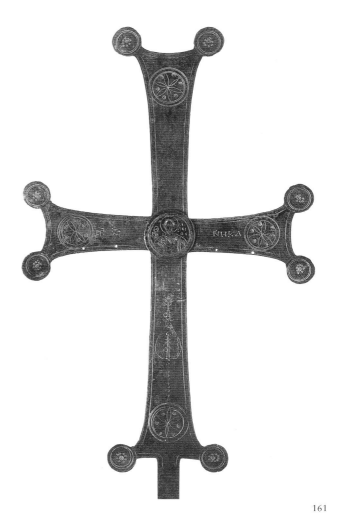

161

was built up on a flat surface, probably of a wood such as pine. The hole at the top of the plaque appears to be more recent.

Dalton 1901, no. 554. CJSE

161 Processional cross with bust of St Basil

Possibly Constantinople, 10th to 12th century

Oxford, Ashmolean Museum, Department of Antiquities, 1980.3

Total H. 380 mm, w. 206 mm

Roper Collection. Bought by the Ashmolean in 1980.

Latin cross, made of a thin sheet of brass, with relatively broad arms which flare at their extremities and terminate at the corners in large discoid finials. The bottom edge of each lateral arm is pierced twice for *pendilia*. The lower arm of the cross continues downward in a tang. At the centre of the cross is a compass-drawn medallion over which is attached a silver-inlaid roundel with an incised bust portrait of

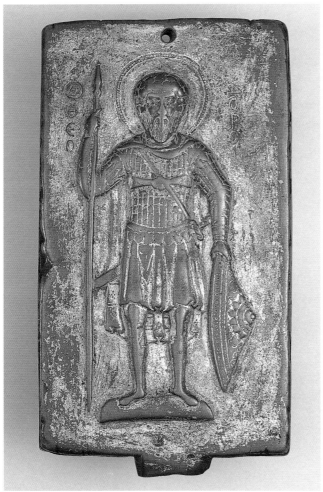

160

St Basil, with an identifying inscription. The obverse of the cross has incised decoration consisting of a pair of lines forming an outer border and, within the four arms, compass-drawn medallions enclosing rosettes with double punched circles between their six petals. Smaller punched circles ornament the terminal disks on the arms. From the top of the medallion in the lower arm a row of double punched circles extends upward to support a pointed ovoid motif embellished with stippling and rows of single punched circles. An inscription with dotted serifs, [I]H[σοῦ]C X[ριστό]C NHKA ('Jesus Christ is victorious'), is divided between the lateral arms of the cross. The reverse side of the cross has a pair of incised lines surrounding its edge and a broad strip of metal inlaid to reinforce the vertical arms.

This object is a smaller and more simply decorated version of no. 175. The inscription referring to the victorious Christ appears in many contexts. The roundel with St Basil may not be contemporary with the cross: the lettering differs somewhat from that on the cross itself. A gilded and nielloed bust medallion of St Basil appears on a discoid finial of the silver Adrianople cross (Bouras 1979, fig. 15).

A similar cross, but with more elaborate decoration closer to that of no. 175, was recently on the market (*Kunst der Antike*, Galerie Günter Puhze, Freiburg im Breisgau, cat. 8 (1988–9), no. 78); this cross has the same victorious Christ text, but inscribed sideways on the upper arms, as the Anastasia text is on no. 175. Another related cross recently appeared in New York (see no. 175), and the right arm of yet another was excavated at Aboba Pliska (F. Uspenski *et al.*, 'Aboba-Pliska', *Bulletin of the Russian Archaeological Institute in Constantinople* 10 (1905), p. 287, pl. LVI,6), together with other church items datable to the tenth and eleventh centuries (Mango 1994, p. 199). For comments on the shape and decoration, see no. 175.

Unpublished. Mango, forthcoming. MMM

162 Coin-weight

Constantinople, early 11th century

London, BM, M&LA 1980,6–1,265

Max. diam. 18.6 mm. Weight 3.56 g

Roper Collection. Bought by the British Museum in 1980.

Discoid copper-alloy weight struck on the obverse: + / ΔY / O, and on the reverse: TE/TAP/TⲰN ('[nomisma] of two quarters').

This weight was clearly intended for checking the light-weight nomisma known as the *duo tetarton*, a coin first introduced by Nikephoros II Phokas (963–9; Grierson 1982, p. 196). The word *tetarton* is related to the word for a quarter, and Dworschak suggested that the word signified that a quarter of a scruple had been taken off the weight of the nomisma (Dworschak 1936, pp. 77–81). The phrase

duo tetarton thus implies a coin lessened by two quarter quarters. Hendy suggests a date for these weights in the later part of the reign of Basil II and Constantine VIII (976–1025; Hendy 1972, pp. 79–80; Hendy 1985, p. 508). For an excavated example from Corinth, see Davidson 1952, no. 1609, pl. 94.

G. M. M. Houben, *The Weighing of Money*, Zwolle, 1982, p. 8, fig. 5. CJSE

162 (enlarged) 163 (enlarged)

163 Coin-weight

Constantinople, early 11th century

London, BM, M&LA 1980,6–1,268

Max. diam. 18.2 mm. Weight 4.16 g

Roper Collection. Bought by the British Museum in 1980.

Discoid copper-alloy weight struck on the obverse with an inscription in three lines, +HΛI / OCEΛH / NATON, and, on the reverse, with one in five, TOΔE / EΛAΦPO / TEPON / TOYTOY / APΓEI.

The inscriptions can be read together as: '*Helioselanaton*: a lighter than this is not valid'. *Helioselanaton* was a term applied to the last issue of histamena of Basil II and Constantine VIII (976–1025). For similar examples, see Bouterove 1666, p. 140, and Grierson 1973, pp. 57–8.

Unpublished. CJSE

164 Silver-gilt weight from the reign of Theodora

Constantinople, between 11 January 1055 and 31 August 1056

London, BM, M&LA 1992,5–1,1

Max. diam. 32.8 mm. Weight 32.96 g

Bought by the British Museum in 1990.

Discoid silver-gilt weight struck on the face with a nimbed bust of the Mother of God Blachernitissa, wearing a tunic and *maphorion*, and inscribed OYΓΓIA MIA ('one ounce'). The reverse is struck with a bust of the Empress Theodora wearing a crown with cross and *pendilia*, a pearl collar and a loros. In her left hand she holds a sceptre decorated with pellets, and in her right a *globus cruciger*; in the field to left,

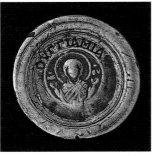 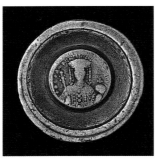

164 (face) 164 (reverse)

her name in Greek letters, preceded by a cross. Around the edge of the weight is a nielloed inscription in Greek: 'O Mother of God, protect Theodora *Augusta*, born of the purple'.

Despite the loss of much of the gilding and some of the niello, the general condition of the weight is good. This makes its actual weight all the more puzzling. An ounce of around 33 g would suggest an eleventh-century pound of some 396 g, a figure far in excess of that proposed in the most recent study of Byzantine metrology (E. Schilbach, *Byzantinische Metrologie*, Munich, 1970, pp. 166–8). There is no evidence to suggest that the denominational inscription is a spurious addition: traces of gilding are present within its letters and the triangular-sectioned punch employed for the serifs of the letters is identical to that used on the nielloed inscription. For the moment this metrological problem remains unresolved (unless this object is not a weight but some form of imperial donative).

The Empress Theodora ruled for two brief periods in the mid eleventh century: the first with her sister Zoe between 20 April and 11 June 1042, the second from the death of Constantine IX on 11 January 1055 until her own death on 31 August 1056. On the basis of coin parallels it is clear that the weight belongs to the latter period. Tetartera dating from that reign have an identical bust of Theodora on their reverse, and the bust of the Mother of God is best compared with that on a two-thirds silver miliaresion in the Dumbarton Oaks Collection, Washington, D.C., also issued in 1055–6 (Grierson 1973, pp. 752–3, pl. 62). The only other silver weights officially issued during the entire Byzantine period are a small group of coin-weights intended to correspond to the silver basilika issued by Andronikos II and Michael IX (1294/5–1320; S. Bendall, *A Private Collection of Palaeologan Coins* (private publication), 1988, pp. 77 and 110, no. 383).

C. J. S. Entwistle and M. Cowell, 'A note on a Middle Byzantine silver weight', Θυμίαμα στη μνήμη της Λασκαρίνας Μπούρα, Athens, 1994, pp. 91–3, pls 47–8. CJSE

165 Gold and enamel reliquary-cross

Probably Constantinople, early 11th century

London, BM, M&LA 1965,6–4,1

H. 61.2 mm, W. 30.9 mm, thickness 8.7 mm; L. of chain 622 mm

Said to have been excavated on the site of the Great Palace, Constantinople. Adolphe Stoclet Collection, Brussels, subsequently in the possession of Philippe R. Stoclet. Bought by the British Museum in 1965.

Gold and cloisonné enamel pendent reliquary-cross, hinged to open. The enamel plaque is missing from the front; on the cruciform plaque set into the reverse of the cross is a figure of the Mother of God, standing on a *suppedaneum* in an attitude of prayer, her hands in front of her chest, palms outward, the abbreviated identifying inscription in Greek above her head. To her right on the transverse arm of the cross is a bust of St Basil the Great, to her left a bust of St Gregory Thaumaturgus; each is flanked by Greek letters of an abbreviated identifying inscription.

The enamel is *Senkschmelz*: the figures are silhouetted against the bare metal of the plaque instead of having an enamelled background as on no. 141. The plaque is composed of two gold sheets, the face-plate cut out to take the cloisonné enamel. The cellwork comprises gold strip of various gauges; the cloisons are soldered to one another and, where they meet it, to the face-plate; they are also presumably soldered to the backing-plate. Many joins have an excess of solder, resulting in small areas of gold in the surface of the enamel; 'dummy cells' (deliberately contrived areas of gold) are employed. There are some losses of enamel.

The silhouettes cut into the plaque take account of the outlines of the garments in which the figures are depicted. The facial features are greatly simplified: the eyes are simple roundels filled with black enamel, and the eyebrows, indicated by a single strip of gold without any added colour, are fashioned from the cloison which also defines the nose.

The Mother of God is depicted wearing a translucent blue *chiton*, a translucent blue *maphorion* with an opaque yellow border, and opaque red shoes. The *maphorion* has a quatrefoil of dummy cells on the hood, which is lined in white or provided with a white veil; a white mappa is tucked into the girdle. The draperies, drawn with strips of different gauges, are not particularly coherent, although the representation of the garments and the pose of the figure are successfully rendered. The *suppedaneum*, depicted in reverse perspective, is enamelled in semi-translucent green.

St Basil's hair, worn short, and slightly receding at the temples, is translucent brown; it may originally have been black. The beard, appearing to grow from behind the ears, is long, pointed and slightly wavy; beard and moustache are the same colour as the hair of the saint's head. St Basil's beard fits into the 'v' of his *omophorion*, which is white

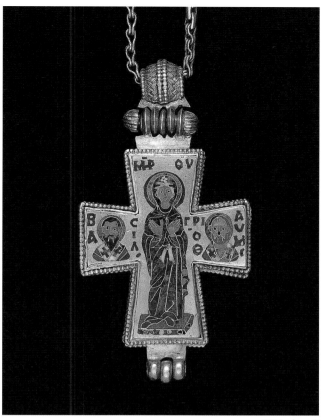

165 (enlarged)

with black crosses, worn over a blue and red *paenula*. The indication of drapery is minimal: on either arm a single straight cloison separates the colours of the *paenula*.

St Gregory's hair, blue-grey in colour, is shortish and slightly wavy; from near the centre of a receding hairline descend two short cloisons. His beard is short, rounded, and blue-grey in colour, stopping short just below his ears. He wears a white *omophorion* with black crosses, over a blue and red *paenula*, under which is a semi-translucent green *chiton*. The depiction of drapery is confined to a single short cloison separating the colours of the *paenula*.

The cross belongs to a type of *Senkschmelz* ('sunk enamel', i.e. with figures silhouetted against bare metal) characterised by simplified facial features reminiscent of representations in *Vollschmelz* ('full enamel', i.e. with fully enamelled backgrounds) of around 900, such as those on the votive crown of Leo VI (886–912) in Venice (exh. cat. *Treasury of San Marco* (1984), no. 8). The similarity is, however, deceptive, and there are good reasons for dating the *Senkschmelz* group over a hundred years later, to the early eleventh century (D. Buckton, 'Chinese whispers: the premature birth of the typical Byzantine enamel', *Byzantine East, Latin West: Art Historical Studies in Honor of Kurt Weitzmann*, Princeton, forthcoming).

Sale cat. Sotheby's, London, 27 April 1965, lot 34; J. Beckwith, 'A Byzantine gold and enamelled pectoral cross', *Beiträge zur Kunst des Mittelalters: Festschrift für Hans Wentzel zum 60. Geburtstag*, Berlin, 1975, pp. 29–31; Tait 1986, pp. 206–7, no. 503. Exhibited: *Jewellery* (1976), no. 359. DB

166 Silk from the tomb of Edward the Confessor

Eastern Mediterranean or western Asia, about the middle of 11th century

London, Victoria and Albert Museum, Textiles and Dress Collection, 2, 3 and 4–1944

(i) 43 × 94 mm, (ii) 83 × 87 mm and (iii) 43 × 62 mm

Found in the tomb of Edward the Confessor in Westminster Abbey when it was accidentally broken during preparations for the coronation of James II in April 1685 (not 1686 as stated on the labels). Given to the V&A by Mrs A. L. Inge in 1944. Further fragments of this textile are in Westminster Cathedral. The Byzantine enamelled gold cross is now lost. The whereabouts of the piece of ribbon which had been around the king's head and which was evidently once kept together with these fragments is also now unknown.

Three small fragments of undyed silk, originally cream, in weft-patterned weave. From more complete textiles with the same design it can be recognised that one fragment (i) shows the head of a griffin and part of a roundel frame, another (ii) shows the body and wing of a dove and part of a roundel frame and that the third (iii) has, on the left, the breast of the same dove and, on the right, the breast and wing of an identical but reversed dove. The complete design is of roundels in staggered rows linked diagonally by twists in the outer border of the roundels. In one row the roundels contain paired panthers and, in the other row, paired griffins; both pairs of animals are rampant and back-to-back, with their heads turned towards each other; above the griffins is a crescent, and above the panthers a symbol with a disk surmounting curved horns. Between the roundels are paired doves, their heads turned to peck a branch of the stylised tree that grows between and over them, or paired falcons, their wings raised and their beaks touching. The roundel frames themselves are decorated with segments of a grid-like pattern of lozenges with double hooks or volutes at their points.

Labels in late seventeenth-century handwriting read as follows: (i) 'part of ye cote wch was next to ye searcloath on ye boddy of King Edward ye Confessor taken from it in Aprill 1686 whe[n] ye tombe was found open, & ye little peese was a small part of a ribin tied a bout his head / there was then found a gold cros hanging to a gold chaine, soposed to have bin a bout his neck, ye cross was very neatly maid on on[e] side a crusifax on ye other a pct of ye then pope, & was to open but nothing then in it, ye gold waied a bout 30 peeses, ye king had it & now hath it', (ii) 'the

searcloath yt was next ye Body of King Edward ye Confesser found open in Aprill 1686, and then taken out'; (iii) 'a peese of ye shroud, or that wch was a sheet, on ye out side of ye boddy of King Edweard ye confesor, taken ofe Aprill 1686'.

Weft-patterned tabby, the ground tabby, the pattern weft-faced 1:2 twill, the weft in the following order: 1 pick ground weft, 1 pick pattern weft, 1 pick ground weft, 2 picks pattern weft. Warp yarn z-twist undyed silk; approx. 24–32 ends per cm, alternately paired and single; weft yarns undyed silk without twist, the pattern weft thicker; approx. 33–5 picks ground weft and 49–53 picks pattern weft per cm. Lengthways repeat estimated at 34 cm, widthways (reverse) repeat, at 17 cm. Fragment (ii) has the remains of a diagonal seam.

Since the fragments are from the same textile, the truth of the statements on the labels that they come variously from the king's coat, cerecloth and shroud must be doubted. The

traces on fragment (ii) of a diagonal seam suggests that, rather than a simple shroud or pall, the source was one of the king's garments.

Edward the Confessor was King of England from 1042 to 1065. The design of this silk with roundels set in staggered rows instead of, as in nos 137, 138, 139 and 190, directly above one another, is typical of this period. The closest comparison is with a silk used for the pontifical stockings or buskins found in the grave at Bamberg of Pope Clement II (d. 1047), where the weave is identical and the design, colour and scale very similar (S. Müller-Christensen, *Das Grab des Clemens II. im Dom zu Bamberg*, Munich, 1960, pp. 44–6, 65–8, pl. II, figs 31–8; for the weave, see R. Schorta, 'Anmerkungen zur Technik einzelner Gewebe aus den Bamberger Grabfunden', in: H. Herrmann and Y. Langenstein (eds), *Textile Grabfunde aus der Sepultur des Bamberger Domkapitels*, Munich, 1987, pp. 81–2, 88, Zeichnung 10, 'Papststrumpfbindung'). From among a

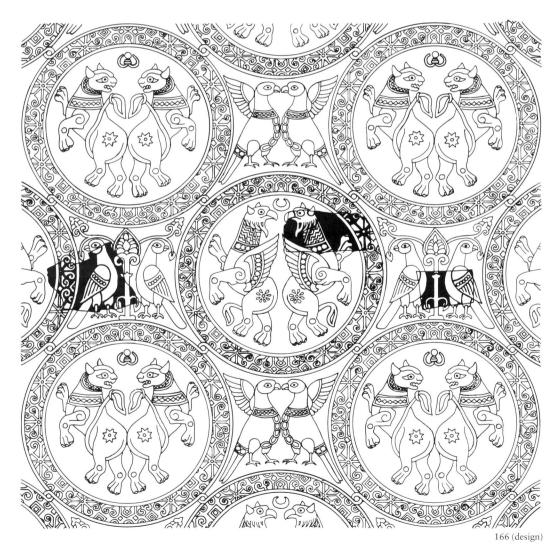

166 (design)

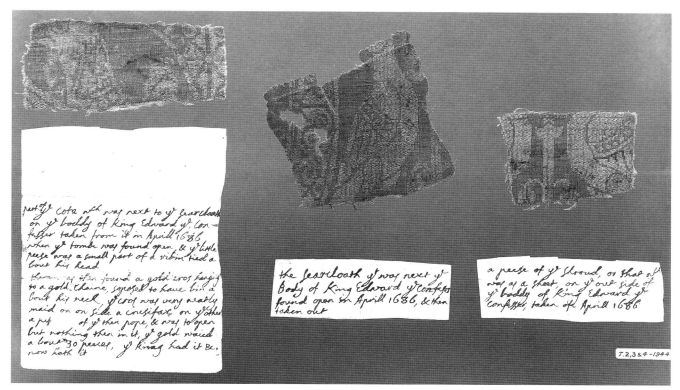

part yt cote wch was next to yt fearcloath
on yt boddy of King Edward yt Con-
fessor taken from it in Aprill 1686
when yt tombe was found open, & yt little
peece was a small part of a ribin tied a
bout his head
theare if then found a gold cros hang
to a gold chaine, supposed to have bin a
bout his neck, yt cros was very neatly
maid on on side a crucifax, on yt other
a pic of yt then pope, & was to open
but nothing then in it, yt gold waied
a bout 30 peeces, yt King had it &c.
now hath it

the fearcloath yt was next yt
Body of King Edward yt Confessor
found open on April 1686, & then
taken out

a peece of yt shroud, or that yt
was, as a sheet, on yt one side of
yt boddy of King Edward yt
confessor, taken off April 1686

T.2,3 & 4 -1944

166

number of somewhat less close comparisons, the following four can be mentioned: the same design on a red silk in incised compound twill weave used as the main textile of the cope from Clement II's grave, where the border is a green version of the same thing; on a greenish-yellow fragment again in incised compound twill believed to be from the chasuble of Archbishop Arnold I of Trier (d. 1183; the silk presumably woven earlier); a variation on the design on fragments of undyed silk, once more in weft-patterned tabby, said to be from the coronation tunic of the Emperor Henry II (1014–24; Müller-Christensen, *op. cit.*, pp. 40–1, 65–8, pl. I, figs 21–4, 87–8 and 90; A. F. Kendrick, *Catalogue of Early Medieval Woven Fabrics* (Victoria and Albert Museum), London, 1925, nos 1023 and 1025; L. von Wilckens, 'Zur kunstgeschichtlichen Einordnung der Bamberger Textilfunde', in: Herrmann and Langenstein, *op. cit.*, pp. 64–6, figs 4, 5 and 7, see also pp. 148–9, no. M16; S. Müller-Christensen, H. E. Kubach and G. Stein, 'Die Gräber im Königschor', in: H. E. Kubach and W. Haas, *Der Dom zu Speyer*, Munich, 1972, figs 1512–13).

Discussing these Edward the Confessor fragments, Krijnie Ciggaar believes that the cloth was received by the English king as a coronation gift, as remuneration for services of some sort rendered to the Byzantine Emperor (Ciggaar, p. 90). In reality, given the comparatively wide availability of figured silk by this period and the fact that those in this group are not of outstanding quality (Müller-Christensen describes the weave of Clement's buskins as very unevenly executed), there is no need to think in terms of diplomatic exchange. The Byzantine origin is not even certain: of the range of examples with this or related designs, the probability is that some, if not the majority, were woven in Islamic centres, and that the crescent above the griffins on most versions of the design might even be considered as a mark of Islamic, specifically Persian, production. In this case, the best that can be said is that, as an early example of a *diaspros* silk, the Edward the Confessor fragments are representative of the general appearance of one of the types of textile being made in Constantinople at the time (see Introduction).

Charles Taylour (i.e. Henry Keepe), *A True and Perfect Narrative of the Strange & Unexpected finding the Crucifix and Gold-Chain of that Pious Prince St. Edward the King and Confessor*, London, 1688, p. 10; Bishop Patrick, *Auto-Biography*, ed. J. H. Parker, Oxford, 1839, pp. 192–4; Flanagan 1956, pp. 498–9 and notes; K. Ciggaar, 'England and Byzantium on the eve of the Norman Conquest . . .', *Anglo-Norman Studies* 5 (1982), pp. 78–96; E. Crowfoot, F. Pritchard and K. Staniland, *Textiles and Clothing* (Museum of London, Medieval Finds from Excavations in London, IV), London, 1992, p. 86, fig. 59. HG-T

167 The Bristol Psalter

Constantinople, first half of 11th century

London, British Library, Additional MS 40731, folios 76v–77r

Folio approx. 105 × 90 mm

Bought by the British Museum from Western College, Cotham, Bristol, on 13 January 1923.

The book is open to show the end of Psalm 45 and the start of Psalm 46 (Psalms 46 and 47 in the Authorised Version, but the Septuagint (Greek) text differs considerably). Psalm 46 ('Clap your hands all ye nations') begins on the left page beneath a gold title. In the upper part of the right page are two flying angels carrying the ascending Christ seated on a rainbow within a blue mandorla and with a second rainbow beneath his feet. An asterisk indexes the image to Psalm 46.6: 'God has gone up with a shout'. In the lower margin we see the Mother of God between the apostles headed by Peter and Paul, with the inscription: 'The apostles are the mighty ones of the earth'. This is indexed by a cross to the final verse above: 'God's mighty ones of the earth have been greatly exalted' (Psalm 46.10). As a result of trimming of the pages the images are damaged at the right and at the lower edge. They are also flaked and worn and in general show signs of heavy use of the book.

In the type of book known as the marginal Psalter, of which this is an example, small images in the broad margins left for the purpose interpret and illustrate the text of the Psalms in a variety of ways. An image of the Ascension as an interpretation of Psalm 46.6 already occurs in the ninth-century Chloudov Psalter (and also in the Theodore Psalter, no. 168), but here the makers of the book took advantage of the lower margin and the text immediately above it to make a second interpretative point – that the apostles witnessing the Ascension are 'the mighty ones'. Such opportunism is characteristic of the flexible and intelligent approach to illustration found in the marginal Psalters. The diminutive size of the book, for even before trimming it is unlikely to have measured more than about 115 × 95 mm, suggests that it was intended for private use.

Catalogue of Additions to the Manuscripts 1921–1925, London, 1950, pp. 150–4; S. Dufrenne, *L'illustration des psautiers grecs du moyen âge* (Bibliothèque des Cahiers archéologiques, 1), Paris, 1966, pp. 47–66, col. pls 3–6, pls 47–60. Exhibited: *Byzantine Art a European Art* (1964), no. 279; *Christian Orient* (1978), no. 3.

JL

168 The Theodore Psalter

Constantinople, Studios Monastery, 1066

London, British Library, Additional MS 19352, folios 189v–190r

Folio 230 × 185 mm

Bought by the British Museum at Sotheby's sale of the library of

Henry Perigall Borrell, numismatist of Smyrna, 2 February 1853 (lot 65). Said by the auctioneer to have been obtained by Borrell 'from the library of the Archbishop of Scio [Chios]' (Madden's Diary, 2 February 1853).

This opening occurs after the end of Psalms and before the start of Odes (Canticles) and is the first of three that relate to the history of this particular manuscript. At the left is the start of a series of short verses on the life of David, written in large gold display capitals. In the accompanying unframed images God, at the top, despatches his angel to David. Below, we see the angel approach the shepherd boy as he plays a transverse flute to his sheep and goats (and dog). At the bottom, the angel gestures to lead David away. On the right page, David indicates the danger to his flocks from wild beasts. Below, he approaches Samuel, who at the bottom anoints him in the presence of his father Jesse and his brothers. Captions in gold minuscule script identify the speakers ('The angel to David', 'David to the angel', etc.). The frequent use of gold to highlight the drapery of the figures is conspicuous. Despite the wear resulting from frequent handling, the figures retain a jewel-like quality with their delicate workmanship and fragile, elongated proportions.

This manuscript is of pivotal importance for the understanding of Byzantine art. It was made in 1066 for Abbot Michael of the Studios Monastery in Constantinople by the monastery's protopresbyter, Theodore, who came originally from Caesarea. Its format is that of a marginal Psalter (cf. no. 167). The Studios may also have had a special role in the production of this type of book at an earlier date. Certainly there is in the Theodore Psalter a special veneration for the ninth-century iconophile polemicist and abbot St Theodore the Studite. This book, however, is a much larger and more splendid production than any of the surviving ninth-century marginal Psalters. Careful examination of the layout shows that the Theodore of 1066 was not merely the scribe of the book but must have been its planner and artist as well. And Abbot Michael seems to have been not merely the commissioner of the book but also the author of the verses on David that receive such superlative treatment. Michael is promoted as a new David who like any abbot must lead his flock of monks, but he is also a more original new David in having composed these Psalm-like verses.

S. Der Nersessian, *L'illustration des psautiers grecs du moyen âge*, II (Bibliothèque des Cahiers archéologiques, V), Paris, 1970; Spatharakis 1981, no. 80; J. C. Anderson, 'On the nature of the Theodore Psalter', *Art Bulletin* 70 (1988), pp. 550–68; J. Lowden, *Early Christian and Byzantine Art*, forthcoming. Exhibited: *Christian Orient* (1978), no. 4.

JL

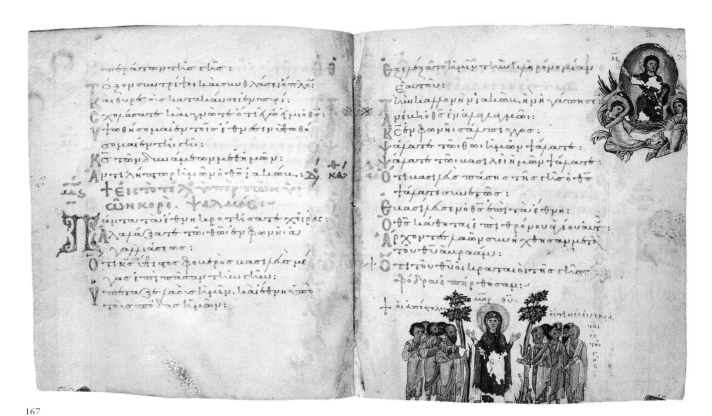

167

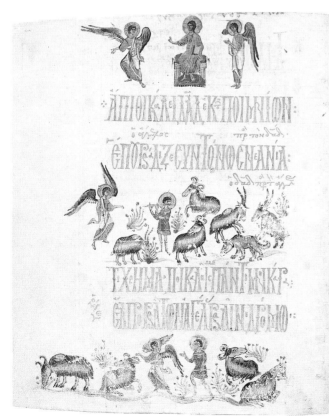

168

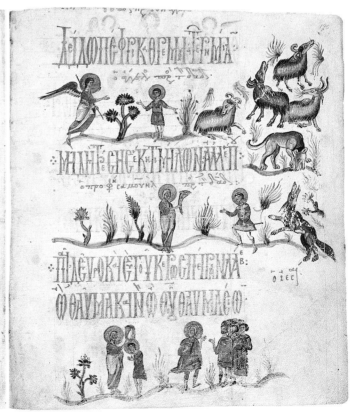

169 Saints for September: the miracle of St Michael at Chonai

Constantinople, probably between about 1070 and 1080

London, British Library, Additional MS 11870 (Menologion), folios 59v–60r

Folio approx. 420 × 320 mm; image about 200 × 100 mm (max.)

In the hands of a certain Doukas Miteleneas on 9 April 1699 (folios 73r, 108r). Bought by the British Museum in 1841 from the estate of the Revd Dr Samuel Butler, Bishop of Lichfield (d. 1839).

At the left is the end of the commemoration of St Babylas, Bishop of Antioch (4 September), and at the right the start of the commemoration of the miracle of the Archangel Michael at Chonai (6 September), the title in gold script. The image shows St Michael, with a wand, diverting the stream that threatened to engulf the church. At the right the monk Archippos stands in prayer before the stylised oratory. The whole is set in a complex frame of knotted marble columns supporting an arch, within a much larger panel of decoration with a repeating motif of small enamel-like flowers in medallions. There are various signs of later use: a note at the top records the date of the feast, and at the bottom two different hands record that the text comprises seven leaves. The prickings above the image show that it was once protected by a silk curtain sewn in.

This massive book, now consisting of 273 folios and covering only September, is but the surviving first volume of a ten-volume set of such hagiographic texts, in the arrangement devised in the second half of the tenth century by Symeon Metaphrastes ('the re-phraser'). It is the most lavishly illustrated of the 850 or so such volumes still in existence. Originally each commemoration had an image, but the first three have been cut out (presumably for use as icons) and the pages replaced in the sixteenth century. Twenty-two images remain. Some are subdivided to show smaller scenes of torture and martyrdom, many probably devised for this particular context. Any subsequent volumes from this set are lost, although the table of contents on folios 1–5 includes the commemorations for October as

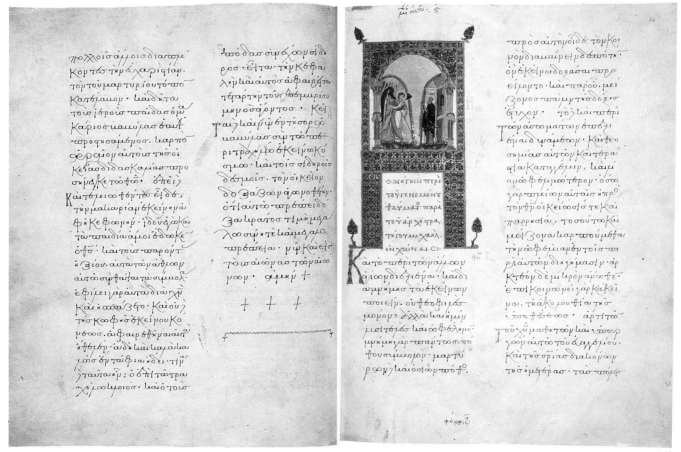

169

well as September. Throughout the manuscript there are signs of considerable use.

C. Walter, 'The London September Metaphrast Additional 11870', *Zograf* 12 (1981), pp. 11–24, figs 1–26; N. P. Ševčenko, *Illustrated Manuscripts of the Metaphrastian Menologion*, Chicago, 1990, esp. pp. 118–25 and fiches 3D2–3F1. Exhibited: *Byzantine Art a European Art* (1964), no. 354; *Christian Orient* (1978), no. 5. JL

170 Homilies of St Gregory of Nazianzos

Constantinople, around 1100

Oxford, Bodleian Library, MS Canon. Gr. 103, folios 2v–3r

Folio 315 × 240 mm; image 202 × 152 mm

Bought by the Bodleian at the sale of the Canonici Collection, Venice, in 1817.

Gregory, dressed as a monk rather than as a bishop, writes the opening of his Easter homily on the page he holds. A magnificent headpiece on the facing page encloses the gold title to the homily. The decoration is symmetrical, and the larger medallions enclose colourful birds and griffins. The initial A of the text ('Ἀναστάσεως) is appropriately formed by an image of the Anastasis: Christ, standing on the broken gates of hell, raises the kneeling Adam, while Eve waits. Above, a flying angel observes, and acts as the diacritical mark indicating soft breathing, a sort of apostrophe, to the A. Both pages are worn and damaged and have had their margins replaced in modern times. The lead white pigment used for the highlights on Gregory's drapery, hair and beard has turned grey. Both pages seem to be the work of the same artist, although there are differences in pigment and technique. The blue used on the left page is noticeably darker than on the right, and the border was painted over the gold-leaf ground, whereas on the right page the gold was applied as a liquid ('shell gold') over a carmine base, and after the other pigments. Presumably the artist worked on the pages at different times.

The image was executed on a specially prepared double leaf or bifolio of prefatory material. The first folio was ruled for the text of the table of contents, while the second

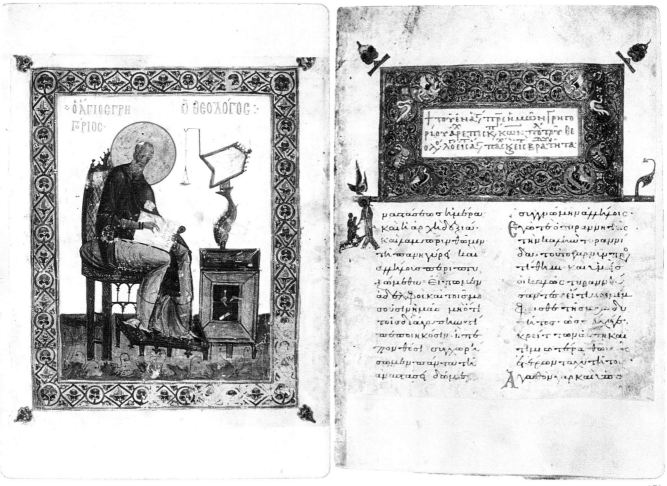

170

folio has only a simple ruling to locate the miniature. In addition to the full-page frontispiece, each of the subsequent homilies in this large volume was provided with a carefully painted headpiece, often in the shape of a Π, most of them including figures or scenes. There is a further historiated initial, the Baptism on folio 146r. The fact that Gregory (Bishop of Sasima, Nazianzos, and, briefly, of Constantinople) is dressed as a monk in the frontispiece probably implies that the manuscript was destined for use in a monastery and does not reveal the personal affiliation of the artist. In its scale and the type of its decoration the book can be seen as a companion to the illustrated Metaphrastic menologion manuscripts (such as no. 169) and other collections of homilies, such as those of St John Chrysostom.

G. Galavaris, *The Illustrations of the Liturgical Homilies of Gregory Nazianzenus*, Princeton, 1969, pp. 232–3, figs 275–86; Hutter 1977, no. 35, figs 179–94; Hutter 1982, p. 332. Exhibited: *Byzantine Art a European Art* (1964), no. 347. JL

171 Serpentine roundel with the Mother of God

Probably Constantinople, 1078–81

London, Victoria and Albert Museum, Sculpture Collection, A.1–1927

Diam. 175 mm

In the Monconys Collection in Lyons by the seventeenth century; after 1661 in the Abbey of Heiligenkreuz near Vienna. Acquired by the V&A in 1927.

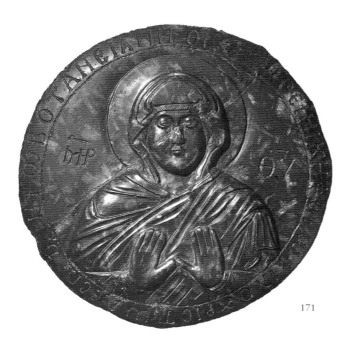

171

Serpentine medallion carved with a bust of the veiled and haloed Mother of God in prayer, her hands raised in front of her, with the palms facing outwards. She is identified by an abbreviated inscription on either side of her head. Around the edge runs an inscription invoking the help of the Mother of God for the Emperor Nikephoros III Botaneiates (+Θ[ΕΟΤΟ]Κ[Ε] [ΒΟ]ΗΘΕΙ ΝΙΚΗΦΟΡѠ ΦΙΛΟΧΡΙCΤѠ ΔΕCΠΟ[Τ]Η ΤѠ ΒΟΤΑΝΕΙΑΤΗ). On the back is the roughly scratched outline of the bust of the Mother of God and the letter M. The medallion was broken diagonally across the middle and repaired some time prior to its acquisition by the V&A.

Together with a smaller double-sided jasper cameo also in the Victoria and Albert Museum, which shows the standing figure of Christ blessing on the obverse and, on the reverse, a cross with an inscription referring almost certainly to the Emperor Leo VI (886–912), this is one of the very few hardstone carvings which can be dated with some degree of precision (Wentzel, figs 4–5, and *passim*). As a result it is of the utmost importance as a touchstone for late eleventh-century Byzantine sculpture. Its function, however, remains obscure: too large and heavy to be worn, it was perhaps set into an item of church furniture or inlaid above a door, at the centre of a lintel or at the crown of an arch.

I. Chifletio, *Vetus Imago Sanctissimae Deiparae in Jaspide Viridi . . . inscripta Nicephoro Botaniatae, Graecorum Imperatori*, 1661; F. de Mély, 'Le camée byzantin de Nicéphore Botaniate', *Fondation Eugène Piot: Monuments et Mémoires*, VI, 1899, pp. 195ff; M. H. Longhurst, 'A Byzantine disc for South Kensington', *Burlington Magazine* 50 (1927), pp. 107–8; H. Wentzel, 'Datierte und datierbare byzantinische Kameen', *Festschrift Friedrich Winkler*, Berlin, 1959, pp. 10–11, fig. 1; D. Talbot Rice, *The Art of Byzantium*, London, 1959, no. 150; J. Beckwith, *The Art of Constantinople*, London, 1961, pp. 118ff; J. Beckwith, *Early Christian and Byzantine Art*, 2nd ed., Harmondsworth, 1979, p. 245, fig. 208; H. Belting, 'Eine Gruppe Konstantinopler Reliefs aus dem 11. Jahrhundert', *Pantheon* 30 (1972), p. 266, fig. 9; P. Williamson (ed.), *The Medieval Treasury: the Art of the Middle Ages in the Victoria and Albert Museum*, London, 1986, pp. 90–1. Exhibited: *Art byzantin* (1931), no. 121; *Masterpieces* (1958), no. 100; *Byzantine Art a European Art* (1964), no. 119, *Splendeur de Byzance* (1982), no. St.3. PW

172 Jasper cameo of the Mother of God

Probably Constantinople, 11th or 12th century

London, BM, M&LA 69,7–12,4

H. 64 mm, W. 38.5 mm, greatest thickness 6.6 mm

The property of a M. Le Carpentier when exhibited at the 1865 Paris Exhibition. Bought by the British Museum four years later from a M. Schmidt, of Paris (a M. Schmidt had also exhibited at the 1865 Exhibition).

Oval cameo of jasper, carved in low relief with a figure of the Mother of God in orant pose, standing on a *suppeda-*

neum. Her halo is in intaglio, as are the small identifying letters M and Θ (for 'Mother of God'), one to either side of it. The whole composition is surrounded by a broad border.

C. Diehl, *Manuel d'archéologie byzantine* Paris, 1889, p. 628; Dalton 1901, no. 109; Dalton 1915, no. 10. Exhibited: *Musée rétrospectif*, Paris (Palais de l'Industrie), 1865, no. 285 (Catalogue du moyen âge); *Masterpieces* (1958), no. 85; *Splendeur de Byzance* (1982), no. St. 4. DB

173 Bloodstone cameo of St George

Probably Constantinople, 11th or 12th century

London, BM, M&LA 1916,11–8,1

H. 40.9 mm, W. 28.2 mm, greatest thickness 10.2 mm

Given anonymously to the British Museum in 1916.

Oval cameo of bloodstone, carved in high relief with a half-figure of St George. He is depicted wearing military costume, a sword carried over his right shoulder and small round shield on his left arm. The saint's halo is in intaglio, as is his

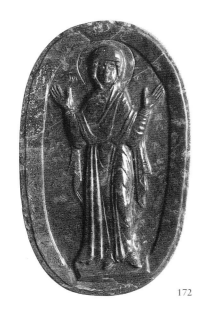
172

173

174

identifying inscription. The shield is chipped, and a piece at the left-hand edge of the stone has broken away and been re-attached.

Buckton 1981, p. 189, fig. 8c (caption transposed with that of 8b).
 DB

174 Sardonyx cameo of Daniel and the lions

Probably Venice, early 13th century

London, BM, M&LA 1983,7–3,1

25.5 × 20.7 mm

Bought by the British Museum in 1983.

Oval cameo of brown and bluish white sardonyx, carved in low relief with a nimbed orant figure between two crouching lions, the figure identified by a partly monogrammatic engraved inscription in Greek: 'The Prophet Daniel'. The background and the highest relief are brown, and the intermediate layer white. Daniel wears a Phrygian cap, a cloak over a short tunic, buskins and boots. The lions fit neatly between the hem of his cloak and the edge of the stone.

Of five other sardonyx cameos with this iconography, two – in St Petersburg and Turin – are attributed by Paul Williamson to eleventh- or twelfth-century Byzantium. The remainder – in St Petersburg, Munich and Cividale – share the squat proportions of the British Museum's Daniel figure and are also carved from three colour-layers of the stone. Williamson sees these as inspired by eleventh- and twelfth-century Byzantine models and convincingly ascribes them to early thirteenth-century Venice.

Sale cat. Sotheby's, London, 16 June 1983, lot 47; P. Williamson, 'Daniel between the lions: a new sardonyx cameo for the British Museum', *Jewellery Studies* 1 (1983–4), pp. 37–9, col. pl. IIA. DB

175 Processional cross of St Anastasia

Possibly Constantinople, 10th to 12th century

Oxford, Ashmolean Museum, Department of Antiquities, 1980.2

Total H. 625 mm, W. 403 mm

Roper Collection. Bought by the Ashmolean in 1980.

Latin cross, made of a thin sheet of brass, with narrow arms which flare towards the end, terminating in ovoid finials at the corners. The lower edge of each lateral arm is pierced with three holes for *pendilia*; a tang, now broken, continues below the lower arm. A plain glass medallion is mounted at the centre of the cross, and four small bosses ornament the arms. The obverse surface of the cross has incised decoration consisting of an outer border of punched dots between parallel lines, and a row of three semicircles which project inward from the border at the ends of the four arms. Near the extremities of the cross are compass-drawn medallions

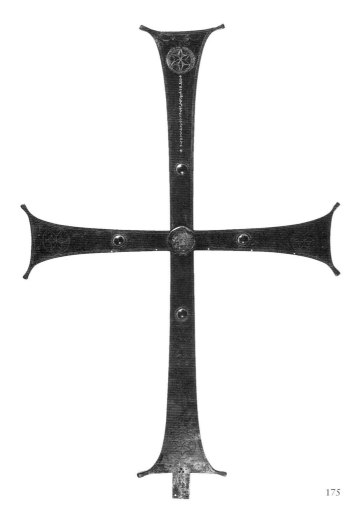

175

Images of saints often occupy the same position on pectoral and other small crosses (e.g. Temple, *op. cit.*, nos 54, 57, 67). The dedication of 'The *signon* of the *Theotokos tou mastou*' is written on the silver cross of Matzkhvarichi (C. Mango, *op. cit.*, p. 42). *Signon* is one of the words used in *typika* of the eleventh and twelfth centuries with reference to processional crosses and icons (Bouras 1979, p. 24) which were carried on various feasts such as Palm Sunday or the Elevation of the Cross. When not being carried, processional crosses could have been displayed in the church (Mango 1986, nos 7, 42). In view of the fact that elaborately decorated silver-sheathed crosses may have been relatively common in medieval monasteries (C. Mango, *op. cit.*, p. 46), crosses as simple as nos 161 and 175 could have belonged to modest village churches.

Unpublished. Mango, forthcoming. MMM

176 St Luke and the beginning of his Gospel

Constantinople, second half of 10th century, with images added in second quarter of 12th century

London, British Library, Burney MS 19 (Gospel Book), folios 101v–102r

Folio 220 × 175 mm; image about 155 × 135 mm

At San Lorenzo el Real, El Escorial, in 1809; acquired by Dr Charles Burney (d. 1817). Bought for the British Museum in 1818.

St Luke bends forward to write his Gospel. The image is very well preserved, with the pigments clear and intense. It is surprising to note that the artist drew the frame free-hand, although there was a network of incised guide-lines that he could have followed, and that he set the image some 20–30 mm to the left of centre, leading to damage at the left and an awkward blank space at the right. On the facing page is a decorative headpiece of the stylised flower-petal type, with an enlarged initial E of similar type, and a gold title.

This quite small but very carefully written Gospel Book of the second half of the tenth century was further embellished by the addition of a set of images of the evangelists in the second quarter of the twelfth century. Matthew (folio 1 verso) and John with his scribe Prochorus (folio 165r) were inserted on additional leaves. But Mark (folio 101v) and Luke were painted on original pages facing the start of their respective Gospels, pages which had been left blank in the tenth century. Placing these images to the left of centre may indicate that the book was not unbound, and that the artist considered it disagreeable to attempt to work any nearer the fold of the central gutter. The distinctive style of the images, if it is the work of a single hand and not a more widespread trend, has suggested the activity of a 'Kokkinobaphos Master', so called after the two most remarkable books in

enclosing six-petalled rosettes. From the top of the medallion on the lower arm a stylised palmette on a long stalk extends upwards to the boss. In a corresponding position on the upper arm is a Greek inscription, + CHΓNO THC AΓHAC ANACTACHAC + ('The standard [cross] of St Anastasia'), arranged vertically to be read from the left-hand side of the cross. The reverse is plain except for an incised double line surrounding the edge and a compass-drawn circle at the centre.

A very similar cross, now in Athens, gives the name of St Peter (exh. cat. *Byzantine and Post-Byzantine Art* (1986), no. 193). Other crosses name St Paraskeve (Campbell 1985, no. 177) and St Sabas (C. Mango, 'La croix dite de Michel le Cérulaire et la croix de Saint-Michel de Sykéôn', *Cahiers archéologiques* 36 (1988), p. 43). Michael Psellos speaks of one dedicated to St Michael (C. Mango, *op. cit.*, p. 47). An inscribed full-length portrait of St Anastasia appears at the centre of the reverse side (the crucified Christ is on the obverse) of a tenth-century cross in London (R. Temple, *Early Christian and Byzantine Art*, London, 1990, no. 66).

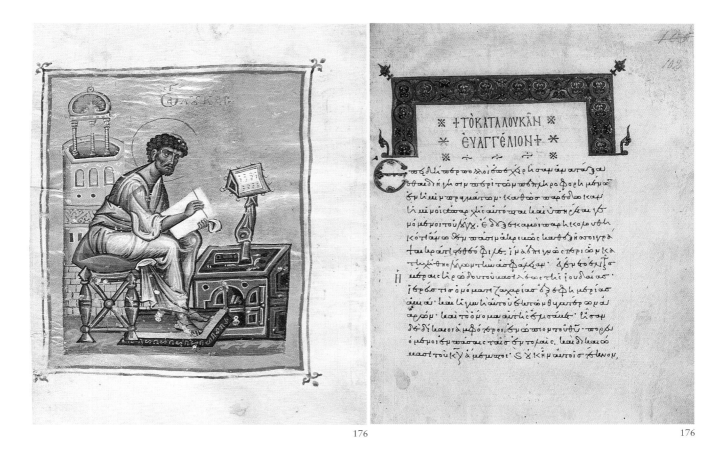

176

176

this style. Members of the immediate family of the Emperor John II Komnenos were among the donors or recipients of these books. It is thus interesting to note that in the twelfth century an old Gospel Book was thought appropriate for improvement, and presumably for private use, even at the very highest levels of Byzantine patronage.

Summary Catalogue, pp. 54–5; J. C. Anderson, 'The illustrated sermons of James the Monk: their dates, order, and place in the history of Byzantine art', *Viator* 22 (1991), pp. 69–120. Exhibited: *Byzantine Art a European Art* (1964), no. 314; *Christian Orient* (1978), no. 7. J L

177 St Matthew and the beginning of his Gospel

Constantinople, before 1139, probably in the 1120s or 1130s

Oxford, Christ Church, MS gr. 32 (Gospel Book), folios 5v–6r

Folio 185 × 135 mm; image approx. 122 × 98 mm

In the possession of *Kyr* Isaak (?Comnenos) in 1139 or earlier. Birth notices of relatives of *Kyr* Isaak Comnenos *pansebastos sebastos*, 1170–3. Donated to a monastery of St Phokas in Constantinople by George Psepharas in 1397/8. In the Monastery of Philotheou on Mount Athos in the sixteenth and seventeenth centuries; in the possession of Antonios Triphilis, around 1730.

Acquired in 1735 by William Wake, Archbishop of Canterbury, and willed to Christ Church on his death in 1737.

Matthew bends forward from his seat and dips his pen. On the facing page is a headpiece of stylised floral design inhabited by various pairs of birds, beasts, and winged sphinxes. The initial B below is formed by a fox reaching up to bite the foliage. Both pages are worn and dirty, and the parchment has buckled and folded. It is therefore remarkable that the image has suffered so little. Even where the page is creased most of the pigment remains. The silk guard to the page is of uncertain date.

Originally this book contained images of the other three evangelists. Like the Matthew they were on pages that were integral to the structure (not single leaves), but they have been cut out. Stylistically the painting is closely related to that in nos 176 and 178, but the craftsmanship is noticeably less fine. Is it a hastier or less costly work by the same artist, or the work of an assistant, or of an imitator? We have no certain way of knowing. The date of 1139 (?) (the last letter is illegible) and the mention of members of the Comnenos family shed light not only on this book but on its relatives as well. Although intended for private ownership, it contains liturgical indications to allow its user to follow the Gospel lections in church services. A curiosity is that a large section

of the book (twelve quires, fols 54–145) was written on parchment originally ruled for a much larger manuscript. Anderson has argued that this was the Topkapi Octateuch (Istanbul, Topkapi Saray, MS gr. 8), but the measurements of the ruling make this impossible. The parchment was for a book with approximately fifty lines in a text-block only some 230 mm tall (see fols 57–8). The Octateuch generally uses 51–2 lines, but in a block 328–333 mm tall. The parchment must have been left from a different project, unless it was misruled in a gross error (unlikely for so many folios).

J. C. Anderson, 'A twelfth-century instance of reused parchment: Christ Church College, Wake gr. 32', *Scriptorium* 45 (1990), p. 216, pls 23–5; Hutter 1993, no. 24, col. pls III–IV, figs 345–56.

<div style="text-align:right">JL</div>

178 The Codex Ebnerianus

Constantinople, between about 1125 and 1150

Oxford, Bodleian Library, MS Auct. T. inf. 1. 10 (New Testament without Apocalypse), folios 80v–81r

Folio 204 × 155 mm; image 147 × 113 mm

Adapted for liturgical use and additional leaves supplied by Ioasaph of the Constantinopolitan monastery of the Hodegon (assisted by the hieromonk Gregorios) in 1391. Notes of family births and baptisms, 1532–9 (in Constantinople?). Acquired early in the eighteenth century by Hieronymus Wilhelm Ebner von Eschenbach (d. 1752) of Nuremberg (hence the name Codex Ebnerianus). Bought at auction by the Bodleian Library in 1819.

The seated St Mark holds his pen over the blank book on his knee, and with his left hand supports his chin. He gazes intently out of the image to the right, towards the opening words of his Gospel. In the arch above at a smaller scale is an image of the Baptism. The whole is set within a panel of exceptionally rich floral ornament, around which are verses on the evangelist written in gold. The gold title on the facing page is set in a headpiece of similar style, joined to the initial A. Both pages are certainly the work of the same hand, and in superlative condition. The faded red text on the right page is a later liturgical addition (see below).

This book, one of the high points of Byzantine illumination, is illustrated with Canon Tables, with full-page or nearly full-page images of the evangelists and authors of the

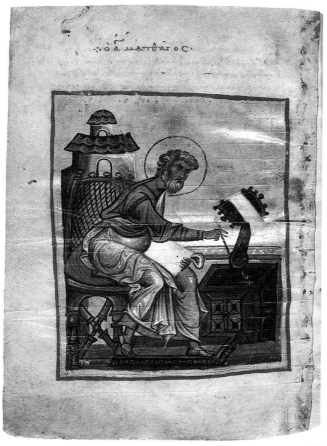

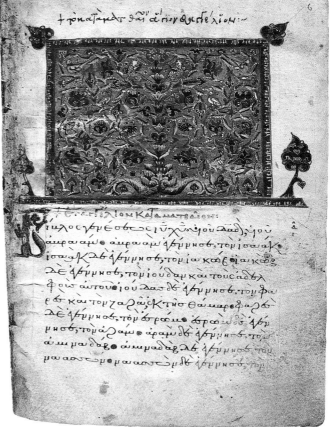

<div style="text-align:center">177</div>

<div style="text-align:center">177</div>

Acts and the Epistles, and with sumptuous decorative head-pieces. The combination of an evangelist with a Gospel scene is explained by liturgical use: the opening of Mark is read on the feast of the Baptism. The artist is believed to be the 'Kokkinobaphos Master', who worked for members of the imperial family (cf. nos 176 and 177). The condition of the paint surfaces is evidence of his technical mastery. The silver book-cover was made for Ebner before 1738 and incorporates a Byzantine ivory of Christ enthroned, of tenth or possibly eleventh century date. It is obvious at either side of the base of the ivory, and around the halo, that the figure has been cut from a larger, presumably rectangular, panel. The surviving traces of gold and colour on it do not look original. While it is possible that the ivory has decorated the book's cover since the twelfth century, it is usually thought to be an eighteenth-century addition.

Hutter 1977, no. 39, col. pl. III, figs 225–55; Turyn 1980, pp. 146–50; Hutter 1982, pp. 333–4; Cutler 1994, pp. 11, 49, 107, 167, 217, fig. 4. Exhibited: *Byzantine Art a European Art* (1964), no. 296. JL

179 The London Cruciform Lectionary

Constantinople, 12th century

London, British Library, Additional MS 39603, folios 1v–2r

Folio 370 × 280 mm

Owned by Methodios, Bishop of Herakleia (1646–68), later Patriarch of Constantinople (d. 1679). Apparently removed from the Pantocrator monastery, Mount Athos, to the monastery of Xenophon during the War of Independence. Purchased from Xenophon by the Hon. Robert Curzon in 1837. Bequeathed to the British Museum by Darea Curzon, Baroness Zouche (d. 1917).

A large illuminated initial E, incorporating two flower-stems and a gesturing hand, marks the opening of St John's Gospel (1.1–17) and the first of the readings from the Gospels prescribed for each day of the Greek church year, beginning on Easter Sunday. The smaller initial on the facing page marks the opening of the next part of John's text (1.18–29), prescribed for reading on the following day. All the minuscule text has been written first in carmine and then in gold ink. Above each line of text, similarly treated accents

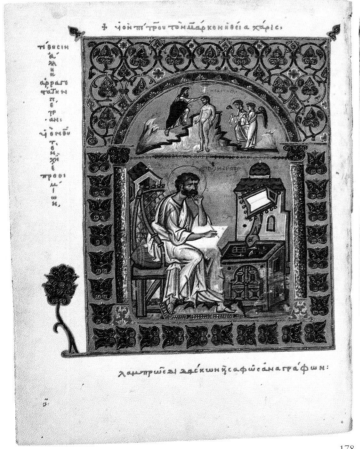

178 178

179

merge with the ekphonetic notation guiding the chanting of the Gospel text. Both pages are laid out imposingly in the shape of a cross, with foliate decoration at the corners.

Only four Greek manuscripts written throughout in cruciform survive. Apart from the ninth-century Gospel Book now at Princeton (Garrett MS 1), all are Gospel Lectionaries dating from the twelfth century. Another twelfth-century lectionary in Washington is partly written in cruciform. All reflect lavish expense and were presumably so shaped at the request of a donor eager to highlight the special nature of his gift to a religious foundation. Although the London volume is no longer credited as the personal work of the emperors Alexios and Manuel Komnenos, it is certainly conceivable as work made for an emperor.

Catalogue of Additions to the Manuscripts 1916–1920, London, 1933, pp. 84–5; J. C. Anderson, *The New York Cruciform Lectionary*, University Park, Pennsylvania, 1992, pp. 76–80, 87–9. Exhibited: *Christian Orient* (1978), no. 6. S McK

180 The Psalter of Queen Melisende

Jerusalem, between 1131 and 1143

London, British Library, Egerton MS 1139, folios 9v–10r

Folio 215 × 140 mm; image 143 × 99 mm

A French-speaking friar, Frere Ponz Daubon, wrote his name in a late twelfth- or thirteenth-century hand, upside-down on the unnumbered front paste-down. Subsequently said to have belonged to the Grande Chartreuse at Grenoble and later (in 1840?) to a Dr Commarmont of Lyons, from whom it was bought by Professor Guglielmo Libri for the London booksellers Payne and Foss. Bought by the British Museum from Payne and Foss on 12 November 1845.

The manuscript is open in the cycle of full-page images that preface the Psalms. On the left, Christ descends into hell, its broken gates and locks beneath his feet, and raises Adam from his tomb. Eve lifts her hands in entreaty behind Adam, while King David and his son Solomon stand at the front of a group at the right. Above Christ's head are two flying angels holding standards bearing the letters SSS (*Sanctus Sanctus Sanctus*: 'Holy, Holy, Holy'). On the facing page, an angel sits beside the empty tomb from which Christ has risen, leaving only his winding-sheets behind. Three sleeping soldiers huddle together in the foreground, while at the left the two Marys and Salome approach (Mark 16.1), two holding ointment-jars to anoint the body. The pages are in superlative condition, the pigments intense and brilliant.

This superbly executed manuscript is believed from evidence in the calendar, litany and prayers to have been made for Melisende, Queen of Jerusalem during the Latin rule in the Holy Land. It is datable between 1131 and 1143. The book is written entirely in Latin, but the prefatory images are Byzantine in iconography and style. None the less, a certain hesitancy and aridity in the way these full-page images were painted suggest that they are the work of an artist required to produce a careful imitation of Byzantine painting, rather than the 'natural' expression of a painter from, for example, Constantinople. An inscription beneath Christ's feet in the Deesis image, BASILIUS ME FECIT ('Basilius made me'), provides us with the name of the artist. Within the book there are also sumptuous fully decorated pages in a completely un-Byzantine style, and smaller images of saints in yet another style. It is therefore interesting to note that, when a variety of styles or modes of representation were available, it was the Byzantine tradition that was considered most appropriate for the principal images.

H. Buchthal, *Miniature Painting in the Latin Kingdom of Jerusalem*, Oxford, 1957, esp. pp. 1–14, pls 1–19. J L

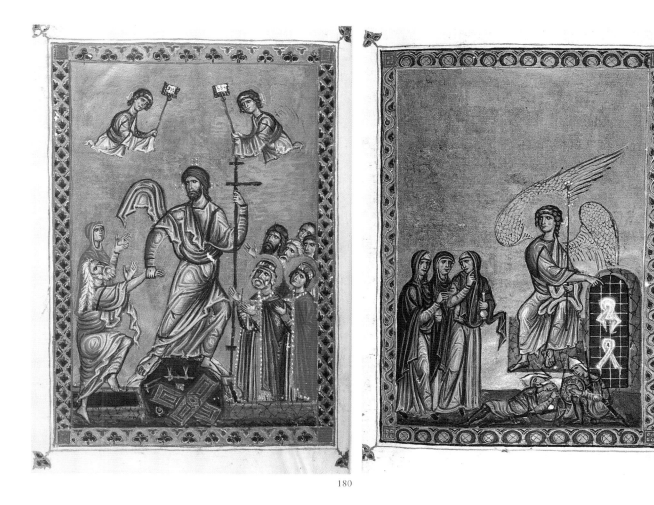

180

180

181 Ivory covers of Queen Melisende's Psalter

Jerusalem, between 1131 and 1143

London, British Library, Egerton MS 1139

Front cover 217 × 145 mm, back cover 221 × 144 mm

Now detached from Egerton MS 1139.

The original ivory covers of the Melisende Psalter show six scenes from the life of David, accompanied by virtues and vices on the front and, on the back, six works of charity (Matthew 25.35–6) carried out by a figure in imperial dress. Numerous inscriptions ensure that the viewer interprets the images correctly. These large panels were constructed from remarkably thin sheets of ivory (no more than about 4 mm in thickness), into which the relief had to be cut. Because the maximum width available was about 11 cm, it was necessary to join two panels of ivory horizontally on the front cover and vertically on the back in order to achieve the desired dimensions. The cutting necessary for the lap of the joint further weakened the already fragile ivory, which has

broken extensively in these areas. Small pieces of turquoise, ruby and jet were used to decorate the panels. Some traces of red pigment can also be seen on the front, and on the teeth and jaws of the upper pair of battling creatures on the back.

The lack of any extensive illustration of the life of David (a traditional element) in the images in this Psalter is explained by the covers of the book. Although the choice of David for the front cover has western precedents, as in the Carolingian Psalter of Charles the Bald (Paris, Bibliothèque Nationale, MS lat. 1152), there are no close parallels for the use of so many scenes. The back cover is even more unusual. The phrases of Matthew 25.35–6 are followed closely in the six medallions ('I was hungry . . . thirsty . . . homeless . . . naked . . . sick . . . in prison'). But the actions which in the Gospel account are carried out by the good Christian are here the work of an emperor, or maybe of six rulers, for each wears a different type of imperial Byzantine costume. Given the connection with Queen Melisende we can perhaps see in these images the ideal of her husband, King Fulk, as the Christian ruler. This ruler is also a successor of

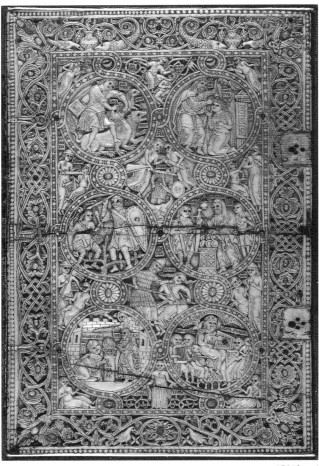

181 (front)

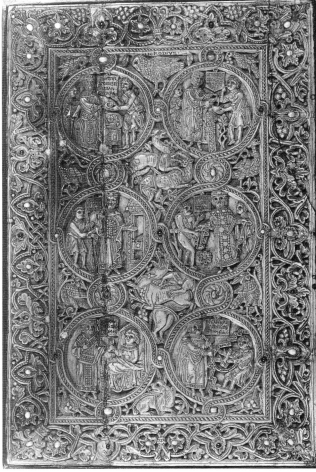

181 (back)

David, the author of the Psalms, in a special way, as a king in Jerusalem. At the same time he is also the 'Blessed man' of the opening words of Psalm 1.

Goldschmidt and Weitzmann 1934, no. 224; F. Steenbock, *Die kirchliche Prachteinband im frühen Mittelalter*, Berlin, 1965, no. 90; J. Lowden, 'The royal imperial book and the image or self-image of the medieval ruler', in: A. Duggan (ed.), *Kings and Kingship in Medieval Europe* (King's College London Medieval Studies, x), London, 1993, pp. 226–8. JL

182 Rosette casket

Byzantium, 12th century

Cambridge, Fitzwilliam Museum, Department of Applied Arts, M.18–1904

H. 147 mm, L. 249 mm, W. 194 mm

Spitzer Collection, Paris; McClean Collection. Bequeathed to the Fitzwilliam Museum by Frank McClean (1904).

Casket of wood, covered with carved bone plaques. The casket is rectangular; the hinged lid is a truncated rectangular pyramid with a flat sill surrounding it. In the centre of the lid is a rectangular bone plaque carved with a confronted griffin and lion either side of a tree with two pairs of acanthus scrolls. On the body of the casket, two to a side, are square bone plaques carved with a griffin (four plaques), a backward-looking lion (twice) or a bear (twice); a tree with acanthus leaves appears in most of the plaques. The sides of the casket are bordered with bone strips carved with rosettes; on either of the longer sides there is a central vertical strip carved with two rosettes. The lid is bordered with bone strips carved with a running scroll containing, alternately, a trefoil leaf and a stylised bunch of grapes. The casket is further decorated with polychrome intarsia work.

The wooden casket, to which the bone plaques are attached with bone pegs, is relatively modern, as is the polychrome intarsia work: both probably date from the time the

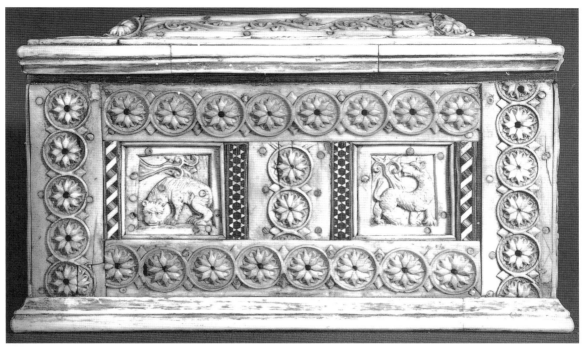

182

casket spent in the Spitzer Collection, which is notorious for its 'restorations'. The carved bone plaques, however, originally decorated a casket, as can be seen by comparison with other examples, notably three in the Victoria and Albert Museum. Byzantine 'rosette caskets' are generally thought to have been produced mainly in the twelfth century.

Dalton 1912b, pp. 94–6, no. 36, pl. VII; Goldschmidt and Weitzmann 1930, p. 43, no. 52, pl. XXXIII,a–e. DB

183 Steatite fragment with St Paul

Probably Constantinople, 12th century

London, BM, M&LA 1973,12–5,1

57 × 51 × 7 mm

Bought by the British Museum in 1973.

Small fragment of a much larger steatite plaque, carved with the head and torso of St Paul, who is named in an inscription, and the right-hand edge of a framing arch. St Paul reaches out with his right hand, and holds a book in his left. He has an ornately engraved halo, which fingers can be seen touching in a gesture of blessing. The fragment is in excellent condition, and the carving is very fine. The modelling of St Paul's face is very bold and smooth, his hair and beard being indicated by the lightest of marks. In contrast his robes are more sketchily drawn; traces of gilding can be seen on them.

In its original condition, this icon probably showed a

183

second figure, of St Peter, to the left of St Paul, both being blessed by Christ, above them, all framed by the arch. Such a scene is known in steatite, although more commonly Christ is blessing martyred warrior saints (see Kalavrezou-Maxeiner 1985, nos 21, 28). The reverse of this piece is unworked, which suggests that it was intended to be set into a frame rather than remain free-standing

Kalavrezou-Maxeiner 1985, no. 37. AE

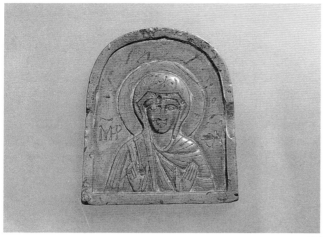

184

184 Steatite with the Mother of God

Probably Constantinople, 12th century

London, BM, M&LA 89,5-11,13

47 × 41 × 4 mm

From Tartûs, northern Syria. Bought by the British Museum from the Revd G. J. Chester in 1889.

Steatite plaque carved with a half-figure of the Mother of God in an attitude of prayer, in an arched frame. The face is worn, and chipped over the right eye. There is the usual abbreviated inscription. The drapery is indicated by thin sketchy lines, which radiate from the neck. The plaque is thin, and consequently the carving is shallow.

The small size of this steatite suggests that it may originally have been framed as a pendant.

Dalton 1901, no. 111; Kalavrezou-Maxeiner 1985, no. 92. AE

185 Steatite carved with Feasts of the Church

Probably Constantinople, 12th century

London, Victoria and Albert Museum, Sculpture Collection, A.17-1920

Max. H. 107 mm, max. W. 68 mm

Bought by the V&A in 1920.

Steatite fragment carved with two scenes divided by a raised border. At the top is the Nativity with the washing of the newly-born Christ and, in the top left-hand corner, the approaching Magi. The disconsolate Joseph sits facing away from the scene. Below are the remains of the upper half of the scene of the Transfiguration, showing Christ standing between Moses and Elijah (for the original form see below). The relief is broken on all sides and was until 1984 inaccurately restored with coloured plaster (see Longhurst, fig. 11, and *Late Antique and Byzantine Art*,

fig. 41). The surface is extremely rubbed, with consequent loss of detail.

This fragment originally formed part of a larger icon showing the Twelve Feasts of the Church, an extremely rare complete example in steatite being that in the treasury of Toledo Cathedral (Kalavrezou-Maxeiner 1985, pls 31-3). By reference to the Toledo icon and a further fragment in the Benaki Museum, Athens (*op. cit.*, pl. 35) it can be demonstrated that the scene to the left of the Nativity panel (of which only a thin strip survives) was the Annunciation, while that to the left of the Transfiguration was the Baptism of Christ. The Transfiguration itself, now truncated, was originally completed below by the inclusion of the three crouching figures of Sts Peter, James and John.

Longhurst 1927, p. 47, fig. 11 on p. 48; *Late Antique and Byzantine Art*, Victoria and Albert Museum, London, 1963, fig. 41; A. Bank, 'Les stéatites. Essai de classification, méthodes des recherches', *Corsi di cultura sull'arte ravennate e bizantina*, Ravenna, 1970, p. 375; Kalavrezou-Maxeiner 1985, pp. 150-1, no. 53, pl. 34. PW

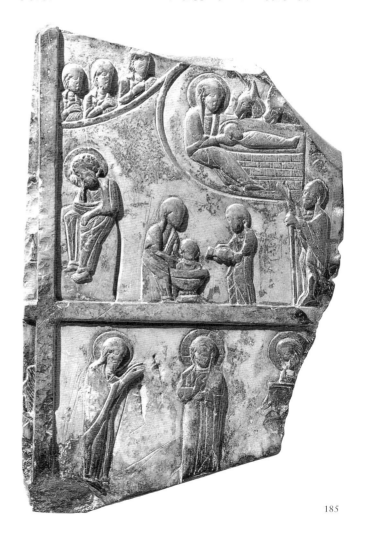

185

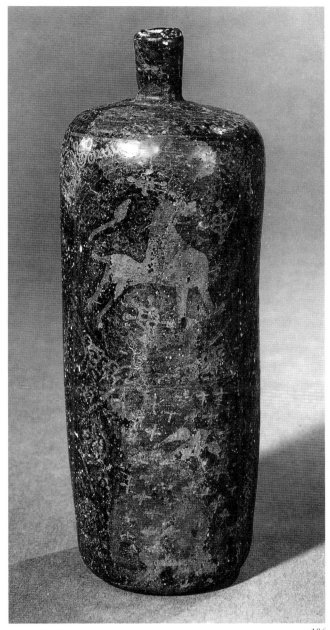

186

186 Scent-bottle

Eastern Mediterranean, 12th century

London, BM, M&LA 1977,7–1,1

H. 152mm

Bought by the British Museum in 1977.

Cylindrical bottle of thick purple glass, with a short neck, also cylindrical. The glass has been blackened by weathering. The vessel originally had gold painted decoration, which is preserved in only a few places: elsewhere it has left

bluish grey traces. The decoration of the body comprises three medallions containing (i) a leopard or similar animal, (ii) a symmetrical pomegranate tree and six birds, and (iii) a quadruped, probably a hound; below each medallion is a panel containing a bird against a background of crosslets; between the panels are strips or ornament based on running scrolls or zigzags. The shoulders of the bottle are decorated with a bird (perhaps originally two), eight-pointed stars and scribbled scrollwork. Similar scrollwork fills the interstices between the medallions

A similar, though larger, bottle is in the Corning Museum of Glass, Corning, New York (*Glass from the Ancient World: the Ray Winfield Smith Collection*, Corning, 1957, no. 526; J. Philippe, *Le monde byzantin dans l'histoire de la verrerie*, Bologna, 1970, p. 120, fig. 66; A. Grabar, 'La verrerie d'art byzantin au moyen âge', *Monuments Piot* 57 (1971), p. 99, fig. 10). Fragments of bottles found at Paphos, Cyprus, also relate to the British Museum vessel (A. H. S. Megaw, 'More gilt and enamelled glass from Cyprus', *Journal of Glass Studies* 10 (1968), figs 5–6, and 'A twelfth-century scent-bottle from Cyprus', *Journal of Glass Studies* 1 (1959), pp. 58–61, fig. 1).

A. H. S. Megaw, 'A twelfth-century Byzantine scent-bottle', *British Museum Occasional Papers* 10 (1980), pp. 25–30. DB

187 Painted glass bangles

Eastern Mediterranean, 12th century

London, BM, M&LA 1979,11–2,1/2

Max. diam. 77 mm and 80 mm

Given to the British Museum by Saeed Motamed in 1979.

Two bracelets, one of black and the other of deep blue glass, both annular and originally round in section. They are painted, originally in white, with stylised birds and abstract line motifs, the latter for the most part based on zigzag or hatched patterns. The decoration relates closely to that on the gold-painted bottle, no. 186, and the bracelets are likely also to date from the twelfth century. They represent a late stage in the development of Late Antique and Byzantine glass bangles, of which the British Museum has a great number of earlier examples, mainly from Egypt.

Unpublished. DB

187

188(a–b) *Sgraffito* pottery

Eastern Mediterranean, first half of 12th century

Byzantine red ware decorated by scratching through white slip, applied to the interior before lead glaze was added and the vessels fired, is known as *sgraffito* ware. The glaze, with the passage of time or in the conditions in which the vessels survived, usually discolours the white slip in this type of pottery, which is therefore sometimes called cream-glazed red ware.

Since the development of sub-aqua sport, many *sgraffito* vessels have come on to the market intact, it is presumed from sunken cargo-ships.

188(a) Dish

London, BM, M&LA 1979,4–4,1

Diam. 260 mm, H. 56 mm

Bought by the British Museum in 1979.

The vessel is of unusual shape, having fairly straight sides flaring from a pronounced foot-ring; its general appearance is of a shallow inverted cone. The inside of the dish is raised in the centre. The slip was applied so carelessly that some spilled over on to the exterior of the vessel; the slip which had encroached on the outside was covered with a water-soluble red pigment, presumably applied to blend with the unglazed red exterior and disguise the pale drips and dribbles until after the sale of the vessel. (It is assumed that the vessel had formed part of a trader's cargo; its condition when acquired by the British Museum showed it to have been under water for a considerable period.)

The decoration comprises a bird and foliage. While the drawing is less stylised and more hesitant than on many examples, the combination of motifs and technique date the dish to the twelfth century.

Unpublished.

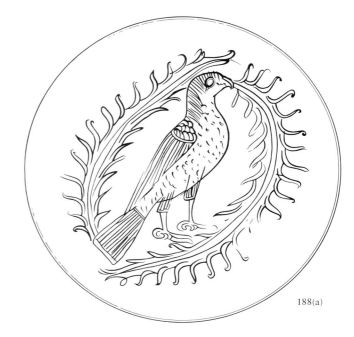

188(a)

188(b) Plate

Lent by Paul Hetherington

Diam. 211 mm, H. 40 mm

Shallow plate with foot-ring and out-turned flat rim, which slopes very slightly downwards into the plate; the interior is perceptibly raised in the centre. The *sgraffito* decoration comprises a stylised bird and foliage, drawn confidently, with spirals and other motifs on the flat rim. Parallels abound for details of both bird and foliage (see V. H. Elbern, 'Mittelbyzantinische Sgraffito-Keramik: Neuerwerbungen für die Frühchristlich-byzantinische Sammlung', in *Berliner Museen* 22 (1972).

Unpublished. DB

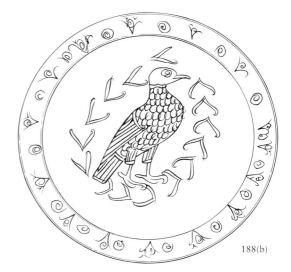

188(b)

189 Consecration cross (*stauropegion*)

Possibly either Aphrodisias or Ainos, 1172

Oxford, Ashmolean Museum, Department of Antiquities, 1952.437

Total H. 210 mm, w. 130 mm, thickness 3 mm

From the region of Enez (Ainos) in Turkish Thrace; acquired in Istanbul in 1926. Given to the Ashmolean by Georgina Buckler (1952).

Latin cross, thick and heavy, cast in bronze in a single piece, with broad flaring arms having inwardly cusped ends and knob finials on the corners. An integral tang descends below the lower arm; it is broken off beneath a large hole. Both faces of the cross bear a lengthy Greek inscription in single-stroke lettering. The text is complete on one side and abbreviated by about 105 letters on the other, where it has been further reduced by wear, particularly on the upper arm. The complete text is as follows: '+ Consecration by cross carried

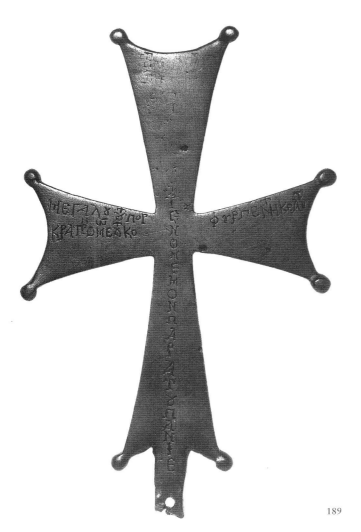

189

out by the most godly metropolitan of Stauropolis of Caria, the lord Leo, at the church of our holy father Nicholas, who is among the saints, under the Emperor Manuel Comnenus, porphyrogenitus and autocrator, and Michael, the most holy ecumenical patriarch, on 10 July indiction 5, the year 6680 [1172] +'

The wording of the complete text is very close to that given in the *Euchologion* for engraving on the cross set up for the consecration of a new church. Goar's rubric in the *Euchologion* specifies that the cross was to be set up in the apse, behind the altar. It has been suggested that the inscription which is incomplete on one side of the cross continued on the staff into which the cross was inserted, and that this other version of the text may have omitted mention of the patriarch and the date (Buckler). The patriarch named in the complete text on the cross is Michael III (1169–77).

Although the extensive text inscribed on the cross identifies the consecration as carried out by Leo, Metropolitan Bishop of Stauropolis (Aphrodisias) in Caria, it is debatable whether the church of St Nicholas, where this cross was set up, was in his see in Asia Minor, which was near the area of conflict with the Seljuq Turks. It has been suggested that the church was, instead, situated near Ainos (Enez), in Thrace, where the cross is said to have been found. The cross was seen early this century in the monastery church of Skaliotissa, near Enez. Leo signed a synodal decree at Constantinople in 1166/7; the see of Stauropolis survived in name until the fourteenth century (Roueché).

This twelfth-century cross is heavier and thicker in body, and has broader arms, than the other two Ashmolean crosses, nos 161 and 175. For shape, the cross can be compared with a tenth-century example, inscribed with the name of St Paraskeve (Campbell 1985, no. 177; the arms here, however, terminate in three disks), as well as with a fragmentary cross in New York, decorated with incised figures (Nesbitt 1988, no. 10). The inscribed cross of Nicetas from Corinth and one dated 899 are likewise similar but flatter, having disks at the corners (exh. cat. *Byzantine Art a European Art* (1964), no. 555; Bouras 1979, fig. 30). The inwardly cusped arms recall silver crosses in Geneva and elsewhere, although the arms themselves are narrower (Mango 1988, figs 2, 5, 7, 9).

L. Petit, *Bulletin of the Russian Archaeological Institute in Constantinople* 13 (1908), p. 19; W. H. Buckler, 'A memento of Stauropolis', *Byzantinische Zeitschrift* 28 (1928), pp. 98–101; C. Roueché, *Aphrodisias in Late Antiquity*, London, 1989, pp. 167, 325; Mango, forthcoming. MMM

190 Royal mitre from the tomb of the Holy Roman Emperor Henry VI

Sicily or southern Italy, late 12th century, incorporating contemporary textiles from the eastern Mediterranean or western Asia (perhaps Constantinople) the western Mediterranean (probably Spain), and from Germany and Sicily.

London, BM, M&LA 78,9–7,1–3

Approx. 180 × 600, 440 × 75 and 430 × 75 mm

Bought in 1878 from the Revd Greville Chester. Found in the tomb in Palermo Cathedral of the Emperor Henry VI (d. 1197, reburied 1215): probably removed when the tomb was opened in 1781. In 1781 the mitre was at the feet of the corpse. In 1491, however, when the tomb had also been opened, the mitre had been on the emperor's head: '*In testa di lu quali chi era una biritta di zandadu blancu, frixiata di oru, cu dui pizzi ad modum di mitra, cu dui pinnaculi darreri, cussi comu su pinti l'imperaturi in la ecclesia di Muntiriali*' ('On his head there was a cap of white zendal, with orphreys of gold, with two peaks in the manner of a mitre, with two pinnacles . . .[?], just like on the painting of the emperor in the church at Monreale' (Daniele, p. 41). The British Museum also possesses a fragment of pink and gold silk from the tomb of Henry VI, said to be part of a *drappo* or pall (other fragments are in Palermo Cathedral) and the silk lining of a shoe; from the tomb of Frederick II, the British Museum has a small piece of a funerary crown (M&LA 78, 9–7,4–6).

Fragmentary royal mitre, the fragments now mounted as three units: the remains of the crown of the mitre, and two lappets. The six constituent textiles are as follows: (i) the main textile of the crown; (ii) the main textile of the lappets; (iii) a braid sewn around the bottom of the crown and around the bottom of the lappets; (iv) a braid sewn lengthways down the lappets; (v) a narrow braid which edges the wider braids; and (vi) two sections of fringe across the ends of the lappets. As reconstructed, the mitre was comparatively soft and shallow, additionally embellished with a fourth braid, which ran up the centre front and back of the crown and along the ridge. The fourth braid is now missing but is known from Daniele's 1784 publication: the three sections he illustrates exactly correspond in size to the stitch marks still visible on textile (i). There may once also have been a linen lining, but this would have been unlikely to survive the conditions of burial.

Textile (i), of undyed silk, preserves part of a very large-scale design. As shown in the reconstruction of the design by Flanagan, this consisted of repeating roundels containing paired eagles or eagle-headed monsters against a background of curling stems and leaves with perched birds. The frames of the roundels have curling stems enclosing lotus flowers between inner and outer pearled borders. At the four points where the roundels touch there are small roundels with stylised foliage inside a pearled border. The space between the roundels has a cross-shaped motif of foliage including tightly packed

190

overlapping leaves (for a similar but smaller design, see Volbach 1969, fig. 71).

Weft-patterned weave, the ground tabby, the pattern weft-faced tabby, one pick of ground weft followed by one pick of (thicker) pattern weft. Warp yarn z-twist undyed silk; approx. 80 ends per cm. Weft yarns undyed silk without twist; approx. 30 picks of each weft per cm. Lengthways repeat estimated at 72 cm, widthways (reverse) repeat at 36 cm.

Textile (ii), of undyed silk, is mainly hidden beneath braids, but its design of medium-sized repeating roundels has been partially reconstructed by Flanagan. The roundel frames are built up from tear-drop shapes with simplified lotus flowers as an inner ring; the spaces between the roundels have a cross-shaped arrangement of curling leaves; the main motif inside the roundels is not represented, but the background to it includes curling stems and foliage.

Tabby-tabby lampas weave, the binding warp threads hidden in the ground behind pairs of main warp thread, one pick of ground weft followed by one pick of (thicker) pattern weft. Warp yarns z-twisted undyed silk; approx. 70 ends per cm of the main warp and approx. 18 per cm of the binding warp. Weft yarns undyed silk without twist, approx. 28 picks of each weft per cm. Lengthways repeat estimated at 32 cm, widthways repeat 32 cm or, if reversing, 16 cm.

Textile (iii), of coloured silk and gold thread (all now discoloured), is a braid or ribbon originally 55 mm wide but with the border broken off in many places. The design consists mainly of stylised plants with a central straight stem and curling side stems ending mostly in trefoils. Birds perch

at various places and a four-footed animal stands on the base-line. Diagonal bars break up the design into triangular and trapezoidal segments and the orientation of the design changes to the opposite border in successive segments. The border is of curling stems and trefoils.

Tablet-weaving, weft-brocaded and warp-patterned, pattern areas in 4\1 warp-faced twill, gold ground in 1/4 twill (P. Collingwood, *The Techniques of Tablet-Weaving*, London, 1982, p. 346, pl. 205). Warp yarns probably originally of four different colours, silk z-twisted, s-plied; approx. 160 ends per cm. Main weft not visible; brocaded weft strips of gilded silver foil tightly s-wound around an s-twist silk core; approx. 35 picks of each weft per cm. Pattern repeat uncertain.

Textile (iv), of coloured silk and gold thread, is a braid or ribbon 52 mm wide. The design, oriented lengthways, is of roundels containing alternately pairs of birds and beasts flanking a stylised tree; in the spandrels, a smaller simplified plant; plain outer borders.

Probably tablet-weaving, weft-brocaded, ground in 3/1(?) warp-faced twill. Warp yarn z-twisted, s-plied silk, probably originally yellow or red; approx. 160 ends per cm. Main weft yarn z-twisted; brocaded weft, strips of gilded silver foil s-wound around an s-twisted silk core; approx. 22 picks of each weft per cm. Pattern repeat 8.1 cm.

Textile (v), a braid 6 mm wide, is of silk, originally red, and gold thread. Two simple geometric designs are present, both based on lozenges.

Brocaded tablet-weaving; warp yarn, red silk, without twist, s-plied; approx. 52 ends in the braid. Main weft yarn, red silk, without twist; brocaded weft yarn, gilded strips of animal membrane s-wound around an s-twist silk core

190 (reconstruction)

190 (design)

190 (reconstruction)

(powdered gold?); approx. 18 paired picks of each weft per cm.

Textile (vi), cut fringe, approx. 80 mm long, of undyed silk, the band or braid across the top hidden by textile (ii).

The missing braid, illustrated by Daniele, was approximately 25 mm wide and, for a design, had curling stems forming volutes and roundels, the roundels separated by small crosses and containing an Arabic inscription: 'Good fortune, prosperity and glory'. The style of the foliage was similar to that on textile (iv), and the technique and materials were probably the same.

The range of textile types represented by Henry VI's mitre reflects the variety of cultural influences present in Sicily under the Norman kings and their Hohenstaufen successors, Henry VI and Frederick II. Sicily had a silk-weaving industry of its own, perhaps dating back to Byzantine rule and boosted by the Greek silk-weavers captured by Roger II in Greece, and three of the mitre's four braids – (iv), (v) and the missing braid with the Arabic inscription – are likely to have been made locally, as was the cloth of the *drappo*. But tablet-weaving was a stronger tradition in north-western Europe, and (iii), the ribbon around the brim of the crown, although of a type often referred to as 'Palermo', is more likely to have been made in Germany. (From among many parallels in Germany, see in particular the main braid of a mitre found in Bremen: M. Nockert *et al.*, *Ärkebiskoparna från Bremen*, Stockholm, 1986, no. 24.) Also on technical grounds, the main textile of the lappets (ii) can also be identified as a probable import: the manner in which, in the ground, the threads of the binding warp are hidden by pairs of main warp thread is matched by silks known to have been woven in Islamic Spain. The weave of the main textile of the crown (i) is a variation of the weave of the Edward the Confessor fragments, no. 166, and like that could in theory have been executed anywhere in an area extending eastwards as far as Persia. In this example, however, the huge scale and the static quality of the design point to a Byzantine origin.

The Byzantine influence in Sicily was particularly strong in court ritual, and, in terms of their decoration at least, the vestments from Sicily that survive as part of the imperial regalia in Vienna – the Mantle of Roger II and the Alb and Dalmatic of William II – are the closest thing we have to vestments worn by the Byzantine emperors. At first sight it is difficult to place Henry VI's mitre into this tradition. In their hat-like manifestation, whether the domed type of the eastern church or the form with two points used in the West, mitres were a comparatively recent invention. There are no extant examples or depictions of them from before about 950. Where they can be identified, they are almost always worn by churchmen, especially bishops (J. Braun, *Die liturgische Gewandung*, Freiburg im Breisgau, 1907, pp. 424–48; E. Piltz, *Kamelaukion et Mitra*, Stockholm,

1977, pp. 20–1, 70–2, figs 162–86). However, these mitres did have ancient origins: in classical antiquity, a *mitra* in Greek and its Latin equivalent, an *infula*, was a band or fillet tied around the head, worn by priests and the high-born. The tradition of wearing such a fillet survived into the Christian era, and the hat-like mitres, as well as the caps worn by kings under their metal crowns, should really be understood as a support for these fillets: the lappets that hang down the back represent the ends of the fillet, and the band around the crown, present on all the surviving early western mitres of hat form, represents the fillet itself (for illustrations, see Braun, *op. cit.*, figs 224–33; Schramm and Mütherich 1962, p. 401, no. 166b).

The ecclesiastical appearance of some of the Sicilian vestments has been explained by an agreement between Roger I and the pope in 1098, as a result of which the rulers of Sicily were in effect their own papal legates (Braun, *op. cit.*, pp. 456–7; P. E. Schramm, *Herrschaftszeichen und Staatssymbolik*, I, Stuttgart, 1954, pp. 77–80). But in the case of two mitres, that found in the tomb of Henry VI and another reportedly found in the tomb of William I, Déer has suggested, instead, an imitation of the practice in Constantinople of removing the crown from the head of the dead emperor at burial and replacing it with a purple band (Déer, p. 17). The fact that Henry VI's mitre would have been lower and softer in appearance than contemporary church mitres could be taken to support Déer's view. This mitre could then be seen not as a Byzantine vestment as such but as a vestment inspired by Byzantine practice.

F. Daniele, *I regali sepolcri del duomo di Palermo*, Naples, 1784, pp. 37–41, pl. H; J. Déer, *Der Kaiserornat Friedrichs II.*, Zurich, 1952, pp. 11–19; Flanagan 1956, p. 498, fig. 2; P. E. Schramm and F. Mütherich, *Denkmale der deutschen Könige und Kaiser*, Munich, 1962, no. 186; H. Granger-Taylor, 'Three figured silks from the tomb of the emperor Henry VI at Palermo: evidence for the development of lampas weave?', in: S. Desrosiers (ed.), *Soieries tissées autour de la Méditerranée de la fin du Xe au XIIIe siècle*, Paris, 1995, forthcoming. HG-T

The Crusades and Latin rule

Starting in the last years of the eleventh century, military expeditions had been mounted by Christian powers in the West with the object of wresting holy sites from Islamic control; some of them enjoyed short-term success. On the First Crusade (1096–9) Jerusalem had been captured, and a crusader kingdom set up there. The Third Crusade (1189–91), in which Richard I of England, 'Coeur de Lion', had taken part, had resulted in the capture of Acre and the foundation of a Latin empire in the East.

At the beginning of the thirteenth century the Fourth Crusade, on its way to drive the Saracen from the Holy Sepulchre in Jerusalem, arrived in Venice. The crusaders, mainly from northern Europe, needed Venetian ships but, unable to pay for the passage in advance, entered into certain undertakings, including the promise of a sizeable proportion of any conquests they might make. For various reasons the crusaders abandoned their original objective and instead attacked Constantinople, the richest city in Christendom. It fell to the crusaders in 1204, remaining under Latin rule until 1261, when it was retaken by the Byzantines.

The increasing contact between East and West, although sometimes violent, inevitably led to cultural cross-fertilisation. So many works of art were looted from Constantinople between 1204 and 1261 that the impact of Byzantium on the West was particularly strong. The influences were not all one-way, however, and Byzantine art of the twelfth and thirteenth centuries showed an increasing awareness of western traditions.

191 Icon of St George and the youth of Mytilene

Holy Land, middle of 13th century

London, BM, M&LA 1984,6–1,1 (National Icon Collection, no. 13)

268 × 188 mm

From an English collection, sold as a nineteenth-century Russian icon at Christie's on 31 March 1978, lot 196. Bought by the British Museum in 1984.

Egg tempera and gold leaf on gesso over linen on a pine panel. The young unbearded saint, identified by a red-painted Greek inscription, is depicted on a white horse with red harness, a smaller figure mounted behind him. The saint

is diademed and wears a red flowing cloak, ribbed cuirass over a blue tunic, and red hose; he carries a red staff or lance. The small figure wears a pale blue tunic and black hose, and grasps a glass containing a red liquid. Below the horse is a mountainous landscape and sea. The rest of the background and the saint's halo are of gesso modelled into a three-dimensional scroll pattern, on which there are traces of silver. Much of the gesso has been lost from the edges of the composition.

The iconography depends on a Greek text of the post-humous miracles of St George: the small figure is a young Christian from Mytilene, in captivity on the island of Crete. The boy was forced to serve his Saracen masters with food and drink but, in the very act of offering a glass to one of his captors, was rescued by St George and carried home over the Aegean. The three-dimensional scrollwork, originally silvered, imitates the precious-metal revetments found on some icons. The style of the painting has been compared with wall-paintings in the Kalenderhane Camii in Istanbul (a cycle of St Francis of Assisi) and the miniatures of the Arsenal Bible (Paris, Arsenal, 5211), both indicating a mid thirteenth century date. While the iconography and the gesso work indicate an eastern origin, the prominent bulging eyes of the figures and the 'Gothic swing' of the composition seem to belong to the western artistic tradition. This mixture of influences is characteristic of an art produced in the eastern Mediterranean at the time of the Crusades. Lydda, the cult centre of St George in the Holy Land, could well have been the place of manufacture; Cyprus has also been proposed.

R. Cormack and S. Mihalarias, 'A Crusader painting of St George: "maniera greca" or "lingua franca"?', *Burlington Magazine* 126 (1984), pp. 132–41, colour illustration front cover; D. Mouriki, 'Thirteenth-century icon painting in Cyprus', *Griffon*, n.s., 1–2 (1985–6), pp. 9–112. Exhibited: *Byzantium to El Greco* (1987), no. 9. RC

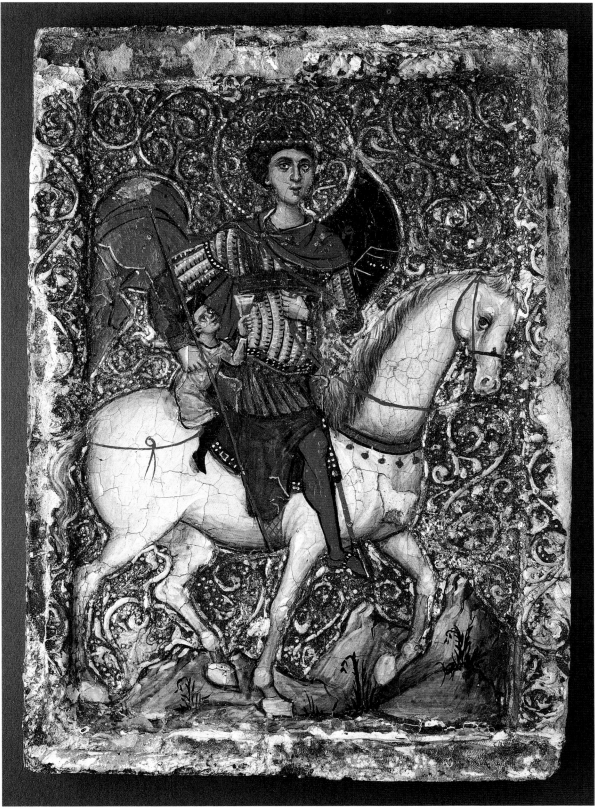

191

192 Liturgy of St Basil

Eastern Mediterranean, perhaps Constantinople, 12th century

London, British Library, Additional MS 34820

3155 × 220 mm

Bought by the British Museum in 1896 from the Revd Dr John Samuel Dawes, chaplain at Corfu.

At the deacon's cry of 'The doors! The doors!', the Liturgy of St Basil 'the Great' (about 330–79) moves a stage forward in the liturgy of the Eucharist. The congregation recite the Creed, the priest and the congregation exchange a short introductory dialogue, and then the priest begins the first of a sequence of long prayers proffering adoration and ecstatic praise to God. At the end of this prayer the congregation chant the Trisagion ('thrice Holy'), or Sanctus.

This parchment roll preserves an early version of one of two parallel Byzantine formularies for the ritual of the Eucharist which are still used by the Orthodox Church. Unlike the Liturgy of St John Chrysostom (about 347–407), that attributed to St Basil has since around 1000 been celebrated only ten times each year. It is apparently based on earlier practice in Cappadocia and may owe only its general structure to St Basil. Surviving manuscripts show that even after the ninth century the text of the Liturgy of St Basil underwent many changes. Annotations in the right margin of this one draw on a version different from and probably later than the main text, which is similar to that of the earliest surviving witnesses.

Catalogue of Additions to the Manuscripts 1894–1899, London, 1901, p. 100. SMcK

193 St John and the beginning of his Gospel

Southern Italy or Sicily, mid to late 12th century

Glasgow, University Library, MS Hunter 475 (Gospel Book), folios 274v–275r

Folio 185 × 140 mm; image approx. 150 × 95 mm

Ex libris Caesar de Missy, London, 1748. Acquired by Dr William Hunter at the sale of de Missy's library in 1776 (lot 1638). Bequeathed by Hunter to the University of Glasgow (1783).

The left page shows the transmission of St John's Gospel. The hand of God (awkwardly drawn) extends from a segment of heaven at the top right and instructs the evangelist. The tall standing figure of John turns his head towards heaven, holds a scroll in his left hand, and with his right instructs the youthful scribe seated on a stool at his feet. The scribe extends beyond the frame in an unusual way. The Gospel text begins on the facing page with an enlarged E, beneath a title and headpiece all executed in gold and a red-purple pigment. The scribe probably did his own decoration on this page, but the facing image is by a

192

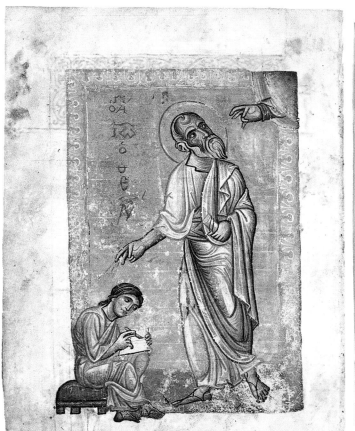

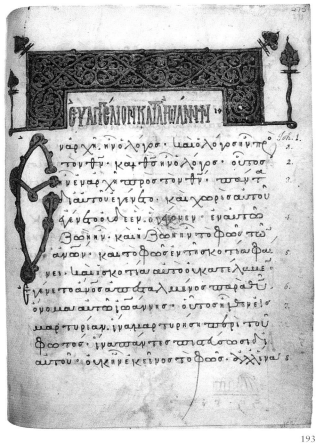

193

193

different hand. The book shows signs of heavy use. The left page is worn and discoloured, and the verdigris green has deteriorated markedly. Some of the gold on both pages has been offset on to the facing surface.

The treatment of the frame in this image is odd – the artist seems to have suppressed it where it conflicted with some other part of his design. Similar unusual features characterise the other evangelist images in the book. There is no doubt that the artist was a skilled craftsman, but he was not in the mainstream of the Byzantine tradition. The Gospels were written in two sections by two scribes, the first supplying the Matthew, and the second from Mark to John. Although the script is different, the images are by a single hand (the Matthew now very flaked), implying a single phase of work for the book. Evidence from the script, initials, headpieces and images all suggests that the book was produced in a Greek context in southern Italy or Sicily. It remained in use there for some time, to judge by an added section at the front, of fourteenth or fifteenth century date, which begins with instructions for a wedding service, in Italian written phonetically in Greek characters and accented.

J. Young and P. H. Aitken, *A Catalogue of Manuscripts in the Library of the Hunterian Museum in the University of Glasgow,* Glasgow, 1908, pp. 394–7; I. C. Cunningham, *Greek Manuscripts in Scotland*, Edinburgh, 1982, no. 59; N. Thorp, *The Glory of the Page*, London, 1987, no. 12, col. pl. 2. JL

194 Illustrated Gospels

Periphery of the Byzantine world, perhaps Cyprus or Palestine, late 12th century

London, British Library, Harley MS 1810 (the four Gospels), folios 173v–174r

Folio 225 × 165 mm; image approx. 127 × 108 mm

In a monastery dedicated to Prophetes Elias (the prophet Elijah) in about the seventeenth century (fol. 269r). Subsequently in the collection of Robert Harley, Earl of Oxford (d. 1724). Bought for the British Museum in 1753.

The manuscript is open in St Luke's Gospel. Originally the scribe broke off near the end of Luke 11.26 at the bottom of the left page, writing the last three words in an enlarged script above the image on the right, but a later hand repeated the three words at the bottom of the left page. The scribe then left twenty-one lines blank on the right page, recommencing with Luke 11.27, numbered in the Byzantine

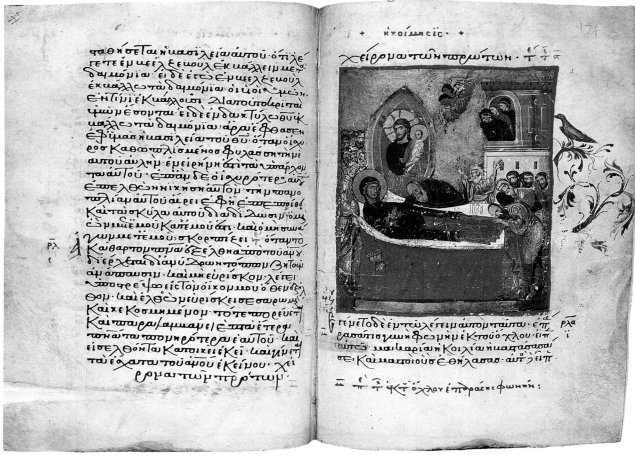

194

system as chapter 40 and entitled below in gold 'On the lifting up of the voice from the crowd'. In this space the artist painted the image of the Koimesis (the Dormition of the Virgin), its title in gold at the top. The Mother of God is stretched out on her bier, her eyes closed in death. The mourners are led by St Peter at the left, swinging a censer, and St Paul, who bends to embrace her feet. The accompanying apostles indicate their grief, while Christ in a blue mandorla carries the swaddled childlike soul to heaven. Two angels swoop down while three women mourn in an upper window at the right. Although most of the image is in good condition, some parts have been restored, notably the angels and the heads of the apostles at the back of the group to the left. The background has also been crudely re-gilded, while yellow paint was used to fill gaps in Christ's halo. The brilliant red border is also a later restoration.

This manuscript is one of the relatively rare examples from Byzantium of the integration of images of Christ's life into the text of the Gospels. The death of the Mother of God, however, is not mentioned in the Gospels. (Based on apocryphal accounts it was established as a major feast of the Byzantine Church by the sixth century.) The justification for including the image at this point is the reference in Luke 11.27 to the woman who said to Christ: 'Blessed is the womb that bare thee and the paps which thou hast sucked'. There are a further nineteen large images like the Koimesis in the book, in addition to the usual evangelist-as-author miniatures. The condition of the images throughout is puzzling, and most seem to have received significant attention, perhaps in the sixteenth century. Very likely, they had flaked extensively. The pigments used were duller and grainier than in the original work, and the gilding over what looks like a layer of brown varnish is notably crude. But the unusual repertoire of ornament, as in the bird alongside the Koimesis, or the figures and animals in the Canon Table pages, suggests that even the original artist was not in the mainstream of Byzantine artistic production (though Carr believes this ornament to be part of the later restoration).

Carr, 1987, esp. pp. 55–69, 251–2; microfiches 6C12, 6D12, 6F5–7A7; *Summary Catalogue*, p. 122. Exhibited: *Christian Orient* (1978), no. 10. JL

195 Sts John and Prochorus, and the beginning of John's Gospel

Eastern Mediterranean, perhaps Nicaea, first quarter of 13th century

Manchester, John Rylands University Library, MS Greek 17 (Gospel Book), folios 271v–272r

Folio approx 235 × 170 mm; image 155 × 115 mm

Notes of various sixteenth-century owners/users: the hieromonk Neophytos, Papageorgis, Georgios, and liturgical notes of 1549/50. In the possession of Athanasios *amartolos* of a church or monastery of the Pantanassa in 1729 (fols 1–4, 352).

On the left page the Gospel is transmitted from God through the evangelist John to his scribe Prochorus (identified, like John, by a faded marginal inscription). John stoops and turns his head towards the word of God, represented by the 'speaking' hand, and lifts his left hand in a gesture of acceptance. He dictates with his right to Prochorus who sits on the ground displaying the sole of his left foot. He looks up at the evangelist, lifting his left hand (he accepts the word), and with his right penning the opening of the Gospel ('In the beginning was the word . . .') on a large ruled panel. The drapery behind his shoulder forms an exaggerated, almost intestinal, series of folds. Despite heavy wear (note the drops of wax on John's elbow), the miniature is in good condition. The facing page has suffered much more. The upper corner has been so heavily thumbed that almost all the pigment has worn off the headpiece, leaving the crimson lake underdrawing. The square headpiece is divided into nine smaller squares in a symmetrical design; there are peacocks above, and a chained monkey atop a stylised tree at the right. Beneath, the title and opening of the Gospel are written entirely in gold. The initial E is formed of five fish and a human figure, perhaps a fisherman.

The image of John and Prochorus was painted on a single leaf, blank on its recto, and preceded by another single leaf on which the scribe wrote the *kephalaia* list for John, blank on its verso. The two leaves are original and were marked by the scribe as comprising quire 38 (ΛΗ visible in the inner lower margin of folio 271v). The other evangelist images, and the prefatory images of Moses on Mount Sinai (fol. 2v) are also on single leaves (*contra* Buchthal 1983, p. 82). Quire 1 is missing, and doubtless this contained ornamental

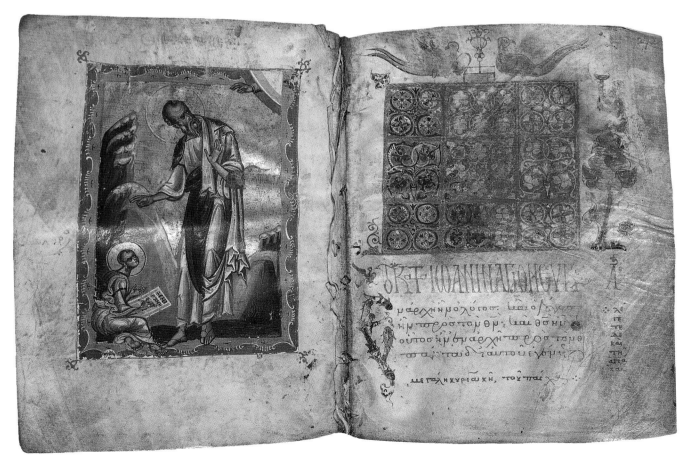

195

Canon Tables. Much of the design of this book, its ornament and images, including even details such as the display of the underside of a foot, goes back to works of the 'Kokkinobaphos Master' about a century before. The opening of St John's Gospel is noticeably more worn than the other Gospels. Probably this means that the book continued to be used, but primarily in Easter ceremonies, presumably into the eighteenth century (e.g. folio 352v).

Buchthal 1983, pp.82–6, figs 85–92; Carr 1987, no.72, pp.107–11, 113–18, fiche 9C1–9C10. JL

196 St James and the beginning of his Epistle

Eastern Mediterranean, first half of 13th century

Cambridge, University Library, MS Add. 6678 (Acts and Epistles), folios 44v–45r

Folio 187 × 130mm; image 90 × 94mm

Possibly on Samos in the seventeenth century – see below. Collection of W. Makellar, DD, of Edinburgh; purchased at the Makellar sale in 1898 (lot 3013) by Arthur William Young. Presented by Young to Cambridge University Library in 1933.

The scribe left blank more than half of the left page to allow space for a square image of St James to preface his epistle, which has a title in gold display capitals and a simple gold initial I. James is clad in the usual classical dress of an apostle, over which he wears the white scarf-like *omophorion*, decorated with large black crosses, which marks him out as a bishop – traditionally, the first Bishop of Jerusalem. He holds a book in his covered left hand, identifying him as an author. Although the image shows him frontally, his eyes are turned away from the viewer, perhaps towards the text of his letter on the right page. Despite some flaking of the pigments and rubbing of the gilding, the image is in good condition, and the portrait of the saint holds the viewer's attention. On the right page a later hand has emended the text of James 1.11 so that the rich man will fade away not 'in his ways' but 'in his vices'.

In addition to the image of James, there are images of each of the other authors of the epistles (Peter, John, Jude

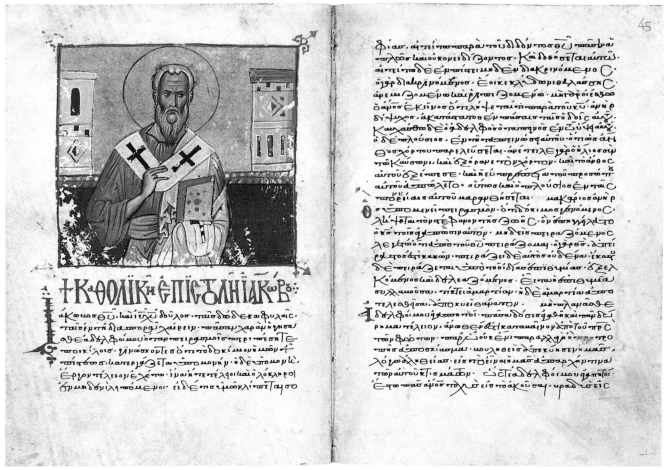

196

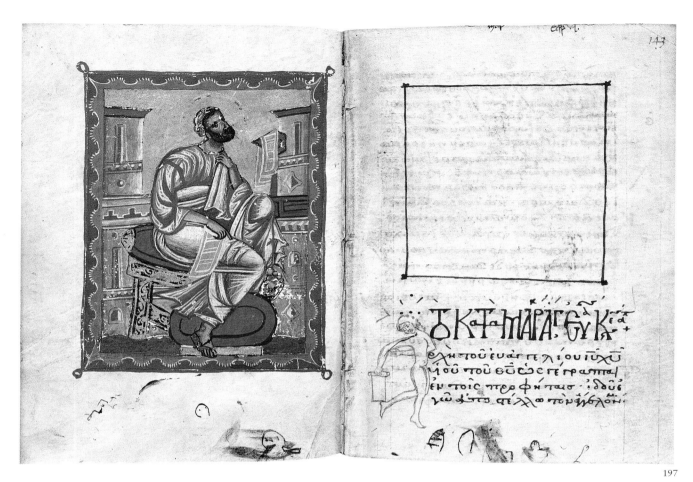

197

and Paul) at the appropriate points. Acts is prefaced not by an image of Luke, however, but by a medallion of Christ in the centre of a decorative headpiece. Surviving original quire marks from Γ ('3') on fol. 17r show that Acts was always intended to begin a new volume, but Carr has proposed that this manuscript was originally followed by an illuminated Psalter text, now in a private collection in Switzerland, and that the two were rebound as separate volumes in the monastery of Prophetes Elias on the island of Samos after 1672.

Carr 1987, no. 37, pp. 160 n. 27, 289, fiche 5F10–5F12, 5G10–5G12. JL

197 St Mark and the beginning of his Gospel

Eastern Mediterranean, perhaps southern Greece, second quarter of 13th century

Cambridge, Gonville and Caius College, MS 403/412 (Gospel Book), pp. 142–3 (folios 71v–72r)

Folio 197 × 145 mm; image 132 × 104 mm

In the possession of Robert Grosseteste, Bishop of Lincoln (d. 1253), probably acquired after 1230, and bequeathed by him to the Franciscan house in Oxford. Lent to the Cambridge Franciscan Richard Brinkley in the early sixteenth century. Presented to Gonville and Caius College by Thomas Hatcher in 1567.

St Mark is central in the image, in a curiously mannered pose. His head is thrown back, and he turns to look at the viewer. The face, unfortunately, is worn and damaged. His left hand grips his *himation* near the neck, while his right holds the top of a blank scroll with ruled panels and points downwards, perhaps to the start of his Gospel on the facing page. One of his feet hangs down in front of the cushioned footstool, while the other appears above its upper edge, displaying the underside of the sole and toes. The artist painted the straps on Mark's sandals on both the upper and lower sides of his feet. On the facing page the scribe ruled a square frame for the headpiece and wrote out the title and first four lines of the Gospel in the same crimson lake. At the left he (or someone else) sketched a naked dancing figure holding a scroll in the shape of the letter A. A later user scribbled in the lower margins.

Only two of the four evangelist images, inserted on single

leaves, have survived (the other is of Luke, on p. 238), but an offset on p. 371, the start of St John's Gospel, is clear enough to show that an image of a standing John and seated Prochorus once faced this page. Although we can thus assume a full set of four images, all four headpieces were left as blank spaces, and the initials as sketches. Either the book was required before they were completed, or no competent artist was available at the time. The book is of particular interest owing to the presence of marginal annotations in the hand of the Franciscan scholar Robert Grosseteste, a key figure in promoting a knowledge of Greek in thirteenth-century England. Marginal corrections in Greek in Grosseteste's hand throughout the book indicate that he collated it carefully against another Greek Gospel manuscript. It is not known how, when or where he acquired this book. A later hand provided an interlinear Latin translation of some words, especially at the start of Matthew and Luke; the user was a beginner in Greek.

R. W. Hunt, 'The library of Robert Grosseteste', in: D. A. Callus (ed.), *Robert Grosseteste, Scholar and Bishop*, Oxford, 1955, pp. 131, 135; Buchthal 1983, pp. 78–80, figs 83–4; Carr 1987, no. 36, pp. 117–20, fiche 9B7–9B12; A. C. Dionisotti, 'On the Greek studies of Robert Grosseteste', in: A. C. Dionisotti, A. Grafton and J. Kraye (eds), *Uses of Greek and Latin, Historical Essays*, London, 1988, pp. 19–39. JL

198 Services for the consecration of a church, and other rites

Eastern Mediterranean, perhaps Constantinople, about 1200

London, British Library, Additional MS 39584

4750 × 210 mm

Owned by the Hon. Robert Curzon (d. 1873). Bequeathed to the British Museum by Darea Curzon, Baroness Zouche (d. 1917).

At the end of a long liturgical roll come instructions for the ceremony of erecting a cross on the site of a new church. Below these is a depiction of such a wooden cross, together with alternative texts that should be written on it by the patriarchal notaries. A prayer addressed to God Pantocrator and intended to accompany the ceremony concludes this section.

A roll, as opposed to a codex, was commonly used in Byzantine liturgical ceremonies. Unlike papyrus rolls of antiquity, it bears text written at right angles to the edges and on both sides. The roll format, like that of the use of uncials in lectionaries, seems to have been a conscious archaism and intended to link later Byzantine liturgical practice with the Early Christian period.

Catalogue of Additions to the Manuscripts 1916–1920, London, 1933, pp. 56–7. Exhibited: *Christian Orient* (1978), no. 9. SMcK

198

199 Limestone capital reused as a well-head

Probably Italy, 12th or 13th century

Polesden Lacey, Surrey, the National Trust

H. 790 mm, W. 870 mm; thickness 870 mm

Acquired, after 1906, by the Hon. Mrs Ronald Greville, who bequeathed Polesden Lacey to the National Trust (1942).

Limestone capital, reused as well-head, carved in relief on all four faces. The decoration consists of acanthus-stems at the corners, sprouting on three sides into acanthus-scrolls, inhabited by small-scale animals: a lion, a monkey, two rodents and two dog-like creatures. On two sides, there is a chalice, sprouting more acanthus leaves, one with a stem topped by a pine-cone and a superimposed interwoven cable knot.

Most of the elements of the decoration can be paralleled in twelfth-century Byzantine sculpture: the acanthus-scroll and cable-pattern occur together on the sculptured frame of a mural icon at Nerezi, founded in 1164, while the small dog-like creatures occur on a chancel slab from the same church (Grabar 1976, II, no. 88, pl. LXXVIIa and LXXVIIIa). However, the combination of elements, particularly the superimposition of a geometric pattern over the stem, suggests an incomplete understanding of Byzantine decoration, making a western source, probably in Venice, likely. The gallery panels from the church of San Marco there, dated to the last decade of the eleventh century, include the same decorative elements of chalice, acanthus leaves, lion's

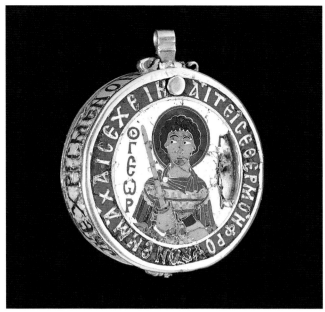

200 (enlarged)

head mask and stem (*op. cit.*, no. 73, pl. LI), although they are in higher relief than on the well-head.

Unpublished. RKL

200 Gold and enamel pendent reliquary

Thessaloniki, 13th century

London, BM, M&LA 1926,4–9,1

Diam. 37.5 mm, thickness 10.5 mm

Engraved on the annular bezel is a mid-eighteenth-century Georgian inscription suggesting that the reliquary once contained a fragment of the True Cross which belonged or had belonged to St Kethevan, a Georgian queen martyred by Shah Abbas I in 1624. The reliquary was bought by the British Museum in 1926, with the help of donations from the National Art-Collections Fund and from O. M. Dalton.

A round gold and cloisonné enamel box with a suspension-loop and an annular hinged lid, within which is a hinged rectangular flap, opening to reveal an embossed supine figure. Round this flap are spaces filled with wax. The base is enamelled with a half-figure of St George in military costume, an unsheathed sword raised in his right hand, his left holding the mouth of the scabbard. There is an identifying inscription. Surrounding the half-figure is an enamelled inscription in Greek: '[The wearer] prays that you will be his fiery defender in battles'. Round the edge of the reliquary, also in enamel, runs the Greek inscription 'Anointed with your blood and myrrh'. The hinged rectangular flap is covered with an enamel supine figure of St Demetrius, identified by an inscription.

199

As Professor Cormack points out, the inscription running round the edge of the British Museum reliquary can refer only to relics of St Demetrius. This inscription, the inscription which surrounds the half-figure of St George, and the half-figure itself all share a single enamelling base and were therefore fired at the same time. If the reliquary is compared with a very similar example at Dumbarton Oaks, Washington, D.C. (Ross 1965, 111–12, pls LXXIV–LXXV, col. pl. H), it will be seen that the annular lid is almost certainly a replacement for a discoid one bearing a representation of St Demetrius.

The special veneration in which St Demetrius and his relics were held in Thessaloniki suggests that the reliquary was made there. Grabar identified thirteenth-century Crusader models for the supine figure of St Demetrius, and this dating is consistent with the twelfth- and thirteenth-century style of enamel on the reliquary: the half-figure of St George has a background of opaque enamel, and the letters of the inscriptions are fully enamelled against a background of a contrasting opaque colour.

O. M. Dalton, 'An enamelled gold reliquary', *Recueil d'études, dédiées à la mémoire de N. P. Kondakov*, Prague, 1926, pp. 275–7, pl. XXX, and 'An enamelled gold reliquary of the twelfth century', *British Museum Quarterly*, I (1926–7), pp. 33–5, pl. XVI; A. Grabar, 'Quelques reliquaires de Saint Démétrios et le martyrium du saint à Salonique', *Dumbarton Oaks Papers* 5 (1950), pp. 3–28 (pp. 16–18, no. 6, figs 16–17), and 'Un nouveau reliquaire de Saint Démétrios', *DOP* 8 (1954), pp. 307–13 (pp. 308–13), reviewed by P. J. Alexander in *Speculum* 31 (1956), p. 370; Ross 1965, p. 111; Wessel 1967, no. 63; *RBK* II (1971) (s.v. 'Email', cols 126–7; M.-M. Gauthier, *Les routes de la foi: reliques et reliquaires de Jérusalem à Compostelle*, Paris [Fribourg], 1983, pp. 40–4, no. 19; Cormack 1985, p. 64, fig. 19; Tait 1986, no. 504. Exhibited: *British Antique Dealers' Association Golden Jubilee Exhibition* (London, Victoria and Albert Museum, 1968), no. 186; *Jewellery* (1976), no. 360. DB

201(a–b) Double-sided enamelled copper medallions

Eastern Mediterranean, 12th or 13th century

London, BM, M&LA

With opaque enamel covering most of the metal, as on no. 200, the use of gold could be thought of as a luxury. Certainly copper was increasingly used as an enamelling base in this period, although this may have had something to do with influences from the West, where enamel on copper was the norm in the twelfth and thirteenth centuries.

A double-sided medallion with half-figures of Christ and the Mother of God in copper cloisonné enamel was found in 1983 at Isaccea (ancient Noviodunum), Romania, in a context said to suggest an eleventh or twelfth century date (F. Topoleanu, 'Un médaillon byzantin en émail cloisonné découvert à Noviodunum', *Revue des études sud-est européennes* 26 (1988), pp. 311–17). Marvin Ross dated an example with Sts Basil and Nicholas in the Dumbarton Oaks Collection, Washington, D.C., to the eleventh century, although most of his comparative material would now be thought of as twelfth (Ross 1965, no. 155).

201(a) Sts George and Theodore

M&LA 1906,11–3,1

Max. diam. 37.8 mm (including frame), thickness 4.1 mm

Given to the British Museum by C. J. Wertheimer in 1906.

Double-sided copper cloisonné enamel medallion with half-figures of, on one side, St George and, on the other, St Theodore, both in military costume and each holding a martyr's cross in front of his chest. Their cloaks are decorated with inverted heart-shapes; on the right sleeve of their tunic is a decorative roundel. Identifying inscriptions are composed of letters outlined in metal strip and filled with enamel contrasting with the colour of the background. All the enamel on the medallion is opaque; most of it survives intact, although with a porous appearance. The gold frame is modern.

O. M. Dalton, *Proceedings of the Society of Antiquaries of London* 21 (1905–7), pp. 194–7, fig. 6; Dalton 1911, p. 498–9, 506, fig. 304; Dalton 1925, p. 338, pl. LXII; Ross 1965, p. 106 (conflating nos 201a and 201b).

201(b) Sts Basil and Nicholas

M&LA 1911,5–12,1

Max. diam. 38.7 mm, thickness 2.6 mm

Bought by the British Museum in 1911.

Double-sided copper cloisonné enamel medallion with half-figures of, on one side, St Basil and, on the other, St Nicholas, each wearing an *omophorion* and holding a book in his swathed left hand. The letters of the identifying inscriptions are outlined in copper strip and fully enamelled.

201(a) 201(b)

All the glasses used on the medallion are opaque; there are losses from both sides, and the enamel has discoloured, possibly as a result of burial.

Dalton 1911, p. 498–9, 506; Dalton 1925, p. 338, pl. LXII; Ross 1965, p. 106 (conflating nos 201a and 201b). D B

202 Pilgrim-flask with soldier-saints and the Church of the Holy Sepulchre

Holy Land, 12th or 13th century

London, BM, M&LA 76,12–14,18

H. 57 mm, W. 38 mm

Given to the British Museum by Augustus Wollaston Franks in 1876.

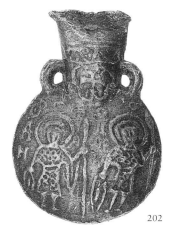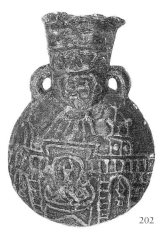

202 202

Lead-alloy ampulla with domed discoid body, pierced lugs at the shoulders, and a flared neck with the rim crushed. Round the neck is an applied band of cut-out heart-shapes with, below, on either side of the ampulla, a Greek cross with flared terminals within a vegetal scroll border, both in relief. Relief decoration on the body of the flask comprises, on one side, two full-length military saints and, on the other, an architectural composition.

Each of the saints holds a spear in his left hand, his right gripping the top of a kite-shaped shield resting on the ground. Although crudely rendered, cells on the saints' bodies suggest chain-mail; inside roughly drawn haloes there is an indication of short hair. In the field are Greek letters. On the other side of the ampulla is a building with exterior and interior conflated. A central open-domed section is flanked by, left, a dome surmounted by a cross and, right, a tower in two stages with a conical or pyramidal roof surmounted by what appears to be a crescent. Under the central section is a dome or arch, from the centre of which hangs a lamp: to either side is an arcade with, below, a masonry wall pierced by an arch, from the keystone of which is suspended a lamp. Below the lamp hanging from the central dome or arch is an indeterminate motif, a twist or plait lying on some sort of container or platform.

The soldier-saints were identified by Dalton as Sts Aetius and George. The inscription identifying the latter saint can easily be pieced together from the Greek letters around the figure, and the identification is not in doubt. In the case of his companion, below the symbol for 'Saint' are an alpha and an eta, followed by an empty space; on the other side of the figure there is a tau or a rho, or a combination of the two, above an iota and, finally, an omicron with a tail, denoting a terminal s. While this undeniably spells 'Aetios', one of the Forty Martyrs of Sebaste, it is far more likely that the letters should be read as 'De[me]trios', George's usual companion-saint: his name appears on a Middle Byzantine

cross (de Grüneisen 1930, no. 175, now in the British Museum) with the initial letter looking like an alpha (A) rather than a delta (Δ).

Although in the past this ampulla would have been dated to the sixth century, the mail garments and, particularly, the kite-shaped shields with which Sts Demetrius and George are equipped indicate a date after about 1100 and place the ampulla in the context of the Crusades. The architectural composition on the other side of the ampulla is, indeed, a recognisable depiction of the Church of the Holy Sepulchre as rebuilt by the Byzantine emperor Constantine IX Monomachus (1042–55). The indeterminate motif at the very centre of the composition is to be interpreted as the shroud left behind at the Resurrection: there is a much clearer twelfth-century representation of it in mosaic (E. Kitzinger, *The Mosaics of Monreal*, Palermo, 1960, fig. 2, and L. Kötzsche-Breitenbruch, 'Pilgerandenken aus dem Heligen Land', in *Vivarium, Festschrift Theodor Klauser zum 90. Geburtstag* (*Jahrbuch für Antike und Christentum*, Ergänzungsband 11), Münster, 1984, pl. 30b) and an eleventh-century western example in ivory, where the exterior and interior of the Church of the Holy Sepulchre are also conflated (Kötzsche-Breitenbruch, *op. cit.*, pl. 30c).

The ampulla, probably containing oil from a lamp in the Church of the Holy Sepulchre, may have been crimped at the rim immediately after filling. The pierced lugs suggest that it was designed to be worn on a cord or thong round the neck.

C. Roach Smith, *Collectanea antiqua*, V, London, 1861, pl. xxxix, fig. 1; Dalton 1901, no. 997. C J S E / D B

203 Pilgrim-flask with Resurrection scenes

Holy Land, 11th to 13th century

London, BM, M&LA 1902,5–29,24

H. 71 mm, W. 53 mm

From El Azam, Egypt. Bought by the British Museum in 1902.

Pewter ampulla with discoid body and straight-sided neck, both now flattened. On either side of the neck, which is split in two places, is a cross within an arch, both in relief.

Relief decoration on the body of the ampulla comprises, on one side, two women at the Sepulchre and, on the other, the incredulity of Thomas. The Sepulchre, a gabled construction surmounted by a cross, is flanked by the two women, approaching from the left, and the angel, seated to the right. Above the scene is the Greek inscription 'The Lord is risen', and, enclosing the whole, an annular inscription '+ Blessing [*eulogia*] of the Lord from the holy places'.

In the second scene, Christ stands on a footstool, a book in his left hand, his right pulling Thomas's hand towards his side. Christ is flanked by eight apostles to his left and, to his right, four apostles below a rectangular feature, a hanging-lamp and a column. A Greek inscription above, in two lines, reads '+ My Lord and my God +' (John 20.28).

The Doubting Thomas scene can be found on two other ampullae: one at Monza and a fragment at Bobbio (Grabar 1958, nos 9, 10). The thirty-six surviving ampullae at Monza and Bobbio are traditionally associated with the period of the Lombardic Queen Theodolinda, and there is little reason to doubt that they all date from the period around 600.

There are a number of similarities between the British Museum ampulla and those of Monza and Bobbio. The scene of the tomb is extremely conservative, depicting the two Marys on one side and the larger angel on the other (cf. Grabar, nos 5,18), and Christ pulling St Thomas's hand towards his side is in much the same pose as on the Monza example, but here the similarities end. Whereas the Monza and Bobbio ampullae group six apostles on either side of Christ, the British Museum ampulla has two groups of four on the right and one group of four on the left; the space which this leaves in the composition has been filled with what is almost certainly a curtain hanging from a rail attached to a volute capital behind Christ. The scene is therefore much more confined, and the inscription is placed above a ceiling – a feature not found in the Monza and Bobbio ampullae, although a hint of a floor similar to that on the British Museum ampulla is visible on the Bobbio fragment. The figure of Christ has an elongated body, tight-fitting upper sleeves and drapery with pronounced 'nested v-folds'; none of these features compares well with the Monza and Bobbio ampullae, where the garments are loose-fitting, and the body is wide, with the head much larger in proportion to it. The figure of St Thomas is seen from behind on the British Museum ampulla, with the outline of both buttocks visible though his garment, whereas the Monza and Bobbio examples show a three-quarter front view of him. A rear view is seen in an ivory triptych of the Nativity in Paris (Musée du Louvre, Département des Objets d'art, OA 5004), usually dated to the later tenth century. The heads with curly hair and the draperies which cling to the body but form distinct ridges may also be successfully compared on the triptych and the ampulla. Indeed, the concern with the interior setting, the elongation of the figure and the compactness of the individual apostles in relation to the background recalls ivories from the so-

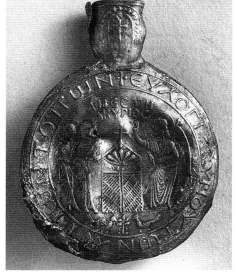

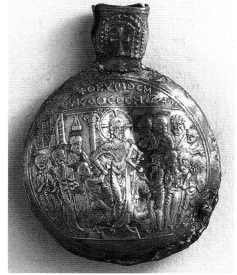

203

203

called 'painterly group', to which the triptych belongs. All these factors collectively rule out a date in the sixth century for the ampulla. The conservatism of the iconography makes dating difficult, but it would seem that the ampulla could not have been produced before about 1000, and it may have been made considerably later.

E. Kitzinger, *Early Medieval Art in the British Museum and British Library*, 3rd ed., London, 1983, pp. 42, 116, fig. 14. CJSE/MAM

204(a–d) Moulded glass cameos

Byzantium, 11th and 12th centuries, and Venice, 13th century

London, BM, M&LA

Over two hundred mass-produced glass cameos, mostly with representations of saints and identifying inscriptions in Greek or Latin, are known to have come from more than sixty different moulds. From their subject matter and distribution it is evident that most of them were pilgrims' souvenirs or holy medals. Those made from translucent glass are likely to have been made in Byzantium in imitation of cameos carved from precious or semi-precious stones; the opaque examples, whether with Greek or Latin inscriptions, were manufactured in thirteenth-century Venice for sale at shrines throughout Christendom. Whether moulds were taken from Byzantium to Venice in the wake of the Fourth Crusade or impressions of Byzantine glass cameos were employed as new moulds, it is clear that production by the thirteenth century was concentrated on the Venetian lagoon.

Wentzel 1959, pp. 50–67; Ross 1962, pp. 87–91; H. Wentzel, 'Zu dem Enkolpion mit dem Hl. Demetrios in Hamburg', *Jahrbuch der*

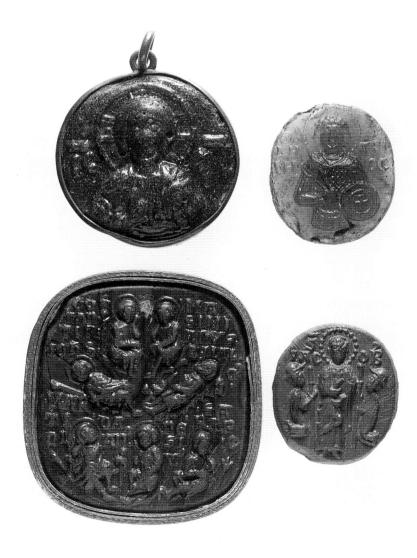

204(a–d) (enlarged)

Hamburger Kunstsammlungen 8 (1963), pp. 11–21; M. Vickers, 'A note on glass medallions in Oxford', *Journal of Glass Studies* 16 (1974), pp. 18–21; D. Buckton, in exh. cat. *Venetian Glass* (1979), pp. 13–15; D. Buckton, 'The mass-produced Byzantine saint', *Studies supplementary to Sobornost (Eastern Churches Review)* 5 (1981), pp. 187–9.

204(a) Christ Pantocrator

M&LA S.323

Diam. 34 mm

From Istanbul. Slade Collection. Bequeathed to the British Museum by Felix Slade (1868).

Discoid, translucent blue with blue-black striations, mounted in silver as a pendant. The half-figure of Christ is cross-nimbed, and has the right hand raised in benediction in front of the chest and a book in the crook of the left arm. In the field, to either side of the figure, is the abbreviated Greek inscription 'Jesus Christ'.

No other medallion from the same mould is recorded.

Nesbitt 1871, no. 323; Dalton 1901, no. 686; Wentzel 1959, no. 1, pp. 51, 55, 56; Wentzel 1963, p. 22. Exhibited: *Venetian Glass* (1979), A(a).

204(b) St Demetrius

M&LA 70,11–26,16

30 × 26 mm

Given to the British Museum by Lord Stanley of Alderley in 1870.

Oval, translucent blue-green. The half-figure of the saint has a dotted nimbus and wears military costume; he hold a spear in his right hand, the left concealed by a small round shield charged with a Greek cross in a circle. The inscription, in Greek, reads 'St Demetrius'.

Three other cameos from the same mould are in the British Museum, and further examples are in Athens, Berlin (from Venice), Bologna, Chilandari (Mount Athos), Hamburg, Kikko (Cyprus), Naples, Nicosia, Oxford (from Jerusalem), Parma, Toronto and Washington, D.C.

Historical facts about St Demetrius are few, but he was usually, like St George, St Procopius and St Theodore, depicted as a soldier. The great centre of his veneration was at Thessaloniki.

Wentzel 1957, no. 37; Buckton 1981, fig. 8b (captioned 8c). Exhibited: *Venetian Glass* (1979), A(h).

204(c) The Seven Sleepers of Ephesus

M&LA OA 835

47 × 43 mm

Thought to have been in the collection of Charles Towneley between 1803 and 1805: the card mount bears the manuscript legend 'The gift of Ld. Northwick to C.T. ap. 1803'. The Towneley Collection came to the British Museum in 1805.

Curved rectangle, opaque brick-red glass with dark brown striations, cast with a representation of the Seven Sleepers of Ephesus and mounted, probably in the eighteenth century, in deckle and gilt-edged card. The seven figures, shown in attitudes of sleep with staffs and axes beside them, are identified by the inscriptions COSTANTIN, MASIMIANVS, IOHS, MALC', MARTINIAN', DANESIV' and SARAPIO'.

Other cameos from the same mould are in Moscow, Naples, Paris and the Vatican.

The Seven Sleepers are said to have been Christians of Ephesus who took refuge in a cave from the Decian persecution of 250 and were walled up. Over a century later the cave was discovered and opened, and the martyrs emerged to give timely testimony against a current heresy denying the resurrection of the body, before returning for ever to their resting-place. Their names are recorded as Constantine, Maximian, John, Malchus, Martinianus, Dionysius and Serapion.

Wentzel 1957, no. 45. Exhibited: *Venetian Glass* (1979), A(b).

204(d) St James with pilgrims

M&LA S.359

29 × 26 mm

Slade Collection. Bequeathed to the British Museum by Felix Slade (1868).

Oval, brick-red glass cast with a figure of St James between two kneeling pilgrims. The saint, who has a halo of dots, blesses the pilgrims, who wear broad-brimmed hats and carry staffs. The inscription reads S.IACOB' ('St James').

Two other cameos from the same mould are in the British Museum. Other examples are in Athens, Berlin, Novgorod, Oxford (from Egypt), Philadelphia, the Vatican, and Washington, D.C.

St James the Greater, the first of the apostles to be martyred, was beheaded by Herod Agrippa in the year 44 (Acts 12.1–2). He is the patron saint of pilgrims.

Wentzel 1957, no. 34. Exhibited: *Venetian Glass* (1979), A(k). DB

The Late Byzantine period

During the Latin occupation of Constantinople, a community of the Byzantine ruling class had been established at nearby Nicaea, in Asia Minor, another at Trebizond, on the south-eastern shore of the Black Sea, and a third in Epirus, in western Greece. It was the community at Nicaea that had become the Byzantine government in exile. The Latins, weakened by attacks from all sides, had only a fragile hold on Constantinople after mid-century and, in the temporary absence of the Venetian fleet, their main defence, offered little more than token resistance when the Byzantines recaptured their city in 1261.

But the last Byzantine dynasty, the Palaeologans, had come to power in a tiny empire in terminal decline. The Turks were settled in Anatolia, the Serbs were making inroads from the north, there was no shortage of western factions striving to reimpose their domination, and the Byzantine ruling class was riven with dissension stemming from its fragmentation in exile. Sporadic, somewhat doubtful alliances with the Serbs, the Seljuqs and, now, the Ottomans were generally ill fated, as were desperate attempts to achieve church unity between Constantinople and Rome to lessen the military threat from the West and, even, enlist military support against the enemies of Byzantium.

Against this background of hopelessness, Late Byzantine artists and their patrons performed a miracle. A programme of restoration of buildings in their looted capital brought in its wake an extraordinary flowering of monumental art. Breathtaking mosaics and wall-paintings were echoed in superb icons – some of them in mosaic – and manuscript illumination. The shattered economy may have prevented the replacement of the gold and silver furnishings looted by the westerners, but what filled the void was beyond price.

205 The Constantine Bowl

Probably Byzantium, 13th or 14th century

London, BM, M&LA 1901,6–6,1

Diam. 129 mm, H. 49 mm

Tyszkiewicz Collection, Rome. Bought by the British Museum in Rome in 1901, with funds provided by 'Friends of the British Museum' or 'Friends of the National Collections'.

Bowl of hard-fired buff fabric with yellowish clear glaze. The exterior is decorated with an incised chequerboard pattern in blue and white slip beneath the glaze. The interior

is engraved with two profile portraits in roundels, one either side of a depiction of Christ. An inscription engraved round the interior, close to the rim reads VAL.COSTANTINVS.PIVS. FELIX.AVGVSTVS.CVM.FLAV.MAX.FAUST[A] . . . (a quarter of the inscription is missing, along with a sizeable portion of the bowl, which has been restored).

The bowl was initially dated to the early fourth century on the basis of the inscription, which presumably identifies the portraits as those of Constantine I and his second wife, Fausta. However, Byzantine glazed pottery is seldom, if ever, found in contexts earlier than the seventh century, and, in style, the depiction of Christ is Late Byzantine,

205

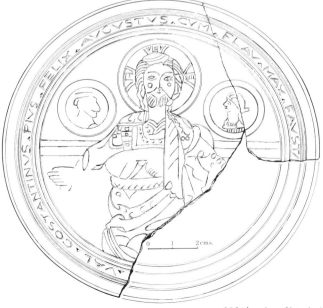

205 (drawing of interior)

perhaps Italo-Byzantine. The date of this central depiction would appear to conflict with the inscription, both in its content and in the use of Latin, and the bowl has been dismissed as a fake. However, the fabric and shape of the vessel – as well as the glaze, which also covers the engraving on the interior – are not inconsistent with the probable date of the Christ figure: the distinctive chequerboard design is found in the Late Byzantine pottery now known as 'incised ware', which includes yellow-glazed buff-fabric bowls (Talbot Rice, pp. 64–5).

The context in which the bowl was produced is problematical, but a Late Byzantine bowl with a contemporary depiction of Christ and a Latin inscription mentioning Constantine could have been made in one of the great monasteries. In these there were Latin scholars as well as potters, and there may well have been a work of art to act as a model for the engraving in the bowl. As a diplomatic gift, sent from one monastic house or episcopal see to another, it would have underlined the Constantinian legacy shared by all of Christendom.

H. Wallis, *Egyptian Ceramic Art*, London, 1900, pp. 27–37, pl. XII; Dalton 1901, no. 916; J. Strzygowski, 'Die Konstantin-Schale im British Museum', *Orient oder Rom: Beiträge zur Geschichte der spätantiken und frühchristlichen Kunst*, Leipzig, 1901, pp. 61–4; J. Strzygowski in *Byzantinische Zeitschrift* 10 (1901), p. 734, vol. 11 (1902), pp. 671–2, and vol. 12 (1903), p. 436; A. de Waal, 'Altchristliche Thonschüsseln', *Römische Quartalschrift für Archäologie und Kirchengeschichte* 18 (1904), pp. 318–19; C. M. Kaufmann, *Handbuch der christlichen Archäologie*, Paderborn, 1905, p. 401, fig. 148; H. Leclercq, *Manuel d'archéologie chrétienne depuis les origines jusqu'au VIIIe siècle*, II, Paris, 1907, pp. 549–50, fig. 366; J. Wilpert, 'Die "Konstantin-Schale" des British-Museum', *Römische Quartalschrift für Archäologie und Kirchengeschichte* 21 (1907), pp. 107–16; F. Cabrol and H. Leclercq, *Dictionnaire d'archéologie chrétienne et de liturgie*, III/2, Paris, 1914, pp. 2645–6, fig. 3240; D. Talbot Rice, *Byzantine Glazed Pottery*, Oxford, 1930, p. 65; K. R. Dark in *Burlington Magazine*, December 1994. Exhibited: *Fake? The Art of Deception*, London (British Museum), 1990, no. 185. KRD

206 Icon of St John the Baptist

Constantinople, around 1300

London, BM, M&LA 1986,7–8,1 (National Icon Collection, no. 15)

251 × 202 mm

Formerly the property of a Greek family who left Anatolia for Switzerland in 1921, the icon was bought by the British Museum in 1986, with the help of the National Art-Collections Fund, British Museum Publications Ltd and Stavros Niarchos, Esq.

Painted in egg tempera on gold leaf on a wood panel surfaced with gesso and linen; the panel has a raised border. The half-figure, slightly turned to his right, is set against a gold background; he wears a green mantle and red tunic over a hair shirt, holds a tied scroll in his left hand and raises his right in blessing. The halo is defined by two concentric circles inscribed into the gold ground. Both the halo and painting overlap the raised border in places. He is identified by a Greek inscription in red on either side of the halo: 'St John' to the left and *o Prodromos* ('the Forerunner') to the right. The panel has suffered considerable damage from woodworm and has split. The painted surface has been lost from three of the corners.

Many Byzantine representations of St John the Baptist depict him as emaciated and unkempt, as an ascetic and a man of the wilderness. By contrast, this icon shows him with dishevelled hair and a straggly long beard but as a calm and noble figure. The figure has an immediacy, seeming to come forward from the panel: the illusion is created by the firm modelling of the flesh and garments against the un-relieved gold ground and by the extension of the figure and the halo on to the raised border. Comparison with mosaics and frescos in the *parekklesion* of the church of St Mary Pammakaristos, now the Fetiye Camii, in Istanbul, suggests both a Constantinopolitan attribution and a date of around 1300.

R. Cormack and S. Mihalarias, 'Two icons, more or less Byzantine', *Apollo* 124 (1986), pp. 6–10, col. pl. I; D. Buckton, 'A Byzantine icon for the British Museum', *National Art-Collections Fund Review*, 1987, pp. 84–5. Exhibited: *From Byzantium to El Greco* (1987), no. 11. RC

207 St Matthew and the beginning of his Gospel

Perhaps Constantinople, 1285

London, British Library, MS Burney 20 (Gospel Book), folios 6v–7r

Folio 190 × 150 mm; image of St John approx. 140 × 110 mm

Acquired by Dr Charles Burney (d. 1817). Bought for the British Museum in 1818.

The Evangelist Matthew writes the opening words of his Gospel in the book held on his lap. The awkward gesture of his right hand, however, suggests blessing rather than writing. The long scroll on the lectern has a fictive text written from right to left, perhaps intended to suggest Hebrew although it more closely resembles Arabic. Note the weights hanging on cords from the lectern, used to hold down the pages of a scribe's exemplar. Although the pigments were very thickly applied there has been little flaking. Traces of glue above the image reveal that it was once protected by a silk curtain. On the facing page is a headpiece with the gold title below: 'The Gospel according to Matthew. Chapter 1', and a simple gold B. The ornament of the headpiece was

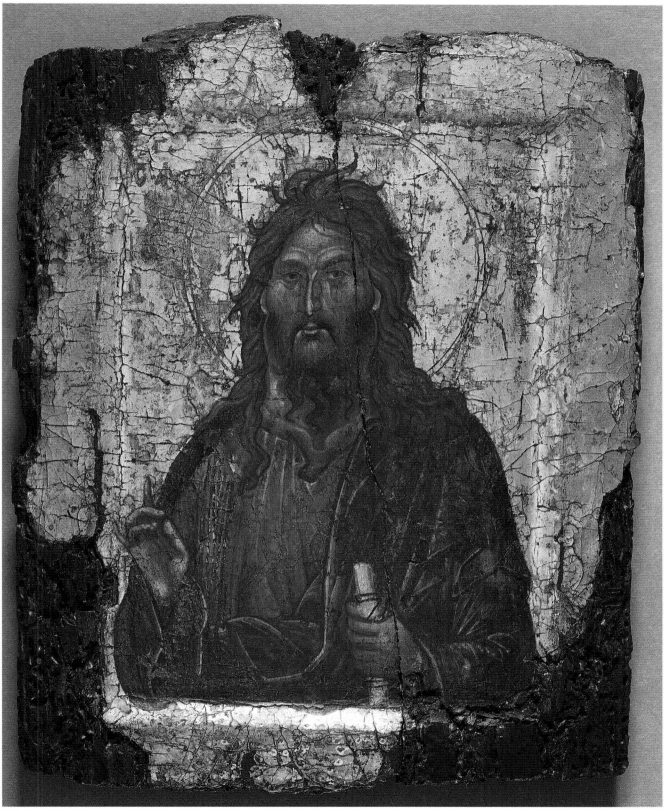

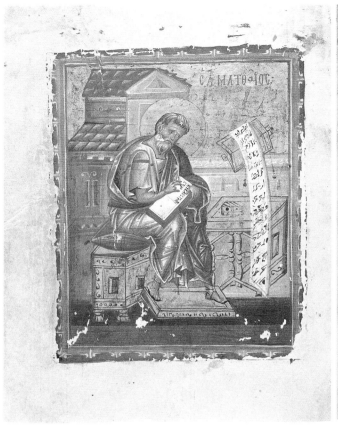

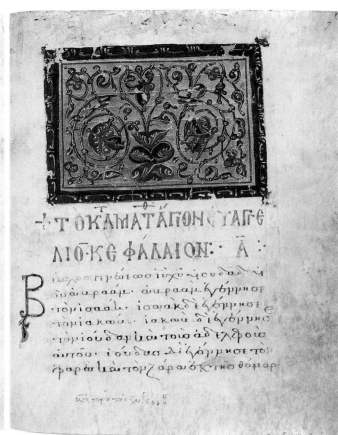

207

207

drawn freehand, and is lopsided as a result. The characteristic blue-green pigment used extensively in the image and the headpiece suggest that the same artist painted both.

The scribe noted on fol. 288v, at the end of St John's Gospel, that he completed the book on Wednesday 30 May 1285. He names himself with various self-deprecatory epithets as the hieromonk Theophilus. Unfortunately he does not mention where or for whom he was working. Few illustrated Byzantine manuscripts are precisely dated, which gives particular importance to this book. It is a manuscript of good quality, although not representing the very highest levels of craftsmanship of the late thirteenth century.

Summary Catalogue, pp. 55–6; Turyn 1980, pp. 42–4, pls 26, 103b; Spatharakis 1981, no. 195. Exhibited: *Byzantine Art a European Art* (1964), no. 326; *Christian Orient* (1978), no. 11.　JL

208　Christ as the Ancient of Days

Possibly Constantinople, 1297 (Gospels, fols 3–294), second half of 14th century (Apocalypse, fols 295–324, and fol. 139?) and mid 10th century (fols 13, 88 and 230)

Cambridge, University Library, MS Dd. 9. 69 (Gospel Book, with added Apocalypse), folio 139r

Folio 204 × 145 mm; image 194 × 145 mm

Written by the scribe Michael Mantylides for *Kyr* Georgios Mougdouphes (fol. 293). Acquired by John Moore, Bishop of Ely, before 1697. On his death in 1714, his library was purchased by George I, and presented to Cambridge University in 1715.

The right page (folio 139) is a single leaf of parchment, with an image of St Luke on its verso facing the opening of his Gospel on fol. 140r. The image that is displayed is on the recto of the St Luke, and shows Christ in the centre as an old man with grey hair and beard, clothed in white. He is identified by inscription as the Ancient of Days (Ὁ Παλαιὸς τῶν ἡμερῶν), following a vision of God in Daniel 7.9ff. The bust-length figure is set in a lozenge-shaped aureole of shades of blue and grey. In the four corners are the four beasts of Ezekiel's vision (Ezekiel 1.10), identified by Christian commentators, following Apocalypse 4.6–10, as the

four evangelists Matthew (man), John (eagle), Mark (lion) and Luke (calf). The whole is set on a gilded ground, and the image extends to the very edge of the page on all sides but, despite this, is well preserved. The facing page is blank on both sides, and follows the end of the *kephalaia* list for Luke.

This book is an intriguing compilation. To the Gospels written in 1297 was added a set of three evangelist images on single leaves, salvaged from an older book. Their style marks them out as products of the tenth century, perhaps of between about 930 and 950 (although Belting argued that they are archaising reproductions of tenth-century models made in 1297). The St Mark (fol. 88) was pasted in with the help of a strip of parchment with a mid-tenth-century *minuscule bouletée* text, quite possibly a fragment of the book from which the images were salvaged. Perhaps the Luke from the set was missing or damaged already at this time. But both the images on the leaf that was supplied (fol. 139) are much too large for the book they were placed in; even the Luke on the verso is about 178 × 135 mm. When made, therefore, this leaf cannot have been intended for its present location. Perhaps it was included when the Apoca-

lypse and various prayers were added at the end of the book in the second half of the fourteenth century (although Spatharakis felt the leaf could date from 1297). The combination of images of the Ancient of Days with St Luke on a single leaf is difficult to parallel at any date.

H. Belting, 'Stilzwang und Stilwahl in einem byzantinischen Evangeliar in Cambridge', *Zeitschrift für Kunstgeschichte* 38 (1975), pp. 215–44; Turyn 1980, pp. 63–6; Spatharakis 1981, no. 210, figs 379–81. JL

209 St Mark and the beginning of his Gospel

Constantinople, late 14th century

Oxford, Christ Church, MS Gr. 28 (Gospel Book), folios 59v–60r

Folio 242 × 173 mm; image 171 × 122 mm

Written by the scribe Gregorios, possibly of the Hodegon monastery. In a monastery of St Nikolaos Kalochoris in around 1500; in the possession of the priest Nikolaos Stangilos in about 1720. Subsequently owned by Antonios Triphilis. Acquired by William Wake, Archbishop of Canterbury, in 1735, and willed to Christ Church on his death in 1737.

Mark sits holding a partially unrolled scroll in which a later hand has written the opening of his Gospel. The image, although skilfully executed, is odd in some ways: the elegant position of the feet is not consistent with the position of the knees and legs, the upper body is disproportionately large, the desk floats awkwardly in space, and the seat has only two legs. The note at the bottom of the page is an instruction left by the scribe as to what the artist was to paint on the page. On the facing page the headpiece is a hastily executed freehand pattern, perhaps added later. The initial A consists of two struggling animals. It was painted on a gesso patch which partially obscures the text, and is presumably a later addition. A later owner attached a small metal clip to the left page to assist in locating it. The book has been well thumbed, but remains in good condition.

The images of Mark, Luke and John were painted on integral leaves of the book, but the Matthew is a later addition (late fifteenth century). The scribe left spaces for and notes of the intended content of the decoration. The headpiece of John (fol. 138r), for example, was to include the Trinity, but was never executed. The artist left blank the page intended for the Luke image (fol. 96v), and painted it instead on fol. 97r, where the scribe had asked for a headpiece including the Birth of John the Baptist. As a result, the scribe had to begin the text of Luke on fol. 97v, leaving blank the upper half of that page for a headpiece (not executed). At this point, therefore, the scribe had prepared the parchment for the artist, but he did not begin writing Luke until after the artist had mislocated the image. In addition to the added Matthew image, Hutter has proposed that the Nativity headpiece to Matthew is a still later addition of the seven-

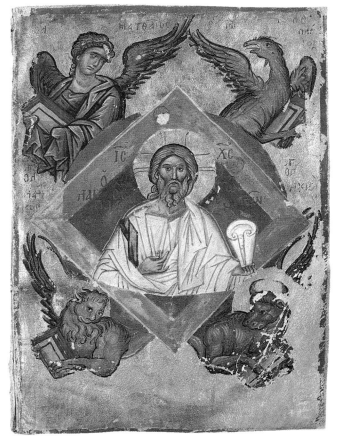

208

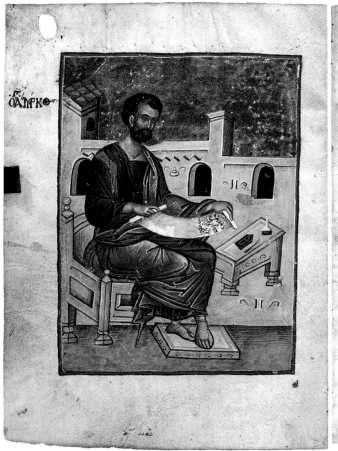

209

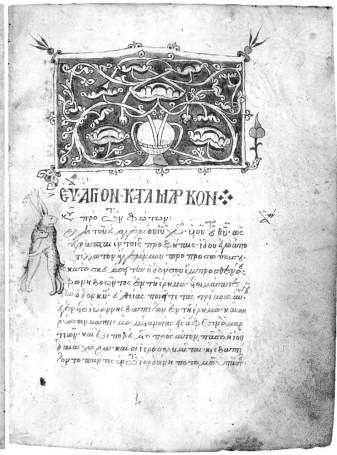

209

teenth century, following the original scribal instructions. This implies not only that the book remained in use for several centuries but that efforts were made to increase its splendour.

Hutter 1993, no. 51, col. pls X–XII, figs 663–710. JL

210 The beginning of St Matthew's Gospel, with added image

Byzantium, around 1300 (or possibly mid 12th century), and 19th century

London, British Library, Additional MS 39591 (Gospel Book), folios iiiv–1r

Folio 155 × 110 mm; image 113 × 85 mm

Bought by Robert Curzon in 1834 from the monastery of St Sabas near the Dead Sea. Bequeathed to the British Museum by Darea Curzon, Baroness Zouche (d. 1917).

On the left is an added single leaf of parchment, its recto pale but its verso darkened to make it more like the original page at the right. For the image of St Matthew, the artist

mistakenly used the traditional type of St Mark, and the partially misunderstood text on the book on the lectern is the opening of Mark's Gospel. The gilding and colouring of the image are strikingly un-Byzantine. On the facing page is a decorative headpiece surmounted by two peacocks flanking a fountain, with a third perched at the right. The page is worn and dirty.

This good-quality Gospel Book of around 1300 was 'improved' for Robert Curzon. Only the Matthew is completely new. Images of Mark, Luke and John (fols 44v, 74v and 124v) and their facing headpieces are original, but were significantly overpainted at the same time. A page from a printed book or paper in Roman script lay against the Mark while it was damp, and some letters were transferred on to the evangelist's red cushion. This restoration must have been done after the acquisition of the book, not by the monks of Mar Saba to make it more saleable.

Robert Curzon, *Catalogue of Materials for Writing . . .*, London, 1849, p. 22, no. 7; *Catalogue of Additions to the Manuscripts 1916–1920*, London, 1933, pp. 68–9. JL

211 Marble capital

Constantinople, 13th or 14th century

Lower Kingswood, Surrey, Church of the Wisdom of God

H. 280 mm, W. 200 mm; thickness 180 mm

Brought from Constantinople, after 1861, by Dr E. H. Freshfield. Placed in the church at Lower Kingswood in 1902 (see no. 42).

Marble capital, of narrow rectangular shape, sharply cut. In the centre of each side is a boss in the form of a tripartite shield. The main face has a cruciform monogram of Greek letters, inscribed in a circle, each of the other sides a motif of stylised palmettes. The monogram can be read as *Elenis* (of 'Helena').

The size and base of this capital indicate that it stood on a colonette of a window or iconostasis. Its shape is characteristic of the early fourteenth century. It appears identical in size and decoration, though in rather better finish, to one in the Louvre (exh. cat. *Byzance*, Paris (Musée du Louvre), 1992–3, no. 321), which was given by the Oecumenical Patriarchate, Istanbul, in 1886.

Dr Freshfield was told that the capital had come from the church of St Nicholas of the English, the chapel of the

211

English regiment of the Varangian Guard. The building is also known as the Bogdan Saray, or Moravian Palace. In origin it seems to be a building of the fourteenth century, possibly a funerary chapel associated with the nearby monastery of the Prodromos in Petra (Müller-Wiener 1977, p. 108).

Unpublished. RKL

212 Steatite Crucifixion scene

Byzantium, late 13th century

London, BM, M&LA 1972,7–1,1

59 × 47 × 6 mm

Bought by the British Museum in 1972.

Steatite plaque carved in relief with the crucified Christ, flanked by the Mother of God and St John. There are numerous breaks around the rim, and the figures have been polished smooth by wear, resulting in the loss of much detail of faces. The Crucifixion fills the space, the figures and cross all extending beyond its borders. In the centre is Christ, relatively upright on the cross, although his head is slumped on his right shoulder. Both flanking figures raise their right hands to their faces in mourning, and the Mother

210 (folio iiiv)

of God reaches out to Christ, appearing to touch him with her left hand. Only Christ is named, in a small and scratchy inscription on the cross. The remains of gilding can be seen on Christ's halo.

The iconography of the Mother of God is very unusual: in no other Crucifixion scene does she gesture towards Christ with her left hand only, let alone touch him. The proportions of both Christ and St John, with their broad hips and narrow chests, indicate a Late Byzantine – Palaeologan – date for this carving.

Kalavrezou-Maxeiner 1985, pp. 45–6, no. 117. AE

213 Steatite icon of the Mother of God Hodegetria

Byzantium, 14th century

London, BM, M&LA 78,11–1,62

75 × 64 × 12 mm

In the collection of Francis Douce before 1830; bequeathed to Dr S. R. Meyrick in 1834. Given to the British Museum by Major-General Augustus Meyrick in 1878.

Steatite plaque carved in relief with a half-figure of the Mother of God, holding the infant Christ in the crook of her left arm and indicating him with her right hand. Christ holds a scroll in his left hand; his right is raised in blessing. The figures are flanked by two columns with lion-head capitals supporting an arch, in the spandrels of which are two nimbed and bearded figures holding open scrolls. Letters are visible on these scrolls. The plaque is deeply carved, and the robes of the Mother of God are rendered with broad, bold lines. The stone is unusually dark for steatite and has a few areas of discoloration; there are some breaks around the rim, and the face of Christ is badly worn.

The mother of God and the infant Christ conform to the iconographic type known as the Hodegetria ('she who

shows the way'), although on this icon there is the inscription Ḣ ÁΛΥΠΟC ('she who is without pain'). A rubbed inscription on the top border identifies the left-hand bearded figure as St John of Damascus; as a hymnographer to the Mother of God, he is probably accompanied by St Cosmas the Melode, St Joseph the Poet, or St Theophanes.

S. R. Meyrick, 'Catalogue of the Doucean Museum at Goodrich Court, Herefordshire', *Gentleman's Magazine* 6 (1836), p. 493, no. 97; Dalton 1901, no. 112; A. V. Bank, *Prikladnoe isskustvo Vizantii IX–XII vv.*, Moscow, 1978, p. 103, fig. 94; Kalavrezou-Maxeiner 1985, no. 134. AE

214 Gold seal of Thomas, Despot of Epirus

Epirus (north-western Greece), between about 1313 and 1318

London, BM, M&LA 62,7–29,1

Max. diam. 32.7 mm

Acquired by the British Museum in 1862.

Discoid gold *bulla*, made from two sheets of gold, one larger and folded over the edge of the other. The channel which once held the cord or ribbon of the document is flattened; there is a loss and discoloration to the top at this point, as well as slight damage to the bottom. Obverse: in relief, the archangel Michael, full-length, in imperial costume, a sceptre in his right hand and an orb in his left, each surmounted by a patriarchal cross. There is an abbreviated inscription identifying the figure. Reverse: in relief, the despot, full-length, in imperial costume, a sceptre in his right hand and the *anexikakia* in his left: the sceptre is surmounted by a Greek cross. His crown is lost, but its *pendilia* survive. Above, left, is the hand of God, blessing; to either side of the despot's head is the inscription X/ΡΙ Κ/ΡΙΟΥ

212

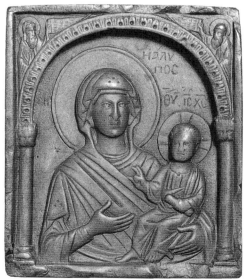

213

214 (obverse)

214 (reverse)

(probably to be interpreted as 'Hand of the Lord'), and to either side of his body the inscription, also in Greek, 'Seal of Despot Thomas [of the] Angelos [dynasty]'.

The Despotate of Epirus was one of the independent Greek states (cf. Nicea, Trebizond) which came into being after Constantinople fell to the Crusaders in 1204. It was founded by Michael I Komnenos Doukas, ruler from 1205 to 1215. His brother Theodore (1215–30) captured Thessaloniki from the Latins in 1224 and was crowned emperor there, thus becoming a rival to the Emperor of Nicaea, John III Vatatzes (1221–54). In 1242 John forced Theodore's son to substitute the title *despotes* for 'emperor'. Nicene forces took Thessaloniki in 1246 and ultimately conquered much of Epirus. By 1264, however, Epirus had regained its independence and continued to be ruled by *despotai* until 1318, when Thomas was assassinated by his Italian nephew Nicholas Orsini and Epirus passed into the control of the Orsini family.

The choice of the archangel for the obverse of the seal is an allusion to the descent of the despot from the Angelos family. For Thomas to seal in gold was, however, to usurp the prerogative of the Byzantine emperor, and Professor Seibt has argued that this would have happened only after around 1313, when Epirus was practically at war with Constantinople. A document signed by Thomas, which can probably be dated to August 1318 (Seibt), is known only in a Latin translation (P. Lemerle, 'Le privilège du despote d'Épire Thomas I pour le vénitien Jacques Contareno', *Byzantinische Zeitschrift* 44 (1951), pp. 389–96). A gold *bulla* is mentioned in the text.

P. Grierson, 'Byzantine gold bullae', *Dumbarton Oaks Papers* 20 (1966), p. 246, n. 39; W. Seibt, 'Ein Goldsiegel des Despoten Thomas von Epirus aus dem frühen 14. Jh.', forthcoming. DB

215 Gold ring

Probably Constantinople, 13th to 15th century

London, BM, MLA AF 271

Max. diam. 26.5 mm, L. of bezel 11.3 mm

Bequeathed to the British Museum by Sir Augustus Wollaston Franks (1897).

Gold finger-ring with hollow fluted hoop and shoulders, both of which expand to an octagonal bezel. The shoulders are decorated with a band of chevrons, the bezel with a deeply engraved cruciform monogram within a punched octagonal border.

The ring is difficult to date with precision, as parallels for the shape of the hoop and bezel can be found on rings ranging in date from the thirteenth to the fifteenth century. A gold ring of similar form and construction in the Stathatos Collection, Athens, formed part of a group of jewellery said to have been found near Thessaloniki with coins of Isaac II Angelus (1185–95) and Alexius III Angelus (1195–1204). Although its bezel is engraved with a bust rather than a monogram, the ring is in other respects almost identical to the British Museum example (Coche de le Ferté, pp. 40–1, no. 22). That rings of this form continued, albeit in western Europe, well into the last quarter of the fourteenth or first half of the fifteenth century is attested by another ring in the British Museum. Of gilded bronze, this also has an octagonal bezel and fluted shoulders, the latter pounced on one side with a floriated crown above three fleurs-de-lys, and on the other with a tiara above two crossed papal keys, indicating perhaps that it was made for one of the French popes (Dalton 1912a, no. 833). Dalton read the monogram of the Byzantine ring as 'Manuel'. Although there is no alpha or upsilon among its constituent letters, this is not an implausible suggestion, given the abbreviated nature of some Palaeologan monograms (cf. S. Bendall and P. J. Donald, *The Later Palaeologan Coinage*, Bath, 1979, pp. 39, 57, 87, and 255). Rather less likely is Dalton's attribution of the ring to Manuel II Palaeologus (1391–1425).

Dalton 1901, no. 171, p. 27; Dalton 1912a, no. 94, p. 16; E. Coche de la Ferté, 'Bijoux byzantins de Chio, de Crète, de Salonique', *Collection Hélène Stathatos: Les objets byzantins et post-byzantins*, Limoges (?), 1957, pp. 40–1, fig. 30. CJSE

215 (enlarged)

216 Cruciform polycandelon

Possibly Constantinople, 12th to 14th century

Oxford, Ashmolean Museum, Department of Antiquities,
1980.10

Diam. 350mm

Roper Collection. Bought by the Ashmolean in 1980.

Cruciform brass polycandelon cast as a single openwork
piece. Its four equal arms project from a central disk; flaring
outwards, each arm terminates in another disk with an
outer keyhole-shaped tab. At its corners, each arm has a
pair of flat rings which probably held the stems of glass
lamps; the other holes in the middle of the five openwork
disks are smaller and were perhaps simply decorative. An
openwork pattern of a cross composed of four rings enclos-
ing a trefoil is repeated in the five disks; the four arms are
filled with tripartite palmettes pointing inwards. Four lugs
for suspension straps or chains project upwards between the
outer disks and the arms. There is a modern repair to one
arm.

A common Byzantine object of copper-alloy, the poly-
candelon or chandelier supported a series of glass lamps and
was suspended by three or four chains or straps. Some were
made in sets to illuminate large areas, such as church in-
teriors. A few are cylindrical and fitted with dolphin-shaped
brackets terminating in rings for the lamps. A greater
number take the form of a horizontal wheel or tray, incor-
porating the rings within the decorative openwork body.
Most polycandela are circular; some are rectangular, while
the cruciform type is relatively rare – some in silver date to

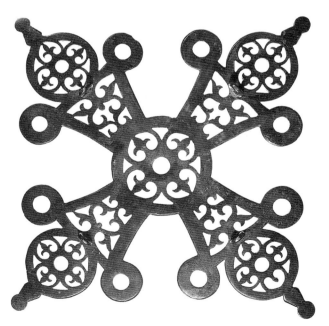

216

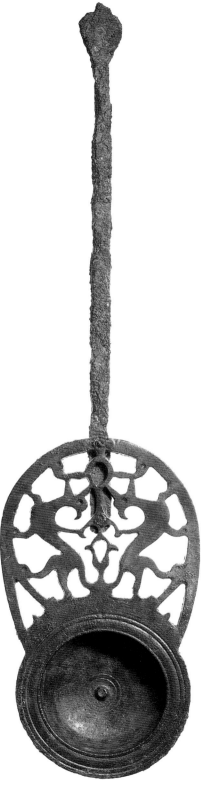

217

the mid sixth century (Boyd 1992, nos 28–30). In general, most copper-alloy polycandela and related lighting devices have been attributed to the sixth and seventh centuries, but a few examples are considered medieval: an Islamic set at Kairouan, Tunisia, Byzantine sets from Bithynia and Crete, and the Ashmolean type (see also: Bouras 1982, pp. 479–91).

An unpublished polycandelon in the Metropolitan Museum, New York, closely resembles that in the Ashmolean but differs from it in some respects, including having a larger diameter (435 mm). Whereas the Oxford example was cast in one piece, that in New York has four arms which were made separately and joined at their inner ends between a pair of central rings; the openwork patterns within the arms also differ slightly. Both objects have lugs for suspension and unequivocally functioned as polycandela. Other identically shaped and decorated devices, equipped with upper suspension straps and lateral sockets, were hung vertically, rather than horizontally, as candle-holders (Bouras 1982, p. 481, fig. 7; Campbell 1985, no. 194) or as parts of massive chandeliers (*choroi*) placed under church domes. Several *choroi* containing such openwork crosses are known from Serbia: one at Markov Manastir incorporates disks perforated to form the name of King Vukašin (d. 1371). Related light-holders, said to be of an earlier date, have been cited near Volos and on Mount Athos (D. Todorovič, 'Polijelej y Markovom manastiry', *Zograf* 9 (1978), pp. 28–36). Given similarities with both the Cretan (probably ninth to eleventh century) and the Serbian openwork, the Ashmolean polycandelon should perhaps be dated to between the twelfth and fourteenth centuries.

Unpublished. Mango, forthcoming. MMM

217 Copper-alloy *katsion* (censer with handle)

Probably the Balkans, 14th century

Oxford, Ashmolean Museum, Department of Antiquities, 1980.19

Total L. 365 mm, w. of bowl 78 mm, H. 19 mm

Roper Collection. Bought by the Ashmolean in 1980.

Cast copper-alloy censer composed of a shallow bowl on a broad foot. From one side of the rim extends a curved open-work plate to which a long iron handle, now corroded, is riveted. The symmetrical decoration of the plate consists of a pair of addorsed griffins with confronted heads and legs spread apart; between them is a small palmette. Metal strips form a U-shaped frame at the top of the plate, while other strips connect the hind legs and backs of the griffins to the centre of the plate. The upper rim and inner centre of the bowl are decorated with concentric grooves.

Similar vessels are in Athens, Mistra and Serbia (exh. cat. *Byzantine and Post-Byzantine Art* (1986), no. 220). This type of funerary censer, called a *katsi* or *katsion*, is recorded by the eleventh century (*op. cit.*, no. 229). It is sometimes equipped with an openwork domed lid, which may be missing in this case. Free-standing censers with openwork domed lids are numerous in the early period, and are particularly associated with Egypt. At least two such censers, standing on three feet rather than a single foot, have a horizontal handle (Campbell 1985, nos 110, 112), and could be considered prototypes of the *katsi*.

Unpublished. Mango, forthcoming. MMM

218 The Codex Crippsianus

Constantinople, early 14th century

London, British Library, Burney MS 95, folios 34v–35r

Folio 300 × 220 mm

Owned by the monastery of Vatopedi, Mount Athos. Acquired from Prince Alexander Bano Hantzerli by E. D. Clarke and John Marten Cripps after 1802. Purchased in 1808 by Dr Charles Burney (d. 1817), whose library was bought by the British Museum in 1818.

218

219

219

Two large decorated initials mark the beginning of the *De Pyrrho* by the fourth-century BC orator Isaeus. The titles of a prefatory summary and of the speech itself are written in red ink. All the text is written on the highly polished parchment in a clear uncomplicated minuscule, using very few abbreviations.

The Codex Crippsianus is one of the primary witnesses of the texts of the minor Attic orators Andocides, Isaeus, Dinarchus and Antiphon. It was probably copied by a scribe of the imperial chancery working in his spare time for a wealthy patron. This scribe has recently been identified by Lamberz as Michael Klostomalles. The minor Attic orators appear to have survived only as a result of scholarly activity during the Palaeologan revival, perhaps towards the end of the thirteenth century and almost certainly not long before the production of the present manuscript.

W. Wyse, *The Speeches of Isaeus*, Cambridge, 1904, pp. i–xlvii; N. G. Wilson, 'Some palaeographical notes', *Classical Quarterly*, n.s., 10 (1960), p. 202; N. G. Wilson, *Scholars of Byzantium*, London, 1983, p. 229; *Summary Catalogue*, pp. 86–7; E. Lamberz, 'Schreiber der Kaiserkanzlei in Urkunden und Handschriften der Palaiologenzeit (ca. 1280–1360)', forthcoming. SMcK

219 Babrius's fables, annotated by Demetrius Triclinius

Constantinople, first half of 10th century, and Thessaloniki, early 14th century

London, British Library, Additional MS 22087, folios 23v–24

Page 175 × 125 mm

Found at the Great Lavra, Mount Athos, by Minoides Mynas in 1842. Bought from Mynas by the British Museum in 1857.

Three verse fables (nos 70–2) from the collection made by the ancient author Babrius tell of the marriage of War to Arrogant Pride (Hubris), of a farmer's conversation with the sea, and the jackdaw's foiled attempt to win a beauty contest. Each concludes with a moral in verse, the first warning of the consequences of arrogance. At the end of the second fable a supplementary moral message in prose has been highlighted by the scribe in uncials. Annotations in black ink are additions and amendments made by the Palaeologan scholar Demetrius Triclinius. Most distinctive is his method of deletion by encirclement, as seen on line 3 of fable 70 and line 11 of fable 71.

This manuscript, the discovery of which gave rise to the first edition of Babrius's fables in 1844, remains the principal witness to that text. It contains 123 fables, arranged alphabetically by their first letter and divided into two books. The identification by Turyn in 1957 of Triclinius's hand in the annotations has further elucidated the emendation of a poetical text employed by a late Byzantine textual critic whose editorial work on the ancient Greek dramatists was highly influential and is deservedly well recognised as crucial in shaping the texts we now read.

A. Dain, 'Sur deux recueils de Babrios trouvés par Minoïdes Mynas', *Bulletin de l'Association Guillaume Budé*, 4 sér., 1 (1960), pp. 113–21; N. G. Wilson, *Scholars of Byzantium*, London, 1983, p. 250; *Babrii Mythiambi Aesopi*, ed. M. J. Luzzatto and A. La Penna, Leipzig, 1986, pp. xxii–xxv. SMcK

220 Miniature mosaic of the Annunciation

Constantinople, early 14th century

London, Victoria and Albert Museum, Sculpture Collection 7231–1860

152 × 102 mm

Purchased in 1859 from the Webb Collection; previously in the possession of M. Delange, who is said to have acquired it in Italy.

The panel is entitled 'The Annunciation' (in black Greek letters across the top). The two figures are likewise identified in inscriptions: the Archangel Gabriel and Mother of God (the letters in both inscription panels are damaged). Elsewhere there are signs of ancient abrasion and damage and of repairs.

The technique of miniature mosaics was to set the tesserae in wax on wood. Although one might have presumed that the tiny tesserae were of coloured stone and glass (with the gold and silver tesserae having wafers of leaf sandwiched in glass or alternatively with the gold tesserae made of gilded copper), the Museum has always described the cubes as of gold, silver, lapis lazuli and other semi-precious stones.

The mosaic shows the moment of the announcement by the Angel Gabriel to Mary: 'You shall conceive and bear a son, and you shall give him the name Jesus' (Luke 1.26–38). The festival is celebrated on 25 March. The attributes of the figures are well known in Byzantine art. The archangel holds one hand up in a gesture of speech and in the other holds a sceptre, tipped with a highly ornate cross motif; probably this is the emblem of the fleur-de-lys. Mary holds a distaff, alluding to the Apocryphal Gospels in which she has an upbringing in the Temple at Jerusalem and where she would spin and weave the priest's vestments. A beam comes down from heaven, and, as more usual in Byzantine art, there is no dove of the Holy Spirit descending within the light.

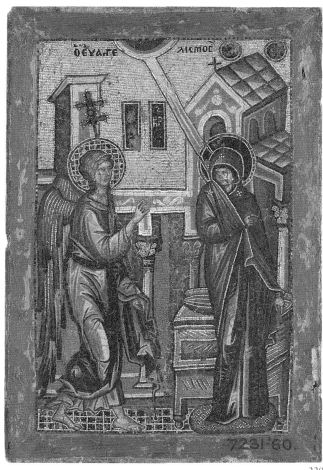

220

The iconography is therefore conventional enough. What is striking about the mosaic is its emphasis on the temporal narrative and its highly decorative and rich texture. The moment of the Incarnation is amplified by the turning movement of the angel and the shrinking timidity of Mary. They are portrayed as if in a tiled setting, although this is a rather literal reading of an ornamental design. The action is taking place in the foreground, defined by the device of a low portico; the setting is given spatial depth by a number of foreshortened elements, such as the backless wooden throne and the architectural structures which grow out of the wall but compositionally lead the eye of the viewer to the figures. Both the haloes are richly ornamented. Colour and shade is strongly contrasted in the modelling of the angel, and it is this modelling which gives considerable volume to the figure. All these features are distinctively found in the art of the fourteenth century, particularly the interest in highlighting the narrative of the biblical events.

In the course of publication, this mosaic has been dated to the eleventh or twelfth century, the thirteenth century and the first half of the fourteenth century. Its figural style and

use of architectural elements for the construction of a virtual stage-setting has convinced all recent commentators that the date of the mosaic is close to that of the wall mosaics of the Kariye Camii in Constantinople (second decade of the fourteenth century). Nevertheless, the dynamic figural style is equally easy to compare with the dome mosaics of the Pammakaristos church in Constantinople (first decade of the fourteenth century). It has always been closely connected with the Twelve Feasts miniature mosaic in Florence (Museo dell'Opera del Duomo), and the relationship is sufficiently direct for workmanship by the same artist to have been suggested. A date in the first quarter of the fourteenth century is likely for both pieces.

In deciding the provenance of miniature mosaics, nearly all of which are from the period after 1261, the key factors have been seen as their rarity, their exquisite manufacture and their use of precious materials. Consequently all miniature mosaics have been attributed to Byzantine court circles in Constantinople, although one might have said that this is exactly the kind of object that could have been anticipated from workshops in Venice; they certainly appealed to Italian taste, and by the fifteenth century most miniature mosaics were in Italy, mainly in the papal collection in Rome: twenty-five were in the possession of Pope Paul II (1464–71). Despite the highly decorative character of miniature mosaics, it has been assumed that they were made as icons for devotional use in church.

Dalton 1911, p. 432 (who refers to the *Gazette des Beaux-Arts* 1 (1859), p. 157 (A. Darcel); Longhurst 1927, pp. 48–9; D. Talbot Rice, 'New light on Byzantine portative mosaics', *Apollo* (1933), pp. 265–7, fig. IV; S. Bettini, 'Appunti per lo studio dei mosaici portabili bizantini', *Felix Ravenna* (1938), pp. 7–39, esp. p. 28 and fig. 14; Talbot Rice, *Art of Byzantium*, London, 1959, fig. XXXVIII and caption; I. Furlan, *Le icone bizantini a mosaico*, Milan, 1979, no. 31; O. Demus, 'Two Paleologan mosaic icons in the Dumbarton Oaks Collection', *Dumbarton Oaks Papers* 14 (1960), pp. 89–119 (see also O. Demus in *Phaidros* 3 (1949), pp. 190–4 and pl. 13); A. A. Krickelberg-Pütz, 'Die Mosaikikone des Hl. Nikolaus in Aachen-Burtcheid', *Aachener Kunstblätter* 50 (1982), pp. 9–141; Williamson 1986, pp. 170–1. Exhibited: *Masterpieces* (1958). The mosaic was exhibited only in the London showing, and there is no printed catalogue entry. RC

221 Icon with four Church Feasts

Constantinople or Thessaloniki, between about 1310 and 1320

London, BM, M&LA 52,1–1,1/2 (National Icon Collection, no. 1)

388 × 256 mm

The icon, in two pieces, arrived in the Department of Manuscripts of the British Museum (now of the British Library) in 1851, together with Syriac manuscripts from the monastery of St Mary Deipara, near the Natron Lakes in Egypt (18.812–18.821). It was transferred to the Department of Antiquities at the beginning of 1852.

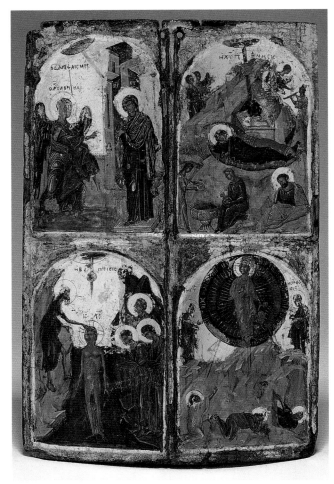

221

Egg tempera and gold leaf on a wood panel prepared with linen and gesso; the surface of the curved panel is carved into four arched compartments. The compartment at the top left is painted with the Annunciation: the angel approaches from the left, while Mary stands on the footstool of a throne to the right, against an architectural background. In the compartment at the top right is the Nativity, with Mary reclining on a mattress in the centre of the composition, the infant Jesus in the manger above her, adored by ox and ass, and angels and shepherds in rocky scenery at the top. In the bottom left-hand corner of the scene two midwives bathe the newly born Christ, while Joseph is seated to the right, in contemplative pose. The lower left-hand compartment of the panel contains the Baptism of Christ: St John the Baptist, standing on rocks to the left, baptises Jesus, who stands nude in the river Jordan, while angels wait with towels on the river bank to the right; the scenery is mountainous; the hand of God appears from the centre top. The lower right-hand compartment is painted with the Transfiguration. Christ, in a central mandorla,

stands on the summit of Mount Tabor, with Elijah to the left and Moses to the right. In the foreground are the disciples Peter, James and John, in contorted poses on the ground.

The painting is of high quality, minutely executed in rich, bright colours, with gold leaf used for some highlighting. Dalton (1909) dated it to the twelfth century, but the late thirteenth or early fourteenth century dating proposed in the exhibition catalogue *Masterpieces* (1958) is preferable: the dramatic treatment of the Transfiguration with the apostles in contorted poses on the ground (Matthew 17.6: 'they fell on their face, and were sore afraid') was developed by Byzantine artists only in the second half of the thirteenth century, and elements such as the elongated figure of the Baptist and the architectural setting of the Annunciation can best be paralleled in the fourteenth century. The miniature qualities of the icon can be stylistically related to wall-paintings in the church of St Nicholas Orphanou, at Thessaloniki, datable to about 1315 (Xyngopoulos 1964), although it is impossible to say whether the artist was based in Constantinople or Thessaloniki.

Dalton 1901, no. 987; O. M. Dalton, 'A Byzantine panel in the British Museum', *Burlington Magazine* 14 (1909), pp. 230–6; Dalton, *Byzantine Art and Archaeology*, Oxford, 1911, p. 319, fig. 155; Gabriel Millet, *Recherches sur l'iconographie de l'évangile aux XIVe, XVe et XVIe siècles*, Paris, 1916, pp. 104, 124, 184, 229, 678: D. Ainalov, *Vizantiiskaya zhivopis' XIV veka* (Byzantine painting of the 14th century), St Petersburg (Petrograd), 1917, pp. 79–81; O. M. Dalton, *East Christian Art*, Oxford, 1925, pp. 264–5, pl. XLV; Victor Lazareff, 'Byzantine ikons of the fourteenth and fifteenth centuries', *Burlington Magazine* 71 (1937), p. 255; V. N. Lazarev, *Istoriya vizantiiskoi zhivopisi* (The history of Byzantine painting), I, Moscow, 1947, pp. 22, 362 n. 27; II, Moscow, 1948, pl. 310. Exhibited: *Masterpieces* (1958), no. 212; *Byzantium to El Greco* (1987), no. 12. RC

222 Icon of St Peter

Constantinople, about 1320

London, BM, M&LA 1983,4–1,1 (National Icon Collection, no. 7)

687 × 506 mm

Discovered in a London restorer's studio, the St Peter lay under layers of whitewash and varnish on the back of a seventeenth-century icon of Christ, from which it has now been separated. Bought by the British Museum in 1983.

Egg tempera and gold leaf on a cedar panel prepared with a coarse tabby linen and gesso. Set against a gold ground, the half-figure of the bearded apostle is depicted looking half to his left and holding an open scroll in his right hand; the scroll is white, with Greek letters in black. He is dressed in tunic and pallium painted with broad strokes and flat planes in pastel colours: a greyish blue for the tunic and an apricot tint for the pallium. The halo is

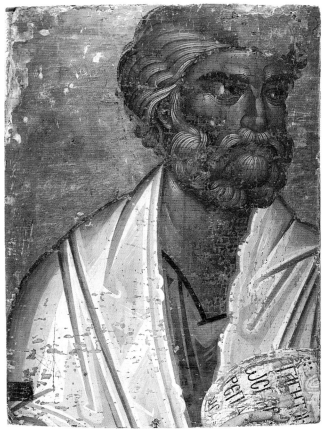

222

defined by two concentric arcs inscribed into the gold background. The icon has been cut down all round: the figure is off-centre and only part of one hand is visible. The panel has been damaged by woodworm, and the surface of the icon has suffered some abrasion; the nose has been restored.

The panel has been cut down from its original size but probably always showed the saint in half-figure. The Greek text on the scroll is from 1 Peter 2.11: 'Beloved, I beseech you as aliens and exiles to abstain from the passions of the flesh that wage war against your soul'. The text would seem particularly suitable for a monastery setting. It is possible that this icon was one of a set made for a sanctuary screen. It has been dated to the period around 1320 on the grounds of its stylistic similarity to the mosaics and wall-paintings of the Chora monastery, now the Kariye Camii in Istanbul (about 1315–21). It is close enough to suggest that the same artist might be responsible.

S. Mihalarias and R. Cormack, 'A major new discovery: a Byzantine panel of the fourteenth century', *Zygos* 2 (1983), p. 130ff; K. Weitzmann, *The St Peter Icon of Dumbarton Oaks*, Washington, D.C., 1983, p. 17, fig. 13; M. Cheremeteff, 'The transformation of the Russian sanctuary barrier and the role of Theophanes the

Greek', in: A. Leong, *The Millennium: Christianity and Russia 988–1988*, Crestwood, New York, 1990, pp. 107–40. Exhibited: *The Icon of St Peter*, London (Barbican Art Gallery), 1983; *Two Icons of St Peter*, Washington, D.C. (Dumbarton Oaks), 1986; *Byzantium to El Greco* (1987), no. 16. RC

223 Triptych with the Mother of God and saints

Byzantium or, possibly, Venice, first half of 14th century

The National Trust, Polesden Lacey (Surrey)

H. 397 mm, W. 279 mm (open)

Collection of the Hon. Mrs Ronald Greville, who bequeathed Polesden Lacey to the National Trust (1942).

Painted in egg tempera and gold on gesso, canvas and wood, the triptych has a gabled top, with the wood elaborately carved. Each panel is divided into three registers. The central panel shows the Crucifixion at the top, the Mother of God enthroned with the infant Christ and flanked by angels and Sts Peter and Paul in the centre, and four female saints in the bottom register, (from left to right) Sts Lucy, Margaret, Theodosia and Catherine. The left wing shows the archangel Gabriel (forming an Annunciation scene with the Mother of God on the right wing) at the top, St Cosmas, the Archangel Michael and St Damian in the middle, and St George on horseback killing the dragon at the bottom. The right wing has the Mother of God of the Annunciation in the gable, Sts Nicholas, John the Baptist and Anthony in the middle, and Sts Francis of Assisi, Dominic and Louis of Toulouse at the foot. The symbols of the four evangelists are depicted on the upper part of the middle register on all three panels. Inscriptions with the saints' names are all in Latin and painted in red. At the time of writing, the back of the triptych could not be examined.

Both iconographically and stylistically, the triptych displays a mixture of Byzantine and western features. The selection of saints includes some of Byzantine origin, like St Theodosia, and others of western origin, such as Sts Louis of Toulouse, Dominic and Francis. The rendering of certain saints, e.g. Nicholas, John the Baptist, Anthony, Theodosia, Cosmas and Damian, is in a decidedly Byzantine style; other saints and scenes, such as the enthroned Mother of God, Sts Francis, Dominic and Louis of Toulouse, as well as the Crucifixion, are rendered in a style which is more Italian and often associated with Venice.

Frinta has proposed a solution to the question of provenance of the triptych and the place of training of its artist by linking it with a number of panels, e.g. the Sterbini Diptych in the Palazzo Venezia, Rome, and a panel with the Mother of God, Christ and an angel in the Musée de la Renaissance, Chateau d'Ecouen (formerly in the Musée de Cluny, Paris: Frinta 1987, figs 1 and 4), which Garrison had

described as the work of Venetian workshops, probably in an Adriatic city (Garrison 1949, index 247, p. 98, and index 612A, p. 224). Frinta attempts to refine this provenance. His proposal is that the artist of the Polesden Lacey triptych worked in one of the harbour towns of the Dalmatian coast of the Adriatic (Zadar, Split or Dubrovnik), and was the younger (but more talented) contemporary of another (proposed) Dalmatian artist, the Master of the Leningrad Diptych (Lazarev 1954, p. 80, fig. 76). Frinta believes that both these artists specialised in commissions for Franciscan patrons. Since Frinta sees the stylistic origins of the painter of the Polesden Lacey triptych as Apulian (and the use of red for the Latin inscriptions and a ligature in the name of Franciscus in the Sterbini Diptych as suggesting a 'Greek formation of the painter'), he is even prepared to venture an identification of the artist as Barisinus dei Barisini (born in Bari), the father of Tomaso of Modena (Gibbs 1989). Frinta supposes that the Polesden Lacey triptych was painted in Dalmatia for a Franciscan monastery located in a place where there was a special cult of St Theodosia of Constantinople. He dates it after 1317, since it includes a representation of St Louis of Toulouse (d. 1297, canonised 1317). He excludes Venice as the provenance or the destination of the triptych on the grounds that the mixture of eastern and western saints on this and other paintings in his group implies a 'unionist' climate of thought which he believes was impossible in Venice.

Frinta's grouping of panels is a useful advance, and the attribution of the workshops to Dalmatia depends primarily on the present location of a number of the pieces in this region. However, a number of considerations must leave his attribution in doubt (we wish to acknowledge the assistance of Dr J. Cannon in this research). The choice of the Crucifixion and the Annunciation for the gable has parallels in Venice (examples in Pallucchini 1964), and might be taken as an indication of a provenance there. On the other hand, the inclusion of St Theodosia of Constantinople in this panel might be taken as an indication of a Byzantine rather than western provenance (her representations are found on Sinai, Mouriki 1990, fig. 39, and in the British Museum icon of the Triumph of Orthodoxy, no. 140). In addition, the conspicuous Byzantine elements of the Polesden Lacey triptych might indicate the participation of a Byzantine painter, rather than the adoption of Byzantine iconography and style by a non-Byzantine artist. Constantinople itself or Venice remain serious possibilities for the place of production of the triptych.

M. S. Frinta, 'Searching for an Adriatic painting workshop with Byzantine connection', *Zograf* 18 (1987), pp. 12–20, fig. 5.

RC/MV

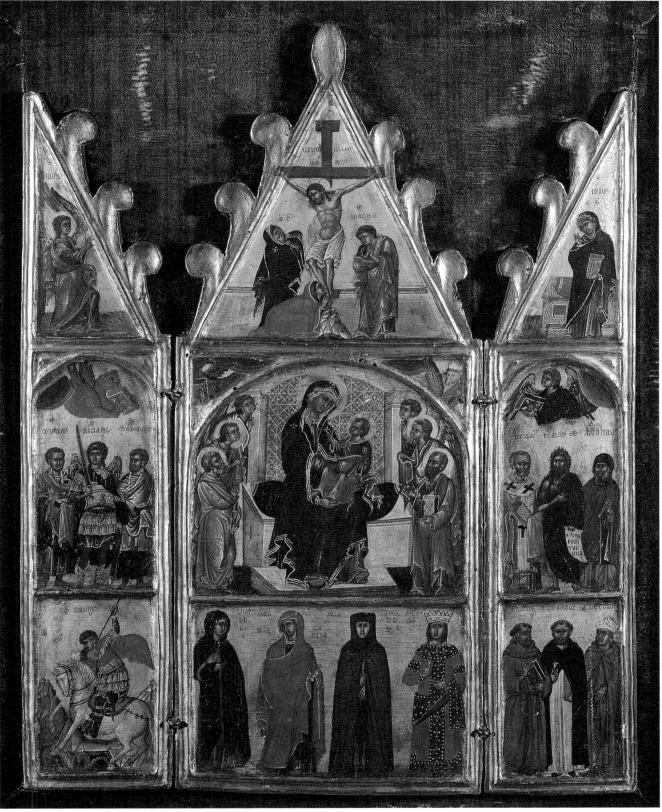

223

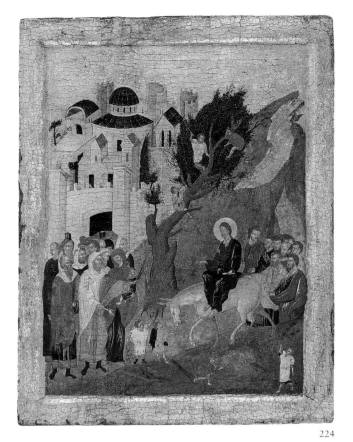

224

224 Icon with the Entry into Jerusalem

Probably Constantinople, about 1400

Private collection

449 × 334 mm

Acquired in 1992.

Painted in egg tempera on gold over gesso, canvas and wood, the icon shows, on the right side of the composition, Christ, riding on an ass and followed by his disciples, approaching Jerusalem. On the left, opposite Christ, stands the crowd. Between the two groups is a tree with a thick trunk; three children have climbed it and are cutting branches. Other children, on the ground, are welcoming Christ. The city of Jerusalem occupies the left background; while the right is occupied by the Mount of Olives. There is overpainting on the right-hand group of figures.

The small dimensions of the panel indicate that it originally belonged to a set of *Dodekaorton* icons. Its general iconographic scheme, in which Christ is approaching Jerusalem from right to left, instead of the more usual left to right, places it with a series of icons which display the same arrangement (Vokotopoulos 1977–9, pp. 309–21, pls 115–22; Chatzidaki 1983, no. 28; exh. cat. *Byzantine*

and Post-Byzantine Art (1986), no. 95; exh. cat. *Ikonen* (1993), no. 35). The earliest of these icons is a Constantinopolitan work of the 1370s or 1380s, today in the Sterling and Francine Clark Art Institute in Williamstown, Massachusetts (Alpatov 1976, fig. 84; Vokotopoulos 1977–9, pp. 314–16, pls 116, 118). The exact parallel to our icon is a Cretan panel from the island of Levkas, dated to the third quarter of the fifteenth century (Vokotopoulos 1977–9, pp. 309–21, pls 115, 117, 119). Both the London and Levkas icons display abbreviated versions of an iconographic scheme exemplified in the Williamstown icon. For example, the figure on the extreme left edge of the left-hand group, who, for no obvious reason, has his head turned away from his companions, is shown in the Williamstown icon conversing with two men standing behind him. Whether the Williamstown icon stands as the direct prototype of the other two is, of course, not known.

The exhibited icon should be dated around 1400 and seen as a Constantinopolitan product. Stylistic parallels to this icon include the icon of the Triumph of Orthodoxy in the British Museum (no. 140), which is also dated around 1400 and attributed to Constantinople.

R. Temple, *A Brief Illustrated History of Icons*, London, 1992, pp. 9–10, pl. on p. 34 and detail on front cover. MV

225 Embroidered belt or border

Probably Constantinople or Thessaloniki, mid 14th century

London, BM, M&LA 1990,12–1,1

Approx. 1950 × 75 mm

Previously in the Iklé Collection, St Gallen; sold at Christie's, South Kensington, 7 November 1989, lot 171. Bought by the British Museum in 1990. A smaller fragment of the same embroidery is in the Hermitage Museum, St Petersburg (Oriental Dept, no. w.1179). This had been bought in 1902 in the bazaar in Istanbul by the Swedish archaeologist F. R. Martin and was subsequently acquired by the Russian Archaeological Commission. The Hermitage piece measures approx. 880 × 75 mm; it also has two cut ends, but the motifs are oriented parallel to one edge of the strip. The style of the embroidery matches the lower end of the British Museum piece and, as there, the base textile is of salmon pink silk.

Long narrow strip embroidered in gold and silver thread with details in coloured silk thread or a combined metal and silk thread. Within repeating ogival quatrefoil frames, eighteen in total, three motifs repeat: a wyvern (two-footed dragon), a falcon accompanied by two sprigs, and a helm with paled mantling surmounted by a crest, the crest the forepart of an animal with the appearance of a bear. To either side of the helm are the Cyrillic letters БРАНКО ('Branko'; in four cases the N and the K form a ligature, as do the A and N in the fifth). Between each two quatrefoils is a panther's mask and, in spaces at the sides, there are four

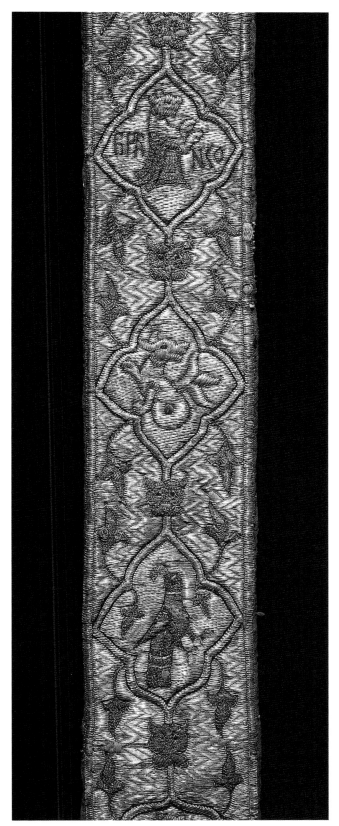

225

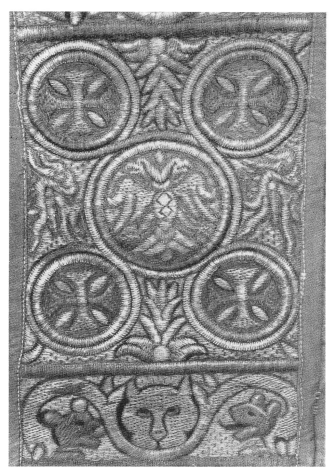

225 (detail of embroidery on Patmos)

pointed tripartite leaves or blooms. At five quatrefoils from the bottom of the strip the style of the embroidery changes slightly and the quatrefoils become much more rounded. The outer border is plain. The side edges are turned under, and the ends cut. The lining is modern.

The embroidery is worked on, and almost completely covers, a crimson silk base textile in 1/3 twill weave, warp yarn z-twist, approx. 32 ends per cm, weft yarn without twist, approx. 44 picks per cm. A little below the point where the style of embroidery changes, the base textile changes to a salmon pink silk in simple tabby weave; warp yarn z-twisted, approx. 38 ends per cm, weft yarn without twist, approx. 28 picks per cm, visible on the reverse at one side, a single thick selvedge cord of linen or hemp. Undyed support textile of linen or hemp, simple tabby weave, both yarns z-spun, approx. 25 ends per cm, approx. 15 picks per cm. Above the silk base textile and below the metal embroidery threads there is padding built up from z-spun cotton threads: these cotton threads are laid singly and lengthways under the gold backgrounds but below the motifs and the quatrefoil

borders occur as an s-plied cord which follows the contours of the design.

The metal threads are all formed from silver-gilt hammered wire, almost rectangular in section (BM Scientific Research file 6225). Although all the metal is gilded, two different colours have been used, a whiter wire for the quatrefoil borders and for the outlining, and a yellower wire for the wyverns, the demi-bears or lions and the backgrounds. For most of the surface of the embroidery the wire is employed straight and is surface-couched in twos or threes: for the figures and the background within the quatrefoils the couching forms a bricked pattern, and in the background outside it creates chevrons; in the borders of the quatrefoils and in the outer borders, wire in pairs or threes is worked backwards and forwards crossways. The wire is also used twisted: the panther's masks, the helms, the falcons and the leaves are built up from threads consisting of a thin silver-gilt wire loosely s-wound around an s-twisted silk core of either crimson, green or light blue; these semi-coloured areas are outlined by two pairs of wire that were twisted together as they were couched.

Silk embroidery thread without twist was used in split-stitch to outline the areas in gold thread: the quatrefoil borders and some of the wyverns are outlined in dark blue, the bears in crimson, and two of the wyverns in pea-green. Silk threads satin-stitched in the same three colours fill in certain details. The inscriptions were originally filled with black silk thread, but this has rotted away. The combined silk-and-metal threads are couched with z-twisted silk threads of appropriate colours; most of the gold thread is couched with an apricot silk thread, now faded, and the whiter gold threads are couched with white silk. The crimson embroidery thread was dyed using kermes insects (BM Conservation Research report 1991/19).

Since 1902, when Stojan Novaković sent a description and photographs to the Serbian Royal Academy in Belgrade, the St Petersburg fragment has been known among Serbian historians as 'the belt of Sebastocrator Branko'. Sebastocrator Branko Mladenović, son of Prince Mladen, was a magnate at the court of the Serbian Tsar Stefan Dušan (1331–55) and, after 1334, governor of the city of Ohrid. He died before 1365. Two generations of Brankovićs, direct descendants of Branko Mladenović, played a major political role in the last phase of independence of the medieval Serbian state.

Serbian aristocrats of the fourteenth and fifteenth centuries wore elaborate and very long belts, with two hanging looped ends. Even though the combined length of the British Museum and Hermitage fragments is more than 280 cm, the probability is that the embroidery originally formed such a belt. These belts and information about them from inventories, wills and other documents in the archives of Dubrovnik are discussed by J. Kovačević in

Srednjovekovna Nošnja Balkanskih Slovena, Belgrade, 1953, pp. 174–9, and by B. Radojković in *Nakit kod Srba*, Belgrade, 1969, pp. 44–8. Fourteenth-century wall-paintings in churches, showing aristocrats wearing such belts, include portraits of the Sebastocrator (later Despot) Jovan Oliver at Lesnovo (1341), Sebastocrator Vlatko and Knez (Duke) Paskač at Psača (1358), Ostoja Rajaković in the church of the Mother of God Perivleptos (1379) at Ohrid (see V. J. Djurić, *Vizantijske freske u Jugoslaviji*, Belgrade, 1975, pls 62, 74 and 85 respectively). An alternative that must be considered is that the embroidery was some sort of border, though the fact that there is no reverse in the design, as occurs, for example, at the back of the neck of ecclesiastical stoles (Johnstone 1967, pls 29–47) makes it unlikely that it was ever worn like a stole or attached to a piece of clothing. The relationship between the Hermitage piece, with the motifs arranged horizontally, and the British Museum piece, with the motifs vertical, is not yet fully understood.

The function and context of the two 'Branko' pieces may become clear after the full publication of gold-embroidered strips with floral, zoomorphic and heraldic ornaments (including two-headed eagles) from a tomb excavated at the church of St Nicholas at Staničenje (built 1331–2), in eastern Serbia. At their ends 'Ivan Alexander, Tsar of the Bulgars and Greeks' (1331–71) is embroidered within oblong cartouches. The strips would appear to be a gift from the Bulgarian tsar, brother-in-law of the Serbian tsar Dušan, to the unidentified nobleman buried at Staničenje. A brief description is given by R. Ljubinković, 'Crkva Sv. Nikole u Staničenju', *Zograf* 15 (1984), pp. 76–84; see also S. Gabelić, 'Prilog poznavanja živopisa crkve Sv. Nikole kod Staničenja', *Zograf* 18 (1987), pp. 22–36.

The identification of the owner as Branko Mladenović rests on the inscription 'Branko' and the evident date of the embroidery: the helm is of a fourteenth-century type, and the design as a whole is typical of that century. The only difficulty consists in the crest, apparently a demi-bear, whereas Branko Mladenović's descendants, the Brankovićs, are known to have used a lion as their emblem. One explanation could be that the animal is in fact a lion, though of very stylised appearance. Another might be that the father had used one crest and his sons another. The imprecise nature of the Serbian heraldry of the period is illustrated by the fact that the arms on the embroidery do not include a shield.

Heraldry had reached Serbia from western Europe, via Hungary and, probably more significantly, northern Italy. At the same time Serbian architecture and visual arts had been influenced by western European Gothic, something that is visible in the ogival quatrefoils of the embroidery. Its overall design can be compared to a number of western pieces, such as the Opus Anglicanum altar frontlet made

between about 1290 and 1340 by the nun Johanna of Beverley, now in the Victoria and Albert Museum, and a set of Italian orphreys of between about 1330 and 1350 now in the Art Institute of Chicago (exh. cat. *The Age of Chivalry* (1987), no. 442; F. Galloway, *Indian Miniatures, Textile Art*, London, 1994, no. 15). However, the technique of this embroidery – in particular the gold thread based on wire employed for both figures and backgrounds, the silk thread in a restricted range of colours, and the cotton quilting – is typical of Byzantine embroidery.

A close parallel for the Branko embroidery in terms of technique and style in detail is a famous Byzantine ecclesiastical embroidery, an epitaphios or stole in the monastery of St John the Divine on Patmos (Johnstone 1967, p. 100 and pls 31–4, and A. D. Kominis (ed.), *Patmos: Treasures of the Monastery*, Athens, 1988, p. 209, figs 8 and 9). Here the main design is of half-figures of Christ, the Mother of God and saints, but smaller more formalised motifs include, in addition to the imperial double-headed eagle, a panther's mask and animal heads in profile that are very close to the problematic bear or lion of the Branko embroidery. It seems likely that both embroideries were made in the same workshop. The Patmos stole has usually been dated to the fifteenth century, but the similarity to the Branko piece suggests that it, too, belongs in the fourteenth.

The British Museum piece unpublished. For the Hermitage piece see the following Serbian publications: Stojan Novaković, 'Vizantijski činovi i titule u srpskim zemljama XI–XV veka', *Glas SKA* 78 (1908), pp. 248–9; K. Jiriček, *Istorija Serba*, II, Belgrade, 1923, p. 57; L. Pavlović, 'Prilog izučavanju srpskog srednjovekovnog dvorskog veza: Pojas Sevastokratora Branka', *Neki Spomenici Kulture* 2 (1963), pp. 5–30, figs 1–5; M. Ćorović-Ljubinković, 'Predstave grbova na prstenju i drugim predmetima materijalne kulture u srednjovekovnoj Srbiji', in *O Knezu Lazaru*, Belgrade, 1975, pp. 171–83, fig. 34. HG-T/ZG

226 Epitaphios of Nicholas Eudaimonoioannes

Greece, 1407

London, Victoria and Albert Museum, Textiles and Dress Collection, 8278–1863

Approx. 850 × 1400 mm

In 1756 recorded as being in the monastery of the Santi Apostoli in Naples. According to Cajetani, it had been brought to Naples in 1628, from 'Calata' in Sicily. Bought by the V&A in 1863 from Canon Franz Bock.

Large twill-weave cloth of crimson silk embroidered in gold and silver thread and coloured silk thread. In the centre, the dead Christ, laid on a stone slab, is attended by two angels carrying liturgical fans; the clothing, haloes and fans are in

226

metal thread outlined in coloured silk, the skin and hair in shades of cream and brown silk, and Christ's five wounds in red silk. In the corners, inside quadrant frames, are busts of the four evangelists, employing the same conventions. In the field, plant rinceaux spring from two Greek crosses and sprout large tulip-like flowers, small single leaves, trefoils and half acanthus leaves; the stems and outlines are in gold and the leaves and flowers in dark yellow, light and dark blue and white. There is similar but smaller-scale plant decoration in the corners and an acanthus border in the quadrant frames. Around the outside of the cloth there is a long Greek inscription in gold thread, divided into sections by three crosses. Two of these sections are verses from the *troparion* for Good Friday: 'The honourable Joseph [of Arimathea], having taken down from the wood [of the cross] the spotless body of Thee [O Jesus] and having wrapped it up in a clean winding-sheet together with aromatics, taking upon himself to afford it a becoming burial, laid it in a new grave'. 'Seeing at the grave the women who were carrying perfumes, the Angel cried out "The ointments fitting [to be used in the burial] for mortal beings are lying here, but Christ, having undergone death, has shown himself [again] after another form".' The third section of the inscription is a dedication: 'Prayer of the servant of God Nicholas Eudaimonoioannes with his wife and children in the year 6915 [1407], indiction 15'. (Words and letters now missing can be restored on the basis of the Grimaldi drawing (see below).) Other inscriptions identify the evangelists, abbreviate the name of Christ, and so on.

Crimson silk base textile, 1\3 twill weave, warp yarn z-twist, approx. 38 ends per cm, weft yarn without twist, approx. 40 picks per cm. Undyed support textile, of linen or hemp, coarse tabby weave, both yarns z-spun, approx. 9 ends and 7 picks per cm. Central panel an appliqué of finer tabby weave linen, both yarns z-spun, approx. 18 threads per cm in both directions. Gold embroidery thread a strip of gilded silver tightly s-wound around an s-twist yellow silk core. Silver embroidery thread, rather thicker than the gold, a strip of silver tightly s-wound around an s-twist undyed silk core. Both metal threads surface couched and worked throughout in pairs: in the haloes and the edges of the slab the metal threads are maintained parallel to each other and are couched in a chevron pattern; in the drapery they follow the contours of the design and are outlined by a coloured silk thread; in the floral patterning and in the smaller inscriptions the metal threads themselves form the outlines; in the main border inscription they are worked backwards and forwards crossways. The haloes, the borders of the slab, the cross and the fans are padded with z-spun cotton threads laid between the metal thread and the crimson base textile. The main inscription is also padded, but here the cotton threads have been s-plied into a cord. The variously coloured silk threads used for the skin, hair and flowers are

without twist and are worked in split stitch following the contours (the surface of the slab appears originally also to have been covered in black or brown silk in split stitch, but now nearly all this is lost). The white, blue, red, green, brownish yellow and brown(?) silk threads used for outlining are worked in split stitch and are again without twist. The silk threads used to couch the metal threads, browny yellow for the gold and white or blue for the silver, are slightly z-twisted. The embroidery is worn and extensively repaired, the metal oxidised. Where the metal thread is missing, the black lines visible are the traces of the oxidised silver and not original drawing.

An epitaphios is a large cloth carried in procession in the Good Friday services and for which the early term was *Great Aër*. The decoration, with the body of the dead Christ accompanied by angels with fans and with the symbols or figures of the evangelists in the corners, is conventional. In this example, the verses from the *troparion* emphasise the Good Friday theme.

The Eudaimonoioannes family held an important position in the history of the Morea (in the Peloponnese) as archons of Monemvasia from the thirteenth century until the Turkish conquest. The Nicholas mentioned here in the dedication may well be the Nicholas Eudaimonoioannes who acted as Manuel II's ambassador to the Venetians in 1416 and as one of the emperor's delegates to the Council of Constance in 1414–17.

Stylistically and technically this epitaphios fits well into the tradition of Byzantine and later Greek metal thread embroidery. The two differences in technique between this object and no. 225 are that here much more of the crimson ground has been left visible and all the metal thread consists of flat strips of metal wound around a silk core, the type of thread known as *chrysonemata* or 'spun gold', whereas on the earlier embroidery all the metal thread is wire.

Although thought to have been in Sicily and known to have been in Naples, this epitaphios was presumably commissioned by Nicholas Eudaimonoioannes for donation to a church in his native Morea. It is likely to have been made somewhere in the Greek peninsula but was possibly a product of the capital, Constantinople.

M. Cajetani, *De vetusto altaris pallio ecclesiae grecae christianorum in cimeliarchio clericorum Theatinorum Domus SS. apostolorum Neapolis diatriba*, Naples, 1756; D. Rock, *Textile Fabrics* (South Kensington Museum), London, 1870, no. 8278; C. Rohault de Fleury, *La Messe*, v, 1883, p. 45; A. J. B. Wace, 'An epitaphios in London', *Εἰς μνήμην Σπυρίδωνος Λάμπρου*, 1935, pp. 232–5; Millet 1947, pp. 89–94, pls 181, 196–7; I. D. Stefanescu, *Voiles d'iconostase, tentures de ciboires, aërs, aërs ou voiles de processions*, in: Analecta, Universitatea din Bucureşti, Institutul de Istoria Artei, II, Bucharest, 1944, p. 104; Johnstone 1967, pp. 99, 120–1. A drawing, probably of the eighteenth century, is in the Grimaldi manuscript no. 168, p. 23, in the Ambrosian Library, Milan. HG-T

227

227 Cypriot *sgraffito* bowl

Cyprus, 13th or 14th century

Private collection

Diam. 140 mm, H. 100 mm

Pottery bowl, internally glazed and decorated with a central stylised human figure surrounded by spirals, incised beneath the glaze. Green and brown paint has been applied to the interior in broad streaks, running across the incised designs, and this combines with the incised decoration to produce an ornate appearance.

The bowl is an example of the large and highly decorated series of Cypriot *sgraffito* ware, which was produced on the island during the Late Byzantine and Post-Byzantine periods. Although these distinctive vessels were primarily intended as domestic pottery, they frequently survive complete as they were also placed in graves; the find-spot of this example, however, is unknown. The series, in general, forms an important link between Byzantine and later Cypriot pottery.

Unpublished. KRD

228 Icon of the Nativity

Crete, beginning of 15th century

Lent by Michael Peraticos

665 × 640 mm

Formerly in the Volpi Collection.

Painted in egg tempera on gold, over canvas, gesso and wood, icon of the Nativity. The Mother of God dominates the scene, lying on a red pallet in front of a cave with the swaddled child in the manger and the animals in attendance. She is watching the bathing of the child in the bottom left corner. Joseph is conversing with a shepherd at bottom right. The three Magi, on horses, approach from the left. Two groups of angels appear on either side of the rocky mountain; the ones at the left are in prayer, those at the right are bowing in veneration. An angel talks to a shepherd on the extreme right (the Annunciation to the Shepherds). A young shepherd, seated on a rock, is playing the flute. Some sheep are drinking water from a stream; others are nibbling the branches of a tree. A white dog, curled up, is sleeping on the bank of the stream. A goat in the bottom right-hand corner is scratching its ear. A black dog is calmly watching Joseph and the shepherd talking. Of an inscription in Latin running along the arc of the sky only a few letters survive.

The icon is iconographically and stylistically connected with a series of Cretan fifteenth-century icons in the Byzantine Museum in Athens (exh. cat. *Icons of Cretan Art* (1993), no. 202), on Patmos (Chatzidakis 1985, no. 39), in the Greek Institute in Venice (Chatzidaki 1993, no. 12) and the Hermitage, St Petersburg (Felicetti-Liebenfels 1956, pl. 129). However, the Peraticos icon must be the earliest of them. It has been suggested that all these icons depend on a prototype, presumably executed in Constantinople. Common iconographic features between the above Nativity icons and the Nativity fresco from the *Peribleptos* at Mistra (about 1370: Chatzidakis 1981, pl. 47; Mouriki 1991, fig. 11), of an undeniably Constantinopolitan character, also indicate this.

The gap between the *Peribleptos* fresco and the above Nativity icons is filled by an icon from a private collection in Germany (unpublished), which should be dated slightly later than the *Peribleptos* and associated either with Constantinople itself or with the work of Constantinopolitan painters documented in Candia, Crete, from the last decades of the fourteenth century (Cattapan 1968, pp. 35, 37–8, 41–2; Cattapan 1972, pp. 204, 205, 218–20). If we compare the Peraticos icon with the icon from the German collection, we see that the latter is much simpler in the rendering of the landscape and does not include the animals in naturalistic poses, a feature deriving from Italian painting (Chatzidakis 1974, p. 204; *Byzantium to El Greco*, p. 166), which is easily understood if associated with the conditions

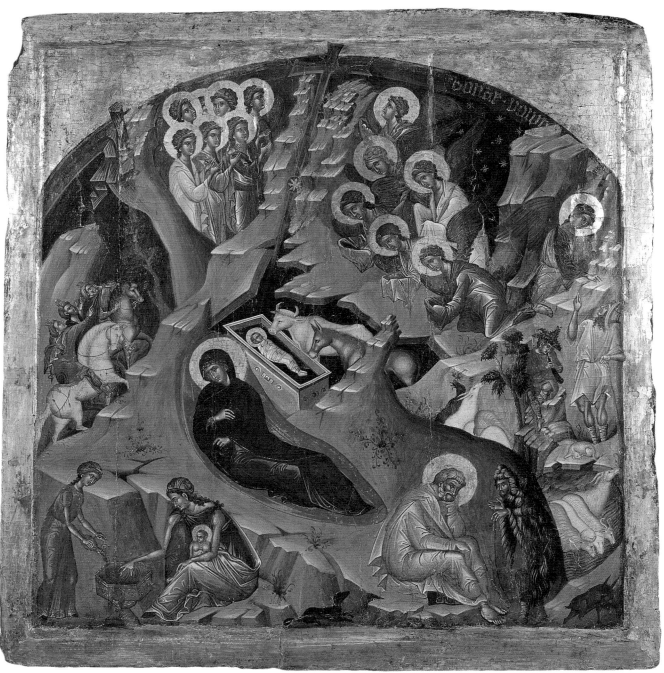

228

prevailing on Crete at the time as a result of the Venetian occupation of the island.

The Latin inscription running along the arc of the sky may indicate that the icon was commissioned by a Venetian living on Crete (*Byzantium to El Greco*, p. 167).

Garrison 1949, p. 114, no. 293; Lazarev 1967, p. 407, fig. 574; Chatzidakis 1974, p. 120, pl. AB.2; Chatzidakis 1982, no. 10. Exhibited: *Byzantium to El Greco* (1987), no. 30. MV

229 Icon of St Jerome

Probably Crete, early 15th century

London, BM, M&LA 1994,5–1,1 (National Icon Collection, no. 26)

Painted surface 345 × 270 mm, excluding a partly gilded edging of about 6 mm all round

Once in the possession of Ruskin, the panel was given to William Ward and purchased from him by Alfred de Pass. It was exhibited at the Burlington Fine Arts Club in 1905 and presented to the National Gallery in 1920 (no. 3543). Transferred to the British Museum in 1994.

Painted in egg tempera on gessoed cypress wood, the icon represents St Jerome extracting a thorn from the lion's foot. Good condition, apart from the new golden background, the re-painted figure of the lion, and an accidental circular damage by the animal's head. In a rocky landscape and in front of a small ornamented three-aisled basilica, St Jerome stops writing and uses his pen to tame the wild animal. Seated on a massive wooden throne he is represented as an elderly long-bearded monk. Cinnabar red emphasises his hat and his hooded and furry mantle, which opens to reveal a crimson tunic. Although no inscription indicates his name, he is identified by the Latin text of his book which exhorts: 'Overcome wrath by patience; love the knowledge of the Scriptures and you will not love the sin of the flesh' (Davies 1988, pp. 117–18; Write 1947, p. 417).

In art historical literature the rocky background setting of St Jerome's miracle has generally been treated as a byzantinising stylistic element in a panel of the fourteenth-century Venetian school (Davies 1951, p. 422). However, the material, subject matter and iconography of the picture indicate an eastern origin. Cypress was both a Mediterranean alternative to Italian poplar wood (exh. cat. *Art in the Making* (1989), p. 11) and a medium used to support Greek icons (exh. cat. *Byzantium to El Greco* (1977), p. 52). The miracle of the lion, a rare theme in the Latin West, was often set in rocky landscapes by fourteenth-century Byzantine artists (as in a fresco from the monastery of St Nicholas Orphanos in Thessaloniki: Xyngopoulos 1964, p. 21, pl. 119). Its iconography derives from Late Byzantine art and is repeated in icons attributed to the Venetian state of Crete (a sixteenth-century Cretan copy is illustrated by Shapley

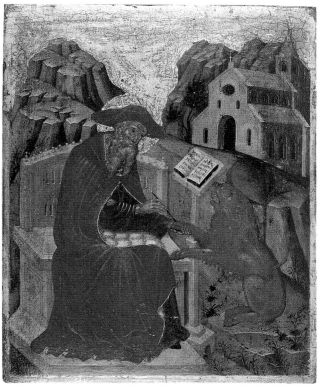

229

1968, p. 11, pl. 26). In Cretan icons the ornamental motif of the three-aisled basilica is frequently represented, formulating a standardised background for Orthodox and western subject matter, and therefore an allusion to the Graeco-Latin culture of post-Crusader Byzantium. (Examples of landscape with a small three-aisled church are found in: Vokotopoulos 1990, p. 17, n. 8, pl. 81, exh. cat. *Candia to Venice* (1993), p. 120, no. 27, and *Byzantium to El Greco* (1977), p. 52, no. 49.)

M. Davies, *The Earlier Italian Schools*, London, 1951, p. 422, and (revised by D. Gordon) *The Early Italian Schools: Before 1400*, London, 1988, pp. 117–18, pl. 82; R. van Marle, *The Development of the Italian Schools of Painting*, IV, The Hague, 1924, p. 39; N. Kondakov, *The Russian Icon*, Oxford, 1927, p. 74 (note by Minns); Pallucchini 1964, p. 216, pl. 678; B. Ridderbos, *Saint and Symbol: Images of St Jerome in Early Renaissance Art*, Groningen, 1984, p. 37, pl. 18; G. Ring, 'St Jerome extracting the thorn from the lion's foot', *Art Bulletin* 27 (1945), p. 193; F. A. Write, *Selected Letters of Jerome*, London, 1947. Exhibited: *A Collection of Pictures, Drawings . . . and other Works of Art*, London (Burlington Fine Arts Club), 1905. VF

230 Icon of the Deesis

Crete, second quarter of 15th century

Private collection

680 × 480 mm

The icon was bought in November 1991 at auction at Sotheby's. Before that it was in the possession of a Zurich art dealer, who had bought it at auction at Christie's.

Egg tempera and gold on gesso and canvas on a single piece of wood. The entire upper part was recently regilded. The icon represents the Deesis: Christ is in the middle of the composition, seated on a high-backed wooden throne with a red thick cushion on it. His feet rest on another red cushion, placed on a wooden footstool. He is blessing with his right hand and holding in his left an open Gospel Book, in which is written, in Greek, 'Come unto me, all ye that labour and are heavy laden, and I will give you rest. Take my yoke upon you, and learn of me' (Matthew 11.28–9). The Mother of God is standing on the left of the composition, and St John the Baptist on the right. They both make a gesture of supplication with their hands.

The small dimensions of the icon suggest that it was meant for an individual. Its subject, which is associated with salvation, is also especially relevant for a private commission.

The iconographic scheme of the Deesis, as it appears on this icon, conforms with that employed by Cretan icons of the fifteenth century. Three of these icons are signed by the painter Angelos (second quarter of the fifteenth century; Vassilaki-Mavrakaki 1981, pp. 290–8; Vassilaki 1989, pp. 208–10): one is in Viannos, Crete (exh. cat. *Icons of Cretan Art* (1993), no. 157), a second on Sinai (heavily overpainted; Drandakis 1990, pl. 77), and a third in the Kanellopoulos Collection in Athens (Chatzidaki 1983, no. 5). A fourth example is to be found in a composite icon in Sarajevo, with the Deesis in the middle (Weitzmann *et al.* 1982, pl. on p. 321), which bears the signature of Nikolaos Ritzos (about 1460–1503). The style of the London Deesis is very close to that of Angelos's icons. Convincing comparisons are not only with the Deesis icons by Angelos but also with single features of other icons signed by him, such as the depiction of Christ Pantocrator enthroned, from the island of Zante (exh. cat. *Byzantium to El Greco* (1987), no. 33).

A full technical analysis of the paint, involving examination under infra-red and ultra-violet light, as well as pigment analysis, has been carried out by Dr Libby Sheldon, of University College, London. The fifteenth century date arrived at on iconographic grounds is confirmed by the pigments, which compare closely with those used in Italy in the fifteenth century. They are of excellent quality, implying that the icon was a relatively costly commission. X-ray examination has shown that the Gospel Book on Christ's knee was originally lower and further to the right.

Sale cat. *Icons, Russian Pictures and Works of Art*, Sotheby's, London, 28 November 1991, lot 553, col. pl. on p. 101. MV

231 Icon of St John the Baptist

Crete, about 1450

London, Society of Antiquaries, no. 91

515 × 360 mm

The icon was presented to the Society by its Fellow G. McN. Rushforth, shortly before his death in 1938. It had been bought in Milan.

Painted in egg tempera on gold over gesso, canvas and wood, the winged St John is shown full length in a frontal pose. He is dressed in his usual sheepskin (*melote*) and *himation*. His right hand is raised in front of his chest, in blessing. In his left hand he holds an open scroll and a long staff terminating in a cross. The Greek text of the scroll reads: 'Repent ye: for the kingdom of heaven is at hand' (Matthew 3.2 and 4.17). The background is gold, apart from a lower register, which is green, signifying the ground on which the saint stands. The name of the saint in Greek ('St John the Forerunner'), abbreviated, is written on the gold background at the level of his head. The panel has its original frame.

St John is shown winged like an angel, as the messenger sent to earth to prepare the way for Christ (Malachi 3.1; Matthew 10.10; Mark 1.2; Luke 7.27). The iconographic type of the winged St John does not go any further back than the late thirteenth century, e.g. a wall-painting in St Achilleios at Arilje, Serbia, of 1296/7 (Lafontaine-Dosogne 1976, p. 128, fig. 8). Our icon represents one of the iconographic variations of the winged St John in which he is shown in frontal pose without the chalice containing his head. Most examples of this variation are in post-Byzantine icons, for example an icon attributed to the Cretan artist Michael Damaskinos, of the second half of the sixteenth century, in the Sinaitic *metochion* of St Matthew in Heraklion, Crete (exh. cat. *Icons of Cretan Art* (1993), no. 113), but an icon of the late fourteenth century in the Tret'yakov Gallery (Smirnova 1989, p. 268, pls 55–6), which has been associated with Theophanes the Greek (exh. cat. *Vizantija* (1991), no. 59), may be evidence of the evolution of the type, at least from the late fourteenth century, and its possible Constantinopolitan connections. In Cretan icon-painting there is a preference for the winged St John turned to one side, an iconographic type established by the painter Angelos in the second quarter of the fifteenth century (Lafontaine-Dosogne 1976, pp. 121–43, figs 1–6; Potamianou 1989–90, pp. 105–10, figs 1–4). However, the Cretan icon of the Soci-

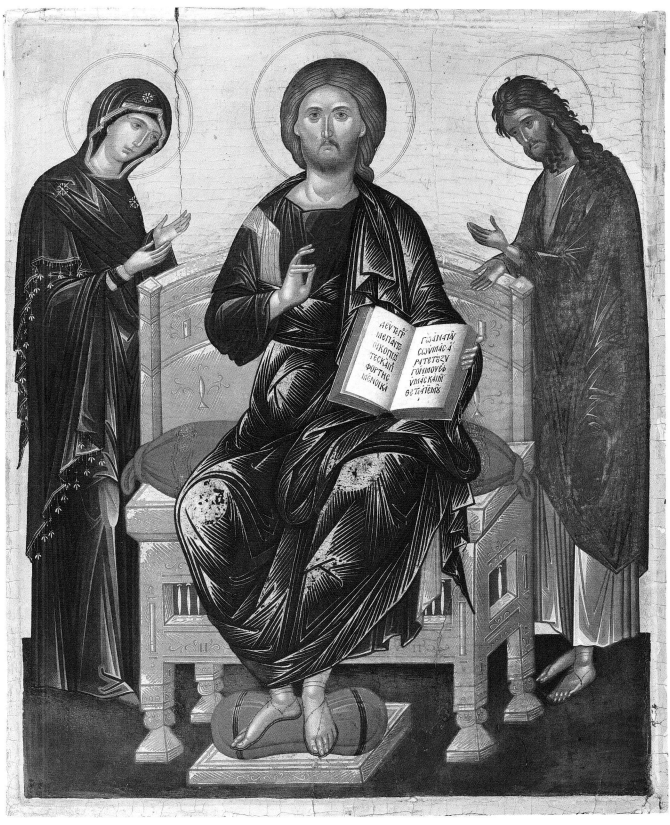

230

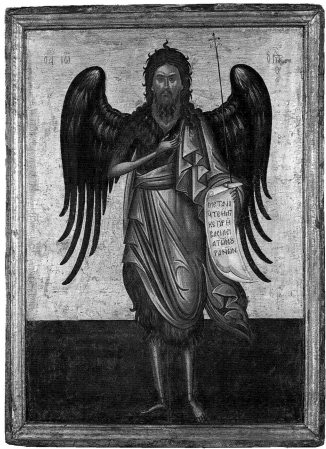

231

ety of Antiquaries of London, dating from the mid fifteenth century, indicates that the winged St John, full length and in frontal pose, was also introduced into Cretan icon-painting at about the same time. This is further supported by Cretan icons of the second half of the fifteenth century, e.g. the composite icon in Tokyo by Andreas Ritzos (doc. 1451–92), with St John on the frame (Koshi 1973, fig. 1; Chatzidakis 1985, pl. 201), where the saint has exactly the same pose but is not winged.

Antiquaries Journal 18 (1938), pp. 291–2, pl. LXV and pp. 409–10 ('Notes'). MV

The fall of Constantinople

By the end of the fourteenth century the Byzantines were facing one enemy only. The Ottomans had overrun the Serbian and Bulgarian empires and, despite brief intervals of peace, now threatened Byzantium from all sides. A last effort to enlist military support from the West by offering church unity between Constantinople and Rome took the Emperor John VIII Palaeologus and the Patriarch of Constantinople to a council held at Ferrara in 1438 and Florence in 1439. A humiliating Act of Union was signed, which caused terrible dissension in Constantinople and, in any case, failed to win desperately needed reinforcements.

The frontiers of Byzantium were by now the city walls of Constantinople, besieged by the armies of the Ottoman sultan, Mehmet II. On 29 May 1453, after more than eleven hundred years, the Christian city founded by Constantine the Great finally fell, and with it its empire, Byzantium.

Byzantine art lived on, however, particularly in the hands of Cretan painters, one of whom, Domenikos Theotokopoulos, made his home in Spain, where he became known as El Greco, 'the Greek'. Crete had been a Venetian colony since the time of the Latin occupation of Constantinople, a place where Byzantine and western artistic traditions mingled, and, in keeping with their special – if at times turbulent – relationship with Byzantium, the Venetians themselves continued to nurture Byzantine art.

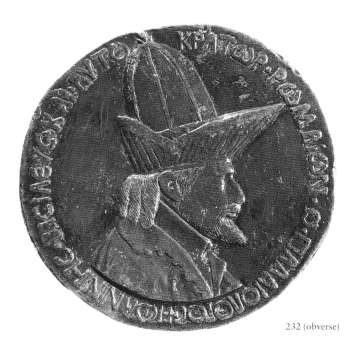

232 (obverse)

232 Portrait medal of John VIII Palaeologus, by Pisanello

Ferrara, 1438–9

London, BM, CM 1907,2–4,2

Max. diam. 103 mm

Given to the British Museum by Alfred de Pass in 1907.

Lead medal, cast. Obverse: John VIII is portrayed in profile to the right, wearing a hat with a high upturned brim, pointed at the front, and tall crown. His image is surrounded by the Greek legend 'John, Emperor [Basileus] and Autocrator of the Romans, the Palaeologus'. Reverse: a second, equestrian, portrait of the emperor, dressed for hunting with a bow and quiver. He prays before a wayside shrine. To the left a mounted page rides into the background. The reverse is signed, both in Latin and Greek, 'the work of Pisano the painter' (Antonio Pisano, called Pisanello).

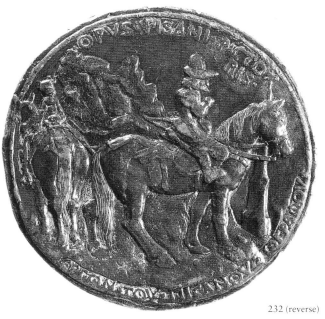

232 (reverse)

Although this is often called 'the first true portrait medal of the Renaissance' (Scher 1994, p.45), there seems to be no evidence for this universal art historical belief. The supposition probably develops from the very specific circumstances of the medal's production. John VIII arrived in Ferrara in October 1438 at the invitation of Pope Eugenius IV for a council intended to unite the Roman Catholic and Greek Orthodox churches. Plague forced the Council to shift to Florence in February 1439. Pisanello's presence in Ferrara and drawings by his hand relating to the medal's reverse (now in Paris) allow the inception, if not execution, of the piece to be precisely dated. Because this is the first easily datable medal, scholars have been seduced into thinking that it has also to be the first produced, citing the exceptional circumstances of its 'invention'. It is thought to have been inspired by the existence of a large gold medallion of Justinian (see no.61), and the much-copied medals of Constantine and Heraclius in the collection of the Duc de Berry – which were then considered antique. Niccolò d'Este, Marquis of Ferrara and the Council's host, seems to have owned a specimen of the latter by 1436, and it was probably on the initiative of Niccolò, or his son and heir Lionello, that Pisanello was commissioned to model the emperor's portrait, deliberately reviving what was considered to have been antique practice and commemorating his presence in Ferrara. Whether or not it was the first Renaissance medal (and there must remain some doubt on that score), it was certainly influential, and the portrait became a source for artists of all kinds when they wished to depict an oriental, a middle easterner or an exotic.

G. F. Hill, *A Corpus of Italian Medals of the Renaissance before Cellini*, London, 1930, p. 7, no. 19i; for more general discussions of this medal see R. Weiss, *Pisanello's Medallion of the Emperor John VIII Palaeologus*, London, 1966. S. K. Scher, 'Pisanello: John VIII Palaeologus', in: exh. cat. *The Currency of Fame: Portrait Medals of the Renaissance*, Washington–New York, 1994, pp. 44–6, no. 4. LS

233 Bull of Union

Florence (Papal Chancery), 6 July 1439

London, British Library, Cotton MS Cleopatra E.iii, folios 80v–81

570 × 735 mm

Owned by Sir Robert Cotton (d. 1631). At the death of his grand-son, Sir John Cotton, in 1702, the manuscript became by gift national property. Incorporated into the British Museum on its foundation in 1753.

To left and right, the Latin and Greek texts of the Papal Bull, announcing, with the consent of the Emperor John VIII Palaeologus, the agreement arrived at between the eastern and western Churches at the oecumenical council convened at Ferrara in 1438 and continued at Florence in 1439. 'Let the heavens be glad and let the earth rejoice' (Psalm 96.11), announce the opening words: now at last has ended the long division between East and West. Agreement is outlined on the vexed question of whether the Holy Spirit proceeds from or through the Son, on the doctrines of transubstantiation, purgatory and hell, on papal supremacy and the order of precedence among the eastern patriarchs.

Below the Latin text are the papal *rota* and subscription of Eugenius IV, followed by the subscriptions of eight cardinals, the Latin patriarchs, thirty bishops and three religious, all of which are countersigned by the humanist scholar Flavio Biondo. Below the Greek text is the lone signature in red ink of the Byzantine emperor. No seals have survived with this copy of the bull.

Out of the many originally made (perhaps as many as three hundred), only eighteen copies of the Bull of Union survive. Of these the best copy, now in Florence and preserving all the western and Greek subscriptions, together with the papal and gold imperial bullae, may be one of five complete copies said to have been drawn up. Eight copies, including the present document, lack the Greek subscriptions except that of the emperor.

Despite the enthusiasm and optimism voiced in the Bull, union was ill-fated. Seen as conceding everything to the Latins, it served only to create further divisions at Constantinople. The rescue from the Turks by the West, which John VIII had sought by it, never happened.

H. I. Bell, 'A List of original Papal Bulls and Briefs in the Department of Manuscripts, British Museum', *English Historical Review*, 36 (1921), p. 417, no. 221; *Concilium Florentinum: documenta et scriptores*, series A, vol. I: *Epistolae Pontificiae ad Concilium Florentinum spectantes*, ed. G. Hofmann, II, Rome, 1944, pp. viii–ix, 68–79, no. 176. SMcK

234 Grant by Mehmet II to the Genoese of Galata

Constantinople (Ottoman Chancery), 1 June 1453

London, British Library, Egerton MS 2817

505 × 135 mm

Apparently acquired at Pera by Antoine Testa, of the Austrian Embassy, Constantinople, before 1827. Bought by the British Museum through Baron Leopold Henry Alphonse de Pritzbuer, acting on behalf of an anonymous vendor, presumed to be Alfred Testa, in 1898.

Long paper roll bearing the Greek text of a grant of religious and commercial liberties to the inhabitants of Galata, the Genoese settlement facing Constantinople across the Golden Horn. At its head is inscribed the *tughra* (monogram) of the Ottoman ruler Mehmet II, and at the foot is the signature in Arabic of Zaganos Pasha, dated 1 June 1453.

233

When Constantinople fell on 29 May 1453, Angelo Lomellino, *Podestà* of Galata, quickly sought favour with the victors. He ordered the gates to be opened to Zaganos Pasha and sent congratulations to Mehmet. Genoese envoys were then sent out to request confirmation of privileges previously enjoyed under the Byzantine emperor. Three days later the ambassadors Babilano Pallavicini and Marco de'Franchi secured a modest agreement, and received from Zaganos Pasha the present *firman*. Although Galata soon declined as a commercial centre, the religious privileges granted in 1453 formed the basis of the minority rights of the Latin Church throughout the Ottoman Empire until the latter's collapse in the twentieth century.

Catalogue of Additions to the Manuscripts 1894–1899, London 1901, p. 562; E. Dalleggio d'Alessio, 'Le texte grec du traité conclu par les Génois de Galata avec Mehmet II, 1 juin 1453', *Hellenika* 11 (1939), pp. 115–24; E. Dalleggio d'Alessio, 'Traité entre les Génois de Galata et Mehmet II (1er juin 1453): Versions et commen-

taires', *Échos d'Orient* 39 (1942), pp. 161–75; T. C. Skeat, 'Two Byzantine documents', *British Museum Quarterly* 18 (1953), pp. 72–3; S. Runciman, *The Fall of Constantinople, 1453*, Cambridge, 1965, pp. 162–3. SMcK

235 Icon of the Ascension

Crete, second half of 15th century

London, Victoria and Albert Museum, Collection of Prints, Drawings and Paintings, 15–1940

457 × 368 mm

Bequeathed to the V&A by Alex Tweedee (1940).

Painted in egg tempera on gold over gesso, canvas and wood, the icon represents the Ascension of Christ. The composition is divided into two parts. The upper half is occupied by the circular mandorla of Christ, which is

234

carried by two flying angels. The lower half includes the Mother of God orans in the middle, escorted by two angels, with the twelve apostles, in two groups of six on either side of her. Between the upper and the lower part is the rocky background of the composition, the Mount of Olives, where, according to the Gospels, the Ascension took place. Of the Greek inscription, 'The Ascension', originally on either side of Christ's mandorla, only the right half survives.

The small dimensions of the icon indicate that this is a *Dodekaorton* icon originally belonging to a set of twelve decorating the frieze on top of the *iconostasis* beam of a church *templon*. Its painter has adopted Late Byzantine iconography, as seen in examples such as the mosaic icon of the Twelve Feasts in Florence (Museo dell'Opera del Duomo), dated to the first quarter of the fourteenth century and attributed to a Constantinopolitan workshop (Lazarev 1967, fig. 490). This iconography of the Ascension is found in a series of fifteenth-century Cretan icons: a composite icon in Tokyo painted by Andreas Ritzos (doc. 1451–92), in which the Ascension occupies the central part (Koshi 1973, fig. 1), and on the frame of a composite icon in Sarajevo (Weitzmann *et al.* 1982, pl. on p. 321), painted by the son of Andreas Ritzos, Nikolaos (about 1460–1503). Other relevant examples are an icon recently acquired by the Byzantine Museum, Athens, which is thought to date from earlier than the Ritzos panels (exh. cat. *Icons of Cretan Art* (1993), no. 205), an icon from the collection of the Greek Institute in Venice (Chatzidaki 1993, no. 13), an icon owned by the Amalieion Orphanage, Athens (Chatzidaki 1983, no. 30), and an icon from the Charokopos Collection in Kephalonia, attributed to Andreas Ritzos (*Kephalonia* 1989, p. 230). It is to this series of icons that the V&A Ascension belongs, both iconographically and stylistically.

Unpublished. MV

236 Icon of St George and the dragon

Crete, 16th century

Windsor Castle, The Dean and Canons of Windsor

546 × 457 mm

The icon was presented by the Very Revd the Hon. Gerald Wellesley, nephew of the first Duke of Wellington, and Dean of Windsor from 1854 to 1882.

Painted in egg tempera on gold over gesso, canvas and wood, the icon shows St George on horseback, killing the dragon. The saint is in military costume, holding in his right hand a spear which he plunges into the mouth of the dragon, a winged monster in the lower part of the composition. The princess, to the right, is fleeing in fear. Behind her stands the castle of Lassia, from where her parents and their

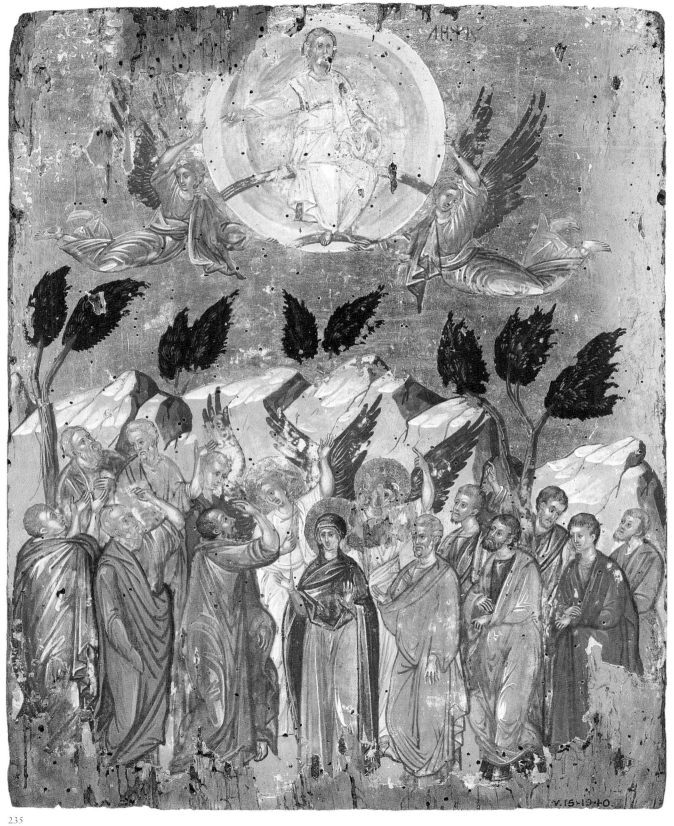

235

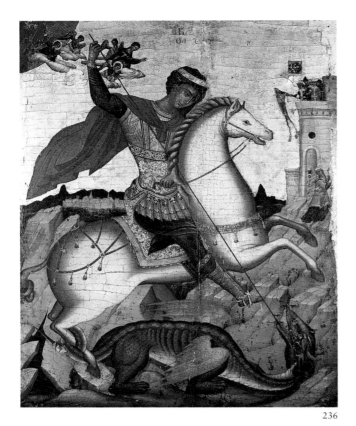

236

attendant watch the event. The background is rocky, and on the left a walled city is shown. In the upper left corner Christ appears in the sky, followed by four angels, and blesses the saint. Traces of the saint's name are visible on the golden background above his head.

The iconography of St George on horseback killing the dragon has adopted features which were introduced into Cretan painting of the first half of the fifteenth century (Vassilaki 1989, p. 213, figs 30–1; Chatzidaki 1993, no. 4), such as the costume and the red mantle of St George, the type of horse, its rearing in fear, and the representation of the dragon as a winged monster. An icon of this type in the Benaki Museum, Athens (Vokotopoulos 1987, pp. 410–14, pls 66 a, c, 69c; Vassilaki 1989, pp. 208–15, fig. 23), bearing the signature of Angelos (second quarter of the fifteenth century: Vassilaki-Mavrakaki 1981, pp. 290–8); Vassilaki 1989, pp. 208–10), shows that Angelos must have played a decisive role in the establishment of this iconographic variant in Cretan icon-painting. Certain elements, however, in the Windsor Castle icon consist of later additions to the iconography of the scene and place the icon in the sixteenth century: the golden crown worn by the saint, the princess's garments, the rendering of the walled city in the background, and the blessing Christ and angels in the sky. The scene is usually interpreted as symbolising the triumph of

good over evil; the Windsor Castle icon has also given a narrative character to the scene by introducing details of the princess and her parents. However, the symbolic character is emphasised by the presence of the blessing Christ and the angels.

Unpublished. MV

237 Triptych with the Koimesis and saints

Probably Mount Athos, end of 16th century

London, BM, M&LA 1994,1–2,2 (National Icon Collection, no. 20)

H. 170mm, W. 260mm (open)

Bequeathed to the British Museum by Guy Holford Dixon, JP (1994).

Painted in egg tempera on gold over gesso, canvas and wood, the triptych is in a poor condition of preservation. The central panel has a depressed triple arch with a double moulding, into which the two wings fit when the triptych is closed. The Koimesis (Dormition of the Virgin) occupies the central panel of the triptych, with the busts of Sts Cosmas the Poet and John of Damascus, holding inscribed scrolls, above. The left wing has full-length representations of St John Chrysostom and St John the Baptist, in frontal poses, with a bust of St George at the top. The right wing shows St Gregory the Theologian and St Basil, full length, and a bust of St Demetrios. Identifying inscriptions are in Greek. The back of the triptych is not painted.

The peculiar shape of this triptych, with its triple depressed arch, places it with a number of others, dating from the sixteenth and seventeenth centuries, in the Museum of the City of Athens (exh. cat. *Byzantium to El Greco* (1989), no. 69), the Benaki Museum, Athens (exh. cat. *Holy Image, Holy Space: Icons and Frescoes from Greece*, Baltimore, 1988, no. 79), the Louvre (exh. cat. *Byzance* Paris, 1992–3, no. 370), the Staatliche Museen, Berlin (Elbern 1979, no. 4), the Ekonomopoulos Collection (Baltoyanni 1986, nos 100 and 130) and an auction at Sotheby's (only the central panel, Sotheby's 1992 icon sale, lot 259). Of these triptychs the closest, both iconographically and stylistically, to that in the British Museum are those in the Museum of the City of Athens, the Louvre and the auction at Sotheby's, all dated to the sixteenth century. These triptychs have adopted the established Cretan iconography for the subjects they represent. For example, the Dormition of the Virgin and the Church Fathers on the British Museum triptych can be paralleled with those found on the composite icon by Nikolaos Ritzos (about 1460–1503) in Sarajevo (Weitzmann *et al.* 1982, 1982, pl. on p. 321); St John the Baptist is similar to that on the frame of the composite icon by Andreas Ritzos (doc. 1451–92) in

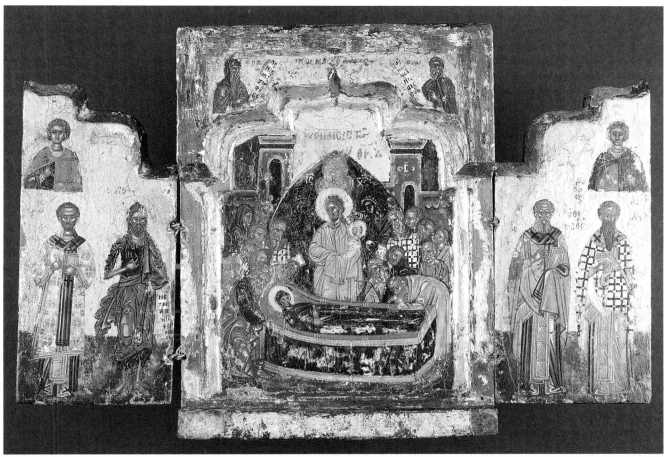

237

Tokyo (Koshi 1973, fig. 1); St George and Demetrius in bust repeat the iconography found on the frame of an icon with the Mother of God enthroned holding the infant Christ in the Benaki Museum, Athens, which is attributed to the Ritzos workshop (Chatzidaki 1983, no. 18). It is not obvious, however, whether the British Museum triptych and the others of the same type were produced on Crete. It is mainly their shape and woodcarving which suggest an origin outside the island. From the evidence of the Benaki Museum triptych, which is iconographically connected with Mount Athos (though stylistically different from the rest), and of the Ekonomopoulos Collection triptychs, also connected with northern Greece, Mount Athos cannot be excluded as the place where all these triptychs were

made. If this were the case, their Cretan iconography and style can easily be explained: Cretan painters were active on Mount Athos at the time and had created a strong Cretan tradition there (e.g. Theophanes the Cretan and his sons, Euphrosynos, Zorzis: M. Chatzidakis, *Études sur la peinture postbyzantine*, London, 1976, no. I, pp. 18–22; no. V, pp. 311–27; no. VI, pp. 273–91; M. Chatzidakis, *O κρητικός ζωγράφος Θεοφάνης. Ἡ τελευταία φάση τῆς τέχνης του στίς τοιχογραφίες τῆς Ἱεράς Μονής Σταυρονικήτα*, Mount Athos, 1986, *passim*; M. Chatzidakis, *Ἕλληνες ζωγράφοι μετά τήν Ἅλωση (1450–1830)*, I, Athens, 1987, pp. 289, 297).

Unpublished. M V

Key to abbreviated references

Exhibition catalogues

A l'aube de la France
 A l'aube de la France. La Gaule de Constantin à Childéric, Paris (Musée du Luxembourg), 1981.

Age of Chivalry
 Age of Chivalry: Art in Plantagenet England, London (Royal Academy of Arts), 1987.

Age of Spirituality
 Age of Spirituality: Late Antique and Early Christian Art, 3rd to 7th Century, New York (Metropolitan Museum of Art), 1977–8 (catalogue: New York, 1979).

Anglo-Saxon Connections
 Anglo-Saxon Connections, Durham (Cathedral Treasury), 1989.

Art byzantin
 L'Exposition d'art byzantin à Paris, Paris, 1931.

Art in the Making
 Art in the Making: Italian Painting before 1400, London (National Gallery), 1989.

Byzantine and Post-Byzantine Art
 Byzantine and Post-Byzantine Art, Athens (Old University), 1986.

Byzantine Art a European Art
 Byzantine Art an [sic] European Art, Athens (Zappeion), 1964.

Byzantium to El Greco
 From Byzantium to El Greco: Greek Frescoes and Icons, London (Royal Academy of Arts), 1987 (catalogue: Athens, 1987).

Candia to Venice
 From Candia to Venice: Greek Icons in Italy, 15th–16th centuries, Athens, 1993.

Carvings in Ivory
 An Exhibition of Carvings in Ivory, London (Burlington Fine Arts Club), 1923.

Christian Orient
 The Christian Orient, London (British Library), 1978.

Gallien in der Spätantike
 Gallien in der Spätantike. Von Kaiser Constantin zu Frankenkönig Childerich, Mainz (Römisch-Germanisches Zentralmuseum), 1980–1.

Glass of the Caesars
 Glass of the Caesars, London (British Museum), 1987 (catalogue Milan, 1987).

Greece and the Sea
 Greece and the Sea, Amsterdam (De Nieuwe Kerk), 1987 (catalogue: Athens, 1987).

Icons of Cretan Art
 Εἰκόνες Κρητικῆς Τέχνης (Ἀπό τόν Χάνδακα ὡς τή Μόσχα καί τήν Ἁγία Πετρούπολη), Heraklion, 1993.

Ikonen
 Ikonen. Bilder in Gold. Sakrale Kunst aus Griechenland, Krems, 1993.

Jewellery
 Jewellery through 7000 Years, London (British Museum), 1976.

Liverpool Ivories
 Liverpool Ivories, London (British Museum), 1954–5.

Masterpieces
 Masterpieces of Byzantine Art, Edinburgh (Festival) and London (Victoria and Albert Museum), 1958.

Masterpieces of Glass
 Masterpieces of Glass, London (British Museum), 1968.

Milano
 Milano capitale dell'impero romano, 286–402 d.c., Milan (Palazzo Reale), 1990.

Silver
 Silver from Early Byzantium: The Kaper Koraon and Related Treasures, Baltimore (Walters Art Gallery), 1986.

Sint Michiel
 Sint Michiel en zijn symboliek, Brussels (Paleis voor Schone Kunsten), 1979.

Spätantike
 Spätantike und frühes Christentum, Frankfurt am Main (Liebieghaus), 1983–4.

Splendeur de Byzance
 Splendeur de Byzance, Brussels (Musées Royaux d'Art et d'Histoire), 1982.

Tissu et Vêtement
 Tissu et Vêtement: 5000 ans de savoir-faire, Guiry-en-Vexin (Musée Archéologique du Val d'Oise), 1986.

Treasury of San Marco
 The Treasury of San Marco, Venice, London (British Museum), 1984 (catalogue: Milan, 1984).

Venetian Glass
 The Golden Age of Venetian Glass, London (British Museum), 1979.

Vizantija
 Vizantiia Balkany Rus': Ikony kontsa XIII – pervoi poloviny XV veka, Moscow, 1991.

Wealth of the Roman World
 Wealth of the Roman World: Gold and Silver, AD 300–700, London (British Museum), 1977.

Other works

Adhémar 1934
 J. Adhémar, 'Le trésor d'argenterie donné par Saint Didier aux églises d'Auxerre (VIIe siècle), Revue archéologique, 6th ser., 4 (1934), pp. 44–54.

Alpatov 1976
 M. Alpatov, Le icone russe: Problemi di storia e d'interpretazione artistica, Turin, 1976.

Andreae 1980
 B. Andreae, Die römische Jagdsarkophage (Deutsches Archäologisches Institut, Die Sarkophage mit Darstellungen aus dem Menschenleben 2), Berlin, 1980.

Apicius
 J. André (transl. and ed.), Apicius, L'Art culinaire: 'De re coquinaria', Aix, 1965.

Babelon and Blanchet 1895
 E. Babelon and J. A. Blanchet, Catalogue des bronzes antiques de la Bibliothèque Nationale, Paris, 1895.

Bailey 1988
 Catalogue of Lamps in the British Museum, III: Roman Provincial Lamps, London, 1988.

Balog 1958
 P. Balog, 'Poids monétaires en verre byzantino-arabes', Revue Belge de Numismatique 104 (1958), pp. 127–37.

Baltoyanni 1986
 C. Baltoyanni, Icons: Demetrios Ekonomopoulos Collection, Athens, 1986.

Bellinger 1966
 A. R. Bellinger, Catalogue of the Byzantine Coins in the Dumbarton Oaks Collection and in the Whittemore Collection, I: Anastasius I to Maurice, 491–602, Washington, D.C., 1966.

BMC
 W. Wroth, Catalogue of the Imperial Byzantine Coins in the British Museum, 2 vols, London, 1908.

BMC V
 W. Wroth, Catalogue of the Coins of the Vandals, Ostrogoths, and Lombards, and of the Empires of Thessalonica, Nicaea and Trebizond in the British Museum, London, 1911.

Bouras 1979
 L. Bouras, The Cross of Adrianople, a silver processional cross of the Middle Byzantine period (Benaki Museum, Selections, 1), Athens, 1979.

Bouras 1982
 L. Bouras, 'Byzantine lighting devices', Jahrbuch der Österreichischen Byzantinistik 32 (1982) (XVI. Internationaler Byzantinistenkongress, Akten II/3), pp. 479–91.

Bouterove 1666
 C. Bouterove, Recherches curieuses des monoyes de France, Paris, 1666.

Boyd 1992
 S. A. Boyd, 'A "metropolitan" treasure from a church in the provinces: an introduction to the study of the Sion Treasure', in: S. A. Boyd and M. M. Mango (eds), Ecclesiastical Silver Plate in Sixth-Century Byzantium, Washington, D.C., 1992, pp. 5–37.

Breccia 1938
 E. Breccia, 'Le prime richerce italiane ad Antinoe (Scavi dell'Instituto Papirologico Fiorentino negli anni 1936–1937)', Aegyptus 18 (1938), pp. 285–310.

Brouskari 1985
 M. Brouskari, The Paul and Alexandra Canellopoulos Museum. A Guide, Athens, 1985.

Brown 1984
 Katharine R. Brown, The Gold Breast Chain from the Early Byzantine Period in the Römisch-Germanisches Zentralmuseum (recte: Three Byzantine Breast Chains: Ornaments of Goddesses and Ladies of Rank), Mainz, 1984.

Bruce-Mitford 1983
 R. Bruce-Mitford, The Sutton Hoo Ship-Burial, III (ed. A. C. Evans), London, 1983 (pt i: pp. 1–479; pt ii: pp. 480–998).

Buchthal 1983
 H. Buchthal, 'Studies in Byzantine illumination of the thirteenth century' Jahrbuch der Berliner Museen 25 (1983), pp. 27–102.

Buckton 1981
 D. Buckton, 'The Mass-produced Byzantine

saint', *Studies Supplementary to Subornost* (*Eastern Churches Review*) 5 (1981), pp. 187–9.

Buckton 1983–4
D. Buckton, 'The beauty of holiness: *opus interrasile* from a Late Antique workshop', *Jewellery Studies* 1 (1983–4), pp. 15–19, colour pl. 1.

Cabrol 1907
F. Cabrol, *Dictionnaire d'archéologie chrétienne et de liturgie*, 1, pt 2, Paris, 1907.

Cahn and Kaufmann-Heinemann 1984
H. A. Cahn and A. Kaufmann-Heinemann (eds), *Der spätrömische Silberschatz von Kaiseraugst*, Derendingen, 1984.

Camber 1981
R. Camber, 'A hoard of terracotta amulets from the Holy Land', *Actes du XVe Congrès International d'Études Byzantines (Athènes, 1976)*, II: *Art et Archéologie, Communications 'A'*, Athens, 1981.

Campbell 1985
S. D. Campbell, *The Malcove Collection: a Catalogue of the Objects in the Lillian Malcove Collection of the University of Toronto*, Toronto–Buffalo–London (Ontario), 1985.

Cameron 1985
A[lan] Cameron, 'The date and owners of the Esquiline Treasure: the nature of the evidence', *American Journal of Archaeology* 89 (1985), pp. 135–45, pls 29–30.

Carr 1987
A. W. Carr, *Byzantine Illumination 1150–1250*, Chicago, 1987.

Catalogue of Additions
British Museum, *Catalogue of Additions to the Manuscripts, 1916–1920*, London, 1933.

Cattapan 1968
M. Cattapan, 'Nuovi documenti riguardanti pittori cretesi dal 1300 al 1500', Πεπραγμένα τοῦ Β' Διεθνοῦς Κρητολογικοῦ Συνεδρίου (Canea, 1966), III, Athens, 1968, pp. 29–64.

Cattapan 1972
M. Cattapan, 'Nuovi elenchi e documenti dei pittori in Creta dal 1300 al 1500', θησαυρίσματα 9 (1972), pp. 202–35.

Chatzidaki 1983
N. Chatzidaki, *Icons of the Cretan School, 15th–16th Centuries* (Benaki Museum), Athens, 1983.

Chatzidaki 1993
N. Chatzidaki, *From Candia to Venice: Greek Icons in Italy, 15th–16th Centuries*, Athens, 1993.

Chatzidakis 1974
M. Chatzidakis, 'Les débuts de l'école crétoise et la question de l'école dite italogrecque', Μνημόσυνον Σ. Αντωνιάδη, Venice, 1974, pp. 169–211.

Chatzidakis 1981
M. Chatzidakis, *Mystras. The Medieval City and the Castle. A Complete Guide to the Churches, Palaces and the Castle*, Athens, 1981.

Chatzidakis 1982
M. Chatzidakis, *L'art des icônes en Crète et dans les îles après Byzance*, exh. cat., Charleroi (Palais des Beaux-Arts), 1982.

Chatzidakis 1985
M. Chatzidakis, *Icons of Patmos: Questions of Byzantine and Post-Byzantine Painting*, Athens, 1985.

Codex Justinianus
P. Krueger, T. Mommsen, T. Schoell and G. Kroll (eds), *Corpus Iuris Civilis*, I: *Institutiones, Digesta*, II: *Codex Justinianus*, III: *Novellae*, Berlin, 1945. C. H. Mouro and W. D. Buckland (transl. and eds), *The Digest of Justinian*, Cambridge, 1904.

Cormack 1985
R. Cormack, *Writing in Gold: Byzantine Society and its Icons*, London, 1985.

Crum 1929–30
W. E. Crum, 'Colluthus, the martyr and his name', *Byzantinische Zeitschrift* 30 (1929–30), pp. 323–7.

Curle 1923
A. O. Curle, *The Treasure of Traprain, a Scottish Hoard of Roman Silver Plate*, Glasgow, 1923.

Cutler 1994
A. Cutler, *The Hand of the Master: Craftsmanship, Ivory and Society in Byzantium (9th–11th Centuries)*, Princeton, 1994.

Dalton 1901
O. M. Dalton, *Catalogue of Early Christian Antiquities and Objects from the Christian East in the Department of British and Mediaeval Antiquities and Ethnography of the British Museum*, London, 1901.

Dalton 1909
O. M. Dalton, *Catalogue of the Ivory Carvings of the Christian Era with Examples of Mohammedan Art and Carvings in Bone in the Department of British and Mediaeval Antiquities and Ethnography of the British Museum*, London, 1909.

Dalton 1911
O. M. Dalton, *Byzantine Art and Archaeology*, Oxford, 1911.

Dalton 1912a
O. M. Dalton, *Franks Bequest: Catalogue of the Finger Rings . . . in the British Museum*, London, 1912.

Dalton 1912b
O. M. Dalton, *Fitzwilliam Museum, McClean Bequest: Catalogue of the Mediaeval Ivories, Enamels, Jewellery, Gems and Miscellaneous Objects Bequeathed to the Museum by Frank McClean, M.A., F.R.S.*, Cambridge, 1912.

Dalton 1915
O. M. Dalton, *Catalogue of the Engraved Gems of the Post-Classical Periods . . . in the British Museum*, London, 1915.

Dalton 1925
O. M. Dalton, *East Christian Art*, Oxford, 1925.

Davidson 1952
G. R. Davidson, *Corinth: Results of the Excavations conducted by the American School of Classical Studies at Athens*, XII: *The Minor Objects*, Athens–Princeton, 1952.

Davis 1861
N. Davis, *Carthage and her Remains*, London, 1861.

de Grüneisen 1930
W. de Grüneisen, *Collection de Grüneisen, catalogue raisonné: Art chrétien primitif du haut et du bas moyen âge*, Paris, 1930.

Delbrueck 1929
R. Delbrueck, *Die Consulardiptychen und verwandte Denkmäler*, Berlin, 1929.

Delivorrias 1987
see exh. cat. *Greece and the Sea* (1987), above.

Delmaire 1988
R. Delmaire, 'Les Largesses impériales et l'émission d'argenterie du IVe au VIe siècle', in: F. Baratte (ed.), *Argenterie romaine et byzantine*, Paris, 1988.

de Ridder 1915
A. de Ridder, *Les bronzes antiques du Louvre*, II: *Les instruments*, Paris, 1915.

Dieudonné 1931
A. Dieudonné, 'Poids du bas-empire et byzantins des collections Schlumberger et Froehner et de l'ancien fonds du Cabinet', *Revue numismatique* 34 (1931), pp. 11–22.

Dodd 1961
E. Cruikshank Dodd, *Byzantine Silver Stamps*, Washington, D.C., 1961.

Drandakis 1990
N. Drandakis, 'Μεταβυζαντινές εἰκόνες (Κρητικὴ Σχολή)', Σινᾶ. Οἱ θησαυροί τῆς Μονῆς, Athens, 1990, pp. 125–32.

Dürr 1964
N. Dürr, 'Catalogue de la collection Lucien Naville au Cabinet du Numismatique du Musée d'Art et d'Histoire de Genève', *Genava* 12 (1964), pp. 1–42.

Dworschak 1936
F. Dworschak, 'Studien zum byzantinischen Münzwesen, I, 2: Das Tetarteron', *Numismatische Zeitschrift*, new ser., 29 (1936), pp. 77–81.

Effenberger-Severin 1992
A. Effenberger and H. G. Severin, *Das Museum für Spätantike und Byzantinische Kunst Berlin* (Staatliche Museen zu Berlin), Berlin, 1992.

Elbern 1979
V. H. Elbern, *Das Ikonenkabinett der Frühchristlich–Byzantinischen Sammlung*, Berlin, 1979.

Errera 1916
I. Errera, *Collection d'Anciennes Étoffes Égyptiennes*, Brussels, 1916.

Felicetti-Liebenfels 1956
W. Felicetti-Liebenfels, *Geschichte der byzantinischen Ikonenmalerei*, Olten–Lausanne, 1956.

Firatli 1990
N. Firatli, *La sculpture byzantine figurée au Musée archéologique d'Istanbul* (Bibliothèque de l'Institut français d'études anatoliennes d'Istanbul, XXX), Paris, 1990.

Flanagan 1956
J. F. Flanagan, 'The figured silks', in: C. F. Battiscombe (ed.), *The Relics of St Cuthbert*, Durham, 1956, pp. 484–525.

Forien de Rochesuard 1987
J. Forien de Rochesuard, *Album des poids antiques*, III: *Rome et Byzance*, Paris, 1987.

Franks 1860
A. W. Franks, 'On recent excavations at Carthage,

and the antiquities discovered there by the Rev. Nathan Davis', *Archaeologia* 38 (1860), pp. 202–36.

Garrison 1949
E. Garrison, *Italian Romanesque Panel Painting*, Florence, 1949.

Garrucci 1846
R. Garrucci, 'Pesi antichi del Museo Kircheriano', *Annali di Numismatica di Fiorelli* 1 (1846), pp. 201–11.

Garrucci 1858
R. Garrucci, *Vetri ornati di figure in oro trovati nei cimiteri dei cristiani primitivi di Roma*, Rome, 1858.

Garrucci 1881
R. Garrucci, *Storia del arte cristiana nei primi otto secoli della chiesa*, 6 vols, Prato, 1881.

Gatty 1883
C. T. Gatty, *Catalogue of the Medieval and Later Antiquities in the Mayer Museum*, Liverpool, 1883.

Gauckler 1910
P. Gauckler, *Inventaire des mosaïques de l'Afrique*, II: *Afrique proconsulaire (Tunisie)*, 1910.

Gazda 1981
E. K. Gazda, 'A marble group of Ganymede and the eagle from the age of Augustine', *Excavations at Carthage conducted by the University of Michigan* 6, Ann Arbor, 1981.

Gerke 1940
F. Gerke, *Die christlichen Sarkophage der vorkonstantinischen Zeit* (Deutsches Archäologisches Institut, *Studien zur spätantiken Kunstgeschichte* 11), Berlin, 1940.

Gibbs 1989
R. Gibbs, *Tomaso da Modena: Painting in Emilia and the March of Treviso, 1340–80*, Cambridge, 1989.

Gibson 1994
M. Gibson, *The Liverpool Ivories*, London, 1994.

Goldschmidt and Weitzmann
A. Goldschmidt and K. Weitzmann, *Die byzantinischen Elfenbeinskulpturen des X.–XIII. Jahrhunderts*, I: *Kästen*, Berlin, 1930, II: *Reliefs*, Berlin, 1934.

Grabar 1946
A. Grabar, *Martyrium: Recherches sur le culte des reliques et l'art chrétien antique*, Paris, 1946.

Grabar 1963
A. Grabar, *Sculptures byzantines de Constantinople (IVe–Xe siècle)* (Bibliothèque archéologie et historique de l'Institut français d'archéologie d'Istanbul, XVII), Paris, 1963.

Grabar 1976
A. Grabar, *Sculptures byzantines du moyen âge*, II: *XIe–XIVe siècle* (Bibliothèque des Cahiers archéologiques, XII), Paris, 1976.

Grégoire 1907
H. Grégoire, 'Ľ ΕΠΑΡΧΟΣ ΡΩΜΗΣ: A propos d'un poids-étalon byzantin', *Bulletin de Correspondence Hellénique* 31 (1907), pp. 321–7.

Grierson 1973
P. Grierson, *Catalogue of the Byzantine Coins in the Dumbarton Oaks Collection and in the Whittemore Collection*, III: *Leo III to Nicephorus*

III, 717–1081, pt I: *Leo III to Michael III*, Washington, D.C., 1973.

Grierson 1982
P. Grierson, *Byzantine Coins*, London–Berkeley–Los Angeles, 1982.

Harden 1967–8
D. B. Harden, 'Late Roman wheel-inscribed glasses with double-line letters', *Kölner Jahrbuch für Vor- und Frühgeschichte* 9 (1967–8), pp. 43–55, pls 9 and 10.

Haseloff 1990
G. Haseloff, *Email im frühen Mittelalter. Frühchristliche Kunst von der Spätantike bis zu den Karolingern*, Marburg, 1990.

Hendy 1972
M. F. Hendy, 'Light weight solidi, tetartera, and the Book of the Prefect', *Byzantinische Zeitschrift* 65 (1972), pp. 57–80.

Hendy 1985
M. F. Hendy, *Studies in the Byzantine Monetary Economy* c. 300–1450, Cambridge, 1985.

Hinks 1933
R. P. Hinks, *Catalogue of the Greek, Etruscan and Roman Paintings and Mosaics in the British Museum*, London, 1933.

Hutter
I. Hutter, *Corpus der byzantinischen Miniaturenhandschriften*, I–III: *Oxford, Bodleian Library*, Stuttgart, 1977–82; IV: *Oxford, Christ Church*, Stuttgart, 1993.

Inan and Alföldi-Rosenbaum 1979
J. Inan and E. Alföldi-Rosenbaum, *Römische und frühbyzantinische Porträtplastik aus der Türkei: neue Funde* (Deutsches Archäologisches Institut), Mainz, 1979.

Johnstone 1967
P. Johnstone, *The Byzantine Tradition in Church Embroidery*, London, 1967.

Jungfleisch 1932
M. Jungfleisch, 'Les dénéraux et estampilles byzantins en verre de la collection Froehner', *Bulletin de l'Institut d'Egypte* 14 (1932), pp. 233–56.

Kalavrezou-Maxeiner 1985
I. Kalavrezou-Maxeiner, *Byzantine Icons in Steatite*, 2 vols, Vienna, 1985.

Kaufmann 1910
C. M. Kaufmann, *Zur Ikonographie der Menas-Ampullen*, Cairo, 1910.

Kautzsch 1936
R. Kautzsch, *Kapitellstudien: Beiträge zu einer Geschichte des spätantiken Kapitells im Osten vom vierten bis ins siebente Jahrhundert* (*Studien zur spätantiken Kunstgeschichte* 9), Berlin–Leipzig, 1936.

Kendrick 1920–1
A. F. Kendrick, *Catalogue of Textiles from Burying Grounds in Egypt*, I–III, London, 1920–1.

Kephalonia 1989
Κεφαλονιά, ένα μεγάλο μουσείο, Εκκλησιαστική τέχνη, I, Athens, 1989.

King 1960
D. King, 'Sur la signification de "Diasprum"', *Bulletin de Liaison du Centre International d'Étude des Textiles Anciens* 11 (1960), pp. 42–7.

King 1981
D. King, 'Early textiles with hunting subjects in the Keir collection', in: M. Flury-Lemberg and K. Stolleis (eds), *Documenta Textilia: Festschrift für Sigrid Müller-Christensen*, Munich, 1981, pp. 95–104.

King and King 1990
M. King and D. King, *European Textiles in the Keir Collection, 400 BC to 1200 AD*, London, 1990.

Kiss 1969
Z. Kiss, 'Les ampoules de St. Ménas découvertes à Kôm el-Dikka (Alexandrie) en 1967', *Études et Travaux* 3 (1969), pp. 154–66 (Centre of Mediterranean Archaeology, Polish Academy of Sciences, Warsaw).

Kiss 1973
Z. Kiss, 'Les ampoules de St. Ménas découvertes à Kôm el-Dikka (Alexandrie) en 1969', *Études et Travaux* 7 (1973), pp. 138–54 (Centre of Mediterranean Archaeology, Polish Academy of Sciences, Warsaw).

Kitzinger 1937
E. Kitzinger, 'Notes on early Coptic sculpture', *Archaeologia* 87 (1937), pp. 181–215.

Kitzinger 1940
E. Kitzinger, 'The Sutton Hoo ship-burial, v: The silver', *Antiquity* 14 (1940), pp. 40–50.

Kitzinger 1977
E. Kitzinger, *Byzantine Art in the Making*, Harvard–London, 1977.

Koshi 1973
K. Koshi, 'Über eine kretische Ikone des 15. Jahrhunderts von Andreas Ritzos im Nationalmuseum für Westliche Kunst in Tokio', *Bulletin annuel du Musée national d'art occidental* 7 (1973), pp. 37–44.

Kötting 1950
B. Kötting, *Peregrinatio religiosa*, Regensburg, 1950.

Lafontaine-Dosogne 1976
J. Lafontaine-Dosogne, 'Une icone d'Angélos au Musée de Malines et l'iconographie du St Jean-Baptiste ailé', *Bulletin des Musées Royaux d'Art et d'Histoire*, 6th ser., 48 (1976), pp. 121–43.

Lazarev 1954
V. Lazarev, 'Maestro Paolo e la pittura veneziana del suo tempo', *Arte Veneta* 8 (1954), pp. 77–89.

Lazarev 1967
V. Lazarev, *Storia della pittura bizantina*, Turin, 1967.

Lehmann 1945
K. Lehmann, 'The girl beneath the apple-tree', *American Journal of Archaeology* 49 (1945), pp. 430–3.

Longhurst 1927
M. H. Longhurst, *Catalogue of Carvings in Ivory at the Victoria and Albert Museum*, pt I, London, 1927.

L'Orange 1933
H. P. L'Orange, *Studien zur Geschichte des spätantiken Porträts*, Oslo, 1933.

Manafis 1990
K. A. Manafis, *Sinai. Treasures of the Monastery of St Catherine*, Athens, 1990.

Mango 1986
see exh. cat. *Silver* (1986), above.

Mango 1988
C. Mango, 'La croix dite de Michel le Cérulaire et la croix de Saint-Michel de Sykéôn', *Cahiers archéologiques* 36 (1988), pp. 41–9.

Mango 1992
M. Mundell Mango, 'The purpose and places of Byzantine silver stamping', in: S. A. Boyd and M. M. Mango (eds), *Ecclesiastical Silver Plate in Sixth-Century Byzantium*, Washington, D.C., 1992.

Mango 1994
M. Mundell Mango, 'The significance of Byzantine tinned copper objects', in: θυμίαμα στή μνήμη τῆς Λασκαρίνας Μπούρα, Athens, 1994, pp. 221–7, pls 115–19.

Mango and Bennett 1994
M. M. Mango and A. Bennett, *The Sevso Treasure*, I, Ann Arbor, 1994.

Mango, forthcoming
M. Mundell Mango, *Catalogue of Late Antique and Byzantine Antiquities in the Ashmolean Museum, Oxford* (with scientific contributions by C. Mortimer and P. Northover).

Martiniani-Reber 1986
M. Martiniani-Reber, *Lyon, Musée Historique des Tissus: Soieries sassanides, coptes et byzantines Ve–XIe siècles*, Paris, 1986.

Matzulewitsch 1929
L. Matzulewitsch, *Byzantinische Antike. Studien auf Grund der Silbergefässe der Ermitage*, Berlin–Leipzig, 1929.

Metzger 1981
C. Metzger, *Les ampoules à eulogie du musée du Louvre*, Paris, 1981.

Morey 1959
C. R. Morey, *The Gold-Glass Collection of the Vatican Library, with Additional Catalogues of other Gold-Glass Collections* (ed. G. Ferrari), Vatican City, 1959.

Morgan 1886
T. Morgan, *Romano-British Mosaic Pavements*, London, 1886.

Mouriki 1991
D. Mouriki, 'The wall paintings at the Pantanassa at Mistra: models of a painter's workshop in the fifteenth century', in: S. Ćurčić and D. Mouriki (eds), *The Twilight of Byzantium: Aspects of Cultural and Religious History in the Late Byzantine Empire*, Princeton, 1991, pp. 217–31.

Müller-Wiener 1977
W. Müller-Wiener, *Bildlexikon zur Topographie Istanbuls* (Deutsches Archäologisches Institut), Tübingen, 1977.

Naville and Lewis 1894
E. Naville and T. Hayter Lewis, *Ahnas al Medineh (Heracleopolis Magna)* (Egypt Exploration Fund, 11th Memoir), London, 1894.

Nesbitt 1871
A. Nesbitt, *Catalogue of the Collection of Glass formed by Felix Slade, Esq., F.S.A.*, London, 1871.

Nesbitt 1988
J. W. Nesbitt, *Byzantium: the Light in the Age of Darkness*, New York (Ariadne Galleries), 1988.

Palatine Anthology
W. R. Paton (transl. and ed.), *The Greek Anthology*, 5 vols, Cambridge, 1968–80 (Loeb Classical Library).

Pallucchini 1964
R. Pallucchini, *La pittura veneziana del trecento*, Venice–Rome, 1964.

Petrie 1925
W. M. Flinders Petrie, *The Tombs of the Courtiers at Oxyrhynkhos*, London, 1925.

Petrie 1926a
W. M. F. Petrie, *Glass Stamps and Weights*, London, 1926.

Petrie 1926b
W. M. F. Petrie, *Ancient Weights and Measures*, London, 1926.

Pink 1938
K. Pink, *Römische und byzantinische Gewichte in österreichischen Sammlungen*, Vienna, 1938.

PLRE
The Prosopography of the Later Roman Empire, I (AD 260–395) A. H. M. Jones, J. R. Martindale and J. Morris, Cambridge, 1971; II (AD 395–527) J. R. Martindale, Cambridge, 1980; III (AD 527–641) J. R. Martindale, Cambridge, 1992.

Popescu 1976
E. Popescu, *Inscriptiile Grecesti si Latine din secolele IV–XIII descoperite in Românian*, Bucharest, 1976.

Potamianou 1989–90
M. Acheimastou-Potamianou, 'Δύο εἰκόνες τοῦ Ἀγγέλου καί τοῦ Ἀνδρέα Ρίτζου στό Βυζαντινό Μουσεῖο', Δελτίον τῆς Χριστιανικῆς Ἀρχαιολογικῆς Ἑταιρείας, ser. 4, 15 (1989–90), pp. 105–17.

Pulszky 1856
F. Pulszky, *Catalogue of the Fejérváry Ivories*, Liverpool, 1856.

RBK
K. Wessel and M. Restle (eds), *Reallexikon zur byzantinischen Kunst*, Stuttgart, 1963–.

Regling 1913
K. Regling, 'Glasstempel', in: A. Conze *et al.*, *Altertümer von Pergamon* (Königliche Museen zu Berlin), I, Berlin, 1913.

RIB
S. S. Frere and R. S. O. Tomlin (eds), *The Roman Inscriptions of Britain*, Gloucester, 1991.

RIC VII
P. M. Bruun, *Roman Imperial Coinage*, VII: *Constantine and Licinius, AD 313–337*, London, 1966.

RIC VIII
J. P. C. Kent, *Roman Imperial Coinage*, VIII: *The Family of Constantine I, AD 337–364*, London, 1981.

Rosenberg 1922
M. Rosenberg, *Zellenschmelz*, III: *Die Frühdenkmäler*, Frankfurt am Main, 1922.

Rosenberg 1928
M. Rosenberg, *Der Goldschmiede Merkzeichen*, 3rd ed., IV: *Ausland und Byzanz*, Berlin, 1928.

Ross 1962
M. C. Ross, *Catalogue of the Byzantine and Early Mediaeval Antiquities in the Dumbarton Oaks Collection*, I: *Metalwork, Ceramics, Glass, Glyptics, Painting*, Washington, D.C., 1962.

Ross 1965
M. C. Ross, *Catalogue of the Byzantine and Early Mediaeval Antiquities in the Dumbarton Oaks Collection*, II: *Jewelry, Enamels, and Art of the Migration Period*, Washington, D.C., 1965.

Russell 1982
J. Russell, 'Byzantine *instrumenta domestica* from Anemurium: the significance of context', in: R. L. Hohlfelder (ed.), *City, Town and Countryside in the Early Byzantine Era*, New York, 1982.

Sabatier 1862
J. Sabatier, *Description générale des monnaies byzantines*, I, Paris, 1862.

Salmi 1945
M. Salmi, 'I dipinti paleocristiani di Antinoe', *Scritti dedicati alla memoria di Ippolito Rosellini nel primo centenario della morte (4 giugno 1943)*, Florence, 1945, pp. 159–69.

Sams 1982
G. K. Sams, 'The weighing implements', in: G. F. Bass and F. H. van Doorninck, Jr, *Yassi Ada*, I: *A Seventh-Century Byzantine Shipwreck*, I, College Station, Texas, 1982.

Schlumberger 1895
G. Schlumberger, 'Poids de verre étalons monétiforms d'origine byzantine' *Revue des Études Grecs* 8 (1895), pp. 59–76.

Shapley 1968
F. R. Shapley, *The Kress Collection: Italian Paintings XIII–XV Century*, London, 1968.

Shelton 1981
K. J. Shelton, *The Esquiline Treasure*, London, 1981.

Shelton 1985
K. J. Shelton, 'The Esquiline Treasure: the nature of the evidence', *American Journal of Archaeology* 89 (1985), pp. 147–55, pls 29–30.

Smirnova 1989
E. Smirnova, *Icons of the Moscow School, 14th–17th Centuries*, Leningrad, 1989.

Spatharakis 1981
I. Spatharakis, *Corpus of Dated Illuminated Greek Manuscripts (Byzantina Neerlandica*, VIII), Leiden, 1981.

Stauffer 1991
A. Stauffer, *Die mittelalterlichen Textilien von St. Servatius in Maastricht*, Riggisberg, 1991.

Strong 1966
D. E. Strong, *Greek and Roman Gold and Silver Plate*, Ithaca–London, 1966.

Strzygowski 1904
J. Strzygowski, *Koptische Kunst* (Catalogue général du Musée du Caire), Vienna, 1904.

Summary Catalogue
Summary Catalogue of the Greek Manuscripts (unpublished draft copy in the Students' Room of the Department of Manuscripts, British Library, dated 1992).

Tait 1986
H. Tait (ed.), *Seven Thousand Years of Jewellery*, London, 1986.

Torp 1969
H. Torp, 'Leda Christiana: the problem of the interpretation of Coptic sculpture with mythological motifs', *Acta ad archaeologiam et artium historiam pertinentia* 4 (1969), pp. 101–12.

Totev 1983
T. Totev, *Preslavsko zlatno c'krovishche*, Sofia, 1983.

Turyn 1980
A. Turyn, *Dated Greek Manuscripts of the 13th and 14th Centuries in the Libraries of Great Britain* (Dumbarton Oaks Studies, XVII), Washington, D.C., 1980.

van den Ven 1970
P. van den Ven, *La vie ancienne de S. Syméon Stylite le Jeune (521–592)* (*Subs. Hag.* 32), I, Brussels, 1962; II, Brussels, 1970.

Vassilaki 1989
M. Vassilaki, 'A Cretan icon of St George', *Burlington Magazine* 131 (1989), pp. 208–14.

Vassilaki-Mavrakaki 1981
M. Vassilaki-Mavrakaki, ''Ο ζωγράφος Ἄγγελος Ἀκοτάντος: τό ἔργο καί ἡ διαθήκη του (1436)', *Θησαυρίσματα* 18 (1981), pp. 208–14.

Vikan 1984
G. Vikan, 'Art, medicine and magic in early Byzantium', *Dumbarton Oaks Papers* 38 (1984), pp. 65–86.

Vikan, forthcoming
Catalogue of the Menil Collection, Houston, Texas.

Visconti 1793
Lettera di Ennio Quirino Visconti intorno ad una antica supelletile d'argento scoperta in Roma nell'anno 1793 (written 7 August 1793), ed. P. P. Montagnani-Mirabili, Rome, 1827.

Vokotopoulos 1977–9
P. L. Vokotopoulos, 'Μία πρώιμη κρητική εἰκόνα τῆς Βαϊοφόρου στή Λευκάδα', *Δελτίον τῆς Χριστιανικῆς Ἀρχαιολογικῆς Ἑταιρείας*, 4th ser., 9 (1977–9), pp. 309–21.

Vokotopoulos 1987
P. L. Vokotopoulos, 'Δύο εἰκόνες τοῦ ζωγράφου Ἀγγέλου', *Φίλεια Ἔπη*, II, Athens, 1987, pp. 410–14.

Vokotopoulos 1990
P. L. Vokotopoulos, *Εἰκόνες τῆς Κέρκυρας*, Athens, 1990.

Volbach 1969
W. F. Volbach, *Early Decorative Textiles*, Feltham, 1969.

Volbach 1976
W. F. Volbach, *Elfenbeinarbeiten der Spätantike und des frühen Mittelalters*, 3rd ed., Mainz, 1976.

von Falke 1913
O. von Falke, *Kunstgeschichte der Seidenweberei*, Berlin, 1913.

Vopel 1899
H. Vopel, *Die altchristlichen Goldgläser*, in: *Archäologische Studien zum christlichen Altertum und Mittelalter*, V, Freiburg im Breisgau, 1899.

Walter 1979
C. Walter, 'Marriage crowns in Byzantine iconography', *Zograf* 10 (1979), pp. 83–91.

Walters 1899
Catalogue of the Bronzes, Greek, Roman, and Etruscan, in the Department of Greek and Roman Antiquities, British Museum, London, 1899.

Walters 1915
H. B. Walters, *Select Bronzes, Greek, Roman and Etruscan, in the Departments of Antiquities*, London, 1915.

Walters 1921
H. B. Walters, *Catalogue of the Silver Plate, Greek, Etruscan and Roman, in the British Museum*, London, 1921.

Ward *et al.* 1981
A. Ward, J. Cherry, C. Gere and B. Cartlidge, *The Ring from Antiquity to the Twentieth Century*, London–Fribourg, 1981.

Webster 1929
T. B. L. Webster, 'The Wilshere Collection at Pusey House in Oxford', *Journal of Roman Studies* 19 (1929), pp. 150–4.

Weitzmann 1935
K. Weitzmann, *Die byzantinische Buchmalerei des 9. und 10. Jahrhunderts*, Berlin, 1935.

Weitzmann 1979
see exh. cat. *Age of Spirituality* (1977–8), above.

Weitzmann *et al.* 1982
K. Weitzmann, G. Alibegashvili, A. Volskaya, G. Babić, M. Chatzidakis, M. Alpatov and T. Voinescu, *The Icon*, New York, 1982.

Wentzel 1959
H. Wentzel, 'Das Medaillon mit dem Hl. Theodor und die venezianischen Glaspasten im byzantinischen Stil', *Festschrift für Erich Meyer zum 60. Geburtstag*, Hamburg, 1959, pp. 50–67.

Wentzel 1963
H. Wentzel, 'Zu dem Enkolpion mit dem Hl. Demetrios in Hamburg', *Jahrbuch der Hamburger Kunstsammlungen* 8 (1963), pp. 11–24.

Wessel 1967
K. Wessel, *Die byzantinische Emailkunst vom 5. bis 13. Jahrhundert*, Recklinghausen, 1967.

Westwood 1876
J. O. Westwood, *Descriptive Catalogue of the Fictile Ivories in the South Kensington Museums*, London, 1876.

Williamson 1986
P. Williamson, *The Medieval Treasury: the Art of the Middle Ages in the Victoria and Albert Museum*, London, 1986.

Wulff 1909
O. Wulff, *Altchristliche Bildwerke* (Königliche Museen zu Berlin), Berlin, 1909.

Xyngopoulos 1964
A. Xyngopoulos, *The Frescoes of St Nicholas Orphanos in Thessaloniki*, Athens, 1964.

Glossary

addorsed
back-to-back

aedicula
architecturally articulated niche

akakia, anexikakia
cylindrical pouch of purple silk containing dust, carried by the emperor on ceremonial occasions and symbolising humility and mortality, transience, etc.

Akathistos
'not seated', a hymn sung in honour of the Mother of God while the congregation stands

amartolos
'sinner'

Ammonian sections
short sections of the text of the Gospels, divided according to the system traditionally attributed to Ammonius Saccas of Alexandria (c.175–242), numbered and marked in the margins of Gospel manuscripts as finding aids; referred to in the **canon tables** attributed to Eusebius of Caesaraea

ampulla (plural: *ampullae*)
vessel used by pilgrims to carry sanctified oil, water, earth, etc. from a holy site

Anastasis
the Resurrection, represented in art by Christ trampling the gates of hell and freeing Adam, Eve, etc.

anexikakia
see akakia

annular
ring-shaped

apotheosis
deification, the transformation of a mortal into a god

aureus (plural: aurei)
standard unit of Roman coinage, gold coin, **solidus**

autocrator
'emperor'; after 629 one of the titles of an emperor

bezel
part of a finger-ring distinct from the hoop, usually broader than the hoop and decorated, inscribed or set with a gem, etc.; annular frame for glazing, etc.

Blachernitissa
an image of the Mother of God with her hands in front of her, palms displayed (see no. 171); from the Blachernai church in Constantinople, which housed the **maphorion** and various icons of the Mother of God

bulla
seal attached to a document

canon tables
system of cross-referencing between the different Gospels, attributed to Eusebius, Bishop of Caesaraea (313–39/40)

carinated
ridged; with a sharp break in profile resulting in a projecting angle

cerecloth
waxed winding-sheet

chi-rho
first two letters of 'Christ' in Greek (ΧΡ), combined into a monogram (see no. 4)

chiton
tunic fastened on the shoulders and tied around the waist, worn as an undergarment or by soldiers, huntsmen, labourers, etc. for ease of movement

chlamys
cloak fastened on the right shoulder by a **fibula** to leave the right arm free; first a short military garment but by the 6th century longer and an item of court costume

clavus (plural: *clavi*)
stripe woven into or sewn on to clothing, often denoting rank or status

cloisonné
'partitioned', divided by metal strips set on edge (cloisons) holding inlay, enamel, etc.

collet
collar-like strip of metal used as a setting for gems, etc.

colobium
sleeveless or short-sleeved tunic, the garment worn by Christ in early representations of the Crucifixion

comes (plural: *comites*)
'companion', title of an adviser to the emperor, with various responsibilities

comes Augustorum
comes with an assignment linked to the emperor or imperial family

conch
semi-dome over an apse or rounded niche, sometimes decorated to resemble a shell

consul
title of great honour, of a year's duration, with only two holders at a time; consuls were expected to hold a banquet, distribute consular **diptychs** and arrange public games in the Hippodrome

contrapposto
pose in which one part of the body is twisted in relation to another, esp. with the shoulders on one axis and the hips on another

crux gemmata
cross studded with gems

crux monogrammatica
cross of which the upright is formed of the Greek letter *rho* (Ρ) as a symbol of Christ and Christianity (see no. 5)

cubicularius
chamberlain, official of the imperial bedchamber

cuirass
armour for the torso, of leather or metal

cyma
double-curved, with s-shaped profile

Deesis
'entreaty', a composition showing Christ flanked by the Mother of God and St John the Baptist, who are turned towards him with gestures of intercession

diaspros
'two whites': see **lampas**

diptych
pair of panels of wood, ivory, metal, etc. joined laterally to one another, usually by means of hinges; consular diptychs (see no. 62) were issued by a **consul** on his appointment

diskopoterion
set of liturgical vessels comprising chalice and paten

dodekaorton
'twelve', the twelve major feasts of the Church, comprising the Annunciation, Nativity, Epiphany, Presentation, Transfiguration, Birth of Mary, Presentation of Mary and **Koimesis** (all fixed), and Palm Sunday, the Ascension and Pentecost (movable); Passiontide and Easter form a separate category

donativa
gifts given to soldiers at regular intervals and on special occasions

doxology
'glorification', liturgical formula of praise, esp. at the conclusion of a prayer, etc.

eidikos
head of the *eidikon*, or imperial treasury

ekphonetic notation
'declaimed notation', musical notation (*neumes*) in the form of hooks, dots and oblique strokes written above the text of **lectionaries** to assist in the chanting or cantillation of lessons from the Bible

engrailed
having inward-curving sides

eparch
title of several officials, the most important being the Eparch of the City, the Governor of Constantinople

epitaphios
large silk used to represent the bier of Christ in the Burial of Christ procession on Holy Saturday

Eros (plural: erotes)
Cupid, a nude winged youth

Euchologion
prayer-book used for services, ceremonies, etc.

ex-voto
votive offering

exagium solidi
official control weight for the **solidus**

fibula (plural: *fibulae*)
fastener or clasp, especially for securing a cloak (see **chlamys**)

gens
clan, extended family

gesso
gypsum or chalk bound with size or fish-glue as a ground on which to paint

globus cruciger
orb surmounted by a cross, an insignium of the emperor as a Christian ruler

grozed
trimmed with an instrument similar to pliers

guilloche
simple interlace, twist or plait

hellenistic
referring to the eastern Mediterranean world between the time of Alexander the Great (356–323 BC) and the Roman conquest of the region (late 2nd–1st century BC)

hieromonk
monk ordained as a priest

himation
long loose outer garment, the Greek equivalent of the **pallium**; also the dark cotton mantle worn by monks and nuns

histamenon (plural: histamena)
full-weight gold **nomisma** between about 965 and 1092; later used for concave base coins

Hodegetria
'who shows the way', an image of the Mother of God holding the infant Christ on her left arm and gesturing towards him with her right hand; Christ holds a scroll in his left hand and blesses with his right

iambic trimeter
Greek verse consisting of six iambuses (an unaccented or short syllable followed by an accented or long syllable) or their equivalents

Iconoclasm
religious movement of the 8th and 9th centuries which denied the holiness of icons and rejected their veneration; the periods 730–87 and 814–43, when the veneration of images was officially banned and icons were destroyed

iconostasis
screen between the sanctuary and nave of a church, for displaying icons

incuse
impression made by the face of a die or stamp

intaglio
sunk or negative relief (in contrast to 'cameo', raised or positive relief)

intarsia
form of mosaic inlay

kantharos
cup with two large handles

kephalaion
chapter

ketos
sea-monster

knop
rounded protuberance on the stem of a chalice, candlestick, etc.

Koimesis
'falling asleep', one of the twelve great feasts of the Church, in the Catholic Church the Dormition of the Virgin Mary; represented in art by the Mother of God lying on a bier, the apostles grouped around her, Christ in the centre holding a miniature swaddled figure of the Mother of God (her *eidolon*, or soul) and hovering angels waiting to carry this to heaven

labarum
military standard, cruciform from the time of Constantine; also a monogram denoting Christ or Christianity, usually the **chi-rho**

lampas
repeating weave used for silk textiles where the pattern is in a contrasting texture to the ground

lanx
serving-dish, usually interpreted as rectangular (see no. 15)

lappets
vertically hanging ribbons

largitio
'largess', ceremonial distribution of gifts, especially by the emperor

lection
a liturgical reading

lectionary
liturgical book containing **lections** for reading in services, arranged according to the church calendar

loros
long scarf, esp. the richly decorated stole worn by emperors and empresses

lunate
crescent-shaped

mandorla
'almond', usually almond-shaped aureole surrounding an entire figure to indicate the presence of God's power; round a seated figure it may be circular

maphorion
long sleeveless tunic with hood; traditional attire of the Mother of God and holy women

mappa
folded white cloth thrown down to signal the start of races, etc. in the circus; an attribute of consular and, later, imperial office

menologion
collection of saints' **Vitae** arranged according to their feast days in the church calendar

metochion
monastic establishment subordinate to a larger monastery

milaresion
silver coin, usually of a type in use between the 8th and 11th centuries

minuscule
script used in manuscripts from about 800, more compact and faster to write than the **uncial**

missorium
large serving-plate

moline
with forked outward-curving terminals

monophysite
believer in Christ as a single divine being, as opposed to the Orthodox belief in his dual (divine and human) nature

nebris
skin of a fawn

nicolo
variety of onyx with a light-blue layer over black, often imitated in glass

niello
black material, usually silver sulphide, used as a decorative inlay, esp. on silver

Nike (plural: *nikai*)
winged personification of victory

Nikopoios
'bringer of victory', frontal image of the Mother of God holding in front of her a disk bearing an image of Christ

nimbus
halo

nomina sacra
'sacred names', contracted forms of the names of Jesus, Christ, Israel, Jerusalem, etc. employed by Christian scribes

nomisma (plural: *nomismata*)
'coin', the basic gold coin, the **solidus**

ogival
double-curved, one curve being convex, the other concave

omophorion
long white scarf decorated with crosses, worn by bishops

Opus Anglicanum
English medieval embroidery

opus interrasile
pierced work, creating an openwork design from sheet metal

orans, orant
(a person) in the Early Christian attitude of prayer, with arms extended sideways and upwards

orphrey
gold embroidery; rich embroidery; a band of such work

paenula
heavy cape or cloak covering the entire body, pulled on and off over the head

Palaeologan
of the ruling dynasty (1261–1453) of the last Byzantine emperors

palla
wide cloak worn by Roman women

pallium
wide cloak worn by Roman men; wide scarf worn by western bishops

paludamentum (plural: *paludamenta*)
see **chlamys**

Pantocrator
'all-powerful', 'almighty', an image of Christ, often enthroned, holding a book on his left knee and making a gesture of benediction with his right hand

parekklesion
side-chapel; parallel church

patera
shallow bowl, usually with a handle

pattée
with arms expanding in width towards their extremities

pedum
shepherd's crook

pelta
crescent, esp. with the inner arc replaced by two smaller arcs, producing a shape with three points instead of two

pendilia
hanging ornaments

peplos (plural: *peploi*)
loose tunic worn by women, usually secured on the shoulders and falling in folds, with an inside-out swag at front and back

Peribleptos
church, monastery, etc. dedicated to the **Theotokos** he Peribleptos ('the Celebrated')

plasma
opaque variety of quartz

pounce
mark with a punch, esp. with a line of dots

praetor
police and judiciary official in the late Roman empire

prefect
title of authority, governor (e.g. Praetorian Prefect, Prefect of the City)

primikerios
senior of any group of officials (from the Latin *primicerius*, 'the one whose name is first on wax tablets')

pteruges
apron-like armour of leather or metal

putto (plural: *putti*)
chubby naked boy

pyx, pyxis (plural: pyxes, *pyxides*)
box or container

quaestor
high-ranking official, originally responsible for drafting laws

rebated
having a continuous rectangular groove or step cut on an edge

repoussé
relief produced by hammering metal from the back

sakkos
tunic (originally of sackcloth), a symbol of asceticism, penitence, etc.; later a т-shaped tunic with slit neck and broad sleeves, an imperial and ecclesiastical garment (for bishops and above)

samit
silk textile with design usually in contrasting colours

scholia
commentaries on texts, usually written in the margins of manuscripts

sedes gestatoria
chair constructed to be carried through crowds on bearers' shoulders

segmentum
woven patch of cloth applied as decoration to clothing

semissis
half-**solidus** coin

siliqua
common silver coin of the late Roman period

situla
bucket

solidus
the standard late Roman and Byzantine gold coin

steatite
stone, usually greenish in colour

suppedaneum
foot-stool

tabby
weave in which the warp units pass successively over and under single units of weft (plain or cloth weave)

tablion
one of a pair of embroidered panels sewn at right-angles to the edges of a **chlamys**

tabula ansata
'tablet with handles', commonly the representation of a tablet with lateral triangular handles, to carry an inscription

tempera
binding medium for powdered pigment

templon
screen separating the sanctuary from the nave in a church

terminus ante quem
point in time before which something must have happened, been made, etc.; cut-off date

terminus post quem
point in time after which something must have happened, been made, etc.

tessera (plural: *tesserae*)
cube from which mosaics are made

tetarteron
light-weight **solidus**; after 1092, a small flat copper coin of similar form

Theotokos
'God-bearer', the Mother of God

thiasos
revelry of the Dionysiac entourage of satyrs, maenads, etc.

thyrsos
staff capped with leaves or with pine-cone finials, an attribute of Dionysus and his entourage

tremissis
coin worth a third of a **solidus**

triptych
three panels of wood, ivory, metal, etc. joined laterally, usually by hinges, the side-panels normally folding over and concealing the centrepiece

Trisagion
'thrice holy', the Byzantine name for the western *Sanctus* (Isaiah 6.3, Revelation 4.8)

troparion
form of hymn, esp. connected with a particular Church feast

tyche
fate, fortune; personification of good fortune as protectress of a city

typikon (plural: *typika*)
liturgical calendar with instructions for each day's services; set of regulations for the administration and liturgical observances of a monastery, etc.

uncial
majuscule script (capitals) in use until about the 9th century, after which books were written in **minuscule**, with uncials used only to emphasise part of the text, etc.; relating to the ounce

vir clarissimus
'most honoured man': title of distinction, usually for public office holders, created during the late Roman empire

vir inlustris
title of distinction

Vita (plural: Vitae)
life, biography, esp. of a saint

volute
spiral scroll

weft-faced compound twill
repeating weave used for silk textiles, in which the pattern is usually created by contrasting colours of weft bound in 1:2 twill (see **samit**)

Coins appendix

Monetary history of the 4th and 5th centuries

1 Gold solidus of Constantine I, issued 313–15, mint of Trier. *Obv.*: laureate bust of Constantine I. *Rev.*: figures of Peace and the State, giving wreaths to the emperor. CM 1866,7–2,13, *RIC* 16

2 Gold solidus of Valens, issued 364–7, mint of Constantinople. *Obv.*: bust of Valens, wearing pearl diadem, cuirass and cloak. *Rev.*: two emperors with spears, together holding Victory standing on a globe, who crowns them both. CM 1860,3–29,118 (de Salis Gift), *RIC* 5b2

3 Gold solidus of Theodosius I, issued 383–7, mint of Aquileia. *Obv.*: bust of Theodosius I, wearing pearl diadem, cuirass and cloak. *Rev.*: two emperors seated, holding globe, Victory behind. CM 1990,5–41,5, *RIC* 40b

4 Gold bullion bar, late 4th century. Found in Kronstadt, Romania. Stamped, with inscriptions naming two officials, Flavianus and Lucianus, involved in its manufacture and assaying. CM 1894,12–7,1

5 Gold bullion bar, late 4th century. Found in Hungary. Impressed with three stamps (l. to r.): naming an official, Lucianus, involved in the manufacture; depicting three imperial busts; showing the goddess Fortuna seated, holding a palm branch and cornucopia, with an inscription indicating Sirmium (Mitrovica, Serbia) as the mint. Lent by the Museum of the Bank of England

6 Silver coin of Constantine I, issued 336–7, mint of Constantinople. *Obv.*: bust of Constantine I, wearing rosette diadem, cuirass and cloak. *Rev.*: soldier, holding spear and shield. CM 1857,8–12,665, *RIC* 131

7 Silver coin of Crispus, issued 324–5, mint of Nicomedia. *Obv.*: laureate bust of Crispus, wearing cuirass. *Rev.*: Constantine I with his three sons, standing under arch. CM 1897,7–5,2, *RIC* 89

8 Silver coin of Constantine II Caesar, issued 330–5, mint of Constantinople. *Obv.*: inclined bust of Constantine II wearing diadem. *Rev.*: figure of Victory, holding wreath and palm branch. CM 1983,2–6,1, cf. *RIC* 54

9 Silver full-weight siliqua of Constantius II, issued 351–5, mint of Constantinople. *Obv.*: bust of Constantius II wearing pearl diadem, cuirass and cloak. *Rev.*: votive wreath celebrating the emperor's thirtieth anniversary. CM B4443 (de Salis Gift), *RIC* 102

10 Silver reduced siliqua of Constantius II, issued *c.*358, mint of Arles. *Obv.*: bust of Constantius, wearing pearl diadem, cuirass and cloak. *Rev.*: votive wreath celebrating the emperor's thirtieth anniversary. CM B1774, *RIC* 261

11 Silver siliqua of Theodosius I, issued 383–8, mint of Constantinople. *Obv.*: bust of Theodosius, wearing pearl diadem, cuirass and cloak. *Rev.*: votive wreath celebrating the emperor's tenth anniversary. CM 1981,9–9,16, *RIC* 77b

12 Silver siliqua of Arcadius, issued 392–5, mint of Constantinople. *Obv.*: bust of Arcadius, wearing rosette diadem, cuirass and cloak. *Rev.*: votive wreath celebrating the emperor's tenth anniversary. CM 1956,4–9,28 (T. W. Armitage Bequest), *RIC* 87b

13 Silver siliqua of Zeno (457–74), mint of Constantinople. *Obv.*: bust of Zeno, wearing pearl diadem, cuirass and cloak. *Rev.*: votive wreath. CM B4639 (de Salis Gift)

14 Bronze coin of Constantine I, issued 330–5, mint of Constantinople. *Obv.*: bust of Constantine, wearing rosette diadem, cuirass and cloak. *Rev.*: two soldiers, standing either side of two standards. CM B4402, *RIC* 59

15 Bronze coin of Constantine I, issued 330–5, mint of Trier. *Obv.*: bust of Constantine, wearing rosette diadem, cuirass and cloak. *Rev.*: two soldiers, standing either side of two standards. CM 1856,4–20,10, *RIC* 537

16 Bronze coin of Constantine I, issued 335–7, mint of Constantinople. Obv: bust of Constantine, wearing rosette diadem, cuirass and cloak. *Rev.*: two soldiers, standing either side of single standard. CM 1971,6–10,46, *RIC* 137

17 Bronze coin of Constantius II, issued *c.*348, mint of Constantinople. *Obv.*: bust of Constantius, wearing pearl diadem, cuirass and cloak. *Rev.*: Roman soldier assaulting enemy horseman. CM 1876,5–5,72, *RIC* 81

18 Bronze coin of Constantius II, issued 355–61, mint of Constantinople. *Obv.*: bust of Constantius, wearing pearl diadem, cuirass and cloak. *Rev.*: Roman soldier assaulting enemy horseman. CM 1983,9–1,12, *RIC* 144

19 Bronze coin of Valentinian I, issued 364–7, mint of Constantinople. *Obv.*: bust of Valentinian, wearing pearl diadem, cuirass and cloak. *Rev.*: running figure of Victory, holding wreath. CM 1951,11–15,2462 (J. W. E. Pearce Bequest), *RIC* 21a

20 Bronze coin of Theodosius I, issued 378–83, mint of Constantinople. *Obv.*: helmeted bust of Theodosius, with spear and shield. *Rev.*: emperor with captive on ship. CM 1951,11–15,2424 (J. W. E. Pearce Bequest), *RIC* 52a

21 Bronze coin of Theodosius I, issued 378–83, mint of Constantinople. *Obv.*: bust of Theodosius, wearing pearl diadem, cuirass and cloak. *Rev.*: figure representing Constantinople seated. CM 1951,11–15,958 (J. W. E. Pearce Bequest), *RIC* 57d

22 Bronze coin of Theodosius I, issued 378–83, mint of Constantinople. *Obv.*: bust of Theodosius, wearing pearl diadem, cuirass and cloak. *Rev.*: votive wreath celebrating the emperor's tenth anniversary. CM 1951,11–15,1183 (J. W. E. Pearce Bequest), *RIC* 63b

23 Bronze coin of Marcian (450–7), mint of Constantinople. *Obv.*: bust of Marcian, wearing pearl diadem, cuirass and cloak. *Rev.*: emperor's monogram. CM 1930,7–9,15 (given by L. A. Lawrence), *LRBC* 2250

24 Bronze coin of Zeno (476–91), mint of Constantinople. *Obv.*: bust of Zeno, wearing pearl diadem, cuirass and cloak. *Rev.*: emperor's monogram. CM 1849,7–17,283, *LRBC* 2279

The foundation of Constantinople in history and coinage

1 Bronze commemorative medallion of Constantine I, *c.*330, mint of Rome. *Obv.*: helmeted bust of figure representing Constantinople, robed, holding spear. *Rev.*: figure of Constantinople enthroned, crowned by figure of Victory. CM 1844,10–15,308, *BMCRM* 4

2 Bronze commemorative medallion of Constantine I, *c.*330, mint of Rome. *Obv.*: helmeted bust of figure representing Constantinople, robed, holding spear. *Rev.*: figure of Constantinople enthroned. CM B11433, *BMCRM* 5

3 Bronze commemorative medallion, *c.*330, mint of Rome. *Obv.*: helmeted bust of figure representing Rome. *Rev.*: wolf and twins. CM B11434, *BMCRM* 6

4 Bronze commemorative medallion, *c.*330, mint of Rome. *Obv.*: helmeted bust of figure representing Rome. *Rev.*: wolf and twins in a cave, with two shepherds. CM B11435, *BMCRM* 7

5 Bronze coin of Constantine I, *c.*330, mint of Constantinople. *Obv.*: bust of Constantine I, wearing pearl diadem. *Rev.*: labarum piercing snake. CM 1890,8–4,11, *RIC* 19

6 Bronze coin of Constantine I, *c.*330, mint of Constantinople. *Obv.*: laureate bust of Constantine. *Rev.*: emperor holding spear and shield. CM 1982,10–34,199, *RIC* 16

7 Bronze coin of Constantine I, *c.*330, mint of Constantinople. *Obv.*: laureate bust of Constantine. *Rev.*: figure of Liberty standing on ship, holding two wreaths. CM 1982,10–34,200, *RIC* 18

8 Bronze coin of Constantine I, *c.*330, mint of Constantinople. *Obv.*: bust of Constantine, wearing rosette diadem. *Rev.*: figure of Rome, seated, holding figure of Victory who crowns her with a wreath. CM B4390, *RIC* 23

9 Gold solidus of the deified Constantine, *c.*337, mint of Constantinople. *Obv.*: bust of Constantine, wearing veil. *Rev.*: Constantine in four-horse chariot riding towards the Hand of God, which reaches from heaven to greet him. CM 1986,6–10,1, *RIC* 1

10 Gold solidus of Constantius II, issued 355–61, mint of Constantinople. *Obv.*: bust of Constantius, wearing pearl diadem. *Rev.*: figures of Rome (l.) and Constantinople (r.), both holding shield with inscription celebrating the emperor's fortieth anniversary. CM 1889,6–4,42, *RIC* 129

The house of Constantine and the imperial image

1 Gold medallion of Constantine I, *c.*326, mint of Thessalonica. *Obv.*: Constantine wearing the ceremonial robes of a consul, with sceptre and globe. *Rev.*: Constantine wearing toga, holding globe and sceptre. CM 1844,10–15,308, *RIC* 146

2 Gold two-solidus piece of Constantine I, *c.*327, mint of Nicomedia. *Obv.*: inclined head of Constantine. *Rev.*: seated figure of Rome, holding Victory on globe. CM 1853,5–12,218, *RIC* 133

3 Gold medallion of Constans, issued 337–40, mint of Thessalonica. *Obv.*: bust of Constans, wearing rosette diadem, cuirass and cloak. *Rev.*: three emperors, Constantine II, Constantius II and Constans, together in military dress. CM 1848,8–19,160, *RIC* 21

4 Gold medallion of Constantius II, issued 355–61, mint of Nicomedia. *Obv.*: Constantius wearing helmet and cuirass carrying spear and holding Victory, who reaches out to crown him with a wreath. *Rev.*: figure of Constantinople, enthroned, holding sceptre, and figure of Victory on globe who reaches out with wreath to crown her. CM 1845,1–9,118, *RIC* 99

5 Gold medallion of Constantius II, issued 347–55, mint of Antioch. *Obv.*: bust of Constantius, wearing pearl diadem, cuirass and cloak. *Rev.*: figure of Constantinople enthroned, holding sceptre, and figure of Victory on globe. CM 1867,1–1,916, *RIC* 69

6 Gold medallion of Constantius II, issued 333, mint of Constantinople. *Obv.*: bust of Constantius, wearing laurel wreath, cuirass and cloak. *Rev.*: Constantius in military dress, bearing a standard with two further standards behind. CM 1845,1–9,119, *RIC* 66

7 Gold siliqua of Constantine II, issued 330–40, mint of Antioch. *Obv.*: inclined head of Constantine. *Rev.*: figure of Victory, holding wreath and palm branch. CM 1844,4–25,2554, *RIC* 15

8 Gold siliqua of Constantine II, issued 330–40, mint of Antioch. *Obv.*: inclined head of Constantine. *Rev.*: emperor's name within wreath. CM 1961,8–3,1, *RIC* 32

9 Gold solidus of Constantius II, issued 347–55, mint of Antioch. *Obv.*: bust of Constantius, wearing the ceremonial robes of a consul, holding sceptre and globe. *Rev.*: two emperors, Constantius and Constans, nimbate, wearing consular robes, each holding sceptre and globe. CM 1930,7–5,1, *RIC* 75

10 Gold solidus of Constantius II, issued 347–55, mint of Antioch. *Obv.*: bust of Constantius, wearing pearl diadem, cuirass and cloak. *Rev.*: Constantius, standing in two-horse chariot, scattering coins and holding sceptre. CM 1867,1–1,918, *RIC* 77

11 Gold two-solidus piece of Constantius II, issued 347–55, mint of Antioch. *Obv.*: bust of Constantius, wearing rosette diadem, cuirass and cloak. *Rev.*: figures of Rome and Constantinople enthroned together, each holding figure of Victory on globe who reaches out to crown them with a wreath. CM 1867,1–1,917, *RIC* 101

12 Gold solidus of Julian II the Apostate (361–3), mint of Antioch. *Obv.*: bust of Julian, wearing pearl diadem, consular robes, holding sceptre and mappa. *Rev.*: Julian enthroned in consular dress, holding sceptre and globe. CM 1959,10–4,1, *RIC* 204

13 Gold solidus of Julian II the Apostate (361–3), mint of Antioch. *Obv.*: bust of Julian, wearing pearl diadem, consular robes, holding sceptre and mappa. *Rev.*: Julian in consular robes, holding sceptre and mappa. CM 1867,1–1,928, *RIC* 205

The houses of Valentinian and Theodosius

1 Gold medallion of Valentinian I, issued 367–75, mint of Trier. *Obv.*: bust of Valentinian I, wearing pearl diadem, cuirass and cloak. *Rev.*: figures of Rome and Constantinople enthroned, each holding a figure of Victory, who reaches out to crown them. CM 1854,5–29,5, *RIC* 10

2 Gold solidus of Valentinian I, issued 364–75, mint of Nicomedia. *Obv.*: bust of Valentinian I, wearing imperial mantle, holding sceptre and mappa. *Rev.*: two emperors, Valentinian I and Valens, enthroned, nimbate, each wearing

imperial mantle, holding sceptre and mappa, with feet resting on barbarian captives. CM 1845,1–9,123, *RIC* 16a

3 Silver miliarensis of Valens, issued 364–7, mint of Siscia. *Obv.*: bust of Valens, wearing pearl diadem, cuirass and cloak. *Rev.*: two emperors, Valens and Valentinian I, in military dress, each holding labarum and globe. CM 1869,5–6,6, *RIC* 3b

4 Gold medallion of Gratian, issued 375–9, mint of Trier. *Obv.*: bust of Gratian, wearing pearl diadem, cloak and cuirass. *Rev.*: figure of Rome, enthroned, holding spear and globe. CM 1867,1–1,937, *RIC* 38d

5 Silver miliarensis of Valentinian II, issued 378–83, mint of Aquileia. *Obv.*: bust of Valentinian II, wearing pearl diadem, cloak and cuirass. *Rev.*: emperor in military dress, holding shield and labarum. CM 1954,5–8,5, *RIC* 23b

6 Silver miliarensis of Theodosius I, issued 378–83, mint of Siscia. *Obv.*: bust of Theodosius, wearing pearl diadem, cuirass and cloak. *Rev.*: emperor in military dress, holding labarum and shield. CM 1846,3–27,22, *RIC* 23b

7 Gold solidus of Theodosius I, issued 378–83, mint of Constantinople. *Obv.*: bust of Theodosius, wearing pearl diadem, cuirass and cloak. *Rev.*: figure of Constantinople enthroned, holding sceptre and globe. CM R0270, *RIC* 43a

8 Gold two-solidus piece of Eugenius (392–4), mint of Trier. *Obv.*: bust of Eugenius, wearing pearl diadem, cuirass and cloak. *Rev.*: figures of Rome and Constantinople enthroned, each holding figure of Victory on globe, who reaches out to crown them. CM 1867,1–1,949, *RIC* 99

9 Gold medallion of Honorius, c.400, mint of Rome. *Obv.*: bust of Honorius, wearing pearl diadem, cuirass and cloak. *Rev.*: figure of Rome, enthroned, holding spear and globe. CM 1867,1–1,952, *BMCRM* 1

10 Gold solidus of Arcadius, issued 375–8, mint of Constantinople. *Obv.*: bust of Arcadius, wearing pearl diadem, cuirass and cloak. *Rev.*: figure of Constantinople enthroned, holding sceptre and globe. CM R0285, *RIC* 67c

11 Silver miliarensis of Arcadius, issued c.404, mint of Rome. *Obv.*: bust of Arcadius, wearing pearl diadem, cuirass and cloak. *Rev.*: emperor in military dress, holding spear and shield. CM 1867,7–4,105

The 5th century: East Roman Christian civilisation and the end of the western empire

1 Gold solidus of Theodosius II, issued 408–20, mint of Constantinople. *Obv.*: full-facing, helmeted bust of Theodosius, holding spear and shield. *Rev.*: figure of Constantinople, enthroned, holding sceptre and figure of Victory on globe, who reaches out to crown her with wreath. CM 1866,12–1,4145

2 Gold solidus of Theodosius II, issued c.420, mint of Constantinople. *Obv.*: full-facing, helmeted bust of Theodosius, holding spear and shield. *Rev.*: figure of Constantinople, enthroned, holding sceptre and cross on globe. CM 1872,6–6,7

3 Gold solidus of Theodosius II, issued c.420, mint of Constantinople. *Obv.*: full-facing, helmeted bust of Theodosius, holding spear and shield. *Rev.*: figure of Victory holding cross. CM 1904,6–4,155

4 Gold solidus of Valentinian III, issued c.425–6, mint of Constantinople. *Obv.*: full-facing, helmeted bust of Valentinian III, holding shield and spear. *Rev.*: two emperors, Theodosius II (l.) and Valentinian III (r.) enthroned, nimbate, each holding cross on globe and mappa. CM 1860,3–29,226 (de Salis Gift)

5 Gold solidus of Eudocia, issued c.422, mint of Constantinople. *Obv.*: bust of Eudocia, wearing diadem and imperial robe; above, the Hand of God reaches down in blessing. *Rev.*: figure of Victory holding cross. CM 1896,6–8,125

6 Gold solidus of Pulcheria, issued 450–7, mint of Constantinople. *Obv.*: bust of Pulcheria, wearing diadem and imperial robe; above, the Hand of God reaches down in blessing. *Rev.*: figure of Victory holding cross. CM 1860,3–29,181 (de Salis Gift)

7 Gold solidus of Licinia Eudoxia. issued c.443, mint of Constantinople. *Obv.*: full-facing bust of Eudoxia, wearing imperial robe and radiate diadem with cross. *Rev.*: Eudoxia enthroned, holding cross on globe. CM 1860,3–29,228 (de Salis Gift)

8 Silver miliarensis of Marcian, issued 450–7, mint of Constantinople. *Obv.*: bust of Marcian, wearing pearl diadem, cuirass and cloak. *Rev.*: emperor in military dress, nimbate, holding spear and shield. CM 1866,7–21,17

9 Gold solidus of Leo II and Zeno, issued c.474, mint of Constantinople. *Obv.*: full-facing, helmeted bust of emperor, holding spear and shield. *Rev.*: two emperors enthroned, Leo II (l.) and Zeno (r.), nimbate, each holding mappa. CM 1853,1–5,14

10 Gold solidus of Romulus Augustulus, issued c.476, mint of Rome. *Obv.*: full-facing, helmeted bust of emperor, holding spear and shield. *Rev.*: figure of Victory, holding cross. CM 1874,7–14,8

11 Gold solidus of Zeno, issued c.490, mint of Constantinople. *Obv.*: full-facing, helmeted bust of emperor, holding spear and shield. *Rev.*: figure of Victory, holding cross. CM 1875,5–3,18

12 Gold tremissis of Ariadne, issued 474–91, mint of Constantinople. *Obv.*: bust of Ariadne, wearing robe and diadem. *Rev.*: cross in wreath. CM 1870,2–6,1

13 Gold solidus of Anastasius, issued 491–8, mint of Constantinople. *Obv.*: bust of Anastasius, wearing robe and diadem. *Rev.*: Victory holding cross. CM 1860,3–30,1022

The empire's neighbours in west and east

1 Silver coin of Odovacer (476–93), mint of Ravenna. *Obv.*: bust of Odovacer, wearing cuirass and cloak. *Rev.*: monogram of Odovacer in wreath. CM 1882,4–5,1

2 Gold solidus of Julius Nepos, issued 476–80, mint of Milan. *Obv.*: full-facing, helmeted bust of emperor, holding spear and shield. *Rev.*: figure of Victory, holding cross. CM 1864,11–28,206 (given by E. Wigan Esq.)

3 Gold solidus of Theoderic in the name of Anastasius (493–526), mint of Ravenna. *Obv.*: full-face, helmeted bust of Anastasius, wearing cuirass, carrying spear and shield. *Rev.*: Victory holding cross. CM 1846,2–4,2, *BMC V* 63

4 Gold solidus of Theoderic in the name of Anastasius (493–526), mint of Ravenna. *Obv.*: full-face, helmeted bust of Anastasius, wearing cuirass, carrying spear and shield. *Rev.*: Victory holding cross (monogram of Theoderic in legend to right). *BMC V* 65 (de Salis Gift)

5 Silver half-siliqua of Theoderic (493–526), mint of Milan. *Obv.*: bust of Theoderic, wearing pearl diadem and cuirass. *Rev.*: monogram of Theoderic. CM 1844,4–25,2597, *BMC V* 81

6 Silver half-siliqua of Baduila (541–52), mint of Ticinum. *Obv.*: bust of Anastasius, wearing cuirass and cuirass. *Rev.*: title and name of Baduila, within wreath. CM 1853,7–16,586, *BMC V* 14

7 Gold solidus of Gondobald (473–516). *Obv.*: helmeted, full-face bust of Anastasius, carrying spear and shield. *Rev.*: Victory holding cross; monogram of Gondobald in left field. CM 1860,3–50,1005 (de Salis Gift)

8 Silver siliqua of Gunthamund (484–96), mint in Africa. *Obv.*: bust of Gunthamund, wearing pearl diadem, cuirass and cloak. *Rev.*: DN in wreath. CM 1867,1–1,2224, *BMC V* 1

9 Silver dirhem of Shapur II (307–79). *Obv.*: bust of Shapur, wearing mantle and crown. *Rev.*: sacred fire, in which is seen bust of deity between two attendants. CM 1862,10–4,57 (de Salis Gift)

10 Silver dirhem of Yazdagird II (438–57). *Obv.*: bust of Yazdagird, wearing mantle and crown. *Rev.*: sacred fire-altar between two attendants. CM 1920,5–15,193

Age of Justinian

Anastasius (494–518)

1 Gold solidus, mint of Constantinople. *Obv.*: three-quarter facing bust, with helmet and cuirass, holding spear and shield. *Rev.*: Victory holding cross. CM 1664,11–28,216 (given by E. Wigan Esq.), *BMC* 2; 1906,11–3,3 (Parkes Weber Gift)

2 Gold semissis, mint of Constantinople. *Obv.*: profile bust, wearing diadem and cuirass. *Rev.*: Victory seated on shield and cuirass. CM 1896,6–8,126, *BMC* 6; 1852,6–30,9, *BMC* 7

3 Silver siliqua, mint of Constantinople. *Obv.* as last. *Rev.*: VOT/MVLT/MTI in wreath. CM *BMC* 16

4 Copper nummus, pre-reform coinage (491–8), mint of Constantinople. *Obv.*: bust, wearing diadem. *Rev.*: monogram of Anastasius in wreath. CM B6786 (de Salis Gift); *BMC* 59; 1951,11–15,1384 (J. W. E. Pearce Bequest)

Post-reform copper coinage (498–518), mint of Constantinople

5 Follis (40 nummi). *Obv.*: profile bust, wearing diadem and cuirass. *Rev.*: large M under cross. CM 1914,7–5,13 (given by M. S. Pritchard Esq.); B6790, *BMC* 18

6 Half-follis (20 nummi). *Obv.* as last. *Rev.*: large K, cross to left. CM B6796 (de Salis Gift), *BMC* 32

7 Decanummium (10 nummi). *Obv.* as last. *Rev.*: CONCORD around large I surmounted by cross. CM 1860,7–31,1 (given by the Hon. J. L. Warner), *BMC* 34; 1904,5–11,60, *BMC* 35

8 Pentanummium (5 nummi). *Obv.* as last. *Rev.*: large E. CM B6783 (de Salis Gift)

Justin I (518–27)

9 Gold solidus, mint of Constantinople. *Obv.*: three-quarter facing bust in military gear (helmet, cuirass, spear and shield). *Rev.*: male angel holding long cross and orb. CM 1946,10–4,37 (Oldroyd Bequest); 1867,1–1,1016, *BMC* 2

10 Copper follis, mint of Nicomedia. *Obv.*: bust, wearing diadem and cuirass. *Rev.*: large M between stars and under cross. CM B6832 (de Salis Gift), *BMC* 51; B6734

11 Copper pentanummium, mint of Nicomedia. *Obv.*: bust, wearing diadem and cuirass. *Rev.*: christogram between N and E. CM B6837, *BMC* 47; 1904,4–11,75, *BMC* 48

Justin and Justinian (527)

12 Gold solidus, mint of Constantinople. *Obv.*: the emperors seated, Justin to left, Justinian to right, with cross between their heads. *Rev.*: angel facing, holding cross and orb. CM 1904,5–11,16, *BMC* 5; 1862,7–14,7, *BMC* 7

Justinian I (527–65)

13 Gold solidus, mint of Constantinople. *Obv.*: three-quarter facing bust, with spear and shield. *Rev.*: facing angel holding cross and orb. CM 1852,6–30,11, *BMC* 5; B6852, *BMC* 3

14 Gold solidus, mint of Constantinople. *Obv.*: full-faced bust, with orb and shield. *Rev.* as last. CM 1904,6–4,81, *BMC* 11

15 Silver miliarense, mint of Constantinople. *Obv.*: bust, wearing diadem and cuirass. *Rev.*: Justinian standing facing, holding spear and shield. CM 1859,10–13,64, *BMC* 26; 1904,4–3,11, *BMC* 27

16 Copper follis, mint of Constantinople. *Obv.*: facing bust, wearing helmet and cuirass, with orb and shield. *Rev.*: large M under cross, between ANNO and regnal year. CM 1906,11–3,4, *BMC* 45; B6887, *BMC* 42

17 Copper follis, mint of Antioch/Theoupolis. *Obv.*: Justinian enthroned facing, holding sceptre and orb. *Rev.*: large M under cross. CM 1849,7–17,387, *BMC* 282; B6876 (de Salis Gift), *BMC* 277

18 Silver siliqua, mint of Carthage. *Obv.*: profile bust. *Rev.*: monogram in wreath. CM 1853,7–16,322, *BMC V* 2; 1853,7–16,323, *BMC V* 5

19 Copper follis, mint of Rome. *Obv.*: profile bust. *Rev.*: large M under cross. CM B7072, *BMC V* 12; B7071, *BMC V* 10

20 Gold solidus, mint of Ravenna. *Obv.*: facing bust, holding orb and shield. *Rev.*: angel holding staff with christogram and orb. CM 1867,1–1,1021, *BMC V* 38

21 Gold semissis, mint in Sicily. *Obv.*: profile bust. *Rev.*: Victory seated inscribing numerals on shield. CM 1849,11–21,29, *BMC V* 42; 1904,5–11,10, *BMC* 20

Justin II (565–78)

22 Copper follis, mint of Constantinople. *Obv.*: Justin and Empress Sophia seated on double throne, he holds orb, she holds cruciform sceptre. *Rev.*: large M between ANNO and regnal year. CM 1909,11–5,6 (given by R. C. Thompson)

23 Copper half-follis, mint of Carthage. *Obv.*: facing busts of Justin, helmeted, and Sophia, crowned. *Rev.*: two Victories holding shield ornamented with stars, over K NM (20 nummi). CM B7189, *BMC* 268; 1904,6–4,19, *BMC* 266

24 Gold solidus, mint of Ravenna. *Obv.*: facing bust, holding globe surmounted by Victory, and shield. *Rev.*: Constantinopolis seated facing, holding spear and orb. CM B7194, *BMC* 289; B8756

Justin II and Tiberius II Constantine (26 Sept–5 Oct 578)

25 Gold solidus, mint of Constantinople. *Obv.*: crowned, facing busts of Justin and Tiberius. *Rev.*: angel holding staff with christogram and orb. CM 1938,10–2,1

Tiberius II Constantine (578–82)

26 Gold solidus, mint of Constantinople. *Obv.*: crowned, facing bust in consular robes, holding mappa in right hand and eagle-tipped sceptre in left. *Rev.*: cross on four steps. CM 1867,1–1,1025, *BMC* 11; B7222, *BMC* 3

27 Copper half-follis, mint of Thessalonica. *Obv.*: Tiberius and Empress Anastasia on double throne, he holds orb, she holds sceptre. *Rev.*: large K between ANNO and regnal year. CM 1904,6–4,153, *BMC* 60

28 Copper follis, mint of Nicomedia. *Obv.*: crowned, facing bust in consular robes, holding mappa and eagle-tipped sceptre. *Rev.*: large M between ANNO and regnal year. CM 1904,6–4,140, *BMC* 65

29 Silver half-siliqua, mint of Carthage. *Obv.*: crowned, facing bust. *Rev.*: cross dividing LV–XM, VNDI below, all within wreath. CM 1864,7–16,21, *BMC* 146; 1868,5–9,7, *BMC* 147

30 Gold tremissis, mint of Ravenna. *Obv.*: profile bust, wearing diadem and cuirass. *Rev.*: cross on steps. CM 1849,11–21,692, *BMC* 159

Maurice Tiberius (582–602)

31 Gold solidus, mint of Constantinople. *Obv.*: Maurice as consul, enthroned, holding mappa and cross. *Rev.*: angel holding staff and orb. CM 1868,5–9,8, *BMC* 1

32 Gold solidus, mint of Antioch/Theoupolis. *Obv.*: facing bust in plumed helmet, holding orb. *Rev.* as last. CM B7278, *BMC* 7

33 Copper half-follis, mint of Thessalonica. *Obv.*: Maurice and Empress Constantina on double throne supporting orb between them and each holding sceptre. *Rev.*: large K between ANNO and regnal year. CM *BMC (Tiberius II)* 59

34 Copper 12 nummi, mint of Alexandria. *Obv.*: profile bust, wearing diadem and cuirass. *Rev.*: cross between I and B. CM B7394, *BMC* 220; B7395, *BMC* 221

35 Silver half-siliqua, mint of Carthage. *Obv.*: facing bust in plumed helmet and consular robes, holding mappa and orb. *Rev.*: cross on steps within wreath. CM 1852,9–3,87, *BMC* 229; 1904,5–11,231, *BMC* 230

36 Copper decanummium, mint of Syracuse. *Obv.*: helmeted, facing bust, holding orb. *Rev.*: large X; SECI in angles. CM 1859,10–13,66, *BMC* 249; B7404, *BMC* 51

Phocas (602–10)

37 Gold solidus, mint of Constantinople. *Obv.*: crowned, facing bust, holding orb. *Rev.*: angel holding staff and orb. CM 1904,5–11,293, *BMC* 1; 1848,8–19,115, *BMC* 12

38 Copper follis, mint of Antioch/Theoupolis. *Obv.*: Phocas and Empress Leontia standing, he holds orb, she holds cruciform sceptre. *Rev.*: large M between ANNO and regnal year. CM *BMC* 102 (de Salis Gift)

39 Gold solidus, mint of Jerusalem. *Obv.*: facing bust, wearing crown and cuirass, holding cross. *Rev.*: angel holding staff and orb. CM 1969,5–18,1

Iconoclasm

Dynasty of Heraclius

Revolt of the Heraclii (608–10)

1 Gold solidus, mint of Carthage. *Obv.*: facing busts of Heraclius (beardless) and his father the Exarch Heraclius (bearded), both bare-headed and in consular robes. *Rev.*: cross on steps. CM 1867,1–1,1034, *BMC* 338

2 Copper follis, mint in Cyprus. *Obv.*: facing busts as last, but wearing crowns with pendilia. *Rev.*: large M between ANNO and 'regnal' year of the revolt. CM 1970,7–5,3

Heraclius (610–41)

3 Gold solidus, mint of Constantinople. *Obv.*: facing busts of Heraclius (with long beard and whiskers) and Heraclius Constantine, each wearing chlamys and crown. *Rev.*: cross on steps. CM *BMC* 41; 1839,12–24,471, *BMC* 39

4 Gold solidus, mint of Constantinople. *Obv.*: full-length figures of Heraclius (in centre with long beard and moustache) and his sons Heraclius Constantine and Heraclonas (Augustus from 638), each holds an orb and wears chlamys; Heraclonas wears plain cap, not crown. *Rev.* as last. CM 1904,5–11,317, *BMC* 55

5 Silver hexagram, mint of Constantinople. *Obv.*: Heraclius and Heraclius Constantine on double throne, each wearing crown and chlamys. *Rev.*: cross on steps. CM 1852,2–20,60, *BMC* 102

6 Copper follis, mint of Constantinople. *Obv.*: full-length figures of Heraclius, Heraclius Constantine and Empress Martina, each wearing crown and chlamys, and holding orb. *Rev.*: large M between ANNO and regnal year. CM *BMC* 170 (de Salis Gift)

7 Silver half-siliqua, mint of Carthage. *Obv.*: bust of Heraclius, beardless, wearing crown and chlamys. *Rev.*: facing busts of Heraclius Constantine, in crown and chlamys, and Martina, in crown with long pendilia and chlamys. CM 1849,7–7,171, *BMC* 343; 1853,1–5,166, *BMC* 344

8 Silver hexagram, mint of Ravenna. *Obv.*: Heraclius and Heraclius Constantine on double throne, each wearing crown and chlamys, and holding orb. *Rev.*: cross on steps. CM *BMC* 440–1

Constans II (641–68)

9 Gold solidus, mint of Constantinople. *Obv.*: facing bust, wearing crown and chlamys, holding orb. *Rev.*: cross on steps. CM 1904,6–4,420, *BMC* 7; 1904,10–8,3, *BMC* 6

10 Gold solidus, mint of Constantinople. *Obv.*: facing busts of Constans, with long beard and wearing plumed helmet and chlamys, and Constantine IV (Augustus from 654), wearing crown and chlamys. *Rev.*: cross on steps between full-length figures of the emperor's younger sons Heraclius and Tiberius (Augusti from 659). CM 1933,4–14,26; 1904,10–8,27, *BMC* 54

11 Gold solidus, mint of Constantinople. *Obv.*: facing bust of Constans, with long beard and moustache, wearing plumed helmet. *Rev.*: Constantine IV between Heraclius and Tiberius, each wearing crown and chlamys, and holding orb. CM 1853,7–16,71, *BMC* 65; 1904,10–8,24, *BMC* 68

12 Copper follis, mint of Thessalonica. *Obv.*: facing bust of Constans II, wearing plumed helmet. *Rev.*: large M under bust of Constantine IV, and between busts of Heraclius and Tiberius, all wearing crown and chlamys, and holding orb. CM *BMC* 253 (de Salis Gift)

13 Gold solidus (small module), mint of Carthage. *Obv.*: facing bust, beardless, wearing crown and chlamys. *Rev.*: cross on steps. CM 1904,10–8,1, *BMC* 267; Bank Collection R106, *BMC* 268

Mezezius (usurper in Sicily, 668–9)

14 Gold solidus, mint of Syracuse. *Obv.*: facing bust with beard and long moustache, wearing plumed helmet and cuirass, holding orb and shield. *Rev.*: cross on steps. CM *BMC (Constantine IV)* 54 (de Salis Gift)

Constantine IV (668–685)

15 Gold solidus, mint of Constantinople. *Obv.*: three-quarter facing bust, beardless, of Constantine IV, wearing helmet and cuirass, holding spear. *Rev.*: cross between figures of the emperor's brothers, Heraclius and Tiberius (both deposed in 681), each wearing crown and chlamys, and holding orb. CM 1904,6–4,428, *BMC* 4; 1904,6–4,427, *BMC* 5

16 Copper follis, mint of Carthage. *Obv.*: facing bust, wearing helmet and cuirass, holding spear and shield. *Rev.*: large M between bust of Heraclius and Tiberius, each wearing crown and chlamys, and holding orb. CM *BMC* 59 (de Salis Gift)

Justinian II, first reign (685–95)

17 Gold solidus, mint of Constantinople. *Obv.*: facing bust of Christ, wearing pallium and colobion, hand raised in benediction, with cross behind head. *Rev.*: full-length figure of Justinian wearing crown and loros, holding cross. CM Bank Collection R108, *BMC* 15; 1852,9–22,23, *BMC* 14

18 Gold solidus, mint of Syracuse. *Obv.*: facing bust of Justinian, wearing crown and chlamys, holding orb. *Rev.*: cross on steps. CM Bank Collection R218, *BMC* 35

Leontius (695–8)

19 Gold solidus, mint of Constantinople. *Obv.*: facing bust, wearing crown and loros, holding akakia and orb. *Rev.*: cross on steps. CM 1867,1–1,1052, *BMC* 2; 1904,12–3,7, *BMC* 4

20 Copper follis, mint of Ravenna. *Obv.*: facing bust, wearing crown and loros, holding orb. *Rev.*: large M under cross. CM *BMC* 72

Tiberius III (698–705)

21 Gold solidus, mint of Constantinople. *Obv.*: facing bust, wearing crown and cuirass, holding spear and shield. *Rev.*: cross on steps. CM 1904,10–8,62, *BMC* 3

Justinian II, second reign (705–11)

22 Gold solidus, mint of Constantinople. *Obv.*: bust of Christ, wearing pallium and colobion, hand raised in benediction, cross behind. *Rev.*: half-length figures of Justinian and his son, Tiberius (Augustus 705–11), each wearing crown, divitision and chlamys, holding cross between them. CM 1848,8–19,120, *BMC* 1; George III Collection, *BMC* 2

23 Copper follis, mint of Constantinople. *Obv.*: facing busts of Justinian and Tiberius, wearing crown and chlamys, holding between them patriarchal cross on globe inscribed PAX. *Rev.*: large M between ANNO and regnal year. CM *BMC* 8 (de Salis Gift)

Philippicus Bardanes (711–13)

24 Gold solidus, mint of Constantinople. *Obv.*: facing bust, wearing crown and loros, holding orb and eagle-tipped sceptre. *Rev.*: cross on steps. CM 1848,8–19,121, *BMC* 1

Anastasius II Artemius (713–15)

25 Gold solidus, mint of Constantinople. *Obv.*: facing bust, wearing crown and chlamys, holding orb and akakia. *Rev.*: cross on steps. CM *BMC* 2

Theodosius III (715–17)

26 Gold solidus, mint of Rome. *Obv.*: facing bust, wearing crown and loros, holding orb and akakia. *Rev.* as last. CM 1848,8–19,122, *BMC* 4

The Isaurians

Leo III (717–41)

27 Gold solidus, mint of Constantinople. *Obv.*: facing bust of Leo, wearing crown and chlamys, holding orb and akakia. *Rev.*: facing bust of his son, Constantine V (Augustus from 720), wearing crown and chlamys, holding orb and akakia. CM 1864,11–28,222 (given by E. Wigan Esq.), *BMC* 8; George III Collection, *BMC* 9

28 Silver milaresion, mint of Constantinople. *Obv.*: cross on steps. *Rev.*: names and titles of Leo and Constantine across field. CM 1914,7–5,4 (given by M. S. Pritchard Esq.), *BMC (Leo IV)* 7; *BMC (Leo IV)* 8

29 Gold solidus, mint of Rome. *Obv.*: facing bust of Leo, wearing crown and chlamys, holding orb and akakia. *Rev.*: similar facing bust of Constantine. CM *BMC* 30 (de Salis Gift); 1867,1–1,1057, *BMC* 31

Constantine V (741–75)

30 Gold solidus, mint of Constantinople. *Obv.*: facing bust of Constantine V, wearing crown and chlamys, holding cross and akakia. *Rev.*: similar facing bust of the deceased Leo III. CM 1904,12–3,12, *BMC* 3; 1867,1–1,1054, *BMC* 5

31 Silver milaresion, mint of Constantinople. *Obv.*: cross on steps. *Rev.*: names of Constantine and Leo III across the field. CM 1906,11–3,21 (Parkes Weber Gift), *BMC* 14

32 Copper follis, mint of Constantinople. *Obv.*: facing busts of Constantine V and his son, Leo IV (Augustus from 751), wearing crown and chlamys. *Rev.*: facing bust of Leo III,

wearing crown and loros, holding cross. CM George III Collection, *BMC* 25; 1904,6–4,473, *BMC* 23

33 Gold solidus, mint of Rome. *Obv.*: facing busts of Constantine and Leo IV, wearing crown and chlamys; Constantine holds orb and akakia; all below the Hand of God extending from heaven. *Rev.*: cross on steps. CM *BMC* 59 (de Salis Gift)

Artavasdus (742–3)

34 Silver milaresion, mint of Constantinople. *Obv.*: cross on steps. *Rev.*: names of Artavasdus and his son Nicephorus across field. CM 1913,5–15,1

Leo IV the Khazar (775–80)

35 Gold solidus, mint of Constantinople. *Obv.*: facing busts of Leo IV and his son Constantine VI (Augustus from 776), wearing crown and chlamys. *Rev.*: facing busts of the emperor's father Leo III and grandfather Constantine V, wearing crown and loros. CM 1848,8–19,125, *BMC* 1; 1846,9–10,161, *BMC* 2

36 Gold solidus, mint of Constantinople. *Obv.*: Leo IV and Constantine VI on double throne, wearing crown and chlamys. *Rev.* as last. CM 1852,9–3,33, *BMC* 3

Constantine VI and Irene (780–97)

37 Gold solidus, mint of Constantinople. *Obv.*: facing busts of Constantine VI (beardless) and his mother Irene, wearing crowns, he in chlamys and holding orb, she in loros with sceptre in left hand and orb in right hand. *Rev.*: Leo III, Constantine V and Leo IV seated facing, each wearing crown and chlamys. CM 1868,7–27,1, *BMC* 2; 1867,1–1,1059, *BMC* 3

38 Gold solidus, mint of Constantinople. *Obv.*: facing bust of Irene, wearing loros and crown, holding orb and sceptre. *Rev.*: facing bust of Constantine VI, wearing crown and chlamys, holding orb and akakia. CM 1852,9–3,34, *BMC* 4; 1867,1–1,1060, *BMC* 5

Irene (797–802)

39 Gold solidus, mint of Constantinople. *Obv.* and *rev.*: facing bust of Irene, wearing crown and loros, holding orb and sceptre. CM 1852,9–3,35, *BMC* 1

Nicephorus I to the Amorians

Nicephorus I (802–11)

40 Gold solidus, mint of Constantinople. *Obv.*: facing bust, wearing crown and chlamys, holding cross and akakia. *Rev.*: similar facing bust of the emperor's son Stauracius (Augustus from 803). CM *BMC* 4; 1904,6–4,440, *BMC* 7

41 Copper follis, mint of Constantinople. *Obv.*: facing busts of Nicephorus and Stauracius, each wearing crown and chlamys. *Rev.*: large M between XXX and NNN. CM 1904,5–11,421, *BMC (Leo V)* 12

Michael I Rhangabe (811–13)

42 Gold solidus, mint of Constantinople. *Obv.*: facing bust, wearing crown and chlamys, holding cross and akakia. *Rev.*: facing bust of the emperor's son Theophylactus (Augustus from 811) wearing crown and loros, holding orb and sceptre. CM 1902,6–7,27, *BMC* 1

43 Gold tremissis, mint of Constantinople. *Obv.* and *rev.* as last. CM 1986,4–21,12

44 Silver milaresion, mint of Constantinople. *Obv.*: cross on steps. *Rev.*: names of Michael and Theophylactus across field. CM 1904,5–11,390, *BMC* 2

45 Copper follis, mint of Syracuse. *Obv.*: facing bust of Michael, wearing crown and loros, holding cross. *Rev.*: facing bust of Michael wearing crown and chlamys, holding orb. CM 1904,6–4,499, *BMC (Michael III)* 20

Leo V the Armenian (813–20)

46 Gold solidus, mint of Constantinople. *Obv.*: facing bust, wearing crown and chlamys, holding cross and akakia. *Rev.*: facing bust of the emperor's son Constantine (Augustus from 813) wearing crown and loros, holding orb. CM *BMC* 1 (de Salis Gift); 1905,4–8,5, *BMC* 2

47 Copper follis, mint of Syracuse. *Obv.*: facing bust of Leo, wearing crown and loros, holding cross. *Rev.*: facing bust of Constantine (beardless), wearing crown and chlamys, holding orb. CM 1867,1–1,2348, *BMC* 31

The Amorians

Michael II the Amorian (820–9)

48 Gold solidus, mint of Constantinople. *Obv.*: facing bust, wearing crown and chlamys, holding cross and akakia. *Rev.*: facing bust of the emperor's son Theophilus (Augustus from 821 or 822), wearing crown and loros, holding orb and sceptre. CM *BMC* 1 (de Salis Gift); 1867,1–1,1061, *BMC* 2

49 Copper follis, mint of Constantinople. *Obv.*: facing busts of Michael and Theophilus, both crowned, the former wearing chlamys, the latter loros. *Rev.*: large M between XXX and NNN. CM 1918,5–3,10 (Revd E. S. Dewick Bequest)

Theophilus (829–42)

50 Gold solidus, mint of Constantinople. *Obv.*: facing bust, wearing crown and chlamys, holding patriarchal cross and akakia. *Rev.*: facing busts of the emperor's father Michael II and young son Constantine (Augustus from 830 to his early death c.831), each wearing crown and chlamys. CM 1905,10–6,32, *BMC* 8; 1848,8–19,127, *BMC* 6

51 Copper follis, mint of Constantinople. *Obv.*: three-quarter figure, wearing loros and crown, surmounted by plume, holding labarum and orb. *Rev.*: name of emperor across field. CM 1904,6–4,496, *BMC* 20; 1852,7–3,328, *BMC* 24

52 Gold solidus, mint of Syracuse. *Obv.*: facing bust, wearing crown and loros, holding cross. *Rev.*: as obv. but wearing chalmys and holding orb. CM 1846,9–10,166, *BMC* 31

Coinage and the triumph of Orthodoxy

Michael III (842–67)

1 Gold solidus, mint of Constantinople. *Obv.*: facing bust of Theodora (the emperor's mother and regent until 856), wearing crown and loros, holding orb and sceptre. *Rev.*: facing bust of Michael III and half-length figure of Thecla (the emperor's sister), both crowned; the former wearing chlamys, and holding orb, the latter wearing loros, and holding cross. CM 1867,1–1,1066, *BMC* 2; 1925,5–7,17

2 Gold solidus, mint of Constantinople. *Obv.*: facing bust of Christ, wearing pallium and colobion raising hand in benediction; cross behind head. *Rev.*: crowned, facing busts of Michael III and Theodora, the former wearing chlamys and the latter wearing loros. CM George III Collection, *BMC* 3; 1848,8–19,136, *BMC* 4

3 Gold solidus, mint of Constantinople. *Obv.* as last. *Rev.*: facing bust of Michael, wearing crown and loros, holding labarum and akakia. CM 1896,6–8,13, *BMC* 5

4 Copper follis, mint of Constantinople. *Obv.*: facing bust of Michael, wearing crown and loros, holding orb and akakia. *Rev.*: similar bust of the emperor's favourite Basil (Augustus from 866). CM *BMC* 11 (de Salis Gift); *BMC* 12

The Macedonians

Basil I (867–86)

5 Gold 4 solidi, mint of Constantinople. *Obv.*: facing bust of Christ, nimbate, wearing pallium and colobion, raising hand in benediction, holding Gospels. *Rev.*: crowned facing busts of Basil (bearded) and his son Constantine (Augustus from 868 until his death in 879), holding labarum between them; the former wearing loros, the latter chlamys. CM 1864,11–28,223 (given by E. Wigan Esq.), *BMC* 1

6 Gold solidus, mint of Constantinople. *Obv.*: Christ enthroned, nimbate, wearing pallium and colobion, raising hand in benediction, holding Gospels. *Rev.*: busts of Basil and his son Constantine as last, but holding cross between them. CM 1852,9–3,27, *BMC* 4; 1904,6–4,441, *BMC* 2

7 Copper follis, mint of Constantinople. *Obv.*: Basil and Constantine on double throne, each wearing crown and loros, holding labarum between them. *Rev.*: names of emperors across field. CM *BMC* 17 (de Salis Gift); 1914,7–5,24 (given by M. S. Pritchard Esq.)

8 Copper follis, mint of Constantinople. *Obv.*: facing half-length figure of Basil flanked by his sons Constantine (right) and Leo (Augustus from 870). Basil wears crown and loros, holds akakia; his sons each wear crown and chlamys. *Rev.*: names of the three emperors across field. CM 1853,1–5,186, *BMC* 21; *BMC* 2 (de Salis Gift)

Leo VI (886–912)

9 Gold solidus, mint of Constantinople. *Obv.*: facing bust of Virgin praying, wearing pallium and maphorion. *Rev.*: facing bust of Leo wearing crown and jewelled chlamys, holding orb. CM 1906,5–3,1, *BMC* 1

10 Gold solidus, mint of Constantinople. *Obv.*: Christ enthroned, nimbate, wearing pallium and colobion, hand raised in benediction, holding Gospels. *Rev.*: full-length figures of Leo and his son Constantine (Augustus from 908), each wearing crown, divitision and loros, and holding orb; holding cross between them. CM *BMC* 3 (de Salis Gift); Bank Collection R115, *BMC* 4

11 Copper follis, mint of Constantinople. *Obv.*: Leo and his brother Alexander (Augustus from 879) on double throne, each wearing crown and loros, holding labarum between them. *Rev.*: names of the two emperors across field. CM 1952,2–20,65, *BMC* 11; *BMC* 12

Alexander (912–13)

12 Gold solidus, mint of Constantinople. *Obv.*: Christ enthroned, nimbate, wearing pallium and colobion, raising hand in benediction, holding Gospels. *Rev.*: Alexander standing wearing crown, divitision and loros, holding orb; his hand extended towards St Alexander wearing pallium and colobion, who is crowning the emperor. CM 1905,4–8,11, *BMC* 1

Constantine VII Porphyrogenitus (913–59) and Romanus I Lecapenus (920–44)

13 Copper follis, mint of Constantinople. *Obv.*: crowned facing busts of Constantine VII and his mother Zoe (regent 914–19) holding cross between them; the former wearing loros and the latter chlamys. *Rev.*: names of Constantine and Zoe across field. CM 1852,9–3,239, *BMC* 2; 1853,1–5,182, *BMC* 3

14 Gold solidus, mint of Constantinople. *Obv.*: Romanus I standing, wearing crown and loros, holding orb; his left hand extending towards Christ, wearing pallium and colobion, who is crowning him. *Rev.*: crowned facing busts of Constantine VII (son of Leo VI) and Christopher (eldest son of Romanus, Augustus, 921–31); the former wears loros, the latter chlamys, holding cross between them. CM *BMC* 39

15 Gold solidus, mint of Constantinople. *Obv.*: Christ enthroned, nimbate, wearing pallium and colobion, raising hand in benediction and holding Gospels. *Rev.*: crowned, facing busts of Romanus I and Christopher holding cross between them, the former wearing loros, the latter chlamys. CM *BMC* 36 (Cracherode Bequest); 1848,8–19,130, *BMC* 35

16 Silver milaresion, mint of Constantinople. *Obv.*: cross on steps, oval medallion with crowned bust of Romanus I. *Rev.*: names of Romanus, his sons Stephen and Constantine (Augusti 924–45), and Constantine VII across field. CM 1853,7–16,316, *BMC* 42; 1909,10–5,27

17 Gold solidus, mint of Constantinople. *Obv.*: facing bust of Christ, nimbate, wearing pallium and colobion, raising hand in benediction and holding Gospels. *Rev.*: facing bust of Constantine VII, wearing crown and loros, holding orb. CM 1862,4–16,3, *BMC* 44

18 Gold solidus, mint of Constantinople. *Obv.*: Christ enthroned, nimbate, wearing pallium and colobion, raising hand in benediction and holding Gospels. *Rev.*: crowned figures of Constantine VII and his son Romanus II (Augustus from 945) holding cross between them, the former wearing loros, the latter chlamys. CM 1905,12–5,4, *BMC* 7; *BMC* 8 (de Salis Gift)

19 Copper follis, mint of Constantinople. *Obv.*: facing bust wearing crown and jewelled chlamys, holding labarum and orb. *Rev.*: name and title of Constantine across field. CM *BMC* 15; 1904,6–4,505, *BMC* 14

Nicephorus II Phocas (963–9)

20 Gold histamenon nomisma, mint of Constantinople. *Obv.*: facing bust of Christ, nimbate, wearing pallium and colobion, raising hand in benediction and holding Gospels. *Rev.*: crowned facing busts of Nicephorus II and Basil II (infant son of Romanus II and step-son of Nicephorus, co-emperor from 960) with cross held between them, the former wearing loros, the latter chlamys. CM 1850,11–22,5, *BMC* 1; 1906,7–6,1, *BMC* 2

21 Gold histamenon nomisma, mint of Constantinople. *Obv.* as last. *Rev.*: facing busts of Virgin, wearing stola and maphorion, and Nicephorus, wearing crown and loros, holding cross between them. CM 1905,12−5,5, *BMC* 3

22 Silver milaresion, mint of Constantinople. *Obv.*: cross on steps with medallion containing bust of Nicephorus wearing crown and loros. *Rev.*: name and titles of emperor across field. CM 1904,4−3,23, *BMC* 6; George III Collection, *BMC* 7

John I Tzimisces (969−76)

23 Gold tetarteron nomisma, mint of Constantinople. *Obv.*: facing bust of Christ, nimbate, wearing pallium and colobion, raising hand in benediction and holding Gospels. *Rev.*: facing bust of Virgin, in stola and maphorion, crowning John I, wearing loros and holding orb, under the Hand of God. CM 1935,11−7,267 (T.G. Barnett Bequest); 1852,9−3,59, *BMC* 1

Decline and debasement

Basil II (976−1025)

1 Gold histamenon nomisma, mint of Constantinople. *Obv.* as last. *Rev.*: crowned, facing busts of Basil and his brother Constantine VIII (co-emperor from 961) holding cross between them; the former wearing loros and under the Hand of God, the latter wearing jewelled chlamys. CM Bank Collection R114, *BMC* 11; 1846,10−3,15, *BMC* 10

2 Gold tetarteron nomisma, mint of Constantinople. *Obv.* and *rev.* as last. CM 1862,7−14,11, *BMC* 1

3 Silver milaresion, mint of Constantinople. *Obv.*: facing bust of Virgin, nimbate, in pallium and maphorion, holding the infant Christ. *Rev.*: legend in honour of Virgin across field. CM *BMC (John I)* 7

4 Silver milaresion, mint of Constantinople. *Obv.*: cross on steps between crowned busts of Basil, in loros, and Constantine, in chlamys. *Rev.*: names and titles of emperors across field. CM *BMC* 14 (de Salis Gift); 1914,7−5,7 (given by M. S. Pritchard Esq.)

Constantine VIII (1025−8)

5 Gold histamenon nomisma, mint of Constantinople. *Obv.*: facing bust of Christ, wearing pallium and colobion, raising hand in benediction and holding Gospels. *Rev.*: facing bust wearing crown and loros, holding labarum and akakia. CM 1852,9−3,43, *BMC* 3; 1867,1−1,1070, *BMC* 4

Romanus III Argyrus (1028−34)

6 Gold histamenon nomisma, mint of Constantinople. *Obv.*: Christ enthroned, nimbate, wearing pallium and colobion, raising hand in benediction and holding Gospels. *Rev.*: Virgin, in pallium and maphorion, crowning Romanus, wearing saccos and loros and holding orb. CM George III Collection, *BMC* 1; 1846,9−10,171, *BMC* 2

7 Silver milaresion, mint of Constantinople. *Obv.*: Virgin, nimbate, on footstool, wearing pallium and maphorion, holding infant Christ. *Rev.*: Romanus on footstool, wearing crown, saccos and loros, holding cross and orb. CM *BMC (Romanus IV)* 7 (de Salis Gift); 1918,5−3,26 (Revd E. S. Dewick Bequest)

Michael IV (1034−41)

8 Gold histamenon nomisma, mint of Constantinople. *Obv.*: facing bust of Christ, as before. *Rev.*: facing bust of Michael, wearing crown and loros, holding labarum and orb, under the Hand of God. CM 1905,10−6,32, *BMC* 1

Constantine IX (1042−55)

9 Gold histamenon nomisma, mint of Constantinople. *Obv.*: facing bust of Christ, as before. *Rev.*: facing bust of Constantine, wearing crown and jewelled chlamys, holding sceptre and orb, between two large stars. CM 1867,1−1,1072, *BMC* 7

10 Silver milaresion, mint of Constantinople. *Obv.*: Virgin praying, standing on stool, wearing pallium and maphorion. *Rev.*: Constantine standing, wearing crown and military gear, holding cross and resting hand on sheath of sword. CM 1914,7−5,6 (given by M. S. Pritchard Esq.); 1846,9−10,192, *BMC* 16

Theodora (1055−6)

11 Gold histamenon nomisma, mint of Constantinople. *Obv.*: Christ standing on stool, nimbate, wearing pallium and colobion, holding Gospels. *Rev.*: Theodora and the Virgin holding labarum between them, the empress wearing crown, saccos and loros, the Virgin in pallium and maphorion. CM 1867,1−1,1075, *BMC* 5; 1844,5−12,66, *BMC* 4

Michael VI Stratioticus (1056−7)

12 Gold tetarteron nomisma, mint of Constantinople. *Obv.*: facing bust of Virgin praying, wearing pallium and maphorion. *Rev.*: Michael standing on stool, wearing crown, saccos and loros, holding cross and akakia. CM 1852,9−3,49, *BMC* 1; Bank Collection R119

Isaac I Comnenus (1057−9)

13 Gold histamenon nomisma, mint of Constantinople. *Obv.*: Christ enthroned, nimbate, wearing pallium and colobion, raising hand in benediction and holding Gospels. *Rev.*: Isaac standing, wearing crown and military gear, drawn sword in hand. CM 1905,4−8,18, *BMC* 2; *BMC* 3

Constantine X Ducas (1059−67)

14 Gold histamenon nomisma, mint of Constantinople. *Obv.* as last. *Rev.*: Constantine on stool, wearing crown, saccos and loros, holding labarum and orb. CM *BMC* 2; 1929,4−5,15

15 Gold tetarteron nomisma, mint of Constantinople. *Obv.* as last. *Rev.*: Virgin, in pallium and maphorion, crowns Constantine, wearing saccos and loros and holding orb. CM *BMC* 5 (de Salis Gift)

16 Silver ⅓ milaresion, mint of Constantinople. *Obv.*: Virgin praying, standing on stool, wearing pallium and maphorion. *Rev.*: name and titles of emperor. CM 1913,12−5,3 (given by M. S. Pritchard Esq.)

17 Copper follis, mint of Constantinople. *Obv.*: Christ standing on stool, nimbate, wearing pallium and colobion, holding Gospels. *Rev.*: Constantine and Empress Eudocia (on left) holding labarum between them, each wearing crown and loros. CM 1852,9−3,248, *BMC* 18; 1852,9−3,249, *BMC* 19

Eudocia (1067)

18 Gold histamenon nomisma, mint of Constantinople. *Obv.*: Christ enthroned, nimbate, wearing pallium and colobion, hand raised in benediction, holding Gospels. *Rev.*: Eudocia standing between Michael VII and Constantius, the sons of Constantine X; the empress wearing crown, saccos and loros, and holding jewelled sceptre; her sons, in similar costume, each hold orb and akakia. CM *BMC* 2 (de Salis Gift)

Romanus IV Diogenes (1068−71)

19 Gold histamenon nomisma, mint of Constantinople. *Obv.*: Christ standing, nimbate, wearing pallium and colobion, crowns Romanus and Eudocia, both wearing saccos and loros and holding orb. *Rev.*: Michael VII (in centre), Constantius (left) and Andronicus (the sons of Constantine X and Eudocia), each wearing crown, saccos and loros, and holding orb and akakia. CM 1848,8−19,33, *BMC* 1; *BMC* 2

20 Gold tetarteron nomisma, mint of Constantinople. *Obv.*: bust of Virgin, wearing pallium and maphorion, holding the infant Christ. *Rev.*: crowned, facing busts of Romanus, wearing loros, and Eudocia, wearing jewelled robe, holding orb between them. CM 1935,11−17,768 (T. G. Barnett Bequest); 1867,1−1,1077, *BMC* 5

Michael VII Ducas (1071−8)

21 Gold tetarteron nomisma, mint of Constantinople. *Obv.*: bust of Virgin wearing pallium and maphorion, holding the infant Christ. *Rev.*: crowned facing busts of Michael, wearing loros, and Empress Maria, in jewelled robe, holding cross between them. CM George III Collection, *BMC* 12.

22 Silver milaresion, mint of Constantinople. *Obv.*: cross on steps between busts of Michael, wearing crown and jewelled chlamys, and Maria, wearing crown and loros. *Rev.*: names and titles of emperor and empress. CM 1852,9−3,102, *BMC* 20

Nicephorus III Botaniates (1078−81)

23 Electrum histamenon nomisma, mint of Constantinople. *Obv.*: Christ enthroned, nimbate, wearing pallium and colobion, raising hand in benediction and holding Gospels. *Rev.*: Nicephorus standing, wearing crown and loros, holding labarum and orb. CM 1904,6−4,442, *BMC* 11; 1867,1−1,1081, *BMC* 9

Copper anonymous folles, mint of Constantinople, 969−1092

24 Class A2 (attributed to Basil II). *Obv.*: bust of Christ nimbate, wearing pallium and colobion, holding Gospels. *Rev.*: 'Jesus Christ, King of Kings' across field. CM 1867,1−1,2366, *BMC (John I)* 9; *BMC (John I)* 18 (de Salis Gift)

25 G (attributed to Romanus IV). *Obv.*: bust of Christ nimbate, wearing pallium and colobion, raising hand in benediction and holding scroll. *Rev.*: bust of Virgin praying, wearing pallium and maphorion. CM *BMC (Constantine IX)* 24 (de Salis Gift); 1904,6−4,532, *BMC (Constantine IX)* 20

26 I (attributed to Nicephorus III). *Obv.*: bust of Christ nimbate, wearing pallium and colobion, raising hand in benediction and holding Gospels. *Rev.*: ornamented cross. CM 1852,9−3,379; 1852,9−3,377

The Comnenan Reform

Alexius I Comnenus (1081−1118)

Pre-reform coinage (1081−92)

1 Electrum tetarteron nomisma, mint of Constantinople. *Obv.*: Christ nimbate, wearing pallium and colobion, raising hand in benediction and holding Gospels. *Rev.*: Alexius, wearing crown and loros, holding sceptre and orb. CM 1904,5−11,397, *BMC* 25; *BMC* 26 (de Salis Gift)

2 Copper follis, anonymous class K, mint of Constantinople. *Obv.*: bust of Christ, cross behind, wearing pallium and colobion, raising hand in benediction and holding Gospels. *Rev.*: figure of Virgin praying, nimbate, wearing pallium and maphorion. CM *BMC (Constantine IX)* 26 (de Salis Gift); 1904,6−4,532, *BMC (Constantine IX)* 26

3 Electrum histamenon nomisma, mint of Thessalonica. *Obv.*: bust of Christ nimbate, wearing pallium and colobion, holding Gospels. *Rev.*: St Demetrius, nimbate in military garb and holding sword, presenting labarum to Alexius, wearing crown and loros. CM 1904,5−11,348, *BMC (Alexius III)* 12; *BMC (Alexius III)* 11 (de Salis Gift)

Post-reform coinage (1092−1118)

4 Gold hyperperon, mint of Constantinople. *Obv.*: Christ enthroned nimbate, wearing pallium and colobion, raising hand in benediction and holding Gospels. *Rev.*: Alexius, wearing crown, divitision and jewelled chlamys, holding labarum and orb, the Hand of God above. CM 1849,11−21,65, *BMC* 4; 1904,5−11,398, *BMC* 5

5 Electrum aspron trachy, mint of Constantinople. *Obv.*: Virgin enthroned nimbate, weaing pallium and maphorion, holding the infant Christ. *Rev.*: Alexius, wearing crown, divitision and sagion, holding jewelled sceptre and orb. CM 1905,4−8,26, *BMC* 13

6 Billon aspron trachy, mint of Constantinople. *Obv.*: Christ enthroned nimbate, wearing pallium and colobion, holding Gospels. *Rev.*: facing bust of Alexius, wearing crown and jewelled chlamys, holding sceptre and orb. CM *BMC* 19 (de Salis Gift); *BMC* 14 (de Salis Gift)

7 Copper tetarteron, mint of Constantinople. *Obv.* and *rev.* as last. CM *BMC* 42 (de Salis Gift); 1904,6−4,540, *BMC* 41

John II (1118−43)

8 Gold hyperperon, mint of Constantinople. *Obv.*: Christ enthroned nimbate, wearing pallium and colobion, raising hand in benediction and holding Gospels. *Rev.*: half-length figures of Virgin, wearing pallium and maphorion, and John, wearing crown and loros and holding akakia, with Hand of God overhead; they hold a cross between them. CM 1905,4−8,37, *BMC* 13; 1852,9−3,55, *BMC* 12

9 Electrum aspron trachy, mint of Constantinople. *Obv.* as last. *Rev.*: John, wearing crown, divitision and chlamys, and St George, in military garb and holding sword, holding cross between them. CM 1852,9−3,66, *BMC* 45; *BMC* 47 (de Salis Gift)

10 Gold hyperperon, mint of Thessalonica. *Obv.*: as last. *Rev.*: Virgin, wearing pallium and maphorion, crowns John, wearing divitision and loros and holding labarum and akakia. CM 1867,1–1,1083, *BMC* 43

Manuel I (1143–80)

11 Gold hyperperon, mint of Constantinople. *Obv.*: bust of Christ, beardless and nimbate, wearing pallium and colobion, raising hand in benediction and holding scroll. *Rev.*: Manuel wearing crown, divitision and chlamys, holding labarum and orb, under Hand of God. CM 1849,11–21,83, *BMC* 8; 1918,5–3,18 (Revd E. S. Dewick Bequest)

12 Electrum aspron trachy, mint of Constantinople. *Obv.* as last. *Rev.*: Virgin, nimbate wearing pallium and maphorion, crowns Manuel, wearing divitision and loros, and holding akakia and labarum. CM *BMC* 19 (de Salis Gift)

13 Electrum aspron trachy, mint of Constantinople. *Obv.*: Christ standing on dais, nimbate and wearing pallium and colobion, raising hand in benediction and holding Gospels. *Rev.*: facing figures of Manuel, wearing crown, divitision and loros and holding sheathed sword, and St Theodore, in military garb and holding sheathed sword. CM 1905,4–8,32, *BMC* 28; *BMC* 29 (de Salis Gift)

14 Electrum aspron trachy, mint of Thessalonica. *Obv.*: Virgin enthroned, nimbate and wearing pallium and maphorion, holding the infant Christ. *Rev.*: Manuel, wearing crown, divitision and chlamys and holding akakia, and St Demetrius in military garb, holding labarum between them. CM 1905,4–8,35, *BMC* 31; 1904,6–4,69, *BMC* 33

15 Copper tetarteron, mint of Constantinople. *Obv.*: Virgin, nimbate and wearing pallium and maphorion, raising arms to the Hand of God. *Rev.*: Manuel wearing crown, divitision, loros and sagion, holding sceptre and akakia. CM *BMC* 59; *BMC* 60

Andronicus I (1183–5)

16 Gold hyperperon, mint of Constantinople. *Obv.*: Virgin enthroned, nimbate and wearing pallium and maphorion, holding the infant Christ. *Rev.*: Christ wearing pallium and colobion and holding Gospels, crowning Andronicus, who wears divitision, loros and sagion and holds labarum and orb. CM *BMC* 1; 1849,11–21,84, *BMC* 2

17 Copper tetarteron, mint of Thessalonica. *Obv.*: bust of St George, nimbate and wearing tunic, cuirass and sagion, holding spear and shield. *Rev.*: Andronicus, with forked beard, wearing crown, divitision and loros, holding labarum and orb. CM *BMC* 19 (de Salis Gift); *BMC* 20 (de Salis Gift)

Isaac Comnenus, usurper in Cyprus (1184–91)

18 Billon aspron trachy, ?mint of Nicosia. *Obv.*: Virgin enthroned, nimbate and wearing pallium and maphorion, holding infant Christ. *Rev.*: Isaac wearing crown, divitision and chlamys and holding akakia, and St George in military garb and holding sword, holding orb between them. CM 1852,9–3,340, *BMC (Isaac II)* 16; 1852,9–3,318, *BMC (Isaac II)* 17

Isaac II Angelus (1185–95)

19 Gold hyperperon, mint of Constantinople. *Obv.* as last. *Rev.*: Isaac wearing crown, divitision and loros and holding sceptre, under Hand of God, with the Archangel Michael in military garb, holding sword in sheath between them. CM Bank Collection R123, *BMC* 3

20 Copper tetarteron, mint of Thessalonica. *Obv.*: bust of Archangel Michael, nimbate, wearing loros and holding jewelled sceptre. *Rev.*: bust of Isaac wearing crown and loros and holding sceptre and akakia. CM 1852,9–3,316, *BMC* 44; 1852,9–3,313, *BMC* 47

Alexius III Angelus-Comnenus (1195–1203)

21 Gold hyperperon, mint of Constantinople. *Obv.*: Christ standing on dais, nimbate and wearing pallium and colobion, raising hand in benediction and holding Gospels. *Rev.*: Alexius wearing crown, divitision and chlamys and holding akakia, and St Constantine wearing crown, divitision and loros, holding cross between them. CM 1905,12–5,6, *BMC* 3; 1867,1–1,1090, *BMC* 4

22 Electrum aspron trachy, mint of Constantinople. *Obv.* as last. *Rev.* as last, but each holds sceptre, and hold labarum between them. CM 1905,4–8,30, *BMC* 8

The Crusades

The Latins in the east

County of Edessa

1 Copper coin, Baldwin II (*c*.1110–18). *Obv.*: the count in chain armour and conical helmet, holding sword and cross. *Rev.*: bust of Christ nimbate. CM 1860,4–2,23

Principality of Antioch

2 Copper coin, Bohemund I (1098–1104). *Obv.*: bust of St Peter nimbate, raising hand in benediction and holding cross. *Rev.*: cross as the Tree of Life, Б Н М Т in angles. CM 1965,12–8,1

3 Copper coin, Roger (1112–19). *Obv.*: St George on horseback spearing dragon. *Rev.*: name and title of Roger in Greek. CM 1847,5–17,180; C1935

4 Billon denier, Bohemund III (1149–63). *Obv.*: bare head right. *Rev.*: cross. CM 1937,5–19,4 (Given by Mrs Vinicombe)

5 Billon denier, helmet type in name of Count Bohemund, issued *c*.1163–88, class C. *Obv.*: helmeted head to left. *Rev.*: cross with crescent in one angle. CM C4657; C4662

Kingdom of Jerusalem

6 Gold bezant, imitating dinars of the Fatimid caliph al-Amir (1101–30), issued in the 12th century. CM C1945; C1946

7 Gold bezant, in Ayyubid style with Christian legends, *c*.1250s. CM C1951

8 Gold *Agnus Dei* bezant, ?1260s. *Obv.*: cross, liturgical acclamation. *Rev.*: Lamb of God. CM 1979,5–4,1

9 Silver imitative dirham with Christian legend, issued at Acre, with date 1251. CM 1983,2–23,7 (given by R. W. Douglas Esq.)

10 Billon denier, in the name of 'King Baldwin', issued *c*.1140s–60s. *Obv.*: cross. *Rev.*: Tower of David. CM 1906,11–3,4954 (F. W. Parkes Weber Gift); 1876,2–2,5

11 Billon denier, in the name of 'King Amalric', issued 1160s–*c*.1219. *Obv.*: cross. *Rev.*: dome of the Holy Sepulchre. CM 1935,4–1,10326 (T. B. Clarke-Thornhill Bequest); 1938,10–7,284 (given by E. S. G. Robinson Esq.)

12 Billon denier, regency of John of Brienne (1212–25), 'Damiata' type. *Obv.*: cross. *Rev.*: facing crowned bust. CM C4694

County of Tripoli

13 Gold bezant, imitating dinars of the Fatimid caliph al-Mustansir, issued in the 12th century. CM 1879,7–9,15

14 Billon denier, in the name of 'Count Raymond', star and crescents type, later 12th century. *Obv.*: cross. *Rev.*: star and crescent. CM 1852,9–3,258; 1855,8–6,34

15 Silver gros, in the name of 'Count Bohemond', probably Bohemond VI (1268–74). *Obv.*: cross in octafoil. *Rev.*: star in octafoil. CM 1887,10–5,8; 1920,9–7,593 (F. W. Hasluck Bequest)

Kingdom of Cyprus

16 Electrum white bezant, Hugh I (1205–18). *Obv.*: Christ enthroned, raising hand in benediction and holding Gospels. *Rev.*: king wearing crown and chlamys, holding cross and orb. CM 1852,9–3,365; 1925,1–5,184

17 Silver gros grand, Henry II (1285–1306, 1312–24). *Obv.*: king seated on curule chair with animal-headed arms, wearing crown and cloak, holding sceptre and orb. *Rev.*: cross of Jerusalem. CM 1889,6–4,56; 1892,2–4,4

18 Silver gros grand, Peter I (1359–69). *Obv.*: king seated on wide throne, wearing crown and cloak, holding sword and orb, shield with lion of Cyprus by his side. *Rev.*: cross of Jerusalem. CM 1884,7–5,13

19 Silver gros grand, James II (1460–73). *Obv.*: king on horseback, wearing crown and long robe, holding drawn sword. *Rev.*: cross of Jerusalem. CM 1965,12–8,3; 1885,5–5,31

Frankish Greece

20 Copper coin, William I de Villehardouin, prince of Achaea (1246–78), struck at Corinth. *Obv.*: cross. *Rev.*: the

Acrocorinth. CM 1914,4–2,24 (given by M. Rosenheim Esq.); 1873,3–1,1

21 Billon denier tournois, William of Villhardouin, prince of Achaea (1246–78), struck at Clarenza. *Obv.*: cross. *Rev.*: *chatel tournois*. CM C1886; 1853,5–6,7

22 Billon denier tournois, Guy II de la Roche, duke of Athens (1287–1308), struck at Thebes. *Obv.*: cross. *Rev.*: *chatel tournois*. CM 1914,4–2, 748 (given by M. Rosenheim Esq.)

Latin empire of Constantinople

23 Billon trachy. *Obv.*: Christ enthroned. *Rev.*: emperor crowned by Virgin. CM B7604; 1920,8–17,124

24 Billon trachy (type sometimes attributed to Latin kingdom of Thessalonica). *Obv.*: Christ seated. *Rev.*: St Helena and St Constantine holding cross between them. CM B7591; B7592

The Greek successor states

Empire of Nicaea

Theodore I Comnenus-Lascaris

25 Billon trachy, mint of Nicaea. *Obv.*: Virgin enthroned, nimbate and wearing veil, mantle and tunic, holding infant Christ. *Rev.*: Theodore, wearing crown and long tunic and holding labarum, and St Theodore in military garb holding spear, holding cross between them. CM 1904,5–11,448, *BMC* V 3; 1904,5–11,470, *BMC* V 2

26 Silver trachy, mint of Magnesia. *Obv.*: Christ enthroned, nimbate, wearing pallium and colobion, and holding Gospels. *Rev.*: Theodore, wearing crown, mantle, tunic and sash and holding sheathed sword, and St Theodore in military garb and holding sheathed sword, holding star on staff between them. CM *BMC* V 1; 1977,11–3,1

John III Ducas-Vatatzes (1222–54)

27 Gold hyperperon, mint of Magnesia. *Obv.*: Christ enthroned, nimbate, raising hand in benediction and holding Gospels. *Rev.*: John, wearing crown and loros, and holding labarum and akakia, blessed by Virgin, nimbate in pallium and maphorion. CM 1852,9–3,61, *BMC* V 13; 1849,11–21,70, *BMC* V 8

28 Silver trachy, mint of Magnesia. *Obv.*: Christ enthroned, nimbate, holding Gospels. *Rev.*: John wearing crown, tunic and sash, and St Constantine wearing crown, tunic and sash, holding cross surmounted by star between them. CM 1852,9–3,113, *BMC* V 25

29 Silver trachy, mint of Magnesia. *Obv.*: Virgin enthroned, wearing pallium and maphorion, holding the infant Christ. *Rev.*: John, wearing tunic, mantle and sash and holding labarum and orb, crowned by Christ in pallium and colobion and holding Gospels. CM 1852,9–3,112, *BMC* V 27; 1852,9–3,111, *BMC* V 28

30 Billon trachy, mint of Thessalonica. *Obv.*: St Demetrius wearing military garb, holding spear and shield. *Rev.*: John enthroned, wearing crown and tunic, holding sceptre and orb. CM 1852,9–3,342, *BMC* V 31

31 Copper tetarteron, mint of Magnesia. *Obv.*: bust of St George, nimbate, wearing cuirass and cloak, holding spear and shield. *Rev.*: John, wearing crown, mantle, tunic and sash, holding labarum and akakia. CM 1860,3–26,109, *BMC* V 36

Theodore III Ducas-Lascaris (1254–8)

32 Gold hyperperon, mint of Magnesia. *Obv.*: Christ enthroned, nimbate, wearing pallium and colobion, raising hand in benediction and holding Gospels. *Rev.*: Theodore, wearing crown, tunic, mantle and sash and holding labarum and sword in sheath, crowned by Virgin in pallium and maphorion. CM 1852,9–3,59, *BMC* V 1; 1852,9–3,60, *BMC* V 2

33 Billon trachy, mint of Magnesia. *Obv.*: St Tryphon standing. *Rev.*: Theodore wearing crown, mantle and tunic, holding labarum-headed sceptre and orb, under Hand of God. CM *BMC* V 5 (de Salis Gift)

Empire of Thessalonica

Theodore Comnenus-Ducas (1224–30)

34 Silver trachy, mint of Thessalonica. *Obv.*: Christ enthroned, nimbate, wearing pallium and colobion, holding

Gospels. *Rev.*: Theodore, wearing crown, tunic and sash, and St Demetrius, in military garb and holding drawn sword, holding cross in circle on staff between them. CM 1904,5–11,406, *BMC* V 1

35 Copper tetarteron, mint of Thessalonica. *Obv.*: name and titles of emperor across field. *Rev.*: cross on steps between busts of Theodore, crowned and holding scroll, and St Demetrius, with sword and shield. CM 1853,1–5,188, *BMC* V 5; 1849,7–17,444, *BMC* V 6

Manuel Comnenus-Ducas (1230–7)

36 Silver trachy, mint of Thessalonica. *Obv.*: bust of Christ, nimbate and wearing pallium and colobion, raising hand in benediction and holding Gospels. *Rev.*: Manuel, wearing crown, mantle, tunic and sash and holding volumen, crowned by Virgin, wearing pallium and maphorion. CM *BMC* V 1 (de Salis Gift)

37 Billon trachy, mint of Thessalonica. *Obv.*: Archangel Michael. *Rev.*: Manuel and Archangel Michael holding representation of city of Thessalonica between them. CM 1919,5–11,4

John Comnenus-Ducas (emperor 1237–42, despot 1242–4)

38 Billon trachy, mint of Thessalonica. *Obv.*: Archangel Michael, nimbate. *Rev.*: John seated holding sceptre and akakia. CM 1904,6–4,529, *BMC (Isaac II)* 37

Empire of Trebizond

39 Manuel I (1238–63), silver trachy. *Obv.*: Virgin enthroned wearing pallium and maphorion, holding the infant Christ. *Rev.*: Manuel wearing crown, tunic and mantle, holding labrum and akakia, being crowned by the Hand of God. CM 1862,10–2,23, *BMC* V 4; 1862,10–2,24, *BMC* V 3

40 Manuel I, silver asper. *Obv.*: St Eugenius holding cross and robe. *Rev.*: as last. CM 1938,7–26,20; 1862,10–2,48, *BMC* V 11

41 Theodora (1285), silver asper. *Obv.*: St Eugenius holding cross. *Rev.*: Theodora wearing crown, tunic and sash, holding orb, left hand on breast, crowned by Hand of God. CM 1938,5–17,17; 1938,5–17,18

42 Alexius IV (1417–46), silver asper. *Obv.*: St Eugenius on horseback holding cross. *Rev.*: Alexius on horseback, wearing crown and tunic, holding sceptre. CM 1982,9–32,3; 1982,9–32,7

The end of the empire

Michael VIII Palaeologus (1261–82)

1 Gold hyperperon, mint of Constantinople. *Obv.*: bust of Virgin praying within city walls of Constantinople, with six groups of towers. *Rev.*: Michael, wearing crown and loros, supported by the Archangel Michael, kneeling to be crowned by the seated Christ who holds a scroll. CM *BMC* 3 (de Salis Gift); 1867,1–1,1092, *BMC* 2

2 Silver trachy, mint of Constantinople. *Obv.*: Virgin seated, wearing pallium and maphorion, holding medallion of the infant Christ. *Rev.*: Michael, in crown, mantle and long tunic, with hand on heart, and Archangel Michael. CM 1986,4–21,13

3 Copper trachy, mint of Constantinople. *Obv.*: seraph holding sceptre. *Rev.*: Michael wearing crown, mantle and long tunic, holding sceptre and orb. CM *BMC* 12 (de Salis Gift)

Michael VIII and Andronicus II (1272–82)

4 Copper trachy, mint of Thessalonica. *Obv.*: bust of St Demetrius. *Rev.*: Michael and his son Andronicus II holding sword between them, Archangel Michael above. CM B7618 (de Salis Gift)

Andronicus II (1282–1328), sole reign 1282–95

5 Gold hyperperon, mint of Constantinople. *Obv.*: bust of Virgin praying within walls of Constantinople. *Rev.*: Andronicus nimbate, wearing crown and loros, kneeling before Christ, nimbate, wearing pallium and colobion, and holding Gospels. CM 1839,12–24,477, *BMC* 1; 1918,5–3,20 (Revd E. S. Dewick Bequest)

Andronicus II and Michael IX (1295–1320)

6 Gold hyperperon, mint of Constantinople. *Obv.*: as last. *Rev.*: Andronicus (left, with forked beard) and Michael, each wearing loros and with hand on heart, kneeling either side of Christ, who crowns them. CM 1867,1–1,1094, *BMC* 16; 1918,5–3,21 (Revd E. S. Dewick Bequest)

7 Silver basilikon, mint of Constantinople. *Obv.*: Christ nimbate, enthroned, raising hand in benediction and holding Gospels. *Rev.*: emperors crowned and wearing loros, holding labarum between them. CM 1900,1–4,25 (given by the Hellenic Society), *BMC* 43; 1904,4–3,30, *BMC* 42

Andronicus III (1328–41)

8 Gold hyperperon, mint of Constantinople. *Obv.*: Anna of Savoy, draped, and John V wearing loros (wife and son of the emperor), both holding sceptres. *Rev.*: Andronicus nimbate, crowned and wearing loros, kneeling before Christ, nimbate and holding Gospels. CM *BMC (Andronicus II)* 24 (de Salis Gift); *BMC (Andronicus II)* 25

9 Silver basilikon (gilt), mint of Constantinople. *Obv.*: Christ enthroned, raising hand in benediction and holding Gospels. *Rev.*: Andronicus wearing crown and loros, and St Demetrius standing on stool. CM 1860,3–26,35, *BMC* 1

John V (1341–91)

10 Silver half-hyperperon (stavraton), mint of Constantinople. *Obv.*: bust of Christ nimbate, raising hand in benediction and holding Gospels. *Rev.*: facing bust of John, nimbate, wearing helmet-like crown, and draped. CM 1904,5–11,402, *BMC (John VIII)* 1; 1904,4–3,31, *BMC (John VIII)* 2

11 Silver $\frac{1}{16}$ hyperperon, mint of Constantinople. *Obv.* and *rev.* as last. CM *BMC* 1

With John VI Cantacuzene (1347–53)

12 Gold hyperperon, mint of Constantinople. *Obv.*: bust of Virgin praying, within walls of Constantinople. *Rev.*: John V and John VI, kneeling either side of Christ. CM *BMC (Andronicus II)* 20 (de Salis Gift); 1862,4–17,5, *BMC (Andronicus II)* 21

With Anna of Savoy (1351–4)

13 Copper assarion, mint of Thessalonica. *Obv.*: Anna holding sceptre and representation of the city of Thessalonica. *Rev.*: John V holding sceptre and akakia. CM 1859,10–13,70

Manuel II (1391–1423)

14 Silver half-hyperperon, mint of Constantinople. *Obv.*: bust of Christ nimbate, raising hand in benediction and holding Gospels. *Rev.*: facing bust of Manuel nimbate, wearing helmet-like crown, and draped. CM 1904,5–11,400, *BMC* 2; 1927,6–7,4

15 Silver $\frac{1}{8}$ hyperperon, mint of Constantinople. *Obv.* and *rev.* as last. CM 1982,6–32,5; 1982,6–32,6

16 Copper tornese, mint of Constantinople. *Obv.*: Manuel, holding sceptre, and St Demetrius, holding labarum, on horseback. *Rev.*: Palaeologan monogram. CM *BMC* 14 (de Salis Gift)

John VIII (1423–48)

17 Silver half-hyperperon, mint of Constantinople. *Obv.*: bust of Christ nimbate, raising hand in benediction and holding Gospels. *Rev.*: facing bust of John nimbate, crowned and draped. CM 1990,6–2,1 and 2

Constantine XI (1448–53)

18 Silver half-hyperperon, mint of Constantinople. *Obv.*: bust of Christ nimbate, raising hand in benediction and holding Gospels. *Rev.*: facing bust of Constantine nimbate, crowned and draped. CM 1990,6–2,9 and 10